D1735706

The

HOMOEROTICS

of

ORIENTALISM

The

HOMOEROTICS

of

ORIENTALISM

JOSEPH ALLEN BOONE

COLUMBIA UNIVERSITY PRESS NEW YORK

COLUMBIA UNIVERSITY PRESS
Publishers Since 1893
New York Chichester, West Sussex
cup.columbia.edu
Copyright © 2014 Columbia University Press
All rights reserved

Library of Congress Cataloging-in-Publication Data

Boone, Joseph Allen.
The homoerotics of Orientalism / Joseph Allen Boone.
pages cm
Includes bibliographical references and index.
ISBN 978-0-231-15110-8 (cloth : alk. paper) —
ISBN 978-0-231-52182-6 (ebook)
1. Homosexuality in literature. 2. Eroticism in literature. 3. Orientalism
in literature. 4. Homosexuality in art. 5. Orientalism in art.
6. European literature—History and criticism. 7. Middle Eastern
literature—History and criticism. 8. Orientalism—Europe.
I. Title.
PN56.H57B66 2014
809'.93353—dc23

2013030656

Columbia University Press books are printed on permanent
and durable acid-free paper.

This book is printed on paper with recycled content.
Printed in Canada
c 10 9 8 7 6 5 4 3 2 1

Cover image: Rudolf Lehnert, *Jeune Kayble en Algerie (orig. 1914,*
retouched with gouache and pastels 1932).
Courtesy of the Musée L'Elysée, Lausanne, and Edouard Lambelet.
Cover design: Evan Gafney Design
Book design: Lisa Hamm

References to websites (URLs) were accurate at the time of writing.
Neither the author nor Columbia University Press is responsible for URLs
that may have expired or changed since the manuscript was prepared.

In Memory of

TIMOTHY COOK

1954–2006

brilliant political scientist,

devoted friend to many,

extraodinary raconteur, and

unrepentant Francophile

CONTENTS

Acknowledgments xi

Preface: Re-Orienting Sexuality xvii

PART I: THEORY AND HISTORY

1. HISTORIES OF CROSS-CULTURAL ENCOUNTER, ORIENTALISM, AND THE POLITICS OF SEXUALITY 3

Reading Contrapuntally: Two Captivity Narratives 6

Goals, Interventions, Political Reverberations:
The Queen Boat Raid in Cairo 16

Said and *Orientalism*'s Legacies 23

Historical Contexts and Travelers' Testimonies 27

From Armchair Anthropology to Islamicate Sexuality Studies 44

2. BEAUTIFUL BOYS, SODOMY, AND *HAMAMS*: A TEXTUAL AND VISUAL HISTORY OF TROPES 51

The Beautiful Boy 54

The Sodomite and Sodomized 67

The Bath or *Hamam* 77

The Hypervirile Male Other 90

The Cruel and Effete Pasha 96

The Eunuch or Castrated Male 98

The Dancing Boy 102

PART II: GEOGRAPHIES OF DESIRE

3. EMPIRE OF 'EXCESSE,' CITY OF DREAMS: HOMOEROTIC IMAGININGS IN ISTANBUL AND THE OTTOMAN WORLD 111

Figures of Ottoman Plentitude, East and West 114

Taxonomizing Desire in Ricaut and Gazali 116

Drift, Desire, and Dissolving Designs in Loti's *Aziyade* 120

Of Encyclopedias and Cinema: Erotic Taxonomies in Koçu, Erotic Thresholds in Özpetek 144

4. EPIC AMBITIONS AND EPICUREAN APPETITES: EGYPTIAN STORIES I 163

Hyperbolic Histories of Egyptian Homoeroticism 171

Monumental Manhood and Other Recurring Tropes 180

Homo-Orientalism and Romanticism in Klunzinger 189

Homoerotic Spectacle, Orientalism, and the Realistic Detail in Flaubert 193

The Return of the Repressed in Durrell's *Alexandria Quartet* 203

The Hetero-Homoerotics of Mailer's "Big One": *Ancient Evenings* 209

5. COLONIALISM AND ITS AFTERMATHS, GIDE TO CHAHINE: EGYPTIAN STORIES II 223

No Time for Monuments: Fantasies of Reciprocity in Gide's *Carnets d'Égypte* 224

The Closet, Colonialism, and Sexual Predation in Maugham's "Cairo" 229

"H-O-M-O-S-E-X-U-A-L-I-T-Y" in the City Novels of Mahfūz and al-Aswānī 233

Epic Ambitions Revisited: Camp Monumentality in Chahine's Cinema 237

PART III: MODES AND GENRES

6. QUEER MODERNISM AND MIDDLE EASTERN POETIC GENRES: APPROPRIATIONS, FORGERIES, AND HOAXES 255

Middle Eastern Poetic Legacies 259

Improvisations on an Ottoman Original:
The Anonymous *Le livre des beaux* 262

Ethnopornography, Early Photography, and Visual Equivalents
of the *Şehrengiz* 270

Obscene Hoax: Crowley's Poetic Masquerade 279

Reviving the *Rubbiyat*: States of *Onrust* in De Haan's *Kwatrijnen* 286

Lyrical Minimalism, Diverse Monotony, and
Gide's Modernist Revision of Travel Narrative 290

Forbidden Taliban 298

7. LOOKING BACKWARD: HOMOEROTICISM IN MINIATURIST PAINTING AND ORIENTALIST ART 305

Decoding Middle Eastern Miniaturist Painting 307

European Art and the Orientalist Tradition 336

8. LOOKING AGAIN: TWENTIETH- AND TWENTY-FIRST-CENTURY VISUAL CULTURES 361

From Pre-Raphaelitism to Late Modernism 362

Postmodern Interventions 368

Photographic Legacies 383

Erotica and Pornographic Traditions 396

Visual Manifestations in Popular Culture 408

Homo-Orientalism on Screen 413

Notes 423 | *Index 475*

Color plates follow page 190

ACKNOWLEDGMENTS

Our writing projects not only take time but sometimes need to find *their* time. This has certainly proved true of *The Homoerotics of Orientalism*, a project I conceived in the 1990s. A stint chairing my department in the first half of the next decade, however, not only interrupted its process but left me wondering whether I'd ever have the energy to write a book again. To make matters worse, when I looked back at the shape of the book I'd outlined and the articles on the subject I'd published, I felt the material seemed dated, part of a moment in postcolonial theory that had already passed. Luckily, a fellowship at the Huntington Library awaited the end of my tenure as chair, and I figured that, if nothing else, I still knew how to read and research—and what more beautiful location to do so than at the Huntington? As luck would have it, working my way back into both of those activities— reading and research—not only rekindled my interest in this project; it precipitated a series of discoveries and epiphanies that gave it a new lease on life: revised thesis, historical depth, an expanded cross-cultural frame of reference, entirely new chapters.

My original project had focused primarily on projections of and fantasies about Middle Eastern homoeroticism in the work of nineteenth- and twentieth-century Western male writers. The rare book holdings at the Huntington, however, gave me the opportunity explore the prehistory of this literature, delving into hundreds of European travel narratives and histories about the Ottoman and Persian Empires, Arabic-speaking domains, and the Maghreb that had been written in the 250 years preceding 1800. And the litany of references to men's homoerotic practices in these regions—much more extensive than I'd originally thought—began to make me suspect that these texts were doing more than using sexual aspersions as political propaganda directed against infidels, doing more than projecting their own hidden desires and fears onto these foreign geographies—although, of course, both were also part of the story. If these

discoveries in the rare book room filled my mornings, my afternoons were spent in the library's tea garden reading a spate of just-published, theoretically sophisticated, and dazzling histories of Middle Eastern sexuality written by scholars (notably, Andrews and Kalpakli, Najmabadi, Ze'evi) whose fluency in Persian, Arabic, and Ottoman and modern Turkish languages allowed them to use archives that—as I detail in my preface and first chapter—radically shifted prior understandings of the degree to which male homoerotic behavior had once been an institutionalized aspect of these cultures. Between these books hot off the press and the dusty tomes I was discovering in the rare book room (such as the pamphlet "A Wonderful Accident," detailed at the beginning of chapter 1), my original thesis about Orientalism's homoerotic undercurrents gained new traction, along with a historical density and cross-cultural frame of reference that fundamentally transformed what I wanted to say and how I wanted to say it.

In a nutshell, I discarded virtually everything I'd previously written (perhaps 30 pages survive in this book) and, in the summer of 2007 I started all over, beginning on page one. Now, six years later, I feel the result is a book that has finally "found" its moment. More than ever, the arguments and narratives of cross-cultural exchange unfolded in *The Homoerotics of Orientalism* hold relevance for our present day, in which Middle Eastern politics and culture loom large on the world stage. At the same time, this contemporary moment is one in which the politics of sexuality—including break-through victories for gays and lesbians—continue to trigger passionate feelings and vehement reactions at home and abroad. If there is any "lesson" to be extracted from the long process of this book's emergence, then, it is the simple fact that a delay in one's best-laid plans is sometimes the best thing that can happen to one's scholarship: today this book offers a perspective that, in its earlier formulations, it could never have dreamt of encompassing, for the resources were not yet available to make its present scope conceivable.

Portions of this book grew out of their earlier articulations in the following articles and essays: "Modernist Re-Orientations: Imagining Homoerotic Desire in the Nearly Middle East," *Modernism/Modernity* 17.3 (2010): 561–605; "Vacation Cruises; or, The Homoerotics of Orientalism," *PMLA* 110 (1995): 89–107; "Rubbing Aladdin's Lamp," in *Negotiating Lesbian and Gay Subjects*, ed. Monica Dorencamp and Richard Henke (NY: Routledge 1994): 149–76; and "Mappings of Male Desire in Durrell's *Alexandria Quartet*," *South Atlantic Quarterly* 88 (1989): 40–77. The author is grateful to all these presses for permission to reprint and reproduce aspects of these materials.

A number of fellowships have made this book a reality, and I am immensely grateful for the support given by the Huntington Library (in conjunction with the USC Early Modern Studies Institute), Guggenheim Foundation, National Humanities Center, Liguria Study Center for the Humanities and Arts, and

Rockefeller Foundation's Bellagio Center. The last three of these fellowships were residencies which, however differing in length, provided the opportunity of daily refining my ideas by rubbing them up against some of the sharpest minds I've ever met. The entire group of fellows at the Liguria Center in Bogliasco, Italy, formed a magical circle in which creativity abounded among us all: Wendy Mitchinson, Erminia Ardissimo, Carlos Vazquez, Sandro Del Rosario, Matthew Sullivan, Karin Guisti, Rex Lingwood, Tiffany Mills, Jennifer Compton, Maria "Clemmon" Garcia, and Andrew Sundstrom. At the NHC in North Carolina, Mia Bay, Ellen Stroud, Michael Kulikowski, Jered Farmer, Mariella Bacigalupo, and Don Solomon—along with a staff of exemplary librarians including Eliza Robertson, Jean Stroud, and Josiah Drewry—stood out among the many presences whose inspiration and friendship made going to the Center each morning a joy rather than a chore; it was at the NHC, moreover, that I began to amass the bulk of the visual materials that compose the final two chapters, another turn that I would not have expected early on in this project.

Those friends and colleagues who took the time to read and critique parts of this book have my profound gratitude, as do those who have invited me to test out its sometimes controversial contents in public venues at crucial stages of its composition: Moshe Sluhovsky, Rebecca Lemon, Phiroze Vasunia, Bill Handley, Carla Kaplan, Leo Braudy, Martin Meeker, David Román, Susan McCabe, Deborah Nord, Patsy Yaeger, Wendy Moffat, Ali Behdad, Erin Carlston, Jennifer Wicke, and Mary Ellis Gibson. A special "shout out" goes to my chair, Meg Russett, who not only made resources available to help fund the color plates included in these pages but who also introduced me to "her" Istanbul by inviting me to participate in a summer Fulbright program at Boğaçizi University—in the process sharpening my awareness of the role that the Ottoman Empire once played in this book's subject-matter and, not least, endearing me to a network of friends in Turkey whose warm generosity has proved unstinting on subsequent research trips: Özlem Öğüt, Kağan Bican, Kim Fortuny, Adem Güzel, Hande Tekdemir, and Gunvald Ems, among many others. In seeking assistance in translating Ottoman and modern Turkish sources, I was lucky to be able to draw on the talents of Fatih Kursan, Yekta Zulfikar, and N. Evra Gunhan; other questions of translation were adeptly fielded by Megan Reid concerning Arabic, Phiroze Vasunia concerning Greek and Latin, and my close friend Jack Yeager concerning the finer points of French.

In addition to the tangible assists lent by all the above, I want to salute the many other friends and colleagues who have supported not only my work but my well-being over the years: Emily Anderson, Sue and Alan Armstrong, Ellen Bialo, Dorothy Braudy, David Boger, Brandon del Campo, Kate Chandler, Ken Corbett, Michael Cunningham, Stuart Curran, Lan Duong, Alice Echols, Molly Engelhardt, Rita Felski, Gail Finney, Kate Flint, Chris Freeman, Marjorie

Garber, Peter Gadol, Marianne Hirsch, Bill and Adam Holt, Dana Johnson, Kevin Kopelson, Michelle Latiolais, Kari Lokke, Madga Maczynska, Richard Meyer, Katie Mills, Viet Nguyen, Marjorie Perloff, Marilyn Reizbaum, Frank Taplin, Ricardo Trejo, Debra Shostak, Lisa Straus, Charles Van Der Horst, Nancy Vickers, Bob Vorlicky, Marianne Wiggins, Susan Winnett, and Joe Wittreich. A number of graduate students at USC have proved invaluable research assistants, but the "shining knight" of them all has been Alex Young, who time and again went the extra mile in tracking down seemingly impossible-to-locate works of art in order to secure the permission rights needed to reproduce the images that enliven these pages. My thanks, as well, to Jay Marietta, Ed Kozaczka, Alexis Landau, Pamela Grieman, and Alicia Garnier, for the time they spent as RAs working on this project.

I've been fortunate to give talks related to this book at a number of institutions and venues whose receptive audiences have kept me on my toes: Princeton University, University of Michigan, Bowdoin College, University of Virginia, UNC-Chapel Hill, Duke University, UNC-Greensboro, Cornell University, University of Puerto Rico, Wake Forest University, University of Genoa, UC Santa Cruz, UC Santa Barbara, UCLA, UC-Davis, UC-Riverside, Georgetown, Ohio State University, University of Wisconsin at Madison, SUNY-Buffalo, the Getty Center, the Eighteenth-Century Studies Group at the Huntington, the Durrell School of Corfu, the Modernist Studies Association, and the Literary, Visual, and Material Cultures Initiative at USC—my gratitude to all the hosts involved in arranging these events. Ever since Philip Leventhal first solicited the manuscript in 2007, Columbia University Press has been unflagging in its support; under Philip's guidance the manuscript has become stronger (and leaner, believe it or not!) at every stage, and the process has been made considerably easier by the good graces of his editorial assistant Whitney Johnson, Jordan Wannemacher, Roy E. Thomas, Lisa Hamm, and Ben Kolstad as well as by Kate Bresnahan's able copy-editing. To list the staff members at all the museums, galleries, and collections lending their assistance would be impossible, but I would especially like to thank Liz Kurtulik at Art Resource and Kajette Solomon at the Bridgeman Art Library for their ever-punctual responses to my many inquiries and their impressive sleuth-work.

The support of my home institution, the University of Southern California, in writing this book has been extraordinary: I want to express my gratitude, first, for the generous financial assistance made available by Dani Byrd, vice-dean in USC's Dornsife College, which helped defray the formidable cost of obtaining the permission rights for my illustrations; second, for the semester's release-time granted by Michael Quick and Howard Gilman that allowed me to pen the final words to this book; and, last but not least, for the emotional and professional support of Beth Meyerowitz, who served as Dean of Faculty during my years as

department chair—the best university administrator I've ever worked with and a role model for us all.

Deepest thanks, as well and as always, to my immediate family: my dearly loved parents, who never stinted on their sons' educations (or book allowances!) and allowed us all to become the adults we needed to be; and my band of brothers (and their extended families), whose pride in what I do has always humbled me and inspired me to try to live up to their expectations.

I dedicate this book to the memory of one of the smartest people I've ever known, Tim Cook, a friend from graduate school days in Madison, Wisconsin. His vivacious love of life and learning was tragically cut short by brain cancer in 2006; he was undergoing treatment in Los Angeles just as I began reconceptualizing this project. But while memorializing his passing, I also want to single out for a special tribute two friends whom I consider quintessential "survivors," in all senses of the word: Dale Wall and Judith Holt, who have known me longer than nearly anyone else I can think of, and whose sustaining friendships, I hope, will survive the passing of many more years.

The transcription and transliteration of Arabic, Persian, and Ottoman words into the Latin alphabet and thence English is a task made difficult by a number of factors: the absence of certain letters and sounds from one language to the other, the number of Arabic words that have over the centuries passed in whole and in part into Persian and Ottoman languages with modified spellings, the differing practices of including diacritical marks among scholars in the field and in Romanized translations over time. Whenever possible I have attempted to follow the most current, accepted usage for these terms; when determining a consensus has not been possible—and often for clarity's sake given the context of the discussion—I have followed the usage of the primary or secondary source at hand.

PREFACE

RE-ORIENTING SEXUALITY

Thirty seconds make a difference. Except for this half-minute, the silent film *Mektoub, Fantasie Arabe*—a six-minute pornographic reel shot in France in the late 1920s—would seem to conform to the well-trodden if banal Orientalist sexual fantasy of penetrating the harem. An enterprising French tourist named Dickie invades the sérail of one d'Abd-el-Zab to obtain some "unique" snapshots with his camera. ("Zab" is Arabic for penis, an inside joke that, like "Dickie's" auspiciously chosen name, indicates this pornographic fantasy is being staged as a contest of phallic domination between cultures.) It only takes minimal coaxing by Dickie to convince the harem's two female inhabitants to unveil, undress, and then belly-dance to the clicks of his camera. Before long, the intrepid ethnopornographer, to use İrwin Cemil Shick's apt term,[1] has not only joined in the action (while still taking pictures) but brought enlightened "Western" sexual knowledge to the women by introducing them to the joys of cunnilingus (the intertitle reads *Caresse inconnue au sérail!* ["caress unknown to the harem!"]). All the action to this point plays as predictable Orientalist fantasy, with Dickie's role as voyeur and amateur pornographer standing in for both the aroused male spectator and the filmmaker who creates and controls the fantasy scenario.

Predictable, that is, until the entrance of El-Zab and a male slave interrupts Dickie's frolic. Seeking to avenge his honor, the outraged master first threatens the interloper but then chooses to show his "magnanimity" (so the intertitle puts it) by sodomizing him while Dickie is simultaneously forced to fellate El-Zab's man-servant. Sandwiched between the two robed figures, whose costumes clearly mark them as "other," Dickie submits to this double penetration with surprising gusto. The *ménage à trois* lasts a scant half-minute, after which the action devolves into a series of heterosexual and lesbian pairings. Dickie,

meanwhile, resumes his trigger-happy role as voyeur-photographer until El-Zab ejects him from the tent in a comic turn that ends the film where it began, and the final title card reads *Mektoub! C'était écrit!* (It is written!). Yet this return to narrative quiescence, which ironically appropriates the fatalistic Arabic expression "mektoub" as its own final word, can't quite paper over the difference thirty seconds make. That difference can be measured, first of all, by the fact that only three of the thirty-eight examples of French vintage erotica on the DVD set on which this "fantasie Arabe" appears include instances of male–male sexuality, and second, by the fact that two of these three occur in Orientalized settings. Within Western fantasies of the "Orient" lies the potential for unexpected eruptions of sex between men that, however temporarily, disrupt European norms of masculinity and heterosexual priority.[2]

Mektoub's staging of homosexual activity in a Middle Eastern setting is not an isolated incident in popular culture's borrowings of Orientalist motifs. Hector France's fictionalized travel narrative, *Musk, Hashish, and Blood* (originally published in 1886 as *Sous le Burnous*), consists of a series of lurid vignettes that pit brute male force (both Algerian and European) against female submission (always Algerian or African). The unremittingly heterosexual drive of the narrative undergoes an abrupt turn, however, in a late chapter titled "Secrets of the Desert." Here, the narrator makes the reader privy to an event that reminds him of "Sodom and Gomorrah and the rest of the doomed Cities of the Plain": a midnight performance in the middle of a desert encampment, before an all-male Arab audience, of a group of dancing boys whose "lewd" movements inspire several of the "manly soldier-like" spahis to seek out the effeminate youths in the shadows after the performance (fig. 0.1).[3] While the revelation of this "secret" world is meant to titillate, the masculine anxiety generated by the text's depiction of men coupling with partners of the same sex is palpable in the book's soon-to-follow climax. For the final chapter, set in a French colonial encampment, overwrites the desert scene of Arab sodomy by depicting a different kind of debauch altogether, one in which naked dancing "negresses" (instead of dancing boys) entertain an audience of lusty French soldiers (instead of "soldier-like" Arab pederasts). As the spectacle devolves into a total orgy, heterosexual norms, colonial control, and race-gender hierarchies are reinstated in one fell swoop.

The fetish-like aspect of such stagings of male homoeroticism within the *mise-en-scène* of Orientalist fantasy—here one moment, gone the next—is even more graphically rendered in an otherwise forgettable soft-core adult film released in the late 1980s titled *Sahara Heat*.[4] Also known as *Amantide—Scirocco*, this French-Italian production features a sultry blonde model who has accompanied her husband to a Maghrebian location where his work at an oil-drilling facility leaves her bored and listless until she begins exploring the mysterious streets of the medina, experiencing an erotic reawakening as dark Arab eyes caress her

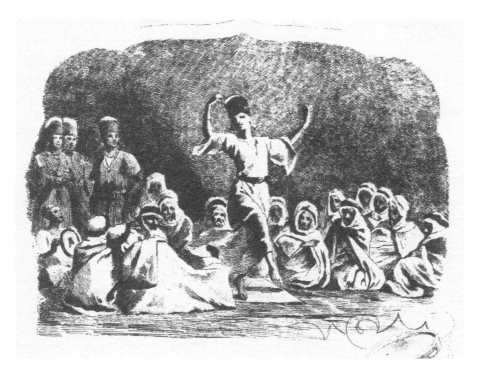

FIGURE 0.1. **Depravities in the desert.**

Paul Avril's illustration for France's *Musk, Hashish, and Blood* (1886).

scantily clad body (one of the film's many improbabilities is that she would take to the streets in such dress). A series of sexual encounters ensues, culminating in an increasingly kinky affair with the owner of an Arab café (himself a French colon). During a climactic tryst, the bar owner signals for his young café assistant to join them in a *ménage à trois*. Tellingly, the film's single instance of full frontal male nudity occurs as the North African youth strips bare. This sight is followed by another "first": the shock that registers on the woman's face as the two men reach over her body to begin kissing each other with knowing familiarity. That this irruption of homoeroticism might be discomfiting to the straight male spectators for whom the film's *Penthouse* aesthetic seems designed was confirmed, ironically, when the film resurfaced on a cable channel some years later: both the frontal male nudity and the kiss establishing the men's sexual relationship had been edited out of the sequence. What is structured as a parenthesis in the action in *Mektoub* and *Musk, Hashish, and Blood* is deliberately excised in this rebroadcasting. In this instance, the operation of the fetish (now you see it, now you don't) becomes the disciplinary mechanism of homophobia.[5]

As examples of the Orientalist imagination whose artistic credentials are minimal, these texts might seem unworthy of sustained attention. But it is precisely as examples of popular culture, stripped to the most basic of narrative templates, that they illuminate a dynamic central to this book's thesis: namely, the ghostly presence of something "like" male homoeroticism that haunts many Western men's fantasies and fears of Middle Eastern sexuality. While the association of foreignness with exoticism and perversity is a phenomenon common to most cultures, the phantasmic intensity with which Western imaginations have associated the Muslim world with male homoeroticism is noteworthy; no other geographical domain onto which the Anglo-European gaze has fixed its sometimes imperial, sometimes covetous, sometimes simply curious eye has been so associated with the specter of male–male sexuality over the centuries. Musing on such homoerotic "hauntings" of the past into the present, Dina Al-Kassim writes of the limits, for scholars of sexuality, "of knowing and naming the desire that we moderns hear"—or think we hear—"in the archive." Al-Kassim is referring to Muslim culture and the gap between its present regimes of sexuality and its disavowed homoerotic pasts, whereas the primary focus of this book concerns Anglo-European perceptions and fantasies of that heritage. But the critical issue for both projects remains the same: how can scholars excavating the history of sexuality responsibly put into words those "desires" that they feel they "hear" in past eras or in cultures different from their own, when such expressions only reach them as echoes, as ghosts, as translations, traversing time and space? Further, how is the desire to retrieve such traces of sexuality complicated when those half-heard desires are ones that have traditionally been marginalized and tabooed, censored and distorted, both in their home cultures and abroad? Faced with abundant cautions about the dangers of inadvertently projecting one's own culturally learned scripts of sexuality onto other cultures, queer scholars have been schooled, perhaps too well at times, to respect the limits "of knowing and naming" these ghostly textual voices as they echo across time and space. And yet, as Al-Kassim also warns, such wariness comes at a certain expense—"the equal risk" of "obliterating a legible if not quite translatable desire, especially when found in the archive,"[6] out of the fear of appearing to overstep disciplinary and cultural boundaries.

Crossing such boundaries is a risk that this project is willing to take. It does so in order to open a dialogue between Western perceptions and fantasies of homoeroticism in the Middle East, queer theory as it has evolved over the past decade, and the burgeoning field of sexuality studies in the Islamicate world.[7] One of the more pressing needs in humanistic study—as contemporary world politics demonstrates—is a more nuanced understanding of the myriad ways in which the West and the Middle East have been constructed in opposition to each other. Through its reading of literary, textual, and visual artifacts produced over

some four hundred fifty years, *The Homoerotics of Orientalism* probes the deep history of homoerotic fascination and homophobic aspersion that has played no small role in contributing to this mythic divide. The degree to which the vast regions of the Middle East—itself a not unproblematic term[8]—has been fodder for European *heterosexual* fantasy over the centuries is well documented, as is the degree to which the practice of Orientalism theorized by Edward Said has frequently been viewed as a heteroerotic one, in which an all-powerful, masculine "West" seeks to penetrate a feminine, powerless, and sexually available "East" in order to possess its resources. What has undergone less systematic scrutiny, however, is the large number of Anglo-European (and, later, U.S.) writers, artists, travelers, and thinkers—by and large men—who over the centuries have found themselves gripped by and compelled to attempt to represent what, to their eyes, has seemed to be the relative openness, to say nothing of abundance, of erotic relations between men in the Islamicate world.

Sometimes this homoerotic element is the result of overwrought flights of imagination, based on misprisions of unfamiliar sexual and cultural practices, and sometimes it stems from contact with the culture at hand. Sometimes it has been overtly figured as voyeuristic spectacle (enjoyed at a distance that attempts to maintain a boundary between self and other), and sometimes it has formed the clandestine goal of the traveler's erotic journey (attempting to cross that self–other divide through sexual encounter). Whether feared or desired, the mere *possibility* of sexual contact with or between men in the Middle East has covertly underwritten much of the appeal and practice of the phenomenon we now call Orientalism, sometimes repeating but just as often upending its assumed operations. Traces of this undertow abound in fiction, diaries, travel literature, erotica, ethnography, painting, photography, film, and digital media, and it encompasses real and imaginary geographies that reach from North Africa across Egypt, the Levant, and the Arab peninsula to the domains once encompassed by the Persian and Ottoman empires. In expected and unexpected ways, this vast body of work is indelibly marked by its encounter with cultures that, in Dror Ze'evi's words, "reveal none of [the modern West's] fixed, rigid boundaries distinguishing heterosexuality from homosexuality, and almost no sense of deviance from a compelling norm."[9]

The destabilizations that ensue from Europeans' exposure to these alternative understandings of sexuality—calling into question Western conceptions of masculinity, manhood, sexual/textual authority, progress, and civilization—form a rich terrain for analysis congruent with theoretical developments in many overlapping fields of intellectual inquiry: interdisciplinary and cross-cultural studies, studies in the history and theory of sexuality, studies in comparative literary and visual representation, queer theory (including its turn to transnational and diasporic subjects), and the endeavors of Middle East scholars to "queer"

their own discipline. The latter scholarship—much of which has appeared since 2005, which proved to be something of a watershed year in the field—has special resonances for this project. While uncovering and making sense of the homoerotic subtexts of Orientalism's retellings and representations is valuable in its own right, this archive only stands to gain by being read in proximity to, and beside, the explosion in scholarship now being produced by a generation of sophisticated theorists and historians of sexuality whose fluency in Arabic, Persian, and Ottoman Turkish has allowed them to unearth a vast archive of materials illuminating historical constructions of same-sex Islamicate sexuality. The texts that scholars like Janet Afary, Sahar Amer, Walter G. Andrews, Kathryn Babayan, Mehmet Kalpakli, Selim S. Kuru, Joseph A. Massad, Afsaneh Najmabadi, Khaled El-Rouayheb, Everett Rowson, and Dror Ze'evi have made available, along with the increasing translation of documents from this archive into Western languages, make it possible—as never before—to place the homo-eroticizing trajectories of Orientalism into a more dynamic framework that reverberates in intellectually challenging directions.

Hence a secondary aim of this project is to put the representations emanating from my primary European sources into dialogue, at appropriate moments, with examples selected from this Middle Eastern archive. I do so by employing what Edward Said, in *Culture and Imperialism*, has called a contrapuntal mode of analysis. Such a mode of reading—about which I will say more shortly—allows one to attend, as in music, to "various themes play[ing] off one another with no privileging of the one over the other" in order to grasp a "composite" built of atonalities. In such overlaps one can begin to perceive those affective desires and queer affinities that "we moderns hear in the archive" but cannot quite name. *The Homoerotics of Orientalism*, then, deliberately tugs in two directions at once—on the one hand, toward an excavation and interpretation of the sexual politics of Orientalism's homoerotic subtexts; on the other, toward a contextualization of the Middle Eastern sexual economies that have historically framed these Western encounters with alterity. It is my hope that what may at times appear a tension between these two goals becomes, instead, a productive aspect of this book's methodology. Inspired by Valerie Traub's observations about the benefits of creating a dialogue—whatever the challenges—between Western-originated queer theory and Islamicate studies,[10] I suggest that using the lens of male homoeroticism to bring Western and Middle Eastern discourses into proximity can help to dislodge the Eurocentric biases and historicist logic that have traditionally organized the binary relation of Orient and Occident in an unequal hierarchy (one in which the West always represents a more advanced stage of development, while the East is perpetually doomed to play catch-up). In *Provincializing Europe*, Dipesh Chakrabarty posits the necessity of conceptually repositioning Europe, its intellectual traditions, and its teleological narratives of

progress as simply one part, albeit an indispensable one, of a "radically heterogenous" world, rather than as the tacitly assumed center from which all ideas radiate outward to the less enlightened.[11] Likewise, the unsettling reverberations set into motion by Western encounters with homoeroticism in the Middle East begin to "provincialize" not only Europe but also its received histories of sexuality, calling into question the self-defeating logic that has traditionally posited East and West, hetero- and homosexuality, pre-modern and modern, as mutually exclusive terms. As such, unraveling the homoerotics of Orientalism also has the critical potential to help scholars rethink the distinction between acts-based understandings of sexuality (assumed to be pre-modern) and identity-based understandings (assumed to be modern) that, since Michel Foucault's *The History of Sexuality*, have been accepted as axiomatic in studies of sexuality and queer theory.[12]

A number of relatively recent studies focused on issues of sexuality, gender, and/or empire have made bridging the imagined divide between East and West the keystone of their methodologies, often to dazzling results that inspire my own cross-cultural endeavors. Perhaps the most audacious and creative is Walter G. Andrews and Mehmet Kalpakli's *The Age of Beloveds: Love and the Beloved in Early-Modern Ottoman and European Culture and Society* (2005), which uses literary representations of the "beloved," most often a youthful male object of desire, to argue that Ottomans and Europeans in the early modern era were actually "much more *like* one another than either group [is] like us today."[13] For an earlier period, Sahar Amer in *Crossing Borders: Love Between Women in Medieval French and Arabic Literatures* (2008) brilliantly uncovers a tradition of cross-cultural literary borrowing, one in which Old French texts depicting female same-sex desire take their cue from medieval Arabic literature. As one commentator notes, Amer's illumination of "a shared history that crosses the imagined divide between worlds throw[s] into stark relief the confidence with which the East/West distinction is deployed today to justify countless forms of Orientalism."[14]

Likewise, Mary Roberts's *Intimate Outsiders: The Harem in Ottoman and Orientalist Art and Travel Literature* (2007) makes an important intervention in studies of European art and Turkish social history by tracking the cross-cultural connections forged between European women artists and their Ottoman female patrons who were also harem wives.[15] Predating the 2005 watershed I previously mentioned, Nabil Matar's *Turks, Moors, and Englishmen in the Age of Discovery* (1999) contains an exemplary chapter that demonstrates how the intensified English rhetoric of sodomy used to demonize the Turks—in response to anxieties about Ottoman imperial ambitions—was borrowed from tropes used to demonize native Americans in the conquest of the New World Americas.[16] Some of these studies draw on multiple languages to develop their archives; some

create dialogues between cultural production and consumption; some use a primary focus on European literature to encompass a wide-ranging triangulation of disparate cultures. But all of these works, as well as the essays that Kathryn Babayan and Afsaneh Najmabadi have gathered together in *Islamicate Sexualities: Translations Across Temporal Geographies of Desire* (2008), demonstrate in their various ways the power of "historical interarticulations and complications of Eastern and Western bodies, desires, aesthetic traditions, and analytical paradigms" to confound "the very terms by which our understanding of East and West are devised."[17] For neither term is served by a binary logic that, as Lisa Lowe argues, "suppress[es] the specific heterogeneities, inconsistencies, and slippages" that make up East and West alike.[18]

Reading for such "interarticulations and complications," such "inconsistencies and slippages," as they simultaneously betray and disguise their presence in textual expressions is, of course, the traditional forte of the literary specialist trained to read closely and deeply, attending to nuance, suggestion, indirection, and contradiction in the written word and in the narrative structures and genres used to convey meaning—a fact that explains, perhaps, why some of our most astute readers of culture began their careers as literary scholars. Likewise, the cultural work undertaken in this book overwhelmingly owes to the perspective I bring to its sources as a literary scholar trained in close reading—or what I have called, elsewhere, "close(ly felt) reading"[19]—and in theories of narrative.

All the materials amassed in this archive—from Italian travel accounts to epic Ottoman poems, from Persian miniatures to French pornography, from Arab *ghazals* to Dutch *rubbiyats*—are forms of cultural storytelling, a fact as true of visual texts as written ones. Attending to the complex, often contradictory, structures of meaning that exist within and between these myriad stories—asking how they are told as well as why they are told—yields a degree of analytical depth, of interpretive finesse, sometimes absent in cultural studies and in traditional modes of historical research. The former practice, when too broadly synthetic or too narrowly ideological, tends to assemble its evidence piecemeal and with equal weight across the board in service of a predetermined story, while in the latter discipline the empirical rather than interpretive status of the assembled materials forms its primary value. In contrast, the method of contrapuntal reading advocated in the following pages attempts to imagine the interpretive possibilities that exist between the lines, on the micro-level of narrative, in order to ferret out the important but sometimes nearly invisible role that a homoerotics of Orientalism has played in constructing the West's received histories of sexuality. On a macro-level, this project aims to contribute to the larger epistemological project, shared with the forementioned scholars, of helping to undo the binary pairings that have tended to define East and West, conceptions of normative and non-normative sexualities, and practices and identities in oppositional terms.

In the process, I hope to illuminate the myriad, rather than singular, forms of sexuality and eroticism that have in fact always traversed these politically freighted, ideologically constructed divides from a number of directions.

The two figures of speech I have just used—"reading between the lines" and "reading deeply"—merit some further words of explanation. For at least some historians, the idea of reading between the lines is tantamount to finding "what is not there," creating castles in the air rather than uncovering hard facts;[20] such activity only confirms the suspicion that literary interpretation is feckless and irresponsible, and no more so than when it attempts to address "real world" problems. But, as should by now be clear, "reading between the lines" signifies, for my purposes, a *critical* sensitivity to complexity and nuance as well as a *creative* ability—imaginative at times, to be sure, but also deeply analytical—to take the "betweenness" of the words that form the "lines" on the page as opportunities for rumination, for teasing out the latent possibilities of meaning that their choice, arrangement, connotative possibilities, and placement within larger units of structure and generic modes suggest; such a mode of reading helps us perceive the subtle ideological layerings and psychological compulsions that compel the narrative inscription in the first place. In the same vein, "reading deeply" means to suggest the activity of paying sustained attention to the multiple discourses that comprise any narrative act, entertaining both the synchronic and diachronic paths that words, phrases, sentences, style, repetition, and verbal echoes and dissonances create in a text. Such connotations of "depth" should not be confused with what Eve Kosofsky Sedgwick identifies as "the topos of depth or hiddenness" and attendant "drama of exposure" that she associates with the practice of paranoid or suspicious reading dominating much literary and cultural theory for two decades. As Sedgwick explains, such a hermeneutics of suspicion assumes in advance that a text can only be read against itself or as symptomatic of its own repressions—a process that, as Rita Felski wittily puts it, "rediscovers its own gloomy prognosis in every text."[21] In contrast, the kind of deep or close(ly felt) reading I have in mind opens one up to surprise, the unforeseen, and discovery; it heightens the imaginative curiosity, the ability to make surprising connections, that underlies lasting scholarship.

Several critics have promoted interpretive models that inform the reading methodology developed in these pages, particularly as I place the European archive of Orientalist erotics into dialogue with documents, images, and ephemera emanating from various regions of the Middle East. I have already mentioned Said's evocative concept of reading contrapuntally. True, the meanings he gives the term "contrapuntal" throughout *Culture and Imperialism* range widely and sometimes clash: contrapuntalism describes simultaneously a more or less traditional understanding of comparative literature as a discipline, the overlapping yet dissonant histories of metropolitan center and colonized periphery,

and, as already mentioned, the idea of musical counterpoint, in which various themes play off each other without one taking precedence. The latter musical analogy strikes me as the most helpful, providing a non-univocal model for "think[ing] through and interpret[ing] together experiences that are discrepant, each with its particular agenda and pace of development, its own internal formations, its internal coherence and system of external relationships, all of them coexisting and interacting with others."[22] In regard to my use of Western source materials—some of which, on first and even second glance, may seem stereotypically Orientalist—I also find great inspiration in the methodology that Ann Laura Stoler advocates for reading "along the grain" of the colonial archive, rather than pushing "against" it as much postcolonial and transnational theory has tended to do. That is, instead of automatically considering such material to be "skewed and biased," and therefore unlikely to yield anything we don't already know, Stoler encourages the scholar to "allow oneself to falter" in reading, following the "stammer" of the archive and listening for "unsure and hesitant sorts of documentation," the hiccups and marginal asides that are audible even within the most official colonial pronouncements and protocols. Reading "along the grain" of the archive all the better reveals its contents as "condensed sites of epistemological and political anxiety."[23] As one such site, the homoerotics of Orientalism becomes a crucial nodal point for unraveling the interimplications of sexuality and power in Western constructions of the East.

To break out of dualistic modes of thought, Sedgwick has proposed that we abandon the prepositions *beneath* and *beyond* as metaphors for critical interpretation, since both can too easily transform into narratives of origin and telos. In their place, Sedgwick suggests that we embrace the conceptual possibilities of the term "beside," which suggests "a number of elements may lie alongside one another, though not an infinity of them."[24] Like Said's notion of contrapuntality, Sedgwick's "beside" opens up the possibility, methodologically speaking, of examining a range of desires and affects in relations that are contingent, proximate, and partial. Such a planal perspective is particularly well suited to the study of cross-cultural encounters and sexualities, both of which are inherently multivocal. Even when one relation or set of relations is prioritized—for we prioritize, perforce, by the very act of writing critically—the governing conception driving one's passion to interpret remains open to dialogue, conditionality, multi-perspectivalism, and conceptual complexity. This notion of reading "beside" nicely complements Stoler's notion of reading "along" the grain; it also resonates with Roberts's practice of cross-cultural analysis, in which "attending to the movement of ideas and images across cultural boundaries" makes it possible to analyze authority moving in multiple directions. Attending to multidirectional flows is a central conceit in recent global, transnational, and diasporic studies; it also marks debates about the migration of queer theory to

non-Western cultures.[25] So, too, the contrapuntal interplay between the various texts, artifacts, and representations taken up in the following pages—as well as the contrapuntal interplay between cultures, time periods, literary genres, and artistic modes—can bring into heightened prominence the underlying queerness of the words and worlds of the familiar and foreign, the past and present. As Ali Behdad puts it, such interplay provokes the "rediscovery of new traces of the past today, a recognition that transforms belatedness into a politics of contemporaneity."[26]

Having given a sense of my goals and outlined my method of reading, I want to make some caveats, primarily about what this project is *not*. First, while it draws deeply on recent studies on the history of Islamicate sexuality and while it shares affinities with attempts to "queer" the broad field known as Near East or Middle East area studies, this book is not an example of the field itself, given my lack of in-depth training in the languages needed to read these source materials in the original. Fortunately, however, the increased translation of relevant texts makes it possible to engage intelligently, if partially, with its literatures of sexuality. While much of what I say about these sources may not surprise the Middle East studies specialist, I hope the specific angle of vision I bring to this body of literature by putting it in proximity to European perspectives, projections, and representations inspires continued conversation between our disciplines and fields of expertise. Second, this book maintains a tangential or proximate relation to studies in transnationality, globalism, and diaspora that have largely superseded the postcolonial turn of the 1980–1990s. *The Homoerotics of Orientalism* may best be said to exist "beside" such scholarship—including the transnational turn in queer theory—rather than being an example of the same enterprise. My primary focus on Anglo-European representations as they emerge from the contact zone of cross-cultural encounter and on the homoerotic undercurrents of Western Orientalism situates my work in a sometimes but not always congruent intellectual framework with transnational queer theorists. Third, this is not a work of history, although it fills a gap in literary history. The historian's methodologies, standards of data collection, and use of empirical evidence necessarily differ from the interpretive aims of literary-cultural inquiry. Fourth, this book is not a work of art history, even though it aims to contribute to the burgeoning study of visual culture. The criteria that the traditional art historian brings to bear on visual representations—provenance, display, reception—sometimes but not always inflect my reading of images that I have culled from a variety of visual media and analyze in tandem with nonvisual modes and genres of cultural expression.

Fifth, my focus on male homoeroticism means that the role played by women in this study is limited. Women, of course, are not immune from participating in the male homoerotics of Orientalism I trace here; one thinks of Sylvia

Sleigh's feminist revision of the male hamam in her painting *The Turkish Bath* (see chapter 2), the implications of Isabelle Eberhardt's quest for erotic fulfillment with North African men dressed as an Algerian man, and the fact that the main illustrator literally and figuratively giving body to the homoerotic subtexts of Reşat Ekram Koçu's *İstanbul Ansiklopedisi* was female (see chapter 3). Such overt participation, however, is minimal. But this doesn't mean women do not also leave their trace on my subject matter in more subtle ways—for instance, in the Islamicate segregation of male-female worlds, a formation that, on the one hand, fostered the intensely male homosocial public sphere that assigned desire between men a structural place within its system, and that, on the other, no doubt greatly influenced what foreigners (again mostly male) assumed they were seeing in the public spaces to which they had access. The realm to which they didn't have access—the private and domestic spheres occupied by Middle Eastern women—is what gave rise, as so many travel narratives document, to clichéd fantasies of Sapphic goings-on in the harem. While female-female eroticism was indeed written about by Middle Eastern writers, primarily in medical treatises and bawdy compilations (both by men), it is much more difficult to create a contrapuntal interplay between Western and Middle Eastern sources on lesbianism of the sort that this book attempts; the homoerotics of female Orientalism is an elusive story that has yet fully to be told.[27]

Along with these caveats, I'd like to address a few of the specific challenges that a project of this nature entails and relate these challenges to ongoing debates in contemporary theory. The first has to do with this book's scope and breadth, ranging as it does from tales of capture by Algerian corsairs to postmodernist examples of Iranian art. It is difficult enough to honor the specificities of cultural differences and sexual practices within a given area or epoch; doing so across nations, cultures, and languages complicates the task considerably. Western scholars analyzing non-European contexts face the added challenge, as Chakrabarty notes, of needing to "avoid the much-feared academic charges of essentialism, Orientalism, and monolingualism," a task only exacerbated by the fact that we always "think out of particular accretion[s] of histories that are not always transparent to us."[28] The problem isn't simply a "Western" one, however. Middle East scholar Dror Ze'evi, too, feels the need to defend his synthetic study of patterns in four centuries of Ottoman sexual discourse against charges of essentialism, underlining his conviction that in "discussing discourses of sex . . . a long-durée historical method is required."[29] In both Western and Eastern scholarship on Islamicate gender and sexuality, there has also been the tendency to apply textual sources from earlier periods indiscriminately to the present, a practice that feeds into the stereotype of the "Orient" as a changeless, timeless realm.[30] Tied to the complexities of negotiating the breadth encompassed by this project is the fact that Middle East studies is far from uniform; specialists in its various branches—languages,

literatures, political history, social history, religion, philosophy—may espouse widely varying attitudes about the exploration of issues touching on sexuality (and particularly homosexuality) and about the applicability of Western scholarship to their fields. The non-specialist in Middle East studies, moreover, is likely to be unaware of historically and regionally conditioned tensions between, say, Arabists and Ottomanists, or Ottomanists and Persian scholars, creating minefields for the unwary. At the same time, as Khaled El-Rouayheb and other scholars of the Middle East forcefully argue, "an *overemphasis* on . . . differences" can obscure continuities that extend over time and region and make systematic analysis both possible and desirable.[31] And, as Traub and Al-Kassim state in pointed critiques of what they identify as a tendency to reverse-essentialism in one prominent critique of gay human rights organizations working in the Middle East, there is a real danger in rejecting all interactions with the "foreign" in the name of a presupposed and isolating cultural authenticity.[32]

A second challenge involves what might be seen as the Eurocentrism of a project that prioritizes Western perspectives and literary imaginings of the Middle East. Such a concern relates to Chakrabarty's call to de-center or "provincialize" Europe as the fount from which knowledge flows outwards to third-world geographies. It also marks the critique that Arnaldo Cruz-Malavé and Martin F. Manalansan make, in the context of the rapid globalization of gay culture, about the "unidirectional path" of criticism that takes Western culture as the point of origin and places non-Western societies in "the discursive position of 'targets' of such exchanges."[33] While the writers and artists considered in this book indeed make non-Western societies their subject matter and sometimes do so by objectifying and speaking for the objects of their contemplation, the act of representing alterity does not mean that all perceptions originating in the West are inevitably made in bad faith; such a viewpoint overlooks the degree to which the dialogic nature of such "exchanges" may inform and, at times, transform the narrating observer.

Another challenge this work faces is that of writing frankly yet inoffensively about homosexuality in the context of the Middle East. Janet Afary glosses this problem at the beginning of *Sexual Politics in Modern Iran*, when she notes that "even speaking about the pervasive homoeroticism of the region's pre-modern culture [has] been labeled 'Orientalism,'" and Najmabadi wryly notes that "crossing from eros to sex" in discussions of homoeroticism in Iranian scholarship "seems to make everyone screech to a halt."[34] Potentially offensive words are one matter. Visual images are another, as some strong responses to the visual component of my research have instructed me. While, as Jarrod Hayes warns, the Western-based critic needs to be careful not to lapse into "armchair" sexual tourism or voyeurism when discussing non-Western desires and erotics, I think he is also right to be suspicious about the underlying motives that occasionally

have singled out gay-focused work on the Middle East as especially exploitative.[35] Why a thoughtful analysis of Lehnert and Landrock's photographs of semi-nude male models in Tunis and Cairo should incite a more negative response than Malek Alloula's reproduction of postcards of nude "harem" women in Algeria bespeaks, I suspect, a degree of unconscious homophobia at work (I should make clear that I am talking as much about Western reactions to such imagery as non-Western reactions). My solution has been to make it clear that the sexually explicit materials incorporated here are integral parts of an overall argument, not descriptive iterations that uncritically replicate the offending exoticism of the text or image at hand.

A fourth challenge has to do with the efficacy of using conceptions of homosexuality, gay identity, and queerness as they have evolved in the modern West to describe and understand Middle East formations of same-sex desire over time. The debate goes in many directions, from admonishments to avoid anachronistically applying the term "homosexuality" to sexual cultures that operate outside the hetero/homo binary, to warnings about the globalization of gay identity as yet one more pernicious instance of a "colonial narrative of development and progress"[36] (a universalizing narrative that casts the non-West as pre-modern and backwards, in need of the West's "missionary" efforts to achieve sexual liberation). Then there are those voices that argue, to the contrary, that these warnings, "in spite of [their] stated anticolonial intentions, might lead to an Anglo-American monopoly on queerness that repeats the exclusionary gestures many constructionists have used to define Western homosexuality."[37] Such inflexible constructionism, in turn, as Al-Kassim and Najmabadi point out, unthinkingly falls back on the Foucauldian distinction between sexual acts and sexual identities as a default mode of understanding Middle East homoeroticism, thereby obscuring the actual interplay of practices (what one does) and identity (what one thinks one is) throughout Islamicate history up to the beginning of the twentieth century. The self-declared lover of boys in early modern Ottoman and Persian society may not profess a "homosexual identity" in the modern sense, but neither is he simply performing an act, as the very emotions—romantic love as well as sexual desire—with which he invests the object of his affection attest. As thorny as some of these questions may be, what now seems clear to many theorists is the degree to which the distinction Foucault makes between an eastern *ars erotica* (based on acts) and a Western *scientia sexualis* (based on identities) is not only, as Traub states, "historically inaccurate" in terms of Middle East history but also orientalizing. Indeed, by distinguishing the sexual economies of East and West in these broad terms, Foucault is able "to establish [the] pre-modern/modern periodization"[38] that supports his argument about the West's evolution of a disciplinary regime of modern sexual types, while the East remains locked in a timeless *ars erotica*.

A logical outcome of Foucault's ideas—not necessarily ones that Foucault, however, would have embraced—has been the increasingly politicized debates about whether either modern "gay identity" or queer theory is transferrable to non-Western contexts, or whether both signal a further colonizing of the third world by American and European power. Joseph A. Massad's denunciation of gay international rights organizations represents one extreme. Another variation of this stance resonates in Jasbir K. Puar's theory of "homonationalism" as the project whereby U.S. gay citizens collaborate with the nation-state in demonizing Muslims as queerly perverse terrorists.[39] As Traub notes, however, it is one thing to resist "the cultural imperialism implicit in any unidirectional importation of a conceptual apparatus derived largely from European and Anglo-American perspectives,"[40] and it is quite another to create binaries so absolute that one is either totally complicit or totally excluded and uniformly subjected to "epistemic . . . violence" (the phrase is Massad's). Human agency disappears in the process. One corollary of such suspicion-laden or paranoid readings is the implication that *any* Muslim or Arab who embraces Western gay ideals (increased visibility, civil rights, equality) has been co-opted by the West. Such logic overlooks the fact that these men and women are sexual subjects whose choices, desires, and self-identifications are always in the process of change, just as the sexual ethos of all societies and cultures continually evolves, often in unpredictable ways.

Arjun Appadurai's insights into the workings of globalization in *Modernity at Large* weigh in usefully in this context. As he reminds us, "globalization is itself a deeply historical, uneven, and ever localizing process. . . . [D]ifferent societies appropriate the methods of modernity differently."[41] Local cultures, that is, annex the global into their own practices in ways that often make it work for them, and the same can hold for "imported" concepts like gay and lesbian identity or queer theory. Ruth Vanita hence forcefully argues for the political and everyday usefulness of the term "gay" in contemporary India, noting with no little irony that often those who rail most vociferously against "the use of these terms in third-world contexts" are "those who have already obtained most of their basic civil rights and liberties in first-world environments." Likewise, in a study of same-sex desires in Thailand, Peter A. Jackson cautions against overestimating the power of external sexual discourses and appellations to eclipse indigenous systems of sex and gender; in fact, the circulation of the English word "gay" in contemporary Thai culture illustrates how Western conceptions of homosexuality and gay identity are being borrowed, retooled, and transformed to fit the priorities of the local culture, "in the processing becoming as much Thai as Western, if not more so."[42]

As so often, Eve Sedgwick deserves a last word on these complex issues. Literary-cultural critics, she urges, need to attend to "the middle ranges of agency" that theories relying too strongly on the opposition between hegemony

and subversion fail to capture or encompass. This intermediate zone, where most subjectivities are in fact lived, offers the only "effectual space for creativity and change."[43] Listening to the voices of that "middle range" through the cross-cultural and contrapuntal analysis of the homoerotics of Orientalism is what this book is about. I write convinced that it is time to find more flexible ways of analyzing the traces of desires past and present, echoing across spaces and traversing populations, cultures and subcultures, disciplinary fields, and individuals. One step is to trust our intuitions and honor the human desire to understand other cultures and alternative ways of being in the world, even at the risk of revealing the limits of our knowledge and the blind spots that our subject-positions inevitably create. Rather than seeing these limits as reasons to desist in advance, I prefer to view them as shared boundaries that, touching upon and overlapping with other scholars' areas of expertise and training, extend the flow of knowledge and discovery beyond ourselves. In contrast to the hermeneutics of suspicion that has achieved widespread currency in the academy, Sedgwick calls for reparative modes of reading that seek to ameliorate, to bring together, rather than to attack and dismantle; several years ago my colleague David Roman made an eloquent plea for an academic ethos of critical generosity.[44] Between these two concepts, an alternative way of knowing, sharing, and producing knowledge glimmers, limning a conceptual framework in which the affective desires, pleasures, politics, and hopes driving the lives we lead and the work we do participate in a community of deeply felt, richly imagined scholarship.

Such are the main questions that underlie and animate the chapters of this book. Part One, "Theory and History," lays out the broad historical, theoretical, and methodological backgrounds for the chapters that follow. It consists of two chapters that have been designed as complements to each other. The first, "Histories of Cross-Cultural Encounter, Orientalism, and the Politics of Sexuality," examines the numerous travel narratives and histories, dating from the early modern period through the long eighteenth century, that make mention of male homoeroticism in Islamicate cultures, juxtaposing their rhetorical and imagistic patterns with the sexual themes and tropes permeating a variety of Middle Eastern texts. In addition, this chapter surveys the critical debates that have surrounded Orientalism since Said's groundbreaking work and examines the sexual politics motivating various attempts to explain the seeming prevalence of same-sex desire in the Middle East over the centuries. Conceived as a companion to this introductory overview, chapter 2, "Beautiful Boys, Sodomy, and *Hamams*: A Textual and Visual History of Tropes," homes in on a series of highly charged tropes that recur throughout the history of Orientalist and

Middle East homoerotics, tropes that have been assembled from a diverse archive of original source material and visual images that have rarely been brought into specific contact.

Part Two, "Geographies of Desire," comprises three related chapters, and it focuses on specific geographical locales or sites that have proved especially fertile for Anglo-European and American literary imaginations. Chapter 3, "Empire of 'Excesse,' City of Dreams: Homoerotic Imaginings in Istanbul and the Ottoman World," uses Pierre Loti's classic love story, *Aziyade* (1876), to investigate the overflow of homoeroticism that, for many writers, is synonymous with Istanbul's liminal position as the meeting point of West and East, Europe and Asia. The chapter frames its analysis of Loti with readings of the erotic catalogues featured in both European and Ottoman early modern writings about Istanbul, and it concludes with related topoi in Reşad Ekram Koçu's *İstanbul Ansiklopedisi*, and Ferzan Özpetek's debut film *Hamam*. The role played by Egypt in the homoerotics of Orientalism and its literary representations forms the subject of the next two chapters. Chapter 4, "Epic Ambitions and Epicurean Appetites: Egyptian Stories I," examines how associations of Egypt with monumentality, hyperbole, and mythic grandness inspire the efforts of three European writers—Gustave Flaubert, Lawrence Durrell, and Norman Mailer—to ensure their literary reputations by making Egypt their source of inspiration, only to find their creative authority and procreative masculinity challenged by Egypt's associations with polymorphous perversity. Chapter 5 continues these "Egyptian Stories" by looking at the colonial and anticolonial manifestations of homoeroticism in a series of texts ranging from André Gide's *Carnets d'Égypte* and Youssef Chahine's filmography to the tenement-city novels of Najib Mahfūz and 'Ala' al-Aswānī.

The final part, "Modes and Genres," also consists of three chapters, organized around issues of genre, form, and period. Chapter 6, "Queer Modernism and Middle Eastern Poetic Genres: Appropriations, Forgeries, and Hoaxes," examines how a group of early-twentieth-century, experimental European writers—some hardly known, one anonymous—give voice to bawdily homoerotic subject matters by appropriating Middle Eastern poetic forms and touting their literary creations as "found" Middle Eastern manuscripts. These efforts exist in contiguity to other early-twentieth-century Orientalist cultural trends, including ethnopornographic writing parading as serious scholarship and North African homoerotic photography, and they share conceptual affinities with Gide's modernist rewriting of travel narrative in *Amyntas* (1906). Chapters 7 and 8 focus on the rich visual heritage that, contrary to received opinion, attends the homoerotics of Orientalism, proposing a method of analysis in which modern queer affective desires retrain our eyes to see anew images created in the past as well as the present. The former chapter analyzes, first, the homoerotic codes in Middle Eastern miniaturist painting and, second, the traces of same-sex male

desire in nineteenth-century Orientalist salon art. The latter chapter focuses on the ideological work performed by Orientalist-inflected manifestations of homo-eroticism in myriad visual cultures (both Western and Middle Eastern) of the twentieth and twenty-first centuries, ranging from modernist and postmodern-ist painting and photography to the visual worlds of pornography, advertising, cartoons, and film.

I would like to bring this preface to a close with a simple observation: namely, that the intellectual desire to communicate ideas—to make connections, to make *a* connection—motivating the critical act of scholarship shares some-thing in common with the deep human desire present in most, if not all, cultures to travel to strange lands in order to encounter the unknown and unfamiliar, most often experienced in the form of cultural difference. As *The Homoerotics of Orientalism* hopes to show, the physical or imaginative impulse to cross borders and enter the realms of the foreign and unknown is not simply a case of establishing unidirectional domination over or penetration of some monolithic Middle East "Orient." The act of crossing—whether travel-ing, writing, or reading—also tacitly signifies one's willingness to offer oneself up to unsuspected, multiple ways of being. The traveling mind and mindful traveler become, in such instances, intimate participants as well as spectators in culturally specific situations that, on occasion, transform hitherto unques-tioned certitudes into unknowns that must be confronted and worked through. Nearly four centuries ago, in a manual auspiciously titled *Instructions and Directions for Forren Travell*, James Howell warned his readers, in language that seems ready-made for the literary critic of culture, "Forren Travell oftentimes makes many to wander from themselves as well as from their Countries . . . they go out Figures . . . and return Cypheres."[45] What geographies might lie beyond the thresholds of scholarly imagination, waiting to be refigured, if more of us "wander[ed] from ourselves" in wandering from "our countries," if more of us relinquished our preconceived notions of right and wrong, power and discipline, normativity and marginality, sameness and difference, distance and proximity, self and other? How too might the terms "homoeroticism" and "Orientalism," the two operative words of my title, each find itself refigured, wrenched apart and re-conjoined to create new meanings, through their con-trapuntal engagement both with each other and with the ever-ongoing process of cross-cultural exchange?

Part One

THEORY

and

HISTORY

One

HISTORIES OF CROSS-CULTURAL ENCOUNTER, ORIENTALISM, AND THE POLITICS OF SEXUALITY

Postcolonial archival work, in short, ought to restore to the science of colonialism its political significance in the current global setting. What would emerge out of such a reading is not a specialized erudite knowledge of Europe's guilty past but the provoking rediscovery of new traces of the past today, a recognition that transforms belatedness into a politics of contemporaneity.

Ali Behdad, *Belated Travelers*[1]

Uncle Sam getting "screwed at the pump" by an Arab sheik: it's hard to think of a more sensationalist visual representation of East–West relations than the coupling depicted in a cartoon that appeared in the gay magazine *Numbers* in 1980, in which a hoary-headed Uncle Sam takes it up the rear from a robed Arab man who dominates him in gloating if not to say orgiastic triumph (fig. 1.1). Reflecting the defeatist mood of the United States during that year's oil crisis as increasingly frustrated American drivers lined the blocks for hours waiting their turn at the gas pump, this illustration deploys a call to patriotism, xenophobic stereotyping, homophobia, and camp sensibility to articulate nothing less than a manifest national anxiety in which America's loss of international clout is equated, tellingly, with an emasculating loss of phallic supremacy.

More than twenty years later, a similarly suspect mix of politics and sexuality appeared in an anonymously doctored photograph widely circulated on the Internet after the U.S. invasion of Iraq. In this image, a naked figure is shown sodomizing a donkey that stands placidly by a wire fence in a desert landscape. Now the butt of the joke is the sodomizer, given that the turbaned face attached to the scrawny man having sex with the donkey is that of Osama bin Laden (the online image is too small to reproduce successfully here, but the photograph

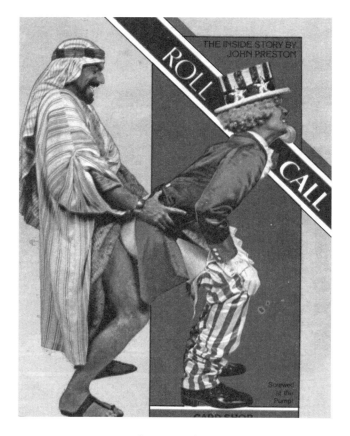

FIGURE 1.1 **Sodomy as political ammunition.**

Unsigned cartoon in *Numbers* magazine (1980). Courtesy of Don Embinder, publisher.

can easily be found by googling the search phrase "osama bin donkey").[2] Rather than a symbol of foreign power overwhelming an emasculated United States, this depiction of sodomy denotes dehumanizing bestiality and, by association, the uncivilized, animalistic nature of America's once "number one" terrorist— stereotypes belied by the sophisticated organizational apparatus that kept bin Laden out of the CIA's reach for nearly a decade. Given the historical association between sodomy and bestiality as equivalent categories of sin, on the one hand,[3] and between sodomy and Muslim men, on the other, this image of "bin Laden" is implicated in the xenophobia and homophobia that characterize the *Numbers* cartoon. Using sodomy to dehumanize bin Laden took yet another turn in a caricature that, as Jasbir K. Puar reports, appeared on posters across midtown Manhattan after 9/11. Here, the Empire State Building anally impales a turbaned bin Laden, accompanied by the legend, "The Empire Strikes Back . . . So you like

skyscrapers, huh, bitch?"[4] The penetrating phallus has returned to the service of the nation—even if, in an ironic twist escaping the artist's intention, this reassertion of dominance depends on the participation of the United States in a symbolic act of male sodomy.[5]

Despite the cartoonish cast of such representations, these reflections of xenophobia, nationalism, and homophobia are sobering in their real-world implications and referents. Using aspersions of homosexuality as a political tool differentiating East and West takes a more prosaic, but nonetheless revealing, turn in a recent flare-up between Turkey and Greece. Trading insults is a typical part of the sports rivalry in these two nations. But when a YouTube video posted by Greek soccer enthusiasts accused the Turkish Republic's founding father, Mustafa Kemal Ataturk, of being homosexual, outraged Turks responded by reminding their neighbor of its reputation as the birthplace of pederasty. Meanwhile, the Turkish judiciary took the dramatic step of banning YouTube broadcasts.[6] History, inevitably, fuels this dispute, given that Greece, the so-called birthplace of Western civilization, was in fact part of the Ottoman East from the fall of Athens in the mid-fifteenth century to its declaration of independence in 1821, and this period of Turkish rule (known in Greece as *Tourkokratia*) underlies the animosities that exist between the two countries to this day. In the light of this history, the YouTube name-calling exchange represents a fascinating return of the repressed, one in which charges of male homosexuality—who has "it," and who doesn't—become the trigger for a display of mutual xenophobia.

As this book demonstrates, these conjunctions are hardly unusual. In formats fictional and nonfictional, public and private, written and visual, generations of Anglo-Europeans since the opening of the Middle East to Western diplomacy and trade have recorded their impressions of the seemingly rampant exercise of sodomy and pederasty that haunts their imagined and actual encounters with its cultures, issuing in everything from shrill diatribes against this ungodly "vice" that separates heathens from the saved to poetic reveries in which male homoeroticism subtly insinuates itself as a temptation no longer to be resisted. The essence of any Orientalizing erotics lies in the projection of desires deemed unacceptable or forbidden at home onto a foreign terrain, in order to reencounter those desires, in the words of Walter G. Andrews and Mehmet Kalpakli, "at a safe distance in stories, gossip, and even the respectable garb of social science."[7] Sometimes, as in the case of what seems "like" homosexuality, that distance proves not to be so safe after all, dissolving the boundary between self and other and reconfiguring both in the process—or, conversely, revealing the extent to which that "other" already exists within the self, haunting its self-definitions.

This chapter historicizes these projections and perceptions of male homo-erotic desire from a variety of facets. Their accretive force is designed to sug-gest a methodology of reading flexible enough to capture the nuances and

complexities—discursive, political, psychological—that attend the homoerotic subtexts embedded in Orientalism and that make the cultural work that these iterations perform worth examining in the first place. I begin with a contrapuntal example of close reading, drawing on two seventeenth-century documents (one Ottoman and one English) in which male-male sexuality plays a central role in order to illustrate the unexpected congruences that result upon considering such documents in tandem. Building on this reading, the next two sections address the contributions this project hopes to make, the benefits of examining the homoerotics of Orientalism for our contemporary moment, and the legacy of Said's theorizing of Orientalism as a discursive system of knowledge over the past three decades. The heart of the chapter lies in the fourth section, which traces recurring references to sodomy and pederasty in a vast number of European narratives about the Muslim world dating from the early modern period to the nineteenth century. Creating a bridge between this archival material and twentieth-century historical, socio-ethnographic, and sexological studies of homoeroticism in the Middle East, the final section analyzes the contradictions embedded in these Eurocentric speculations and, in contrast, begins to contextualize the social scripts and socio-communal codes that Muslim cultures have produced around issues of male homoerotic desire, practice, and love.

READING CONTRAPUNTALLY: TWO CAPTIVITY NARRATIVES

What story ensues when we read side by side two seemingly disparate seventeenth-century texts that just happen to situate sexuality between men at the juncture where myths of East and West collide? One English, the other Ottoman; one a didactic religious tract less than ten pages long, the other a flowery narrative poem of nearly 300 couplets: the first is an anonymous pamphlet published in London in 1676 (never reissued) and titled *The True Narrative of a Wonderful Accident, Which Occur'd Upon the Execution of a Christian Slave at Aleppo in Turky*; the second is the seventh tale or *mesnevi* of a book-length verse narrative by Ottoman poet Nev'izade 'Atayi completed in 1627. Despite their overt differences, the ideological objectives and sexual resonances of these two narratives illuminate each other—and in the process illuminate the history of sexuality—in ways that demonstrate what may be gleaned by venturing outside of disciplinary constraints and reading representations of the past contrapuntally.

The shorter, seemingly less complex *A Wonderful Accident* is an unabashed example of Christian propaganda, narrated in a sensationalist idiom aimed at

titillating and horrifying its audience. In 1676 Turkish imperial ambitions were at their zenith: the Ottoman army had seized part of Poland; seven years later, it would lay siege to Vienna in its most audacious attempt to see all Europe submit to Ottoman control. Written under the shadow of this palpable threat, this cheaply produced document recounts the horrific fate a "handsome young French slave" suffers when subjected to Turkish male lust, figured as "that horrid and unnatural sin (too frequent with the *Mahumetans*) *Sodomy*."[8] While the trajectory that follows is typical of martyrdom narratives, replete with a miraculous apotheosis as its climax (the "wonderful accident" of the title), the tale is encased in a frame calculated to place the "unnatural sin[s]" of the Turks at as far a remove from English mores as possible: constructed as a letter addressed to an anonymous "Sir," the unnamed English narrator doesn't recount his own experience but retells a "history" that has, in turn, been told to him by merchants returning from Aleppo.[9] On one level, the pamphlet's framing device places the reader at five levels of remove from the narrated events, thereby establishing a moral as well as geographical gulf between its English audience and those brute desires to which "Mahumetans" are too often "addicted." Likewise, the fact that the victim is French, rather than English, brings the horror home to Europe but strategically stops it short of leaping the English Channel. On another level, however, the narrator inadvertently begins to close that gap by directing doubtful readers to seek out the many "Turkey-Merchants" who frequent "Elford's Coffee-House in George-yard in Lombard Street" whom, he avers, will "confirm the thing." The contagious buzz of coffeehouse gossip keeps Turkish sodomy alive and well in the heart of London.

The "handsome" eighteen-year-old Christian slave (presumably captured from a merchant vessel by Turkish privateers[10]) has been left alone at his wealthy master's home with the master's steward. The latter Turk is one of those of his nationality "much addicted" to sodomy and, having had his "lustful Eyes" on the good-looking youth for some time, finds the moment propitious for executing his "Villa[i]nous design." Failing to persuade the youth to "consent to his (more than Brutish) Devillish desires" with promises and flattery (2), the steward resorts to violence. However, the slave, virtuous Christian that he is, refuses to yield his chastity to such "Devillish" ploys; during the ensuing struggle the Turk dies; and the beset youth, anticipating the "Cruel and Tyrannical nature of the Turks" (3) upon discovery of this mishap, runs away in hopes of finding sanctuary in the city's European enclave (where, incidentally, the Levant Company maintained its headquarters).

His attempt to escape, however, is stymied when he bumps into his master returning home, and, sure enough, he's charged with murder of the steward. But in a reversal that momentarily dissolves the opposition between Europe and Other, the magistrate hearing the charges deems the slave's story to be true

and upholds his innocence. Why? Because the magistrate has an agenda up his sleeve: his hope is that the case will serve as an object lesson helping "deter the Turks from the base sin of *Sodomy*" (4), a social problem that he no less than the pamphlet's author feels to be too pervasive among his countrymen. Ironically, however, his Turkish cohorts pressure the *bashaw* to reverse his decision, not because they dispute the charge of rape or because they're concerned about sodomy one way or the other, but because they are worried that freeing a slave who has killed a superior will set a bad example among other slaves, upsetting the socioeconomic order (in fact, the magistrate has just been summoned to Aleppo to deliver verdicts on a recent local uprising against the Ottoman Porte—internecine local politics thus frame the pamphlet's "exported" morality tale). As such, the pamphlet's overt intention—to use the horror of male sodomy to demonize the infidel Other—momentarily rubs up against a strand of social realism that complicates a simplistic interpretation of Ottoman mores and morals. Nothing is as clear-cut as it seems.

Social realism, however, is abandoned in the execution scene that follows, an allegory of Christian martyrdom set into motion by the pious youth's prayer that God grant some "bodily sign" of his "innocence" (5). God's "sign" soon follows, but not before the pamphlet's narrator delivers a voyeuristic peek at the handsome prisoner's naked physique. For as our "Chast[e] Martyr" (6) is "strip'd stark naked," his nudity "discovers" to his onlookers a most "lovely body" (5)—the same physical charms, one presumes, firing the steward's rapist desires. This narrative striptease, ironically, no less than the steward's "lustful" (2) gaze, eroticizes the Christian youth as an object of desire. Illuminating in this regard is Silke Falkner's analysis of the rhetorical use of sodomy in early modern German *turcica*. Drawing on the genre's affinity for *hypotyposis*—the rhetorical deployment of especially vivid imagery and linguistic codes to help readers "see" the described scenario as if unfolding before their eyes—Falkner provocatively asks what it means when a nude male Christian body is textually displayed as the object of a specifically Muslim gaze. In such instances, not only do German readers become an intimate onlooker to the display, they also occupy, perforce, the position of the gazing, sodomitical infidel. And such textual simulations of seeing, Falkner suggests, may in fact arouse covert feelings of pleasure in place of the Christian ire they are meant to produce.[11]

The homoerotic undercurrents of displaying the martyr's body at the moment of death echoes throughout Western religious art—depictions of Saint Sebastian come to mind. But I suspect the immediate template for *A Wonderful Accident* lies in the medieval legend of St. Pelagius, a martyrdom narrative that pits Muslim sodomy against Christian faith as embodied in the figure of a beautiful youth. The thirteen-year-old Pelagius, held as an exchange-prisoner in the government of ʿAbd al-Rahmân III in tenth-century Cordoba, boasts a beauty so stunning

that the caliph orders him to court decked in royal clothes and offers all sorts of rewards if the boy becomes his lover—the sole condition being that Pelagius convert to Islam. Pelagius, of course, refuses: the legend makes it clear that Christ is the male spouse for whom Pelagius has been keeping his body chaste. 'Abd al-Rahmân next attempts to fondle the youth, at which point Pelagius strikes back, not only with fists (as does the French slave in *A Wonderful Accident*) but with words. "Do you think me," he sneers, "like one of yours, an effeminate?" Clearly, *despite* his purity of mind and body, Pelagius already *knows* about the "effeminate" sodomitical vices associated with the Moorish court. This suggests "complications . . . that [the author] cannot quite control," Mark D. Jordan comments in a tour de force reading of the documents surrounding the legend.

Pelagius's refusal to exchange his heavenly destiny for the earthly rewards that would ensue if he became the caliph's minion leads to his dismemberment. In the poetic rendering by the Saxon canoness Hrotswitha, his beautiful, severed head is miraculously preserved from flames in response to the prayers of the faithful. But before this apotheosis, a curiously destabilizing event is narrated, one that circles back to the problematically eroticized nude body of the hero of our English pamphlet. For Pelagius follows his defiant rejection of the caliph's advances by immediately stripping off the raiment he's been forced to wear. Standing naked as a jay-bird, the thirteen-year-old reveals the body of a "strong athlete in the palaestra." No doubt meant to symbolize Pelagius' rejection of worldly riches and his possession of a masculinity lacking in the "effeminates" who serve the ruler, the action nonetheless creates an erotic frisson that belies the narrative's moral. So, too, does the allusion to the Greek tradition of the palaestra or gymnasium, given the role of the latter in the tradition of Greek pederasty. As Jordan succinctly puts it, "Pelagius the martyr is quite plainly Pelagius the ephebe, the type of young male beauty,"[12] and nubile beauty is a striking element in Jan Luyken's illustration of the legend in *Martyrs Mirror* (1687) (fig. 1.2).

Just as Pelagius's beauty of face and strength of body are read as signs of his inner faith, so too the narrative display of the nude male body in *A Wonderful Accident* becomes part of its Christian hero's apotheosis. For in the same sentence that "discover[s]" and thus uncovers his "lovely *body*," the reader is informed that this flesh is inhabited by a yet "more lovely *soul*" (5). The miracle toward which the arc of the narrative has been building, the wonder-filled "accident" announced by the pamphlet's title, comes to fruition after the youth's execution by decapitation: the dogs that tear at the bodies of the group of Turkish rebels executed on the same day won't touch the Christian youth's body; nor does the corpse putrefy for the ten days it lies unattended. His lovely flesh, that is, remains "chaste," its intact beauty (as in the case of Pelagius's severed head) serving as God's outward "sign" of the victim's inner purity. In resisting the sexual advances of the heathen Turk and maintaining the "Virtue of a devout

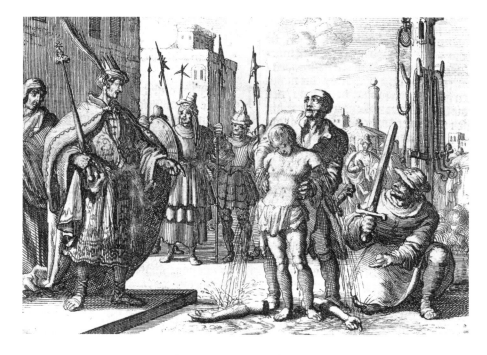

FIGURE 1.2. **Pelagius as prototype for *A Wonderful Accident*.**

Jan Luyken's illustration for Thieleman J. van Braght, *Martys Mirror* (1685) 1:252. Courtesy of the Mennonite Library and Collections, Bethel College, KS.

and Chast[e] Christian" (6), the martyred slave becomes an example of the spiritual rewards awaiting those faithful who follow the path of the righteous.

Not unlike *A Wonderful Accident*, the seventh tale of 'Atayi's *Heft han* also traces a religious allegory, one that is just as proselytizing despite its poetic form. In it, too, capture at sea by the infidel Other, homoerotic tensions, imprisonment, legal judgments, escape attempts, and reversals of fortune play prominent roles. Moreover, its conclusion also celebrates "lovely souls" in "lovely bodies" attaining a heavenly reward. At the same time, for Western readers this poem may seem to issue from another world altogether. For unlike *A Wonderful Accident*—unlike, for that matter, any Western literature until the twentieth century—the final tale in this verse narrative is a love story between men that ends happily. Andrews and Kalpakli provide a prose summary of the narrative, where its analysis plays a key role in their unfolding of the social-sexual scripts of Ottoman manhood. Rather than quote from their redaction, I return to the original in its couplet form in order to tease out the figural and narrative elements of its telling (images, parallels, reversals, chiasmus, repetition with a difference) that convey an array

of ideological meanings that, for all the tale's literary artifice, create a revealing interface with *A Wonderful Accident*.[13]

The story begins with a folkloric staple. Two prosperous merchants of Istanbul who are "each other's [best] comrade and companion" sire two wonderful sons, Tayyib and Tahir. Given that Tayyib means "beautiful" and Tahir means "pure," the two boys share between them the enslaved French youth's two distinguishing marks: purity and beauty. As they reach "the springtime of life"—seventeen or eighteen years of age—these friends turn to those archetypal pleasures that tend toward youthful folly: sex, wine, and music. The deaths of their parents leave them with inheritances that allow them to indulge in these sensual pleasures. Relishing the pangs of love, they chase after the "heart-throbbing beauties" of both genders of Galata and Goksu, and they frequent Pera's all-male wine establishments (see an equivalent in fig. 1.3). Here, their "unreserved lovers," in 'Atayi's metaphor, flirtingly "count the threads of their beards" (these newly sprouted beards are the signature of Tayyib and Tahir's recently developed manhood).[14] That this takes place in a tavern named "*Köse*" is an inside joke, since the word *köse* also means "beardless lads," those very objects of desire who are counting the two heroes' whiskers. Of course, all these polymorphous pleasures—concubines, boys, wine—prove as fleeting as youth itself: Tayyib and Tahir spend their inheritances, suffer rejection by their fair-weather comrades, and in desperation set off across the Mediterranean to join a popular order of Sufi dervishes based in Egypt. As 'Atayi puts it, with delicious understatement, "They smelled the mortal rose and hit the road."[15]

Hitting the road, however, cannot reverse the wheel of fortune when it's on a downward spin: the ubiquitous storm at sea and shipwreck of romance narrative follows; next the two survivors are plucked from the sea by a warship as "full of infidels as hell"—"blood-thirsty Franks" (the Ottoman term for European Christians) who put Tayyib and Tahir in chains. An even worse fate looms when the vessel reaches shore: they are separated from each other for the first time in their lives. Numbering among their infidel captors are two valiant noblemen "resembling the sun and the moon," Sir John (*Can*) and Janno (*Cano*). These nearly identical men (*Cano* being a derivative of *Can*) claim the equally mirroring Tayyib and Tahir as their respective slaves, carrying them off to their separate estates in an undefined European country. At this point, 'Atayi's poem becomes a captivity narrative, but one that *reverses* the opening proposition of *A Wonderful Accident*: here virtuous Ottoman youths are at the mercy of Christian unbelievers, instead of a virtuous Christian at the mercy of Muslim infidels. But this is an inversion with a difference: for Tayyib and Tahir's masters, unlike the villainous steward of the English text, are elegant, good-hearted gentlemen who are "heart-stopping beauties" in their own right. Forthwith, each youth not only "falls captive" *to* his master, but secretly "falls captive *for*" him; in 'Atayi's

FIGURE 1.3. **Levend and entertainer in an Ottoman wine tavern.**

Tayyib and Tahir's tavern revels find a pictorial equivalent in Fazil Bey, *Huban-name* [Book of Beautiful Youth]. T 5502, fol. 0041. Courtesy of Istanbul Univ. Library. Intriguingly, Metin And glosses the seated figure in the Ottoman image as "the one who is eating away his inheritance [by] having fun in the meyhane"—actions paralleled in the *Heft han* story.

metaphor, their adoration transforms what would otherwise be "beheading" grief (as literally befalls Pelagius and the Christian martyr) into rapture that lifts their heads up "to the mountain of love."

At this juncture, the perspective narrows to the plight of Tayyib, wasting away in a dungeon. Fortuitously his master Sir John happens to visit, feels sorry for the lad, and sends him to work on his estate's grounds, a "rose garden of love" that cannot but lift Tayyib's spirits and mend his health. Thus begins an ascending pattern of improving fortune. One day Sir John holds a party in his garden attended by "several beautiful boys with faces like the moon" and their

FIGURE 1.4. **An Ottoman sohbet in a European setting.**

Tayyib is seated at the table, while Tahir enters at upper left with Sir Janno. Nev'izade 'Atayi, *Khamsa* (1721). W. 666, fol. 138a. Courtesy of the Walters Art Gallery.

male admirers, and the company takes appreciative notice of Tayyib as the wine flows freely and kisses are bestowed all around like roses (fig. 1.4). Here 'Atayi represents the well-documented Ottoman cultural institution known as the *sohbet*, a garden party where lovers and beloveds, elite men and beautiful boys, indulged in poetry, wine, mannered discourse, and flirtation.[16] Tayyib tells his woeful story, moving everyone to tears, and within couplets Sir John has fallen "deeper and deeper" in love with his slave. Empowered by his benefactor's compassion, Tayyib confesses his grief at being separated from his soul-mate Tahir. This leads Sir John to send for Sir Janno and Tahir, who too have fallen in love like "moon and sun uniting in the same sign of the zodiac." Both couples now reunite in bonds of amorous intoxication and paradisiacal bliss.

This private Eden, however, must undergo a series of public trials suggesting that homoerotic love occupies a precarious place in its world—which is set in Europe, even though it manifests the trappings of elite Ottoman male culture. These tests are set into motion when a meddling "busybody" spies on the lovers in their private garden and reports what he sees to the head of the local police,

a Christian zealot who "believ[es] the love of beauties a crime." Fueled by Puritanism, sexual repression, and spiteful jealousy that burns inside him "like a wrathful fire," this foe of the flame of true passion throws the two noblemen into prison and readies to behead Tayyib and Tahir. (Recall the fate of the handsome Christian martyr in *A Wonderful Accident*.) Comparable to the Turkish judge in the English pamphlet, this prosecutor also uses the situation to serve a moral agenda: to "make [the two youths] an example for others to dread." However, the crowd of onlookers, playing a role similar to that of the Aleppo citizens, is moved to pity for the two young men, and *again* for reasons that are pragmatic and political. "Is it meet . . . to foul our names in eyes of friend and foe?" they ask (here I follow Andrews and Kalpakli's rhyming couplets): "If we start killing prisoners this way / What's to keep Muslim swords from coming into play? / If captives on both sides are caused to die / Who on Judgment day will answer why?"[17] 'Atayi's clever word-plays serve two purposes. First, they deflect the "foulness" that the policeman attributes to homoerotic love onto the fate that their *own* reputations will suffer ("Is it meet . . . *to foul our names* in eyes of friend and foe?" [emphasis added]). Second, the police commander's harsh verdict is implicitly weighed against the far more important "Judgment day" to come. Forced to yield to this argument, the policeman unhappily commutes the death sentences of Tayyib and Tahir to enslavement on a galley.

With this return to the sea, the narrative is ripe for an instance of repetition, which indeed occurs when the boat is beset by Muslim ships that overcome it in battle. As narrative theory teaches, repetition (which necessarily involves difference) is always laden with significance, which is true in this case as well. Tayyib and Tahir are freed by their fellow Muslims and, in an ironic turn of fate, they are given command of the European craft on which they were previously enchained: "the pirates of love became the captains of the sea." Meanwhile, in a neat chiasmus, their former masters, Sir John and Janno, languish in prison chains, occupying the place formerly filled by their beloveds. This nadir, however, proves to be the path to true freedom. Thrown into the company of Muslim prisoners, the two noblemen become interested in Islam, share a dream vision in which a figure wearing green (the Prophet's color) tells them "the gates of their wishes have been opened," awaken to find their chains miraculously sundered, and make good their escape in a rowboat. Simultaneously Tayyib and Tahir have a premonition that impels them to sail in the direction of this drifting craft. They prepare to attack it as an enemy vessel, only to discover that it has delivered their hearts' beloveds to them: "they met friends instead of foes, they saw two beauties coming . . . each met his lover, became friends with each other's lover." Discord yields to concord both in the small instance (mistaken enemies who turn out to be allies) and on the larger metaphysical plane as the last obstacle to happy union—religious difference—is removed by the Europeans' conversion,

allowing all four reunited lovers to return "joyful and happy" to Constantinople, at which point "their pleasure reached the heavens." Narrative coincidence thus becomes an emblem of miraculous providence. Sir John is henceforth known as Mahmud (meaning "praiseworthy") and Janno as Mes'ud (meaning "fortunate"). When at the end of their lives these two couples pass from this world into "the holy garden" of the next, they do so filled with "pure love," and the "magical legend" of their story becomes inspiration for all who open their ears.

So 'Atayi's verse romance ends, as does *A Wonderful Accident*, on an allegorical note, illustrating the heavenly rewards that await those whose love remains "pure." But with a difference, since homoerotic love is the *very* agent of conversion and hence salvation in the tale of Tayyib and Tahir, whereas sodomy is the "unnatural" sin that precipitates the French youth's martyrdom in the English pamphlet. In their discussion of 'Atayi's romance, Andrews and Kalpakli argue that its poeticized sexual scripts reflected a very real dimension of love that existed on many tiers of Ottoman society. Tayyib and Tahir move through a man's typical life stages from youthful folly (chasing *any* beautiful boy or girl) to mature appreciation of true love based on the model of male lover and male beloved. On one level, then, reading these two seventeenth-century texts in tandem reveals a striking *disjunction* between early modern European and Middle Eastern attitudes toward homoeroticism; passions that are vilified in the former are celebrated in the latter, and what is deemed natural in one is deemed unnatural in the other. On another level, however, examining these texts side by side warns against an overly binaristic reading of *either* of these cultures. For instance, while the English *A Wonderful Accident* forms a textbook example of Orientalist projection in the name of religion, in which the home culture's taboos and fears are read onto a literally demonized "devilish" Other, the Ottoman text engages in its own level of fantasy and wish-fulfillment, namely through the fictional creation, by text's end, of a hyper-idealized world in which its happy male foursome never has to face the social pressures of marriage and progeny, a component of the adult Ottoman male's social and sexual script normally *coexisting with* the culture of male beloveds.

Moreover, if the Turkish steward in the former narrative is a projection of European fantasies of brutish heathen lust, the creation of his Occidental counterpart in the *Heft han*, the repressed police official who "believes love a crime," strategically allows 'Atayi to displace onto Europe what was in fact a threatening reality within the Ottoman world itself: namely, the success of growingly powerful conservative religious elements (such as the Kadizadeli and followers of Birgili Mehmet) in demanding that the Sultan crack down on a range of sinful activities ranging from homoerotic activity and wine drinking to coffeehouses. Projecting this social reality onto a Christian infidel allows 'Atayi to critique a threat looming on his home front, but to critique it obliquely

and at a distance.[18] Likewise, if reading these texts beside each other discloses a latent similarity between homophobic English culture and the repressive zealotry that 'Atayi fears threatens the Ottoman heritage of homoerotic bonding, the unabashed homophobia of *A Wonderful Accident* doesn't preclude a degree of homoerotic voyeurism when it comes to displaying the naked charms of its handsome Christian martyr. The linkages and disconnections between so-called "West" and "East" over the terrain of male homoerotic desire reveal, in examples such as these, a complexly imbricated history whose representations and actualities cannot be reduced to the oppositions the popular imagination often summons forth when using charges of homosexuality to categorize and castigate the other.

GOALS, INTERVENTIONS, POLITICAL REVERBERATIONS: THE QUEEN BOAT RAID IN CAIRO

These manifestations of homoeroticism in writings about and artistic representations of the Middle East form the conceptual field that I call the homo-erotics of Orientalism and that this book investigates for its literary, cultural, and ideological valences. Throughout, I suggest that these encounters between and across cultures, mediated through the specter of male homoeroticism, hold a number of important implications. Several of these I have already addressed in the preface. First, as a number of queer theorists working within transnational and global frames have pointed out, such encounters destabilize western-based conceptions of (and preconceptions about) the concept *homo-sexuality* as an identity category and a part of the epistemology of the modern self. Exposure to the social and psychological constructions that other cultures bring to sexual attraction, desire, and bonding serves as a bracing reminder of how contingent are many of the founding assumptions of Anglo-European and American gay life and politics, and of the consequent pitfalls of attempts to speak about sexuality without attending to distinctions varying widely over centuries and geographic regions—distinctions not captured by the relatively modern, western-based binary of "heterosexuality" and "homosexuality."

Second, these encounters—even when only imagined—may precipitate unsettling anxieties of masculinity for male travelers and artists who find both their manhood and desires unexpectedly called into question. Insofar as gender identity is constitutive of individual subjectivity, this denaturalization of masculinity—regardless of the subject's sexual orientation—may also trigger a larger crisis of identity itself. This process can be traced in countless journeys of

self-discovery—André Gide's *L'immoraliste*, T. E. Lawrence's *Seven Pillars of Wisdom*, Paul Bowles's *The Sheltering Sky*—where the dissolution of the coherent self ends in unnerving (and sometimes ecstatic) experiences of self-estrangement, in which one is no longer legible to oneself, much less to one's home culture.

Third, for many writers and artists these crises of sexuality and subjectivity engender profound anxieties of narrative authority that lead to the questioning of previously embraced aesthetic models: the threat and attraction of being "unmanned" by the allure of a polymorphous sexuality that seems to exceed representation is echoed in the fear, in face of such excess, of never creating again. "Art is leaving me, I feel it," the protagonist of *L'immoraliste* confesses, then adds, "What follows the end of desire?"[19] The implication is that the pleasurable exhaustion that follows a surfeit of available sensual experience—itself an Orientalist stereotype—obviates the desirous longing to fill a lack, one of the paramount driving forces of narrative art in the European tradition. From a painterly perspective, a similar aesthetic conundrum surfaces: how to deal with perspective in landscapes where horizon lines are infinite and where light, when not amplifying color, bleaches it out? And how to make sense of, or incorporate into one's art, a Middle Eastern aesthetic in writing and painting that renders the world in terms of non-figural arabesque and geometric abstraction, denaturalizing a Romantic aesthetic based in nature? Or the miniaturist aesthetic, as Orhan Pamuk describes it in *My Name is Red* (2002), in which the attempt "to depict the world that God perceives, not the world [the artist] see[s,]" renders individual perspective meaningless and eliminates the need for authorial signature that, again, motivates so much great art in the western heritage?[20]

Fourth and not least, given the history of ruptures, miscomprehensions, and subterranean connections between Judeo-Christian and Islamic cultures, understanding with greater nuance the role that long-standing traditions of homoeroticism and homophobia have played in the construction of "East" and "West" carries political and cultural resonances for the present moment. It goes without saying that a topic as divisive as same-sex relations, especially between men, is not likely to "improve" American-European and Middle Eastern relations—in some notable recent cases, it has arguably widened the gap. But a more finely honed consideration of *how* misunderstandings, projections, disavowals, and fears rooted in homoerotic desires and homophobic fears have played across several hundred years of conflicted interactions may, at the very least, call into question some of the sexual fictions locking Anglo-European and Middle Eastern cultures into seeming opposition.

One might take as an example the harsh rhetoric condemning homosexuality sounded by contemporary Arab nationalists and Islamic fundamentalists. For four hundred years it was the uptight Christian West that accused the debauched Muslim East of harboring what it euphemistically called the "male vice"; more

recently, Islamic conservatives level the same charge at the decadent West in the name of nation-building and cultural authenticity. In such renderings, homosexuality is yet again figured as a "foreign" contagion; if sexual relations between men occur in the Islamicate world, it is because the West has invidiously exported them to undermine Islamic values. In the process, the entire history of homoerotic relations among males once intricately interwoven into the fabric of Muslim culture despite religious prohibitions is erased and denied.

Yet this narrative of erasure is even more complicated than this simple chiasmus suggests. As recent Middle East scholars have noted, the denials and condemnations of male-male sexuality now propounded by contemporary fundamentalists are, ironically, outgrowths of and belated reactions to the birth of secular modernity throughout the region in the late nineteenth and early twentieth centuries. This latter movement promoted democratic reforms and adoption of "Western" heterosexual norms at least in part as a response to the European representations of its civilizational "backwardness" and sexual "irregularities." As Dror Ze'evi notes of late-nineteenth-century Turkey, "an entire cultural silencing mechanism was galvanized to cleanse [a prior history of sexual] discourse of anything deemed improper." Meticulously canvassing a diverse set of archives—anatomical treatises on the gendered body, the dual system of religious and Sultanate law (*sharī'a* and *kanun*), shadow-puppetry, dream interpretation, and fierce religious debates over the propriety of the Sufi devotional practice of gazing upon beardless youths—Ze'evi demonstrates how unabashedly frank references to same-sex acts and desire were written out of the historical record and repressed from collective memory in the name of western-style modernization.[21] Making similar cases for early-twentieth-century Iran, Janet Afary and Afsaneh Najmabadi argue that the price of Persia's emergence as the new Iranian nation-state was the official eclipse of its long-standing history of male homoerotic bonds as "pre-modern" and the cultivation of heteroeroticism as the new norm. Even more boldly, Najmabadi argues that the "modernist project of women's emancipation"—the promotion of the rights of Iranian women to education, autonomy, and unveiling—triumphed because of the "disavowal of male homosexuality"; in this feminist narrative of progress, male homoeroticism was derided as an archaic sexual practice resulting from the gender segregation of the past.[22]

Likewise, Joseph A. Massad reveals the degree to which "Orientalist depiction[s] of Arab sexual desires" as degenerate and perverse created a counter-discourse among Arab historians, intellectuals, and nationalists, one marked by the insistence that "Arab sexual desires were not all that different from those of Europeans." This "vigorous assimilationism," in turn, led to the "repudiation not only of men's love for boys but also of all desires it identified as part of the Arab past." The literary reception of the Abbasid poet Abu Nuwas offers a

fascinating case study in this regard. Abu Nuwas was at once too important, talented, and famous a writer for Arab intellectuals attempting to revive an indigenous cultural heritage to deny; yet his poetry was too sexually explicit— particularly in its randy homoeroticism—to be embraced with ease, leading to contorted arguments about the unfortunate blip created by the licentious morals of the Abbasid era, in other regards touted as the golden age of Arab-Islamic civilization. Censorship became one way to handle the problem. Thus, as Massad documents, while collected editions of Abu Nuwas published in 1898 and 1905 included his homoerotic verse, "the 1937 edition . . . exclude[d] most of them." Nor did the tendency to see this vice as a foreign import move solely along a European West–Middle East axis. If the internalization by Arab intellectuals of western judgments contributed to their repudiation of the homoerotic elements in their history, so too these intellectuals often placed blame on the "Persian influence" for corrupting Abbasid morals. In such instances, Persia becomes the "Orientalized Other" of Arab-Islamic culture. Indeed, some Arab literary critics attempted to argue that Abu Nuwas was in fact Persian, as if that alone might explain the homoeroticism in his oeuvre.[23]

Understanding, then, these inversions of homophobic attribution requires that the mind simultaneously keep in play a number of complex, contradictory, and competing narratives. In the process of applying double vision to the ideological agendas underlying such rhetorical deployments of homophobic aspersion ("you've got it, not me"), one encounters some surprising, and not always pleasing, similarities between "us" and "them," particularly when it comes to making (charges of) homosexuality a touchstone for cross-cultural impasse.

A contemporary, controversial case in point involves European and Egyptian reactions to the 2001 arrests in Cairo of more than fifty men frequenting the Queen Boat, a floating discotheque moored in the Nile and patronized by gay and bisexual men. Almost immediately the crackdown attracted international attention and outrage. For a critic like Massad, the media feeding frenzy surrounding the unfolding events supports his argument about the negative influence of international gay human rights groups attempting to impose a Western conception of gay identity onto Arabs, using the banner of universal sexual/gay liberation to institute an "internationalization of Western sexual ontology."[24] In Massad's reading, the outcry raised by Western journalists, politicians, and activists only served to ratchet up homophobic rhetoric in the Egyptian press, where the vilification of homosexuality as a specifically western abomination became commonplace. The result was to stigmatize Egyptian same-sex practice more vocally than ever, driving the nascent "gay" movement further underground. Thus, Massad argues, self-righteous Western efforts at intervention ended up increasing state surveillance and personal repression of the very subjects on whose behalf such activists claimed to be working.

To the degree that such "missionary" efforts blindly impose culturally spe-
cific understandings of individual rights and sexual identity onto non-Western
sexualities and subjects, Massad's concern is timely and legitimate. More prob-
lematic, however, is the implication that the only Egyptians possibly interested
in gay rights must be "native informants" who work in "collusion" with Western
activists and who "consort" with "European and American tourist cohort[s]"
at venues such as the Queen Boat. Word choices like "consort," "collude," and
"cohorts" insinuate that those patronizing the riverboat brought their troubles
on themselves by embracing Western-style "gay" identity. But as Scott Long com-
ments, "no culture is impervious to influence or exchange," and "to assume that
men in Cairo . . . adopt an alien identity passively at the promptings of Western
models denies individual inflection or equivocation." "Social understandings
of sexuality," Long writes, "are not fixed. Constantly mutable, they move in the
context of larger cultural changes and interchanges."[25]

If scrutinizing the role of Western gay politics in the Queen Boat case—whether
well intentioned, imperialist, or a bit of both—deconstructs a surface reading of
its international reception, so too a closer look at the event's representation in the
Egyptian popular press reveals a more complicated nexus of issues at work. At first
glance, the reporting seems to present a prototypical clash between proponents of
Arab "authenticity" (the Egypt press echoing conservative religious and political
factions) and "liberal" Western interests intent on imposing their value systems
(gay identity, universal rights). Ironically, the stance of the former echoes, from a
diametrically opposed political point of view, that of the early-twentieth-century
Arab intellectual movement that in the name of *secularization* and modernization
"characterize[d] what they considered unsavory" in their cultural past "as a for-
eign import [for instance, attributing Abu Nuwas's lapses to his putatively Persian
ancestry] and assert[ing] the purity of all they found noble."[26] The deep irony,
of course, is that at this moment in the Arab renaissance the modern West was
positively associated with a *heteroerotic* norm that the Middle East should emulate
in order to enter the realm of progressive modernity. But not now: "Be a pervert,
and Uncle Sam will approve," blazoned the headline of one Egyptian article
dismissing American concerns over the likely violations of human rights of the
defendants in the Queen Boat case. Likewise, the newspaper *Al-Akhbar* warned
Egyptians to resist "the globalization of perversion," while another charged the
defendants with bragging that they'd "imported" their deviant sexual practices
"from a European group."[27]

This narrative of U.S./European imperialist imposition underwent yet another
twist in a feature story in the state-sponsored magazine, *Al-Musawwar*. Linking
the arrested "perverts" to "Lot's people" (the purported original Sodomites) and
accusing them of belonging to "Satanist" anti-Islamist cults, this article was

accompanied by an obviously altered photograph in which the face of the lead defendant, Sherif Farhat, had been pasted onto the body of an Israeli soldier, with a star of David prominently displayed on the latter's helmet and Israeli flag in the foreground (fig. 1.5). Here, another political-religious agenda—rooted in the internecine histories of Egypt and Israel—attaches to and makes use of the (homo)sexual scandal occasioned by the nightclub arrests. Ironically, the composite image traffics in a mode of xenophobic demonization akin to that displayed in the equally fictitious online image linking Osama bin Laden to bestiality and sodomy.

But the narrative of "us" versus "them," in which the targeted "them" keeps shifting, gets even more complicated. For Farhat turns out to have been the member of a powerful political family at odds with the ruling elite; family members, it seems, had made slurs about the sexuality of a relative of the president, which led to the Egyptian State Security's effort to build a case against Farhat by labeling him the ringleader of a blasphemous homosexual cult: "The *kulturkampf* started as petty political payback," writes Long.[28] This is not the only instance in which Farhat found his photographed image subject to manipulation as a tool of discipline. In a nice piece of visual sleuthing work, the English language *Cairo Times* reproduced side by side two photographs that had appeared in consecutive editions of the paper *Al-Akhbar Al-Hawadeth* (fig. 1.6). In both, the image of a

FIGURE 1.5 AND FIGURE 1.6. **"Outing" Lot's people: creative photoshopping in the Queen Boat case.**

Both images Courtesy of the *Cairo Times* (2001).

group of Queen Boat defendants is superimposed on a backdrop of the float-
ing nightclub. In the left photograph, Farhat is depicted head-bowed, shielding
his face with his hand (front row, middle). In the right photograph, one of the
defendants has been snipped out to make room for an inserted full-face image
of the defendant. "As a result Farhat appears twice in the right-hand picture (in
fact he is standing next to himself), something not immediately apparent to
readers."[29] The politics of the alteration are overt: to "out" Farhat and disgrace
his family. The power of shaming—making public sexual secrets that usually
remain private—is also palpable in widely disseminated images of the defen-
dants as they attempt to hide their faces behind masks torn from white prison
clothing (fig. 1.7). To the Middle East viewing audience, the prisoners' fears of
being identified as "deviants" certainly read as shame: "evidence of a practice," as
Long puts it, "that, never mind speaking its name, did not dare show its face."[30]
Uncannily, these masks also transformed the men into ghostly specters, on the
one hand reducing them to an undifferentiated mass of non-individuals whose
entire sinful subculture is on trial, on the other making the *haunting* reality
of same-sex practice—the very history earlier twentieth-century Arab national-
ists had tried to explain away—all the more conspicuous, hence all the more
violently in need of suppression.[31]

Whatever one's reading of this traumatic episode of sexual persecution,
it is clear that its textual disseminations are caught up in the homoerotics of
Orientalism whose legacies this project attempts to trace. Orientalism lingers
in the repeated invocation of a sodomitical East throughout European travel
literature and historiography, just as it lingers in the internalized Orientalism
propelling the nascent Arab awakening's desire to write such perversity out of
its heritage. It marks the attitude of civilizational superiority implicit in many
Western pundits' reacting to the Queen Boat incident as an example of the
region's cultural backwardness and Islam's sexual repressiveness. Equally, the
always-politicized shadow of homoeroticism—both feared and desired—echoes
contrapuntally across this spectrum of reactions, from the perceived threat of
emergent "gay identity" in Egypt to the desires of the arrested men (however
they define their identities) to the policing mechanisms of state control, and from
denunciations of the perverted West (and its "proxies" like Israel) to both local
and international activists' concerns about the oppression faced by Egyptian men
and women who have sex with their own gender. In theorizing the homoerotic
dimensions of Orientalism and its others, then, this study illuminates a history of
representations whose aftereffects reverberate to this day. As the tangled threads
of the Queen Boat scandal illustrate, *The Homoerotics of Orientalism* insists that
such representations are never one-directional but move along multiple and
sometimes contradictory, often simultaneous, vectors. Engaging these vectors
contrapuntally enables one to read, for instance, *The True Narrative of a Wonderful*

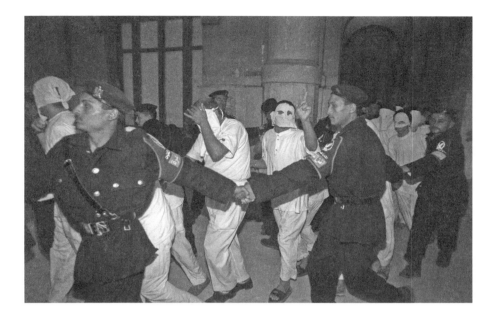

FIGURE 1.7. **Homosexuality's spectral presence.**

Queen Boat Trial Defendants. Courtesy of Norbert Schiller, photographer.

Accident in the afterglow of 'Atayi's contemporaneous love story of Tayyib and Tahir, and to view the ideological work being done in the photoshopped images of Osama bin Laden and the Queen Boat defendant as part of a shared pattern—the homophobic demonization of foreign otherness—that has everything to do with the spectral presence of something "like" a homosexual past reaching into the present. The Middle East, such examples suggest, is not just a blank screen onto which western men have historically projected their fears and repressed yearnings, especially those welling up around the taboo of homosexual desire. That same screen is also alive with the words and worlds of responsive, competing, flickering images that, once we know how to look, and how to read, we can begin to perceive, palimpsest-like, already inhabiting our discursive self-reflections.

SAID AND *ORIENTALISM'S* LEGACIES

The figure most responsible for bringing such Western projections onto the Middle East into a general awareness is Edward Said. Given the echo of his most famous work—*Orientalism* (1978)—in my title, it is appropriate to

review the legacy of his paradigm-shifting work as well as the critiques and revisions that have followed in its wake. Whatever one's ultimate opinion of Said, his definition of Orientalism as a discursive system justifying the Occident's domination of the Middle East single-handedly brought American and Anglo-European academics—and a sizable portion of the educated public—face to face with their hitherto unexamined biases in conceptualizing the Islamicate world. Likewise, Said's theorization of Orientalism virtually created the academic fields of postcolonial inquiry and empire studies, which dominated Western scholarship throughout the 1980s and 1990s. While the interests propelling postcolonial theory have largely moved on to other modes of analysis—including a focus on transnationalism, globalism, race, and diasporic migration—the enduring mark left by *Orientalism* thirty years after its publication can be measured by the fact that three full-length tomes have appeared since 2006 solely aimed at discrediting this book word by word—in order, according to one of these authors, to expose it as "a work of malignant charlatanry in which it is hard to distinguish honest mistakes from willful representations."[32] The gist of these vociferous disagreements hinges on three aspects of *Orientalism*: first, the exasperation among contemporary heirs of the scholarly discipline of Orientalism (which originated among philologists and linguists) at Said's sometimes free and easy use of his sources in order to paint the blackest picture possible of Orientalist scholarship over the past 350 years, damning some scholars unjustly and oddly ignoring others, to create a Manichean view of West versus East; second, the anachronistic projection of imperial and colonial ambitions backwards in time to irrelevant historical periods; and, third, an overreliance on Foucauldian conceptions of knowledge and power that assume in advance what needs to be proved.

Despite these critiques—some of which, especially the manipulation of sources and tendency to find evidence that supports a preformulated thesis, seem in retrospect to have merit—Said's overall thesis continues to be illuminating in ways that only seminal works of scholarship evince. Understood broadly as a discursive force field encompassing everything from ethnic stereotypes promoted in popular culture to national policy and serious scholarship, "Orientalism" for Said articulates and names the combined interests that have constructed the Middle East as "one [of the West's] deepest and most recurring images of the Other." By equating the Middle East with "the exotic, the mysterious, the profound, the seminal," the rational and more highly civilized West justifies its assertion of political, intellectual, and imaginative control over this threatening "Other" by sexualizing and racializing its differences. For my purposes, Said's emphasis on the psychological dimensions of Orientalism is particularly helpful; the representation of the East as a stage, spectacle, and

"tableau vivant" on which Europe acts out its psychic dramas—maintaining all the while the pose of distanced onlooker—speaks to those elements of projection, fantasy, fetishism, and voyeurism that repeatedly mark the erotic trajectories of the texts examined in this book. And, indeed, the appropriation of foreignness to project onto it an otherness that reflects Anglo-European fantasies of sexual taboo is both a rhetorical strategy and a common by-product of Orientalist writing. This alluring otherness, as Said famously argues, has most often been figured as female and hence sexually available, justifying in advance the region's "penetration" by the masculine rationality of European mind (to say nothing of its military powers) in order to contain it. The implicit heterosexism of this model, however, tells only part of the story of the sexual politics of Orientalism.[33]

Likewise, ever since the publication of *Orientalism*, postcolonial theorists by and large sympathetic to Said's overall enterprise have queried essentializing aspects of his theory in order to expand its reach and utility.[34] Nearly everyone agrees that his thesis at times creates and reifies a monolithic "Orient," one that in its vast singularity is all the more easily dominated by an equally monolithic "Occident" whose all-seeing, all-knowing discursive mastery come to seem universal and irreversible. Too strictly applied, this paradigm of Western domination and Eastern subjugation overlooks the variables, inconsistencies, and contradictions composing what are in fact disparate European attitudes and "intentions" vis-à-vis the Middle East. Nor does this template leave room, as numerous critics of Said have shown, for the polyvalent modes and expressions of agency, resistance, control, and dissent with which regions and cultures of the Middle East have confronted European aggression. "Empire," writes Steve Clark, is always a "patchwork of discontinuous and often contradictory interests";[35] so too those colonized encompass heterogeneous intentions and responses that vary according to culture, time period, and specific histories of relation to Europe. Moreover, Said's conflation of the West and empire, of the Middle East and the colonized, elides the history of European interactions with Middle Eastern geopolitical entities like Ottoman Turkey and Persia that were never conquered by Europe and that were the architects of equally powerful empires. Indeed, much of the shared history of Occident and Orient has been one of Europe living in the fear of Islamic domination, rather than the reverse, beginning with the spread of Arab rule and empire from the eighth century through the reign of the Egyptian Mamluks, including the 400-year Moorish habitation of Iberia, continuing with the fall of Christian Constantinople to the Turks mid-fifteenth-century, and climaxing in the threat posed to Western Europe during the Ottoman campaigns against Poland in 1621 and Vienna in 1683.

Postcolonial critics have also commented on the degree to which Said's sometimes monolithic construction of conquering West and conquered East fosters

a binary that solidifies the hierarchy of domination he seeks to dismantle. A glance at the history of shifting political alliances within, as well as between, European and Middle Eastern states not only contradicts myths of an inalterably opposed East and West but also demonstrates the ongoing frequency of contact between Christian and Islamic cultures: Sultan Amurath's eldest son joined the son of the Greek emperor (the latter also plotting with Rome against the Ottomans) in an unsuccessful attempt to overthrow their fathers; Grand Duke Notaras of the Byzantium court declared he'd rather have the Sultan than the Pope as lord of Constantinople (although he changed his tune when Mehmet II demanded Notaras's son as erotic bounty); Francis I of France urged Sulëyman the Great (his ally in forging the Franco-Ottoman alliance of 1536) to invade Hungary to distract Francis's rival Charles V, just as Persia was trying to form an alliance with Charles against the Ottomans;[36] Queen Elizabeth I requested help from Murad II against the Spanish Armada in 1588, while Spain was imploring the Sultan to turn against England.[37] This fluidity of contact also characterized cultural, religious, and personal dynamics. By the twelfth century numerous English scholars were attending Muslim universities in Spain to study Arabic, mathematics, and medicine;[38] Muslims and Christians shared a social life in the taverns, cafes, and markets of the Galata district of Istanbul in what Andrews and Kalpakli describe as linked, proximate relationships;[39] seventeenth-century Westerners noted that the "exemplary conduct" of Turks visiting Christian churches in the European sector of Smyrna put "the [Christian] congregation to shame."[40] The eagerness with which Christian parents from East European provinces annexed by the Ottoman empire sought to enroll their sons in the lists of janissary recruits as a means of insuring their upward mobility meant that the Ottoman Porte (like the Mamluk dynasty before it) seldom had to employ force to meet the annual quotas of tribute-children.[41] Critics of Said like Robert Irwin remind us that after the Protestant Reformation, England and the German countries considered their Catholic neighbors to be more formidable, threatening "Others" than Islam, even during the height of Ottoman advances into eastern Europe.[42]

This fluidity between cultures—however overshadowed by larger histories of opposition and antagonism—encourages us to keep in mind the contingencies, the unforeseen events, the accidental intersections, that challenge dualistic modes of seeing the world. Tracking such cross-currents is also congruent with this project's aims and its use of the concept *Orientalism* as the most conceptually elastic tool for elucidating the homoerotic subtexts and sexual politics attending these encounters of cultures. Without the impetus to uncover and know the Middle East that Said associates with the European will to power, there would be no "homoerotics of Orientalism" or cross-cultural difference to trace; yet the very subcurrents of that homoerotics, operating in- and outside the dominant

structures of Orientalism, become the potentially subversive element that calls the binaries supporting Orientalism's rhetoric of power into question.

HISTORICAL CONTEXTS AND TRAVELERS' TESTIMONIES

The dramatic increase in diplomatic and trade relationships between Europe and the Islamicate world in the early modern period was accompanied by an explosion in published travel narratives and histories of the Middle East, a vast number of which make mention of male homoeroticism. This section distills, from this body of printed material, a series of patterns that illuminate the sexual politics of such cross-cultural contact and set the stage for the literary case studies in the following chapters. In the first half of the sixteenth century, no fewer than 1,000 books on the Ottoman Empire alone were published in England and on the Continent; that number leapt to 2,500 in the second half of the century; in Germany alone, 1,000 imprints of *turcica* were produced in the same century.[43] Arjun Appadurai, reflecting on contemporary patterns of migratory globalization, has written about how the conjunction of increased modes of mobility and new media technologies has created an unprecedented occasion for "experiments in self-making" and the emergence of diasporic public spheres.[44] The early modern period underwent a similar *zeitgeist* as increased modes of mobility (travel to the Levant spurred by trade and politics) intersected with an unprecedented explosion in new media via the burgeoning print industry whose accounts of the Middle East fed an insatiable public desire to learn more about foreign cultures. The result, for travelers and readers alike, was the potential for unpredictable refashionings of both the self and alterity, a potential as catalytic in its time as Appadurai's "experiments in self-making" are in the present era of transnational globalization.

This literature of travel has been the subject of much theorizing in the wake of postcolonial studies. Mary Louise Pratt uses the evocative term "contact zone" to designate those liminal spaces where self and other meet "in terms of copresence, interactions, interlocking understandings and practices" that reshape the subjectivities and desires of colonizer and colonized alike. While Pratt works from the assumption that representatives of empire inevitably acted in bad faith, other travel theorists have focused more positively on the self-transformative experience of such cross-cultural exchanges. Arguing that European narratives of travel are not inevitably, or always, complicit with colonial power, Steve Clark demonstrates how these accounts may also "refigure . . . a more benign ethics of alterity." As he notes, "if the structural function of the journey is to

uncover, bring into relation, there are potential reversals by which the authority of home may be suspended, even repudiated." Likewise, Nigel Leask avers that there are always two local knowledges at work in any cross-cultural encounter, that identification as well as difference mark the traveler's attempt to arrive at cultural interpretation, and that the very anxieties of empire reveal how unstable and porous its claims to authority in fact are. For Dennis Porter, the traveler's psychological desire to leave something behind or achieve something denied at home implies a "powerful transgressive impulse" that is always political.[45] This *désir de l'Orient*, as Behdad puts it, mediates the more pernicious Orientalist desire for knowledge and power and, in displacing the egoistic drive, "compels [the traveler] to give himself over to the everyday experiences of the journey" and the inevitable decenterings that follow.[46] While none of these observations exculpates European travelogues from being expressions of hegemony, they share the conviction that paying more attention to the historical specificity of individual accounts of travel can reveal incongruous elements—the "stutters" of the archive in Stoler's phrase—that complicate one-dimensional narratives of "Western" dominance and "Eastern" subjection.

What, then, do Western travelers' perceptions, and misprisions, of male homoeroticism in the contact zone formed by the Middle East reveal about the range and depth of the constructions, fears, and fantasies that these writers bring to the forms of eroticism to which their travels expose them? What, if anything, can such "stutters" or asides tell the contemporary reader about the erotic practices of and representations emanating from within the cultures they encountered? While the degree of empirical truth that these commentaries reflect will always be open to debate (and often are clearly the product of willfully overheated imaginations), they nonetheless serve as valuable repositories of narrative patterns, themes, and tropes whose cumulative record speaks to specific material realities and moments of cultural interchange. Hence, this section aims to highlight those narrative patterns and tropes that, when brought into proximity, illuminate the sexual and epistemological issues at stake for these observers. As I also attempt to show, these patterns and tropes exist in contrapuntal dialogue with Islamicate sources on similar subjects. To be sure, the primary erotic curiosities that fascinated most European writer-observers were blatantly heterosexual—namely, Muslim practices of polygamy and fantasies of harem life. But a surprising number of these accounts turned their narrative eye, at least for an instant, and at often equally surprising moments, to homoerotic forms of sexual expression that, in contrast to the literally veiled mysteries of female life, appeared—to Western sensibilities—all too visible, too public, staring the observer right in the eye.[47]

The impressions recorded in these early modern European accounts, whatever their taxonomic imperatives and attempts at verisimilitude, are inevitably

colored by a medieval legacy of assumptions about Muslim sexual "perversity." This legacy was primarily disseminated in Christian rhetoric whose political purpose was overt: to incite popular sentiment to retake the Holy Lands from the infidels. An eleventh-century letter spuriously attributed to the Emperor of Constantinople, Alexis I Commenus, singles out sodomy as the most depraved of the various libidinal excesses enjoyed by the Saracens: "We pass on to worst yet. They have degraded via acts of sodomy men of every age and rank: boys, adolescents, young men, old men, nobles, servants, and what is worse and more wicked, clerics and monks . . . !"[48] In *De modo Sarracenos extirpandi* (1318), French Dominican Guillaume Adam, future Archbishop of Sultanieh, confirms the popular myth that the religion of the Saracens permits and praises "any sexual act at all," and he ratchets up the homophobic rhetoric several notches by linking homosexual practice to gender inversion: "there are a great number of effeminate men who shave their beards, paint their own faces, put on women's clothes. . . . [T]he Saracens . . . are shamelessly attracted to these effeminates, and live with them just as among us men and women cohabit publicly."

This perversion of both sexuality and gender, Guillaume insinuates, is not only the fate that awaits European men if the West falls to the Saracens; it is *already* the destiny of all those fair Christian youths enslaved by these infidels. In discomfortingly titillating prose, Guillaume details the means by which the boys' sellers fatten them up, soften their skin with bath treatments, and adorn them in sumptuous clothing—all to make them "plumper, pinker and more voluptuous, and thus . . . more alluring and apt to satisfy the full lust of the Saracens. And when the libidinous, vile, and abominable . . . Saracens . . . see the[se] boys, they immediately burn with lust for them and . . . race to buy [them]."[49] In evoking such rosy flesh, however, Guillaume's language—exemplifying the rhetorical strategy of hypostasis discussed in the representations of Pelagius and the Christian martyr of *A Wonderful Accident*—eroticizes the very bodies of the boys whose corruption he is protesting. If the ideological uses to which aspersions of pederasty are being put are obvious, less predictable are their erotic consequences, as the quasi-pornographic tone of Guillaume's prose reveals. Indeed, one might conjecture that *some* readers might have found inspiration in such rhetoric. Thus Robert C. Davis, in regard to the travel accounts that were to follow in the early modern period, speculates that allusions like these may have inspired homosexually inclined European men to become renegades, a common enough phenomenon in the Mediterranean world. Himself a captive in Algiers from 1579 to 1582, the Spaniard Diego Haedo's hyperbolical testimony that Christian apostates make for the greatest sodomites of all may thus express an unconscious truth—namely, that European articulations equating Muslim culture with male homoeroticism inspired some Europeans to "turn Turk" for reasons not merely mercenary.[50]

Even though Guillaume's inflammatory comments preceded his appointment in Persia, the fact is, as Everett K. Rowson points out, he was already in possession of quite specific facts about the *makhannath* (or effeminate cross-dresser) and Mamluk recruitment practices.[51] In another essay, Rowson analyzes a work of fourteenth-century Cairene literature that forms a telling counterpoint to Guillaume's salacious polemic. Titled "The Plaint of the Lovelorn and Tears of the Disconsolate," this rhymed prose epistle was written by al-Safadī, a leading, innovative writer of his day. Rowson reports that by the Mamluk era in which al-Safadī wrote (he himself was the son of a Mamluk official), homoerotic themes in Arab literature were as commonplace, and as canonical, as heteroerotic subjects.[52] What is especially striking about al-Safadī's epistle is the degree to which it suggests sexual consummation between the two male protagonists without overstepping religious proscriptions (which condemned homosexual activity but not homoerotic sentiment) or the conventions attending the "martyr-for-love" genre (in which frustrated desire becomes the ideal condition for martyrdom). In al-Safadī's text, the narrator falls madly in love with a handsome Turkish soldier whom he invites to his home. Early on the Turkish soldier says that he hopes the narrator will not suffer unrequited desire, speaking of the pleasure that will ensue once God "lay[s] you beside [me] in a single bed" and "permit[s] you to kiss [my] cheeks and drink from [my] mouth, [and] give[s] you the pleasure of undoing the knot of the drawstring from [my] waist and buttocks." This verbal and narrative striptease continues in the speaker's report of their night of passion, as, legs intertwined, "we abandoned restraint . . . [and] what we sought and intended happened"—to which he coyly adds, in the last line of an appended couplet, "But do not ask what happened between us."[53]

Not-naming in this instance is not evidence, as some critics have suggested, that such passion is in fact not physical at all but only an allegory for spiritual love. Nor, as others have argued, is the suggestion of sexual congress a sign of the lovers' depravity in bypassing unrequited yearning for fulfillment in the here and now. As Rowson says, "the protagonists' experience of love is simply portrayed too positively here" to serve as a negative example.[54] Rather, al-Safadī's nuanced handling of the bedding scene creates an adroit balance between the aesthetic conventions of decorum adhering to high romantic literature and Islamic injunctions against sodomy that any explicit description would summon forth. This balance allows the text tacitly to signal erotic fulfillment, thereby not only fulfilling the desire of the narrative but mirroring the lived reality of al-Safadī's readers, for whom the consummation of homoerotic relations existed alongside religious interdiction. What makes al-Safadī's epistle so instructive to read contrapuntally with Guillaume's polemic is what the comparison reveals about the degrees of uneasy coexistence, in each, of religious prohibition and male homoeroticism. In Guillaume,

the heated denunciation of (a foreign enemy's) un-Christian sexual perversity yields the text's own destabilizing erotic "heat" in its lascivious descriptions; in al-Safadī, the author's implicit approval of desire between men creates a rhetorical space in which sexual ends can be attained despite religious injunctions. Furthermore, while Guillaume's depiction of Muslim same-sexuality hinges on a definition of sodomy expressed in terms of hierarchal difference (e.g., age-difference and gender roles), al-Safadī's representation emphasizes romance, and the author deliberately sidesteps ascriptions of age-difference, sexual role, or even sexual act (despite the loosening of drawstrings and baring of buttocks, there is no clue whether penetration is involved, desired, or relevant to this amorous coupling).

Al-Safadī's nuanced homoerotic tale is far from unique. The world of the Levant into which Europeans increasingly ventured was saturated with historical and literary examples of desire, love, and romance between men. The passion of Sultan Mahmud of Ghazni (d. 1030), the founder of the Ghaznavid dynasty (in what is modern-day Afghanistan and Iran), for his former slave Ayaz became, in Janet Afary's words, "the quintessential homoerotic affair in Persian and Turkish literature," a moral fable of abiding love recounted as frequently as the fictional tale of Majnum and Layla and available in sources ranging from Nizamī-i Arūzī-i of Samarkand's *Four Discourses* to Sa'dī's classic *Gülistan*.[55] The latter, the most frequently copied specimen of Middle Eastern literature across the centuries, provides a useful marker of the degree to which the discourse of male love was a commonplace feature of the cultures recounted in European travel narratives. Of the twenty-one anecdotes in its chapter on love, nineteen depict desire between men.[56] The greatest repository of homoerotic literary themes was the *ghazal*, a form of love lyric that, with slight variations, spans Arabic, Persian, and Ottoman languages from the tenth century forward.[57] The wealth of homoerotic sentiments expressed in this literary outpouring, Andrews and Kalpakli insist, is not merely aesthetic but grounded in "social referents" and lived experience. Thus they boldly state, in a corrective to criticism that has tended to lay sole responsibility on Western Orientalism for hypersexualizing its representations of Islamicate culture, "it was easy for the West to eroticize its relations with the Ottoman East because that East had already eroticized its own social and political relations." While Europeans may, indeed, rewrite the erotic to accord to their own fantasies, the erotic—and specifically the homoerotic, to which Andrews and Kalpakli are referring—"was everywhere available for Western scholarship and the Western imagination to discover in the East."[58]

These, then, are the cultural and literary legacies that frame the explosion of travel narratives recounting European encounters with the Middle East beginning in the sixteenth century. Although a fair amount of this literature is as propagandistic as the Crusader sentiments noted above, a surprising number of

these authors saw their task as firsthand observers to be as objective and factual as possible. Accordingly, they fill their narratives with charts, statistics, lists, and breakdowns of information into taxonomic categories that, more often than not, overwhelm their tomes with mind-benumbing rather than titillating detail. Of course cultural biases, national prejudices, and moral sentiments color their observations, especially those describing sexual customs, but once the modern reader strips away the almost pro forma veneer of admonitory rhetoric about and stereotypical epithets for homoerotic acts that frequently accompany these descriptions, what is most evident is the sheer curiosity of inquisitive minds attempting to draw comparisons and contrasts in order to make sense of their encounters with alterity.

This cast of mind epitomizes the repeated observations about the Middle Eastern coffee house as a locus of public homoerotic interaction (fig. 1.8; see also Plate 1). An instructive example occurs in George Manwaring's account of his 1599 travels as an attendant accompanying the British Ambassador to Persia. Particularly interesting is the matter-of-fact way he begins his comments on the sexual practices encouraged by Ottoman coffeehouse culture by noting a *commonality* between East and West: "as in England we . . . go to the tavern, to pass away the time in friendly meeting, so [the Turks] have very fair houses, where this kaffwey is sold; thither gentlemen and gallants resort daily." Such spaces of male homosociality call to mind the reference to "Elford's Coffee-House in George-yard in Lombard Street" in *A Wonderful Accident*, where the narrator receives his insider's information about "Mahumetan" sodomy from "Turky-Merchants" recently returned from Aleppo. This commonality, however, quickly evolves into a contrast as Manwaring explains how the café owners attract clientele by "keep[ing] young boys: in some houses they have a dozen, some more, some less; they keep them very gallant in apparel. These boys are called Bardashes, which [the patrons] do use . . . instead of women."[59] Likewise, in a volume of travels written a decade later, George Sandys mentions that "many of the Coffa-Men" keep "beautiful Boys, who serve as Stales [that is, lures] to procure their customers," and Pedro Teixeira similarly notes the "pretty boys, richly dressed," serving up coffee in Aleppo (the setting of *A Wonderful Accident*.)[60] In Persia, Sir John Chardin comments that coffeehouses, "generally [located] in the finest Parts of the Cities," served as "nothing else in Reality, but Shopes for Sodomy" until their temporary abolishment during Abbas II's reign.[61]

These European representations of sexual difference intersect, intriguingly, with a variety of Middle Eastern texts commenting on coffeehouse and wine-tavern culture. In the mid-seventeenth-century, Ottoman historian Ibrāhīm Peçevi in his *Tarih-i Peçevi* (c. 1640–1650) explains that coffee establishments sprang into vogue the century before, their rise in popularity dovetailing with Süleyman the Magnificent's reluctant banning, under pressure from

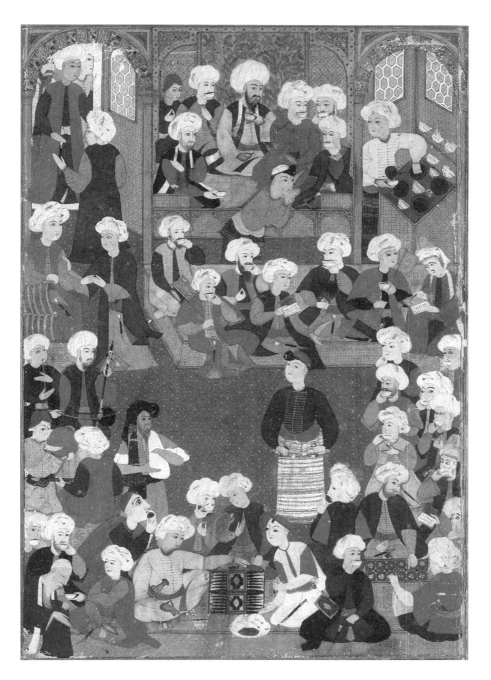

FIGURE 1.8. **Peak hours in the coffee shop. Multiple forms of male camaraderie are on display in this miniature. (See also Plate 1)**

conservative religious revivalists, of Istanbul's popular wine taverns in 1554.[62]
Mostly Greek and Portuguese establishments located in Galata, these taverns
served as the favored meeting places of Turkish pleasure-seekers and their male
minions (recall Tayyib and Tahir's youthful frolics in Galata in 'Atayi's *Heft han*).
Ottoman courtier and social satirist Mustafa Âli, in his deliciously nasty *Tables of
Delicacies Concerning the Rules of Social Gatherings* (c. 1600), sketches a colorful
portrait of these wine taverns.[63] Their patrons, he writes, include "hot-blooded
young men [and] . . . potent youths fond of drinking and fornicating with women
and boys." Female beloveds being prohibited by definition from such gathering
places, these establishments became spaces of socialization where men openly
brought their male beloveds, with whom, Âli writes,

> they eat and drink, and when evening falls they make their way over to
> the tavern's private room. According to the demands of their lust, they
> extract milk from the sugar cane [that is, achieve orgasm] . . . Friday night
> is reserved for approaching, with the abandonment of all decorum, young
> men, and every Friday afternoon for servant boys and beardless lads
> whom they have tucked up their sleeves.
>
> And so, according to the code of wine worshippers, on Fridays [the
> Islamic Sabbath] after prayers they head for the taverns. They clink their
> drinking bowls together and say, 'It's the lucky day for giving a purgative!'
> [i.e., having anal intercourse] because men of the craft trades, being free
> of work that day, and government officials, who are connoisseurs in these
> matters, both wander about 'on the path of aspiration' [i.e., hoping for a
> successful pickup]. One may be certain that when the sun goes down and
> they go home, they spread out the pillow, mattress, and sheets and take
> young beauties and beardless servant boys into their arms.[64]

Once these wine taverns so evocatively described by Âli as sites of sensual
"worship" were banned and replaced by coffeehouses, the homoerotic behaviors
associated with the former quickly shifted to the latter. In turn, the religious
revivalist factions that had advocated the closing of the wine taverns now increas-
ingly inveighed against the coffee shops as threats to social order. Hence in an
edict written at the same time that Manwaring is touring Turkey, one jurist
condemns coffee shops that "take on beardless apprentice boys" in order to
attract "those . . . addicted to [such] love"—and, almost as bad, those addicted
to coffee![65] Within a century, the "problem" of this double addiction—boys and
coffee—appears ubiquitous throughout the empire, evidence of which includes
the guild complaint registered against a neighborhood café where the hiring of
"beardless youths to wait on . . . morally corrupt" customers is said to have led
to a slacking of religious duty, because customers are too busy fornicating to

attend to their prayers: "they openly boast of doing all these reprehensible acts even during times of prayer."[66]

Thus a more complex picture emerges when European and Middle Eastern texts such as these are considered in conjunction, than that of a sexual economy in which Muslim men indulged in sodomy with impunity.[67] Taken together, these sources convey the sense of a thriving but not always welcome homoerotic subculture that—as scholars like Ze'evi, El-Rouayheb, and Andrews and Kalpakli incisively detail—coexisted with *other* subcultures in a multilayered social order whose constituencies often included overlapping members. Note that in most of the European accounts, the tenor is carnal—coffeehouse boys are seen as "kept," sexually available to customers at a price. In contrast, sources like Âli's *Tables of Delicacies* depict a *range* of male objects of desire inhabiting the same environment: idealized beloveds accompanied by their lover-patrons, willing young beauties ripe for the picking, apprentices who are off work on Fridays, servant boys. Likewise, patrons range across classes, professions, ages; they include connoisseurs of pleasure who may equally desire girls and boys, randy young hot bloods, wealthy masters who probably aren't so young, married men, members of the artisan and working classes, elite government administrators, soldiers from the janissary ranks, and (as Âli also notes), the usual number of aging lechers and debauchees. Indeed, it is not always clear *who* among the café's patrons is the pursuer and *who* the pursued—the hot-blooded "young men" that Âli says are fond of fornicating with boys or girls aren't rhetorically distinguishable from those "young men" who are the *objects* being pursued on Friday nights, nor are the "men of the craft trades" depicted as being on the prowl necessarily distinct from "apprentice-boys" who succumb to their advances.

Even more to the point, while these sources attest to a widespread institutionalization of homoerotic behavior, its existence is not unproblematic, as the crackdowns (initially on wine taverns and then on coffeehouses) attest. At such moments, what has hitherto been the mutual coexistence of social groups espousing different value systems reaches pressure points when the religious proponents and guardians of morality gain the upper hand; but, simultaneously, it appears that attempts to suppress any given venue for homoerotic gatherings merely creates another.[68] Complex and sometimes contradictory as such formations may be, it is not hard to see why their very existence and relative visibility aroused the amazement of European visitors for whom such sights were, in more senses than one, "foreign."

This difference in viewpoints is obvious in the contrasting use of tropes of excess—particularly sexual excess—in early modern European and Middle Eastern texts. An opinionated and deeply conservative protestant who begins *The Totall Discourse, of the rare adventures, and painefull peregrinations of long nineteene yeares travayles* (1632) by railing against his hell-bent age, Scot traveler

William Lithgow first records his impressions of Rome, which his rabid anti-Catholicism leads him to label a "second Sodom."[69] Traveling eastward, he observes the habits of the heathen Turks, whom he accuses of being "extreamly inclined to all sorts of lascivious luxury; and generally addicted, besides all their sensual and incestuous lusts, unto Sodomy" (163). (In counterpoint, it is instructive to note that Lithgow's Turkish sojourn occurred within seven years of 'Atayi's composition of the romantic tale of Tayyib and Tahir.) By the time he's reached Fez, all hell has broken loose: "worst of all, in the Summer time, they openly Lycenciate three-thousand common Stewes of Sodomiticall boyes. Nay, I have seene at mid-day, in the very Market places, the Moores buggering these filthy Carrion and without shame or punishment go freely away" (367). One would assume this exponentially increasing outrage might diminish upon Lithgow's return to Europe. Instead, ironically, the "damnable libidinous" excess (266) that has haunted him abroad only multiplies as he crosses back into Italy. For now, ranting at the Papists who have rendered Rome one great "Stewe" (406; note the echo of his description of Fez), Lithgow expends four pages on the depraved practices of a roster of popes and cardinals.

If Lithgow's text illustrates the danger of the plentitude of foreign vice overrunning one's narrative and deconstructing its claim to moral superiority, Âli's chapter in *Tables of Delicacies* (c. 1587) on "Beardless Boys" evinces a quite different attitude toward erotic excess. For in his account sexual plentitude is part of the ironic fun, evinced in the witty catalogue that he provides of the ethnic and national differences in appearance, compliance, and desirability of the far-flung empire's available youth. Among these "delectable morsels," the dancing boys from the East European provinces are "gentle"; the "fierce-looking lads" from Bosnia-Herzegovina turn out to be the most "obedient" and longest-lasting beauties (whereas the "agile lads of Arabia" lose their looks by twenty years of age); the "narrow-waisted" boys of the Inner Provinces (which include Istanbul) are ingenuous flirts whose "outward gentleness" conceals "inward contrariness"; and the list goes on.[70]

Michel Baudier's *Histoire générale du Serrail, et de la cour du Grand Seigneur* (1626) exemplifies another narrative tendency shared by several European travel writers: promised glimpses of the Orient's female mysteries that are derailed by mentions of male homoeroticism. The penetrative image of "enter[ing]" an Ottoman East is the governing trope of the preface, which pledges to usher its readers across the threshold of the forbidden female quarters of the Sultan's seraglio, where "the secret of all things is carefully shut up."[71] The voyeurism implicit in these images appears ready to deliver in chapter 10, "Of the Grand Seigneurs Loves." Here Baudier takes the reader "inside" the hidden world of the harem by *imaginatively* tracking the footsteps of the Sultan as he traverses the women's quarters—which is to say that, at this narrative juncture, Baudier's history becomes *purely novelistic* in its use of narrative omniscience, creating the

illusion that the author is spying on an actual occurrence. First he visualizes the scene of the Sultan's selection of his female companion for the evening. Next he pictures the Sultan joining his concubines in their private outdoors retreat. "*Let us . . . follow him* into his garden, where he is in the midst of his lascivious imbracements," he invites his readers (55; emphases added).

Having thus promised the reader scenes of lascivious titillation, Baudier's narrative makes two abrupt turns. First, he demurs that the violence that the Sultan "observes against those who should see him, forbids [Baudier] to reveal the secret" scene of these "imbracements" after all. Second, Baudier announces that the Sultan's dalliances with these women are "not the most blameable of his affections," and, without pausing, launches into a disquisition on "the detestable excess of an unnatural passion"—the Sultan's "love of men"—that continues to the chapter's conclusion. The ironic effect is that the narrative climax of a chapter initially promising to showcase the Sultan's harem beauties brings into focus, instead, nubile boys:

> He burnes many times for the love of men; and the youngest Boyes which are in the *Levant*, the floure of beautie and the allurement of graces, are destinated to the filthiness of his abominable pleasures . . . This *disorder* is so inveterate . . . [that] of [the] twenty Emperours which have carried the Turkish scepter, you shall hardly find two that were free from this vice. (156)

Baudier proceeds to name names, which in turn leads him to meditate philosophically on the obligations of rulers: what matter all the grand conquests of the Ottoman princes if they themselves are captive to this addictive vice? "The Prince is the Physician of the State; but how can he cure it if he himself bee sick?" (57) Having strayed this far from his original subject matter, Baudier picks up the subject of women in the following chapter, although nothing contained therein equals in shock value the representation of "unnatural passions" to which the reader has just been made privy. To which topic Baudier returns, as if compelled to tell more, in chapter 14, "Of the filthy & unnaturall lust of the [Pashas] and of the great men of the Court." His focus is the "myre of filthy pleasures" into which the governmental courtiers and administrators surrounding the Sultan "plung[e] themselves":

> they abandon their affections to young Boyes, and desperately follow the allurements of their beauties . . . This abominable vice is so ordinary in the *Turks* Court, as you shall hardly find one [pasha] that is not miserably inclined toward it: It serves for an ordinary subject of entertainment among the greatest when they are together; they speak not but of the perfections of their *Ganimedes*. (162)

Now Baudier truly provides "to-the-moment" reporting as his novelistic imagination again takes over, visualizing, complete with dialogue, such a gathering of men: "One sayes, they have brought me from *Hungarie* the most beautiful and accomplished Minion. . . . Another saith, I have lately bought *a young Infant of Russia*. . . . ," and the reported "conversation" goes on. Finally, creating a level of diegetic scopophilia mirroring the voyeurism being incited on the narrative plane, Baudier depicts one pasha asking another to put his newly acquired "Angell" on display—"[he] entreat[ed] him earnestly *to have a sight . . . that he may be satisfied by his eyes*" (162; emphases added)—at which point the narrator inserts a lavish description of the arts used to "beautify" these boys. One is uncannily reminded of Mustafa Âli's cataloguing of various available boys across the empire in *Tables of Delicacies*. Where Âli aims to amuse, Baudier means to scandalize, but the effect implicates Baudier all the more in the "vices" that his own voyeuristic imagination is making visible in the readers' minds. For instead of penetrating the female harem, the reader's mind is penetrated by the sodomitical images that Baudier's prose summons forth. "By semiotically stimulating desire," Falkner reminds us, "texts may facilitate the vice as much as they attempt to combat it."[72]

A similar tension between an excess of titillating homoerotic detail and moralistic outrage characterizes English diplomat Aaron Hill's virulent response to a pederastic tryst he unintentionally witnesses, yet nonetheless proceeds to narrate at great length, in *Account of the Present State of the Ottoman Empire* (1709). Hill has gathered a party of fellow countrymen at an open kiosk in a park overlooking a nearby river to welcome the new ambassador. Enjoying the vista, the group spies, on the opposite bank, a well dressed, middle-aged Turk leading an adolescent boy to a secluded area, where "he began, *to our surprise, and inexpressible confusion*, to prepare himself and his *consenting Catamite*, for acting a Design so hateful to our sight, and such a stranger to our Customs, that we scarce believ'd our Eyes."[73] Despite the ballyhoos and catcalls of the English party, the "lustful Wretch" (81) persists until Hill breaks up the encounter by firing his fowling piece at the man.

There is, however, another reading of the sexual tryst in the park that Hill misses altogether. As noted in the tale of Tayyib and Tahir, Ottoman male elites of the sixteenth and seventeenth centuries perfected the art of the *sohbet* or outdoors garden party. At these refined gatherings, elite lovers and favored youths came together to share wine and delicacies, poetry, mannered discourse, and the unspoken language of "signs" in a sophisticated atmosphere of flirtation, admiration, and seduction. These sohbets were often held in wooded parks and gardens with open kiosks very much like the venue described in Hill's text (fig. 1.9). The Ottoman traveler Evliya Çelebi, writing four decades before Hill, praises the "Loggia Pavilion" of one such pleasure grove where "every afternoon

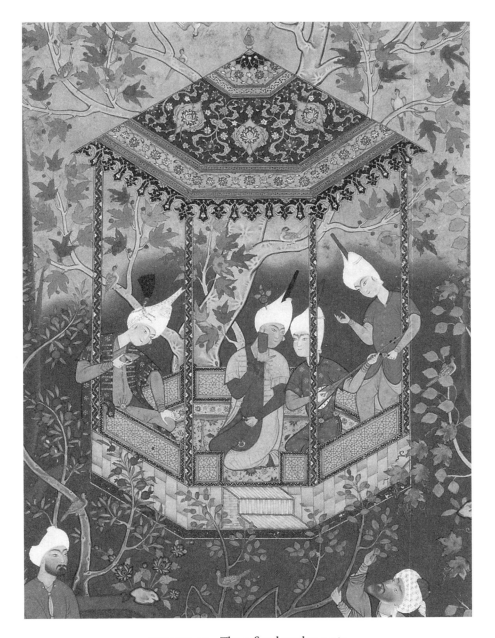

FIGURE 1.9. **The refined garden party.**

Detail from *The Townsman Robs the Villagers' Orchard*, an illustration accompanying the narrative "Rosary of the Pious," in Ibrahim Mirza, *Haft Awrang* of Jami (1556–1565), fol. 179b. Courtesy of the Freer Gallery of Art, Smithsonian, Washington, DC. Purchase F1946.12.179.

[male] lovers gather behind the tall trees and shady spots and flirt with their beloveds. It is a delightful gathering-place for men of culture." Rhapsodizing about the bountiful amenities—flowing water, pleasure-domes, trellises, bowers, kitchens, pantries—of another park, he adds, "Here countless love-struck young men come to sing love songs to the handsome boys they adore. . . . They pour out their emotions so sweetly and sadly that the nightingales get tongue-tied with admiration. In every corner [of the park] there is flirtation and fun and drinking and carousing."[74] Given the popularity of such pleasure spots, it is highly unlikely that Hill's was the only group frequenting the river park on the occasion of the party for the ambassador. And it is entirely possible, following this train of logic, that what Hill's group witnesses are *not* the furtive, crude maneuvers of a wretched scoundrel out to have his way with a minor (the man, after all, is well-dressed—to Hill's surprise—and the boy is compliant). Rather, this encounter might well be the culmination of a flirtation between two attendees at an off-stage *sohbet* occurring in the same park. Tactfully having wandered out of the viewing range of their own party into one of those shady nooks described by Evliya, these two gentlemen have inadvertently strayed into the sight-lines of a more easily shocked and less forgiving English audience. Had the latter been an Ottoman gathering, its participants would no doubt have exercised their good manners by turning their gaze to another aspect of the natural view, respecting the private intentions of the two lovers.

Literally dozens of similar commentaries on Middle Eastern homoeroticism appear in European travel narratives and histories published throughout the eighteenth and nineteenth centuries, repeating with slight variations the attitudes, strategies of representation, and rhetorical expressions surveyed thus far (and in at least one case plagiarizing a prior authority's description word for word[75]). Among these texts, one early-nineteenth-century traveler's comments stand out for the highly personal nature of the encounter of cultural viewpoints they record and for the unusual degree of empathy that ensues. James Silk Buckingham wrote several books about his travels throughout Asia Minor, and nothing is more instructive than comparing his initial reaction to the male "vice" he first witnesses in Baghdad in 1827 and his revised view of love between men in a volume appearing in 1829.[76]

In the former work, Buckingham assumes a censorious tone as he announces his unhappy "duty, as an observer of human nature," to speak "in the least objectionable manner" of objectionable depravities: to wit, the practice he's witnessed firsthand in Baghdad of "boys publicly exhibited and set apart for purposes of depravity not to be named" (166). The second volume, however, sings a surprisingly different tune for one shocked to learn that "the vice" of which he had previously only heard rumors "was not merely imaginary" (168). This change of heart is due to personal circumstances that figuratively and literally open the

writer's eyes to the possibility of an *honorable* passion existing between man and youth, where before he has only imagined debased lust.

The narrative structure Buckingham creates to set forth this revelation is optimally designed to draw readers in and win over their sympathies; and the tenor of its language, compared to the severity of the 1827 volume, assumes the vocabulary of literary Romanticism, as experiences of natural feeling, intuition, and benevolence replace moral outrage. The chapter opens with Buckingham's glowing account of the "favorable impressions" (77) that his hired guide, the Afghan dervish Ismael, has made on him. The depth of Ismael's intellect and metaphysical studies, his lofty soul and independent spirit, his charity to others—all these characteristics incite Buckingham's curiosity to learn why a man of such "overflowing benevolence" (77) has given up worldly possessions to become a wandering dervish. The arc of Ismael's experiences, it turns out, is not unlike the life pattern of sixteenth-century Ottoman males glossed in the story of Tayyib and Tahir: Ismael devotes his early years to serious study till he comes to feel all knowledge is vanity; gives himself over for a period to sensual enjoyments and "forbidden gratifications" (78); reforms and enters a trade (as engraver and jeweler) that allows him enough income to wander the world and satisfy the Romantic restlessness of his "vivid and ardent mind" (79), for which the stimulant of spontaneous feeling makes life worth preserving.

Such spontaneous overflow, indeed, explains Ismael's instantaneous decision to become Buckingham's companion and guide. Upon meeting the narrator in Baghdad, Ismael—following the spontaneous promptings of his heart—declares "I will follow you." He refuses any compensation, explaining "it was my destiny to follow you wherever you might go" since from "the moment I saw you and heard your voice, I felt that your soul contained what I had all my life been searching for in vain." As proof of the depth of his commitment to fulfill this call of destiny, Ismael explains that he will be leaving behind the "one tender object of [his] affections" (80), a beloved he values more than his own existence. Of course, this hint of romance only piques Buckingham's "strong desire to know more of my companion"—who a few pages before was reported to have courted a "pretty damsel of [the] Aphrodinian race" (67) in Kurdistan. This mystery in turn fosters the reader's narrative desire to press onward—who doesn't enjoy a love story?—and Buckingham is even more moved when he witnesses his guide tearfully parting with his beloved's father, a Christian merchant named Elias. The journey commences and the two men become soul mates, discoursing long into each night on high-minded subjects. One evening, however, Buckingham comments how much Ismael must miss Elias's daughter. Ismael corrects him; the object of his life's passion is not a girl but Elias's *son*. "I shrunk back from the confession as a man who recoils from a serpent," Buckingham states, but lest his readers take too much of a thrill in assuming the worst, Buckingham

makes a proleptic leap forward in the very next sentence, where he informs us that he was soon "delighted" to learn that Ismael's love is "a pure and honorable passion," one characterized by "a genuine infusion of *nature*, and in no way the symptoms of a *depraved* feeling" (85; emphases added).

With these words, Buckingham turns on its head two hundred years of European travel commentary, in which "nature," aligned with procreative heterosexuality, is counterpoised to those "unnatural" depravities like sex between men said to flourish in the Levant. At this point Buckingham launches into a six-page digression on the classical tradition of the "honorable" love of boys from Crete to Athens. First Buckingham argues that because Greek love—and its echo in medieval Muslim culture—was rooted in the desire to inspire youth to noble deeds and noble thoughts, these pederastic relationships were by definition "virtuous" and without "corrupt effects" (85–86), regardless of the "flame" (88) of erotic passion and sexual consummation present in them. Yet when Buckingham says his "severe and minute" (90) interrogation of Ismael convinces him that his guide harbors no "impure desires" or "unchaste thoughts" (91) for his beloved, it might seem that Buckingham is now interpreting "platonic" love in the Victorian sense of a non-erotic friendship.[77] Buckingham is in fact making a more nuanced distinction. For when the narrator finally desires, "I could no longer doubt the existence in the East of an affection for male youths, *of as pure and honorable a kind as that which is felt in Europe for those of the other sex*" (93; emphasis added), he is in effect suggesting that purity resides in the *quality* of the passionate eros felt for the love object, not in whether it is physically consummated.

Indeed, on the emotive and sensate level, such romantic "affection" *is* erotic, as Ismael makes clear when he argues that *if* a man can love a woman and desire carnal "enjoyment" of her "person" without acting upon that desire until it is appropriate, so too can a man passionately desire another male (and desire "enjoyment" of his "person") without giving offense to propriety. In effect, Ismael's argument leads Buckingham to conclude there is no qualitative difference between what Ismael feels for Elias's son and the erotic desires drawing together the love interests of any nineteenth-century romantic novel in which the heroine, if not the hero, remains chaste until novel's end. The fact that Ismael's love is for a Christian boy not only adds a note of cross-cultural difference but implicitly demonstrates to Buckingham and his reader that such higher homoerotic feelings are not exclusive to the Orient and parallel those "felt in Europe."

The catch, of course, is that there is no socially sanctioned "happy ending" (such as novelistic marriage) for Ismael's love, and both he and Buckingham remain silent on how to act on erotic feelings in the absence of an approved outlet. On the public level, Ismael's love for the boy is doomed to exquisite frustration, which may illuminate why Ismael chooses to become Buckingham's dedicated

companion, even if it means separating himself from his beloved: such an act of sublimation and triangulation only heightens the as-yet-unfulfilled desire for the original object. In terms of narrative structure, it may also explain part of Ismael's autobiography that Buckingham inserts at this juncture. Six years previous, Ismael tells Buckingham, on a crowded bridge over the Tigris he happened to observe a beautiful Turkish boy "whose eyes met his, as if by destiny" (91). The boy blushes with all the signs of love at first sight, Ismael's head swirls, the two declare their mutual love to the approval of their friends, and they continue meeting for months as they grow into "one soul" (92)—at which point the boy falls fatally ill and Ismael dedicates himself selflessly to the youth's care till the latter's death. If the tragic ending of this love story is ennobling, it is also—to say the least—erotically frustrating, since death erases the possibility of physical consummation in the process.

It is this second tale that ultimately convinces Buckingham of "the existence in the East of an affection" (93) between males every bit as passionate *and* virtuous as any European male's romantic feelings for the female object of his desire. Convinced that such love exists—love that transcends the carnality associated with the male prostitutes in Baghdad from whose approaches he recoiled in his earlier volume—Buckingham narrates a conversion experience, one that may be influenced by social developments in England (including the publicity surrounding the increased persecution of men engaged in sexual acts) and by Romantic literary sensibilities, but one that he would never have reached without his travels abroad.[78] Buckingham's affirmation of passionate homoerotic love, furthermore, circles us back to the idealized world of ennobling male love allegorized in 'Atayi's story of Tayyib and Tahir, and this moment of convergence between European and Middle Eastern perspectives over two centuries serves as a healthy riposte to the voyeuristic Orientalism and titillated homophobia characterizing writers like Hill and Baudier.

Buckingham isn't alone, moreover, in his more generous observations; traveling by its very nature is not always, or simply, voyeuristic or imperialistic. In the opening of *A Voyage into the Levant* (1636), published just one year after Baudier's salacious account of the sodomitical practices of the Sultan and his court, English traveler Henry Blount writes that the true goal of travel is witnessing the unknown precisely in order to *undo* common stereotypes and prejudices. Thus, throughout his narrative he reminds his readers he is reporting "what I found" rather than "censuring [those institutions] by any [preconceived] rule." Criticizing travelers who "catechize the world by their own home," Blount reprimands those who arrive in foreign lands with preconceived opinions, and he presciently advocates an ethos of cultural relativity when he explains that Turkish customs assumed to be "absolutely barbarous" to European eyes in fact conform to "another kind of civilitie, different from ours." Likewise, his nonjudgmental

observations about sodomy when confronted with the friendly hospitality of a catamite accompanying his Ottoman master remind us of a truth that certain travelers, Eastern and Western, have always intuited: that desperately attempting to enforce the boundaries of self and other diminishes rather than expands one's notion of self.[79] In the same vein, Horatio Southgate, an American Episcopal priest serving as a missionary in "the dominions and dependencies of the Sultan," admonishes the readers of his *Travels* (1840) "not to judge" Muslim culture by European standards. Although his narrative makes it clear that he laments the "vice" of same-sex love that has "deeply stained" the "Eastern character," he maintains that while such customs may seem "unpleasing to us, because they belong to a different order of society," they "yet are not more unpleasing than are some of our own peculiarities" in the eyes of the Oriental subject.[80]

These examples of open-mindedness regarding sexual matters that may ensue from travel are not unique to Europeans. One finds their counterpoint in an observation made by Evliya, traveling in Eastern Europe just a few decades after Blount's sojourn in Turkey. Passing through an Albanian town on a festival day, he reports having witnessed "lovers go[ing] hand in hand with their pretty boys," adding that "this . . . quite shameful behavior" is "characteristic of the infidels." But, he adds, "it is their custom, so we cannot censure it." In a fascinating reversal of the modern reader's expectations, however, it turns out that Evliya is not censuring, as may first appear, male homoerotic display. What he judges to be "quite shameful," rather, is the fact that these tipsy "infidel" couples are "danc[ing] about *in the manner of the Christians*" on what is likely a saint's festival day. But, tolerant Muslim that he is, Evliya wisely chooses, like the Reverend Southgate, not to censure those religious "custom[s]" and "manner[s]" not one's own.[81]

FROM ARMCHAIR ANTHROPOLOGY TO ISLAMICATE SEXUALITY STUDIES

Speculations about the causes of homoeroticism in the Middle East are a staple of European travel literature, and they share a series of interrelated contradictions and incoherencies worth attention, not only because they serve as windows into these historical accounts, but also because they anticipate hypotheses put forward in the early twentieth century as sexology emerged as a research field and, later in the century, as the history of sexuality became the focus of serious scholarship. One such contradiction revolves around the "sex" or "love" question. Various travel writers, subscribing to the Orientalist notion that Middle Eastern sensuality is brutish at base, viewed the

prevalence of same-sex male desire as one more expression of rapacious lust, the most expedient means of satisfying urges with little regard for the object satiating those desires ("They are very lascivious Rogues," de Thevenot writes in 1686, "and that for both Sexes").[82] Yet many travelers, like Buckingham, were struck by the apparently *romantic*, as opposed to carnal, tenor of these relations. "It is difficult to account for this taste," French traveler C. F. Volney mused in 1793, "unless we suppose they seek in [members of the same sex] that poignancy of refusal which they do not permit the other."[83] Volney's implication is that since marriages are arranged affairs in which female partners have little say before or after the fact, there is no room for courtship's affective elements: a male youth one is wooing, however, may reject or accept one's overtures. The second-class status of women figures into such deductions. A man's catamites are his "serious lovers," Blount reasoned, precisely because "wives are used (as the Turkes themselves told me) but to dress their meat, to Laundresse, and for reputation."[84] So, too, de Thevenot declared Turks take their wives "for their service as they would a horse," whereas they save their *love* to "spend . . . upon their own sex."[85] Such assertions that boys are the repository of men's romantic feelings contradict, of course, the assumption that such relations are only carnal.

Nearly all travelers attempting to explain these same-sex erotic preferences cite Islam's enforced separation of the sexes as a contributing factor, arguing that male homosexuality (whether manifested as lust, sex, or love) arises as a "second-best" option given the unavailability of unmarried women. But this argument also presents the seeds of its own deconstruction for these erstwhile sexual anthropologists: given the fact that Muslim men are allowed four wives and as many concubines as they can afford (as well as "temporary marriages" for travelers, soldiers, and pilgrims on the road and ready access to female prostitutes in all the major urban areas[86]), European commentators find themselves wondering *why* a hot-blooded male would really need a secondary outlet, given the range of female options. Curiously, this logic leads several observers, such as Lord Charlemont, to deduce the opposite: namely, that polygamy is the culprit "creating" men's desire for other males, since extreme indulgence in a good thing (sex with women) jades the appetite and creates the "consequent desire [to] search after novelty."[87] Ironically, it doesn't occur to the proponents of this view that overindulgence in the "detestable vice" of sodomy should, by the same reasoning, *also* create eventual boredom; instead they portray it as an "addiction" one can't shake.[88]

Aside from the problems apparent from a contemporary perspective in categorizing homosexuality as a compensatory substitute for the real thing, there is a crucial difference between these expressions of overindulgent, overflowing desire and Islamic attitudes toward sexual variety, according to Abdelwahab

Bouhdiba in the first major Arabic-language study of its kind, *Sexuality in Islam* (1985). While Bouhdiba's argument that Islam is fundamentally "an economy of pleasure" is not without its blind spots, as others have shown, his general hypothesis remains relevant. In place of the sexual repression, denigration of the body, and guilt characteristic of Christian tradition, Islam invests erotic life with transcendent meaning if properly used. Muhammad's concern with the importance of foreplay in lovemaking, a wife's right to sex, and coitus inter-ruptus as a legitimate form of birth control all attest to the meaningfulness of sex, and of sexual pleasure, in Islam.[89] Marc Daniel, one of the first European scholars to attempt an overview of the history of male same-sexuality in Arab history, comes to a similar conclusion: "it is not the frequency of homosexuality in Muslim cultures that is noteworthy; it is the frequency of all forms of sexual pleasure."[90] When, however, Daniel speaks of the Prophet's "relative indiffer-ence" to male homosexuality,[91] he overstates the case, as do other sympathetic Western writers, primarily early gay studies scholars who, influenced by the sexual liberation rhetoric of the 1970s and early 1980s, imbued pre-modern Arab-Muslim attitudes toward sexuality with an idealized degree of tolerance, when in fact those outlooks might better be described as perspectives enmeshed in a system of mutually operative contradictions. Hence, while the Qur'an forbids sex between men through its references to the story of Lot and the sodomites, it prescribes no clear punishment, and the Prophet nowhere names *liwāt* (the act of penetration of one male by another) in the list of grave sins against God (*hadd*).[92] Nonetheless, in hadiths attributed to Muhammad and subsequent religious edicts over the centuries, condemnation of sodomy is ubiquitous and by and large unambiguous.

Such condemnations, however, contain their own contradictions: Ali, the Prophet's son-in-law, is reported to have explained the religious prohibition on *liwāt* by averring that men would dispense of women altogether were "carnal penetration of a boy" permitted.[93] A millennium later, when a Moroccan living in seventeenth-century Paris, Ahmad bin Qāsim, set out to correct European misperceptions that Islam approves of homosexuality, he did so by admitting that sex between males, while in no way sanctioned by religion, was indeed "widespread among Muslims." Such comments reveal the gap between theory and practice that has been a hallmark of Islamicate social mores, as well as those of Christians and Jews under Islamic rule, for centuries.[94] While one needs to be wary of universalizing this tendency to separate precepts and lived reality, this fissure between principles and practice nonetheless illuminates the evolution of a social system able to accommodate mutually coexisting con-tradictions, one that can only fully be grasped by stepping outside a Western epistemology predicated on an absolute distinction between knowing and ignorance.

Regarding the status of *liwāt* in Islamic law, it is noteworthy that while the punishments for this sin are harsh (stoning to death being the most extreme), the requirements for proving the charge (also true of *zīnā* or adultery) make it nearly impossible to execute legally. Not only is a minimum of four witnesses (all of whom have to be of trustworthy character, Muslim, free, and male) required in all four official schools of Islamic law, the witnesses must have all seen "the key entering the keyhole," and they are liable to severe punishment if the accusations remain unproved (in some schools, the accused must also confess his guilt, freely and willingly, four times in separate settings). Most important, these prohibitions on *liwāt* do not include non-anal forms of sexual contact, including intercrural intercourse (a minor sin meriting discretionary chastisements). As Ze'evi's review of the history of decrees demonstrates, *sharī'a* or sacred law is often ambiguous precisely to leave room for consensus; likewise, individual judgments are generally discreet in order to keep any single ruling from setting unwanted precedents.[95]

In the Ottoman Empire, moreover, this historical predisposition toward discretion in prosecuting male-male sexuality was echoed in the parallel system of civil law known as *kanun* (also adjudicated by the officers of sacred law known as *kadi*). While the *kanun* provided much more detailed reckonings of categories of sexual misdemeanors and perpetuators, it too leaned toward pragmatism and flexibility, instituting progressive fines according to social status and ceding authority to local community officials to determine penalties. The result was that neighborhood *kadi* tended to look the other way as long as deviations from the norm did not disrupt social harmony. As local administrators, such men were keenly aware of the burgeoning ranks of unmarried, underemployed men populating the empire's urban centers who, if denied all means of sexual release, were likely to become a much more disruptive social force than if allowed some tacitly condoned outlets. The main priority is maintaining undisruptive coexistence, a "live and let live" attitude, as long as social order is upheld, appearances are kept, and no one is hurt.[96]

This pragmatic attitude points to an aspect of Muslim culture that, while historically and regionally variable, helped foster a viable homoerotic subculture: the importance of socio-communal codes of propriety and discretion, in which what is publicly known or avowed is more important than what is privately or discreetly practiced.[97] This is not to say that strong taboos and prohibitions did not exist, but to suggest that such mechanisms of social regulation operate according to socio-communal rather than personal moral codes.[98] The moral standards evolved in local communities, as El-Rouayheb notes in *Before Homosexuality*, are rarely automatic. Rather, they are pieced together out of many components, including "the stock of generally accepted and usually loosely integrated maxims by individuals and social groups according to a myriad of contextual factors."

Hence, even within the same community, one act—say pederasty—"may be appraised differently according to the interest of the observer, the way the act becomes public knowledge, whether it is carried out discreetly or flauntingly, whether the perpetuator is . . . a friend or rival," and so forth.[99] Gradually evolving over time, communal moral values and their regulation—particularly in cultures whose legal systems grant the private realm great latitude—will inevitably be situational and flexible.

The historical prevalence of male homoeroticism within the nonetheless predominantly heteroerotic cultures of the Middle East has also been attributed to the tendency, in these regions, to measure sexuality in terms of active and passive roles rather than, as in Western societies, in terms of gender. This means, among other variables, that a man may with proper discretion penetrate other males, especially those younger than himself, without compromising his masculinity. In such interpretations, phallic dominance is the cynosure of masculinity, not the gender of the object who submits to domination.[100] Arab, Persian, and Ottoman medical treatises up to the mid-nineteenth century find nothing unusual, therefore, about the desires of the *lūtī*, the male who actively seeks to penetrate other males, nor, for that matter, about the passive role of the male youth, the *amrad* or *ghilmān*, who hasn't fully matured into his adult station (presumed to happen from the late teens to mid-twenties as the beard becomes full). It is the predilection of the *ubnah*, the passive adult sodomite, that mystifies the medical authorities and is considered abnormal.[101] But even this sexual system based on activity/passivity is not as fixed as may appear, as the next chapter's discussion of the recurring trope of sodomy demonstrates. Likewise, the tendency among Anglo-European historians to view this ethos of penetrative domination as *the* operative framework legitimating homoerotic relations in Islamicate cultures may impose upon its field of study an overly Westernized idea of phallic masculinity. Even contemporary queer studies, Dina Al-Kassim writes, errs by tending to uphold this so-called "Mediterranean model" as an absolute marker of the difference "between the sexual epistemologies of the East and the West and the distinct subjectivities arising along this declivity." The repeated invocation of this model, Al-Kassim explains, "serves to simplify rather than explain the play of putative license and prohibition in cultures as complexly diverse as those of the Mediterranean and the Islamicate cultures beyond."[102] As the scholarship of Ze'evi and Najmabadi similarly suggests, overemphasis on the masculine-biased dichotomy of penetrator/penetrated may miss out on the complex layerings of male erotics being negotiated in what turns out to be a more polyvalent, pliant realm of homoerotic possibility, bodily pleasure, and prohibitions both overt and internalized.

Maintaining an alertness to the simultaneous, "contingent intersection of several webs of meaning" at once, as Najmabadi puts it in regard to Middle East

sexuality studies,[103] is precisely what queer scholars also need to remember when parsing historical constructions of sexuality in the West, as well as in interpreting the West's representations of the sexual economies of other cultures. Rather than assuming in advance that a unitary logic and univocal narrative—call it "Orientalism"—underlies and overdetermines all Western representations of the Middle East, the critic needs to be prepared to encounter diversities that do not always fall into a neat bifurcation between, for instance, pre-modern erotic practices and "modern" sexual identities or types. European representations of Middle Eastern homoeroticism, once placed within this multivalent framework, begin to reveal something more than the exotic fictions or repressed fantasies of a wishfully dominant culture—although, of course, they are frequently also that. Because these representations exist in dialogue with representations emanating from, and practices rooted in, regions of the Middle East that have always been, themselves, potent spaces of cross-cultural exchange, within which circuits of knowledge and desire flow in multiple rather than singular directions, they also offer contemporary readers something else, something more.

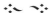

This chapter has attempted to pave the way for such an understanding of the literary and visual texts taken up in chapters 3 through 8 through a layered approach—shifting from "up-close" examples of my reading methodology to "long-view" summations of the genre of European travel narrative, from contemporary resonances of the political stakes of this project to broad overviews of historical formations, from the theoretical advances set into motion by the examination of Orientalism as a discursive mode of knowledge to pseudoscientific theories of sexual attraction in non-western erotic economies. Such a layered approach demonstrates that "reading between the lines" need not be an exercise limited to individual texts. It can also form a model of reading across, between, and "beside" cultural and disciplinary divides. Such close reading between the lines and between texts and cultures brings to the fore alternative stories of same-sex affinities that might otherwise escape comment, indeed that specialists working within single disciplines might not be trained to recognize. In the next chapter I take a different tack to the same subject matter: focusing on a discrete series of representational tropes that, synchronically parlayed across time and space, have also given expression to the homoerotics of Orientalism, its tellings, and its retellings in myriad genres and forms.

Two

BEAUTIFUL BOYS, SODOMY, AND *HAMAMS*

A TEXTUAL AND VISUAL HISTORY OF TROPES

The politics of interpretation demand . . . interference, crossing of borders and obstacles, a determined attempt to generalize exactly at those points where generalizations seem impossible to make.
Edward Said, "Opponents, Audiences, Constituencies, and Community"[1]

While the primary goal of the preceding chapter was to give a sense of the breadth of the homoerotic dimensions that have shadowed the relations of West and Middle East, this chapter homes in on a limited number of tropes that have emerged from this engagement over a period of some 400 years. This shift in approach offers an alternative means of introducing the historical and theoretical vectors mapped in chapter 1 by tracing themes and topoi that cut across the conceptual, geopolitical, literary, cultural, and cross-disciplinary terrains that both chapters share. Three tropes in particular stand out when it comes to depictions of Middle Eastern homoeroticism. One is the ubiquitous image of the beautiful boy as an object of ardent male desire. Second is the myth of age-differentiated and gender-defined sodomy as *the* primary formation of male-male sexuality in Islamicate culture. Third are fantasies of the *hamam* (or bathhouse) as a privileged spatial locus for male erotic encounters. In addition, these pages single out four other patterns worthy of attention: the hyperphallic man, the effeminate tyrant, the eunuch, and the male dancer.

Despite vast differences in temporal, regional, cultural, and generic articulations, the regularity with which these tropes reappear over time and across regions discloses a compass and depth that attests to the resilience, as well as elasticity, of the homoerotic connotations accruing to the Middle East since European explorations gained traction in the early modern period. Analyzing

these topoi as they emerge, evolve, disappear, and reappear in both Middle Eastern and European contexts reveals a fact that readers intuitively know but—because this is how stereotypes work—continually forget: namely, that their meanings prove to be tellingly *unstable*, colliding with and destabilizing each other's authority in ways that call a variety of Orientalist (and Oriental) myths into question. Attending to the deconstructive potential and never completely coherent aspects of these tropes is key to the sections that follow, since it helps mitigate the problems of generalization, transhistoricity, and non-specificity often limiting scholarly attempts to trace patterns over long stretches of time and space.

This chapter embraces the principle that the critical impulse to see the broader picture need not be inevitably reductive or mired in contemporary myopia. A similar challenge has engaged the energies of scholars theorizing the affective desires involved in revisiting the past in search of queer affinities. Carolyn Dinshaw, for one, argues for the critical potential of embracing one's contemporary vantage-point and subjective investments, making them a productive point of departure for "reading backwards." First, such a method can help the queer scholar break from universalizing or teleological narratives that assume a mythic origin (the discovery of where "it" all began) leading to a predetermined end; second, it can open a conceptual space for the forging of affective resonances and contingent relations between the present and the past that speak to our contemporary selves without predetermining the history of marginal sexualities; and, third, it helps make legible those patterns, overlaps, and valences that help the contemporary critic construct these very tropes as analytical nodes of insight and retrospective understanding. From this perspective, one doesn't approach the concept of "the beautiful boy" as a fixed entity that has existed, unchanging and entire, since the beginning of the modern period of contact between West and Middle East to the present day. The trope, rather, provides a conceptual framework that allows critics to piece together—from (in Dinshaw's words) "incommensurate entities" brought into contact "across space, across time"—the diverse sets of relations that constitute the elastic parameters of this topos and make it an expressive sign that speaks to *both* the past and the present, enhancing contemporary understandings of the cross-cultural interplay of homoerotic desires and taboos throughout history.[2]

In a meticulous analysis of analogous tropes of sexuality in the xenological discourses of Orientalism, İrwin Cemil Schick addresses the same problem: how to trace patterns across a broad historical swath without being overly generalizing or shaping in advance what one "finds." "I am not concerned with the causes of each manifestation," he writes, "and therefore do not [always] attempt to correlate them with underlying 'material' conditions. I hope to demonstrate that what unites all the different forms taken by [each individual] trope of

sexuality over the course of some four centuries is its utilization as a technology of space."[3] Similarly, the homoerotic tropes whose "diverse themes and images" this chapter parses retain a spatial integrity even as they evolve and change over time, according to location and means of articulation. Likewise, the myriad ways in which these textual manifestations have circulated, and to whom, and the modes of collection in which they have been preserved or displayed, are also crucial in understanding their seemingly transhistorical allure. While attempting to do justice to these latter contexts, the primary aim in this chapter is to begin to lay bare the ideological implications of these representations as they accrue cultural force over time and play discursive roles in constructing a homoerotics of Orientalism.

Schick focuses exclusively on European tropes of sexual alterity. The seven rubrics I have selected include both Western images and equivalent expressions in a variety of Middle East sources. In bringing Eastern and Western archives into conjunction, my intention is not to argue that one culture's representations directly influenced or shaped those of the other. Rather, reading these cultural manifestations contrapuntally, listening to the echo-effects they create, adds a density of texture that illuminates the staying power, connotative energies, and accretion of meanings that emanate from them. I take to heart Edward Said's call, in the epigraph above, that interdisciplinary scholarship demands "interference, crossing of borders and obstacles, a determined attempt to generalize exactly at those points where generalizations seem impossible to make."

This chapter embraces the challenge of attempting such "generalizations," but always with a sense of the inevitably partial quality of the insights that ensue from such "interference." This challenge takes on added importance given what in some cases might seem—in setting primary sources originating in different centuries and regions side by side—a repetition of the Orientalist tendency to cast all things associated with the Middle East as timeless and unchanging. While paying attention to this danger, critics also need to heed the "overall stability in time and uniformity," as Khaled El-Rouayheb puts it in his study of homoerotic formations in the Arab-speaking Ottoman world, of the region's literary traditions, images, tropes, and genres—a body of literature that shares formal aesthetics that, even as they have transformed over the centuries, depend less on Western-derived notions of originality than on elaborations and repetitions of received forms and poetics.[4] The latter aesthetic practice brings its own set of challenges, but El-Rouayheb's insight also suggests the possibility that Occidental imaginings of Middle Eastern homoeroticism have taken shape against a history of Middle Eastern tropes whose *relative* stability forms an evocative backdrop framing the mercurial perceptions and representations of Islamicate sexuality that pervade European Orientalist discourse.

THE BEAUTIFUL BOY

If there is one motif that consistently threads its way throughout Oriental and Orientalist homoerotics, it is that of the beautiful youth, whose figurations mark centuries of Middle Eastern art and haunt European fantasies about and attempts to understand the region's sexual practices. This topos is perhaps most familiar to modern audiences in the form of the dust jacket (fig. 2.1) of Said's *Orientalism*, which reproduces Jean-Léon Gérôme's 1870 *The Snake Charmer*. Since I analyze the aesthetic and ideological dimensions of this painting more fully in chapter 7, here I simply wish to make the point that its simultaneous appeal and aura of illicitness is rooted, however subliminally, in Western associations of Middle Eastern sensuality with male pederasty. Combining exotic realistic detail and fairytale-like ambience, Gérôme depicts a group of men who feast their eyes on the naked beauty of a prepubescent street performer, while a suggestively phallic snake rises from his arms. As their gazes converge on the boy's front (invisible to the viewer but signified by the snake), the compositional sightlines direct the viewer's eyes to the boy's buttocks. Many critics have noted the discrepancy between the latent homo-eroticism that pervades this complex relay of gazes and the short shrift that Said gives to what he euphemistically terms the "different type[s] of sexuality" subtending Orientalist desire, declaring them, "alas," outside "the province of my analysis here."[5] Said's demurral aside, what *is* salient is the degree to which the erotics that reverberate beneath the "innocent" veneer of Gérôme's paint-ing is the culmination of centuries of literary and artistic imaginings, pro-mulgated by Europeans and Middle Easterners alike, of the youth beloved by men, even as the contradictions that art historians have identified in Gérôme's masterwork point to the deconstructive elements encompassed by and embed-ded in this motif.

The touchstone in Islamicate writing for representations of the youthful beloved is the *ghazal*, a genre of love lyric originating in the Umayyad period, perfected during the Abbasid caliphate, and dominating the literary outpouring of Persia, Mamluk Egypt, and Caliphate Spain before spreading across the Ottoman Empire. Early on the poetic pleasures of celebrating the range and variety of beautiful male youth in this verse form merged with the preexisting genre of *khamriyya* (poetry written in praise of wine), resulting in ghazals dedicated to the beautiful cup-bearer or *saki (saqi)*. Analogously, miniaturist art almost always represents the beloved youth bearing wine vessels and wine cups (fig. 2.2).[6] Attesting to the longevity of this merger of khamriyya and ghazal motifs, Monsieur de Thevenot, traveling in the Levant in 1668, comments that sodomy is so "ordinary [a] Vice" in these parts that their "Songs [poems] are upon no other Subject, but upon that Infamous Love or [upon] Wine."[7]

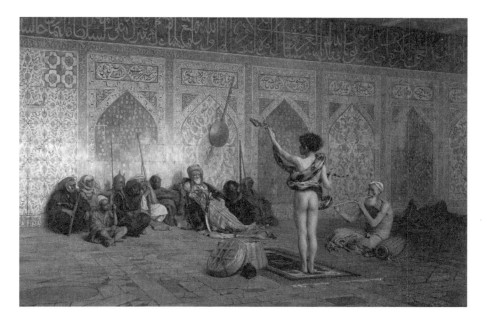

FIGURE 2.1. **Gérôme's original / Said's cover art.**

The Snake Charmer (c. 1870). Courtesy of Bridgeman Art Resources / the Sterling and Francine Clark Art Institute, Williamstown, MA.

These lyrics, running the gamut from soulful yearning and delicate flirtation to bodily blazons and randy celebrations of sexual conquest, rely on a repertoire of stock images to describe the beloved—moon-shaped face, gazelle-like limbs, willowy waist, cheeks like roses, lips like cherries, teeth like pearls, brow like a crescent bow, buttocks like silver moons—that the poet uses as a springboard to demonstrate his command of linguistic puns, sinuous line rhythm, and complex rhyme schemes. While nearly every Arabic, Persian, and Ottoman poet felt compelled to demonstrate his competence in the genre, many of these love lyrics go well beyond rote formalism to express explicitly homoerotic desires aimed at appreciative audiences who found the public recitation of such amorous verse commonplace rather than scandalous.[8] The undisputed master of the ghazal—setting the standard against which poets measured themselves for centuries—was Abu Nuwas, who rose to fame in ninth-century Baghdad. His blend of urbane wit, irreverence, and unabashed sexual admiration of handsome boys infuses, even in translation, this lyric included in Ahmad al-Tīfāshī's famous erotic anthology *The Delight of Hearts*:

There are men who like women
And who make women glad;

FIGURE 2.2. **The wine bearer as object of male desire.**

Portrait of a Young Man with a Wine Bottle, attrib. Mirza Ali. Private collection.

But, as for me, all pleasure comes
In the body of a lad!
When, barely past his fifteenth year
Tendrils of hair begin
To form on his cheeks . . . //
A boy at that age no longer fears
The things we dream of doing

With him, and he's lost his childish soul
That never thought of screwing![9]

Better a downy-faced fifteen-year-old whose hormones are in full riot and who can't get his mind off sex, Abu Nuwas implies, than the blushing adolescent who still is a child at heart.

Evidence of the merger of the genres of khamriyya and ghazal—and the twinned gratifications of what de Thevonet calls "[that] Infamous Love" and the equally forbidden but widely indulged pleasure of wine—marks Abu Nuwas's encomiums to tavern life, where wine-bearer and beloved collapse into the same object of desire:

> Now, I'll take a glass of some clear red wine,
> Passed around the table by a saqi so fine //
> A coltish gazelle who's been well brought up,
> Trained from his childhood to serve those who sup—
> Now in full blossom of flirting and smiles,
> His smell . . . as sweet as his wiles.
> With a beautiful butt, and a handsome cock
> Flexing inside his pants as he walks;
> Invite him to drink, and then drink again:
> He'll open his pants and give you free rein![10]

Here, the pleasures of drinking and pederasty reinforce each other in a continuous loop: wine not only brings patrons into contact with servers as ripe as the grape being drunk ("in full blossom") and loosens boys' inhibitions, but the invitation to share in the festivities ("drink, and drink again," the poet urges) becomes the vehicle of seduction. In one fluid arc, the poem thus swoops from "elevated" tropes for youthful beauty—gazelle-like grace, flowering charms, flirtatious smiles—to the "lower" physical attributes the boy so brazenly flaunts: he may have been raised "to serve" (and thus submit), but his clever "wiles," manifest in his phallic "flexing," grant him a degree of agency within his status as sexual object, at least within Abu Nuwas's fantasy of "open" access.

Middle Eastern poetic invocations of sexually desirable youths undergo a further permutation in the evolution of the Ottoman genre of the *şehrengiz* in the sixteenth century. As an adaptation of the earlier Persian genre of the *şehraşub*—lyrics about attractive craftsmen and shop-boys of a given locale—the şehrengiz typically detailed, in a series of ghazals, the ravishing youth of a given city, providing a sociological cross-section of urban male types from craftsmen's apprentices to bath boys, and from "pretty seller[s] of cucumbers" to ink-stained

calligraphers' assistants.[11] In a şehrengiz dedicated to the beauties of Üsküp, for example, İshak Çelebi lavishes praise on Mehemmed Bekir for being "first in the book of heart-snatchers," whose beauty causes the poet to lose his "mind in drunkenness" and beg, with humorous abjection, for the privilege of being the dog who curls up to sleep on Bekir's doorstep.[12] Another famous proponent of the genre was Fazil Bey, whose *Huban-name* or "The Book of Beautiful Boys" takes the genre's seriality a step further by cataloguing the most desirable boys not just of one city but of the world. The manuscript copy housed in the Istanbul University Library includes delicate miniatures accompanying the various national types enumerated in the poems: thus its textual pleasures are supplemented by visual ones (fig. 2.3).[13] Like Abu Nuwas, Fazil Bey makes the wine-tavern the setting for a paean to a beautiful Greek youth:

> Let him turn, this waiter, like a turnstile,
> Let him move his body like quicksilver
> Let him dance on his beloved
> Then sit on his knee
> Let him mincingly sing a song—
> Is there a difference with the western sun?[14]

The lithesome moves attributed to this youth's "quicksilver" body simultaneously mark the waiter as someone who has moved *through* as many lovers as he has satisfied customers, checking them in and out "like a turnstile": using his sexual charms to attract paying customers is business pure and simple for this Greek beauty. Moreover, by equating his radiance with that of the setting ("western") sun, the poet implies that the youth's ethnic and religious otherness, as a Christian Greek colonized by Ottomans, contributes to his sexual appeal, evincing a homoerotics of Occidentalism at play.

This topos of the beautiful youth pervades many Middle Eastern literary forms and genres. One is the popular debate format, written in both rhymed prose and poetry, in which contenders argue for the desirability of one sex over the other (voicing both positions allowed poets to display their rhetorical skill). The recurrence of the word *ghilmān* ("fair youths") in titles typifying this genre reveals an unabashed proclamation of youths as viable objects of male desire, from ninth-century Arab writer Al-Jāhiz's "Boasting Match over Maids and Youths" [Ghilmān]"[15] to fifteenth-century Abū l-Tuqā al-Badrī's companion treatises "The Paradise Populated by Fair Youth [Ghilmān]: On Beautiful Males" and "The Retrograde Running Star (Qur'ān 81:16): On Beautiful Maidens."[16] Multiple other works, like the prolific writer Mamluk Khalīl bin Aybak al-Safadī's "The Pure Beauty of One Hundred Handsome Boys," sing the praises of boys exclusively.[17]

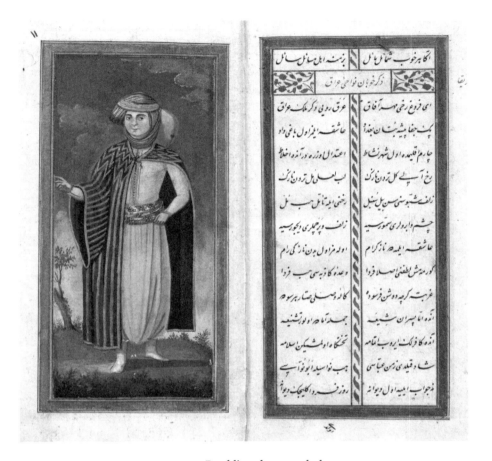

FIGURE 2.3. **Doubling the textual pleasure.**

Miniature and facing poem in Fazil Bey's *Huban-name* (Book of Beautiful Boys). T 5502, fol. 0011. Courtesy of the Istanbul University Library.

We have already seen evidence of this cataloguing tendency in nonfictional treatises like Mustafa Âli's *Tables of Delicacies* (c. 1587), which sardonically informs the reader of the variety of "beardless, smooth-cheeked, handsome, and sweet tempered" youths, ranging from epicene to robust, from demure to spitfire, available throughout the Ottoman Empire.[18] The varied attractions of boys across Turkey's realm also form a refrain in Evliya Çelebi's eleven-volume *Seyahatname* or "Book of Travels." Indeed, the good looks of the local youth and girls (but mostly youth) becomes Evliya's sure-fire measure of the salubriousness of the specific geography he is visiting. Thus, traveling through Montenegro in 1662, he salutes the well-built physiques of the garrison troops, appreciatively

noting their uncovered calves and lack of breeches while attributing their burst-
ing biceps and pectorals to the mild climate.[19] In Berat (modern-day Belgrade),
"the exceptional beauty of all the handsome young men" employed by the silk
merchants captivates Evliya, who praises the shops' covered rooftop gardens
where "friends, companions, and lovers spend all their time chatting up the
boys as they work."[20] Likewise, on his travels to the farther eastern reaches of
the empire, the narrative overview of a town in Kurdistan culminates in the
subsection "In Praise of the Numerous Loveable Sweethearts":

> The loveable boys here, who fill one's heart with desire, [are] young men of
> graceful beauty, modest kindness, and charming looks, with peri-like bod-
> ies and faces bright as the moon. They speak so pleasantly and eloquently
> in their native dialect—*for this is the Orient*—that people with an amorous
> temperament are ravished when they hear them. Their every movement,
> whether they are walking or standing still, transports one into rapture.[21]

For this amorously inspired traveler, the eastern edges of empire constitute his
"Orient"; as in Fazil Bey's salute to the "Western" Greek waiter and Mustafa
Âli's list of nationalities, the attraction of these Kurdish boys lies, at least in
part, in their ethnic and cultural otherness.

Not unexpectedly, the youths inspiring such poetic effusions create discom-
fort for many European travelers. The description that Thomas Herbert, ambas-
sador to the court of Shah 'Abbas in Persia in 1626–1629, gives of the retinue
of wine-bearing boy servants he observes at a sumptuous reception attests to
this cultural difference. Herbert is horrified by the elaborate costuming and
feminine artifice ("vests of gold, rich bespangled turbans and embroidered
sandals, curled hair dangling about their shoulders . . . rolling eyes and ver-
milion cheeks") that mark these "Ganymede boys" as disgusting effeminates
to his eyes.[22] Surprisingly, however, most European travelers acknowledge
the physical beauty of these youths courted by men. A few examples make
the point. "It is strange to see how passionate they are for handsome males,"
comments Mr. T. S., an English merchant taken prisoner in Algiers in the late
sixteenth century, who on more than one occasion lets the reader know that he
also considers *himself* a "very pretty Fellow."[23] "They value beauty, even in men,
more than talent," Adolphus Slade echoes in the second volume of his travels
(1829–1831), remarking, when entertained by the grand vizier of Adrianople,
that the pipe-holder "must be comely" and is always among the "favorites of
the lord." At this point Slade adds in language that comes ambiguously close
to endorsing such practices, "With such an apparatus, presented by a youth *à
la* Ganymede, you may imagine you are inhaling the spirit of nectar."[24] Louis
Dupré's early nineteenth-century renderings of males in the court of Ali Pasha,

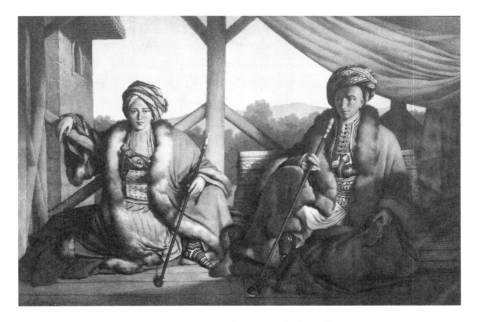

FIGURE 24. **In the court of Ali Pasha.**

Drawing by Louis Dupré, *Voyage à Athens et Constantinople* (1819).

Ottoman vizier in Albania, make this legendary beauty palpable (both Ali and his son Veli were notorious for their pederastic preferences); figure 2.4 depicts the grandsons of Ali Pasha, Ismael and Mehemet (Lord Byron was particularly taken with the latter on his visit to Ali's court[25]).

The importance of male beauty also marks the accounts that many Western writers give of Middle Eastern systems of preferment and advancement. Richard Knolles (1603) tells the story of how the "comely feature[s]" of the younger brother of Wladus Dracula, raised in Mehmet II's court, so agitates the Sultan's passions that he attempts to force the "noble youth," who resists, wounds his assailant, and flees. Wladus Junior, however, seems to have reappraised his "noble" virtue, for he returns to court upon receiving the Sultan's pardon "and so became his *Ganimede*; and was of him [for a] long time wonderfully both beloved and honoured."[26] Circa 1696, Dumont estimates that the "advancement" of half of the Sultan's officers has occurred because of sexual relations with their betters; Slade, commenting on the situation a century and a half later, guesses that eighty percent of the empire's ministers are men "whose [primary] recommendation was a pretty face."[27]

This ideal of the beautiful youth as an accepted object of Middle Eastern men's desire crosses levels of class, nationality, and race. He may be a freeborn citizen,

as elite as the older men who court him; he may be a *levend* "or unattached urban youth from the financially better-off classes";[28] he may be a youthful slave inducted into the government bureaucracy from the provinces who may in time accrue his own wealth; he may be a shop boy or trade apprentice; he may be a student at the medrese attached to the local mosque or a Sufi acolyte; he may be a household servant; he may be a prostitute. Everyone, writes Mustafa Âli in *Tables of Delicacies*, wishes to find servants "as beautiful as the full moon, as famous as Joseph";[29] and the attractiveness of a male slave, as various European travelers note, always fetches a higher price.[30] Thus P. Bossu projects onto the slave market he visits at Algiers the vision of a scene rife with sodomites leering at "the more attractive young Men, who often serve for things that it makes one tremble to tell about."[31]

Given the tribute system continually supplying the Ottoman Porte with youth to staff the janissary guard and the palace administration from as far west as Romania, north as Russia, south as Ethiopia, and east as India, it is not surprising that the iconic beauty of the desirous youth was never restricted to just one national, ethnic, or racial type. The same principle holds for other centers of power in the Middle East. In medieval Egypt under Mamluk rule, Turks seem to have been particularly in demand. The love-interest in Cairene writer Ibn Dāniyāl's shadow-play, "The Man Distracted by Passion and the Little Vagabond Orphan," is figured as "a dusky, black-eyed Turk" with "willowy build" and "copious buttocks," whom the hero first espies when the youth strips down to wrestle at the palaestrum;[32] Egyptian poet Muhammad al-Nawaji bin Hasan bin Ali bin Othman, nicknamed Shams al-Din, sings the praises of the "young male gazelle" he has "chosen from among the sons of the Turks." Ecumenical in his tastes, Shams al-Din also dedicates several verses to the erotic appeal of African men:

> If the stars glitter white
> In the dusk of night
> Against the black body of a sky
> Whose robe has slipped aside,
> Their opposite is even more beautiful;
> For here on earth are other orbs:
> You, black men,
> Shining stars of our days.[33]

As European travelers sometimes discovered to their dismay, the Middle Eastern taste for handsome males was occasionally directed at themselves, constituting a complementary homoerotics of Occidentalism. Describing the "heart-ravishers of this heart-adoring city" in his *Essay in Description of Istanbul*

(c. 1525), Lâtifî declares that "every corner . . . glows like sunrise with the moon-bright faces of Frankish idols," and the poet Revani wittily adds, "Pious one, should you see those Frank boys but once, / You would never cast an eye on the houris in paradise."[34] The Arab poets of Islamic Spain often memorialized the charms of Jewish lads in their love lyrics[35]; Greeks employed in Turkey as dancers and singers are praised for being even more scintillating than the native *köçek*.[36] Fazil Bey's *Book of Beautiful Boys*, mentioned earlier, not only details the charms of Moroccans, Tunisians, Egyptians, Persians, and Syrians, but also includes verbal and visual portraits of pink-cheeked Austrian, British, French, and Russian dandies (see figs 6.5 and 6.6).[37]

If the trope of the beautiful boy crosses class strata and encompasses multiple nationalities and ethnicities, so too it spans a range of gender associations that unsettles Western assumptions about femininity as a given component of the youth's appeal. The latter stereotype is operative in "Don Leon" (an anonymous pornographic poem written in the style of Byron), where the narrator expresses "pleasing doubts of what [the] sex might be" of the Middle Eastern youth filling his pipe and serving him sherbet, since "beauty marked his gender epicene."[38] However, Afsaneh Najmabadi points out the fallacy of using terms like "feminine" or "effeminate" to describe the Middle Eastern male beloved: "Calling amrads effeminate traps [critics], despite their intentions, into transcribing homoeroticism as frustrated heterosexual desire."[39] To some degree, this misconception has its origins in the androgynous aesthetic that was the accepted standard of beauty in pre-modern Islamicate literature and arts. To be sure, what some European travelers see appears, given their culturally shaped understandings of gender, to be "effeminate" and thus feminine (whence Herbert's derogatory verbal portrait of the painted and curled wine servers in Shah 'Abbas's entourage). Likewise, what some other Europeans in fact *desire*—whether they consciously admit it or not—is the girlish boy. Such subconsciously pedophilic desires mark travel writer John Augustus St. John's blazon, in 1844, to "a young Memlock . . . about nine years old, beautiful as an angel" and part of a pasha's harem: "His exquisite little mouth, his fair complexion, his dark eyes, and faintly arched eyebrows, his smooth lofty forehead and clustering ringlets—everything conspired to enhance his loveliness. Anywhere else I should have supposed it to be a girl in disguise."[40]

A century later, in *Arabian Sands* (1959), the well-known explorer Wilfred Thesiger launches into a similar encomium as he recounts his first glimpse of the fifteen-year-old who was to become his constant companion, Salim bin Ghabaisha, clad only in a strip of blue cloth wrapped around his waist: "Antinous must have looked like this, I thought, when Hadrian first saw him in the Phrygian woods. The boy moved with effortless grace, walking as women walk." Symptomatically, however, Thesiger quickly moves to assure his readers of this graceful Antinous' utter masculinity: "A stranger might have thought [bin Ghabaisha's] smooth,

pliant body would never bear the rigours of desert life, but I knew how deceptively enduring were these Bedu boys *who looked like girls.*[41]

Other examples make it clear that male beauty needn't be only female identified to be appreciated; in fact, the desired object can be emphatically masculine in *both* appearance and behavior. This fact is as true of Middle Eastern homoerotic expression as it is of Western travelers' observations. The *amrad* who awakes a straying Sufi's desire in Sa'dī's late-thirteenth-century verse satire is "a well-muscled, power wrestler boy, / A doe-eyed flirt whose arms could chains destroy."[42] Damascan poet Ibn al-Mu'tazz recounts a night of passion with a Turkish soldier who may be the younger partner but who leaves in the morning full of machismo and smug with self-satisfaction, "swing[ing] to and fro in his gait like a forward tyrant." Likewise, al-Tīfāshī appreciatively repeats Abu Nuwas's paean to a lad whose cocky allure dims any woman's charms: "this love I feel [is] / For a boy who struts around / like a young bull."[43]

These latter descriptions—muscled wrestlers and cocky soldiers—beg the question of the age range encompassed by male beloveds. The question is important since part of the discomfort of twenty-first-century readers encountering representations of Islamicate homoeroticism has to do with the pedophilic dimensions of older men's desires for minors. Throughout the "age of beloveds" that had its beginning in the Abbasid world and stretched across Ottoman and Persian empires up to the early twentieth century, it seems fairly clear that the general preference was for the adolescent who has passed puberty and entered his mid-teens but has not yet grown a full beard. Yet even these criteria are slippery to judge, given the fact that many aspects of maturation (such as the growth of a full beard) appeared later in earlier historical periods. Pietro Della Valle notes that the "clean-shaven and beardless" pages in the entourage of an Ottoman sultan are aged anywhere "from twenty to twenty-five to thirty, and even forty years."[44] Even in 1850, MacFarlane observes a nineteen-year-old who shows "no signs of a beard on his chin."[45] The clean-faced beautiful *boy*, in sum, may well be a full-fledged *adult*.

For all the praise of the smooth-cheeked lad in the poetic tradition of the *ghazal*, there also existed a vigorous subgenre debating and sometimes championing the equal merits of youths with facial hair. One mock-treatise, 'Obeyd-e Zākāni's *Rishnāma* or "The Book of the Beard" (dating from the first half of the fourteenth century), is dedicated to the *ghilmān*'s growth of facial hair. Since the Arab-Persian word for facial stubble, *khatt*, can also mean writing, Mustafa Âli is able to play on the sexual/textual dimensions of his desire for a youth who has passed adolescent smoothness:

The sprouting moustache on your lip resembles very fine
Calligraphic writing, the moles are the dots

I have become all confounded because of you,
Whether you scatter your hair over the cheeks or not.[46]

Likewise, Aleppine judge and poet 'Atāllah al-Sādiqī responds to a youth's
fear that his time of "coquetry is past" (because his face has become "downy-
cheeked" and his physique grown "upright") by avowing the boy's facial hair
makes him all the more handsome: "The description of a garden only becomes
attractive if surrounded by sprouting vegetation."[47] A hint of such a "garden"
occurs in an anonymous miniature of a saki in the style of Riza-i 'Abbasi at
the Metropolitan Museum of Art (fig. 2.5); either this youth sports a hairstyle
in which his love-curls have been tied under his chin, which gives him the
appearance of facial hair, or he has a newly sprouted beard.[48]

On the other hand, some male objects of desire were barely adolescent and, in
some cases, prepubescent. Blount, a reliable observer not prone to exaggeration,
reports that the catamites accompanying a pasha's caravan range between twelve
and fourteen years of age. St. John voices his disagreement with Middle Eastern
writers who aver "the beauties of the form" of young men are only realized as
they approach twenty, arguing that boys between thirteen and fourteen years,
"slim and active," are most attractive.[49] With the establishment of European
photographic studios in Egypt, Tunisia, and Morocco specializing in erotic, and
sometimes explicitly homoerotic, images of indigenous life, the topos of the
beautiful boy entered a new realm of visual representation, mass circulation,
and potential exploitation, as attested by the hundreds of nude and near-nude
photographs of youths of sometimes questionable age produced for a European
clientele (see examples in chapter 6). Concurrently, increased European tourism
to colonial enclaves in North Africa and Egypt throughout the twentieth century
has led to explicit articulations of desires for adolescents in the writings of some
Westerners, particularly among those vacationing or taking up residence in the
Maghreb, thus contributing to the charges of sexual exploitation attaching to
these tourist-native liaisons. William S. Burroughs, propositioned by a seven-
year-old in Tangier, drolly comments, "I say anyone who can't wait till 13 is no
better than a degenerate," while Joe Orton recounts being solicited by a ten-year-
old his first day in Tangier and shying away from two thirteen-year-olds because
"it really is too dangerous to go with the little ones."[50]

A more sordid note is struck in Angus Stewart's allusions to the adolescents
who become his houseboys in *Tangier: A Writer's Notebook* (1977) and whose
naked bodies, spied in covert glimpses, he recounts in voyeuristic detail.[51]
Without minimizing the pedophilic (and predatory) desires of an expatriate like
Stewart, it is worth noting that from the perspective of pre-modern society and
many contemporary third-world cultures, the term "underage sex" often car-
ries little meaning and less of the moral condemnation it accrues in European

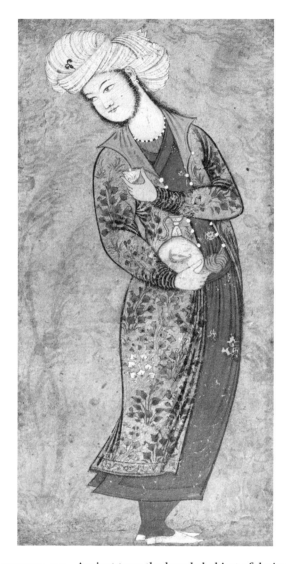

FIGURE 2.5. **Against type: the bearded object of desire.**

Portrait of a Youth, in the style of Riza-i 'Abbasi. Safavid (early 17C). Image copyright © The Metropolitan Museum of Art, New York. Image source: Art Resource, NY.

post-Enlightenment constructions of childhood as an innocent state and sex as an adult activity. In such cultures, children, particularly of the peasantry or the working class—from the Georgian boys whose parents willingly sold them as tribute-slaves to the Riffian boys whom Stewart shelters—are not seen as sexual innocents but practicing adults from the moment they leave the home. Tellingly, the myth that "younger is better" has become so potent a component

of modern European gay lore—and of the stories it has inherited about Middle Eastern pederasty—that many tourists *pretend* to be engaging in what modernized nations term underage sex even when they *aren't*. Orton is a case in point. In his Tangier diary he progressively scales down the ages of his conquests: thus Mohammed, "a very beautiful sixteen-year-old boy" at the beginning of the 9 May entry, is "about fifteen" by 25 May and "fourteen" by 11 June.[52] Age is deceptive on other fronts. The photographer Rudolf Lehnert explains to a French correspondent that the seeming prepubescence of the nude youth in a photograph the latter has purchased is an illusion—it is "customary for Arabs to shave their sexual parts completely," hence the appearance of preadolescence. In fact, this teenager is, he continues, one of his most professionally behaved models.[53]

In sum, the trope of the beautiful boy is never what, on the surface, it seems: if age proves relative—traversing a whole spectrum, differing according to geo-social context and reinscribed to suit the subjectivity of the viewer—so too are the gendered connotations of his "beauty" equally variable, ranging from epicene to masculine, willowy to muscular, refined to rowdy, smooth-cheeked to bearded. What may seem contradictions are, on the one hand, part of the flexibility that has contributed to this trope's longevity; on the other, these multiple facets contribute to what has made this trope so appealing to homoerotic imaginations—whose predilections and fantasies may find any number of points of attachment—as well as a potent source of Orientalist appropriations and destabilizations.

THE SODOMITE AND SODOMIZED

Implicit in the tropes of the beautiful Middle Eastern boy and hypervirile man are supposedly fixed sexual positions: the phallic male who penetrates others, the adolescent youth sodomized by his seniors. As the analysis of the beautiful boy motif has already revealed, however, this youth need not always be soft, beardless, or all that young to be the object of other men's sexual desires and romantic pursuits—indeed, he may be a wrestler, a roustabout, or a cocky soldier well into his twenties. Likewise, a more incisive examination of sodomy and its representations begins to undo assumptions that are commonplace in critical thinking about sex between men in the Middle East. Neither position nor age is quite as fixed as myths of "Oriental" sodomy declare.

Arno Schmitt, writing in 1992 about male-male eroticism from Morocco to Uzbekistan, reflects a conventional stereotype when he states that "it is self-evident that men [of these regions] like to penetrate all kinds of beings," and hence "it is understandable that some men prefer boys to women."[54] This oft-repeated

viewpoint treats Middle Eastern homoerotics as an extension of the Mediterranean model of pederasty (predominantly age-differentiated and, in classical Greece, based on a mentor-pupil bond).[55] The unattributed photograph in figure 2.6—which bears the stylistic markings of Wilhelm von Gloeden, whose Middle-East tropes are discussed in chapter 6—uses age-differentiation to suggest the pederastic nature of the relationship between the two turbaned figures, with the robed status of the older lover figure and naked vulnerability of the younger beloved marking the power differential between the two. The tendency to associate Middle Eastern homoeroticism with a rigid active/passive model subscribes to the widely held belief that, particularly in third-world "macho" cultures, the gender of the body being penetrated is irrelevant as long as the masculinity of the penetrator remains intact. But such truisms, as Al-Kassim and Najmabadi warn, unthinkingly

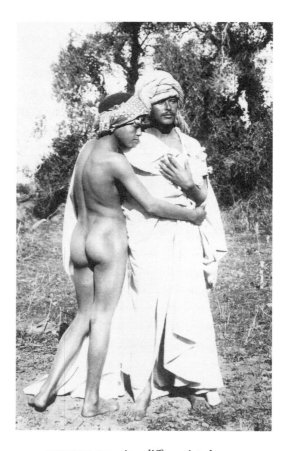

FIGURE 2.6. **Age-differentiated eros.**

Anonymous photograph in the style of Wilhelm von Gloeden (c. 1895). Inventory number 2008.r.4053. Courtesy of the Ken and Jenny Jacobson Orientalist Photography Collection, the Getty Research Institute, Los Angeles.

repeat assumptions about masculine aim and object choice that reinforce binaristic understandings of gender and sexuality: such beliefs in fact may be more reflective of Western-influenced *preconceptions* of machismo than of the sexual nuances of Islamicate cultures.[56] This is not to suggest that the idea of "penetrative" masculine sexuality isn't pervasive in Middle Eastern literature from medieval to present times but that it is *one* strand among others less often highlighted.

The conventional assumption—man on top, boy on bottom—resounds loudly and clearly in the poetry of Abu Nuwas, who rhapsodizes, "O the joy of sodomy! So now be sodomites, you Arabs! // Take some coy lad with kiss-curls twisting on his temple and ride him as he stands like some gazelle."[57] Upholding sodomy as a masculine sport, in which the adult always acts as the aggressor and the youth as beautifully docile recipient, this paean to sodomy is echoed in Samarkind poet Suzani's sacrilegious use of the metaphor of a minaret for his sexual exploits: "Up their asses, my boy-crazed cock . . . // Go, my minaret staff . . // . . . ass-taker by force."[58] Sex, in these examples, is an unabashed expression of male power and domination. Likewise, from sixteenth-century miniatures to twentieth-century decorative arts, various Middle East artifacts depict scenes of male-male sodomy that follow the sexual scripts outlined above. A frieze painted in lacquer on an early twentieth-century Iranian papier-mâché box includes various scenes of heterosexual and same-sex coupling. The positions of the latter are unambiguous: the moustachioed man is the active partner, the smilingly appreciative youth with the iconic moon-shaped face and kiss-curls celebrated by Abu Nuwas is the passive recipient (fig. 2.7, detail). In formal terms, the arabesque design that connects and contains the four couples in the frieze depicts homoerotic pleasure on an equal plane with heteroerotic coupling: aesthetics reflect sexual ideology. While clearly decorative, this box was also designed to be functional, to store jewelry, pens, and like objects. This use-value indicates, in turn, the potential visibility of its "equal-opportunity" representations of sexual variety in the domicile of its owner.

Likewise, the "proper" hierarchy of dominance is observed in an early twentieth-century Persian watercolor (fig. 2.8), which depicts a threesome in which the older man—again turbaned and moustachioed—sodomizes the male youth who in turn sodomizes the woman positioned at the bottom of this descending pyramid. The gender of female partner remains visually ambiguous, her exposed flesh revealing neither breasts nor female genitalia; all that counts are her buttocks, which are indistinguishable in shape and coloration from the boy's, and, like his, are important only insofar as they allow the exercise of the two men's penetrative pleasure.

Not all Arab-Islamic literary and visual representations of sodomy, however, are the straightforward celebrations of age-differentiated sodomy that they may seem on first glance. A case in point is an eighteenth-century illustration in Nev'izade 'Atayi's *Khamsa* (fig. 2.9). On the one hand, the central action

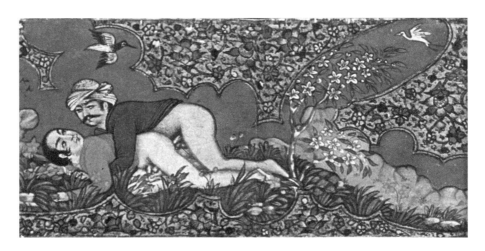

FIGURE 2.7. **Caught in an arabesque embrace.**

Frieze decoration on a lacquered box, Persian (early 20C). Courtesy of the Andrei Koymasky Homoerotic Art Museum Collection. Originally in the Fouroughli Collection, Tehran; current location unknown.

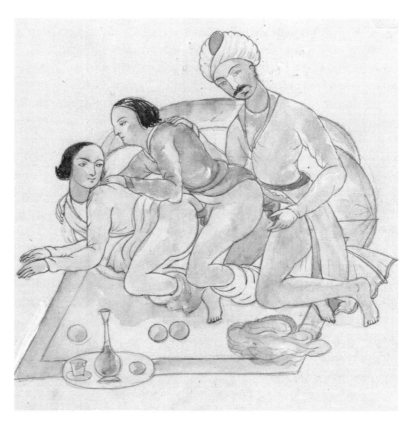

FIGURE 2.8. **Ménage à trois.**

Anonymous. Persian (early 20C). Courtesy of the Kinsey Institute for Research in Sex, Gender, and Reproduction, Bloomington, IN.

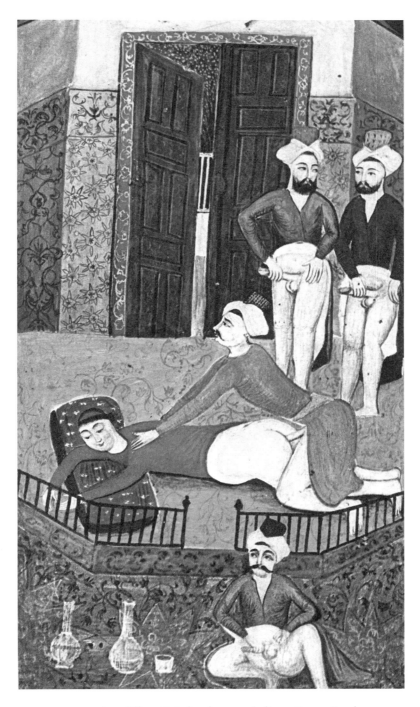

FIGURE 2.9. **Age-differentiated sodomy and alternative erotic pleasures.**

Anonymous. Illustration in Nev'izade 'Atayi, *Khamsa* (mid 18C). Courtesy of the Turkish and Islamic Arts Museum, Istanbul.

inscribes the familiar script: moustachioed turbaned man mounting the boy-ishly plump youth reclining on a pillow on a raised dais that underscores the scene's "to-be-looked-at" quality. On the other hand, this staging makes all the more pronounced the alternative relations and erotic practices occurring among the witnesses to this spectacle—indeed the slightly ajar door to the rear of the platform hints at the porous dimensions of this phantasmatic tableau, its open-ness to new possibilities. Thus, in the front of the raised platform, a single man enjoys the pleasures of autoeroticism, taking in the coupling occurring to his rear with eyes aslant. Meanwhile, the two men to the right add another intrigu-ing element to the scenario. On one level they might be interpreted as waiting their turn to enjoy the youth. Yet on second glance they seem more interested in getting off watching each other as they exchange intense glances. In contrast to the age-differentiated formation of sodomy touted by the medieval poets and reified by many contemporary gay historians of sexuality, a more mobile exer-cise of homoeroticism—here involving adult peers—inhabits the fringes of the pederastic model that occupies center stage.

In fact, such mobility and egalitarianism typify a range of drawings and min-iatures that depict the affective relationships between males of the same age. The seventeenth-century portrait of two Safavid princes attributed to Āqā Mirak (fig. 2.10, detail) uses the device of the book—probably an album of love poems—as the focal point uniting the gazes of these two youths, complementing the intimacy of their clasped hands and touching foreheads. A detail from another delicately executed miniature from the Safavid period (fig. 2.11, detail) shows two youths locked in an embrace whose tender physicality is enhanced by the arabesque that their intertwined arms and hands form—as if a human rendition of the geometric pattern common in Persian and Ottoman design (fig. 2.12). This arrested moment of amorous display hovers between restraint and fulfillment as the lips of the youth in profile approach those of his companion. In an exquisite gesture captur-ing this eternally frozen moment in time, the youth to the left perfectly balances a wine cup without spilling a drop—the sharing of (forbidden) wine being another iconic marker of homoerotic encounters in the miniaturist tradition. Aspects of all these images combine in the virtuoso sixteenth-century depiction of two Ottoman youths playfully wrestling in figure 2.13. Here, the affectionate chuck under the chin, complex intertwining of hand-clasps on each other's arms, and interlocking legs create a portrait of innocent yet amorous play that is at once formally appeal-ing—again calling to mind the arabesque aesthetic—and palpably physical, for the two bodies have so melded into each other that it is nearly impossible to discern where one's limbs begin and the other's end.

The bucolic representation of youthful affection in these miniatures becomes blatantly sexual in an eighteenth-century Safavid miniature (fig. 2.14) whose brushstrokes capture two youths in flagrante delicto in a camphor wood. By

FIGURES 2.10, 2.11, 2.12, AND 2.13. **Arabesque entwinings.**

Top row, *left*: "Two Safavid Princes" (c. 1535), attrib. to Āqā Mirak. Courtesy of the Freer Gallery of Art, Smithsonian Institution, Washington, DC. Lent by the Art and History Trust .LTS 1995.2.51. *Right*: "Two Youths Embracing," Safavid (1630s). Courtesy of the Freer Gallery of Art, Smithsonian Institution, Washington, DC. Purchase F1954.28. Bottom row, *left*: Author's rendering, after Alhambra tile design. *Right*: "Two Youths Romping," Turkish (late 16C). Image courtesy and © The Metropolitan Museum of Art, New York. Image source: Art Resource, NY.

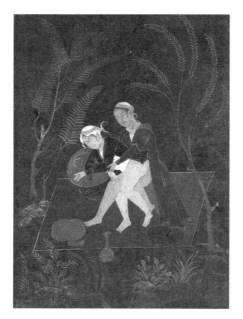 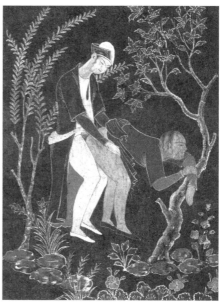

FIGURES 2.14 AND 2.15. **Contrasting pairs in a camphor wood.**

Both Safavid (probably 17C). Courtesy of the Kinsey Institute for Research in Sex, Gender, and Reproduction, Bloomington, IN.

placing this amorous tryst in such an aesthetically pleasing, aromatic setting, the artist lays claim to pastoral associations that add an aura of naturalness and romance to the explicit tableau. The two partners share the same age and status, as their similar headgear and costumes indicate; the contrasting hues of their stacked undergarments add a note of individuality. The ubiquitous wine flagon and the verdant outdoors setting also link this image to the tradition of the sohbet or refined garden party described in chapter 1. Like the sohbet, like this gem of art itself, sodomy has become an aestheticized experience. The stylistically similar Safavid rendering in figure 2.15, again set in a camphor wood brimming with delicate flowers, further destabilizes the script of age-differentiated sodomy. For here, the younger figure is the active partner, reversing the stereotype. One might hypothesize that the adult male being sodomized is supposed to represent the ubnah, a man who takes pleasure in being penetrated and poses a definitional problem in Islamic medical and ethical discourse.[59] But this depiction seems void of any overt attempt to present the passive male as an object of scorn; indeed, the beautiful natural setting works against such judgments.

Reinforcing this sense of fluidity in roles, al-Tīfāshī in *Delight of Hearts* comments both on boys who are "perfectly capable . . . of performing in either of the two possible roles" and their adult partners, who likewise take pleasure in

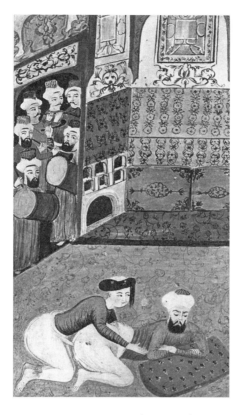

FIGURE 2.16. **Role-reversal.**

Illustration in Nev'izade 'Atayi, *Khamsa* (mid 18C). Courtesy of the Turkish and Islamic Arts Museum, Istanbul.

assuming both active and passive roles with their younger beloveds.[60] Dervish İsmail makes it clear in his *Dellak-name-i Dilküşa* or "Book of Bathboys" (1685) that several of the contemporary dellaks of Istanbul are "swaggering" tops with impressive endowments (like "the cob of [a] hyacinth") hired expressly to "fuck the asses" of their seniors—"gentlemen, pashas, agas, and lords" whose desire to be penetrated belies their superior status in age, status, and wealth.[61] This reversal of roles is illustrated in multiple copies of 'Atayi's *Khamsa*. In one Ottoman copy (fig. 2.16), the youth seems quite happy to be mounting his disgruntled looking senior. While the shock of the onlookers espying the scene, in accord with the accompanying ribald tale, adds a note of scandal to this violation of the publically accepted script for adult male behavior, it is interesting that the percussion instruments being played by the voyeurs have, since Egyptian times, been associated with heightened sexual ecstasy, thus potentially implicating them in the jouissance of the scene.[62]

Such destabilizations in tropes and assumptions about sodomy extend to relations between adult men. Schmitt among others argues that what is unthinkable among Arab males is the idea that "a man could prefer to sodomize adult males." Yet, given the flexibility governing the age range encompassed by "youths," reaching anywhere from twelve to thirty-some years of age, possibilities seem more flexible than such statements allow. What, for instance, of the beloved who is now in his late twenties, or the two court pages who have fallen in love and continue their affair into their thirties, or the merging of roles of master and disciple "between people of more or less equal status" that Janet Afary identifies within Sufi mystical ritual?[63] A hint of this erotic continuity exists in the visual doubling apparent in a detail of a court scene painted around 1616 (fig. 2.17). The viewer's attention is first drawn to the standing boys, the ostensible objects of visual desire, holding wine cup and bow and quiver (symbolically uniting a successful adult male's twinned goals of refined pleasure and athletic prowess).

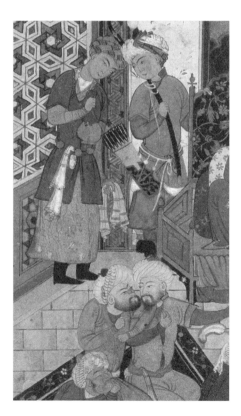

FIGURE 2.17. **Adult affinities.**

Detail from Muhammad-Sherif, *The Shah and the Dervish* in Sa'di, *Bustan*. CBL 297, fol. 16a. Samarkand (1616). Courtesy and © the Trustees of the Chester Beatty Library, Dublin.

Sitting in front of the youths are two bearded men who, as the visual doubling suggests, could be the boys' lover-patrons, but who also, conceivably, foreshadow the affectionate and erotic intimacy that might well continue between these two page boys when they grow up—the parallel angling of the heads of the two boys and the two men make the latter pair a reflection of the former.

Al-Tīfāshī, surveying poetry written in defense of those attracted to males after their beards have sprouted, matter-of-factly notes that such "barbophiles" include "many . . . attracted by adult men."[64] And, as a poem included in al-Tīfāshī's anthology reminds us, even the "fixed" roles of top and bottom may include, on the psychological level, a mutual degree of reciprocity:

> I inserted my cock expertly
> into his secret place;
> then his tongue penetrated my mouth
> in a long French kiss.//
> Fair exchange, no robbery;
> Neither winner nor loser there:
> the powerful and noble-hearted
> are always fair.[65]

Perhaps an idealized sentiment, this lyric nonetheless expresses an attitude—"neither winner nor loser there"—that many interpretations of male sodomy in the Middle East have hitherto obscured. Such an attitude is part of a larger cultural formation that depends on flexibility on all levels, one in which, as Ze'evi notes, "the question of who penetrates whom" is rarely addressed in sacred law, however much acts of sodomy are themselves endlessly discussed and debated. This institutionalization of what Ze'evi notes as strategic flexibility is both inevitable in systems of rule in which roles of power are unpredictably fluid (after all, in Mamluk and Ottoman systems the elite who ran the empire were slaves by birth) and in which Sultan, Emir, or Shah fills the symbolic role of Ultimate Beloved, the object of every subject's desire. Who is on top, who is on bottom, and who is between—all of these permutations turn out to be less than certain in the pre-modern world of homoerotic love and desire in the Middle East. [66]

THE BATH OR *HAMAM*

Compliments of writers like Lady Mary Wortley Montagu and Orientalist painters like Ingres, Gérôme, and Alma-Tadema, the topos of the hamam, or public bath, most frequently conjures up images of luxuriant female sensuality,

in which odalisque-shaped women groom themselves and one another, often in each other's arms.[67] Describing a visit to the hamam is *de rigeur* for the travel writer from the early modern period forward, and male writers in particular enjoy titillating their readers with what they've heard—or most likely read in equally unauthenticated accounts—about the Sapphic goings-on in the female hamam.[68] Not surprisingly, the male hamam also emerges as a suggestive arena of homoeroticism, given its display of the towel-clad male body,[69] the presence of bath boys and masseurs to administer to one's cleansing and ease, and its private resting cubicles (figs. 2.18 and 2.19). For European commentators, such purported goings-on are most often scandalous; for Middle Eastern writers, an unremarkable source of eros.

In his landmark study, Abdelwahab Bouhdiba writes evocatively of the hamam as a transitional zone that links religiously mandated purification rituals, the latent eroticism of a single-sex world, and, for every boy, memories of his banishment from the comforting realm of the female bath on reaching puberty and simultaneous initiation into the competitive realities of male homosociality. "The homosexual element in the practices of the hamam," Bouhdiba continues, is inevitable: "an astonishing promiscuity reigns in the hamam that seems to have survived all the censors and prohibitions." He theorizes that entering the enclosed, moist, heated world of the male bath becomes a return to an infantile world of anarchic desires, a space momentarily outside of time that is saturated in sexual feeling. Whether "an astonishing promiscuity" in fact reigns in an environment where all ages of men gather to socialize several times a week, in mostly open spaces, and where complete nudity is rare may be questionable, but the result is nonetheless an atmosphere saturated in sensuality.[70]

Behind the aspersions of unnatural sexuality leading Louis de Chenier to condemn the public baths of Fez as "receptacles of debauchery" in 1788 and Lord Byron to celebrate those of Istanbul as "marble palace[s] of sodomy and sherbet" a decade later, there is a rich literary tradition in the Middle East evoking the homoerotic pleasures of the bath and its delectable bath boys.[71] In the *Dellak-name* ("Book of Bathboys"; 1685), Dervish İsmail, a former bath-foreman, declares to his lover Yemenici Bali (a renowned bath boy and janissary conscript he has made his "bed companion") his intention to "compose a souvenir for the 2321 glorious, pure, and naked bath boys in the 408 pleasure-giving hamams of the four districts of Istanbul, the city of cities." Wittily eulogizing eleven of the city's most famous or "joy-giving" dellaks of the day, Dervish İsmail's verse descriptions also include practical tips for potential clients, such as specific youths' charms, reliability, favored sexual positions, and fees. Thus, of Yildizbaba Hamam's "fairy-faced" Kiz Softa, the reader is informed that "one-time sex in his private cell in the hamam costs 100 silver coins. Mattress-companionship . . . costs two golden coins, with the condition that anal sex be not more than three

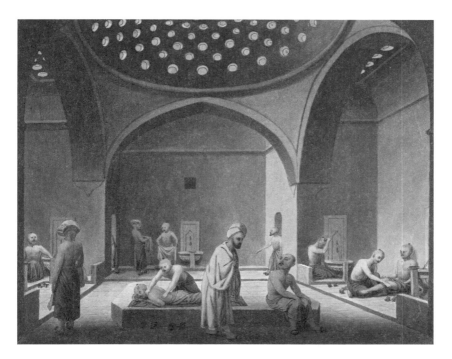

**Middle Eastern depictions
of the male hamam
and a popular bath boy.**

Top: Anonymous artist associated
with the circle of Konstantin
Kapidagli, commissioned by
Stratford Canning, diplomat
in Istanbul (c. 1809).
Mus. no. D.118–1895. Courtesy
of and © Victoria and Albert
Museum. *Bottom*: illustration
in Fazil Bey's *Huban-name*
(Book of Beautiful Boys).
T 5502. Courtesy of the
Istanbul University Library.

times. If [Softa] permits more, then the customer should pay an additional 100 silver coins per time. . . . Even though the boy enjoys his sodomizer and asks for no more silver, the client should nonetheless pay 20 silver coins to the bath attendant."[72] Nor was *hamamiyi* poetry just an Ottoman phenomenon. Like Dervish İsmail, the eighteenth-century Yemeni belle-lettrist Ahmad al-Haymī al-Kawkabānī devoted a whole book to advice, stories, and poems about the joys of the male hamam, including its attractive bath attendants.[73]

Fuzûlî, one of the masters of Ottoman literature, makes the entrance of a beautiful youth into the bath the occasion for a sensuous ghazal in which the very water shines more brilliantly

> when his body came to be seen,
> stripped of his robe,
> like the full moon.
> Then he wrapped himself in an indigo bathrobe:
> truly a naked almond in a field of violets.

Fuzûlî's evocation of the boy's indigo wrap as a field of violets offsetting his body's almond-like whiteness is echoed in the vivid blue bath towels seen in multiple miniatures; simultaneously, Fuzûlî plays on a conventional trope likening the delicacy of a youth's penis to a peeled (therefore white) almond. Next, Fuzûlî converts the image of the wrap-around towel into that of the poet's enwrapping gaze:

> Then came the radiant moment
> When he emerged from the bath, still naked
> But wrapped in my feverish gaze
> Which embraced his divine body.
> And it is there that he has since remained,
> Hidden in a secret corner of my eye.[74]

The embrace of the poet's look, thus, becomes the vehicle by which the transitory moment becomes lasting memory, as precious as physical contact itself.[75]

The historical record reveals that poetic musings like Fuzûlî's were not simply the stuff of creative imaginations. In the early sixteenth century, the Ottoman historian, pornographic writer, and avowed boy-lover Deli Birader Gazali used the fortune he amassed at court to build a complex in Beşiktaş (a suburb on the Asian side of the Bosporus that, like Galata, had the reputation for attracting pleasure-seekers) composed of a mosque, dervish lodge, and magnificent bathhouse that became the talk of Istanbul. This pleasure-palace is memorably evoked by historian Âşık Çelebi, a contemporary of Gazali, who writes that once

Gazali finished the bath, he "staffed it with bath boys[,] each of whose bodies was a silver cypress," whereupon "the beloveds of Istanbul streamed to that bath from all directions, and [following on their heels] the[ir] lovers came, burning hotly in fires of separation, and in that bath they enflamed the wild horses of their hasty desire in the waters of lust."[76] Eventually Süleyman had the bath pulled down, but not because it was a den of unnatural vice. Rather, as Âşık tells it, its destruction was the case of a combination of revenge against Gazali (who'd written a satiric slur about the boyfriend of Vizier İbrahim, the most powerful man in the empire next to the Sultan) and concern because Gazali's monopoly on the market was bankrupting other bathhouse owners and putting their employees out of work.[77] An illustration of a hamam included in a sixteenth-century album of miniatures in the Topkapi Palace Museum (fig. 2.20; see also Plate 2) depicts an interior evocative of Gazali's bathhouse, which was renowned for its magnificent central bathing pool.[78] A closer look (fig. 2.21; see also Plate 3) reveals hints of male intimacy and tender sensuality that supersede locker-room homosociality.[79] Although this cavorting appears relatively innocent, the artist has strategically allowed the wrap of the masseur on the bottom left to fall open, exposing his penis (fig. 2.22), and he has rendered the blue towels of the two men preparing to dive into the pool on the upper right translucent, so that they reveal fully outlined genitals beneath. There is more going on, at least in the miniaturist's imagination, than first meets the eye. The playful activities in the pool depicted in this miniature are almost identically reproduced, albeit by a much less talented hand, in an image decorating a late-nineteenth-century glass box lid (fig. 2.23). The telling difference is that this homosocial activity has been relegated to the background, while the artist uses the foreground to imagine the sexual play occurring in the semi-private cubicle dedicated to massage. While clearly pornographic in intention, this decoration hints at the coexistence of homosexual activity and homosocial bonding within the shared space of this all-male domain; the half-partition forms an apt metaphor for the seen-but-not-seen incorporation of homoeroticism into such public venues.

Given such widespread expressions of the hamam's homoerotic potential, it's no wonder the trope is picked up by foreign visitors to the region. As early as 1610 one finds Dutch traveler Johann Baptiste Gramaye grumbling that men of Algiers and Barbary uniformly use the baths to "expatiate[e] . . . all Lust, Sodomie, and Adulterie."[80] In the 1627 account of his captivity by Algerian corsairs, *Esclave à Algiér*, Portuguese soldier João Mascarenhas strikes a similarly aggrieved (and propagandistic) note, reporting that Turks bring their Christian slaves to the baths to commit sodomy with impunity.[81] Nineteenth-century French traveler C. F. Volney declares that he envies the Turks neither their overheated baths nor—and he italicizes the exclamation that follows—"their *too complaisant Massers!*"[82] In such moments, the hamam has clearly become the site for Western

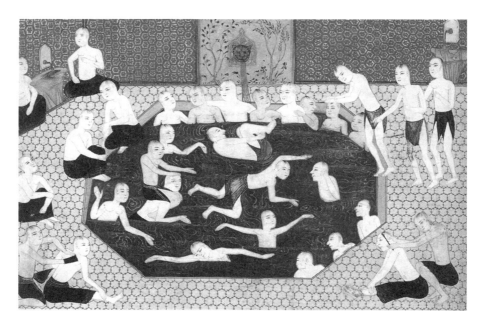

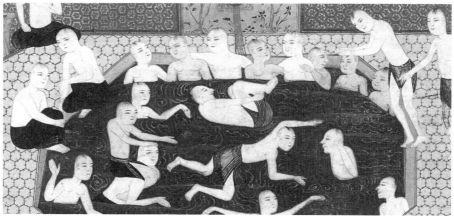

FIGURES 2.20 AND 2.21.
Male camaraderie in the hamam (detail). (See also Plates 2 and 3)

I. Ahmed Album-i. TSM B 408. Courtesy of the Topkapi Palace Museum.

homoerotic projection and fantasy, as is subtly apparent in figures 2.24 and
2.25. The first is an unidentified engraving in a French history of Turkey and
the second a plate in Vivant Denon's lavishly illustrated two-volume account
of Egypt (1802; commissioned by Napoleon during his invasion). Aside from
accurately representing the Muslim custom of shaving all but a topknot from
the head, both artists' depictions of the sculpted bathers' bodies (Turkish in the

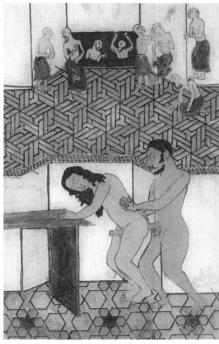

FIGURES 2.22 AND 2.23. **Exposed parts, covert and explicit.**

Left: Detail of figure 2.20, above; note the masseur's parted wrap. *Right*: Painted glass box lid, Persian (early 20C). Courtesy of the Andrei Koymasky collection, the Homoerotic Art Museum Collection. Originally in the Fouroughli Collection, Tehran; current location unknown.

first, European in the second) derive from a Western classical tradition of the male nude that hardly reflects Middle Eastern bodily aesthetics and that hints at a homoerotic appreciation of the unclothed male physique.[83]

Something of these Western bodily aesthetics combines with a homoerotic subtext in the illustrations accompanying the entries on male baths in Turkish historian Reşat Ekrem Koçu's never-finished *İstanbul Ansiklopedisi*, which appeared serially from 1958 to 1972 (I discuss this work in chapter 3). Giving everyday and ephemeral subjects equal standing with historically significant ones, Koçu often used his selection of entries to express, discreetly but palpably, a homoerotic substratum of Ottoman life being erased in the nation's project of modernization. Among the many ways in which he insinuates this subtext into his family-friendly encyclopedia are entries detailing and illustrating every hamam in Istanbul. These architectural gems are, of course, legitimate subjects of historical documentation, and the entries faithfully provide exterior view, architectural floor plan, and interior sketch. The latter sketch, however,

FIGURES 2.24 AND 2.25. **Worshipping the European physique.**

Top: Lithograph from page of unidentified French travel volume (18C). Author's collection.
Bottom: Illustration in Vivant Denon, *Travels in Upper and Lover Egypt* (1803).

FIGURE 2.26. **The lineup: a visual şehrengiz.**

S. Bozcali, details from Koçu, *İstanbul Ansiklopedisi*. Illustrations represent, left to right, entries on the Cinili Hamam (7.4018) and the Davudpaşa hamam (8.4303); a typical dellak (8.4368); a well-known seventeenth-century bath boy Bâli, whose image is included in the entry on dellaks (8.4366) as well as one under his own name (4.2041); and the famous historical figure Patrona Halil (1718), a dellak and janissary who led the rebellion deposing Ahmed III.

inevitably becomes an excuse for depicting impossibly good-looking, shirtless bath attendants. Such illustrations appear innocuous enough when encountered individually. Abstracting the portraits of these dellaks (some historical figures, some purely imaginative and decorative) and setting them side by side, however, makes the homoerotic investment quite clear (fig. 2.26). Historicizing the hamam thus allows Koçu to imbue his volumes with a visual degree of homoeroticism that—as I argue in chapter 3—constitutes a modern-day form of the poetic genre of the şehrengiz.

These sketches appear tame compared to the artwork, executed a decade after Koçu's last volume, of a Turkish artist using the pseudonym "Fero." Despite its seemingly pornographic intent, this pencil line drawing, *The Barracks* (1983)—which can be viewed online at http://www.homoerotimuseum.net/asi/asi01/051.html—riffs on the rich historical associations of the hamam to make a politically evocative statement. Relocating the spectacle of male nudity, display, and cruising to an open-air shower in a military barracks, Fero knowingly combines several motifs: traditional associations of the public bath with sexual opportunity; historical associations of the Sultan's janissary guard with homoerotic behavior (from the eighteenth century forward janissaries' reduced pay meant that many sought employment as dellaks and masseurs); homophobia in the modern Turkish military; and a drawing style reminiscent of European pornographic artists like Tom of Finland. In the background of the drawing, a naked man is drying off in an outdoor shower area as a nearby soldier, half undressed, gazes at him. Meanwhile, in the foreground, a third, shirtless soldier sits with his back to a low divider enclosing the shower area, one hand pressed to his face. The tableau's depiction of gazes adds a psychological density to the composition. The nude man gazes offstage while sporting a tumescent penis: whether he is looking into vacant space or at another man who is the cause of his arousal one can only conjecture. Simultaneously he is being cruised by the man who is undressing beside him in the showering compound. In contrast to these gazes, the man sitting outside the enclosure shrouds his closed eyes with one hand, perhaps because he is weary, waiting his turn, doesn't want to see what's transpiring on the other side of the divider (note the visual resemblance to the half-partition separating the sex occurring in the massage cubicle from main bathing area in figure 2.23), or feels shame for an act he's either contemplated or already committed. The clutched hand covering his crotch, inversely mirroring the one covering his face, intimates as much: either he wishes to repress—press down—the desires he feels, or he is fondling himself because of those desires. Any of these scenarios suggests the complications and contradictions between the emphasis on manhood fostered by military life and the homoerotic desires that may surface in all-male environments.

Fero's depiction makes the hamam more than a simple locus of pornographic fantasies and projections; it becomes a site in which constructions of masculinity

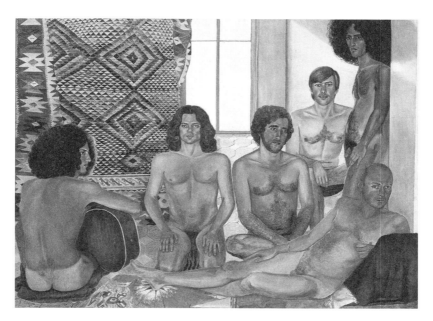

FIGURES 2.27 AND 2.28. **Sleigh's Orientalist citations.**

Top: Sylvia Sleigh, *The Turkish Bath* (1973). Photograph © 2011 courtesy of the David and Alfred Smart Museum of Art, The University of Chicago; Purchase, Paul and Miriam Kirkley Fund for Acquisitions. *Bottom*: Jean Auguste Dominique Ingres, *The Turkish Bath* (1863). Courtesy of the Bridgeman Art Library International / Louvre, Paris.

are engaged and challenged. A similarly nuanced perspective characterizes the last two artworks examined in this section. Neo-realist Sylvia Sleigh's 1973 *The Turkish Bath* provides a bracing feminist revision of Orientalist representations of voluptuous harem women enjoying the baths, combining that revision with a 1970s questioning of traditional modes of masculinity, a celebration of the "feminine" in man, and a valorization of nudity as a return to nature. Although posed to evoke the odalisques of Ingres (compare figs. 2.27 and 2.28), these men aren't presented as sex objects on display; instead, they inhabit their flesh as sexual subjects who manifest a range of body types and ages, sport long hair, allow themselves the vulnerability of posing nude for the female artist, and appear so comfortable cohabitating the same space with other nude men that questions of sexual orientation are beside the point. Simultaneously, Sleigh displaces the typical signifiers of Orientalism; the female lute player of nineteenth-century salon painting has been replaced by a guitar-strumming, Afro-headed hippie, and textiles like American quilting and a zodiac print replace the richly patterned Turkish carpets favored by a Delacroix or Gérôme.

Similarly compelling, in a more meditative vein, is the 2005 photographic portrait by Swiatek Wojtkowiak titled *Moroccan Hamam* (figure 2.29). Alone in a changing room where deep shadows and murky green hues create a sense of unworldly interiority and privacy, a tanned young man, wrapped in the

FIGURE 2.29. **Discovering Manhood.**

Swiatek Wojtkowiak, *Hamam in Western Sahara (Morocco)*. Courtesy of the photographer.

FIGURE 2.30. **Object versus subject status.**

Detail of Gérôme, *The Snake Charmer.* See figure 2.1.

traditional waist-towel, stares at his image in a cracked mirror, one hand raised
to his face. The style of beaded necklace around his neck links him to the con-
temporary present. While his ethnicity is hard to read, his blonde hair suggests
he is a foreign visitor in Morocco. The changing room itself is defamiliarizing.
Instead of the expected Moorish architectural features, the battered metal lock-
ers could come from any high school gym—the universalizing tendency of
much Orientalism is here reworked with specific intent. The image is composed
so that we look over the young man's lithe torso and follow the line of his gaze
toward the mirror in which he contemplates his image. The angle of vision
recalls the backside view of the naked snake charmer in Gérôme's painting—a
boy so completely subjected to the gaze of spectator and onlookers that his sole
identity is that of "cute" object (fig. 2.30). Wojtkowiak's composition achieves a
much more subtle, contemplative vision of masculine subjectivity. This young
man, no longer a boy, on the cusp of adulthood, is more than an object of the
viewer's spectatoral desire: like Sleigh's models, he is a person who possesses

his own subjectivity—or, more accurately, is in the process of locating his own identity—as he gazes into the mirror. This looking glass, however, confuting the mirror's traditional function in the history of art, does not reflect back to the photograph's viewers the "truth" of its gazing subject's being. Uncannily, hauntingly, all *we* are allowed to view is the youth's darkened silhouette, the top of his head and shoulder backlit by a corona of light: whatever image he sees, or conjures up, or aspires to become, remains his own. In the solitude of this particular moment of self-reflection, a moment facilitated by the defamiliarizing environs of this emptied dressing room in a hamam somewhere in Morocco, the story of this youth's maturation remains a blank slate—like the darkened silhouette of the boy's reflection in the mirror. But this is no tabula rasa on which we can write: as caught by Wojtkowiak's lens, this youth is poised to be the author of his own story.

The hamam has figured as the catalyst of homoerotic desire in film as well. Chapter 3 examines one such film, Ferzan Özpetek's Italian-Turkish production, *Hamam: Il Bagno Turko* (1997; *Steam: The Turkish Bath*). Two decades earlier, Salah Abu Seif's *Hammam al-Malatily* (1973; *The Malatili Baths*) made its titular location—a Cairo institution at the time frequented by a gay clientele—the shelter for the protagonist, a young man who has come to Cairo to seek work and finds himself destitute; he is picked up by an older habitué of the hamam, an artist whose unsuccessful attempt to seduce him is a rare instance of homosexuality handled with relative nonjudgment in Egyptian film.[84] If Özpetek and Seif make the hamam the occasion for serious explorations of masculinity-in-crisis, Jean-Daniel Cadinot, a well-known French director of gay porn, uses the hamam as a primary setting in two films shot in the Maghreb, *Harem: Sex Bazaar* (1984) and *Hammam* (2004). Drawing on a cast of Maghrebian and French actors, these films wildly mix authentic location shots with Orientalist porn-props, most of which have little place in a real hamam (red fezes, shiny cushions covered in cheap fabric, and Aladdin vests straight from the tourist bazaar). Yet the very fact that the trope of bath, both in its representations in classical Middle Eastern literature and in its modern avatars, can range from the poetic to the pornographic suggests why it has remained such a consistently productive site for homoerotic imaginings and for Orientalist projections over the past four hundred years.

THE HYPERVIRILE MALE OTHER

The myth of the beloved boy is complemented by a corresponding fantasy figure capable of inciting equal amounts of anxiety and desire in Occidental imaginations: the unremittingly virile man of Middle East extraction. From

the anonymous novel *The Lustful Turk, or Lascivious Scenes from a Harum* (1828) to Edith Hull's *The Sheik* (1921), this figure exerts such sexual magnetism that the female virgins (white captives in both instances) whom he takes by force find themselves sexually awakened to their "true" feminine desires in the very act of rape. For European men, this trope of hypervirility can equally incite anxiety (of being less satisfying than the mythic sheik) or envy (of the plentitude of submissive, adoring women who serve the master of the harem). Kathryn Tidrick's *Heart-Beguiling Araby*, which traces the historical evolution of British and Continental myths of the hypermasculine Arab, argues that J. L. Burckhardt, one of the first Europeans to give an "eyewitness" account of Bedouin desert life, put "the finishing touches" on the myth of the Arab male as more rugged and straightforward than other men—a myth of "pure" unspoiled masculinity constructed out of late-nineteenth-century Anglo-European worries that its male population had become too civilized, too soft, too enervated in a world in which the sexes were more equal and everyday life no longer beset by violence and hazard.[85] The manly ruggedness that Burckhardt attributes to Arabs is a quality other writers indiscriminately apply to *all* men of the Middle East, peninsular Arabs or not. After all, as its title indicates, *The Lustful Turk*'s Dey Ali is a Turk, and Hull's Sheik is Algerian (or so we are led to believe until his English ancestry is finally revealed).[86]

Such Orientalized icons of virility also lend themselves, subtly, to homoerotic appropriation and appreciation. Two evocations of this trope by homosexual artists, the Orientalist painter Anne-Louis Girodet de Roussy-Trioson and twentieth-century society portraitist Cecil Beaton, illustrate the point (figs. 2.31 and 2.32). In the former's portrait of Mustafa Sussen of Tunis, painted in 1819, the subject directs a gaze at the viewer that, hovering ambiguously between threat and desire, suggests more about the artist's attraction to his model than about Mustafa's unknowable predilections. Similarly, the handsome legionnaire captured by Beaton's lens, taken when the British photographer was sent to North Africa to document the war effort in 1942, looks back with an intense gaze, echoing Mustafa's, that gives Beaton's portrait its subtextually homoerotic allure.

Such examples are part of a larger history of visual representation in which the depiction of threateningly potent Arab masculinity carries an erotic charge. Two famous Orientalist paintings, Eduard Charlemont's *The Moorish Chief* (1878) and Henri Regnault's *Execution Without Judgment* (1870), add a clearly racialized element to this mix of signifiers. This emphasis is underscored by both artists' use of Granada's Alhambra as backdrop, summoning forth specters of the Moorish incursion into Europe. Everything about the larger-than-life figure Charlemont depicts (fig. 2.33; originally titled *Guardian of the Seraglio*) exudes confidence and mastery, beginning with his imperturbable gaze. Within

FIGURES 2.31 AND 2.32. **The masculine gaze, returned.**

Left: Anne-Louis Girodet de Roussy-Trioson, *Mustafa Sussen of Tunis* (1819). Courtesy of Bridge-man Art Resources / Musée Girodet, Montargis, France. *Right*: Cecil Beaton, *Arab Legionnaire* (c. 1943), illustration in Beaton, *Near East* (1942). Courtesy of the Imperial War Museum, London.

the angles of perspective that Charlemont establishes, the chieftain stares *down* at his viewers, looking them not only in the eye but from a higher point of elevation that is indexed by the steps his feet are straddling. The spectator remains as much the object of his penetrating gaze as vice versa. All the while, his countenance remains inscrutable: the sharp contrast of his white robe and dark visage counter the attempt to read any expression, beyond sheer supremacy and disdain, in his gaze (fig. 2.35). Likewise, his upright posture imbues his entire body with a phallic rigidity rendering him invulnerable to outside threats of engulfment or penetration, and the lethal scimitar that he holds iterates the menacing threat that he poses to anyone who challenges him. The untainted "purity" of his elemental maleness—to paraphrase Burckhardt— is emphasized in the contrast between the opulently golden, arabesque architectural interior he occupies and the pristine whiteness of his robes, a whiteness broken only by the crimson length of fabric that drops vertically from his waist, over his crotch, and down to the hem of his garment; simultaneously, this dazzling whiteness throws into high relief his racial "otherness."

Many of these traits—verticality, elevation, disdain, threat—typify Regnault's use of the same setting and similar depiction of Moorish masculinity (fig. 2.34). Regnault was often lauded as an innovative painter who might have pushed Orientalist genre painting beyond its conventional stereotypes had he not

FIGURES 2.33, 2.34, AND 2.35.

Unperturbed masculinity.

Left top: Eduard Charlemont, *The Moorish Chieftan* (1878). Courtesy of the John G. Johnson Collection, Philadelphia Museum of Art. Cat 951. *Right top*: Henri Regnault, *Execution Without Judgment under the Moorish Kings of Grenada* (1870). Courtesy of the Musee d'Orsay, Paris. *Bottom*: Detail of *The Moorish Chieftain*.

died prematurely (he was killed in battle in the Franco-Prussian war in 1871). The Andalusian Moorish civilization whose traces Regnault sought to recapture among the Arabs of present-day Morocco (where *Execution* was painted) provided the artist, as Hollis Clayson argues, with a "screen onto which [he] project[ed] a radical model of social and racially alternative masculinity," a model self-consciously championed in opposition to contemporary French bourgeois ideals of manhood.[87] As in Charlemont's painting, the Moorish executioner exemplifies untouchable maleness occupying an elevated position at the top of the stairs from which he towers over the viewer. The potential for violence suggested by the sword that Charlemont's chief dangles at his side is fully realized here: the withdrawn blade has just finished its dirty work as the executioner wipes it clean, a physical movement that brings his taut musculature into relief. Meanwhile, he disdainfully looks to the side, as if his victim no longer even merits attention. The decapitated victim lying at his feet, head having toppled to the bottom step, becomes a chilling reminder of the symbolic castration that awaits those who challenge, in Clayson's words, this figure's "absolute physical and political power."[88] Yet the fact that Regnault makes the executioner's face an uncanny double of that of his victim (their muscular brown arms also seem cut from the same cloth) points to the fine line separating power and powerlessness, law and transgression, in this fantasized regime of über-masculinity.

The potential for such gendered meanings to take on homoerotic connotations suffuses the same artist's watercolor, *Hassan and Namouna* (1870; fig. 2.36; see also Plate 4), executed upon Regnault's return from Morocco to France. The "expansive muscular torso" and "aloofness, even dreaminess" that Clayson associates with *Execution Without Judgment* is here introjected into an explicitly eroticized tableau in which the physical and emotional *disconnection* between male and female figures was glaring even to contemporary critics. "Wide apart indeed are these two beings, both young and beautiful," wrote Theophile Gautier, "who are placed at each end of a divan." Gautier seems most intrigued by the female figure's autoerotic self-sufficiency, her "unattentive[ness]" to Hassan's glorified "spare, muscular . . . voluptuousness," as she "follows out her dreams" playing her guzla. But equally destabilizing, within the scene's overtly heteroerotic framing of master and concubine, is the reversal of gender codes in Hassan's recumbent posture: the "beautiful, languorous man," notes Clayson, "usurp[s] the stock role played by the reclining female odalisque." Thus Regnault not only puts Hassan's masculine beauty and bare torso at the visual center of the painting (relegating the female to its margins), he simultaneously eroticizes him as the (im)passive object of the viewer's gaze: it is hard not to see Hassan's virile, iconic masculinity as the painting's emotional core.[89]

These Orientalist depictions of masculinity and prowess are mirrored in classical Arab literature, where poets' phallic boasts are a common feature

FIGURE 2.36. **Destabilizing the romantic narrative. (See also Plate 4)**

Henri Regnault, *Hassan and Namouna* (1870). Courtesy of Roger Benjamin. Private Collection.

of the sexual bravado typifying the ribald genres of mixed prose and poetry, *sokuf* and *mujun*, as well as the obscene literary modes of *hazl*, *hajr*, and *tanz*.[90] While literary cultures worldwide manifest equivalent forms of phallocentric braggadocio, many of these Middle Eastern texts take more overtly homoerotic shadings. When Abu Nuwas, sacrilegiously calling on his Maker, declares "Allah knows, none has / A member of the size / Of mine," his invitation for readers to measure his endowment—"come, / Take my prize! / Test it—hold it in your hands"—however farcical, implies a shared sexual interest. The Persian poet Suzani's similarly obscene tribute to his phallus becomes an attempt to seduce a youthful male passerby: "My boy-crazed cock . . . ass-taker by force // I made my song of this hard cock so flagrant / To catch, or so I hoped, the passing vagrant."[91] If such poets jestingly draw attention to their endowments, so too, ironically, several early modern European commentators follow their lead, expending questionable amounts of textual energy speculating about Middle Eastern men's genitalia. In such instances, fascination with sexual otherness veers into impromptu lessons in comparative anatomy, including speculations

ranging from the effects of climate on the glans to suppositions that the "naturally much [longer]" foreskins of Arabs is the origin of the practice of circumcision.[92] In the late nineteenth and twentieth centuries, such observations are superseded by increasingly voyeuristic observations—often disguised as scientific observation—about the size of "Arabic" genitalia that become the conduit, simultaneously, for covert expressions of homoerotic desire and overt articulations of anxiety among Anglo-Europeans who fear themselves less priapically blessed. Both attitudes attest to the persisting legacy of the trope of Middle Eastern hypervirility and its intersection with the homoerotics of Orientalism.

THE CRUEL AND EFFETE PASHA

A variation on the all-powerful male figure that also contributes to Orientalist homoerotics is the ruler whose unlimited power and sadistic cruelty coexist with a tendency toward voluptuous indolence, resulting in the flaw of "effeminacy" that European writers historically projected onto the Islamicate world.[93] This stereotype of the polymorphously perverse yet powerful man, as honed in practices of sadism as he is in debauchery, is primarily the phantom of Western imaginations, spawned by equal amounts of desire (to have such power at one's fingertips), fear (of the unscrupulous means by which such power asserts its dominance), and anxiety (that such sensual indulgence becomes an addiction that is ultimately unmanning). Aubrey Beardsley's cover illustration for an edition of *The Thousand Nights and a Night* exploits this trope (fig. 2.37), representing Ali Baba as a sensuously corpulent, effeminately bejeweled despot whose sybarite tastes might as easily include tormenting a harem of boy-slaves as maintaining a household of houris. Such unnatural tastes and effeminacy form the subtext of Louis Strimpe's hand-stenciled illustration in the January 1914 issue of *La Gazette du Bon Ton,* "L'Encens, Le Cinname et la Myrrhe: Robes de Soir" (fig. 2.38). Strimpe's kneeling pasha, wrists limply extended, evinces a "feminine" vanity that all but eclipses that of the three women (bearing gifts like the New Testament's wise men from the "Orient") to his rear, who are modeling the season's fashions; the inclusion of the ephebe-like boys bearing the parasols and holding the pasha's train creates a subliminal link between the pasha's feyness and his presumed sexual predilections. This dichotomy between omnipotent power and so-called Asiatic effeminacy also underlies the feverish representation that T. E. Lawrence—a figure whose repressed homosexuality and masochism are matters of record— gives of the fawning yet cruel Turkish bey who presides over his capture at Dera'a, and whose sexual advances begin the process of degradation that ends

FIGURE 2.37. **The debauched despot.**

Aubrey Beardsley, *Ali Baba*, Cover Art for *Thousand and One Nights* (1897).

FIGURE 2.38. **His highness's fashions.**

Louis Strimpe, *L'Encens, Le Cinname et la Myrrhe: Robves de Soir*. Hand-stenciled illustration in *La Gazette du Bon Ton* (January 1914).

in Lawrence's rape and self-shattering. Summoned to the bey's bedroom, Lawrence finds himself confronted by a "bulky," "breathless," corpulent man who lies on his bed "trembling and sweating" in his nightgown—the stereotype of the effeminized sensualist. However, when Lawrence resists the man's efforts to "paw" his stripped body, the bey reveals his power, forcibly biting Lawrence's neck till he draws blood, kissing him (thus collapsing sadistic and same-sex desire), then working the point of his knife into the flesh between Lawrence's ribs before turning him over to his soldiers to sodomize and torture.[94]

A more recent illustration of Western tendencies to conflate Eastern tyrants, effeminacy, and perversion occurs in the 2007 film *300*, adapted from Frank Miller's graphic novel, which retells the story of the Battle of Thermopylae. On the one hand, the Persian Xerxes is depicted as hypermasculinity personified (he's seven feet tall, made of pure muscle, and, moreover, wins the battle against the Spartans), and yet, on the other, as inextricably feminine (and, by association, homosexual). Visual cues to the latter range from Xerxes's plucked eyebrows and mascaraed eyes to shaved head, pierced nipples, and kinky wardrobe made of chains. The sexual ambivalence connoted by this gay-coded image is counterbalanced, equally ambiguously, by the film's representation of Hellenic masculine heroism. For the cinematography also positions the valiant Spartans as homoeroticized objects of the gaze: examples of overly muscled male pinups clad in well-packed leather thongs. As Sundip Roy puts it, "When the Spartan king clashes with the Persian emperor Xerxes it's meant to be the clash of civilizations. It feels more like a bar brawl between two gay fashion statements—muscle bear without body hair versus effete sissies with lots and lots of piercings."[95] One reason the film can get away with such blatant stereotyping and its hyperbolic depiction of Greek (e.g., Western) values threatened by perverse invaders from Asia Minor is the contemporary political context in which the film was made: the U.S.-led invasion of Iraq amid warnings of an equally looming Iranian "menace," which, as Jasbir Puar has shown, inaugurated a new epoch of queer-inflected Islamophobia.[96] But while the bifurcation the film creates between civilized man and barbarian other draws on connotations of sexual deviance to distinguish these positions, these suggestions—as with other manifestations of this trope—rebound on themselves, implicating the spectator in the Orientalist homoerotics that make Xerxes's outrageous queerness the flipside of Western fantasies of prowess and military might showcased in beefcake glory.

THE EUNUCH OR CASTRATED MALE

The paradoxical combination of power and effeminacy in figures like Beardsley's effete Ali Baba or *300*'s butch-femme Xerxes pervades a related trope: the

eunuch. At once a slave who frequently attained an immense degree of influence in governmental and public life, as often a black African as a Caucasian, the eunuch represented a disturbing anomaly in European conceptions of racialized heterosexual masculinity and increasingly became a lightning rod for an array of anxieties triggered by European constructions of manhood. For Enlightenment- and Romantic-era Europeans in particular, as Ali Behdad has demonstrated, the eunuch emerged as the emblem, par excellence, of generalized sexual perversity; he is the "common tool [to be used] in every possible sort of perversion," one early twentieth-century pseudo-sexologist gushes, as likely to be called forth to service women as to be used as an instrument of pederasty.[97]

Such a gamut of erotic speculation points to the degree to which the eunuch's status as the liminal "twilight man" who ambiguously bridges states of being became the touchstone for a variety of European sexual myths and fictions.[98] The literature reveals an obsessive degree of speculation, mostly contradictory, about degrees of castration (testicles, penis, or both), methods (crushing, cutting, etc.), and effects.[99] Rumors of the eunuch's continued "sexual functioning" *despite* his "lack" only fueled fascination in this figure.[100] If these indignations stem from the unimaginability of the non-phallic man capable of exercising heterosexual desire (or, perhaps even more intimidating, satisfying the harem's odalisques without experiencing normative "phallic" release), a similar destabilization of sexual and gender assumptions attends the eunuch in his most visible role as guardian of the royal master's harem. The sentinel at the entrance forbidding entry to all other men, he is also the only male besides the master privileged to witness what Baudier calls the "lively Images of Love and the Graces" shut away in the oda. Indeed, Baudier's figure of the "Hatred and Terror" projected by the "troope of black and hideous Eunuches" standing guard outside the harem, ready to behead any trespasser, condenses a number of European cultural anxieties about phallic and racialized manhood, rites of heterosexuality, and related fears of castration.[101]

Because of his contradictory position as a male subject, the eunuch is some-times represented in European lore as an emblem of hapless effeminacy and sometimes as a coded symbol of desire. Leon Bakst's costume design for the Black Eunuch in the 1910 Diaghilev production of Rimski-Korsakov's *Schehe-razade* (fig. 2.39) renders the powerful slave a caricature of gender liminality. This eunuch may bear a phallic sword, but it emerges from a vaginally-shaped sleeve, and his cream-colored sash serves as bustier, giving him the sugges-tion of breasts. The overall effect is one of camp rather than awe-inspiring fear. Likewise, various writers use the language of effeminacy to invoke "horror" at what Gautier terms these "sexless monsters." Being cut "clean to the belly," in de Thevenot's phrase, leaves them "dull and spiritless . . . with the yellow shriveled appearance of decrepit old age" even when young; according to Slade, their bodies turn soft, flabby, bloated—macabre perversions of the odalisques they protect.[102]

FIGURES 2.39 AND 240. 'Faces' of the eunuch: from camp to come-hither.

Left: Leon Bakst, *The Black Eunuch*. Costume design for *Scheherazade* (1910). Photo credit Eric Lessing / Art Resource, NY. *Right*: Frank Duvenet, *Guard of the Harem* (1880). Courtesy of Bridgeman Art Resources / the Cincinnati Art Museum.

By means of these associations, the eunuch becomes synonymous with homosexuality. A number of nineteenth-century Orientalist paintings of harem guards (who were always eunuchs) capitalize on this association, depicting their subjects with languorous gazes, open lips, and sometimes inviting bodily postures that suggest, however subliminally, sexual availability (fig. 2.40).[103] Many commentators simply assumed that a gelded youth served as his master's instrument of pederasty, adducing that the lack of a penis (and therefore inability to penetrate a woman) meant that the eunuch must perforce enjoy being penetrated as his sole source of erotic pleasure. These homoerotic associations are visually signaled in Lecomte du Nouÿ's 1876 grand-scale painting *The Guard of the Seraglio: Souvenir of Cairo* (figure 2.41; detail 2.42; see also Plate 5). Here, the supine, invitingly open bodies of the black male eunuchs guarding the entrance to the seraglio mimic the recumbent positions of female odalisques and seem enveloped in a postcoital haze, striking languid poses more commonly assigned to the women of the interior than to the knife-wielding guardians who reside on its threshold. The

FIGURES 241 AND 242. **The eunuch as homoeroticized odalisque**
(detail). (See also Plate 5)

Jean Lecomte du Nouÿ, *La porte du sérail: souvenir du Caire* (1876). Courtesy of the Pierre Bergé
Collection, Paris.

metonymic association of these lolling, half-naked male bodies with the invisible
female ones inside is reinforced by its visual echo of paintings like Delacroix's
Women of Algiers (1830), with its implicit suggestion of the female homoeroticism
pervading the lives of women shut away together. One sexual deviancy (lesbian-
ism) suggests and attaches to the other (eunuchs as fodder for homoerotic use)
in Orientalist fantasies of forbidden Middle Eastern erotic delights and terrors.

THE DANCING BOY

The image itself seems innocuous enough, but the figure depicted in Gerard Jean Baptiste Scotin's drawing (fig. 2.43)—the professional dancing boy or *köçek*[104]—roused some of the fiercest of all reactions among European spectators. As Metin And notes in *A Pictorial History of Turkish Dancing*, dancing boys were an established institution throughout the Middle East and North Africa, performing in taverns and cafes, at court, in wedding processions, and at religious festivals.[105] In 1582, at the fifty-day festival celebrating the circumcision of Sultan Murat III's son, thousands of dancing boys represented the guilds in day-long parades and festivities; two centuries later Fazil Bey dedicated a şehrengiz to forty-three of Istanbul's most famous boy dancers (or *çengi*); 1804 traveler J. L. S. Bartholdy estimated there were 600 registered dancing boys in Istanbul alone.[106] As was the case with coffee boys, male dancers were commonly assumed to be sexually available for pay (indeed, Fazil Bey represents most of the dancers in the *Çenginame* as prostitutes). In addition to his profession's specific association with same-sex practice, the köçek also seemed to provoke a special degree of unease in European spectators because of his unmanly attire and feminine mannerisms. Likewise, the mimicry of heterosexual intercourse that comprised a central role in the köçek's undulating moves evoked outbursts of disgust. "The dance," Vivant Denon wrote in 1803, describing an Egyptian religious festival marking Muhammad's birth, "made hasty strides toward lasciviousness; and this was all the more disgusting, as the performers, all of them of the male sex, presented, in the most indecent way, scenes which love has reserved for the two sexes in the silence and mystery of the night."[107]

And yet, as And also notes, this revulsion was often coupled with Europeans' inability to hide their sheer fascination with these public performers. Tellingly, many observers found themselves attempting to balance their acknowledgment of the art and skills of the dancers with the lewdness of the enacted performance that so offended their moral sensibilities. So Dr. John Covel wrote in a diary passage (c. 1670–1679) excised from the printed edition: "the sight truly always was pleasant, only these beastly actions were horrible"—a paradoxical sentiment echoed in de Thevenot's 1686 acknowledgment of "a thousand feats of agility of the body" that nonetheless are "all most infamous and lascivious."[108] This fascinated disgust and prurient voyeurism creates, in Herbert's *Travels in Persia, 1627–1629*, an almost breathless pileup of clauses that leaves the reader as dizzy as the dancing it describes. Herbert begins by acknowledging that in Persia "dancing is much esteemed" and that "the Ganymedes and Layesians (wanton boys and girls) foot it even to admiration," executing dances whose motions "revive Bacchus . . . their hands, eyes, and bums gesticulating severally and after each other . . . raising the sport commonly to admiration" (the term "Layesian"

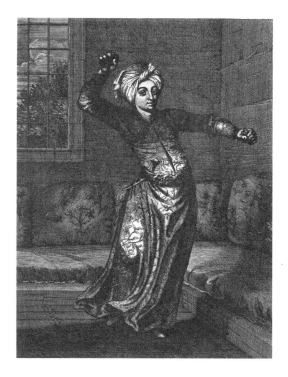

FIGURE 243. **The dancing boy or köçek.**

Tchingui, ou Danseur Turc, engraving by Gérard Jean Baptiste Scotin, in *Recueil de cent estampes représentant différentes nations du Levant, gravees sur les tableaux peints d'apres nature en 1707 & 1708 par l'ordre de M. de Ferriol* (Paris, 1714).

is Herbert's coinage from "Lais," an order of courtesans). "Were this all, 'twere excusable," Herbert continues, and now his syntax becomes as agitated as his dismay, "[but] in a higher degree of perfect baseness, these pederasts affect those painted, antic-rob'd Youths or Catamites . . . [displaying] a vice so detestable, so damnable, so unnatural as forces Hell to show its ugliness before its season."[109]

The turn from qualified admiration to utter condemnation hinges, predictably, on the sodomitical and pederastic desires that these dancing Ganymedes seem to make visible. "The damnable act of buggery," is Dr. Covel's blunt description of the subject evoked by the "lascivious postures" that "a delicate lovely boy" executes with a "lusty handsome man" fifteen years his senior—a "wriggling in the body" and "confounded wanton posture" that Covel correlates with the body politic, protesting that such dancing reflects the vices of "all the effeminate courts . . . of the East." Once again, aspersions of unnatural sexuality, manifested as cultural difference, become a political tool in the ideological

conflicts of East and West. As "horrid" as the sodomitical posturing enacted by these dancing boys, moreover, are the reactions their lasciviousness seems to engender in their appreciative audiences. Covel reports seeing these "beastly" dances "repeated almost every night . . . with great and general applause" at court, once "before the Grand Signor himself." Likewise, de Thevenot's writes that the "abominable Lasciviousness" and "most filthy postures imaginable" he witnesses performed by the Jewish boy dancers of Aleppo transport their watchers to heights of "lust and especially to Sodomy."[110] François Baron de Tott's memoirs recount the tavern brawl that breaks out over an adolescent dancing boy,[111] and Adolphus Slade gives a graphic depiction of the "bedlamite" havoc created at a social function hosted by the local bey when the dancing boys enter, their "lascivious sleepy gestures" stimulating some of the drunken guests to rip off their upper garments and join in the fray. This scandalous behavior reaches orgiastic dimensions as one old grey-beard accosts another *kadi*'s "handsome lad" and causes a general uproar, leading the host to apologize to Slade that such behavior "took place only once in a way" and beg him to refrain from "remark[ing] on what [he] saw." (Slade's extended narrative belies his promise of "discretion.")[112]

Another aspect of the köçek raising storms of psychological disturbance among foreign observers is the presumed violation of gender norms signified by the dress of these so-called Ganymedes. Tellingly, as And notes, it was not true that all male dancers dressed as women or affected female traits; sometimes the suggested "femininity" of the youthful dancer might simply be a matter of longer hair. In cultures where women wore trousers and men flowing robes, some Europeans simply misread sartorial norms, thereby envisioning violations of gender codes that were imaginary or that occurred outside a binaristic understanding of male and female. Two paired seventeenth-century illustrations in an Austrian codex (figs. 2.44 and 2.45) evince the close surface resemblance among male and female performers. Instead of recognizing an androgynous ideal of beauty at work, European travelers tended to see either what seemed an unsettling class of "hermaphrodite[s]" (Klunzinger 1878), "effeminate traits" externalized in a mixture of "partly male and partly female" dress (Lane 1833), or outright transvestism ("wearing the complete dress of a woman, and imitating, with the most disgusting effeminacy, the looks and attitudes of the dancing girls," as Persian ambassador William Ouseley claimed in 1812).[113] At the same time, repeated references to the application of kohl and rouge and curled hair suggests that many male dancers deliberately mimicked feminine traits, distinguishing their appearance from the aesthetics of beauty sported by the typical male beloved, wine server, or coffee boy. The banning of the köçek from public performance in mid-nineteenth-century (never completely enforced, as examples from Loti's fiction and Flaubert's travel journals in chapters 3 and 4 illustrate) indicates the

FIGURES 244 AND 245. **Male dancers (*top*) and female dancers (*bottom*).**

Both illustrations in *Bilder aus dem türkischen Volksleben (Deutsch). Österreich, letztes.* Cod. 8626 V.16.Jh, fols. 117r and 118r. Courtesy of the Österreichische Nationalbibliothek, Austria.

FIGURE 246. **The reality behind the fantasy.**

E. Béchard and H. Délié, *Au Jardin de L'Egbekieh* (Cairo). 2008.R.3. Courtesy of the Ken and Jenny Jacobson Oriental Photography Collection, The Getty Research Institute, Los Angeles.

degree to which Middle Easterners—seeing their heritage negatively reflected back to them in Western writings—began to modify those cultural traditions that seemed to stand in the way of achieving Western modernity, homosexually suspect activities being one of those aspects of a regressive past to be shrugged off. Memories of the simultaneously homosocial and homoerotic tradition of the dancing boy, however, resurface in Reşat Ekrem Koçu's encyclopedia entries on famous köçeks across Turkish history. In contrast to the epicene sensuousness of the boys depicted in these illustrations—attesting perhaps to Koçu's wishful rewriting of the past—photographic evidence appearing in the form of Western tourist postal cards (fig. 2.46) reveals contemporary professional dancers who are

often anything but young, slim, or beautiful.[114] The "threat" of the köçek, like his appeal, resides not only in the performative nature of his craft and its destabilization of gender and sexuality, but also in the subjective eye of the beholder.

In teasing out the homoerotic traces that have shadowed the contacts established between Middle East and Europe over this roughly 400-year period, other historians of sexuality might choose to focus on additional motifs—for instance, the frisson sometimes attaching to representations of cross-racial male pairings, the ribald tradition of shadow puppetry, the ritual of gazing practiced in dervish and Sufi sects, or the repeated trope of the aged and ridiculous lecher who never learns better. The seven tropes on which I have focused, however, best anticipate the content of the case studies that follow, providing a kind of shorthand that allows the reader, in advance, to understand the larger historical dimensions of such tropes, attitudes, and behaviors that, in various avatars and combinations, recur throughout literary manifestations of the homoerotics of Orientalism. What this chapter's overview makes clear is the remarkable resilience and plasticity of these tropes, whose contours overlap historical periods and cultures. On the one hand this resilience is what has led several of them to become Orientalist conventions or clichés. On the other, their very plasticity—their ability to be shaped and reshaped according to context, creator, reader, or onlooker—is what has made them so powerfully attractive to many homosexually inclined European sensibilities that have looked to the Middle East for confirmation of sexual possibilities denied at home. Such plasticity is precisely what creates multiple points of possible attachment to a given trope for varied, not-always-compatible contingents (hence, for some Europeans, the trope of the beautiful boy holds the promise of finding willingly receptive partners, while others look forward to finding youths who will only take an active role to prove their masculinity). This tropic versatility, moreover, is precisely what creates the telling instabilities or deconstructive potential that we have seen at work in all these patterns—be it the fact that the "youthful" boy can range in age from ten to forty and be masculine as well as boyish, that myriad erotic practices beyond age-differentiated sodomy glimmer on the margins of the dominant discourse, that the castrating guardian of the harem is also the castrated eunuch, that the bath attendant may in fact be an old man, that the corpulently fey despot may be the ultimate sadist. Such instabilities allow us to see beyond the generic Orientalist stereotype and to begin to analyze the multiplicities and nuances of meaning that, existing "beside" one another in ever-changing, never-complete patterns, create the levels of complexity that make the homoerotics of Orientalism an intrinsic, necessary component of any analysis of Orientalism itself.

Part Two

GEOGRAPHIES

of

DESIRE

Three

EMPIRE OF "EXCESSE,"
CITY OF DREAMS

HOMOEROTIC IMAGININGS IN ISTANBUL
AND THE OTTOMAN WORLD

Its Situation, by consensus of all Travellers, . . . is the most agreeable and the
most advantageous of the whole Universe. It seems as if the Canal of the Darda-
nelles, and of the Black Sea, were made on purpose to bring [together] the Riches
of the four Quarters of the World.
> Monsieur Joseph Pitton de Tournefort, reaching Constantinople in 1701[1]

To powerful Asia oppos'd, in Europe seated;
Of old the bound to both, and now the head.
Fortune remov'd with the Imperial seat
And with new fortunes this [city] grew far more great.
Not old, a Strumpet whom new lusts defame,
That estimates it no crime not to shame.
> J. C. Scaliger, translated from the Latin by George Sandys, 1615[2]

Neither East nor West but part of both, the city variously called Byz-
antium, Constantinople, Stamboul, and Istanbul has throughout its
rich history always been the site of multiple cultural crossings and
exchanges—whether as second capital of the Roman empire, repository of
Greek culture for a thousand years after the fall of Rome, or modern city of
minarets fashioned after the Ottoman conquest. As travel theory stresses, geo-
graphically demarcated transitional zones provide especially productive sites
for individual and collective projection, in which the typically male traveler,
those masters he serves, and, if he pens his travels, those readers for whom he
writes, may indulge in fantasies of erotic otherness, testing out limits without
wandering too far into the realm of the entirely unknown. Yet such spaces of
cross-cultural mixing and intracultural blurring are equally sites where the

boundaries of self and other are as often confuted as they are confirmed, and where dreams of erotic transgression abut the realities of bruising contact, misunderstanding, and failed connection.

This chapter investigates some of the ways in which the Ottoman Empire and its capital city, Istanbul, have come to function in the West's imagination as one such libidinously charged contact zone (or, as the author of my second epigraph puts it, "[a] strumpet whom new Lusts defame"—those "new Lusts" putatively ones introduced by the conquering Turks). Such projections, of course, cannot be disentangled from the historical reality of the threat Turkey posed to European Christendom as the latter's most potent foe for centuries. For every European visitor filled with awe at the cultural achievements and stupendous wealth of the Osmandi dynasty, many others felt it necessary to distinguish European morals from the "libidinal extravagance[s]" and "Raging Passion of Desire[s]" alleged to run free in this "Licentious Nation."[3] Drawing on a similar image of turbulent overflow, Michel Baudier, an eighteenth-century French traveler, declares the entire Turkish populace—living "far from the light of the true Faith"—carried away by "the excess of all sorts of vice."[4] Great and small, male and female, free and enslaved: none are spared this tendency toward licentious excess. And "excesse," for reasons this chapter explores, becomes a key trope and operative term in the fantasies and fears promulgated in European representations of the land of the Turks and its seat of power, the not-quite-East-but-neither-quite-West city of Istanbul.

Indeed, the mingling of "East" and "West" in Istanbul—a metropolis literally and figuratively positioned at the crossroads of two continents and two historically opposed civilizations—has produced a literature characterized by a particularly explosive mix of craving and carnality. It is also a literature in which the Orientalist quest for the exotic, motivated by the longing to unmask the foreign phantasm of desire in order to partake imaginatively if not actually of its intoxications (typically represented in the trope of the veiled woman), is frequently haunted by equally phantasmatic visions of those "strange love[s]," "infamous propensities," and "lowest debaucheries" by which countless observers allude to the Turkish inclination toward members of the same sex.[5] This proximity of the homoerotic to the heteroerotic in Orientalist fantasies of Istanbul as a site of "erotic crossing" where borders between Occident and Orient, morality and laxity, constraints and excess dangerously blur troubles even the most famous novelistic example of the heterosexual male fantasy of penetrating the female seraglio, Pierre Loti's début novel, *Aziyade* (1876), the analysis of which forms this chapter's centerpiece.

Because *Aziyade*'s textual operations hinge, on the one hand, upon associations of Turkey with erotic excess, and, on the other, upon the evocation of the barriers meant to keep those excesses at bay, this chapter begins by bringing

into dialogue the figural language used by European travelers throughout the early modern period and long eighteenth century to describe the erotic overflow they associated with the Ottoman world and representations *already* well established in Turkish culture celebrating their nation in general and Istanbul in particular as a realm of overflowing bounty. Examining these imagistic patterns contrapuntally culminates in a comparison of two influential pre-1700 texts, one European and one Turkish, whose taxonomic endeavors hinge on discussions of Ottoman sexuality in all its "excesse," including what Baudier termed that most "detestable excesse" of sodomy[6]: Paul Ricaut's widely read, three-volume best seller *Present State of the Ottoman Empire* and Ottoman poet, legalist, and courtier Deli Birader Gazali's pornographic treatise, *The Book that Repels Sorrows and Removes Anxieties*, a send-up of the genre of the erotic instruction manual.

Although Ricaut and Gazali have very different agendas in mind and express themselves in very different genres, their texts overlap in the impulse to categorize libidinal surplus in patterns that anticipate the competing patterns of excess and containment that make Loti's novel so richly ambivalent. In *Aziyade*, winning forbidden female love only serves to unlock the door to more taboo desires. "In those ancient cities of the East, all things are possible" (A 16, V 52), intones the novel's first-person narrator, a British naval officer named "Loti."[7] But as Loti has already mentioned three pages earlier, "all things" in fact include "all the vices of Sodom" (A 13, V 49–50): as in a Freudian slip of the tongue, the nonspecific *things* of page 16 turns out already to been assigned one very specific textual referent—the vice of sodomy. Indeed, the immediate trigger of the narrator's pronouncement, "all things are possible," is Loti's involvement in a scene of homosexual temptation, an erotically charged encounter with a Macedonian Jew that erupts into the text on the very threshold of the narrator's love affair with the married Circassian woman whose name gives the novel its title. The near-simultaneity of the two events is, to say the least, revealing.

The way in which the specter of homoeroticism shadows Loti's grand heterosexual passion—along with the representational strategies that create the novel's collapse of sexual taxonomies—is a running theme in this chapter's attempt to theorize the special and spatial potency that accrues to Ottoman Istanbul as a site of homoerotic crossing in Anglo-European minds. The chapter concludes by showing how the tension between excess and limits framing Loti's representation of the homoerotic is reformulated in two modern Turkish texts: the eleven-volume *İstanbul Ansiklopedisi* (1958–1973), the lifelong, never-completed project of Reşat Ekrem Koçu, and Ferzan Özpetek's 1998 *Hamam: Il bagno turko*, a film that reworks the trope of Istanbul as a site of border-crossing from an explicitly gay point of view. In this cinematic treatment, the homoerotic tenor of the awakening that Istanbul inspires in its married European protagonist is no longer veiled in teasing inference; rather it becomes the primary wellspring of

narrative desire, making the crossing from the known into the liminal space of Istanbul indispensable to its story of erotic and personal discovery.

FIGURES OF OTTOMAN PLENTITUDE, EAST AND WEST

Shimmering magically on the horizon when approached from the Bosporus, its immense diversity overwhelming the onlooker up close: such impressions echo throughout the published descriptions of Constantinople feeding the European desire to learn more of the once-Christian, now-Ottoman world from the sixteenth century onward. Encompassing the geography where the shores of Europe and Asia literally touch and divide, Turkey has long been figured, in both European and Ottoman imaginations, as a threshold between cultures, a site of multidirectional crossings and exchanges. Exemplified by the country's kaleidoscopic mix of cultures—the product of conquest, trade, and location—this overflowing diversity owes much to the policies of the first Ottoman Sultan, Mehmet II, who upon his conquest of the city in 1453 folded its multiple ethnicities, religions, and populations into his nascent empire rather than ostracizing or expunging specific groups. Istanbul's protean diversity, wrote one enchanted British traveler in 1839, "[is] gay, animated, striking, and beautiful, and entirely different from anything I have ever seen in any European city. Franks, Jew, Greeks, Turks, and Armenians, in their various and striking costumes, [are] mingled together in agreeable confusion."[8] This attitude is the culmination of the Ottoman Empire's centuries-long reputation in European eyes as, in the words of M. de Tournefort, the crossroads of the "four Quarters of the World."[9]

Such hyperbole was not simply the product of Orientalizing Western imaginations; equally exuberant descriptions recur throughout Ottoman texts. The image of Istanbul and its empire as a bounty of excess was already being promoted by Ottoman writers, anticipating and helping to shape the metaphors found in the thousands of Western travel narratives that proliferated once the Ottoman Porte and Europe initiated formal trade and diplomatic relations in the mid-sixteenth century. Lâfitî's *Description of Istanbul* (1523–1524) is dedicated to celebrating this most "elect" of worldly paradises as a threshold wedding disparate worlds: "[it is] the meeting place of two seas and two rivers, covered with ornaments and filled with beauties, the most celebrated city from the Orient to the Occident, the bridal ornament uniting the world." Lâfitî proceeds to describe "the varieties, diversities, and multitude of its inhabitants," transforming every intersection in the city into a "gathering place" for

crowds whose "comings and goings are endless" and whose countless numbers spill over into equally "boundless" neighborhoods and streets. In sum, this "city with a thousand attractions" encompasses "all the rarities and the most wonderful curiosities existing on earth."[10] If Lâfitî transforms Istanbul into a microcosm of the nation's unbounded plenty, 100 years later his fellow countryman, the prolific historian Evliya Çelebi, makes such multiplicity-in-diversity the hallmark of the entire empire in his monumental ten-volume *Seyahatname* or "Book of Travels" (c. 1640–1672). Journeying from Egypt to Kurdistan, Evliya catalogues the multiplying attractions—magnificent mosques, labyrinthine bazaars, verdant parks, salubrious climates—of every village, town, and province he visits. And, as noted in chapter 1, he almost always includes ebullient descriptions of the physical beauty of the region's "numerous loveable sweethearts" of both sexes, including the seemingly endless number of "loveable boys . . . who fill one's heart with desire, young men of graceful beauty, modest kindness, and charming loves, with peri-like bodies and faces bright as the moon."[11] This yoking of the empire's diverse plentitude to erotic—and very often homoerotic—abundance crosses over into any number of Ottoman genres, as already seen in Mustafa Âli's lively taxonomy of ethnic and national types of sexually available young men in *Tables of Delicacies* (c. 1600)[12] and the poetic genre of the *şehrengiz*, which praises the male "heart-throbs" of a given city in a series of *ghazals*. What these historical and literary examples make clear is the degree to which excess and eroticism went hand in hand in Ottoman representations of its vibrant culture over a period of several centuries.

For European travelers boundless excess and variety also often figured as a key trope for representing Ottoman difference. But while some like Stephens found "agreeable confusion" in such diversity, others held more ambivalent views of this surfeit, since in their moral and political frameworks unchecked multiplicity spelled a threat to European conceptions of order and self-regulation. The conceit Paul Ricaut employs in his critique of the Turkish tribute-slave system is telling in this regard. The practice of filling the ranks of the Sultan's palace administration and janissary guard with young boys from conquered Christian territories, Ricaut claims, has led to indiscriminate blurring, obliterating the demarcations of descent and legitimacy foundational to what he sees as necessary hierarchical social order. "The continual supply of slaves taken from different Nations," he laments, "fills *Constantinople* with such a strange race, mixture, and medl[e]y of different sorts of blood, that it is hard to find many that can derive a clear line from ingenious Parents."[13]

Underlying Ricaut's worry about the "strange . . . mixture and medl[e]y" that ensues when there are no "clear lines" of differentiation or origin is a more general anxiety, one heightened by Istanbul's historical and geographical positioning as an intermediate zone in which boundaries between self and other blur and

categories of difference cease to demarcate inside and outside: namely, the anxiety that such a blurring of boundaries opens the floodgates to libidinal excesses and forbidden desires that North European morality attempts to keep in check. Writing in 1749 about what he sees as the unchecked libidinal temperaments of Turkish men, Lord Charlemont thus bemoans the fact that "no extent of latitude can satisfy the overheated imagination or set bounds to its wanderings" once set into motion. While he is specifically commenting on Turkish men's access to multiple wives, legal concubines, and female prostitutes, Charlemont's choice of words betrays the worry that the geographical "wanderings" of Europeans who (like himself) have traversed "latitudes" in journeying to the East may cause them to lose track of the proper "bounds" of self-identity, precipitating those figurative "wanderings" of the "overheated imagination" to which he shows himself as susceptible as the supposedly lustful Turk.[14] Not unexpectedly, then, the boundary violations—of self, of national purity, of legitimacy—that these commentators fear as a product of Ottoman excess are repeatedly figured in terms of sexual transgression: licentious overflow, multiplying perversions, unnatural vice. And the most "detestable excesse" (to repeat Baudier's phrase) of the various sexual extravagances or, as Hill puts it, "lascivious luxur[ies]" repeatedly singled out in these travel narratives is that of male sodomy.[15] Indeed, it is the very *proximity* within Ottoman culture of the homoerotic to the heteroerotic that alternately unsettles and fascinates these commentators, a proximity not just phantasmatic but apparent, as chapter 1 has demonstrated, in the very social relations that structured Islamicate male society on multiple levels (administrative, religious, juridical, familial, military, etc.).

TAXONOMIZING DESIRE IN RICAUT AND GAZALI

Before examining how Loti's fascinated but ambivalent projection of such transgressive overflows onto the psychosexual landscape of *Aziyade* introduces a queer undercurrent muddying its heterosexual romance plot, I want to examine the equivalent tensions between morality and multiplicity, limits and excess, order and disorder, that mark the work of two earlier writers, both of whom attempt to make sense of Ottoman "excesse" for their patrons: the seventeenth-century English ambassador's secretary Paul Ricaut and the late-sixteenth-century Ottoman courtier and satirist Deli Birader Gazali, serving in the court of Bayezid II's son. Both diplomats share an explicit interest in Ottoman sexuality and both share an obsession with ordering systems—taxonomies are not solely, as Foucault's distinction between *scientia sexualis* and *ars erotica* would have it, a product of the modern West.

Ricaut's overt aim is to create a taxonomy of Turkish governance to give Christendom's princes a hand over their foe.[16] Methodically setting out to divide and subdivide Ottoman polity into its many constitutive branches, analyzing each part by part, category by category, the secretary begins his three-volume tome by promising to provide "a true Systeme or Model" that will lay bare the principles of Ottoman rule, exposing those pressure points where disorder breaks forth and self-division threatens its seemingly unassailable power. Ironically, however, the very account of these breakdowns begins to disrupt the schematic progression of Ricaut's analysis, for it introduces descriptions of sexual excesses and inversions of "natural" order whose dilatory telling upends the ordering impulse driving the narrative and, at the same time, makes visible the sexual anxieties underlying that impulse. A hint of the narrative disruptions that can ensue when the topic of unnatural sexuality rears its head occurs near the beginning of the first volume, as Ricaut lingers on the "effeminate" (9) reigns of two recent Sultans. One is the mad Ibrahim I, who recently held the throne during a period known as "[the time] when women ruled" because his powerful mother officiated in his stead as Sultana Valide. Ricaut immediately connects this inversion of gender hierarchy to sexual inversion in the case of the current Sultan. For the "effeminate" Mahomet IV, he reveals, is unduly influenced not only by *his* mother but, more egregiously, by his current "handsome young Masayp or Favourite" (9): that is, his male lover. This triple abdication of proper masculinity, natural sexual desire, and monarchal responsibility is in turn linked to the chaos occasioned a few decades before by the battle between Mahomet's mother Turhan Hatice and the Sultana Valide (his grandmother) over control of the throne while Mahomet was in his minority. If the latter woman stands guilty of having usurped male authority by dominating both her son and grandson, Turhan Hatice—who emerges victorious with the backing of the janissaries—is charged with the "unnatural" crime of having put "the whole of the government" in the hands of *her* female lover, "a young audacious woman" who "exercised an unnatural kind of carnality with the said Queen" (10). The systematic analysis of Turkish polity Ricaut has touted as his organizing principle seems forgotten as he lavishes pages of detail on the mayhem and destruction that ensue as the court is torn between the two women's factions (18).

An even more striking example immediately follows in the extended description of the pages of the seraglio, who are being trained to become the Empire's future heads of state and bureaucratic administrators. Systematic evaluation of their education, however, soon falters in the face of Ricaut's revelation of the unruly passions fostered by this pedagogical model. On this occasion, it is the surplus of "libidinous flames" kindled between the pages whose "depraved inclinations" swamp Ricaut's narration: "for want of conversation with [the female sex], they burn in lust one toward another, and the amorous disposition of

youth wanting more natural objects of affection, is transported to a most pas-
sionate admiration of beauty wheresoever it findes it" (31). Indeed, this "amorous
disposition" (33) is so "much talked of by the Turks" (31) that the author feels
obligated to dedicate an additional chapter to the subject. But as he proceeds to
describe how the unchecked lusts of these sequestered youths "boil sometimes
to [such] heat" of jealousy and rivalry that the entire "order" of the seraglio is
thrown into confusion, he reveals that such desire isn't limited to the pages. For
these "libidinous flames" have spread from high-ranking officials who will risk
anything to catch a glimpse of these pages to innumerable Sultans who have
"been slaves to this inordinate passion" (33). Ricaut's multiplying examples of
such "unchecked" homoerotic desire swell the narrative, all but obliterating his
declared aim of providing an unbiased account of the Ottoman state. In face
of slavish "lusts of an unknown and prodigious nature" (54), narrative order
crumbles in face of its own "prodigious" narrative desires.

This tension between overflow and containment, between multiplicity and
boundaries, prefigures the narrative dynamic driving Loti's tale as well as the
metaphors he uses to insinuate the taboo subject of homosexuality into his
novel. In contrast, as the previous chapters have shown, male homoeroticism
was hardly unspeakable, if not always approved, in Ottoman culture. A fascinat-
ing taxonomic counterpart to Ricaut's attempt to contain the combustible excess
of the depraved passions he associates with Turkey's world of permeable borders
exists in *Dāfi'ü'gumūm ve rāfi'ü'humūm* ("The Book That Repels Sorrows and
Removes Anxieties," c. 1491–1511), the pornographic masterpiece of the Ottoman
courtier and poet Gazali. One of the earliest extant examples of Ottoman erotica,
this volume's mixture of prose and poetry spoofs the form and content of the
traditional Middle Eastern manual of sexuality, using moral "instruction" and
mock-censoriousness as pretexts for ribald entertainment and linguistic play.
Its combination of self-reflexive spoofing and mix of generic elements, along
with its formal organization, was recognized in its own time as an innovation,
and its steady recopying over the next three hundred years indicates its popular-
ity.[17] If Ricaut's aim is to create a taxonomy of Turkish governance, Gazali's goal
is to create a taxonomy of desire itself, cataloguing each of its myriad forms.
Detailing with glee infinite sexual acts and types, this send-up of the traditional
Middle Eastern sexual manual *embraces* the excess that Europeans like Ricaut
saw as threatening the boundaries of the normative and permissible. Indeed, the
vice that generates Ricaut's gravest anxieties of narration—sex between males—
becomes the privileged "remover" of "anxiety" announced by Gazali's title.

The introduction creates the fictive pretext for the erotic anecdotes that follow.
In the recent past a group of "pure and loyal" disciples of love—that is to say,
pederasts "addicted to boys with indiscreet asses" and adulterers enamored of
"harlots with long tresses"—has assembled to trade stories of "their true manners

and hidden secrets," news of which has reached the ear of Gazali's patron. His curiosity wakened, the patron asks Gazali to produce a book of similarly "witty conversations" to ward off future sorrows and bring "relief" to lovers—hence the text's title (154–56).[18] The narrating Gazali, identifying himself as the habitué of "reproachable taverns" and a "shameless" lover of "angels with fairy cheeks"— that is, smooth-faced boys—solemnly swears he's undertaken his master's commission "as if it were a religious obligation." This playful irreverence carries over into the opening chapter, which pretends to uphold normative social and religious mandates by offering a mock defense of marriage (it in fact lists all the reasons men should *not* consort with women). This misogynist lampoon sets the stage for the book's centerpiece, an allegorical war between boy lovers (who are paradigms of masculinity) and women lovers (who have been effeminized by consorting with the female sex). Terrified by the threat of being thrashed by the phallic army of boy-lovers advancing on them, the adulterers strike a bargain with the pederasts: to wage a war not of weapons but of words, with each side putting forth its best spokesperson to argue the merits of "cunt" versus "ass." Thus begins a witty, ribald, and altogether obscene dialogue as each camp's representative makes his point in prose and poetry, employing all the clever word plays on sexual acts and anatomy possible. Finally, the pederasts' arguments win the day—after all, mounting *upwards* to "the summit of the ass-mountain" is spiritually more rewarding than *descending* to "the bottom of the pussy pit," so the mock-religious tenor of Gazali's blasphemous allegory goes.

This victory makes for a smooth transition into the next chapter, which creates a detailed taxonomy of modes of homoerotic love and types of boy-lovers, with racy anecdotes and poems illustrating each category. First Gazali illustrates *four* kinds of love—from the unrequited and successful to the loyal and deluded. Next he presents an alternative classification of boy-lovers into *three* types (evincing, *pace* Foucault, identity categories). This he follows with a dissection of the *five* predispositions creating attraction; next, *nine* ways of seducing a youth; and, finally, a list of *eight* favored positions in male coitus. What such numerical cataloguing makes clear is the degree to which these ever-unfolding lists abet the expression and imagining of multiple erotic pleasures. Erotic excess is a desirable quality in Gazali's textual universe, not the fearsome destroyer of boundaries that libidinal overflow represents in imaginations like Ricaut's.

While nearly all sexual desires are acknowledged as having a place in the polymorphous world of Gazali's spoof, the structure of the remaining chapters, like the allegorical war of boy lovers and women lovers, suggests the pride of place given to male homoeroticism. Gazali ends with a tongue-in-cheek apologia in which he stresses that the purpose of his composition has never been the pornographic one of "induc[ing] passion"—no, not at all—but rather that of persuading his readers to "eradicate the source of disorder from the path of righteousness"

(273). Here we see a trace of Ricaut's obsessive language of order and disorder, but now with an entirely different because parodic meaning. Begging forgiveness for "this disobedient even rebellious book," Gazali blasphemously asks his readers to remember him in their "prayer[s]" and show "compassion for this [sex] addict"—after which, in the text's final lyric, he mischievously asks that God grant these supplicants the "key to open any door they wish." After all that has preceded, this image of penetrating thresholds can hardly be taken as spiritual. "Disorder" and "disobedience"—the twin evils against which Ricaut's guide for European princes positions its taxonomy of the present state of the Ottoman Empire—emerge as the ultimate removers of anxiety, the source of textual pleasure and sexual relief alike, in Gazali's pornographic romp, not as the fearsome destroyer of boundaries. Loti is heir to both European and Turkish traditions of representing Ottoman erotic excess and homoerotic possibility: directly, in the case of European travel literature with which he was familiar; indirectly, in the case of Ottoman traditions of male-male love as they filtered into his perceptions while stationed in Turkey, perceptions that became the template for *Aziyade*'s queerly self-subverting story of impossible love.

DRIFT, DESIRE, AND DISSOLVING DESIGNS IN LOTI'S *AZIYADE*

Precisely because it is a novel, *Aziyade* does not offer up—as in Ricaut's history or Gazali's manual—explicit taxonomies of desire or its containment. Nonetheless, not unlike these two texts, Loti's representation of Turkey as an empire of sensuous abandon spawns images, metaphors, and motifs of kaleidoscopic excess and protean possibility on the one hand, and countervailing ones of boundaries, barriers, and limits on the other. Both patterns are interlaced with figures of thresholds, crossings, entrances, and exits that mark both this text and its representation of Turkey—as we have seen in both Ottoman and European representations from the Ottoman conquest to Loti's time—as liminal zones where old verities dissolve and reality takes on the contours of dream fulfillment. The lure of erotic plentitude, it's fair to say, is the primary motor driving the narrative of *Aziyade* and underlying the narrator-protagonist Loti's claim that he is moving beyond the pale of conventional morality, transcending all limits, in the name of a protean freedom of being and sensual satisfaction.

But this vaunted transgression of limits is sometimes less an act of aggressive rebellion than a letting go: it is, as Roland Barthes puts it in a provocative reading of the novel, "precisely a *drift*."[19] A subliminal state of drift, however,

is where the fictional Loti wants to be. Abandonment of familiar moorings (including the repressive morality he associates with the West) is his means of attaining what his contacts back in France deride as nonproductive folly and what he celebrates as the intoxicating "fever of the senses" (A 14, V 50). In the process, the existential connotations of drifting—a word that recurs throughout the novel—take on added ideological freight. On the one hand, drifting can abet Orientalism's political ends, allowing one to disavow responsibility in the very act of appropriating otherness for one's own desires. But on the other hand, to the degree that Loti's protagonist increasingly measures European codes of morality from an Ottoman frame of reference, he contributes—however unconsciously—to the task of decolonization that Dipresh Chakrabarty has termed "provincializing Europe."[20] That is, the continental "drift" that results when East and West collide and intermix in the contact zone formed by the Ottoman political state necessarily repositions European values as only one subset within a larger global context. Thus the act of drifting also works to dissolve the boundaries assumed to divide Europe and the Middle East into binaries based on hierarchies of inclusion/exclusion, civilization/savagery, rationality/irrationality, domination/submission, and the like: categories meant to separate and subjugate fail to preserve their taxonomic integrity in the continual crossing and recrossing of borders, limits, and thresholds occasioned by drifting without predetermined aim or purpose.

As Loti lets himself drift in a world of subconscious desires, so too the trajectory of the narration sets itself adrift, its associative movement creating multiple instances of uncanny repetition and the compulsive replaying of obsessions, and in these overlaps the reader glimpses hints that more is being conveyed than meets the eye. For *Aziyade* consists of brief, numbered, intensely lyrical sections whose order seems as dictated by patterns of spontaneous association as by the logic of causality characteristic of formal realism. Scenes are often impressionistically repeated from multiple perspectives in sections as brief as a sentence or a paragraph, offering prismatic glimpses of a world of difference in a format as "devoid of . . . plan" as the fictive preface claims Loti's unmoored life has been (A 5, V 41). Such associative flux is repeated on the level of the sentence, where teasingly nonspecific wording hints at latent sexual meanings that are then dropped, never confirmed, or suddenly reversed. Barthes likens such swerves away from revelation to the rhetorical device of the *anacoluthon*, in which ideas are introduced but never finish and "drift" away. Such stylistic traits are particularly germane to Loti's representation of and maneuvering around his text's palpable but elusive homoerotic drift.[21]

As a figure of speech, "drift" also evokes the queerly psychosexual undercurrents of *Aziyade*. After all, the very act of asking the question "Do you catch my drift?" insinuates that there is a deeper meaning hidden within the innuendo

that suggests but refuses to name its presence. Such teasing obliqueness calls to mind the operative mechanisms of the phenomenon Sedgwick calls the "epistemology of the closet," in which knowingness and deniability work together to create the open secret. Some of the most homoerotically charged moments in *Aziyade* operate according to a similar logic, in which the narration seems to "wink" at those privileged readers who pick up on its innuendo while bypassing the masses who miss the drift of the implied content. Yet while the metaphor of drift and its narrative correlates express one dimension of this novel's psychological and textual concerns, it is equally true that the protagonist's fantasies of unmoored desire eventually necessitate the imposition of boundaries and limits, expurgations and repressions, to keep the love plot from derailing itself altogether. Ironically, the Orientalist fantasy of "liberation" from morals instantiates a material reality—the fact of homoerotic possibility—that calls for the regulation and containment Loti claims he has transcended. For *Aziyade*'s elliptically conveyed *fantasies* of homoerotic desire and fear are inevitably shaped and framed by a historical *reality* that makes conspicuous what the text renders indirect and latent. In this regard, it is telling that the most blatant hallmarks of conventional Orientalism accrue primarily to the plot's heterosexual romance. In contrast, the narrator's repeated brushes with homoeroticism bring the narrative into jarring proximity with a gritty materiality that cannot be so easily reconfigured as abstraction, metaphor, or allegory.

To understand *Aziyade*'s drift is to enter a representational world in which images of excess and transgression, of erasure and barriers, abound. Such qualities, to put it mildly, dominated the psychology of the man who came to be known to his vast readership as Pierre Loti. One measure of these impulses was his fascination with multiple identities and disguises. Born Louis Marie Julien Viaud in 1850, he chose the single name "Loti" for the largely autobiographical hero of his first novel *Aziyade*—and this Loti (an English rather than French naval officer) in turn assumes Albanian and Turkish costume and the foreign identities of "Arif-Effendi" and "Marketo" while living in Stamboul.[22] Although the last entry in the novel informs the reader that this English "Loti" has died fighting for Turkey against the Russians, the name is resurrected in Viaud's next novel, a South Sea romance titled *The Marriage of Loti*, when members of the Tahitian royal court bestow upon the protagonist, an English naval officer named Henry Grant, the affectionate pet name "Loti." By the publication of his third novel, *Story of a Spahi*, Viaud has assumed the full nom de plume "Pierre Loti," which remains his authorial signature and public identity the rest of his life.

FIGURES 3.1 AND 3.2. **Comfort in costuming.**

Left: Loti dressed as Ramses II (Rochefort, reference H 9). *Right*: Loti in costume in the Turkish Chamber of his mansion at Rochefort (Rochefort, reference H 12). Both photographs courtesy of the Collection Maison de Pierre Loti, © Ville de Rochefort.

Along with noms de plume, Loti was equally enamored of donning costumes and guises, the more flagrantly exotic or foreign the better, and, narcissist that he was, Loti was fond of memorializing his love of masquerade in photographic portraits (figs. 3.1 and 3.2). Whether appearing at a Parisian fancy-dress ball as Ramses II, posing for photographs in Albanian gear as he lounged in the Turkish chamber he created in his house at Roquefort, or donning sundry Eastern outfits while traveling throughout North Africa and the Middle East, Loti reveled in the theatrical possibilities of posing as the other. Such overt role-playing was not just restricted to foreign costume-dress; it was also symptomatic of Loti's profoundly felt psychological compulsion to perform any number of roles as a public celebrity and a writer who, in his novels, essays, letters, and journals, assumed often contradictory enunciatory stances. "Evasions," his biographer writes, "were the leitmotif of his life."[23] Sometimes Loti takes on the role of the defiant, self-destructive Byronic hero in his fiction and correspondence, at other times he assumes the languid pose of the world-weary decadent. Often he is the

Nietzschean hedonist proclaiming his freedom to live outside the law. Occasionally he becomes the nostalgic Victorian wallowing in reveries of a bygone past. Just as easily he transforms himself into the existential modernist who confronts the meaningless void. But foremost Loti reveled in the pose of the Artist whose genius exempted him from everyday conventions, and whose "eccentricities" were excused in advance by a celebrity-hungry audience. Performing this role to the hilt, Loti spent a lifetime flaunting his difference in the public eye and getting away with it—living out, in effect, the open secret, in which states of simultaneous knowing and not-knowing applied equally to performer and his public. In Loti's case, flamboyant behavior that would otherwise have been judged socially unacceptable became, even to his detractors, manifestations of a larger-than-life artistic temperament that made for delicious gossip: showing up at a dinner party with a hunky sailor in tow; joining hands at his own wedding with his latest male protégé (another handsome sailor) "to show publicly the especial feeling I have for him"; using rouge, dyeing his hair, and wearing corsets in the attempt to maintain the illusion of youth.[24]

This performative aspect of Loti's identity moves in several directions relevant to the homoerotic resonances of *Aziyade*. If on the one hand flaunting his difference in public was a way of hiding in full view, on the other his assumption of multiple personae functioned as a defensive barrier—or so he liked to believe—behind which he could keep parts of himself hidden from public scrutiny.[25] "Of that dark stain which exists in my life . . . they have no suspicion," he writes in his journal in 1882, using language as melodramatically self-indicting ("look at me!") as it is enigmatic. In a linked passage, marked with a heavy X, he writes of "that somber thing [*la chose sombre*] that I believed to have been well-hidden from everyone," only to admit his failure to keep that unidentified "thing" under wraps: "I suppose . . . they have put their finger on it."[26] Such teasingly elliptical references strongly suggest that Loti's unacknowledged attraction to men is the "stain" he is trying to hide. However, the ambiguity of Loti's word choices—including the nonspecific "things," "they," and "it"—makes it impossible to say with any certainty that homosexuality, or aspersions thereof, is the missing referent. Similarly suggestive but elliptical phrasing—hinting at meanings that are then retrospectively denied or shrouded in ambiguity—becomes one of the most palpable textual markers of the drift of homoerotic desire inundating the textual world of *Aziyade*.

Such doubleness is intrinsically linked to the author Loti's fascination with the Middle East as a transformative space where—so the fantasy goes—one might become another person, liberate a more authentic self freed of Western repression. Leslie Blanch reports that from childhood Loti was possessed with a desire for *ailleurs,* an "elsewhere" that he associated with the non-Western worlds of North Africa and the Middle East. From brawnily bronzed sailors to mascaraed Moorish women, Loti imbues his romance with the Orient with a polymorphous eroticism that teems with taboo possibilities, the appeal of which

he simultaneously represents as "troubling" and intoxicatingly "delicious."[27] On one level Loti's mix of eros and the exotic is quintessentially Orientalist, as was his experience as a naval officer, where sexual affairs with native women in Tahiti, Senegal, and Istanbul became the grist for his first three novels. But Loti's temperament is made more complex by his particular psychology. For his desire is less to appropriate the other than it is to lose himself *in* otherness, to become someone *other than* himself, other than a representative of "Western civilization" for whom life, as his alter ego in *Aziyade* puts it, is "mapped out, ordered, regulated" (A 167, V 206). Yet the antiestablishment resonances of this desire to escape the known, to veer off the "map" of "regulated" order, are muddied by inner compulsions originating in early childhood and rooted in gender anxieties. A sickly and frail second child, coddled by an overly protective mother, referred to as "Zenzinette" by his beloved older brother, the young Viaud underwent an experience of feminization in a largely all-female household. Abetting his psychological sense of inferiority and unmanliness was Loti's sense of physical unattractiveness: he never grew taller than 5'4", his complexion was swarthy, and he spoke in a "thin treble."[28] Many of the events of Loti's adult life—from his decision to join the navy to his daredevil exploits, from his boasts of innumerable sexual conquests to the hypervirile male companions with whom he surrounded himself—are clearly attempts to compensate for these perceived weaknesses. Such compensatory efforts, however, fostered a strain of indulgent narcissism in Loti in which an excess of self-worship barely veiled feelings of lack. Thus, despising his slight physique, Loti joined a gymnastic school to transform himself into a specimen of muscularity, and in the mid 1870s pushed this desire for bodily perfection to the extreme by becoming a circus acrobat. Willing a desired physical self into being wasn't enough; Loti immortalized his bodily transformation in a series of nude photographs (fig. 3.3). Preening with vanity, the nude Loti who looks out of these photographs becomes the eroticized object of his own desire. "I contemplate the body that I have fashioned for myself," Loti writes as he dons his circus tights, breathlessly adding, "My trunks are tight enough to split . . . Bathing suits of black velvet, so brief I tremble."[29]

The anxieties of masculinity feeding Loti's fantasies of becoming someone other than himself—and the narcissistic projections to which these anxieties led—are integrally tied to his conflicted sexual desires. Very talented at drawing, Loti often made sketches during his travels that reveal a sensual as well as aesthetic appreciation of the male torso. The inclusion of his own image in fig. 3.4, costumed as Harlequin, makes it particularly suggestive of Loti's relation to the closet: he is at once the misfit in this group of handsome and occasionally shirtless men and the only one in their midst participating in a masquerade. At the same time, his figure occupies the very center of the page: he has made himself the indispensable core around which this excess of hypermasculinity

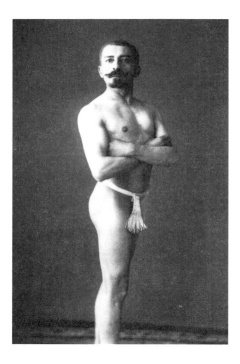

FIGURE 3.3.

Narcissistic self-worship.

Loti nude (Rochefort, reference I 05).
Courtesy of the Collection Maison de
Pierre Loti, © Ville de Rochefort.

organizes itself.[30] Other clues to Loti's sexuality, equally ambiguous and reveal-
ing, crop up throughout his life and career. As his authorial renown grew—and
as his flamboyant public self-displays increased—so too did the gossip his
behavior inspired; the performance of artistic sensibility and eccentricity may
have averted outright name-calling or public condemnation, but it did little to
halt the whisperings that followed his sometimes excessive displays of sexual
nonconformity and decadence.[31] The fact that Loti destroyed many of his journal
entries and papers before he died and that his son continued the process after
his death only adds to the speculations that hover around the question of the
author's homosexuality: in a pattern that repeats itself throughout *Aziyade*,
excessive expression is followed by containment or erasure. But for all that
remains shrouded about Loti's sexuality, the very act of covering, then making
a spectacle of the fact that there is little to see, begins to suggest the homoerotic
subtexts and narrative strategies that infuse *Aziyade* with its uncanny sensation
of unlimited erotic bounty and libidinal drift.

Loti's obsession both with boundaries and with transgressing them marks
the novel from its beginning, which commences with three closely grouped

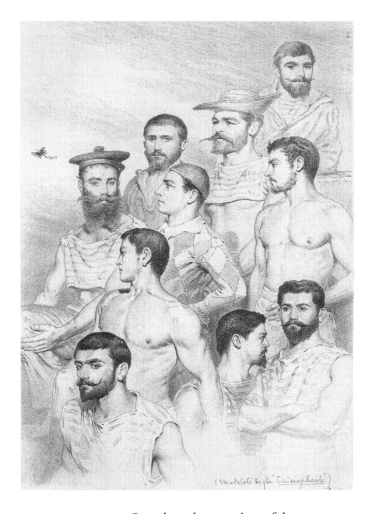

FIGURE 34. **Bare-chested companions of the sea.**

Pierre Loti, *Matelots de la Triomphante* (1885). Courtesy of Alain Quella-Villéger and Patrice Rötig.

scenes in which the repetition of acts of looking and being-looked-upon set the stage—psychologically, narratively, experientially—for the protagonist's movement into an Ottoman world of difference and desire. In the first of these vignettes, written (like the rest of the novel) as a first-person journal entry, the English warship on which Loti serves crosses into Turkish waters at Salonica, where the arriving crew is immediately privy to a gruesome spectacle of a public hanging on shore: "The foreign ships drew alongside just as the executioners on the wharf put the finishing touches to their work" (A 7, V 43). With these broad strokes, the narrator sets the highly charged psychodrama about

to unfold against the historical events of 1876 leading Russia and Turkey to go to war over the Balkans, while other European nations attempted to intervene; international politics frame and facilitate Loti's entrance into the dreamworld of Oriental fantasy that answers his psychosexual desires.

Yet even at this narrative threshold, Loti symbolically positions himself on the other side of the boundary dividing West and East. Representing his English ship as the "foreign" intruder in these waters, rather than vice versa, he already figures himself as one of the Turks watching from the shore. A similar destabilization occurs in Loti's representation of the on-shore execution. At first glance, this spectacle seems designed to confirm European stereotypes of the Sultan's absolute power. Likewise, Loti's voyeuristic detailing of the writhing bodies of the hanged men appears to epitomize the Orientalist trope of Ottoman culture as innately violent. Yet, in a reversal of expectations, the next page informs the reader that these executions have been "demanded" by the French and German governments as a reprisal for a recent massacre of consuls. This spectacle turns out less to be staged for bloodthirsty Turks than for the international gaze of the "grim ironclads" of the "European Powers" (A 8, V 44) that have dispatched their forces to these waters, including the gunboat on which Loti arrives. Not all is as it first looks, in this politically charged tableau of the meeting-ground of East and West: truisms reverse themselves, reprisals demand reappraisals.

These reversals of power and returned gazes continue in the closely grouped narrative vignettes that follow, but they now unfold within the private realms of gender and sexuality. Three days after the execution, Loti finds himself strolling in the "old Musselman quarter" of the city (A 8, V 44) when he senses that he is the object of another's look. "I had supposed myself so utterly alone," he writes, "that I was strangely moved on noticing closer to me . . . behind thick bars of iron, a pair of great green eyes fixed on my own" (A 8–9, V 45). Those eyes belong to the married Aziyade, who is peering out the grilled window of her *haremlik,* and her stare fixes Loti in the feminized position of object—the position in which the narrative has placed the executed victims—on the other side of a literal divide penetrated by her gaze. "[She] gazed at me fixedly," Loti repeats in the immediately following section, fantasizing that as a foreigner or "giaour [who] *hardly counts as a man*" (emphasis added), Aziyade treats him as "a curiosity to be examined at leisure" (A 9, V 45). Being the passive object, the unmanly curiosity stared upon, intriguingly, ignites Loti's sexual desire, which rapidly evolves—or so he proclaims—into the active, manly longing to remove "every conceivable obstacle" separating him from "this fair creature" (A 9, V 46). Of course the *"barreaux de fer"* separating him from Aziyade, like the white veil hiding all but her piercing green eyes, are traditional Orientalist metaphors for the taboos whose transgression incites this tale's desires.

But before Loti sets upon the "mad adventure" (A 11, V 46) of breaking all moral and cultural interdictions in his quest to seduce Aziyadé, an instance of narrative repetition with a difference occurs that begins to hint at the homo-erotic undercurrents that haunt this heteroerotic romance. Loitering on the wharf because he has missed the last English rowboat returning to his gunner (another drawing of a boundary that places Loti on the side of the Ottomans), Loti finds himself under the scrutiny of a new pair of expressive eyes. This gazer is Samuel, a Jewish Macedonian vagabond who exudes animal-like sensuality as he examines Loti with unfeigned interest: "He stretched himself with the winning airs and graces of a big Angora cat, and yawning displayed two rows of small teeth, brilliant as pearls" (10). First gazed on by Aziyadé, now by catlike Samuel: these complementary instances are linked by a series of verbal echoes too carefully crafted to be coincidental. Loti imagines that Aziyadé looks on him as "an object of curiosity [*un objet de curiosité*] to be examined"; now he writes that Samuel "examine[s]" him "with great curiosity" [*avec beaucoup de curiosité*] (A 10, V 46). Aziyadé's gaze bores *down* onto him from a window located "close to me, at the level of my head"; Samuel gazes *up* at Loti from where he sits "on the ground at my feet." In this rhetorical chiasmus, the unearthly phantom of female sexuality personified by the veiled Aziyadé is balanced by Samuel's earth-bound, tactile sensuality. The physical reality of Samuel's presence, moreover, exists in contrapuntal dialogue with the history of Ottoman Salonica, a port city with a major Jewish population whose harbor was home to numerous male as well as female prostitutes, including, according to contemporary eyewitnesses cited by historian Mark Mazower, "young Jewish men offering 'every kind of encounter we might desire.'"[32]

In another verbal echo Loti reports being "strangely moved" by Aziyadé's gaze [*j'eprouvai une étrange impression*] (A 8; V 45) only to narrate, within pages, witnessing "strange scenes" [*d'étranges choses*] with Samuel (A 25, V 51)—scenes that, as we will see, even more directly bring the homoerotic into visibility. The uncanny parallels linking these two meetings are made explicit as Loti declares, immediately after having met Samuel, "How surprised I should have been, had anyone told me that these two, this man and this woman, whom I met the self-same day, were soon to play a part in my own existence" (A 10, V 47). The resulting configuration is more than a triangle: each relationship duplicates the other in ways that allow us to read them as inverse faces of one "self-same" erotic fantasy.

The succeeding sections are propelled by an associative logic suggestive of the subconscious drift of desire dictating the incidents Loti records. Note, for example, the layering of associations that, again, bridge the hetero- and homo-erotic in a letter that Loti inserts into the text immediately after introducing Aziyadé and Samuel. Addressed to Lt. William Brown, a friend stationed in

London, the epistle describes Loti's wooing of Aziyade in histrionic language. In keeping with the voyeurism of the opening scenes, Loti paints his amorous adventure as pure theatre with Brown as his audience: "Opening scene of the melodrama: A dark old room . . . Behold your friend Loti . . ." (A 12, V 48). But, curiously, instead of focusing his correspondent's gaze on the spectacle of either the Orient or Aziyade, Loti makes *himself* the exoticized object of Brown's mental eye, lovingly detailing the sartorial transformation he undergoes as he crosses the threshold of a house in an out-of-the-way part of town whose door, the letter portentously announces, "closes mysteriously behind him" (A 11, V 48). Within await three aged Jewesses who divest Loti of his English uniform and ritualistically array him in the resplendent Turkish dress of an Albanian youth. If such self-objectification textually feminizes (and Orientalizes) Loti, the act of transforming himself into the potent other of his imagination, ready to transgress social, moral, and national boundaries to achieve his sexual ends, simultaneously enhances his fantasy of phallic prowess as he exits this liminal space "through a back door [*un porte de derrière*]" that opens onto a world bearing no trace of the West symbolically discarded with his uniform—"a whole, grotesque, preposterous city of mosques and Eastern bazaars" (A 12, V 49).

Crossing thresholds, however, opens more *portes de derrière* than one. Even as Loti tells Brown how, night after night, he risks his life to spend "one intoxicating hour" in Aziyade's arms (A 13, V 49), the letter is disrupted by an abrupt reference to the homoerotic. Loti describes pausing on a bridge (another threshold) after an evening tryst with Aziyade, where he experiences the deflation that follows Romantic flights of euphoria. Projecting his glum mood onto the city that stretches before his eyes, he remarks that Salonica now "look[s] its shabbiest." But not merely shabby. For "its minarets" resemble nothing so much as "old, half-burnt candles stuck in a dark and noisome town where all the vices of Sodom blossom [*une ville . . . ou fleurissent les vices de Sodome*]" (A 13, V 49–50). A subliminal chain of associations links these seemingly disparate thoughts: the physical as well as spiritual detumescence he experiences after leaving Aziyade is reflected in the minarets that have not only lost their potency ("half-burnt candles") but that, in this unmanned state, preside over a "noisome" and "shabby" cityscape rank with sodomitical "vices"—hardly the postcoital reveries one would expect this new lover to be entertaining.

This seesawing of emotional registers from elation to dejection—as well as the juxtaposition of heterosexual fantasy and sodomitical naming—continues as the present-time narrative resumes. The letter to Brown has strongly implied that Loti and Aziyade are having sex; now Loti admits that his beloved is "not mine yet," for he hasn't penetrated the "material obstacles [*barriers materiellés*]" separating them and epitomized by "the iron grating at her window" (A 15, V 51). Just as we realize that theirs has thus far been only an ethereal union of

minds, not an embrace of warm limbs, Loti reports that ever-faithful Samuel, of whom he is growingly "fond" (A 14, V 52), greets him every night at the jetty, and—again rewriting the prior suggestion that he spends *every* minute of *each* night outside Aziyade's window—the narrator reveals that he in fact spends *most* of his evenings in this "comely" fellow's company. Moreover, with Samuel as his guide, he confides that he has "witnessed many strange scenes in seamen's taverns." "Ah, yes!" he underlines the point, as if compelled to pique the reader's curiosity, "we saw many strange things [*étranges choses*], my vagabond friend and I, in cellars, where strange orgies [*une prostitution étrange*] were held" (A 15, V 52). From "strange scenes" to "strange" sights to "strange orgies": such overlapping wordings tease the reader to imagine more. In the published novel, the tavern scene ends with the image of "men dead drunk on mastic and raki," leaving the nature of their "strange orgies" unspecified. But an added sentence in the author's journal, which served as the template for the novel, leaves no doubt about the nature of the "orgies" in which the drunken sailor-men engage: "That is how things are in Turkey: women for the rich for their pleasures—for the poor, there are boys [*les pauvres ont les jeunes garçons*]" (J 274). Once again, the specter of homoeroticism makes a visceral, gritty appearance in the midst of a story of budding male-female romance. In addition, Loti's admission that he wears "the dress of a Turkish sailor" during these tavern prowls aligns him, however unconsciously, with the very seamen who frequent these dens of iniquity where "boys" provide sexual outlets.

Likewise, Samuel's familiarity with these establishments not only implicates him in this "strangeness" but prepares for the "strange moment" narrated in the next episode. It is two in the morning, the night is idyllic, Loti and Samuel are lying on the ground waiting for the boat that will return Loti to his ship. Sensing Samuel is in a bad temper, Loti impulsively puts "a friendly grip" on his companion's hand "for the first time." His touch, it seems, crosses a hitherto unspoken barrier, unleashing a flood of emotion in his companion, who returns Loti's grasp "with an unnecessary violence" as in "troubled tones" he asks, "What do you want with me?" What follows is a scene of homoerotic revelation: "Some dark, unspeakable suspicion had flashed through poor Samuel's head. In those ancient countries of the East all things are possible. Then he buried his face in his arms, and lay there still and trembling, aghast at himself." One might expect Loti, in keeping with his heterosexual bravado, to write that some dark suspicion is suddenly flashing through his *own* mind, as Samuel's trembling body betrays the secret of the latter's homoerotic desires. Instead, fascinatingly, Loti projects *onto* Samuel the suspicion that Loti might desire *him*, which leads to the narrator's melodramatic declaration that "*tout est possible*" in the East (A 16, V 52–53). The suggestion that Loti himself may harbor sexual feelings for his male companion, however, is quickly overwritten by the

narrative's representation of Samuel's shame at having so misread his master. The outcome of what Loti calls this "strange moment" is even stranger. Samuel has hitherto been represented as too proud to serve as a go-between between Loti and Aziyade, but from this moment forward the now-utterly-abject servant dedicates himself "body and soul" to do Loti's bidding, "risk[ing] life and liberty" to bring Aziyade to Loti. The result is a classic example of sublimated homosocial triangulation. Unable to "have" Loti, Samuel *becomes* the object of his desire: "He has, as it were, sunk his own personality in mine. Wherever I go, and in whatever disguise, there he is, shadowing me, and ready to defend my life with his" (A 16–17, V 53).

Loti's journal presents an even more detailed, explicit, and erotically charged depiction of this scene. In this unexpurgated telling, Daniel (called Samuel in the novel) actively pursues his desires before lapsing into helpless abjection:

> And then [Daniel] took me in his arms, and pressing me to his breast, he ardently pressed his lips to mine . . . [Loti's ellipses] I'd attained my ends, but at the same time horribly surpassed them; I should have foreseen this outcome. . . . And I disengaged myself from his embrace without anger: 'No,' I told him, 'this isn't what I want from you, my poor Daniel, you are mistaken; in my country this kind of love [*ce genre d'amour*] is disapproved of and forbidden. Don't try again, or I will have to send you away.' Then he buried his face in his arms and lay there, still and trembling (J 274–75).

This account clarifies various points that seem incoherent in the novel's version of the same events. The extremity of Daniel/Samuel's abjection, first of all, has an origin; it springs from Loti's unequivocal rejection of the man's ardent embrace and kiss. Loti, meanwhile, reveals the degree to which he's consciously led his companion on, with the specific "ends" of securing the man's services as go-between. Loti also articulates a much fuller consciousness of the "*genre*" of love Samuel feels. Setting aside for the moment the question of whether Loti protests too much in distancing himself from such desires ("this isn't what I want from you"), the passage makes quite clear that in "horribly surpassing" his goal, Loti has *also* surpassed a sexual boundary that calls for an immediate attempt to reinstate that limit by articulating, and thus drawing a line, between acts "forbidden" [*interdit*] in England and sexual practices implied to be commonplace in Turkey. So, even though the manuscript account and the published novel conclude this incident identically, with Daniel/Samuel sublimating his homoerotic yearnings in service of Loti's heteroerotic romance, the fact that Loti now figures his friend as his shadow self has the effect of also rendering Samuel as Loti's homosexual double.

The novel's scenarios of triangulated desire become even more complicated two sections later. Hitherto Samuel has served as the intermediary conveying his master to the trysting places appointed by Aziyade; now he literally becomes Aziyade's "voice" when she asks him to remain in the skiff that serves as a "floating bed" (A 24, V 60) to act as her interpreter. The climax of this "conversation" between lovers, with Samuel serving as the necessary third, comically threatens to become an example of Romantic *liebestod*. Tearful that Loti will someday abandon her, Aziyade suggests they jump into the sea together so that they may die in each other's embrace. The horrified Samuel averts catastrophe by holding the two back and joking about how ghastly drowned corpses look. What makes this comic-melodramatic scene noteworthy is the uncanny instance of narrative repetition with a difference that immediately follows. In the printed text, the section ends with Aziyade's departure; in the author's journal, the continuing narrative discloses an extraordinary act of intimacy that, again, rewrites our previous assumptions:

> And when we were alone, Daniel seated himself near me in the boat; he pressed himself against my breast and rested his head against mine; thus it was that he reposed *every night* for some minutes, immobile and happy; with tenderness, humility, insinuating charm, and persistence, he had obtained from me this strange recompense [*cet étrange salaire*] for his devotion *without limits* [*sans limites*] (J 278; emphases added).

The boundary or "limit" that Loti sternly imposed between the two men when Samuel previously attempted to embrace him ("Don't try again, or I will have to send you away") turns out to be considerably more elastic than the narrative has led us to believe—Daniel, if not the fictional Samuel, gets to embrace his master every night, his "charm" too "insinuating" for Loti to resist. In the former instance, Samuel's contrite reaction had been to bury his face in his arms, *"immobile et tremblant"*; here, at sea, Daniel rests in Loti's arms, against his breast, *"immobile et heureux"*: in this instance of verbal doubling and substitution, happiness has replaced fear. Before, Loti had declared "I had attained my ends, and horribly surpassed them"; now, in a reversal of agency, his companion is the one who obtains an *"étrangere salaire"* from Loti. The price of Daniel/Samuel's "devotion without limits" is clearly Loti's reformulation of the notion of limits itself, one which allows for an overflow, an excess, of the very embraces formerly forbidden.

And the breaching of this barrier leads to another explicit naming of sodomy. "I've never mistaken the unavowed physical desires of this man," Loti confesses, "the sins of Sodom [*le péché de Sodome*] flower everywhere in this ancient city of the Orient where chance has brought us together. But I don't know how to

repulse those humble souls who love me, when it costs me nothing to spare them this kind of pain, the hardest kind of all" (J 278).[33] The demurral with which Loti brings his meditation to a climax doesn't quite hide three facts: first, that he's known all along about Samuel's physical desires; second, that his displacement of the sins of Sodom onto the Ottoman "Orient" doesn't extricate him from their taint (especially given his desire to turn Turk); and, third, that saying that it "costs [him] nothing" to let his companion snuggle up to him every night is not true—there *is* a price to his disciple's "devotion without limits," namely the "*salaire*" that has forced Loti to reconfigure the limits he has previously placed on their friendship.

If this revelation repeats in a happier vein the servant's prior attempt to embrace his beloved master, the return to present-time narration in the private journal unfolds an even more gripping instance of repetition with a difference. When Loti breaks up their cuddle announcing "Enough," Daniel reacts by *replaying* the melodramatic scene that has just occurred between Loti and his sweetheart. In that instance, Aziyade has proposed that she and Loti commit romantic suicide together. Now, it is Daniel who similarly challenges Loti, asking, "Would you jump into the ocean with me?" And he's dead serious, taking Loti in his arms with a violence and strength that nearly capsizes the boat. If, before, Samuel/ Daniel used gallows humor to defuse the situation, it's now Loti's turn to use wit to deflate the moment, reminding Daniel that he can outswim him. In a comic dénouement, the servant grits his teeth, utters a few obscenities, and rows Loti to his gunboat: the master wins the day after all. But the structural repetitions uniting these two moments underline the parallel positions that Aziyade and Samuel occupy in Loti's psychic life—each has become the erotic double of the other.

Almost immediately, the novel compulsively repeats the same narrative pattern, in which an assignation with Aziyade is followed by a moment of tenderness with Samuel. Even more than the previous sequence, the immaterial quality of Loti's grand passion stands in vivid contrast to the corporeal physicality he shares with Samuel. The first scenario details Loti's various subterfuges to join Aziyade late at night on their floating bower of bliss, where his beloved approaches him "so closely veiled" that she appears "a mere shapeless bundle of white"; even as the two sit in an embrace, she remains "as mute and motionless as a white phantom." In essence, Loti experiences the woman of his dreams as just that: less a sentient being than a phantasm of desire that his imagination has already projected onto the East. Even more telling is the erotic upshot of this scenario, for as Loti "trembles" at her touch, "penetrated" with sexual excitement (note his receptive self-positioning), he lapses into sleep-like "languor" (A 23–24, V 60) rather than rapturous lovemaking.

The mirroring scene unfolds once Loti returns to spend the rest of the night in Samuel's craft, which has been hovering at a discreet distance. In the private

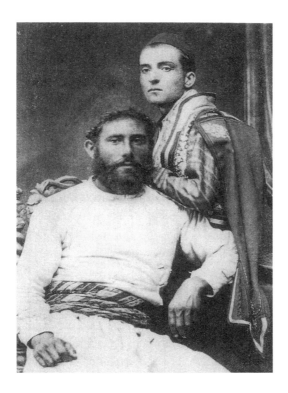

FIGURE 3.5. **Loti as desired youth.**

Photograph of Loti with "Samuel's" original, Daniel, both costumed as Albanians (Rochefort, reference H 4). Courtesy of the Collection Maison de Pierre Loti, © Ville de Rochefort.

journal, Loti's contemplation of his sleeping companion's "antique beauty" leads him to forget the woman of his dreams, as it were, and focus, instead, on the terrifyingly real (and hardly phantomlike) physical attraction he awakens in other men. "The charm that I can exercise over a man plunges me full of troubling thoughts, vague uneasiness, and mysterious horror," he writes. This moment of soul-searching echoes the many evocations in the novel that verge on disclosing the not-quite-specified desires that they seem equally intent to take back. In this case, Loti's homophobic protestation of "horror" at the sexual desire he kindles in men barely covers over the pleasure he derives from being taken as a sexual object, one whose "mask of extreme youth" kindles homoerotic attraction (J 282). Here Loti is scripting an image of himself as a youth desired by men that directly echoes the roles inscribed between male lovers in countless examples of Ottoman love poetry, Sufi devotional literature, and prose redactions (the studio portrait of Loti and Daniel reproduced in fig. 3.5 makes it clear that Loti assumes the role of epicene "youth" in contrast to his more manly companion).

What is most startling about this scene, though, are the details the author *doesn't* elide from the published text. For in the novel Loti relates that he grows mortally cold in his transparently thin shirt (an extraneous detail that draws attention to and objectifies his body). This deathly chill, "penetrating his breast," provides him with an excuse to lift Samuel's covering and "lie down by the side of this friend of fortune's providing." For once Loti becomes the active agent, penetrating Samuel's personal space rather than simply being "penetrated" by sensations. Wrapped under the single covering, both men are simultaneously enveloped "in that overwhelming sleep, *which there is no resisting*" (A 26, V 62; emphasis added). As in the excitation ("trembling") that immediately becomes torpor when he kisses Aziyade earlier, Loti succumbs to instant sleep—sleep that here seems less an avoidance of eroticism than a representation of the conscious mind being subsumed by the id, resulting in a liminal state in which lack of "resistance" facilitates the crossing of boundaries: between consciousness and unconsciousness, between licit and illicit. No wonder that, as expressed in the closing sentence of the paragraph, the boat on which the two sleep curled together "*drift[s]* at random" (A 26, V 62; emphasis added).

There is one further parallel between the two moments, excised from the novel but recorded in the journal. Immediately following this evocation of random drift, Loti writes that Daniel wakes up and, in a line that he then marks out, "received me in his arms in an embrace of unconscious waking," "put his lips on mine," and murmurs "I love you." A perfect example of declaration followed by disavowal, these scratched-out words nonetheless remain legible to the archivist, refusing the authorial attempt to erase the secret just committed to the page. On a structural level, this kiss recalls the earlier one that Daniel has given Loti—with the difference that this instance isn't met with a stern verbal rebuke. In part this is because Loti depicts Daniel's gesture as only half-conscious; his grasp relaxes and he falls back to sleep. But in part Loti doesn't protest because he too has been swept away by the "random drift" of the subconscious that, in obliterating so many limits, has carried him into a foreign terrain of self and desire. And this may be why, in the printed text's conclusion to the night adventure, when day dawns and Loti sneaks back onto his gunboat as furtively as he crawled under Samuel's cloak, he feels "like a thief, only too glad to have escaped notice" (A 26, V282).

If Loti's state of drift has increasingly impeded his ability to draw erotic boundaries, the narrative steps in to do the job of policing desire on his behalf, putting him on alert just when he thinks that he's "escaped notice." For the very next day Loti receives orders to remove to Constantinople, an event severing (so he assumes) his "rash" adventures with both Aziyade and Samuel. The barrier that this impending separation imposes on further intrigue also gives Loti a position from which he can express and excuse his overflow of feelings

for woman and man alike as the product of existential loneliness: *"still letting myself drift*, still letting myself be caught by *every* ardent affection or plausible imitation of it . . . I embrace *anything* that masquerades as love or friendship" (A 28, V 64; emphases added). As is obvious to anyone but the speaker, it's easier to wax poetic about one's drift, as well as to write off one's excessive affections (including the "embrace" of "anything"), when imagining those instances of "love or friendship" are over.

But the Constantinople chapters that follow usher Loti into an even more liminal geography of blurring boundaries, the defensive barriers of the self giving way before the prospect of multiplying thresholds to the exotic and unknown. "Gradually, almost unconsciously, I am becoming Turk," he repeats (A 43, 54; V 80, 91). He plays out this fantasy by moving to Eyoub, a remote quarter of the city where, known as Arif-Effendi, he sets up a residence in which he hopes Aziyade will one day join him in the haremlik joining his bedroom. Intriguingly, this haremlik is architecturally mirrored by a "little room next to mine on the other side" (A 54, V 91)—a room that, as we learn in an unexpected revelation, is *already* occupied by Samuel. For it turns out that Samuel has immediately followed Loti to Istanbul—so much for the boundaries drawn between the two men at the end of part I. The language Samuel uses to explain his reappearance is that of romance narrative—"I have left everything, friends, country, boat, to follow you." Symptomatically, Loti overwrites such avowals with sociological discourse—"I've noticed that such instances of absolute and spontaneous devotion occur far more frequently among the poor . . ." (A 31, V 68)—although one cannot help but recall that "the poor," according to Loti in his journal, are those Turks who resort to boys for sexual pleasure. Loti also attempts to naturalize Samuel's impetuous action by likening him to a naïve child rather than an adult man, a move that helps paper over the reality that he has just invited a *man* whom he *knows* is in love with him to share the bower of bliss he has created for Aziyade.

With the threat of Samuel's presence temporarily desexualized on the level of rhetoric and Aziyade nowhere yet in sight, Loti's bent toward sensual intoxication is projected onto the living excess of the city, into whose "intricate mazes . . . twisting and turning . . . like the windings of a labyrinth" (A 163, V 201) he intrepidly plunges. In the process, glimpses of male-male desire diffuse themselves across the face of the city, sometimes surfacing in the form of vague allusion or teasing connotation, twice occurring as "tourist" spectacles in which Loti partakes. A dramatic example of the latter occurs during Ramadan when Loti and his friend Izeddin Ali end up, at three in the morning, "in an underground den on the outskirts of the city, where young boys of Asiatic race, dressed as *almahs*, performed lascivious dances" (A 45, V 82). The implication that the two have *just somehow* wound up here after traipsing all over Stamboul is belied by

the fact that it takes advance knowledge—on Ali's if not Loti's part—to locate the out-of-the-way venue. What Loti witnesses in this basement den is a performance by the once-fabled *köçek* or dancing boys of Istanbul. Loti's voyeuristic account dovetails with Ottoman cultural politics of the day: by the time he is writing, public performances of the köçek had been banned by Turkish authorities (most immediately, because of the jealous outbreaks among janissaries vying for the attentions of the performers, more generally as part of the overall attempt to modernize the nation by effacing its heritage of male-male love).[34] Nonetheless, the tradition of the dancing boy still continued, albeit more down on its heels than in its heyday, as attested by numerous sources, ranging from travelogues and souvenir postcards contemporary with Loti's text to the lovingly detailed entries on late-nineteenth-century köçek in Koçu's *İstanbul Ansiklopedisi*.[35]

Loti's description of these dancing boys follows a rhetorical pattern that recurs in European accounts, in which the viewer attempts to disguise his curiosity and titillation with declarations of moral repugnance.[36] Thus Loti emphasizes, "To me, it was an orgy [*saturnale*] as sickening as it was novel." One infers that the novelty that so "sickens" Loti is not just the boys' pantomime of sexual coitus, but their violation of gender codes in donning feminine apparel (as Loti's draw-ings and subsequent novels make clear, the author likes his men to be men[37]). Having supplied the reader with a voyeuristic glimpse of this "lasciviousness" in all its gritty exoticism—nothing ethereal about this basement display—the nar-rator strategically moves to distance himself from the spectacle by assuming a man-of-the-world tone that, in spite of itself, simultaneously teases us to imagine more: "I begged to be excused from the end of the entertainment, which must have been worthy of the good times of Sodom. It was dawn when we returned home" (A 45, V 82). Loti draws a line—he doesn't stay for the finale, which his wording explicitly sexualizes with yet another reference to Sodom. But, tellingly, the interval of time between the hour he has entered the den ("about three in the morning") and the time he returns home ("dawn") reveals a certain latitude in drawing that line, since it's obvious that it's taken several hours for the "novelty" of this spectacle to wear off and incite Loti to leave. Not only temporally but spatially, Loti again finds himself occupying an intermediate zone, a liminal space (on the city's outskirts, in an underground den) where the boundaries separating desire and disgust, spectacle and spectator, insider and outsider, excess and regulation, disconcertingly blur, upending Orientalist fantasies of mastery and control.

On a psychological level, such incidents seem to express a surfeit of covert homoerotic desire. On a formal level, they serve as detours in the overt design of the narrative, filling in for the lack of forward momentum in the plot's overt trajectory: reunion with Aziyade. As queer theorists have shown, narrative dila-tion is a frequent strategy in gay writing, deferring the temporal progression

that privileges stories of generation and family; it also creates a state of drift, experienced as suspended animation, that allows the unconscious a space of articulation. Not only does Loti sink into a funk as months pass without Aziyade's arrival; we learn that his depression is also related to the fact that he fears that Samuel, who's been sent to Salonica to seek word of her, may not return. One romantic object again shadows the other within Loti's psyche. Caught in this limbo of doubly frustrated desire, Loti calls upon the local pimp, Old Kairullah, to "bring me women." Ironically, the result is a scene in which Loti's private home is literally invaded by the homoerotic. Explaining that "women are very expensive now," Kairullah advises Loti to consider "less costly diversions." One might think that by now Loti's adventures would have taught him to catch Kairullah's drift, but the old man's "cryptic utterance" doesn't raise an eyebrow until Kairullah returns with "six young Israelite boys in fur-trimmed dresses" who begin to play a "queer kind of music" and dance as Loti, "impassive and motionless as an Egyptian idol," looks on (A 57–58, V 93–94).[38]

As in the prior scene of dancing boys, Loti positions himself as the immobile spectator of a mobile display of perverse desire "worthy of the good times of Sodom." But in this instance of narrative repetition, the remote "underground den" of *jeunes garçons asiatiques* has relocated itself *within* his own hideaway, in the form of *jeunes garçons Israélites*—Samuel may be absent but his sexually suspect trace remains in the ethnicity he shares with these boys. As in the prior scene, fascination temporarily overrides censoriousness as the narrating Loti reveals that, despite the fact that he's now "already grasped the situation," "*curiosity . . . impelled me to probe still further* into this manifestation of human depravity" (emphasis added). This probing he undertakes by telling Kairullah, with deliberate innuendo, that the old man's twelve-year-old son Joseph, "beautiful as an angel," is more appealing than any of these "less costly diversions"—ostensibly to test out just how far the old man will go. Only when Kairullah intimates that that the topic is open to discussion, does Loti—having gone this far—draw back and set a limit, this time literalized in the form of the threshold to his house. "I drove the whole pack out like a herd of mangy cattle," he says, warning Kairullah "never again to show his face inside my doors" (A 57–58, V 93–94).

This scene provides the showy if comic climax of part II. What follows is perhaps the most dramatic example of the novel's repeated strategy of following an eruption of the homoerotic with instant repression, disavowal, or reversal. For the very first words of part III overwrite the prior invasion of Loti's home with the reassuringly normative declaration, "She is here! [*Elle est arrivée!*]" (A 59, V 96). A woman, rather than "mangy" boys for sale, now occupies Loti's "inviolable sanctuary" (A 63, V 101), and the emphatic use of the pronoun "elle" serves to displace the offending effeminacy associated with Kairullah's bestial "herd." But even though Aziyade has arrived in the flesh, the long-deferred romance

that ensues seems curiously immaterial, repeatedly figured as a "fantastic dream" (A 64, V 102) that only exists shut away from the real world, behind the bolted doors of Loti's domicile. At the same time, tellingly, Loti equates the fulfillment of his dream with the ambience and permissiveness of the city he inhabits: "Constantinople is the only place," he declares, "where a man can lead his own life without interference, and assume as many different characters as he pleases—Loti, Arif, and Marketo" (A 62, V 100–1). In some sense, the narrator is right; compared to other regions of the Islamic-Arab world, the possibility of carrying on such a clandestine affair was greater in the more Europeanized state of Turkey, where wives exercised more mobility (the movements of Aziyade and her husband's other three wives between homes in different cities, coupled with the husband's long absences on business, were not untypical) than, say, in parts of the Arabic peninsula. Moreover, as noted in chapter 1, the parallel systems of Ottoman jurisprudence—in which civil law (*kanun*) coexists with religious law (*sharī'a*)—helped to solidify what was already a predisposition to exercise discretion in regard to deviations from the norm—be those extramarital affairs or sex between men—as long as such acts did not unduly disrupt social harmony. In such instances, Turkish jurisprudence encouraged neighborhood *kadi* to look the other way and, in others, to determine penalties on a case-by-case basis. As Loti's very existence in Eyoub demonstrates—where the residents see through but accept his disguise—he benefits from the "live and let live" aspect of Ottoman culture that allowed for multiple, overlapping, conflicting subcultures and worlds to coexist.[39]

Placing Loti's fiction in contrapuntal relation to this legal and cultural context of Ottoman life, then, underlines the degree to which social reality abets not only the romantic fantasy that Loti scripts but the covert desires that his script ushers into being. For if the protagonist's overt fantasy is that of creating a private world of two—living with Aziyade "in some remote corner of the East"—that fantasy reveals a curiously additive quality, as Loti immediately adds, ". . . where my poor Samuel could join us" (A 62, V 100). On the psychodramatic plane, one love-object (female) entails the presence of the other (male) in this charged fantasy of fulfillment. On the plane of action, however, the faithful retainer soon drops out of the narrative—to the point the reader forgets Samuel still lives in the house. This elision wouldn't seem so odd (after all, Loti is now preoccupied with the prized Aziyade) *except* for the fact that references to Samuel are immediately replaced with ones to a male newcomer, Achmet, a young man of "curious charm" and compactly "Herculean strength" (A 65–66, V 104) who now becomes Loti's preferred male companion and, in the snap of a finger, moves into the Eyoub domicile as well. Although the narrative displacement of one handsome man by another suggests Loti has simply refocused his latent desires on a new male object, the triangulation being played out is more complicated.

For structurally Achmet occupies the place of Samuel but with a crucial differ-
ence. First, Achmet becomes Aziyade's "dedicated servant and knight" (A 66,
V 104) with a zeal that mirrors Loti's heterosexual desires (whereas Aziyade for
Samuel is always to some degree an erotic rival). Second, Achmet's devotion to
Loti is represented as a manly comradeship largely devoid of sexual undertones.

Loti spells out this difference as he prepares to return to England at the end of
the novel and attempts to explain to the grief-stricken Samuel why he has prom-
ised to bring Achmet but not Samuel to England in the future: "He . . . could
not understand, poor lad, that there was all the difference in the world between
his own agonizing love [*affection . . . si tourmentée*] for me and . . . Achmet's pure
and brotherly affection [*affection limpide et fraternelle*]." Such a statement, spoken
on the eve of his departure of East for West, repositions its speaker as both Euro-
pean *and* heterosexual, imposing a taxonomy of appropriate ("brotherly") versus
inappropriate ("agonizing") love between men. That this distinction hinges on
drawing a line between the indigenous and the foreign emerges in the botanical
metaphor Loti next uses to distinguish himself from Samuel: "He did not realize
that he was a hothouse plant which could never be transferred to my placid home
in England" (A 143, V 182); this botanical metaphor recalls Loti's prior references
to the "sins of Sodom" as "blossom[ing]" everywhere.[40]

Not only does the narrator impose such stark definitions to separate himself
from the myriad forms of homoeroticism he imagines flowering unchecked in
the "hothouse" of Ottoman sensuality; he begins imposing lines of demarcation
in the very love affair that has inspired him to overleap all limits. From the onset
of Aziyade's arrival, Loti has scripted their romance in anticipation of its end;
proleptic phrases such as "[w]hen I have left Stamboul and bidden her an eternal
farewell . . ." (A 68, V 106) anticipate closure to an event that has barely gotten off
the ground. And as Loti is compelled to script his romance in terms of a finite
ending in order to maintain the illusion that he can contain the East's erotic
overflow, so too he now finds it necessary to create barriers *within* the relation-
ship that will affirm his ability to control his story and shore up his heterosexual
masculinity—an entity that has been put under considerable stress by the excess
of homoerotic signifiers shadowing his immersion into all things Turkish. This
he attempts to achieve by announcing to Aziyade that "another woman is going
to take her place for a day or two" (A 112, V 150). The act is not simply meant to
humiliate Aziyade in order to secure her abjection; Loti is envisioning a narrative
of future division and loss over which he can demonstrate his authorial control
by creating boundaries that leave his ego-defenses impregnable.[41]

The entrance into his private love-nest of Seniha, his newly chosen conquest,
however, spectacularly deconstructs both the Orientalist fantasy of mastering
the "feminine" East and the claim to heterosexual prowess inspiring Loti's deci-
sion to be unfaithful. For when Seniha removes her wrap to reveal the costly

Paris gown she is wearing, Loti finds himself totally turned off; he cannot play Sultan to a woman in European dress. As an "ironic note" enters Seniha's voice, Loti attempts to rewrite his inability to get aroused as an act of manly control. "I mastered myself," he proclaims (literally, "I stiffened myself against myself"), as if he is fighting off temptation rather than experiencing non-arousal. The lady leaves, but not without a final dart as she bursts into "mocking laughter" at his door, causing Loti to flush angrily. Again, he attempts to assert mastery over the importunate turn of events by solacing himself with an evident non-truth: "I controlled myself. . . . I had not put myself out for her in the very least, and the laugh was certainly on my side rather than hers" (A 115, V 153). Tell himself what he may, Loti *has* "put [himself] out" by not putting out at all; his impotence is the clear object of Seniha's laugh. The episode thus takes its place among the other ambiguous scenarios feeding the novel's homoerotic undercurrents.[42]

Nonetheless, to the degree Loti secures Aziyade's acquiescence (she returns home perfectly abject and forgiving), the *fort-da* game that he is playing with her ("go away" / "come back") temporarily succeeds in bolstering his fantasy of mastery. Yet for all Loti's show of authorial control, of deciding the boundaries he will transgress in the name of fulfillment and the limits he will set against desires he finds too engulfing, the story he is scripting exists in contrapuntal dialogue with the outer world of historical events that frame his narrative. This fact even Loti subconsciously registers. For the novel is punctuated with references to the frenzied international diplomacy occurring as Turkey, undergoing transformation into a constitutional Sultanate, prepares to go to war with Russia to defend its national borders. At any moment, the rising patriotism of the Turks might turn against the "European colony" and lead to his expulsion (A 86, V 125). This fear, ironically, mirrors the fantasy of impending rupture upon which Loti's romantic script is predicated—the fantasy that "the time will come when of *our dream of love* nothing will remain" (A 133, V 172; emphasis added). But Loti wants to compose the fantasy on his own terms, which turns out to be the ultimate dream of all.

These contradictions play out in the tale's dénouement. His gunship suddenly ordered to return to England, Loti uses every means at his disposal to prolong his stay. Ultimately he is offered the chance to join the Ottoman army, thereby making good on the fantasy of becoming Arif-Effendi forever. This section ends with Loti's climactic declaration that he has decided to cast his lot with the Turks and remain with Aziyade permanently. Yet, just as the text's undercurrents of homoerotic desire keep unraveling the hero's sternest denials, within hours Loti returns to the office of Pasha who is brokering the deal to declare, in one of the novel's shortest sections, that he's *reversed* his decision. If Loti's equivocations about turning Turk—"yes I will / no I can't"—bear a structural resemblance to the fetishistic operations that govern his relationship to closeted sexuality, this

same structure also marks the closural movement of the novel as it stutters to a close. For once he draws an irrevocable line—between reality and fantasy, West and East, stoic fortitude and luxurious abandon—by reversing his decision to stay, the narrative, paradoxically, does everything it can to keep this ending from occurring.

It is exactly at this moment, knowing that he is leaving, that the protagonist reports his farewell carriage ride with tearful Samuel, declaring that his servant's hothouse love is too exotic for transplantation to English soil. By this point in the narrative most hints of homoeroticism have by and large dropped out of the plot altogether. But the sequence of deferrals and postponements that characterize the narrative as it fights off the closure it has willed into being recapitulates *on the level of structure* rather than on the plane of action or psychodrama the tug between expansion and limits, sexual exploration and boundaries, characterizing the homoerotic pulsations driving the earlier portions of the novel. The sequence of deferred farewells that follows becomes unwittingly farcical in its resistance to the resumption of the linear narrative that has a finite end in sight. On what Loti imagines to be his last night with Aziyade, he marks this moment as *the* end of their tragically thwarted romance, knowing he is "never to return" (A 150, V 189). Ironically, however, his ship's departure is delayed for two days, after which interim, again saying farewell to Aziyade, he bathetically declares, "All was indeed over and beyond recall . . . The Eastern dream is ended" (A 155–56, V 194). Such melodramatic gestures of finality, however, cannot stop the narrative's opposing tendency to remain in a limbo of inaction or drift that, precisely because it is of no consequence, allows otherwise forbidden homoerotic desires to emerge. The push against closure continues when the ship is delayed yet another 24 hours; finally, even on the actual day of departure, there is a temporary delay that grants Loti one final jaunt on shore. Aboard the departing war boat at last, Loti declaims, "Is this the end, my God? . . . the dream is over" (A 168–69, V 207–8). As if a parody of the Freudian diagnosis of the essential components of narrative, *Aziyade* stutters to an end—*fort-da-da-da-da*—a crying gasp that won't be laid to rest until, in yet another reversal, we read that Loti returns to Istanbul several months later, only to find that Aziyade has died and Achmet is missing in battle (poor Samuel goes unmentioned). In despair Loti "turns Turk" once and for all, joining the Ottoman army as Arif-Ussam and meeting his death, so an appended newspaper announcement declares, fighting on the front at Kars: too little, too late.[43]

Such a reluctance to recuperate loss through narrative control is oddly congruent with the psychosexual pull between, on the one hand, the desire to exceed limits and, on the other, the desire to impose boundaries that, as in European and Turkish representations of the Ottoman world, become privileged tropes in fantasies of Istanbul's erotic bounty. In the case of *Aziyade*, this tension between

drift and control, letting go and holding in, suggestion and elision, produces a textual space in which a powerful if subterranean homoerotic undercurrent has been able to enter and shadow the novel's overtly heterosexual trajectory. Writing an end is also to lose sight of this ghostly subtext: another subliminal reason to delay the inevitable. For leaving Aziyade behind is not only a necessary step in Loti's effort to fix his lost love in the form of a finished text that bears her name as its title. More ambivalently, it also means reentering a "mapped out, ordered, regulated" world whose claustrophobic taxonomies have little place for the forbidden thrills of love between men—the "hothouse" exotic passion that, as Loti has previously warned Samuel, "can never be transferred to my placid home in England." But if Loti the protagonist removes himself from the material threat that a history of Ottoman homoeroticism summons forth (first by returning to England; then by marching to his death in battle), Loti the author repossesses those furtive longings in textual form, teasing his readers with glimpses and innuendos of an open secret that dissolves, then reappears, then diffuses yet again into the drift of desire that forms *Aziyade*'s underlying design and makes it a quintessential example of the homoerotics of Orientalism in fictional form.

OF ENCYCLOPEDIAS AND CINEMA: EROTIC TAXONOMIES IN KOÇU, EROTIC THRESHOLDS IN ÖZPETEK

I'd like to close this chapter with two instances in which twentieth-century Turkish figures—one a historian and the other a filmmaker, one a discreet homosexual and the other an openly gay man—make the thematics of Istanbul and homoeroticism the meeting point for East and West. The taxonomizing impulse and figurations of desire that mark the writings of Ricaut and Gazali are mirrored uncannily in the former, Reşat Ekrem Koçu, who enacts a crossing of "East" and "West" in the very format and sheer excess of his encyclopedia. The latter, Ferzan Özpetek, like Loti, dramatizes the drift of desire and the crossing of boundaries that the real and symbolic space of Istanbul facilitates in the film *Hamam*'s story of sexual awakening.

Koçu's lifelong, incomplete project, *İstanbul Ansiklopedisi* (1957–1972), embodies elements of all three writers surveyed in this chapter: the Western imperative to classify and organize that governs Ricaut's survey of Ottoman governance; the reveling in excess that typifies the ever-expanding taxonomy of desire in Gazali's erotic treatise; and the spectral homoeroticism that marks Loti's poetic rendition of foreign crossings in *Aziyade*. As Orhan Pamuk observes in a sensitive reading of Koçu in *Istanbul: Memories and the City*, Koçu, a native of Istanbul trained as

a historian, dedicated his life to documenting the multilayered history of his beloved city, an effort often at odds with the Republic's attempt to downplay its Ottoman past in the name of modernization. But all facets of Istanbul's colorful past were fair game for Koçu, including not only textbook history but every quirky detail that attracted his fancy. Overwhelmed by his growing archives, Koçu decided to systematize his findings in the form of an encyclopedia, thereby ostensibly bringing some kind of order to the sprawling excess of his eclectic collection—which included transcriptions from manuscripts, out-of-print books from defunct libraries, a century's worth of newspaper clippings, vintage photographs, and urban folk legends. This omnivorous collector was obsessed with Western culture, modes of knowledge, and classificatory systems—hence his attraction to the genre of the encyclopedia as an organizing form. But for all of Koçu's enthusiasm for Western taxonomies, his conception of the encyclopedic form was eccentric at the very least, owing as much to the tradition of Middle Eastern wonder books as to the *Encyclopedia Britannica*: alphabetic arrangement was primarily a means of ordering the random subjects, facts, and fictions about Istanbul that, however ephemeral, he found fascinating. Thus the result of his Joycean attempt to "order" the excess of Istanbul (in what he boasted to be "the world's first encyclopedia about a single city") is, as Pamuk notes, more like an eighteenth-century curiosity cabinet, chock full of the collector's subjectively chosen objects, or like the poetic genre of the şehrengiz than it is a demonstration of the rigorously objective classification system associated with the modern encyclopedia as a compendium of organized information, whose entries are sized proportionately to their importance.[44]

The analogy of the şehrengiz is especially relevant to Koçu, a discreetly homosexual man living in a rapidly modernizing culture in the midst of erasing traces of its vibrant subculture of male love. Compiling the encyclopedia became his way of countering this cultural amnesia by memorializing in anecdotal form all sorts of homoerotically tinged events and texts, past and present. These might include citing long passages verbatim from frankly homoerotic literary classics like the *Dellak-name* or *Berber-name* to illustrate otherwise innocuous facts; they might include stories about ruggedly handsome thugs, beautiful youths beloved by older men, and contemporary cross-dressers—or, in one instance, the news flash created by a male stripper who, upon converting to Islam, was approvingly presented at the Belediye Baş mosque by its imam as "a world-famous artist."[45] Yet if the encyclopedia's proliferating volumes served as an archive *preserving* this queer heritage, Koçu's classificatory enterprise simultaneously formed a mode of *closeting*, one in which the "scientific," seemingly disinterested nature of scholarly endeavor protected him from the attacks that a more overt presentation of homoerotic material in the conservative 1950–1960s would have incited. A perfect example is Koçu's method of including information on male hamams.

Documenting this significant aspect of Istanbul's culture is perfectly legitimate but also, as illustrated in chapter 2, allows Koçu to get away with murder. All the more fascinating, then, that this treasure trove of queer history, queer longing, and queer affect passed itself off as respectable reading material for any number of middle-class Turkish families subscribing to its volumes—a feat all the more intriguing given the fact that these volumes especially appealed to the imaginations of adolescent and teenaged boys. Between entries on everything from mosques, museums, and monuments to costumes, customs, and local characters, the young reader was treated to any number of tales about the strange and the marvelous, truly bizarre facts filed under deceptively bland headings, and Horatio Alger–like sketches of poor boys arriving in the city to make their way. The encyclopedia's packaging as family-friendly material was heightened by the inclusion of hundreds of line drawings, whose execution evokes the types of illustrations found in youth-oriented periodicals like *Boys' Life* in the United States during the same time period.[46]

A primary tactic for maintaining an "innocent" façade while incorporating homoerotic content is Koçu's inclusion of dozens of biographical entries—essentially morality tales—recounting the adventures of real-life youths, always beautiful and always penniless, who come to Istanbul to seek their fortune. Some are admonitory in nature, such as in the case of Bulgaroğlu (fig. 3.6), an orphan of Bulgarian origins, who arrives in Istanbul in 1884 and at fourteen becomes a famous dancer in the all-male *meyhanes*. Failing however to respond to the love of his patron, he falls victim to lowlife habits like drinking and gambling, loses his good looks, is caught stealing, and dies in a prison knife fight in his twentieth year.[47] A better fate attends Bilâl Bübül (fig. 3.7), who in 1875 at the age of fifteen escapes forced labor on a Bosporus freighter by diving overboard and, making his way to Galata, gains employment in a coffee shop. His beautiful voice, along with his equally beautiful face and what Koçu calls his "elegant proportions," lead to his being nicknamed the "Nightingale" and painted at the height of his beauty by a German artist. Bilâl never marries, works hard, buys his own coffee shop, and three years before he dies in 1946 at the age of 86 he adopts a fifteen-year-old youth, Ahmed, as future heir of his shop. Just as his employment at fifteen in a café signaled the turn in Bilâl's fortunes, so, in a nice symmetry, he makes the same future available for a reincarnation of his own past.[48]

Often entries read in sequence reveal the associative logic underlying Koçu's homoerotic imagination. An entry on "çiplaks" (figuratively, going barefooted; literally, "naked" or "bare") leads to an entry on Ava Gardner in the movie *The Barefoot Contessa*—neither film nor star have anything to do with Istanbul beyond revealing Koçu's fascination with Hollywood. This camp entry is followed by one on naked male models ("Çiplak Models") in which Koçu reports

FIGURES 3.6 AND 3.7. **Morality tales: stories of uplift.**

Entries on "Bulgaroğlu" and "Bübül (Bilal)," in Koçu, *İstanbul Ansiklopedisi* (6:3112 and 6:3166).

the introduction of nude modeling in art schools, focusing on the careers of two models, circa 1908, the wrestler Sari Hâfiz and kayak rower Sandalci Hristo whose respective images in posing straps accompany the entry (fig. 3.8). Such beefcake shots lead, as if by a process of unconscious affinities, to an entry on "Çiplak Resimlerini Çekdiren Uygunsuzlar" (which roughly translates as "unorthodox nude images"). The subject allows Koçu to elaborate on the rise of commercial male pornography in Istanbul, an industry that specialized in local youths of Greek background. Line drawings taken from two photographic examples of such erotica are reproduced (fig. 3.9). Noting in an aside that the illustrator has added fez and shorts, Koçu assures the reader that both models were fully naked in the original—except, that is, for the Greek flags once attached to the wands in their hands! The youth to the left, Papazzin Dimo, merits his own entry under the letter "D" in the next volume. In another story of youth-gone-bad, Koçu recounts his beauty, entrance into the world of prostitution, status as a "pop star" in the demimonde, and courtship by a gangster before being arrested for murder.

Morality tales such as these abound in the encyclopedia's biographical sketches of young roustabouts and rowdies whose sole claim to fame (and to encyclopedic inclusion) is their misadventures—many come to bad ends, some manage to succeed, but *all* are inevitably handsome and objects of other

FIGURES 3.8 AND 3.9. **Encyclopedic beef-cake and nude models.**

Top: Entry on "Çiplak Model," in Koçu, *İstanbul Ansiklopedisi* (7.3927). *Bottom*: Entry on "Çiplak Resimlerini Çekdiren Ulygunsuzlar" (7.3930).

men's sexual desires. Another favored storyline involves intimate relationships between males—sometimes conveyed in the stories of these street-youths and their admirers or patrons (often the café or meyhane owner who takes them in), sometimes in the narratives of more distinguished historical figures—poets, dervishes, and learned men—smitten with a beautiful youth. And sometimes the evidence that Koçu offers of same-sex love is a mere tantalizing trace, ephemera that he rescues for inclusion even though its subjects are unknowns.

Thus he creates an entry for one "Emir Bey" simply on the basis of a found studio portrait of this man and his boatsman Halil (fig. 3.10). The only information Koçu possesses are the lines written on the photograph's recto, identifying the two men and including two stanzas of verse recited by Halil: "To my master (*bey*), / A handsome man (*levend*), Who grants me esteem and dignity, / Let me take you on a voyage."[49] In face of the overt hierarchy in this relationship of master/servant, these lines reveal a touching reciprocity: just as Emir Bey has granted his servant esteem and dignity, Halil reciprocates with the gift of a lifelong "voyage" of intimacy and this token of their relationship. For Koçu the photograph is the ghostly record of a mode of male relationship that will disappear unless he gives it a place in history; like historians who, in Al-Kassim's words, search for something "like" a recognizable queer affinity in the archives, Koçu attempts to bring the ghost of something like the homoerotic desire he feels into historical consciousness by preserving a record of this photograph in the form of this drawing. Tellingly, the drawing repositions the romantic verse inscribed on the back of the photo as part of the image itself, so that the visual and written texts together can intimate their story.

If these hints of a history of relationships between men form one conduit by which queer resonances enter the encyclopedia, tales of drag-artists and transsexuals form another. We learn of Aliki, who becomes Istanbul's number one stripper in the 1930s, pictured here in costume and with an admirer (fig. 3.11). The sartorial vivacity of the cross-dressed manager of a popular meyhane, Koçu reports, makes "the front pages of the newspapers." The very brazenness of these latter traces of queer lives allows them to "pass" as acceptable reading material—as in Loti's case, there's always room in the public imagination for entertaining, if "perverse," eccentricity. But content that seems perfectly innocuous on the surface is *also* often infused with a subtle homoerotic frisson. The volumes are crammed with entries on the types of young, inevitably male workers that fill Istanbul's streets. There is nothing overtly erotic about the illustrations glossing these professions when viewed individually. But considered as a whole, the sheer *excess* of attractive youths suggests an editorial appreciation that goes beyond the written text (fig. 3.12).

Other illustrations simply become an excuse to picture shirtless or nearly shirtless young men. In the illustration accompanying an entry on the category

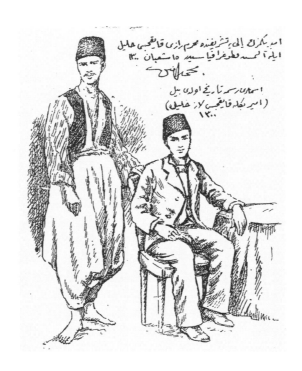

FIGURE 3.10. **Lovers, memorialized.**

Entry on "Emir Bey," in Koçu, *İstanbul Ansiklopedisi* (9.5085).

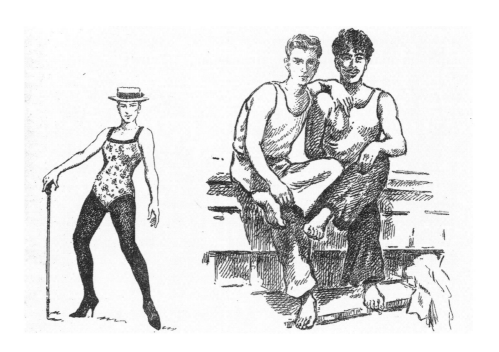

FIGURE 3.11. **Cross-dressing in Istanbul.**

Entry on "Çipicis (Aliki)," in Koçu, *İstanbul Ansiklopedisi* (7.4034).

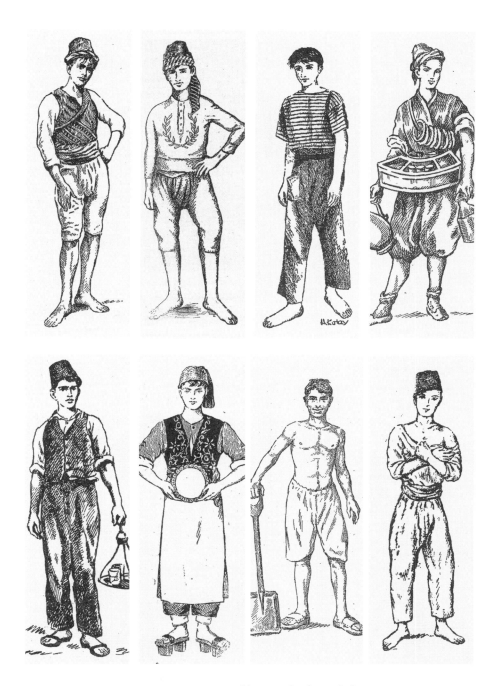

FIGURE 3.12. **Working youth of Istanbul.**

From top left to bottom right: Fisherman (8.4180), fireman (5.2461), second-hand hawker (10.5282), tinkerer (7.3588), tea-boy (7.3940), barber's assistant (5.2521), ditch digger (11.6088), peasant (8.4555). Koçu, *İstanbul Ansiklopedisi.*

"types of men" ("Âdembabatipleri"), the ragged shirt worn by one figure (fig. 3.13), whom the label also identifies as a dancer and bath boy, is torn in a such way to expose both nipples (a representational strategy employed in the North African photographic erotica of Lehnert and Landrock; see chapter 6). An illustration of a legendary Bosporus swimmer and diver (fig. 3.14), first glossed under the entry "The Beautiful Fisherman," reappears several volumes later, in an entry under his actual name, "Mustafa Çakil." The reader now learns that the twenty-four-year-old served as one of the encyclopedia's frequent models—always displaying the greatest "modesty," Koçu adds with a wink. Other glimpses of male flesh make it into these pages on even flimsier pretexts, as in Koçu's entry on the Forrestal, a U.S. plane carrier that docked in the city in 1960 and was briefly open for public tours. Having supplied more details about the boat's dimensions than the occasion merits, Koçu includes a drawing that his American tour guide, Jimmie Castaldo, has made of three fellow sailors—two inevitably shirtless, all three sexy (fig. 3.15). Just as ephemeral is the self-portrait included in the last volume of Hans Fischer, a long-haired hippie who travels to Istanbul when he is sixteen, has a month-long affair with a Turkish businessman "who," Hans is quoted as saying, "loved me very much. . . . [but] wanted to circumcise me," leading the relationship to fizzle (fig. 3.16).

Clearly, the sheer excess of archival lore that vies for inclusion in the encyclopedia is mirrored in the excess of homoerotic signification with which Koçu invests his monumental effort of retrieval and preservation of the history of the actual city, as well as its less tangible history of affective desires and affinities. Koçu's exploitation of the classificatory and taxonomic principles of encyclopedic form makes possible the inclusion, however indirect and coded, of a surfeit of homoerotically charged material; at the same time the ever-expanding, never-ending project captures, in its inevitable incompleteness (after fifteen years and eleven volumes, Koçu had only reached the letter *G*), the uncontainable plenitude, the disordered excess, that Istanbul as a crossroads of multiple cultures has historically represented in European as well as Turkish imaginations.

The meeting of West and East in this city also fosters the emergence of male homoerotic desire in *Hamam* (1997; released as "Steam: The Turkish Bath" in the United States). Written and directed by Ferzan Özpetek, this critically acclaimed film debut unfolds a contemporary story of sexual discovery that benefits from its creator's cross-cultural experiences as a gay man born in Istanbul and raised in Italy. The result is a nuanced work of art that acknowledges the sexual attraction that "foreign" travel and "exotic" difference may incite while avoiding traditional Orientalist stereotypes. On the surface, the

FIGURES 3.13, 3.14, 3.15, AND 3.16. **Baring it all.**

From top left to bottom right: *Âdembabatipleri* (1.211); *The Beautiful Fisherman* (4.2002); Jimmie Castaldo, *Forrestal* (11.5817); Hans Fischer, *Self-Portrait* (11.5768). Koçu, *İstanbul Ansiklopedisi*.

dramatic arc of *Hamam* is similar to that of Loti's *Aziyade*—a heterosexually identified European man travels to Istanbul, crosses a series of literal and figurative thresholds into the unknown, undergoes a liberating expansion of self, discovers a protean realm of eros that includes the homoerotic, dies tragically. But *Hamam* is marked by one significant difference: coming *to* Istanbul, Özpetek's protagonist Francesco comes *out* to himself, learning to embrace the homoerotic impulses that Loti's protagonist so anxiously keeps at bay.

Complementing Loti's vocabulary of limens and limits, Özpetek fills the screen with images of divisions, thresholds, and interiorized spaces that reverberate with latent meaning on both the diegetic level of plot and the plane of visual composition. The film opens with a series of cross-cuts between Istanbul (where Francesco's aunt, Anita, estranged from his mother, Guiliana, has just died) and Rome (where Francesco and his wife Marta live). As the opening shots establish, these two former seats of the Roman Empire are at this point connected only by modes of impersonal technology: embassy faxes, court documents, and letters stamped, sorted, and delivered, by means of which Francesco learns he has inherited his aunt's house in the Fatih district of Istanbul. What he does not yet know is that the property includes an attached, now defunct hamam that years ago his aunt restored and made into an Istanbuli "institution." As Francesco reads in a returned letter that Anita wrote his mother, the hamam is patronized by men from far and wide, grateful for this private "shelter" in which they can discreetly "engage in their caprices." Soon, in a nice deconstruction of Orientalist stereotypes, the trajectory of the film reveals that the most serious divides propelling its drama are not the geo-cultural ones between Europe and Turkey. Rather, they are the divisions that exist, first, between Francesco and his wife Marta; second, within Francesco himself, whose marital unhappiness springs from sexual repression; and, third, between a capitalist-driven modernity (epitomized by the unscrupulous Turkish entrepreneur who wants to level Anita's neighborhood to build a high-rise complex) and reverence for tradition (epitomized by the vanishing world of the hamam).

Traveling to Istanbul with the intention of selling the property as quickly as possible, Francesco undergoes a change of heart as he comes to realize that the legacy his aunt has left him is not only material but spiritual, a gift meant to ameliorate the rupture between deceased sisters. Francesco's transformation begins with his discovery of the packet of "return to sender" letters that Anita has over the decades written to Guiliana to explain why she left Italy for Istanbul. It is symbolically fitting that Francesco is literally drifting between two worlds, seated on a ferry crossing the Bosporus, when he begins reading the letters. Anita's words, conveyed in a voiceover as Francesco makes this crossing, anticipate the rebirth he too is about to undergo. "Istanbul is what I was searching for," Anita writes,

I've only been here a week, and it's taken my breath away, my slumber. How much time I wasted, before reaching here! I have the feeling that it was waiting for me, silent, while I chased after a life as tiring as it was useless. Here things flow more slowly and softly, this light breeze dissolves your worries and vibrates your body. I finally feel that I can start again.

For Anita, Istanbul has provided a space of erotic liberation as well the opportunity to become, as Istanbul's first female proprietor of a male bathhouse, the confidante and equal of the men who enjoy her establishment—men upon whom Anita confesses enjoying spying as they take their private pleasures, reversing the gendered scopic gaze of Orientalist discourse.[50] Like Anita before him, Francesco is about to experience rebirth in a city "wait[ing]" for him to discover his repressed desires in its drift and "flow." And "start[ing] again" is precisely what Francesco does when he opts to stay in Istanbul, taking on the task of restoring and reopening the hamam that Anita has described as a "tribute to the city that has been so generous" to her. "The hamam is a strange place," she writes in another letter, heard as a voiceover as Francesco carries on the restoration, "[where] the steam relaxes *mores*, together with bodies." So, too, Francesco comes to discover: within the warm mist that dissolves outlines and distinctions, bodily senses take precedence, and time and space become more elastic. By assuming his aunt's legacy, Francesco not only gains, like his aunt, a purpose in life but also comes home to the flesh he has denied in himself. Although he may begin his sojourn as an outsider who exoticizes Istanbul's difference, Francesco becomes more than a vacation tourist: like Anita he comes to claim residence in Istanbul because he, too, has been claimed in advance by the mode of being in the world the city offers his soul. Such felt affinity supersedes, Özpetek implies, the Orientalist narrative equating the Middle East with timeless pleasure and self-discovery.

Francesco's geographical and psychosexual crossing from one state of being to another is underlined by lingering shots of doors, passageways, juxtaposed exterior and interior shots, and tracking shots following his movement into increasingly interiorized spaces. A paradigmatic moment occurs early in the film when Francesco, unhappy that his stay has been extended by legal matters, is forced to play tourist. Weaving his way through the bustling street vendors lining the Çiçek Pasaji, he catches sight of an alcove, half-screened by a wall, in which a lone attendant sits by a half-open door. Curious, Francesco steps into the space, whose utter stillness contrasts with the pedestrian flow he has left behind. The next frame focuses on his hands pushing open a second door, at which point Francesco finds himself inside a Christian church whose vast interior—so unexpected and "out of place"—now seems strangely foreign in its

own right. The wordless moment evokes Francesco's wonder at his discovery of simultaneously coexisting worlds, a layering of past and present, East and West. As in *Aziyade*'s overlapping opening scenes, expected divisions and hierarchies do not stay in place in this kaleidoscopic world. This moment is quickly followed by another, when Francesco exits the church and, strolling in Fatih, comes to the aid of an elderly French expatriate who has collapsed in a narrow street and requests that Francesco help him to the nearby Cinili Hamam. The camera assumes Francesco's point of view as he descends the entry steps and passes through the door into the hamam's interior. Inside, in an exchange of reverse shots, Francesco finds himself the object of a bather's intense gaze and looks back—the first indication of male-male attraction in the film—then accepts the older man's invitation to bathe: entering its world of steam, he finds himself transported.

A similarly structured epiphany occurs on Francesco's first entrance into the house he has inherited. His goal is to see the hamam, but its imposing exterior entrance is padlocked, so he is forced to knock on the less obvious, recessed front door of the attached residence. Crossing this shadowy threshold for the first time, he meets the married couple, Osman and Perran, who have resided as its caretakers and as his aunt's beloved companions for decades, along with their attractive university-aged daughter Fussan. "Come, I'll show you," Osman responds, almost ritualistically, to the new owner's request to see the hamam, leading Francesco upstairs to a small, hidden door cut into the wall. "We always used this passage," he says as he steps through the threshold, then takes the padlock off another, inner door that opens onto the upper balcony of the bath. From this vantage point Francesco finds himself looking downwards on the dusty gloom of the bath's atrium, its decayed beauty glimmering in the mote-filled light. Violin music accompanies Francesco as he descends into the lower level, as if impelled by invisible forces to explore its recesses. Silhouetted in a series of door frames, indicative of the thresholds he is crossing, Francesco enters the main bathing chamber, gazing upwards in wonder at the domed ceiling pierced by tiny rays of light, then down at the well-used bathing utensils, remnants of a lost world, as the sounds of stringed Turkish instruments gradually replace the violins. This musical transition contributes to the sensation that Francesco has crossed a psychological threshold, has made an emotional connection to the sensual and interior world the bath signifies.

Francesco's movement into progressively interior spaces continues the same evening when he accepts the family's invitation to dinner. Now it is the daughter Fussan's turn to serve as talismanic guide as she gives him a tour of the house. Moving through shadowy halls and ascending indeterminate flights of dark stairs, she pauses outside the closed door of Anita's bedroom on the top floor. Opening the door, they enter a dimly lit, dreamlike space, filled with objects

of faded beauty once belonging to Francesco's aunt. The significance of the moment is heightened when the camera cuts back to reveal Fussan's handsome brother, Mehmet, nicknamed "Memo," standing in the room and smiling at Francesco. Since there is no establishing shot to signal his entrance, he seems magically to have materialized out of the room's otherworldly aura. That the two future lovers meet in Anita's bedroom is symbolically appropriate; for just as Anita's life in Istanbul provides Francesco with a model for transformation and self-worth, Memo will serve as his threshold to sexual discovery.

This visual language of doors, crossings, interiors, and spaces within spaces—simultaneously mysterious, beckoning, self-revelatory—is used most dramatically at the film's climactic moment of discovery, when Francesco's wife Marta (who has unexpectedly arrived in Istanbul) discovers Francesco and Memo making love in the hamam. Although the viewer has watched the two grow close as they work together to restore the bath, what Marta spies becomes the audience's first visual confirmation that a sexual relationship has begun. Awakening one night to find herself alone (she and Francesco have been sleeping in Anita's room), Marta exits the room; Özpetek positions the camera outside, dramatizing the opening of the door and Marta's entrance into the dark corridor, tracking her movements as she passes through successive doors, then following her gaze as she spies the half-hidden entrance—captured in a close-up of the door latch—that leads to the hamam. More tracking shots follow her movement as she crosses this threshold and moves to the closed door ahead, faintly outlined by the light of the interior it masks—one door is seen through the other, as if framed in an infinite series. Each crossing increases the aura of mystery and impending discovery, compounded as Marta finds herself in the hamam proper. Around the corner and the low entranceway of a recessed bathing cubicle, she glimpses the two men, naked except for their bath towels, resting on the marbled floor in each other's arms in casual intimacy.

Özpetek's visual staging of this revelatory scene is noteworthy. Initially, a point-of-view shot from Marta's perspective reveals a blurred wall in the foreground, with just a hint, through a low aperture on the far right, of Memo. The camera then slowly pans to the right, so that more and more of the inner room (figs. 3.17 and 3.18) fills the space of the screen: the sensation is like that of a curtain being pulled to the side, till the entire focus is a full-screen image of the two men sensually lounging in the steam. A reverse shot set up within the cubicle catches Marta looking in from the outside, her head framed by the threshold, before she slowly pulls back and out of sight; the next shot, located outside the niche, picks up at her action of drawing away. As she stands screen left, absorbing what she has just witnessed, we see through what now appears to be two separate openings into the niche where the two men, still unaware of Marta's presence, can just be glimpsed (fig. 3.19). Marta leans forward for one

FIGURES 3.17 AND 3.18. **Threshold to revelation.**

Images from Özpetek, *Hamam* (1997). Strand Releasing: Turkey/Italy/Spain production.

FIGURE 3.19. **Threshold to self-discovery.**

Image from Özpetek, *Hamam.*

more look; now the men are passionately kissing. Earlier in the evening, when Perran has read the tea leaves in Marta's cup, the older woman says that she sees an inner "anguish" gnawing at Marta that "closes doors." One door, at least, is now open—making visible a truth that, however painful, eventually allows Marta, like Francesco before her and his aunt before him, to embrace Istanbul's world of possibility and remake herself as a better person.

First, of course, Marta is furious at what she deems Francesco's betrayal, despite the fact—as she now reveals—that she has come to Istanbul with divorce papers for Francesco to sign. Initially she accuses him of being a stereotypical sexual tourist, "exploiting the situation" to do what he was afraid to do in Rome. But, gradually, as he explains how "everything has changed since I came here . . . this is the life *I wanted*," she begins to realize the degree to which he actually *has* "changed," has become a happier, more caring person under the influence of the city, of the family that has accepted him as one of its own, and of Memo, who has taught him how to love. As a parting gift, Francesco gives Marta his aunt's letters, which she—in an uncanny instance of narrative repetition—begins to peruse, like Francesco, riding a boat on the Bosporus, floating in an intermediate zone between Europe and Asia. Anita's words to her sister, in which, decades before, she muses about her young nephew's future, not only help Marta begin

to understand her husband; they also speak to her own malaise. "I hope he'll [grow up to] be a free man, a happy man," Anita writes, "because one *can* be happy in this life, Guiliana. *One must.*"

Ironically and tragically, at the very moment that Marta is undergoing this sea change, Francesco is stabbed to death by an assassin hired by the developer whose high-rise project Francesco's refusal to sell has thwarted. Significantly, this murder occurs as he answers the front door of Memo's home, stepping from its dark interior out into the daylight, an act which gives what otherwise might seem an overly melodramatic plot turn a symbolic resonance that is psychodramatically appropriate. It reminds the viewer that Francesco and Memo's passionate blossoming has largely taken place away from the world's eyes and that the sheltered realm of the hamam that has nurtured it is a kind of closet, an intermediate "contact zone" hidden within a violent, often homophobic culture. Until their relationship can leave the shadowy world of steam and "come out" in the external reality that exists outside the hamam, or until society is ready to provide a safe space for them to exist in the light of day, their love remains, Özpetek implies, a truncated and incomplete experience. This message is underlined by the fact that the Turkish Minister for Culture pulled *Hamam* from competition for the country's entry into the best foreign film category for the 1998 Academy Awards, suggesting the social barriers to sexual recognition that still exist and the degree to which gayness troubles the politics of nation and internationality.

With Francesco's demise, Marta becomes the final recipient of the gift of freedom and rebirth first modeled by Anita and then embraced by Francesco, and this unusual twist revises the common trajectory of literary and film plots of gay awakening. This elevation of a female character does not come out of the blue; throughout the script Özpetek sensitively observes the roles that women play in plots of male gay repression and awakening—not just as convenient objects of homosocial triangulation that help disguise homoerotic desires (as in the case of the Loti-Aziyade-Samuel triangle) or as idealized objects of romantic fantasy rather than flesh-and-blood figures (again, Loti's characterization of Aziyade's immateriality provides a relevant comparison). In the film's final frames, we see Marta sitting on the roof of the hamam, holding Anita's elaborate cigarette holder as she pensively but calmly gazes out at Istanbul's domed cityscape: she has *become*, on a symbolic level, Anita. Meanwhile, we hear in a voiceover the text of the generous letter Marta has written Memo—who (like Özpetek) has left Turkey to study film in Europe—and we learn that Marta has chosen to stay in Istanbul to manage the reopened bath, living out Francesco's dream. Like Anita, Marta becomes the letter writer; but, unlike Anita, hers to Memo are not marked "return to sender": a link has been made, cross-cultural understandings occur. "I am here" for you, she writes to her deceased husband's lover, and she

ends her letter speaking of the strange spell (again evoking Anita's words) cast by Istanbul's breezes, caressing her spirit "as if it loves me."

Özpetek's film, then, captures in contemporary terms the histories of crossing and contact that Istanbul has represented in the Western imagination as a liminal space in which sexuality loses its moorings and simply drifts, slipping through the scrim of taxonomies evolved in European culture to distinguish normative and non-normative sexual practices and desires. Yet it is important to recognize that such representations of Europeans experiencing liminality, opening themselves up to new experiences on foreign ground, do not make the zone of contact in which such experiences occur synonymous with freedom or non-differentiation—that dream of sexual utopia is an outsider's fantasy, one exposed by the demonstration of the Turkish disciplinary forces and cultural silences that limit Francesco and Mehmet's expression of love and by the taxonomic and classifying fervor attending erotic experience that Koçu's encyclopedia shares with Gazali's satire, even if such breakdowns and categorizations of knowledge evince less binaristic attitudes toward inclusion, proliferation, and pleasure. What happens when the geographic and symbolic point of contact and crossing between European and Middle East cultures shifts to another geopolitical terrain? The next two chapters take up this question by examining the literary topographies of desire that Egypt—as potent a threshold between "worlds" as Istanbul—represents for Western writers and their Middle Eastern counterparts.

F o u r

EPIC AMBITIONS AND
EPICUREAN APPETITES

I will to Egypt; . . . // I' th' East my pleasure lies.

Antony in Shakespeare's *Antony and Cleopatra*[1]

The sight of writhing naked bodies or sexual acts performed with acrobatic adroitness was hardly new to seasoned viewers of *Rome*, the television series centering on Julius Caesar produced by HBO-BBC from 2005 to 2007. But the drama's quotient of polymorphous perversity went into overdrive with its representation of Egypt's deleterious effects on Marc Antony's manhood in the final two episodes of the series. Four hundred years ago, Shakespeare's *Antony and Cleopatra* also made clear the gender inversions occasioned by Antony's surrender of his properly masculine (and militaristic) Roman identity when he yields to his sexual appetite and the unlimited pleasures embodied in Egypt's legendary queen. "O vile lady! / she has robbed me of my sword" (4.14.22–23), Antony bemoans rather late in the game; and if Cleopatra forms a modern-day Isis (3.6.17), the swordless Antony becomes, like Isis's lover-brother Osiris, a fallen god whose dismembered body is missing its phallus. The seductively but dangerously Oriental lure of voluptuous Egypt, in Shakespeare's account, thus becomes synonymous with the destruction of Occidental masculinity: "manhood . . . ne'er before / Did violate so itself" (3.10.23–24), says Antony's friend Scarus when his commander flees battle at Actium.

 Much has been written about the intersections of sexuality, empire, and gender in Shakespeare's tragedy. I want, instead, to take HBO's depiction of Antony as this chapter's point of departure, for the visual cues in these episodes go beyond the threat of gender reversal to hint at an equal degree of sexual inversion permeating Egypt and bolstering its reputation, in Richard Burton's

hyperbolic phrase, as "that classical region of all abominations."[2] As the preceding chapter demonstrated, Orientalizing European representations of the Ottoman world focus on Istanbul's symbolic position as a threshold linking different civilizations and cultures, an intermediate zone in which an excess of taboo desires simultaneously tempts and threatens the Western observer, whose safety depends on enforcing the boundaries that keep such addictive vices at bay. Similarly, generations of writers since Shakespeare have envisioned Egypt as a realm of unrestrained, voluptuous excess—an excess figured in Cleopatra's "infinite variety" and in Antony's amorous "dotage," which, like the Nile, "o'erflows the measure" (2.2.236; 1.1.1–2). So, too, Egypt is represented as a geographical threshold bridging disparate worlds—not only East and West, but Europe and Africa, Mediterranean and Levant, kingdoms of the Upper and Lower Nile, pagan and monotheistic belief systems, ancient and modern civilizations. Yet there is a salient difference in depictions of Ottoman and Egyptian realms. In Orientalist accounts of Turkish sexuality, the Ottoman world generally retains a sociopolitical and geographical reality that never completely vanishes. European representations of Egypt's bounty, however, tend to vault quickly to a fantastical level, one in which psychosexual projection, erotic spectacle, and monumental excess leave the material referents that have given rise to such imaginings far behind. Sheer monumentality, of course, is the most abiding impression expressed by writers and artists who make Egypt their subject. This emphasis on immensity is understandable, given the sheer size of the ruins visited by travelers and recorded in the superb engravings accompanying the texts produced by Vivant Denon, Edward Lane, and Edward Lane-Poole, the popular canvases painted by Scottish Orientalist David Roberts, and the photographic reproductions of Henri Béchard (figs. 4.1 and 4.2). "Egypt's magnificence, so alien, so remote, and yet still there to be seen," writes Robert Gorham Davis, "has always attracted inventive minds."[3]

What is more curious is the degree to which monumentality also becomes an expression of the novelistic ambitions of a number of Western writers whose bids for literary greatness involve making Egypt the inspiration for writing "The Big One," the Great Novel that will secure the author a place among the "inventive minds" of all time.[4] This chapter focuses on how the novelistic imaginations of Gustave Flaubert, Lawrence Durrell, and Norman Mailer transform Egypt's multilayered history, rooted in the life-giving and death-bestowing rhythms of the Nile, into a polyvalent symbol for the primitive energies of the libido, for the aggressive forces underlying human desire, and for the anarchic free play of the perversions in all their "infinite variety." As Durrell puts it in his *Alexandria Quartet*, Egypt both represents and releases in the Western spectator the "dark tide of eros" that civilization has learned, since its first flourishing on the Nile, to disavow or project elsewhere;[5] Egypt becomes the psychodramatic setting in

FIGURES 4.1 AND 4.2. **Monumental ruins at Karnak.**

Left: David Roberts, *The Great Hall at Karnak* (1838). Inv. TL-18270. Courtesy of the Berger Collection, The Denver Art Museum, Denver, CO. *Right*: Emile Béchard, *Karnak: Allée centrale de la salle hypostile* (1870s). Box T17, R.3.3403. Courtesy of the Ken and Jenny Jacobson Orientalist Photography Collection, The Getty Research Institute, Los Angeles.

which, in Harold Bloom's words, the "monumental sado-anarchism" of modern man's "psychic realities," so deeply repressed as to seem as ageless as the kingdom, plays itself out in extravagant "phantasmagoria[s]" of epic stature.[6]

Saying as much is not to deny the degree of factual documentation and sociological detail that also abound in Europeans' nonfictional and literary accounts of Egypt. The attempts at verisimilitude in travel narratives indeed often mirror the desire for taxonomic comprehensiveness that the preceding chapter examined as a constitutive component of many narratives exploring Turkish culture. Rather, my comments are meant to suggest the sheer *ease* with which writers focusing on Egyptian erotica allow themselves to leap from the empirical to the mythically monumental, transforming Egypt's staggering "sexual provender" (J 4) into a palimpsest of Occidental psychosexual projections, fantasies, moral conundrums, and, in particular, acute exposés of heterosexual Western masculinity in crisis. In inverse proportion to the degrees of masculine (and ultimately authorial) unease that these imagined and real encounters with

Egyptian sexuality engender, the specter of male homoeroticism that this litera-
ture "discovers" in this most ancient of civilizations also becomes "larger than
life," assuming gargantuan proportions that are embodied corporeally as well
as figuratively.

The climactic episodes of the final season of *Rome* provide, in a visual format,
an example of how such projections of hyperbolic and homoerotic perversity play
out in contemporary popular culture. Critics praised the series for its attempt to
recreate the everyday look and feel of life in first-century B.C. Rome. This aura
of historical authenticity, however, gives way to a defamiliarizing dreamscape
when the viewer is transported to Egypt in the second season's ninth episode.
Within minutes, the establishing shots—Alexandria's harbor, thronged streets
where local merchants jostle with Roman centurions, the forecourt of Cleopa-
tra's palace—move into the darkly glimmering interiors of the palace, one room
opening onto another inner sanctum: these confined interiors visually "become"
the whole of Cleopatra's empire as far as the remaining scenes are concerned.
Instead of striking the viewer as mimetic recreations of the past (as is largely
true of the Roman sets), these rooms boast over-the-top designs that look like
stage sets Cecil De Mille might have copied from the tombs lining the Valley of
the Dead, and the effect underlines the artificiality, theatricality, and deadliness
of the psychodrama that unfolds within their walls. This phantasmagoria gets
underway as Lucius Varenius, a centurion in Antony's envoy (and the ethical
center of the series) enters an antechamber where he happens on Posca, the
hitherto stalwartly Roman "Everyman," who has transformed into a decadent
sybarite, eyes mascaraed, earrings dangling, languidly reclining and smoking
opium from a nargil "for my nerves." Posca's startling change foreshadows the
even more shocking transformation that follows as the camera tracks Lucius's
entry into the interior throne room and reveals a disconcertingly Orientalized
Marc Antony in the process of entertaining a titillated Cleopatra and horrified
Roman delegation with a demonstration of how to kill a stag (a role a poor
human is forced to play). If this inhumane "sport" is meant to suggest the degree
to which, in the Barbarian East, Antony himself has become less than civilized,
what jolts the viewer even more than this moral decline is the visual spectacle
of perversity his physical appearance suggests.

Hitherto, Marc Antony has been the icon of macho heterosexuality in the
series, brimming with cocky swagger, hirsute virility, and a way with the
Roman ladies that no other man in the drama has approached. That, however,
was Rome's Antony, not Egypt's co-consort. For when the camera first reveals
Antony "gone native" (as his Roman mistress acidly puts it), his appearance is
a pastiche of contemporary gay visual cues. Egypt has not only gotten under
Antony's skin, infecting him with its barbarian excesses and decadent vices, it

FIGURES 4.3 AND 44. *Rome*'s Marc Antony and Circuit Boy Clones.

Left: James Purefoy as Antony in HBO's *Rome*, season 2. *Right*: Flier for Labor Day party "Glam-Slam" (1994). Author's Collection.

has draped itself over his bronzed epidermis in an array of homoerotic signifiers that no gay viewer—and probably few straight ones—are apt to miss. His kohl-tinted eyes and eyebrows mimic those of Elizabeth Taylor in 1963's *Cleopatra*; the filmy, open robe he wears reveals a Gold's Gym's buffed body, gleamingly depilated; a very twenty-first-century tattoo of an asp curls from his back over his shoulder and seductively encircles his left nipple; an ornate necklace and filmy skirt complete his minimal attire (fig. 4.3). Yet, clad in iconic Egyptian "drag" though he may be, these sartorial signifiers do not, exactly, feminize *this* Antony. Rather, he forms the spitting image of the "circuit boy" clone of the late-1990s who, flying high on ecstasy, might have been found dancing at "Pharaohs: Party with the Gods of the Nile," the Labor Day gay party event promoted in figure 4.4. For the circuit boy, "feminine" accoutrements like jewelry, cosmetics, and exaggerated costuming, combined with "masculine" signifiers like sculpted body and tattooing, paradoxically work both to hyperbolize *and* homoeroticize male virility. So, too, with *Rome*'s Anthony in Egypt, who channels Marlon Brando's Stanley Kowalski gone queer a half-century later.

These homoerotic signifiers do not lessen when Cleopatra plays vamp to this lusciously besotted and bejeweled Antony. No curvaceous Elizabeth Taylor or Claudette Colbert, the series' scrawny actress looks like a teenage boy when, as she and Antony retreat into the recesses of the palace, she shucks her wig to reveal her closely cropped hair. Indeed, in the close-ups of Cleopatra and Antony beginning to make love, the two could easily be taken for two men (one recalls that Shakespeare's queen was played by a boy actor, as the playwright winkingly acknowledges when "she" bemoans a future in which "some squeaky Cleopatra [will] boy my greatness / I' th' posture of a whore" [5.2.220–21]). Continuing this tradition of inversions, *Rome*'s boyish Cleopatra mounts and dominates Antony to his pleasure. Antony's submission to the reign of polymorphously perverse "variety"—and the destruction of his Roman manhood—reaches a climax when, after the debacle at Actium and the lovers' cowardly retreat to Alexandria, he and Cleopatra descend into a world of "numbing debauchery" (so the episode's capsule summary puts it) as they await certain death: Eros effortlessly bleeds into Thanatos in this realm of unbridled libido, this "ancient" seat of all successive civilizations. Six minutes into the final episode of *Rome*, the camera cuts to a shot of the two lovers sitting languidly on twin thrones as they preside over the wreckage of their empire of bliss: a vast orgy of interlaced, naked bodies writhing across on the floor of the throne room (tomblike in its darkness and gloom). The hallucinatory feel of this descent into libidinal anarchy is captured by the wobbling camera, blurred lenses, and fade-across overlays, in which a field of heaving buttocks and entangled limbs makes it hard to determine the genders of any specific coupling but easy to fantasize every possible permutation. Tellingly, the camera pans across a naked man, seen full-frontal, just before yielding to an image of Antony, his legs splayed open and one thrown over the arm of his throne, attired in minuscule skirt and black boots, holding wine goblet aloft like a sexually polymorphous Dionysius. As Antony shortly tells Varenus, "Whores, hermaphrodites . . . this is our only now. It's all we have left."

If *Rome*'s campy hints of queer sexuality unsettle assumptions about one of literature's most famous heterosexual lovers, the conjunction of hypermasculine hero, "unnatural" sexuality, and Levantine setting takes yet another turn in Josephus's account of Antony's proclivities in the *Jewish Antiquities*. Recounting the machinations of the Herod dynasty in Judea, the first-century historian takes Antony's bisexuality as a given. The stepmother of Herod Archelausis, miffed that her "extraordinarily handsome son," the sixteen-year-old Aristobulus, has been overlooked for the high priesthood, sends Cleopatra a missive asking that she intervene with Antony to secure the position for her son. Antony pays no attention to the request until Quintus Dellius attempts to influence Antony

by appealing to the latter's sense of "(sexual) pleasures," informing him how ravishingly beautiful both Aristobulus and his sister Miriamme are. Antony hesitates sending for the girl, Josephus says, because her marriage to Herod might create a diplomatic rift and because he wants "to avoid being denounced by Cleopatra for such an act." Thus he only sends for Aristobulus. The inference is that Cleopatra's jealousies only extend as far as her own sex; Antony's toy-boys are no threat. Ultimately, Josephus continues, Herod finds an excuse not to comply with Antony's command, since he's aware that Antony "was ready to use [Aristobulus] for erotic purposes and was able to indulge in undisguised pleasures because of his power." Note that it isn't the "unhealthy" or degenerate sexual atmosphere of Egypt that awakens Anthony's homoerotic desires in this account; his "undisguised pleasures" are perks of being "more powerful than *any Roman* of his time."[7] And while the desired Aristobulus, as scion of the ruling Jewish family in Judea, is technically an "Oriental," he is equally part of the political machinery of the Roman Empire, not a subaltern whose exotic otherness—according to Orientalist stereotype—awakens latent, perverse desires in Antony. As such, Josephus's history serves as a salutary correction to fantasies in which Egypt's sensual excess is at fault either for effeminizing Antony (as in Shakespeare) or for queering him (as in *Rome*).[8]

The hyperbolic rewriting of history in order to cast Egypt as the "cause" of Antony's descent into debauchery, so spectacularly envisioned in *Rome*, is one example of the tendency of European commentators to make the country's history and customs the springboard for highly personal erotic projections paraded as universal desires. Another instructive example of this process at work occurs in Allen Edwardes and R. E. L. Masters's *The Cradle of Erotica* (1963), in which the authors quote the comments of second-century satirist Lucian as "evidence" of Egyptian men's rampant homosexual proclivities. These suspect sexologists draw the following conclusion from the sexual barbs that Lucian unleashes at Timarchus, the subject of his satire: "To ask facetiously a home-coming traveler whether or not he had experienced an attack of 'sore throat' while in Egypt was the same as asking him whether or not he had become the victim of an Egyptian sexual custom and been orally ravished by a big Egyptian penis."[9] In another volume, *Erotica Judaica* (1967), Edwardes repeats the claim, adding that the saying, "'To suffer a sore throat'" meant "to travel to Egypt, where a stranger was apt to be assaulted in the mouth by the enormous *mentula*."[10] The intimation is threefold: one, ancient Egyptian men were notorious fellators who preyed on foreign males; two, they were extremely well endowed; and three, knowledge of such was so widespread that it led to the joking euphemism in which "to suffer a sore throat" was equivalent to saying one had been orally raped by these Egyptian studs.

Tellingly, none of these claims are made by Lucian in the passage in question. As in all classical invective, Lucian uses the language of sexual putdowns to skewer his subject, achieved in this instance by satirizing Timarchus's penchant for oral sex (a practice generally scoffed at by Romans and Greeks). Thus in Syria Timarchus is nicknamed "Rhodo-daphne" or "Rose-Laurel" (a reference to cunnilingus), and in Egypt, so Lucian's invective continues, "you were called Quinsy" because "you were nearly throttled when you ran afoul of a lusty sailor who closed with you and stopped your mouth" (the herb quinsy was used to treat sore throats).[11] Even though the latter instance of oral sex occurs in Egypt, the purpose is clearly to make fun of Timarchus for oral proclivities that, in fact, involve both men and women, and not to point a finger at Egyptians for their "particularly perverted" sexual customs (in fact, the passage doesn't specify whether the "lusty sailor" in question is Egyptian or not). Most damningly, there is no reference to the penis size of this sailor or other Egyptian men—Edwardes and Masters's comment is sheer authorial fantasy. Finally, nowhere have I found evidence of a colloquialism in which the idea of "suffering a sore throat in Egypt" is shorthand for Egyptian men's penchant to engage in fellatio. Rather, the authors conjure all these salacious elements from a classical reference taken out of context. Why? Because ancient Egypt's "otherness" allows the imaginations of Edwardes and Masters to indulge in a surfeit of homoerotic fantasies thinly disguised as ethnographical "scholarship."

All these examples—*Rome*, Josephus, Lucian—introduce patterns whose repetitions this chapter traces in the homoerotics of Orientalism at work in narrative accounts of Egypt, instances that reach from surmises about the sexual habits of the ancient inhabitants of the Nile to contemporary observations made in travel narratives, and from novelistic recreations to artifacts of popular culture. Throughout this archive one finds a conjunction of several repeating elements: the sheer range of sexual practices attributed to Egyptians throughout history; the imaginative license to which such attributions give rise; the monumental phallicism attributed to Nilotic men; the degree to which Egypt is experienced by foreigners as a spectacle of polymorphous perversity; and, not least, the interrelated anxieties of masculinity, nationality, and narrative authority that beset many European writers confronted with the overflowing homoeroticism they attribute to the landscape they envision. The immediately following sections of this chapter examine, first, the degree to which images of ancient and medieval Egypt have fostered often misplaced fantasies of homoerotic excess—especially in light of the paucity of the historical record—and, second, the degree to which the secondary literature about Egypt has generated a number of recurring homoerotically charged tropes. The last three sections show how this mythic history and these literary tropes are obsessively worked and reworked by three writers—Gustave Flaubert, Lawrence Durrell, and Norman Mailer—invested in

making their visions of Egypt the basis for epic masterpieces as gargantuan as their reputedly epic heterosexual appetites.

HYPERBOLIC HISTORIES OF EGYPTIAN HOMOEROTICISM

Naked Greek Olympians wearing laurels, Roman gladiators striking beefcake poses—these are images of antiquity that one might reasonably expect modern gay men to fetishize. More surprising is the degree to which erotic representations of ancient Egypt have also enjoyed a vibrant life in European and North American gay visual culture. Sometimes ethnicity or race itself is exoticized in such images, as in the 1990 advertising campaign of Aten-Plus Tanning Salon (fig. 4.5). Riffing on the name of the Sun god, the salon promises West Hollywood gay men skin as bronzed as that displayed by the advertisement's Egyptian-clad, muscular model (whom the copy identifies as winner of the Los Angeles "Super-Men" competition). Likewise, epidermis figures in the Egyptian motif used in the flier (fig. 4.6) to promote a club event in Paris, "Black Blanc Beur (Colored Tea Dance)," aimed at the city's gay Muslim minorities. While the intention seems more politically informed ("beur" being French slang for Algerian-French descendents), the vehicle of fantasy used to promote its agenda (the pharaonic drag worn by its model) is at odds with historic reality, given the far greater number of Maghrebians than Egyptians residing in France. Most often, these contemporary gay visual references to Egypt are designed to appeal to the pleasure principle pure and simple, void of any politics, by associating ancient Egypt with absolute hedonism: hence the Palm Springs Labor Day extravaganza titled "Cruising the Nile" that promised among other pleasures a treasure-hunt to find the "staff of RA" (fig. 4.7). In the same vein, a gay Halloween costume party in Newport Beach promoted as its theme "Walk Like an Egyptian" (riffing on the Bangles' song), the gay club L. A. Factory sponsored a "Pharaoh" night presided over by a DJ named "Ra," and the list goes on.

Given these recurrences, it is worth asking what, if any, aspects of ancient Egypt merit this degree of homoerotic appropriation. The ithyphallic art that abounds in temple bas-reliefs, tomb wall paintings, and papyrus rolls has no doubt contributed to perceptions of pharaonic male culture as homoerotic. The ubiquitous erections sported by kings and gods—particularly Min, Osiris, Geb, and Amen-Ra—are in fact symbols of potency, fertility, and regeneration, and thus religiously and ritually significant. However, to viewers lacking such knowledge, these representations can be confusing. An example is the much-viewed bas-relief of Alexander the Great and Amen-Ra in the Sanctuary of Alexander in

FIGURES 4.5 AND 4.6.

Egyptian epidermis eroticized.

Top: advertisement for Tanning Salon
"Aten-Plus" (1990). *Bottom*: flier for
"Black Blanc Beur" (n.d.). Paris club tea
dance. Both author's collection.

FIGURE 4.7. **Queering ancient Egypt.**

Flier for Labor Day Weekend party at the CC Construction Company, Palm Springs, CA (1994).

the Temple of Luxor (fig. 4.8). The two male figures intimately face each other in profile as Alexander (in regal pharaonic dress on the right) prepares to anoint the erection of Ra that points at him. Alexander's status as a homoerotic icon in his own right adds a certain frisson to the scene for contemporary gays. The meaning of the commemorative bas-relief, however, is not erotic but historical and sacred; it records the transmission of divine power to Alexander at his coronation as pharaoh by the priests at Memphis, the culmination of his liberation of the nation from Persian rule in 332 B.C. Ironically, the most "homoerotic" aspect of the image has been added by modern tourists: the darkened residue that surrounds Ra's phallus comes from the number of tourists who have posed for pictures as they've cupped its outline in their hand, no doubt with goofy grins on their faces.

In truth, overt sexual motifs in the extant literature and art of ancient Egypt are limited in number, and those intimating same-sex relationships are even more isolated.[12] Nonetheless, there are a handful of surviving documents that have contributed to legends of rampant Nilotic homoeroticism. Perhaps most intriguing, because Mailer retells the story at length in *Ancient Evenings*, is the

FIGURE 4.8. **Alexander the Great taking measure of Ra's phallus.**

Temple of Luxor bas-relief, photographed by Gianni Dagli Orti. Courtesy of the Art Collection at Art Resource, NY.

myth recounting the combat between Horus and Set to assume Osiris's throne upon the latter's death. The combat takes on a decidedly sexual tone, with sodomy forming a crucial determinant of its outcome, in both surviving papyrus versions of the myth. In the longer version, known as "The Contendings of Horus and Set" (dating from the Twentieth Dynasty circa 1160 B.C.), Set plots a trap for his nephew Horus by inviting the latter to "spend a pleasant hour" with him. Horus responds "with pleasure," evening comes, a bed is spread, and the two lie down together. The epithet generally accompanying Set's name, "great in virility," seems about to prove its merit as Set grows erect and initiates sex with his bedmate: "Set caused his phallus to become stiff and inserted it between Horus's thighs." Horus, however, slips his hand between his buttocks and covertly receives Set's semen in his palm rather than anus. The next day, when Isis (Horus's mother and Osiris's widow) learns of Set's attempt to penetrate her son, she crafts her revenge by helping Horus to ejaculate and then spreading *his* sperm on Set's favorite food, lettuce (considered an aphrodisiac), so that Set unwittingly becomes "pregnant with the semen of Horus" when he eats his greens. Thus, when Set boasts that he has proven his superiority over Horus (and hence right to the throne) by "perform[ing] the labor of a male" on him,

Isis counters by asking the Gods to summon forth both men's semen. Horus's is inside Set, and not the reverse, causing the shame of submission to shift to Set. The older, shorter version of the myth (dating from the Twelfth Dynasty circa 2000 B.C.) is similar, except that it is Isis who instructs Horus, after an initial attempt by Set to seduce him, how covertly to position his hand between his buttocks so that "Set will enjoy it exceedingly" without realizing that he is not actually penetrating Horus.

Sodomy, in this mythic combat, is clearly about aggression and power: he who penetrates dominates.[13] The same message is conveyed in two relevant coffin texts whose sexual boasts at first seem to contradict one another: in one the deceased claims that "Atem has no power over me, / It is I who penetrate [nk] his buttocks," and in the other the deceased brags, "I swallow for myself the phallus of Ra."[14] To penetrate the god of all creation is to express the desire to have power over life itself; to consume the godhead's symbol of life-giving power is—reversing the negative aspersion of being anally "impregnated" as in the Horus-Set myth—to gain divine power through ingestion. Despite the overriding equation of sodomy with power in the "Contendings," various scholars note that the men's contest for supremacy also includes overt expressions of physical desire. Set invites Horus to take pleasure with him (it will be "sweet to [Set's] heart"), and Horus, responding "with pleasure," willingly consents to share Set's bed, leading to Set's admiring exclamations and instructions as Horus disrobes, "How beautiful are your buttocks, how vital! . . . Stretch out your legs. . . ." These ambiguities—is the aim of sodomy here only an act of domination, or also a man's expression of sexual desire for another male?—enrich the punning wordplay that the older text makes between the similar words for "buttocks" (phwj) and "virile potency" (phtj), for Isis advises the younger Horus to defer his uncle's advances by claiming that "My strength [Horus's phwj, understood as his backside] cannot support [the weight of] your strength [Set's phtj, or virile member]."[15] Such linguistic play (a vital component of ancient Egyptian literature) collapses the presumptive binaries of "active" and "passive": the source of male humiliation (penetrated buttocks) is verbally mirrored in that of male virility (the instrument of penetration).

Intercourse between men who are gods is one matter, between men who are humans another altogether. The sole historical record of what appears to have been a clandestine affair between two prominent men exists in fragmentary writing tablets from the Nineteenth through Twenty-Fifth Dynasties (1295–656 B.C) that record the sexual trysts of Pharaoh Neferkare (Pepi II) and his general Sisene (also known as Sasent)—a pairing Mailer imaginatively recreates in his opus. The text recounts the eyewitness account of a commoner, Teti, who, having spied the pharaoh "going out at night, all alone," immediately deduces "then it was true what is said about him, that he 'goes forth,' during the night." As

Dominic Monserrat notes, such language suggests that the pharaoh's "nocturnal cruising" was a matter of public conjecture.[16] Teti tracks Neferkare to the house of the general Sisene, whom the narrative makes a point of noting is unmarried (an atypical rhetorical formulation in ancient Egyptian texts); the pharaoh is surreptitiously admitted to the house by a basket attached to a rope, and "after his Person had done what he desired with [Sisene]," Neferkare returns to his palace (another fragment reports that he returns for several more hours). R. B. Parkinson remarks that the choice of verb used to express Neferkare's "desire" leaves no doubt, first, that it is sexual in nature and, second, that it is done "with" his partner rather than "against" his wishes.[17] On one hand, the affair's clandestine nature implies it needs to be kept hidden, either because such relations were considered immoral or, less punitively, inappropriate behavior for a pharaoh. On the other, the text is neutral about the act of two men having sex—it's the fodder for gossip, not calumny—and notably the sexual act takes place between fully grown men whose stations in life make both exemplars of prowess and authority—this is no encounter of master and ephebe.

In addition to this historical instance, a third source suggesting the status of homosexual practice in ancient Egypt exists in a series of wall paintings in the Fifth Dynasty tomb in Saqqara of two men, Niankhkhnum and Khnumhotep (figure 4.9). Identified as the king's chief manicurists or hairdressers, the two men are depicted in a stylized pose (facing each other, hands clasped) generally used to represent husband and wife in tomb art.[18] Likewise, the stele depicting the Eighteenth Dynasty "heretical" king Akhenaten embracing a nude figure often identified as Smenkhkare, his youthful co-regent, has often been used to adduce a homosexual relationship between the two males. But, as Montserrat has shown in his study of Akhenaten's cultural afterlife, these speculations have as much to do with the curiosity roused by this pharaoh's sexual biology (bas-reliefs uniformly represent him with androgynous characteristics, leading to conjectures that he suffered from a glandular-hormonal disorder or genetic defect). Reclaimed in literary adaptations in the last two centuries as a heroic rebel bucking the status quo by establishing a monotheistic religion and by breaking with idealized standards of figural representation (sculptures "realistically" depict his unattractive features), Akhenaten has become, as Montserrat shows, the standard-bearer for various disenfranchised groups, from Afrocentrists to modern gay liberationists seeking to legitimize their historical roots. Derek Jarman's unfilmed script, *Akhenaten* (written 1975, published 1996) transforms the king into an object of Orientalist high camp, an artistic visionary with radical sexual politics who marries his lover Smenkhkare. In reality, historians are still inconclusive about exactly who Smenkhkare was—whether indeed "he" is a man or woman, or whether "his" name is simply a title assumed by Akhenaten's queen, the famous Nefertiti. Indeed, Victorians seized on Akhenaten as the

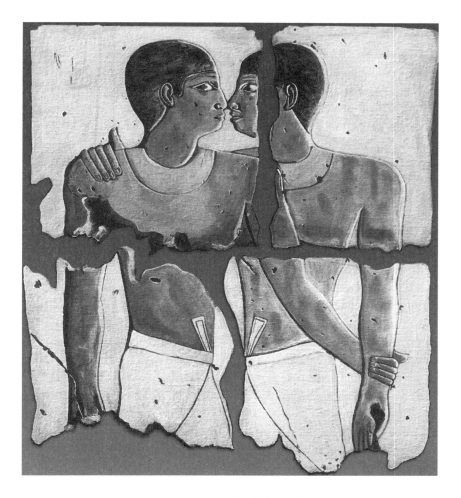

FIGURE 4.9. **Tomb Lovers?**

Greg Reeder, painting of bas-relief in the tomb of Niankhkhnum and Khnumhotep (2012). Courtesy of Greg Reeder © photograph.

"first" modern family man, evincing just how adaptable his image has proved over the ages; likewise, his transformation after the turn of the century into the type of the decadent aesthete and then into an effeminate homosexual illustrates the degree to which Egypt has been made to serve twentieth-century homoerotic fantasies.[19]

Additional Egyptian texts, such as the famous *Book of the Dead*, contain scattered references to male-male sexual practice (most often in the form of admonitions) but hardly provide grounds for the kinds of associations that, ranging from Akhenaten to the club fliers depicted earlier, permeate gay popular culture

today.[20] The picture begins to shift, however, during the centuries of conquest of Egypt—first by Alexander, then by the Romans, next by the followers of Muhammad who captured Alexandria in 641. St. Clement's denunciations of immorality in second-century Alexandria refer to same-sex acts among the sins of his fellow Alexandrians, and although he is clearly a Christian propagandist his rants seem to have some material basis, supported by the importation of Greek and Roman sexual customs into the region.[21] By the time of the Mamluks (the mercenary elite purchased as slaves from the Caucasus who wrested all but nominal control from the Arab Caliphate in the mid-twelfth century), the historical record makes it clear that male homoerotic practice had become an institutionalized part of Cairene society, ranging from the ruling administrative classes to the military corps and comprising the subject matter of love poetry and popular entertainments from shadow-puppet theatre to recitations of the ribald folk tales that Egyptian scribes added to the ever-growing *The Thousand Nights and a Night*.[22] Likewise, from the onset of Mamluk rule, European chroniclers disseminated reports of sodomy as a widespread Egyptian practice, including the accounts of William of Ada in the thirteenth century (reported in chapter 1) and the observations of Irish pilgrim Simon of Semeon in the next century.[23] Propagandistic though much of this testimony is, such observations are echoed in non-European sources that range from the medical observations of Ibn-an-Nafîs, the famous Syrian physician living in thirteenth-century Cairo to Mustafa Âli's chronicle of his Egyptian trip in 1599.[24] The latter, displaying a typically Ottoman bias against his darker-skinned southern neighbors, reports that the Egyptian *jundis*, or common soldiery, "all in accord at night engage in the act of the tribe of Lot . . . and in coffeehouses fight over young boys."[25]

From the early modern period through the nineteenth century, references to Egyptian sodomy by European visitors proliferate. Captured and sold as a slave in Cairo in the late seventeenth century, Joseph Pitts bemoans the general debauchery of the Egyptians, singling out the "Turkish" soldiery (the generic term "Turk" was used to describe any Mamluk despite his country of birth) for terrorizing the male youth of the city with their "addiction to the cursed and unnatural sin of sodomy."[26] Pitts's attribution of this "addiction" to the Mamluks recurs throughout the literature on Egypt: the absence of a system of inheritance and the purchase of every new generation of soldier-slaves from abroad led many Europeans to speculate that this unique system, stripped of the dynastic imperative to produce offspring via marriage, helped foster a predilection for same-sex practices.[27] Hence eighteenth-century French traveler C.-F. Volney attributes the Mamluks' "addict[ion] to that abominable wickedness" of pederasty to their lack of ties to either parents or children, adding that this "contagion" has "spread among the inhabitants of Cairo, and even the Christians of Syria who reside in the city."[28]

This image of a sexual disease spreading from Mamluks to natives to all foreigners who enter this contact zone became a familiar trope. Thus C.-S. Sonnini, French botanist and former navy engineer surveying Egypt's potential for French colonialization in the 1770–1780s, interrupts his discussion of the amenities of Rosetta to lament those "detestable vices" that infect not only its populace but the whole nation. "The passion contrary to nature," he writes, "constitutes the delight, or to use a juster term, the infamy of the Egyptians. It is not for women that their amorous ditties are composed . . . far different objects inflame them . . . This horrid depravation, which to the disgrace of polished nations, is not altogether unknown to them, *is generally diffused all over Egypt*: the rich and poor are equally infected by it."[29] Sonnini's language suggests that part of his worry is that this "inconceivable appetite" is "not altogether unknown" among the "polished nations" of Europe. Further, if this Egyptian lust knows no limits of class (both "rich" and "poor" are equally infected), can it be expected to respect the boundaries of nationality, particularly of a nation—France—investigating the possibilities of occupying Egypt? This interpenetration of colonial interests and attributions of unnatural sexuality recurs, sixty years later, in Edward Lane's admired *An Account of the Manners and Customs of the Modern Egyptians* (1833–1835), which employs a similar image of spreading infection to describe male-male sexual practices. With characteristic understatement, Lane apologizes for feeling it necessary to mention the excessive "indulgence of libidinous passions" that reigns throughout Egypt, including "[a] vice for which the Memlooks who governed Egypt were infamous." This vice, Lane continues, "was so spread by them in this country *as to become not less rare here* than in almost any other country of the East." In Lane's formula, Egypt is the victim of contagion, the Mamluks are the originating cause, and, one assumes (since Lane somewhat equivocally adds that "of late years, *it is said* to be much decreased"), that the civilizing machinery of British empire—in full swing by Lane's day—offers the solution.[30]

Neither the decline of the Mamluks (defeated by Napoleon in 1798 and obliterated by Muhammad Ali in 1811) nor the purity campaigns launched by colonialists, however, lessened speculations about the homosexual penchants of Egypt's citizens or rulers. John Ninet, a French journalist traveling in the country in the second half of the century, repeats the hearsay that Muhammad Ali, viceroy and architect of modern Egypt, was, like his son Ibrahim, "addicted to those grossest Turkish vices which caused his end" (Muhammad was in fact Armenian). Continuing in this vein, Ninet reports that Muhammad's nephew and heir, Abbas I, nurtured the same "domestic vices of his paternal stock," as did his successor, Sa'id, who "but for the unnatural vices which disgraced his private life" was a good ruler.[31] With the increased presence of European powers in Egypt, the "domestic vices" imputed to the native population inevitably

became sources of colonial exploitation, as widespread male and female prostitution swelled in response to Europeans' desires to avail themselves of Egypt's perceived sexual bounty.

Anthony Sattin reports that by the beginning of the twentieth century Egypt had become a "sex destination" for British tourists and expatriates. The prostitute district abutting the Cairo Central Station, he comments, had become "as much a part of the Cairo tour for some foreigners" as the Giza Pyramids: "anything could be bought in Cairo, from the services of Ethiopian slave girls or young boys in the public baths."[32] During World War I and its aftermath, the boy brothels of Cairo were a frequent source of anxiety to British moralists and military leaders alike; despite General Bernard Montgomery's recognition that his soldiers occasionally needed "horizontal relaxation" (leading to his creation of a medically supervised military brothel), and despite (or perhaps because of) his own latent homosexuality, he vocally expressed his discomfort with his men's proximity to the plentiful homosexual enticements of Cairo—and the outbreak of the second world war, thwarting large-scale "clean-up" campaigns in Egypt, meant that such temptations continued to confront Europeans, particularly in Cairo and port cities like Alexandria and Port Said.[33] If myths of rambunctious homoeroticism in ancient Egypt are largely the stuff of wishful imaginations, by the twentieth century sex between men was an undeniable part of the country's landscape. Ironically, its enmeshment in colonial history has facilitated the increasingly homophobic twentieth-century rhetoric that—as in the Cairo Queen Boat scandal examined in chapter 1—holds a generic "West" responsible for importing such vices, thereby displacing and repressing the more distant centuries of non-European invasion and conquest in which institutionalized homoerotic relationships among men formed an intrinsic aspect of Muslim Egyptian life.

MONUMENTAL MANHOOD AND OTHER RECURRING TROPES

Within the varied literature written about Egyptian mores and customs, a number of tropes fueling myths of Egypt's homoerotic bounty occur with some frequency. One of the most common expressions of surprise echoing throughout early travel narratives is the degree of nudity visible to the onlooker in this warmer climate. Especially to northern Europeans conditioned by puritanical attitudes about the body and culturally specific sartorial codes, the array of artlessly uncovered flesh often incited a degree of voyeurism that, on occasion, turned into the grist for foreigners' erotic fantasies. One early traveler little

prone to exaggeration for the sake of titillating the reader, Pietro Della Valle, matter-of-factly reports in 1616 that, of all the Levantine countries in which he has traveled, in Egypt there is "less concern over showing one's private parts," and that working class, fellaheen, and children often "appear half-naked, or rather completely so"—such bodily unselfconsciousness attesting to the endurance of pre-Islamic local customs.[34] Travelers up and down the Nile remark time and again on the nudity glimpsed along its banks, where, as E. Veryard puts it, "great companies of poor Egyptians" toil "for the most part as naked as they were born."[35] Flaubert, too, remarks on the frequent sight of fellaheen "run[ing] to the Nile, strip[ping] off their clothing, and plung[ing] into the water," while his sailors "call out to the bathers pleasantries which were, to put it mildly, indelicate."[36]

While, as might be expected, peasant women's uncovered breasts receive due comment, it is the spectacle of male nudity that seems to strike a particularly scandalous note. The kalandars or saints roaming the countryside completely unclothed repeatedly evoke astonishment—an astonishment accompanied by horror at the sight of supplicant women kissing their glans to induce fertility. When women travelers begin writing of their sojourns in Egypt in the nineteenth century, they also comment on the unclothed men they see, but often with an unselfconscious appreciation lacking in their male counterparts' more dismayed reactions. Frances Cobbe lauds the "broad chests and bronze limbs nearly bare" of Cairene men, while Lucy Duff Gordon, in her humane appreciation of cultural differences, praises the "divine" limbs of Egyptian men, from her steersmen to swimmers nakedly cavorting near her boat to the flash of brown bodies in the green corn fields: "the men [are] half naked and the boys wholly so."[37] Europeans were not the only travelers taking special note of Egyptian men's supposed lack of sartorial decorum. Mustafa Âli repeatedly expresses shock at the exposed flesh he observes throughout Egypt—he seems particularly aggrieved at men's lack of underwear and the short robes of the native military conscripts that barely "reach to the waist." The same revealing garb, Âli gossips, is also worn by "native beardless youth" for whom the soldiers' "sensual appetite . . . is obvious."[38] In Âli's formulation, exposing one's private parts seems tantamount to making one a lover of males. This implicit yoking of male exhibitionism and homosexual practice is mirrored in de Thevenot's comment that the "starke naked" dervishes seen throughout Egypt are "lascivious Rogues, and that for both Sexes."[39] For Âli and de Thevenot's, nakedness equals concupiscence and hence incites any number of "unnatural" vices.

If nudity forms one sexualized motif recurring throughout this literature, a related trope involves the attention paid to Egyptian men's genitals. Sometimes, such scopophilia is understandable, as in Blount's description of those dervishes who wear an "iron Ring through the skin of [their] Yard[s]" (fig. 4.10), ostensibly

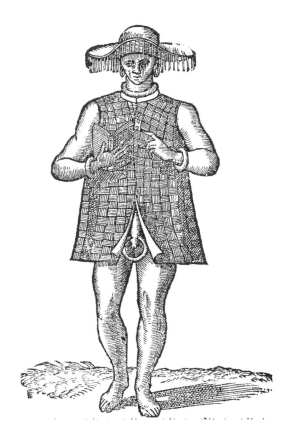

FIGURE 4.10. **A dervish's genital piercing.**

Illustration in Henry Blount, *A Voyage into the Levant* (London, 1636).

to enforce chastity (though the ring can easily be removed, Blount wryly notes). On other occasions, such attention might at first glance seem to be anything but erotic, as when late-sixteenth-century traveler John Sanderson expresses his revulsion at the sight of the "filthie foule circumcised member" of a "starke naked" holy man in Cairo. Ironically, however, the Englishman's alliteration and hyperbolic wording only draw added attention to the dervish's member, just as the adjective "circumcised" makes his penis the sign of his infidel status as exotic "other." Sometimes, phallic attention shifts from men to youths, as in Lane's discreet allusion to the "abominably disgusting" and "indecent tricks" that popular street performers execute with their naked boy assistants, details that for decency's sake he "abstain[s] from describing."[40] The sight Lane occludes is supplied in J. W. McPherson's description of street performances in his survey

of Egyptian *moulids* or Saints-Days; here, one reads of a completely naked and "very handsome lad" of fourteen or fifteen atop a float whose erect "virile organ [dances] to the music in seeming excitement"—its movements up and down activated by a hidden string.[41] From exhibitionist street performers to naked field laborers, from indecently exposed soldiers to lascivious dervishes, the erotic landscape of Egypt teems with potentially suggestive sightings of male nudity in the eyes of writers unaccustomed to such bodily displays.

The tropes of nudity and phallic exhibitionism merge with that of same-sex desire in *Darkest Orient*, a textbook example of barely veiled Orientalist homo-eroticism. Purporting to be the account of the author's journey with a mysterious Eastern employer into the underworld of Levantine eroticism, Riza Bey (likely a pseudonym) declares that his authorial aim is "to lift the veil for European readers" in order to reveal "how much is hidden beneath the East's smiling exterior."[42] This promise of voyeuristic access is made explicit on a Nile trip when the author notices several Egyptian female passengers gawking at a group of men on the river bank. "The men were naked—no very remarkable occurrence on the banks of the Nile," he reports, only to implicate himself in the women's voyeurism as he adds, "but one could not help but be struck by their magnificent physique. Squatting there, statuesque, they made a magnificent picture of male strength." Focalizing his narration through the gaze of the women allows Riza Bey a covert means of expressing his own enthusiastic interest in this spectacle. The thrill he experiences is amplified when he takes up his eyeglass to gape even more: "I put my glasses to my eye. . . . I gasped. I had long known that the men of this land were mightily developed . . . but I was not prepared for what came so glaringly to the eye." These shifts in point of view from what the women see ("they") to an indeterminate pronoun ("one could not help but be struck . . .") to the self-implicating first-person ("I gasped") come to rest on the narrative's real object of interest: those "glaringly" monumental endowments of which Riza Bey has heard so much but now sees firsthand—magnified to even greater dimensions by his phallic eyeglass. On cue, the naked men break into a spontaneous dance that, Riza Bey writes, exhibits the "symmetry of their masculine, muscular development," coyly adding that "other aspects of the scene required no such emphasis." In what is surely the most improbable aspect of this wet-dream fantasy, the ladies disembark to have sex with their favored specimens. Despite the heterosexual thrust of this dénouement, one senses that the whole episode—whether totally fabricated or based on some grain of truth—functions as Riza Bey's excuse to eroticize and exoticize Egyptian men, from their "magnificent" physiques to their no less "mightily developed" signifiers of manhood.[43]

A similar obsession with penis size recurs throughout accounts of the region, from legitimate inquiries to sensationalist exposés. This trope has its beginning in the temple wall bas-reliefs, mentioned earlier, depicting the ritual worship

of erect phalluses; concurrently, in the Old Testament Ezekiel contemptuously describes the Egyptians as men "great of flesh"—or, as Edwardes less euphemistically but not inaccurately translates the Hebrew, "big of meat"[44]—when denouncing the Israelites for committing "whoredom" with their lustful Egyptian neighbors. Even when references to the supposedly monumental endowments of Egyptian men aren't as homoerotically charged as those of Riza Bey, they betray a cluster of anxieties about masculinity and its relation to race and nation that are exacerbated by these continual references to phallicity. Serious Orientalists also reveal a prurient fascination with Egyptian penis size. In *A Personal Narrative of a Pilgrimage to El-Medina and Mecca* (1855–1856), penile proportions become Burton's means of distinguishing the Arab, the Egyptian, and the African negro. Conveying his "findings" in a footnote written in Latin (to ward off the nonspecialist and leave Victorian propriety unruffled), Burton authoritatively declares that

> [t]here is a great distinction between Arabian and African Arabs [Burton's term for modern-day Egyptians], as proven by their penis. The Arabian Arab, being of pure blood, has a very small member. The African Arab, on the other hand, is long, thick, and flabby . . . Valid proof concerning this distinction may be obtained by tracing Egyptian ancestry; hence the Nilotic race, although commonly called 'Arabs,' has the *membrum virile* of the African Negro.[45]

The fact that Burton doesn't include *Aryan* men in this racialized taxonomy suggests that what is at stake in this "scientific" disquisition is a European male anxiety about penis size that needs to be kept under wraps, quarantined in a Latin note that nonetheless conveys its prurient contents loud and clear to those seeking out such information.

That questions of masculinity underlie such comments is even more blatantly displayed in the linking of racial stereotype and sexual perversion in the purportedly scientific *L'amour aux colonies* (1893), written by one "Dr. Jacobus," the alias of Jacob Sutor. This army surgeon claims that his clinical experience while posted to various French colonies has proved, beyond a doubt, that the African Arab—which, like Burton's Hamitic Arab, refers to Egyptians—"is provided with a genital organ, which, for size and length, rivals that of the Negro." He goes into minute descriptions of the "fleshiness" of the penises he's measured, in states both flaccid and erect, before concluding, "with such a weapon does [he] seek anal copulation. He is not particular in his choice, and age or sex makes no difference."[46] Having a large penis, in Sutor's odd chain of logic, creates a desire to have anal intercourse, which in turn manifests itself in homosexual acts. The underlying implication, in both Sutor and Burton, is that the Egyptian,

inhabiting an intermediate zone between Mediterranean Europe and greater Africa, is a hybrid race whose Negroid features come to the fore in his more primal urges, evinced both in his larger genitals and his sodomitical proclivities.[47] If in this case such racist conclusions reveal a fear of miscegenation threatening European purity, in other imaginations Egypt's historical positioning as a meeting place between Europe and Africa has spurred fantasies of poly-racial homoerotic jouissance, as in gay artist George Quaintance's painting *Egyptian Wrestlers* (1952), where the pharaoh's court provides the context for a spectacle of gay male eros in which two equally virile, loin-clothed slaves—one African, one Aryan—engage each other in a cross-racial embrace (fig. 4.11).

Orientalism, excessive endowments, and Egypt also twine together to form the homoerotic frisson running throughout the aforementioned *Cradle of Erotica*

FIGURE 4.11. **Egypt's Contact Zone.**

George Quaintance, *Egyptian Wrestlers* (1952). Courtesy of Volker Janssen, Janssen Publishers.

(1963), Edwardes and Masters' ethnopornographic survey of Eastern eroticism. In the chapter "Genitalia," the two authors, extensively quoting Burton and Dr. Jacobus, trot forth flimsy evidence regarding the "phallic proportions" of Arabs, Egyptians, and black Africans in order to assert that the "Egyptians were, as the Romans regarded them, *bene vasatos* (men with meaty members)."[48] In the same vein, Edwardes in another volume describes Egyptian art depicting men hoisting their robes "to display proudly their thick pendulant genitals" (the description recalls Riza Bey's account of his steamboat cruise) and then adds that their common ancestry with African blacks is proved by their shared "genitories . . . of imposing proportions."[49] The hyperbolized prose that runs throughout such descriptions not only feeds into the myth of monumentality but textually marks Edwardes' excitement in expressing his covert desires while skirting the cultural homophobia of his era by disguising his interests as "scholarship." Orientalist erotica of the Egyptian variety becomes Edwardes's route to self-expression.

In contrast to Edwardes's prurient sensationalism, Richard Critchfield's *Shabbat, An Egyptian* (1978) uses anthropological methods and field work to examine the daily life of the fellaheen, yet indirectly his narrative also participates in the myth of Egyptian hypervirility when Shabbat's mother recounts the story of her son's conception. Distraught at her inability to conceive, one night she enters the ruins of a temple of Ramses III adjacent to the family fields, adorned with bas-reliefs of ancient phallic worship, and offers a prayer to Amen, "god of the penis"—and immediately becomes pregnant (a devout Muslim, she afterwards feels guilty for committing this pagan act). Shabbat (fig. 4.12), as if a present-day manifestation of the ithyphallic art under whose shadow he was figuratively conceived, grows into the epitome of masculinity, boasting strapping muscles visible through his ripped tunic, "hairy chest," "brown muscular arms," and—most vital—an endowment for which he earns the nickname El Tor or the Bull: "because of the size of his penis," his friends joke, "only a donkey could satisfy him."[50] In a village culture ruled by an ethos of masculine domination, where male competition often takes the form, according to Critchfield, of acts of sodomy with other males as well as animals, Shabbat's demonstration of his "sexual prowess" by sodomizing a donkey is part and parcel of the atmosphere of "pagan sensuality" that gives the village "a peculiar air of tolerance" in spite of strict Islamic beliefs: "Everything went, provided it was done discreetly."[51] While Critchfield accurately describes this culture's reinforcement of its system of male dominance through phallic display, his account of Shabbat's sexuality unconsciously aligns less-civilized mentalities, peasant codes of virility literalized in Shabbat's genital endowment, and "perverse" sexual practices (sodomy, bestiality), thereby feeding European stereotypes of Egyptian sexuality.

The tropes surveyed to this point occur as part of a familiar Orientalist pattern in which Egypt is figured as a realm of polymorphous perversity, an anarchic

FIGURE 4.12. **The virile fellaheen.**

Critchfield photograph in *Shabbat, An Egyptian* (1978). Courtesy of the Richard Critchfield Collection, North Dakota State University Institute and Collections.

space of promiscuous excess and libidinal overflow. This is the kingdom imagined by the series *Rome*. It is also the land in which, according to de Thevenot, "no vice comes amiss" (among which vices he includes buggery), and in which, according to Charles Perry, all those "recreations as partake of licentiousness and Wantonness" are "practis'd in the greatest Excess by these People."[52] What Europeans imagine as the result is a debased morality in which "sensual pleasure" is reduced to mere "paroxysms of brutality."[53] Even the fastidious Lane is forced to admit that when it comes to "the indulgence of libidinous passions," the Egyptians exceed any northern country and most of their neighbors.[54] As the colorful phrase, "the fleshpots of Egypt," became an English commonplace to connote the country's general atmosphere of licentiousness and widespread prostitution, commentators repeatedly focused on Cairo and Alexandria as modern cesspools of vice.

These imputations of uninhibited sexual indulgence are tied to another trope recurring throughout this literature: accusations that such excessive promiscuity leads to effeminizing lassitude. Such indolence is the antithesis of the aggressive hyperphallicism simultaneously attributed to Egyptian men: the two contradictory stereotypes exist as inverse images of each other. Sixteenth-century

Mustafa Âli, always eager to denigrate non-Turks, blames this emasculation on the Mamluks, under whose rule the "mother of the world" (Egypt) was left "without a real man" and became a "crafty prostitute."[55] The link between gender, effeminacy, and sexual inversion recurs in descriptions of Egypt's dancing boys as, in Charles Perry's disparaging term, "alias Women."[56] Far more than in comparable accounts of the Ottoman *köçek,* European representations of the *khawal* of Egypt emphasize the dancer's cross-gendered attributes. Such a repudiation of maleness, whether real or imagined, makes the assumed sexuality of the seemingly effeminate dancer all the more vexed an arena of masculine anxiety for outside observers:

> As they impersonate women, their dances are exactly of the same description as those of the *Ghawázee* [female dancers]. . . . Their general appearance . . . is more feminine than masculine: they suffer the hair of the head to grow long, and generally braid it, in the manner of women. . . . they imitate the women also in applying kohl and henna to their eyes and hands like women. In the streets, when not engaged in dancing, they often even veil their faces; not from shame, but merely to affect the manners of women.[57]

Because "imitators of women" are presumed to desire men, these male dancers are also generally assumed to be prostitutes available to other men. The lengthy description that Denon gives of male dancers (see chapter 2) implies their sexual orientation. His explicit reminder that the dancers are "all men" makes even more scandalous their miming "in the most indecent way scenes which love has reserved for the two sexes in the silence and mystery of the night."[58] From a European worldview in which male and female are seen as binary opposites, the logical outcome of the violation of gender convention is a denaturing of sexuality itself, with *one* sex appropriating those acts "love has reserved for the *two* sexes."

In *Colonializing Egypt,* Timothy Mitchell has written of the Western representational tendency to treat all things Egyptian—including Egyptian visitors to the West—as objects on display, exhibition pieces whose "carefully chaotic" arrangement has been orchestrated to satisfy the "isolated gaze" of the spectator.[59] This observation holds for the tropes reviewed above: whether naked peasants cavorting along the Nile, dervishes displaying foreskins run through with iron rings, or dancing boys impersonating girls, these sights are experienced as tableaux displayed for the observer's consumption, edification, and enjoyment. Experiencing Egypt's curiosities as a staged exhibition depends on the illusion of an inviolable boundary dividing spectator and spectacle, subject and object, self and other. The preceding chapter evinced the degree to which

such boundaries are continually being trespassed, redrawn, and reinstated in narratives of Ottoman eroticism. So, too, writers attempting to reproduce the spectacle of Egypt's erotic bounty find that they cannot simply remain distanced voyeurs, for the exhibition of Egyptian sensuality becomes a reflecting glass in which he who gazes finds himself penetrated in turn by his reflection in the supposed Other. Perhaps because of this insistent confrontation of subject and object, Europeans writing about Egypt, even more so than their counterparts describing Ottoman sexuality, fixate on the sheer "staginess," the theatricality, inherent in their fantasies of Egypt as a realm of unbridled eroticism.

Two such writers for whom the "stage" of Egypt provides a theatrical spectacle redolent of same-sex desire are C. B. Klunzinger and Gustave Flaubert, the subjects of the two following sections. The former sees the Egyptian stage through the hazy lens of Romanticism, largely unconscious of his homoerotic investment in his reportage, while the latter imposes a realist's self-consciously denuding eye on the world of sexual profusion and difference in which he delights. In turn, the homoerotic elements in their depictions become narrative spectacles that threaten to dissolve the borders that shore up myths of European masculinity as inviolate and unassailable.

HOMO-ORIENTALISM AND ROMANTICISM IN KLUNZINGER

A German bachelor and physician, Carl Benjamin Klunzinger lived in Upper Egypt from 1872–1877 where, "solitary and without companionship in his researches,"[60] he served as a quarantine doctor in Koseir. In his "Author's Preface," he modestly claims that he has attempted to "clothe" his observations "in a dress that will have some attractiveness for the public" (iv)—an ironic metaphor given the importance of metaphors of disrobing in his work. A second preface by Dr. Georg Schweinfurth makes altogether higher claims for Klunzinger's achievement, distinguishing the author from those tourists who come to the East "to appropriate one thing or another," stay close to the "home comforts of the hotel," and allow the foreign "world to pass before their eyes *as a theatre*" (vii; emphasis added). In contrast, Schweinfurth praises Klunzinger for abjuring the position of distanced onlooker and plunging into the midst of this world, rendering it with a "diagnostic penetration" (ix) honed by his medical practice. By giving the reader "actual facts" rather than romantic fantasies of otherness "overflowing with poetry" (xii), Klunzinger admirably refuses to "obtrud[e] himself upon his reader as a censor of [Egyptian] morals" (xi).

Klunzinger's scientific objectivity, however, is only partially realized in his account of Egyptian life and customs. For in fact a highly subjective perspective, evincing earmarks of literary Romanticism, also colors the physician's point of view. Of particular interest are those moments in which a homoerotic strain enters the text when the author, pace Schweinfurth's claim, figures himself as a spectator watching "the world pass by [his] eyes," an exercise that allows his Romantic imagination to imbue the living spectacle that feeds his unfolding vision with desires that are at the very least subconsciously homoerotic. Indeed, the opening device the author employs to draw the reader into his account involves a narrative conceit that equally invokes the penetrating gaze of the "diagnostician" *and* the fertile imagination of the Romantic poet. Structuring the first chapter around four typical days in an Upper Egyptian town, Klunzinger begins with the fictional ruse that the reader has been transported, "as if by a genie of the darkness of night," to a high mound above the city, from which omniscient vantage point one can see everything: "We are standing," the first sentence begins, on a hill where the air is "so dry and transparent . . . that *the eye can wander unimpeded* to the distant horizon, and take in every detail of the surrounding landscape," including the "confused and labyrinthine collection of houses forming a considerable town" that lies far below. This bird's-eye view reveals a region of "the Mohameton East . . . *much further for the imagination to reach* than the land of the West beyond the Atlantic" (1–3; emphases added). If Klunzinger's goal is (as Schweinfurth claims) the uncovering of "fact," this opening makes it clear that the genie-like wings of "imagination" are the vehicle facilitating a vision of the "Mohameton East" that, in contradistinction to Schweinfurth's declaration, approaches the Transcendental "All" (xii) of unimpeded vision.

From these heights, the narrative perspective plunges to earth, in a movement that is the complement to Romantic transcendence, landing with the reader on the outskirts of the observed town: "We descend and make our way toward the confused mass of houses . . ." (3). Thus begins a narrative "tour" of quotidian Egyptian life as Klunzinger evokes the particulars that bring the scene alive[61]: the bustle of the street, the antics of the donkey-boys, the din of the bazaar into which "[w]e follow the human current for a few steps farther" (9). Soon, the narrator invites the reader "[to] step aside and enter some shop or the other in order that we may quietly, and at leisure, observe how the current of street life moves on." Gazing at the crowd, however, doesn't simply reveal the realism of the everyday. Instead, as "we" watch "man after man cross[ing] the doorway . . . our thoughts *begin to become dreamy*." And in this state of dreamy reverie, as the outward gaze triggers a corresponding inward vision, "we" realize that the parade of men "passing bodily before us" are embodiments of "all the figures that stirred our enthusiasm in our youthful days when we read the Arabic story of the Thousand and One Nights" (16–17; emphasis added).

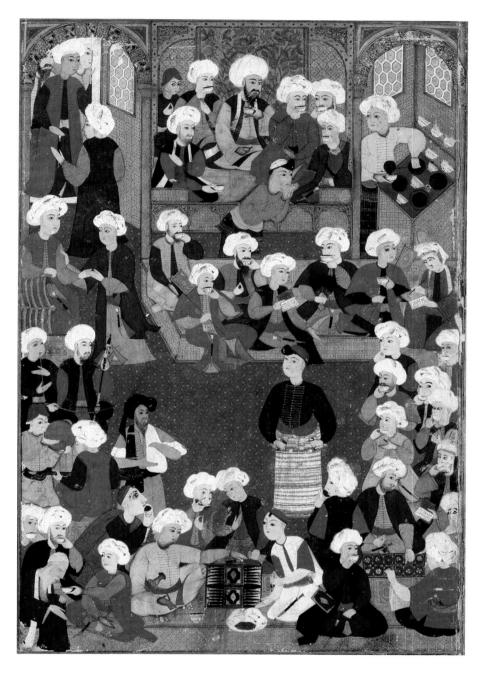

PLATE 1 (FIGURE 1.8) **Peak hours in the coffee shop.**

(Multiple forms of male camaraderie are on display in this miniature.) Ottoman Album CBL 439, fol. 96. Courtesy and © the Trustees of the Chester Beatty Library, Dublin.

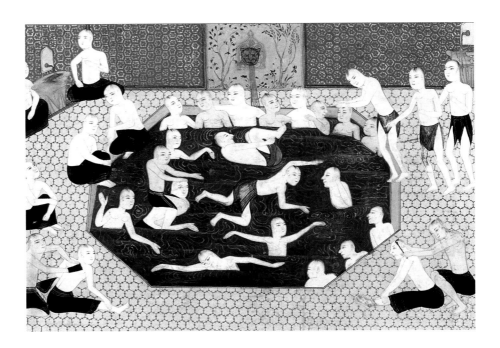

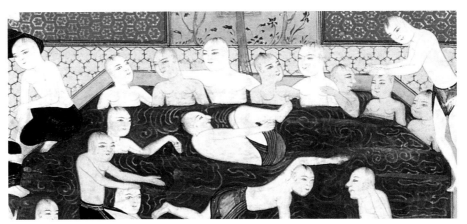

PLATES 2 AND 3 (FIGS. 2.20 & 2.21 DETAIL) **Male camaraderie in the hamam.**

I. Ahmed Album-i. TSM B 408. Courtesy of the Topkapi Palace Museum.

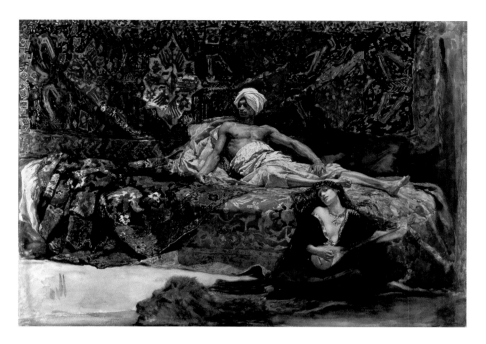

PLATE 4 (FIGURE 2.36) **Destabilizing the romantic narrative.**

Henri Regnault, *Hassan and Namouna* (1870). Courtesy of Roger Benjamin. Private Collection.

PLATE 5 (FIGURE 2.42) **The eunuch as homoeroticized odalisque.**

Jean Lecomte du Nouÿ, Detail of *La porte du sérail: souvenir du Caire* (1876). Courtesy of the Pierre Bergé Collection, Paris.

PLATE 6 (FIG 6.32) & PLATE 7 (FIG 6.33) **Uncanny continuities across a century.**

Top: Rudolph Lehnert, *Jeunes arabes.* Colorized postcard. Tunis (c. 1910). Author's collection.
Bottom: Found photography, reproduced in Thomas Dworzak, *Taliban* (2003). © T. Dworzak
Collection / Magnum Photos.

PLATE 8 (FIGURE 7.7) **Dandy on display.**

A seated dandy wrapped in a fur-lined coat, recto. Read Album. M.386.13. Herat (c. 1600). Image courtesy of the Pierpont Morgan Library, New York. Purchased by J. Pierpont Morgan (1837–1913) in 1911. Photograph © The Pierpont Morgan Library, New York

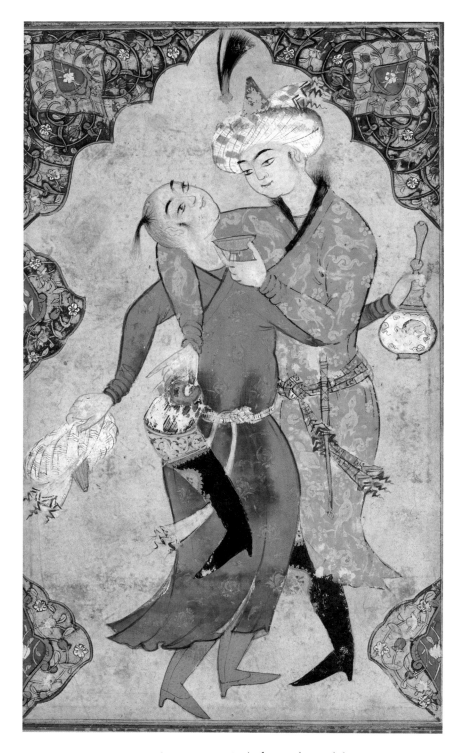

PLATE 9 (FIGURE 7.16) **Arabesque intertwining.**

A Youthful Frolic. Miniature in the Bukhara Style. J. 56.1218. (late 16C) India Office Library of the British Library. Courtesy of the British Library Board.

PLATE 10 (FIGURE 7.17) **Lithesome pastoral.**

'Ali Quli Jabbadar, *Two Shepherds with Sheep and Goats*. Isfahan (c. 1675). Courtesy of the Aga Kahn Museum, Toronto.

PLATE 11 (FIGURE 7.20) **After the debauch: post-coital conversation.**

Miniature in Kalendar Pasa, *I. Ahmed Albumu*. B 408. Ottoman (1603–1618). Courtesy of the Topkapi Palace Museum, Istanbul.

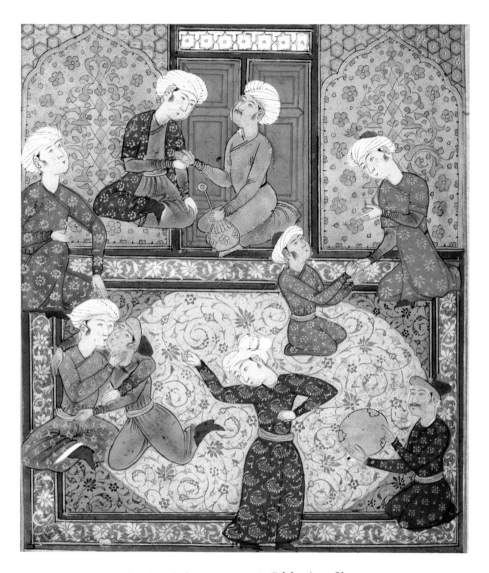

PLATE 12 (FIGURE 7.18) **Celebration of love.**

Miniature in *Kâsim-i Envâr*. BL OR. 11363, fol. 148a. Ottoman, copied in Isfahan (c. 1455–1457). Courtesy of the British Library Board.

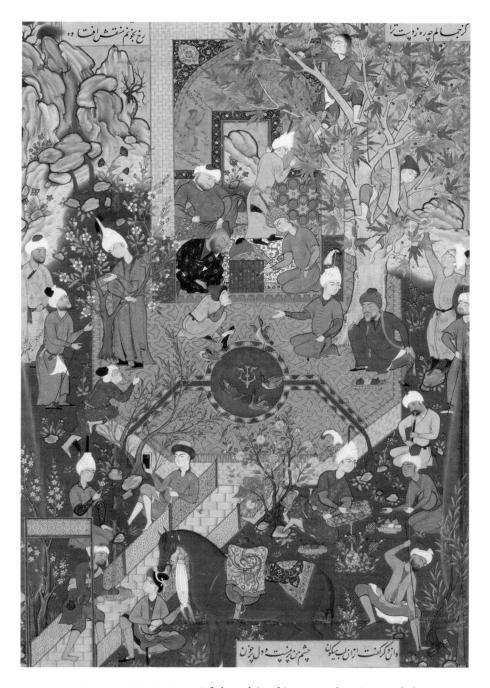

PLATE 13 (FIGURE 7.25) **A father advises his son on choosing a male lover.**

A Father Advises His Son About Love, illustration in "Chain of Gold," Ibrahim Mirza, *Haft Awrang* by Jāmī. Fol. 52a. Safavid (1556–65). Courtesy of the Freer Gallery of Art, Smithsonian Institution, Washington, DC. Purchase: F1946.12.52.

PLATE 14 (FIGURE 741) **Razor erotics.**

Léon Bonnat, *Barber of Suez* (1876). Courtesy of the Curtis Galleries, Inc., Minneapolis, MN.

PLATE 15 (FIGURE 744) **Activity and passivity.**

Girodet, Detail of *Revolt at Cairo*. Bridgeman / Musée National du Château Versailles.

PLATE 16 (FIGURE 8.2) **Innervated (inverted?) masculinity.**

Lawrence Alma-Tadema, *Joseph, Overseer of the Pharaoh's Granaries* (1874). Courtesy of Bridgeman Art Resources / Dahesh Museum, New York.

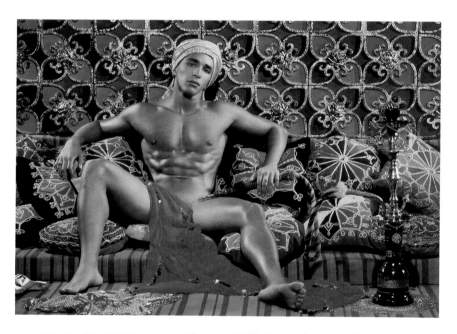

PLATE 17 (FIGURE 8.10) **Pierre and Gilles' pomo-homo Aladdin-Adonis.**

Pierre and Gilles, *Le Fumeur di Narguile—Asiz* (1996). Courtesy of the artists and the Galerie Jérôme de Noirmont.

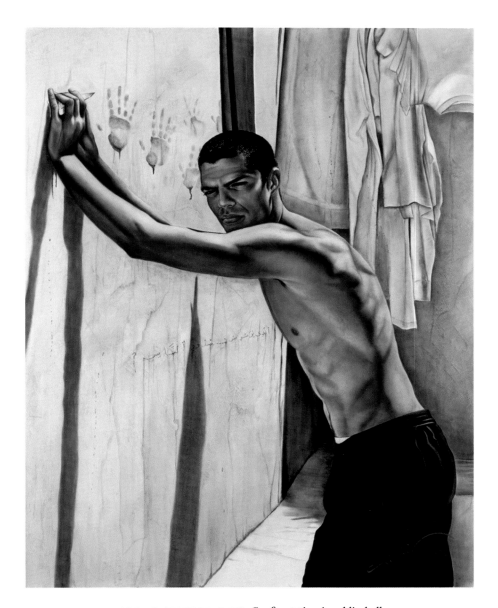

PLATE 18 (FIGURE 8.17) **Confrontation in a blind alley.**

Giliberti, *La cour des maux* (n.d.). From Giliberti, *Voyage secret: Tunisie* (2004).
Courtesy of the artist.

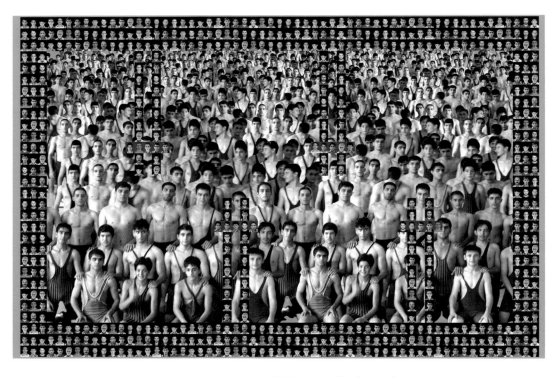

PLATE 19 (FIGURE 8.22) *Huban-name* for the modern age.

Sadegh Tirafkan, *No. 3 Human Tapestry* (2009–2010). Courtesy of the artist.

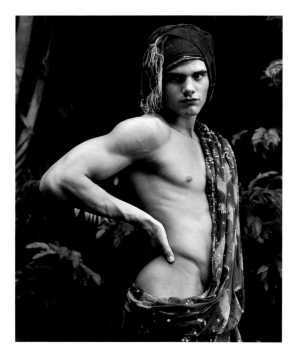

PLATE 20
(FIGURE 8.31)

Celebrity photographers turn East.

Bruce Weber, Peter Johnson as *Arabian Knight*, from *The Chop Suey Club* (1997). Courtesy of and © Bruce Weber.

PLATE 21 (FIGURE 842) **Equal opportunity brothel scene: erotic porosity.**

Miniature in Sa'di's *Külliyat*. BL ADD.24944, fol. 333a. Persian (1566). Courtesy of the British Library Board.

PLATE 22 (FIGURE 845) **Seduction story.**

Miniature from Nev'izade 'Atayi, *Khamsa*. BL OR 13,382 fol. 108b. Ottoman (1738–39). Courtesy of the British Library Board.

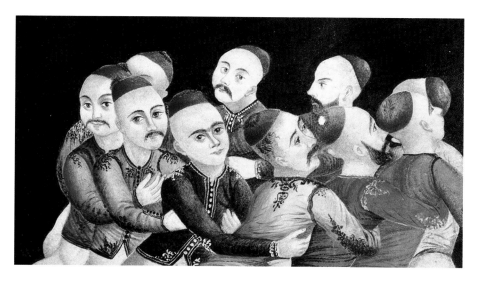

PLATE 23 (FIGURE 848) **Round-robin activities, earthbound and spiritual.**

Detail of miniature from Shaykh Muhammad bin Mustafa Al-Misr, *Tuhfat al-Malk* (1794–1795). Courtesy of the Alain Kahn-Sriber Collection, Paris. Image © Gilles Berquet.

Here, the word "bodily" is key, for the poetic imagination that filters reality through this literary trope inserts into the text a homoerotic strain so innocent and yet so blatant the author may well have remained unaware of what he is revealing. Klunzinger begins these "bodily" observations of passersby by adducing, in Orientalist fashion, a timeless continuity between ancient and present-day Egyptians, proceeding to prove his point by asking us to participate with him in mentally undressing the bodies that pass before "our" gaze. "We shall go even further," he writes, "Let us pick out at random a man belonging to the common people . . . and *divest him* of his outer dress," and next "*strip him*" of his "varnish of Mohammedanism or it may be Christianity" (17; emphases added). The body that finally stands before us denuded of clothes and ideology is the "genuine" thing, an example of perfect Egyptian manhood that has existed unbroken since Pharaonic times. Klunzinger's narrative gaze lingers over this masculine body: "He will be sure to exhibit the same slim yet strong limbs, the broad chest, the same type of face" (17) as his ancestors. In short order, Klunzinger describes the (lack of) dress among the ancient pharaohs, where "even the King in the heat of battle *exposed himself* with nothing on but a short loin-cloth," and then of contemporary Egyptians, any one of whose "well-formed hairy chest is seen through the broad triangular opening in the front of [his] shirt" (18; emphasis added). The result of the "diagnostic penetration" that Schweinfurth lauds in Klunzinger yields a paean to hypermasculinity that, as noted earlier, is a recurrent theme in European fantasies of Egyptian manhood. The supposedly objective gaze, supplemented by imaginative reverie ("our thoughts . . . become dreamy"), creates a potent homoerotic undercurrent in this example of Egyptian Orientalism.

The process by which "facts" become the stuff of erotic projection recurs throughout the "tour" on which the narrator takes the reader. An obligatory stop on "Day Two" is the town's slave market, where those on sale "do not much concern themselves to cover the nude portions of their persons." Yet in the midst of the many naked women on sale, Klunzinger seems more interested in the "little Moor" boy the slave dealer has put on display, "draw[ing] our attention" not only to his white teeth but "to his plump and firm thighs" (35). The equally obligatory excursion to a male hamam puts narrator and reader in the position of passive spectator gazing at a parade of nude male bodies: "We seat ourselves . . . and observe the bathers who pass in succession." Admiration of the male physique also crops up in a boat trip up the Nile, where Klunzinger rhapsodizes about the "Titan shoulders" of the boatmen "heaving . . . to the rhythmic accompaniment of their chants" (115). Klunzinger, in sum, doesn't just bring to Egypt a preexisting "Romance of the East" engendered by tales like those in the *Thousand Nights* and fired by an Orientalist desire to collapse the present into the past—although both of these aspects are present in his work. Rather, his "diagnostic penetration" into quotidian Egyptian life is overlaid with a poetic faculty in which subjective

vision trumps sheer "fact" and tints the spectacle of Egyptian men who come under his gaze with an erotic allure. In such moments, Romantic imagination becomes the medium that allows a homoerotics of Orientalism to express itself in an otherwise rather innocuous document.

The degree to which Romanticism facilitates homoerotic yearning is measurable in Klunzinger's depiction of heterosexuality. Toward the end of "Day One," the narrator escorts the reader to a Greek tavern where "the daughters of Eve of doubtful character may be seen going out and in" (29). A mere stone's throw away, Klunzinger adds, are the haunts of "the frail sisters of the dancing profession" (30), the Ghawazee who are a typical feature of Egyptian travel narratives. "Discarding scruples, let us wander"—so he encourages his readers—"through the headquarters of this tolerated immorality and . . . seize an opportunity . . . of admiring [Egyptian women's] physical charms." Other writers might linger over the occasion and paint a quasi-pornographic picture of such female sensuality. Not so Klunzinger. After a brief review of the costumes of three Ghawazee, he announces that "we" are "convinced of the ugliness of the greater number . . . [and] endeavor to escape from the scene of their activity" as quickly as possible (31–32). Any possible allure these women might possess, he continues, is negated by their vulgar and shrill "peacock" calls, which utterly *destroy the illusion* (31; emphasis added). The distasteful *realism* of female sexuality, that is, strips away any impulse toward the spellbinding reverie of romanticism that, by contrast, colors Klunzinger's admiring descriptions of Egyptian men's virile bodies.

As if to underline the point, the narrator reports that, as we "hasten away," one particularly hideous "Medusa" temporarily blocks "our" exit. "With horror" we manage to "turn away" from this "arresting" figure—Klunzinger's language reeks of castration anxieties—only to find ourselves faced outside the brothel by a beautiful nine-year-old Abyssinian slave girl. This child *seems* a beacon of "innocence" amid this depravity—that is, until she "darts toward . . . and clings to us" (32), making her sexual intention distressingly clear. This Abyssinian maid is no dulcimer-bearing damsel hailing from the ethereal climes of Coleridge but a well-versed sexual player who doesn't need a lofty pleasure dome to ply her trade. Klunzinger's disgust at this instance of female child prostitution is commendable on the humanitarian level. Yet the severity of his reaction seems lopsided if measured against his response to the parallel spectacle of child sexuality of the male gender recorded in his reaction to the naked Moor boy displayed at the slave market. In that instance, recall, the seller underlines the sexual function that the boy is destined to serve by calling attention to his "plump and firm thighs." Klunzinger's repetition of this descriptive detail for the reader's benefit harbors none of the sexual revulsion that his encounter with the Abyssinian girl occasions. To the degree that the latter incident's deflationary realism strips away "illusion," it highlights the

degree of Romantic imagination that infuses the narrative when males are the eroticized objects of the text's gaze.

HOMOEROTIC SPECTACLE, ORIENTALISM, AND THE REALISTIC DETAIL IN FLAUBERT

If Klunzinger's desires go unspoken, little of the erotic escapes Flaubert's observations in his Egyptian travel notes and letters.[62] Rather, this young novelist-in-the-making jots down in rapt detail the multifarious dimensions of the spectacle of Egyptian sensuality parading before his interested gaze. If anything, the realistic grace notes with which he punctuates—and often punctures—his preexisting romance with the Orient heighten his libidinal investment in the scenes he so avidly records. Flaubert's journal entries do not attempt to impose any logical order on the myriad sensations bombarding his consciousness or the chameleon mood swings, from sublimity to boredom, he undergoes; rather, his notes form a series of impressionistic glimpses, often taking the form of lists of images as one sensation yields to another, and as one association leads to the next. Stylistically, these impressionistic fragments combine Flaubert's highly subjective and idiosyncratic perspective with his simultaneous ability to focus on the one detail that makes the observed scene at once personally meaningful to him and resonant for the reader. Adumbrating the monumental grandness of the temple of Esna, Flaubert notes "a yellow cow, on the left, [who] poked her head inside" (120); at Luxor, he muses on obelisks stained with pigeon droppings; at Ramesseum he registers doors of hovels that have been "fashioned from ancient painted coffin-lids" (65, 174). Often operating by means of contrast (between high and low, the sublime and everyday, antiquity and the present), such instances of the telling detail also add a note of deflationary realism to Flaubert's sexual encounters. Taking note of the family of cats that has to be shooed off the mat in a brothel before he can have sex, the stain his ejaculation leaves on the divan, or a famous courtesan's broken tooth—quotidian observations like these render such moments all the more piquant in his erotic sensibility.

Are such observations those of the fetishizing tourist or observant realist? Does Flaubert's eye replicate the appropriative gaze of the Orientalist or mark some other relation to the object of scrutiny? Years later the portrait Du Camp paints of his traveling companion as an armchair tourist seems tailor-made for postcolonialist critique: "He would have liked to travel, if he could, stretched out on a sofa . . . watching landscapes, cities, and ruins pass before him, like the screen of a panorama mechanically unfolding" (140). Such a portrait, however,

sets up a divide between observer and observed, subject and object, living and mechanical, that this traveler's record of everyday experience often belies. Further, Du Camp's image of the "panorama" implies Flaubert gives priority to sight—the sense impression in which Du Camp, as a photographer, was most interested. While the ocular is a dominant note, in fact Flaubert finds *all* his senses stimulated into activity from the moment of his arrival. Upon landing, he writes, "I had my first sight of the Orient . . . I gulped down a bellyful of colors," and if sight here morphs into taste, soon enough smells, sounds, and touch follow, dissolving boundaries between self and other, inside and outside, spectator and "panorama": Flaubert experiences Egypt's bounty in his gut.

Edward Said makes Flaubert's sexual adventures in Egypt a textbook example of Orientalism by focusing on the French writer's account of his affair with the courtesan and professional dancer Kuchuk Hanem. For Said, Flaubert's use of his journal to transform Kuchuk's material presence into poetic musings lays bare the mechanisms of Orientalism and its colonialist erotics: the East's fecundity, gendered as female in Kuchuk's "luxuriant and seemingly unbounded" (187) sensuality, is possessed by a masculine, penetrating West for the latter's aggrandizement. Chapter 1 noted the degree to which the heterosexual tenor of Said's metaphors occlude alternative forms of eroticism underlying the Orientalist enterprise and the fact that the first dancer to catch Flaubert's eye is Hasan el-Belbeissi, a known catamite. Pace Said, the template for Flaubert's erotic experience of Egypt turns out to be less based on gender opposition than on a range of polymorphous desires running in all directions.[63] This spectacle of polymorphous perversity, assailing Flaubert on multiple sensory levels, forms the repeated object of his observations, the subject of his writing, and the source of much of his keenest excitement. As he writes a friend upon first setting foot in Egypt, the "poor imagination" is bedazzled by a "bewildering chaos of colours" that explodes in one's consciousness like "continuous fireworks." This experience of sensory overload cannot be captured simply by recourse to the visual, as Flaubert's simultaneously aural and tactile metaphors imply: "It is like being hurled while asleep into the midst of a Beethoven symphony, with the brasses at their most ear-splitting . . . each detail reaches out to grip you; it pinches you; and the more you concentrate on it the less you grasp the whole" (79).

Homoeroticism forms a repeating component in this cacophony of diverse, fragmented desires. An entry written on arriving in Cairo includes a list of erotically charged first impressions: a wedding procession whose clowns include a man cross-dressed as a woman; a joke about a doctor buggering his donkey in the backyard; a mountebank's seven-year-old boy-assistant wishing everyone prosperity and "long pricks"; oiled wrestlers preening in leather thongs while a male dancer "in drag" executes "splendid writhings of belly and hips." This series culminates in a minutely and lovingly detailed description of Flaubert's

first foray into an Egyptian brothel. But even this heterosexual "end" to the entry is not devoid of homoerotic references: Flaubert notes that this establishment must operate on the sly since the current Egyptian Viceroy, Abbas Pasha, "who is fond only of men," has exiled female prostitute-dancers to the towns of the Upper Nile. When Flaubert repeats his cathouse antics in a letter to Louis Bouilhet, the homoerotic again elbows its way into the account, beginning with a throwaway reference to his dragoman as "one of the most arrant . . . old bardashes that could ever be imagined." And no sooner has Flaubert described his traveling companion, Maxime Du Camp, lusting after the first woman he sees on shore than he qualifies his statement: "But he is just as excited by negro boys. By whom is he *not* excited? Or rather, by *what*?" (43). Clearly, the usual erotic boundaries of the possible—the *whoms* and *whats*—have been thrown out the window, at least on a discursive and hence on an imaginative level, as Flaubert opens himself up to the spectacle of polymorphous sexuality thrilling his senses and flooding his consciousness.

The proliferating associations such openness invites make up a journal entry written two weeks later. Its chain of sensory impressions begins with Flaubert's description of a mountebank's naked boy-assistant parading around with a phallic-shaped object in his mouth; in the background a group of Arabs are singing to a drum; another is telling a story; incense is burning. Sight, sound, smells combine with an array of textual forms—verbal, visual, musical. The next mini-paragraph enigmatically notes, "Turkish bath. Little boy in a red tarboosh who massaged my thigh with a melancholy air." Thus Flaubert's associations slide from the naked street performer's phallic jests in public to a (half) naked boy touching the author within the privacy of an environment associated with erotic trysts. The third paragraph begins, "A bride in the street," describing the sight of a veiled bride so encumbered in her bridal outfit that she can hardly walk. The last paragraph of the entry describes a holy man from Rosetta "who falls on a woman and fucks her publicly"; what strikes Flaubert most is that the other women who are present take off their veils to cover the copulation. In this case, Flaubert's associations move from the veiled bride to veils used to create privacy for—and in a sense sanctify—this public conjoining of the sacred and the profane. A pliable, indeterminate eroticism suffuses this entry's record of sensations and impressions from beginning to end.

For Flaubert, then, contact with different cultural attitudes about sexuality doesn't simply confirm a preexisting set of assumptions; rather, it opens his perception of the possible—and these possibilities become, in turn, welcome sources of stimulation. Flaubert's receptiveness to the various forms of male homoeroticism he sees practiced in Egypt form a case in point. The aforementioned dance performance of Hasan unleashes Flaubert's most extended comments on the practice of sodomy in Egypt. "After lunch . . . we had dancers

in—the famous Hasan el-Belbeissi and one other," Flaubert writes in his journal, describing their filmy costumes, kohl-accented eyes, and muscular undulations whose "lascivious movements" pantomime "a woman about to offer herself" to a man. The homoerotic resonances of this imitation of heterosexual coitus are only accentuated by the impresario's role, as he repeatedly kisses Hasan's bare belly and buttocks.

A letter to Bouilhet elaborates on the details and circumstances of Hasan's performance found in the journal. Having just mentioned that he "haunt[s] the Turkish baths," is "bursting" and needs to "let off steam," Flaubert figuratively "bursts" in an explosion of exclamatory cries when, in an apparent non sequitur, he adds, "We have not yet seen any dancing girls . . . But we have seen male dancers. Oh! Oh! Oh!" (83). Having whetted Bouilhet's desires to full pitch, he describes the performance of the two dancers whose "obscene leerings," along with "the femininity of their movements" and the impresario's "obscene remarks" and familiar gestures, "put additional spice *into a thing that is already quite clear in itself.*" Lest his correspondent be left in doubt as to what this "thing" is, Flaubert spells it out: "I'll have this marvelous Hasan el-Belbeissi come again. He'll dance the Bee for me, in particular. Done by such a bardash as he it can scarcely be a thing for babes" (83–84; emphasis added). A bardash is Flaubert's preferred term for the receptive partner in a sodomitical relationship, and the Bee is a striptease. On the one hand, Flaubert's immediate defense against the "charming corruption" of Hasan and his fellow dancer is to assume the outsider position of artist-observer, noting that their dance "is too beautiful to be exciting" and that their "ugliness" only "adds . . . to the thing as art." On the other hand, as the excited "Oh! Oh! Oh!" and the wish to have Hasan "come again" to perform "a thing that is already quite clear in itself" indicate, the sexuality of the bardash is less easily turned into a purely aesthetic experience than Flaubert's language first suggests.

Having raised the specter of sex between men, Flaubert's letter expands on the subject in a man-of-the-world manner: "Speaking of bardashes, it is quite accepted here. One admits one's sodomy, and it is spoken of at table in the hotel. Sometimes you do a bit of denying and then everyone teases you and you end up confessing." This confirmed womanizer then drolly adds that he too has "considered it part of our duty" to "indulge in this form of ejaculation."[64] The opportunity has not yet presented itself, but "We continue to seek it, however. It's at the baths that such things take place. You reserve the bath for yourself . . . and you skewer your lad in one of the rooms. Be informed, furthermore, that all the bath-boys are bardashes. The final masseurs, the ones who come to rub you when all the rest is done, are usually quite nice young boys" (84–85). Flaubert proceeds to reveal that he's had his "eye on one [youth]" in particular but that when he returns to complete the business, this lad, alas, is absent.

Instead he finds himself in the hands of an aged masseur who "lifts up my *boules d'amour*" and begins "to pull . . . on my prick" (85) before Flaubert stops him—less because the man is fondling his genitals, it seems, than because he's not attractive. Two days after writing this letter, an enigmatic journal entry suggests that Flaubert is still exploring his options: "To the baths—alone—the light through the circles of glass in the domes. Bardashes" (89). Six months later, in response to Bouilhet's query as to whether Flaubert "has consummated that business at the baths," Flaubert responds, "Yes—and on a pockmarked young rascal wearing a white turban. It made me laugh, that's all. But I'll be at it again. To be done well, an experiment must be repeated" (203–4).

There is obviously a degree of performative bravado being inscribed in this letter—Flaubert enjoys making an exhibition of himself, proclaiming his willingness to break taboos—along with a dose of self-deprecating humor. While some critics take this jocularity as reason to dismiss Flaubert's experiment in "this form of ejaculation" as a fiction meant to amuse Bouilhet, devoid of actual erotic intent, the very details that make one chuckle or look askance—the misadventure with the older attendant, the bad complexion of the rascal with whom he finally says he "consummates" the deed—add precisely those realistic notes with which Flaubert typically punctures the textual account of his encounters with the exotic, in the process heightening the jouissance of his recollected experience. In this light, the question of whether Flaubert actually had sex with this boy is less relevant than his newly discovered ability to insert himself within the fantasized scenario without judgment or anxiety. This ability is a direct effect of his perception and embrace of Egyptian morals, sexual attitudes, and generally polymorphous propensities. Indeed, what is remarkable is the sheer *ease* of Flaubert's transition from hetero- to homosexual banter. This is not to suggest that he suddenly renounced his heterosexual proclivities—quite to the contrary, his written record enumerates multiple dalliances with women with relish and exacting anatomical detail. But it does powerfully suggest the degree to which his observations of Egyptian homoeroticism have widened his perception of the conceivable. To be sure, Flaubert's behavior abroad remains "Orientalist" to the degree that he invests the Levant with excessive libidinal content in order to make it serve his considerable psychic and sexual needs—a tendency most perceptible in his descriptions of his heterosexual encounters, crossed as they are by Oedipal desires, castration anxieties, and issues of power.[65] But to the degree that the range of culturally permissible sexual behaviors and practices he witnesses in Egypt enlarges his sense of the possible, his musings reveal a more complex encounter with difference than that inscribed in traditional Orientalist accounts.

Traces of the homoerotic attach to Flaubert's consciousness for the rest of his Egyptian stay. From the Viceroy Abbas Pasha and his dragoman Joseph to

"old Gargar . . . lover of raki and bardashes" (174), the journal makes multiple references to men who have sex with their own gender. Indeed, among the crew employed on his boat, at least three fall in this category. According to Du Camp's recollections, Khalil is a "former bardash" with a "charming behind" whom he suspects has "served as wife to quite a few of the crew"; the tiller Mehemet Bury, who likes to strip completely when he's rowing, may be a great "womanizer" but has his own bardash aboard; the "nice-looking" deck-boy taken on at Thebes, Aouadallah, is identified as Bury's male partner.[66] Meanwhile, the flaunting of phallic sexuality among Egyptian men and recorded by Flaubert maintains a proximity to the homoerotic. When, for instance, a group of mendicants strips "totally naked" to swim out to the boat and beg for alms, the result is "a tutti of cudgelings, pricks, bare arses, yells and laughter" as crew sexually taunts the swimmers; one of the crew, Schimi, breaks into a "naked, lascivious dance" consisting "of an attempt to bugger himself" as he gleefully waves "his prick and his arse" at the interlopers (127). The homoerotic pervades the text more subtly in references, both aesthetic and sensual, to the male form, as when Flaubert contemplates Max bathing in a pond at Karnak— "The look of his naked body, standing on the edge" (171)—or the body of the "little *rais* of fourteen, Mohammed," who accompanies him at Aswan. In what could easily be a description of Lehnert's erotic photographs of Egyptian youth taken sixty years later (see chapter 6), the entry dedicated to this young rower offers up a blazon to his beauty: "his arms were charmingly modeled, with firm young biceps. He had slipped his left arm out of its sleeve, so that on his entire right side, he was as though draped, with his left side and part of his belly uncovered. Slender waist. Folds on his belly that rose and fell as he leaned forward to his oar" (133).

Likewise, the homosocial dimensions of Flaubert's intimate bonds with other men hover on the edge of unacknowledged homoeroticism, as he and Max take turns with the same prostitutes and as he engages prostitutes for his donkey drivers while he watches the men take their turns. But this conjunction of the homosocial and homoerotic most spectacularly occurs on the textual plane in Flaubert's letters to Bouilhet. Having just described his sexual encounter with Kuchuk Hanem, he writes:

> In my absorption in all those things, *mon pauvre vieux*, you never ceased to present. The thought of you was like a constant vesicant, inflaming my mind and making its juices flow by adding to the stimulation. I was sorry (the word is weak) that you were not there—I enjoyed it all for myself and for you—the excitement was for both of us, and you came in for a good share, you may be sure. (130)

In this example of male homosocial desire at its most crystalline, the primary function of Kuchuk's exoticized foreign body is to bond the two correspondents: as she stimulates Flaubert's bodily parts, his mind is inflamed by thoughts of Bouilhet. Egyptian sexuality seems, for Flaubert, not only to open the possibility of cross-cultural homoerotic desire (as in the baths) but to translate itself into desires between European men that might otherwise go unexpressed.

What happens when the female intermediary is removed from such fantasized tableaux? A glimpse of such a possibility occurs in the conclusion of the letter in which Flaubert tells Bouilhet about the sodomitical practices of his fellow Egyptians ("it is spoken of at table"):

> Dear fellow how I'd love to hug you—I'll be glad to see your face again. . . . At night when you are in your room, and the lines don't come, and you're thinking of me, and bored, with your elbows on the table, take a sheet of paper and write me everything—I devoured your letter and have reread it more than once. At this moment I have a vision of you in your shirt before the fire, feeling too warm, and contemplating your prick. (87)

The textual and sexual combine intensely in this "vision," and whatever one may argue about Flaubert's tone or sexual preferences, this letter inscribes the body of an erotic rather than merely homosocial desire—mental vesicants have been replaced by warm pricks.

Nevertheless, the framework in which Flaubert encases this masturbatory scenario presupposes a relation of writing to sexuality that is as potentially disabling as it is momentarily enabling. And this conundrum goes to the heart of what may be most problematic, and most Orientalist, about Flaubert's engagement with Egyptian homoeroticism. For the grandiose ambition that has preceded his voyage and that forms a refrain throughout his travel notes triggers anxieties of narrative authority tied to Western constructions of heterosexual manhood. In the passage above, for instance, Flaubert must first represent the homoerotic reverie as that which takes place when "the lines don't come," when Bouilhet is "bored" with his poetry and abdicates pen for prick. That is, the exotic otherness of sexual perversion is figured as the negation of legitimate artistic vitality, the attainment of which is at once Flaubert's driving desire and his source of gravest anxiety. Throughout the Egypt journal Flaubert uses nonreproductive sexual play as a metaphor to express his despair at not having achieved his ambition of literary greatness. Thus he writes Bouilhet to lament the lack of zeal that has overtaken him, "What is the heart, the verve, the sap? . . . We're good at sucking, we play a lot of tongue-games, we pet for hours; but—the real thing! To ejaculate,

beget the child!" (199). In this phallocentric model of artistic vitality, the pen is the penis only if the desire is heterosexually productive and results in a "child": artistic production and sexual reproduction are identical in this vision of literary (pro)creation.

But time and again throughout his travels Flaubert finds his literary ambitions dwarfed and rendered "sterile" by the monumentality of Egypt. In a lugubrious letter to his mother, he avers that writing gives him the only true "voluptuous joy" he knows, then in the same breath despairs of his lack of productivity, which he links to his immediate environs. For instead of the inspiration he had expected to find, he writes that the Orient of Egypt

> flattens out all the little worldly vanities. The sight of so many ruins destroys any desire to build shanties; all this ancient dust makes one indifferent to fame. At the present moment I see no reason whatever (even from a literary point of view) to do anything to get myself talked about. To live in Paris, to publish, to bestir myself—all that seems very tiresome, seen at this distance. (96)

That "distance" is the perspective provided by Egypt's competing timelessness and monumentality, which in flattening worldly vanities also deflates Flaubert's ability to get it up, to "bestir" himself to the correct "voluptuous" pitch of authorial productivity.

These feelings of frustrated authorship dramatically coalesce with guilty ones of misdirected eroticism in the very letter to Bouilhet that announces his success in having sex with the rascal at the hamam. Tellingly, this is the epistle in which he also bemoans his failure "to ejaculate—to beget the child!" The letter begins with his bleak ruminations on the future—"I see nothing . . . I have no plans, no idea, no project, and, what is worse, no ambition" (198)—and a "profound disgust" fills him when he thinks of his failure to publish and achieve fame. His time spent in Egypt now strikes him as a deferral of real work: "We take notes, we make journeys: emptiness! Emptiness!" This despair leads to Flaubert's put-down of erotic play that leads nowhere—"we're good at sucking, we play a lot of tongue-games, we pet for hours"—only to miss the "real thing," the vital "sap" that produces a book, one's "child." These metaphors culminate in his tongue-in-cheek advice that Bouilhet refrain from copulating so much in order to "conserve" his creative energy. That this flippant remark is followed by Flaubert's similarly cheeky announcement that he's succeeded in his adventure at the bath reveals, however, a darker side to these musings: by implication, the homosexual act whose mention ends the letter is an example of nonreproductive "play," and wasted sperm is intrinsically tied to the emptiness and "profound disgust" that results from his failure of authorial mastery, his inability—both

as man and author—to "beget the child" that will assure him a place in the European pantheon of literary giants.

Given these ambivalent associations of Egypt's diffuse desires with his own nonproductivity or non-monumentality, it is fitting that on the eve of his departure from Egypt Flaubert announces that he senses the artistic "sap" rising inside himself at last: "I feel myself bursting . . . The pot suddenly began to boil! I felt a burning need to write!" (211). By the time he reaches Rome, he reports his brain is seething with ideas for three separate tales; while he is still anxious that "one can't stiffen up enough to create" these "children . . . yet to be born," the narrative desire is now present and he envisions "poetic orgies" as soon as he shuts himself up in his home in France. Within months of returning to Croisset, he announces that he has begun the novel that will become *Madame Bovary*, the spawn of a man whose creative energy now reinforces his heterosexual potency and augurs his future as a monument of French letters.

Thus, for all Flaubert's admirable openness to his Egyptian experiences, his brush with same-sexuality among men in Egypt triggers an uneasiness about what it means to be a writer and a man; on a subconscious level he regards his narrative authority as equivalent to, and dependent upon, a sexual authority associated with Western codes of heterosexual potency, an authority that he cannot afford to lose if he expects to become "the real thing." And yet, at the same time, the homoerotic undertow of his journal and letters home tells another story. Take, for example, the letter in which Flaubert contemplates Bouilhet sitting in front of the fire contemplating his prick. On the one hand, this homoerotic reverie can only occur as a moment out of time—when Bouilhet is "bored" with his writing and "the lines don't come"—because such nonproductive pleasure threatens masculine sexual and narrative authority. On the other hand, the erotic tableau that Flaubert unfolds is, first of all, *of* writing—"take a sheet of paper and write"—and, second, it has taken the *form* of Flaubert's written letter: "At this moment," *he writes*, "I have a vision of you in your shirt. . . ." That which takes place when the lines don't come writes itself into textual existence nonetheless, attesting to the powerful current of homoeroticism that Egypt's spectacle of polymorphous pleasures has engendered, for better or worse, in Flaubert's narrative of his travels and artistic ambitions.

If Flaubert writes his realistic masterpiece, *Madame Bovary*, by abjuring the explosion of the senses that bombard him like "continuous fireworks" during his Eastern travels, the next two sections show how Lawrence Durrell and Norman Mailer make the bedazzling "fireworks" of an often phantasmagoric Egypt the springboard for gargantuan narratives that boldly advertise their epic aspirations. Durrell wasn't shy about promoting himself as heir apparent to Flaubert, Proust, and Joyce, and at the beginning of the second volume of the *Alexandria Quartet* announced his goal of creating a "four-decker novel based on [Einstein's]

relativity proposition" (B n.p.). Likewise, Mailer heralded the long-awaited *Ancient Evenings* as "the nearest I [am] ever going to come to . . . writing a great book."[67] Putting aside the question of whether either venture approaches literary greatness, it's indisputable that the two authors created colossal novels whose ambitions and scope vie with the monumentality of Egypt itself—Durrell's by manipulating time, space, and perspective in the four volumes of his quartet to undermine Enlightenment beliefs in stable reality; Mailer's by traversing two hundred years, two royal dynasties, and the four life spans of one character in a 709-page novel set in a world where incarnation, the transmission of souls, telepathy, and the talking dead inhabit a reality totally unlike our own.

Both Durrell and Mailer's sizable ambitions are inextricably tied to a sense of masculine privilege and phallocentric authority—such privilege is the assumed legacy of a generation of young male authors coming of age in the postwar era who believed it possible to become "giant bards" by writing *the* great novel of the era. Nowhere is this aura of masculine egotism so apparent as in the paeans they offer up to their literary heroes: Durrell's to Henry Miller for producing "a man-size piece of work" that "goes straight up . . . out of [the] gut," and Mailer's to Hemingway as the model for any writer "who takes himself to be both major and *macho*."[68] The "macho" resonances of such authorial ambition reverberate as well in the explorations of masculinity and sexuality that propel the narratives of both *Ancient Evenings* and the *Alexandria Quartet*, explorations intrinsically related to the authors' visions of Egypt—Durrell's acquired firsthand, Mailer's through a decade's worth of scrupulous research. For the erotic possibility that both authors project onto Egypt as a locus of otherness allows them to imagine fictions of sexuality unfettered by the moral orthodoxies and repressive ideologies of the Judeo-Christian West. As such, ironically, their "Egyptian stories" reveal as much about modern Western constructions of self and sex, and about the personal obsessions of Durrell and Mailer, as they do about the erotic realities of their purportedly "foreign" subjects. For Durrell, the mysterious, labyrinthine, polyglot Egyptian city of Alexandria becomes the springboard for action that repeatedly plays out as psychodrama; so, too, Mailer's focus on ancient Egypt transforms his imagined world, in the words of one reviewer, into "an on-and-off metaphor for the repressed consciousness" the author blames for inhibiting contemporary culture.[69]

At same time, as in the texts produced by so many travelers to Egypt, these fantasies of and projections onto Egyptian sexuality unleash floods of polymorphous desire that inevitably include the homoerotic. The spectacle of male-male sexuality is blatantly represented in *Ancient Evenings*, where multiple acts of sodomy mark the plot at crucial turning points, while specters of male homoeroticism haunt the "investigation of modern [bisexual] love" that Durrell announced to be his grand subject in a prefatory note to the *Quartet*'s second volume.[70] As

in Flaubert's journal entries, the ghosts of homoerotic possibility disturbing these representations of Egypt's erotic bounty engender an unpredictable mix of desire, anxiety, and fear that not only provincializes Eurocentric conceptions of heterosexual masculinity and masculine heterosexuality, but that also calls into question the claim to narrative and linguistic prowess—and ultimately to canonical greatness—on which Durrell and Mailer stake their egos and their literary reputations.

THE RETURN OF THE REPRESSED IN DURRELL'S *ALEXANDRIA QUARTET*

Durrell's relationship to British imperialism and colonialism was complex. Raised in India in a family whose colonial roots went back three generations, stationed in Alexandria as a press officer during World War II, Durrell spent his lifetime in exile from England, where he never possessed the rights of a full citizen. Despite the resulting empathies he developed for colonialists and colonized alike, his writings nonetheless often evince an Orientalizing tendency to exoticize other cultures and their practices of sexuality.[71] This sensationalizing tendency pervades the language Durrell uses to describe Eve Cohen, his future wife and original model for the *Quartet*'s archetypal Woman, Justine. As a Jew, Eve becomes Durrell's means of access to "Eastern" sensuality that he penetrates not only as lover and as voyeur but as Anglo novelist intent on transforming her "insider" information into his novel's charged content. "She sits for hours on the bed and tells me all about the sex life of the Arabs," Durrell writes Henry Miller from Alexandria in 1942, ending with a flourish worthy of Edwardes and Masters: "she has seen the *inside* of Egypt to the last rotten dung-blown flap of obscenity."[72] In such a formulation, Eve serves as the archetypal Oriental woman and native informant, fecund, supine, passive, and sexually available, while Durrell occupies the masculine position of the superior, rational West that extracts her mysterious exoticism for his own textual ends. Likewise, Durrell's observations of homosexual practice in Egypt in his letters betray another Orientalist stereotype—the fear of the East's "addictive" lassitude. Writing Miller, he laments that "love, hashish, or boys [are] the obvious solutions to anyone stuck here for more than a few years"; a few months later he adds that "one could not continue to live here without practicing a sort of death—hashish or boys or food."[73] Succumbing to stupefying, addictive appetites that twice make mention of "boys" is tantamount, in Durrell's equation, to the death of the Western masculine self, its superior rationality drowned by a surfeit of dangerous pleasures associated with the decadent "East."

Roughly equivalent sentiments—ranging from voyeuristic delight to irrational fears of self-dissolution—bombard the *Quartet's* protagonist, Darley, from the moment he sets foot in Egypt. Experiencing "failure in all domains of feeling: to write; even to make love" (J 11), this blocked writer and confused sexual subject is, like many real-life travelers before him, at once fascinated and terrified by the seemingly protean world of sexuality that he encounters in the prewar Alexandria of the late thirties—a world composed, he exclaims, of "five races, five languages, a dozen creeds . . . [and] more than five sexes" and a world in which "the sexual provender that lies at hand is staggering in its variety and profusion" (J 4). In turn, the "variety and profusion" of the *Quartet*, with its polyphonic structure, continually shifting points of view, dispersive realities, and multiplying plots, becomes a textual equivalent of the fragmented, anarchic terrain of the instincts that Darley must explore to rekindle his artistic manhood. On the overt level of the love-plot, Darley's negotiation of this libidinal excess repeats a familiar Orientalist pattern, whereby a representative of the West (Darley as lover) dominates, penetrates, and conquers the voluptuous and feminine East (the Egyptian-Jewish beauty Justine). But on another level, the hierarchies of male/female and West/East are turned upside down: first as Darley's role as detached artist-spectator crumbles in face of Justine's protean charms, sweeping him away in a flood of narcissistic desire; second as he learns, at the beginning of the second volume *Balthazar*, that Justine has masterminded their entire romance to serve as a cover for her love affair with an English novelist who, unlike poor Darley, is a successful writer. The belated knowledge of Justine's betrayal unmans Darley, triggering an array of sexual and textual anxieties that three more volumes and seven hundred pages are needed to allay. More immediately, the revelation that his love affair has been a sham triggers in Darley a series of memories and events suppressed from his first-person account in *Justine*. And, tellingly, what these hitherto withheld or repressed events—the recounting of which make up the reader's text of *Balthazar*—reveal are anxieties interwoven with irruptions of homoerotic desire and generated by the colonial encounter with difference.

The spectacular "return of the repressed" staged in *Balthazar* is evoked in surreal set pieces that externalize Darley's interior descent into an Alexandrian dreamscape of projected fears and desires through which he must pass if he is to realize his aims of heterosexual fulfillment and a written text.[74] The "dark tides of Eros" (B 185) unleashed by Darley's feverish mental activity, in turn, are projected onto the foreign geography of a third-world nation whose sexual customs and culture become a screen for expressing the viewing subject's latent desires. Notable among this return of the repressed is the sheer number of homosexual figures rising to the surface of Darley's first-person narration once he is forced to resee his affair with Justine "with new eyes" (B 12). First is the doctor Balthazar,

appearing on Darley's island of exile like "some goat-like apparition from the Underworld" to bring Darley evidence of Justine's betrayal. This Pan-like guide to the underworld is a confirmed lover of men whose homosexuality, says Darley, never compromises his innate masculinity. Second, the first memories that Darley spontaneously recalls once he is convinced of the truth of Balthazar's revelations involve a stereotypically effeminate homosexual expatriate, Toto de Brunel, who has gone unmentioned in *Justine* and whose role as the lapdog of Alexandrian society mavens uncomfortably reminds Darley of the passive role he too has played as Justine's decoy.

If Toto forms a negative mirror in which Darley sees reflected his failure to perform like a "real" man, then the third person who surfaces in Darley's consciousness, the writer *manqué* John Keats, serves as a reflection of Darley's fear of authorial failure. This linking of the sexual and textual in the figure of Keats is underlined when, in the final volume, *Clea*, Darley walks in on Keats taking a shower. For the formerly wimpish journalist, just returned from the front, has been transformed into an ideal of masculinity incarnate who, as Darley exclaims as he gazes at his naked body, now possesses the bronzed physique of a blonde "Greek god!" (C 170). Not only that: this nude Adonis has become a successful writer. Yet, as Darley's telltale exclamation point and breathless voyeurism suggest, even this now-positive model of writerly and masculine authority engenders a homoerotic current that destabilizes apparent significations. Darley's train of associations next dredges up recollections of Scobie, an old-school British colonialist who also defies easy classification: not only does he have pederastic "Tendencies"—directed at the boys of the Nile—for which he claims he is not "fully Answerable" but he also reveals to Darley that he doesn't mind slipping into "female duds . . . when the Fleet's in" (B 23, 33).

The welling up of taboo desires represented by these alter egos culminates in two extended psychodramatic set pieces in which Alexandria's night world takes on the feverish intensity of a Freudian dream text. The first sequence, Darley's imaginative recreation of the orgiastic religious festival of Sitna Mariam—also missing from *Justine*—forms a living embodiment of the polymorphous perverse. "The night accommodated them all" (149), he writes of the crush of delirious celebrants, sacred and profane, as "desires engendered in the forest of the mind" (157) rise to the surface of consciousness and are projected outwards onto the night's riotous events:

> From the outer perimeter of darkness came . . . the hoarse rumble of the approaching procession with its sudden bursts of wild music. . . . From the throat of the narrow alley . . . burst a long tilting gallery of human beings headed by the leaping acrobats and dwarfs of Alexandria, and followed at a dancing measure by the long grotesque cavalcade of gonfalons,

rising and falling in a tide of mystical light, treading the peristaltic measures of the wild music . . . the long shivering orgasm of tambourines struck by dervishes . . . a prostitute singing in the hard clipped accents of the land . . . the cries of children . . . snakecharmers, the freaks (Zubeida the bearded woman and the calf with five legs), the great canvas theater outside which the muscle-dancers stood, naked except for loin clothes . . . and motionless, save for the incredible rippling of their bodies—the flickering and toiling of pectoral, abdominal and dorsal muscles, deceptive as summer lighting. . . . [and a] magnificent-looking male prostitute, whose oiled curls hung down his back and whose eyes and lips were heavily painted. (149–50)

This litany of diverse humanity, "burst[ing]" forth from the darkness like a "long shivering orgasm," incorporates many of the same tropes that this chapter identified as staples in European myths of Egyptian sexuality, down to the unclothed, magnificent bodies of the "muscle-dancers" and the "magnificent-looking male prostitute" who, as objects of the male gaze, recall the accounts of phallic masculinity-on-display narrated by Riza Bey and Klunzinger.

The psychosexual stakes of this descent into libidinal anarchy are underlined by the fact that, in an unusual narrative move, Darley focalizes the entire narration of the festival through the perspective of a character named Narouz. Hence, on the surface, the episode reads as if omnisciently narrated text, rather than Darley's first-person, entirely *fictionalized* creation of Narouz's movements throughout this night. This sleight of hand can't quite conceal the fact that the sensations that Darley is attributing to Narouz are projections of Darley's imagination and therefore expressions of the latter's psychic needs. To the question of why Darley chooses Narouz to stand in as an actor in his own imaginative fantasy, the answer is simple: as a darkly virile Egyptian whose powerful body exudes both passion and control, Narouz embodies, within Darley's libidinal economy, total phallic masculinity—Darley's glimpse through Narouz's loose clothing of his muscled arms, "covered with dark curly hair" (58–59), repeats almost exactly Critchfield's fetishizing description of Shabbat, the all-male, super-endowed peasant who will fuck anyone and anything with pleasure.

As the product of Darley's imagination, then, Narouz's dazed odyssey through the festival's tent city becomes a revealing window onto the psychological crises besetting the protagonist. Narouz's movements ultimately lead him to an aged, grotesque, female prostitute with whom he feverishly copulates, because (so Darley conjectures) he projects onto her voice and body the presence of his unrequited true love, the blonde Clea (she also becomes Darley's heterosexually appropriate object choice in the last volume). Having entered a mutable and

sightless realm where sexuality takes all forms, Narouz in effect *constructs* his desired love object, Clea, out of the prostitute's amorphous, anonymous body. When we remember that Narouz's perceptions are being hypothesized by Darley, the moment becomes pivotal in exposing the stakes involved in the *Quartet's* construction of sexual identity. For what Narouz's encounter with the prostitute reveals about the nature of sexual attraction is that *all* desire is unfixed, that there is no necessary link between sexual instinct and object choice: the only "natural" objects of our desire are those that our fantasies construct, just as Narouz has done with the decrepit prostitute. And Darley should know something about the constructed nature of sexual fantasy, because, in yet another of *Balthazar's* revelations of repressed knowledge, he has not only been a participant in this festival, he has *witnessed* Narouz's copulation in a classic instance of homosocial triangulation ("my memory revives something which it had forgotten . . . myself looking down at them . . . waiting my turn" [160]). The fact that this is one of several erotically charged tableaux that reveal Darley voyeuristically gazing upon naked or nearly naked male bodies—interrupting Balthazar in bed with his boyfriends; walking in on Keats in the shower; and, now, interrupting Narouz's orgasm—suggests the wellspring of homoerotic desire as well as homosexual panic that leads Darley to relay this event as a "closet" narrative, disguising his self-interest behind a seemingly third-person narration.

The destabilizing resonances of this "forgotten" encounter are immediately followed by an account of Scobie's murder, gruesomely kicked to death while cruising the docks in his female duds. By manipulating the actual sequence of events to make the telling of Scobie's death (which occurs earlier in time) follow the moulid's revelation of sexual mutability, Darley's narrative subconsciously serves warning on his analogous potential for perversity: not only do the Scobie's "Tendencies" catch up with the roguish ex-sailor, but the latent homoeroticism given expression in Darley's account of Narouz is overwritten by Scobie's death. This narrative strategy is reminiscent of the moment in *Aziyade* when Loti follows the account of the invasion of his home by the boy-dancers with the declaration, "She has arrived!" thereby overwriting homoerotic threat with heterosexual romance. Textual authority, in both cases, becomes the guarantor of "legitimate" sexual authority.

The welter of polymorphous desires unleashed by Darley's vivid recreation of Sitna Mariam is only a foretaste of the sexual anarchy that reigns during the three-day celebration of Carnival forming the climax of *Balthazar*. "The dark tides of Eros . . . burst out . . . like something long dammed up and raise the forms of strange primeval creatures—the perversions," Darley says of this three-day debauch, whose ruling spirit is masquerade and "utter anonymity" (182, 185). But if Carnival offers Darley a thrilling liberation from conscience and custom—"one feels free," he enthuses, "to do whatever one likes without

prohibition," to sate "all illicit desires" (185)—the festival is simultaneously the site for a more ambiguous reinforcement of repression. For it is here, in this realm of utter possibility, that the effeminate Toto, Darley's negative alter ego, meets his doom in costume, his head run through with a hatpin—yet another of the events suppressed from *Justine*'s text ("Why have I never [before] mentioned this?" (182), Darley quixotically muses). And Toto's murderer is none other than Narouz, Darley's projection of the male principle incarnate. In the act of *narrating* Toto's death, therefore, Darley allows his hypermasculine double (Narouz) to assert itself by slaying his feminine self-image (Toto) and with it vanquish the ghost of his masculine failure and guilty homoerotic desires.[75] With this purgation, Darley begins to reposition himself as a sexual being and artist, heterosexually productive and reproductive, which is the goal to which the rest of *Quartet* dedicates itself. But the task of heterosexual man-making involves a painful contradiction, for what Darley must ultimately excise from himself is any expression of the polymorphous play that Carnival (like the preceding moulid) has revealed to be the truth of all sexual desire. The irony, then, is that Darley's discovery of the arbitrariness of sexual choice—and of the role that imagination plays in creating any object of desire—makes all the more urgent his formulation of a choice toward sexual fixity, toward an absolutism of heterosexual identification and straightforward artistic productivity. For with his successful wooing of European, blonde Clea—a socially appropriate object choice who is the opposite of the darkly exotic, foreign Justine—Darley finally pens the first words of his long-deferred novel, which are simultaneously the *Quartet*'s last words.

At this moment, Darley may appear to have become the apotheosis of the Western writer and Egypt his safely colonized Other, whose perversities *and* temptations he can survey from the authorizing distance of fiction and myth. So how does the reinvigorated manly artist feel, pen in hand and facing the blank page? The reader must take Darley at his word: "like some timid *girl*, scared of the birth of *her* first child" (C 275; emphases added). One is reminded of Flaubert's lament that the nonreproductive, non-consequential sexual play (sucking, tongue games, petting) so easily obtainable in Egypt gets in the way of the male artist's real work: "To ejaculate, to beget the child!" As the proud author-to-be of his own "first child," perhaps Darley's self-identification as a *her* at this propitious moment is simply a joke, or slip of the pen. Nonetheless, this return of the feminine only underlines the degree to which the masculine and textual anxieties filling the *Quartet* have engendered a current of homoeroticism, triggered by Egypt's polymorphous plenty, that continues to haunt the gap between Darley, writing from his island of exile, and Clea, expectantly waiting for his arrival in Paris for a consummation that, within the pages of the text, in fact never occurs.

THE HETERO-HOMOEROTICS OF MAILER'S ‛BIG ONE": *ANCIENT EVENINGS*

Although Mailer chooses to focus on pharaonic Egypt rather than the country's French and British colonial pasts, his 1983 *Ancient Evenings* is reminiscent both of Durrell's bid at epic greatness and the *Quartet*'s enactment of the paradoxes that surface when European constructions of masculine subjectivity come into contact with Egyptian economies of sexuality. Turning (as Freud did before him) to ancient Egypt as the springboard for examining the repressed underside of modern Western civilization, Mailer attempts, with some success, to evoke an alien culture "in which the idea of the human," of human identity itself, is radically "different."[76] In this strange yet uncannily familiar world in which humans enter each other's minds telepathically and in which reincarnation grants them several lives, ontological, psychological, and textual boundaries alike prove extremely porous. What George Stade says of the minds of Mailer's characters is also true of the challenging, sometimes tedious but sometimes dazzling narrative form he creates in order to capture a reality in which multiple temporal and spatial realms exist simultaneously: "minds dissolve, reform, expand, contract, seep into each other, take in and send out those energies we call spirits or gods."[77]

Despite this bold attempt to imagine a psychology and an "ancient" culture radically distinct from our own, Mailer makes ancient Egypt, as several reviewers noted, the vehicle of a critique of contemporary civilization and its discontents.[78] And despite the erudition informing this ten-year labor of love, Mailer also converts ancient Egypt into a blank screen on which to project highly idiosyncratic psychosexual obsessions, a move facilitated by his at times uncritical repetition of stereotypes of Egyptian licentiousness. "Egypt has proved no house of bondage for [Mailer]," so Anthony Burgess quips, "but the terrain of the release of his fantasies."[79] And among the fantasies that Mailer projects onto ancient Egypt, the scenario of homosexual buggery is given pride of place—a fantasy marked by an unusual degree of desire as well as fear. The anxieties attached to such a defiantly articulated fantasy appear to have been contagious, if one is to judge by the homophobic banter characterizing many of the novel's hostile reviewers: note the title Joseph Epstein gave his review essay, "Mailer Hits Bottom" (by which he meant the anatomical bottoms figuring so prominently in this "loathsome" book [68]) and James Wolcott's dismissal of the novel as a "cosmic bummer" (he, like Epstein, cannot resist the anal pun) that attests to Mailer's failure "to scale the heights of immortal fame on the backs of bugger-happy Egyptians."[80]

Indeed, *Ancient Evenings* was long anticipated as the novel that would guarantee Mailer's fame, "establish[ing] him without question as a literary artist of the first rank"[81]—an ambition the author shared with Flaubert and Durrell (fig. 4.13).

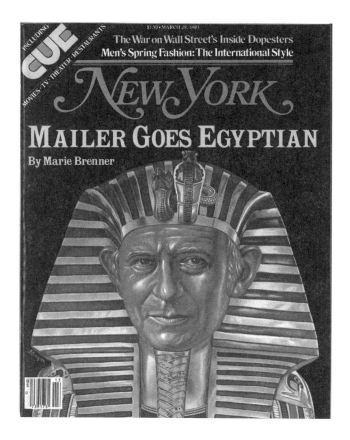

FIGURE 4.13. **Mailer goes Egyptian.**

Eraldo Carugati, cover art for *New York Magazine* (Mar. 28 1983). Courtesy *New York Magazine*.

The incomplete manuscript received the largest advance—roughly 1.4 million dollars—in the history of publishing, creating an unprecedented interest among the general public in Mailer's decade-long endeavor.[82] In the months preceding and following publication, in-depth interviews cropped up everywhere; tantalizing excerpts were published in *Playboy*; and the novel remained on the *New York Times* best-seller list for 20 weeks—even though most readers admitted never finishing its 709 pages. Every major male critic seemed compelled to weigh in (the lack of female commentary on the novel is telling), since, as one reviewer put it, word on the street was that "everything else in his career was foreplay for this, The Big One."[83]

A phrase like "The Big One" evokes in equal measure the monumental egoism and infamous machismo that were part of Mailer's public persona by the seventies—neither of which was lessened by Mailer's own pronouncements

about *Ancient Evenings*. As far back as *Advertisements for Myself* (1959), Mailer had announced his ambition of writing the greatest novel of his generation, "hit[ting] the longest ball ever to go up in the accelerated hurricane air of our American letters."[84] Switching from sports to connubial metaphor, the author declared in an interview headlined "Mailer Finally Delivers 'The Big One,'" "this is my best book, or I've been married to the wrong woman for 11 years."[85] He made similarly "big" claims in a variety of other venues, boasting that his literary "child"—again, note the use of the same metaphor in Flaubert and Durrell—was far and away "the most ambitious book I ever worked on."[86] The adjectives used in the reviews reify this sense of sheer monumentality: Mailer's "Egyptian Novel" is described as "a work of *staggering* ambition," "a *gigantic* novel," "an *extravagant* invention," a "*grandiose*" work, a "*huge* act of imagining." This gigantic novel includes "*spectacularly* imagined" moments, scenes of "*staggering* length," and so forth.[87] Even those many reviewers damning the work phrased their critiques in similarly colossal terms: "wretched in a *big-time* way," a project of "desperate *giganticism*."[88]

Such giganticism, as noted at the beginning of this chapter, is part and parcel of the Orientalizing tropes that for centuries have attached to Egyptian sexuality and particularly to reports of its fabled (homo)eroticism. Nor does Mailer disappoint in this regard: his ancient Egyptians boast voracious sexual appetites, engage in a variety of sexual perversions, and—as far as the male characters go—flaunt their phallic prowess with the glee of dedicated exhibitionists. That phalluses are much on Mailer's mind did not go unnoted. In his *Time* magazine evaluation, Paul Gray comments, with exasperation, that "[t]he sex in the book is . . . droning. The penile proponent dominates; it is the staff of life and the stuff of seemingly endless repetition."[89] This hyper-emphasis on phallic virility jumps off the page even on a casual perusal: descriptions like "a mighty erection . . . strong enough for a man to climb on," "phenomenon of a grand member," "club of a phallus," "the stoutest longest friend any man ever carried," "an erection of prodigious length," and "cock . . . like a bull" recur with alarming frequency.[90]

True enough, within the context of Mailer's attempt to recreate the conceptual world and sacred rites of ancient Egypt, this phallic emphasis serves a more serious purpose, illustrating the transfers of male potency among divine, political, and human realms within this ancient culture's system of beliefs. The central character's declaration that his "member" has "swell[ed] to the size of a King" (306) is not idle hyperbole but an illustration of reverence for the divine that is embodied in the life-renewing phallus of the pharaoh. Thus, when Ramses II, to the delirious cheers of his subjects, brings "forth from beneath His skirt an erection of prodigious length" during the Great Festival depicted near the end of the novel, the text's representation of phallic worship collapses human and divine realms: "Already, it had pushed His garment forward like the prow of a

ship, and, now, since He could not conceal it, he parted the folds of His skirt and showed it forth to the populace. . . . The best and most powerful sign of good luck for all of the Two-Lands was in this confluence between the Gods Ptah and Amon" (587–88). That said, Mailer's emphasis on such phallic exhibitionism seems more than a little suspect, especially insofar as the narrative makes these priapic displays not only the object of the reader's gaze but the subject of narrative desire. As such, Mailer repeats a familiar Orientalist dynamic in which voyeurism becomes a tool of simultaneous penetration, appropriation, and othering.

Acts of violent penetration are an inevitable outcome in a world obsessed with penises and power, and Mailer's novel is filled with such representations. "Everything . . . builds up to someone penetrating someone else, in one orifice or another," one critic complained, "usually with a great deal of humiliation involved for one of the parties."[91] And among such acts of penetration, male sodomy ranks first in Mailer's imagined kingdom of the Nile. It is little wonder, then, that Mailer's graphic representation of sodomy engendered degrees of homophobic panic—as the prior examples of Wolcott and Epstein evince— among literati who had hitherto embraced him as their darling bête noir: But even as his contemporaries mocked the phallicism and anality that accompanied Mailer's obsessive imagining of the sodomitical practices of Egyptian men, few ventured to examine the sheer homoerotic *intensity* of these representations on their own terms.[92]

Before suggesting how Mailer's sodomitical projections participate in the homoerotics of Orientalism this book investigates, a brief synopsis of the novel's complicated plot is in order. *Ancient Evenings* is narrated by the spirit or Ka of Menenhetet, who wakes in a tomb to find himself murdered at twenty-one and in the spectral presence of his great-grandfather, also named Menenhetet, whose task it will be to lead him into the Land of the Dead. In this liminal realm between the living and the dead where time bends back on itself, such that "what is to come . . . could have happened to you already" (96), the younger Menenhetet (hereafter referred to as Meni II) begins to hallucinate a momentous evening in his childhood when he, his parents, and his great-grandfather (hereafter Meni I) were honored dinner guests of Ramses IX for the "Day of the Pig," a holiday dedicated to the ritual observance of this most bestial creature of filth and slime. During this day, everyone must reveal his or her thoughts if asked to do so, no matter how secret (or swinish). If donning a mask allows the Carnival revelers in Durrell's *Quartet* to express their darkest desires, so too the Day of the Pig in *Ancient Evenings*—*the* evening of the title's "ancient evenings"—makes way for an explosive return of the repressed, one from which the narrative line of the rest of the novel follows. For on this auspicious evening, the elder Menenhetet—who, having discovered the secret of incarnation, is living his fourth

lifetime—is commanded by Ramses IX to entertain him with the story of the epic battle of Kadesh, during which Meni I (in his first life) served as the great Ramses II's chief charioteer routing the Hittites. But the gory *war story* that Meni I tells becomes, simply put, the *love story* of Meni and Ramses II—one for which Mailer seems to have found inspiration in the tale of Pharaoh Neferkare and General Sisene discussed earlier, a fact that goes unremarked in the critical literature. In the ancient Egypt that Mailer conjures into being, this love story remains deeply ambivalent, however, despite the electric desires binding Meni I and Ramses II. For love between men inevitably transforms into hatred and a desire for revenge in a phallocentric world in which sex is always an expression of power, and in which power always lies with the penetrator.

It is not coincidental, then, that Mailer prefaces this story with an account of the epic combat whereby the god Horus thwarts his uncle Set's multiple attempts to sodomize him—an account that the elder Menenhetet narrates to his great-grandson from the entombed recesses of their burial pyramid in preparation for their journey to the Land of the Dead. During the first stage of combat, as the two gods wrestle naked in a swamp, the swinish Set reveals a "mighty erection" that causes the younger Horus to lose his footing and fall face forward, at which point Meni I's description goes into hyperbolic overdrive: "Down between His buttocks rammed the hard phallus of Set, and ohhhh . . . what an entrance! Lava was ready to boil. The Nile prepared to froth . . . A scream went up from Horus like the wail of a mortal boy, while Set was throbbing with pride" (71). Horus thwarts his near-defeat with a magical amulet, but not before Meni I's magical words have set his great-grandson's sex organs throbbing in vicarious excitement. "His language had too powerful an effect on me. I was now aroused," Meni II confesses. But he is not simply aroused genitally—he feels his "buttocks" turning to "honey" as he experiences "the power and pleasure of a woman" (72). On the textual level, Meni II's recourse to gender difference to explain his aroused desire channels a conventional if dated concept of sexual inversion: to want a man means one must harbor an inner "woman." On the metatextual level, moreover, Mailer's depiction of the younger Meni's arousal by his great-grandfather's language casts all storytelling, verbal or written, as a form of sexual seduction in which words penetrate the passive listener, stimulating the desire to keep reading. The implication, as in Flaubert and Durrell, is that narrative authority is an expression of masculine potency, for which the textual seduction and penetration of the reader is business as usual.

Meni I proceeds to narrate Set's next seduction attempt, which occurs when Set invites Horus to sup and sleep at his camp. Lulled by the wine and late hour, Horus is in "just the state . . . to receive a few caresses" when Set wakes with the scent of Horus's buttocks driving him "wild" (84) and an erection he can't control. Luckily, as in "The Contendings" papyrus, Horus is able to "fre[e]" his

sphincter from Set's assault just in time to catch his uncle's ejaculation in his palm. Unaware of this sleight of hand, so to speak, the drunken Set falls asleep in "raucous expectations of orgies of possession in years to come" (85). Such hopes are undone, however by Isis's quick thinking, again following the mythic prototype: Set eats the lettuce that she has sprinkled with Horus's sperm, leading the conclave of gods to believe it is Set's "male womb" that has been impregnated by his nephew. Horus's triumph over Set is simultaneously registered—and this appears to be Mailer's inventive addition to the myth—with his attainment of heterosexual competency at this very moment by becoming his mother's lover: in the same sentence that Set ingests the lettuce (and hence Horus's sperm), Horus and Isis begin to make love. As we will see, such patterns of triangulation—in which male homoerotic fulfillment is averted by the last-minute heterosexual intercourse—run throughout *Ancient Evenings*, comprising the "homoerotic heterosexuality" that Mailer's text shares with Durrell's *Quartet* and Loti's *Aziyade*. Meanwhile, the attentively listening, sexually aroused Meni II has the uneasy premonition that his great-grandfather's rehearsal of the Horus-Set combat is part of a strategy, "to put no fine word on it—to bugger me" (94).

Filled with such premonitions, Meni II begins to recall the propitious day, fifteen years before his murder, when his family traveled down the Nile to celebrate the Day of the Pig with Ramses IX. Remembering for Meni is equivalent to entering coexisting planes of reality; narrating these events, he is, magically, both six years old and twenty-one, both dead and alive, both himself and his great-grandfather, living a past that contains a future that has yet to happen. The first significant memory that surfaces for Meni—recalling the plays of repressed memory throughout *Balthazar*—constitutes an Egyptian equivalent of the Freudian primal scene, one that anticipates the novel's many triangulated instances of homoerotic heterosexuality. It is the night prior to the journey to the pharaoh's palace, the boy's mother and Meni I are putting their final touches on a scheme to win Ramses IX's favor while Meni II wanders in the rooftop garden. Blessed since birth with telepathy, the six-year-old enters the mind of his mother, sequestered in another part of the garden, which allows him to see, in his mind's eye, his great-grandfather "push[ing] my mother"—Meni I's own granddaughter—"to her knees before his short white skirt" (109). As she takes the old man's stout member in her mouth, time doubles on itself, and the murdered twenty-one-year-old Meni who is recalling this evening finds himself on *his* knees simultaneously fellating the same man, his great-grandfather, in their tomb. This doubling of realities—so that both acts happen at the same time, indeed on some level become the same act—is recounted in a remarkable passage constructed around a series of conjunctive clauses designed to evoke the rush of the swooning sensations of desire, rage, and joy that overtake Meni II as he deep-throats Meni I:

Through my mother's ears I could hear the unspoken voice of my great-grandfather as he had spoken once to her while her mouth was engorged, *and* with a throbbing upon her face (my face) . . . Menenhetet came forth into her mouth, *so* into my mouth, out of the loins of the dead Menen-hetet, in the alcove of the Pyramid where I knelt *so* did his discharge come like a bolt *and* by the light of its flash I knew how he held her head on the garden of that roof, the iron of his last shuddering pulse dripping its salt onto the back of her tongue, *and* those thoughts passing from his head into hers, *so* was a cock withdrawn from my mouth in the dark, *and* I in the Land of the Dead began to feel a little happy expectation for what might be waiting next. . . . (109–10; emphases added).

At a stretch, one might argue that Meni II isn't "really" fellating Meni I, first of all because both he and his great-grandfather aren't alive and, second, because he might simply be conflating his mother's experience with his own in an act of telepathic overidentification. Regardless, the sheer erotic intensity with which Mailer chooses to represent the immediate sensations of one man engaging in oral sex with another man is undeniable. And it is the locus of "Egypt" that gives Mailer the liberty to indulge in these homoerotic imaginings with such audacity. For the entire metaphysics that Mailer has established as ancient Egypt's "reality"—mirroring temporal planes, doublings of identity, telepathy as mental penetration dissolving the boundary between self and other—are the givens that make the supernatural encounter of the two Menis credible; likewise, the dissolution of boundaries between selves, between genders, and between sexualities subtending this metaphysics makes acts of polymorphous sexuality almost inevitable.[93]

As the narrative returns to Meni II's memories of his six-year-old self spying on the incestuous coupling of his mother and great-grandfather, he remembers "the cheeks of [his] buttocks" undergoing "subtle tumult." The homoerotic implications of such feelings, however, are temporarily overwritten—in another example of homo/heteroerotic triangulation—by a second memory: that of his (female) nurse initiating him into the joys of sex on this same night as she now blows *his* "Sweet Finger." But such normalization proves short-lived. Presented to the magnetic Ramses IX upon the family's arrival at his palace the next evening, Meni finds himself instantly filled with a "strong desire" to submit utterly to this manifestation of divine and earthly power:

I wished to bury my sweet mouth—and everyone assured me my mouth was sweet—on the lips of the Son of Ra, and this desire having come to me, gave permission to the next desire—and I saw myself straining at the tip of my toes to kiss the divine finger between the legs of the Pharaoh. . . . (130)

What follows is another extraordinary passage, nearly a page in length, describing the sexual ecstasy that overwhelms Meni as he kneels to kiss the pharaoh's feet and his tongue begins "to lick the crotch" between these most royal digits. Just as one "desire" (to kiss lips) gives Meni II "permission" to entertain another desire (to kiss Ramses's "divine finger"), so too the sacro-religious dimensions of the scene provide the cover from which Mailer can freely imagine an eroticized scene of contact between two figures who are undeniably male.

Thus begins Meni II's recollection of the long evening of royal entertainments, sumptuous dining, and, beyond everything else, storytelling that follows from Ramses IX's request to hear Meni I's firsthand account of his service as chief charioteer under the glorious Ramses II. This narrative is conveyed over the next 400 pages, sometimes in Menenhetet's first-person words, sometimes in the listening Meni II's summary, and sometimes through the latter's tele-pathic skills, which allow him omnisciently to enter his great-grandfather's consciousness. Despite the tales of battle and conquest, of court intrigues and seductions, of dynastic politics and rebellions, that fill the former charioteer's account, this story becomes, foremost, the tale of the passionate love irrevocably binding Menenhetet and his resplendent king from the moment the two first meet in their twenties: "My Lord, He was beautiful in the way twenty birds are one bird in the instant they turn. . . . He was as beautiful as . . . the sun when it rises and is so young we can look into its face and know the God is young. For the first time in my life, I fell in love with a man. It is the only time. I knew I was born to serve as His charioteer" (251). Praising the beauty of Ramses's face, which "would have been as perfect on a woman as on a man," Meni adds that it was "a pure expression of Maat"—the god of Balance—"that He had so great an Estate below . . . the authority of Egypt dwelt between his thighs" (266–67). As the two share a peasant girl on the march to Kadesh, Meni exults in the fact that his penis "bath[es] in the creams of the Pharaoh," a conspicuous example of hetero-homo triangulation that leaves Meni feeling his "member had been anointed forever" (280–81).[94]

These idyllic feelings, however, come to an end when actual man-to-man sex enters the picture: for, as in the myth of Horus and Set, brutal anal rape becomes the keynote of the three sexual exchanges that occur between Menenhetet and his pharaoh. Each incident, moreover, marks a significant threshold in the novel's structure. The first occurs on the eve of the Kadesh campaign, as Ramses II takes Menenhetet to see the cave where he plans to build his tomb. The whole sequence forms a seductive narrative striptease: first Ramses gives Menenhetet a brotherly kiss that makes Meni's lips feel "radiant"; a few pages later, he orders Meni to kiss him as a pledge not to reveal the location of the future tomb; upon reaching the threshold of the cave after an arduous climb, he embraces Meni in

athletic triumph, eliciting Meni's naive response: "I must say I liked Him then as much as any soldier I had known." The belief that these gestures are signs of martial camaraderie, however, is dispelled in the darkness of the cave when Ramses seizes Meni's head and forces "His member" down Meni's throat: "Then he came forth into my mouth from the excitement of looking into my face." Without pausing, Ramses pushes Meni to his knees, and doggy-style, "thrust up the middle of me tearing I know not what" (287).

Ramses's ecstatic exclamation as he comes—"Your ass, little Meni, is Mine" (288)—attests to the thrill of possession and domination underlying this act. Indeed, the overt purpose of Ramses's rape of Meni is to insure his charioteer's total allegiance in advance of the decisive clash with the Hittites. With a divine pharaoh's wisdom, he knows that Meni will attempt to make up for his "torn" masculinity by working out his rage in battle. The thoughts Mailer ascribes to Meni's consciousness at the moment of orgasm are telling, for the charioteer registers his acquiescence as a shameful surrender of masculine power: "wherefore He came with such force that something in the very sanctuary of myself flew open, and the last of my pride was gone. I was no longer myself but His, and loved Him . . . but also knew that I would never forgive him" (288). Yet the humiliation Meni feels is also intimately connected to the *desires* this experience has awakened in him: "part of [my] shame was for the joy of remembering. My bowels felt gilded . . . A God had entered me. I was not like other men, [but] I felt more . . . a woman" (289). Desire and shame, tellingly, intersect over the question of gender, and Meni's psychic feminization is only resolved when he reclaims his manhood by brutally sodomizing a foreign miscreant nearly as strong as himself. Not only does his "pride . . . [feel] much restored" (308), but he imagines that his "member swell[s] to the size of a King." What Ramses has taken away returns twofold as Meni experiences the "gift" conferred by the pharaoh's phallus: "Even as the very center of me had been stolen by my Pharaoh, so did I steal it from another, and knew it could never stop" (306).

Meni's humiliation at the hands of his beloved Ramses, however, has only just begun. In this twisted love story, phallic masculinity is repeatedly lost, recuperated, and lost again in acts of anality where desire, shame, and assumptions about gender hopelessly compete with each other. Years after Kadesh, Ramses appoints Meni to be keeper of the palace harem. Meni experiences his new position as an emasculating demotion, Ramses's way of reminding Meni that he's not forgotten "how I bled like a woman on the day he separated my buttocks. I might be a General to others, but from his exalted view, I was a little queen" (396). Events quickly come to a head one evening when Ramses orders Meni to accompany him as he has sex with his chosen queens for the night. As Ramses takes Meni by the hand and the two men "walk together" in the harem gardens, Meni experiences a fantasy of egalitarian brotherhood that momentarily melts

his rage: he confesses he's been "starved," for years, "for one sign of His affection" (419). Meni's hunger is shortly fed, however, in more ways than he's bargained for. In front of his giggling queens, Ramses forces Meni to fellate him, then to watch as the pharaoh lies back, opens his muscular legs, and gives "Himself up to the little queens as if He were a woman" (422). Mailer's prose takes on an incantatory lushness as he describes Meni's voyeuristic awe as the king exposes "the mouth that lived between His buttocks" (422) to the oral ministrations of Honey-Ball, one of his queens. All the time, Ramses and Meni clasp hands, and this act of homosocial triangulation brings both men to orgasm simultaneously. The instant Ramses recovers from "coming forth as a woman," he is "ready to stand as a man" and, without further ado, takes Meni from the rear. "Before the women," Meni laments, "[he] made a woman again of me" (424).

Desire and shame once again compete in Meni's psyche, as his fantasy of same-sex comradeship is trumped by what he experiences as emasculating submission: "Holding his hand, I had lived in the waters of Paradise. Not so with His sword. That gave me pain" (424). This pain is as much psychological as physical, for the self-shattering brought on by the inner conflict of desire and fear robs Meni (like Shakespeare's Marc Antony) of his own proverbial "sword." Soon after, repeating the novel's pattern of homosocial triangulations, Meni attempts to reassert his phallic manhood by embarking on a forbidden affair with Honey-Ball—the same queen, no less, whom he's watched rimming Ramses. But even in their lovemaking, he cannot shed the homoerotic pulsations that underlie his desire for revenge; looking at Honey-Ball as they make love, he can only see her mouth on Ramses's "other" mouth in a rush of memory that is as arousing as it is impotent-making: "and I was like a woman again, so rich was my pleasure . . . nothing like a man—so little was I able to stir myself" (435).

For all the glorification of the phallic penetrator in Ramses's repeated buggery of Meni, the text zeroes in on its ultimate source of fascination and dread—the anus, as Meni's memory of Ramses's "other" mouth foretells—in the men's third and final sexual encounter. In this nighttime revel, Ramses now forces Meni, instead of one of his queens, to rim him. What follows for three pages is an intensely lyrical description in which the desire infusing Mailer's writing is equaled only by the exquisite pleasure Meni experiences in his surrender to the act:

> I knew no more defiance than a slave . . . no, I was drawn forward by the tip of my tongue. Like the paws of a dog scratching earth for new mys-teries, so did it quiver to kiss the buttocks of [Ramses]. Even to suffer my nose as a plow, or my tongue as a spade (for His hand was rude!) did not make me feel as if it were being buried in Egyptian mud, no, it was more like entering a temple. . . . [I] was close to believing that I would never

breathe again, just so cruel was the pinch of his buttocks on my nose. . . . The base of His sword trembled against my forehead even as He came forth. . . . Yet He would not release me.

So I continued to kiss and to lick, seeking to give pleasure to Him. (474–75)

The moment's radical significance is linked to the fact that this sexual act irrevocably blurs the line between activity and passivity, control and abjection, top and bottom. Although Ramses "forces" Meni to rim him, Meni is the ostensible "penetrator," entering the gates of a God; likewise, the surrender that Meni feels is matched by the "feminine" position that Ramses is assuming as the object to be penetrated. The democratizing dimensions of these blurring distinctions are signaled in the Edenic language used to describe the aftermath of this encounter, as Ramses and Meni walk "together in the Gardens hand in hand" (477); however temporarily, the rules of phallic power that have hitherto governed relationships between men in the world of this text have been suspended. As such, this sexual act, performed between two men, signals a threshold or boundary whose transgression threatens to dissolve a world based on the phallus, dominance, and gender hierarchy.

And it is at this very point, nearly 500 pages into the text, as if sensing his characters' desires have gotten out of hand, that Mailer starts overwriting the homoerotic tableau upon which he has lavished such careful detail with a blatantly heterosexual plot: Meni begins an affair with Ramses's most politically conniving consort, Nefertiri ("so my buttocks were my own again" [526], Meni proudly declares); Nefertiri pits the two men against each other in a Girardian triangle of romantic rivalry typical of traditional novelistic love plots; under Nefertiri's sway, Meni overreaches as he dares to imagine that he might take Ramses's place, thus evoking the pattern of classical tragic hubris. Meanwhile the six-year-old Meni II, listening to his great-grandfather's tale, discovers that he is his mother and Ramses IX's love child, which instigates a predictably Oedipal plot of dynastic father/son succession. And both levels of story end in Oedipal upset: Meni I is murdered while having sex with Nefertiri by none other than her jealous son; Meni II discovers that his murderer is his stepfather, whom his mother has spurned to become Ramses IX's consort following the events of the Night of the Pig.[95] Amid this swirl of heterosexual intrigue and increasingly traditional plot devices, homoerotic desire doesn't entirely disappear—when Ramses II displays his erection to the adoring crowd during the Festival of Festivals, such is the nature of his sex appeal that Meni can't help but momentarily find himself again "captured by my despised allegiance to that godly phallus—yes! I wanted to be used by [him] again . . . I had an erection of my own" (595). But such moments

are quickly displaced by feverish scenes of dirty sex with Nefertiri and by the convoluted political machinations by which Meni hopes to supplant Ramses as pharaoh.

To make sense of this shift from homoerotic to heterosexual plots, it is useful to ponder the narrative projections of hate and love, fear and desire, to which this text's contemplation of one male's penetration by another has given rise. As Leo Bersani argues, phallocentric cultures promote a powerfully subliminal equation between passive anal sexuality, the breakdown of bodily boundaries, and a shattering of the male ego that is seen as tantamount to death.[96] Whence Meni's sensation, as he is sodomized, "[that] something in the very sanctuary of myself flew open, and the last of my pride was gone" (288).[97] Whence, as well, the god Horus's fear that "the Land of the Dead might yet be carved out of [my] bowels" (73) if Set succeeds in raping him. Within the text's mythology, moreover, the Land of the Dead is the anus: the perilous Duad across which one's spirit must pass is a river of excrement. As Bersani demonstrates, such irrational fears of (yet desires for) self-dissolution are tied to Enlightenment constructions of the ego's boundaries as sacrosanct and whole (hence Meni's metaphor of his integral self as an unbroken "sanctuary" before being riven by anal penetration). Ironically, then, despite Mailer's claim of evoking an entirely alien psychology in recreating the mental world of a culture preexisting Western rationality, he ends up projecting a very modern, European construction of subjectivity onto his male characters when confronted with the conundrum of sodomy. In this light, *Ancient Evening*'s fascination with yet backing away from male homosexual desire seems to express a much larger anxiety—about the meaning of "being" itself—underpinning Western phallocentric structures of thought.

As in the cases of Flaubert and Durrell, these masculine sexual anxieties simultaneously trigger a crisis in narrative authority. Tellingly, *Ancient Evenings* only grants the heterosexual lovemaking of Nefertiri and Menenhetet the status of self-conscious linguistic play. As Nefertiri toys with Meni's erection, she also "played with words in the way I had so often noticed among the most exalted," crooning over

> my coarse peasant cock (and She called it that) and call[ing] it by many other names, for after each tickle of Her tongue, I was "groaner" and "moaner[,]" . . . my "guide" and my "dirty Hittite," my "smelly thickness," and lo, they were all much like the sound you hear in *mtha* . . . and She cooed at it and called it "Nefer" but with a different meaning each time so that it was sweet. "Oh My most beautiful young horse," She said, "my *nefer*, My phallus, My slow fire, My lucky name, My *sma*, My little cock, My little cemetery, My *smat*," and She swallowed as much of my cock as Her royal throat could take. (527–28)

The encounters of Ramses and Meni may be described in equally loving detail by the third-person narrator, but the male subjects of these couplings themselves remain mute. In contrast, the erotic tease whereby Nefertiri prolongs her seduction of Meni I through the telling of stories and then heightens their love-play (as in the passage above) through a series of linguistic puns made possible by the role of intonation in the Egyptian language subtly reinforces a phallocentric conception of reproductive heterosexuality as the necessary basis of productive textuality.[98]

In face of this association, it is all the more ironic that the very form and conception of *Ancient Evenings* celebrates, as Richard Poirer notes, a fracturing of temporal and spatial boundaries. As a corollary of the principle of reincarnation intrinsic to ancient Egyptian thought, any one person's life may find itself endlessly repeated in others' lives and dispersed across a history that itself seems made of repetitions. Hence the Western conception of "self" as a contained or integral being ceases to have meaning within this textual evocation of a bygone world where "the idea of the human is markedly different from what it has been in the West for the last 1,500 years."[99] And, yet, as Bersani hypothesizes, such a deathly shattering of the coherent self is dependent, within the Occidental imagination, on a subliminal linking of anal penetration and male homosexuality. The threat of and desire for self-dissolution that marks Mailer's obsession with sodomy and hence the anus thus manifests itself, in a spectacular example of the return of the repressed, in the splintered format of his text.

Even more ironically, this dispersion of character and plot across temporal and narrative levels depends on a homoerotic act that undermines the novel's belated shift into a heterosexual mode. For, lest the reader has forgotten, the narrative situation that motivates the entire text—the entombed encounter of the recently deceased Meni II and his great-grandfather—also involves a sexual act between the two men, one that frames the entire novel. Toward the beginning of his recollections, as already noted, the younger Meni finds himself on his knees while he "gorge[s] on Menenhetet's cock" (139–40), experiencing in advance the degradation *and* desire that lie at the heart of the older man's tale. When the narrative returns to this frame situation nearly 600 pages later ("I was on my knees . . . [and] with his phallus still in my mouth, I knew the shame of Menenhetet" [687–89]), the reader is reminded that this sexual act has continued, *unabated*, throughout the telling of Meni's history, qualifying for what may well be the longest literary blow job on record.

The homoerotic fantasies unleashed by and legitimated in *Ancient Evening*'s structural and thematic celebration of the polymorphous perverse, then, generates a crisis of masculine subjectivity—call it "the shame of Menenhetet"—that compels Mailer to Promethean efforts to contain the very desires upon which his exploration of ancient Egypt's otherness has depended. If, as Carl Rollyson

has commented, "[t]he unrepressed life that Mailer dreamed of . . . appears in ancient Egypt, where the writer's deepest fears and greatest triumphs can be literally worked out,"[100] some of those "deepest fears" must also be covered over, repressed again. In the process, the homoerotics of Orientalism in which this grandiose, labored, yet audacious novel participates threatens to become another name for Occidental homophobia: desire between men engenders crises of masculinity; love inevitably transforms into hatred. Yet the homoerotics of Mailer's story persist, regardless of his belated effort at containment, in the very Orientalism of the phantasmagoria that Mailer has dreamt into being by projecting his vision of the "unrepressed life" of the libido onto the fictionalized terrain of ancient Egypt. Indeed the prosaic reality of present-day Egypt as a geographical and political actuality barely exists for Mailer, proving more of a hindrance than a help to his imaginings. Asked in an interview for his impressions of the country during his one trip there, Mailer emphatically responded, "Hated it." And why? "The place has become a Third World country," Mailer complained, "It had nothing to do with ancient Egypt and so was terribly distracting to me."[101] Only in the novelistic "ancient Egypt" born of authorial fiat can Mailer indulge, with such utter abandon and without distraction, in the homoerotics of Orientalism kindled by his epic ambitions and deepest desires.

The following chapter continues this discussion by turning to this third-world Egypt and the sexual and textual politics governing the reflection of its colonial and homoerotic substrata not only in European writers such as André Gide and Robin Maugham but in examples of Egyptian fiction and Youssef Chahine's "Alexandria" film quartet. In many ways, Chahine's magisterial ambitions are every bit as gargantuan as those of Flaubert in his journals, Durrell in his *Alexandria Quartet*, and Mailer in his *Ancient Evenings*, but the ways in which his unabashed bisexuality permeates the cross-cultural encounters staged within his films results in a polyphonic texture whose anxieties of authority are radically different from the masculine ones unsettling his Western counterparts.

Five

COLONIALISM AND ITS AFTERMATHS, GIDE TO CHAHINE

EGYPTIAN STORIES II

It's an old evil. In English they call it "homosexuality" and it is spelled H-O-M-O-S-E-X-U-A-L-I-T-Y.

Sheikh Darwish in Najīb Mahfūz's *Midaq Alley*[1]

I'm crazy for boys running about in djellabas like girls, and girls in jeans acting like Rambo!

Chahine's alter ego, Yehia, in *Alexandria Now and Forever*

Interestingly, the term Norman Mailer uses so dismissively, "Third World," to describe his impression of modern-day Egypt (as opposed to his imagined "ancient" Egypt) was coined at an economic conference in 1955, two years after the Egyptian Republic was declared and one year before Nasser assumed its presidency. For some homosexually motivated travelers, the economically underdeveloped or "third-world" status of North Africa was a precondition of its attraction, since widespread poverty made youth more readily available as sexual partners for favors or pay. For others, like Pier Paulo Pasolini (whose film adaptation of *The Thousand Nights and a Night* is discussed in chapter 8), the North African third world represented, in the filmmaker's nostalgic vision of a timeless medieval Orient, the last outpost of the genuine proletariat, whose capacity to enjoy the body fully, without repression, opposed the hegemony of deadening Western bourgeois modernity and morality. "May I say," Pasolini writes, "a bit tautologically, that for me eroticism is the beauty of the boys of the Third World."[2] For yet other men, their voyages of homoerotic self-discovery to Egypt and other countries of the region were inevitably marked by histories of European colonialism, in which the economic, racial, and sexual implications of empire building complicate their narratives of

sexual liberation. This chapter examines the poetics and politics of such narratives by drawing on the examples of a notebook Gide kept during a visit to Egypt in 1939 and a short story that Robin Maugham sets squarely in colonial Cairo of 1898, analyses of which are placed in counterpoint with works by twentieth-century Egyptian artists, including city novels by Najīb Mahfūz and 'Ala' al-Aswānī and the cinematic "Alexandria" quartet directed by Egypt's foremost filmmaker, Youssef Chahine.

Chahine's film quartet inevitably calls to mind the name and location of Durrell's equivalent achievement in fiction. Durrell's *Quartet*, as we saw, is set in the late thirties, just before the coming war rattled England's uncontested rule of Egypt, and a latticework of colonial power plays and counterplots filters into nearly all the sexual relationships explored in the novel. Indeed, it is one of England's colonial operatives, the expatriate "peddyrast" Major Scobie—befuddled employee of the Egyptian Vice Squad and Secret Police—who offers a particularly brazen if unself-aware articulation of the volatile mix of sexual and colonial politics that the present chapter examines when, damningly, he rhapsodizes about a country that, to his way of thinking, is a pederast's paradise existing for his express enjoyment: "Looking from east to west over this fertile delta, what do I see? . . . Mile upon mile of angelic black bottoms!" (J 108). Scobie may claim Egypt as his home, but his cruising eye is that of the mercenary sexual tourist abroad. It reflects the slightly more circumspect gaze with which Gide, in his Egyptian notebook, also evaluates the erotic possibilities that can be had for a few coins and the covert glances with which the closeted British soldier-protagonist of Maugham's "Testament" eyes youthful sexual prospects that—as in the cases of Scobie and Gide—uneasily approach the pedophilic.

NO TIME FOR MONUMENTS: FANTASIES OF RECIPROCITY IN GIDE'S *CARNETS D'ÉGYPT*

Contemporaneous with Durrell's fictional evocation of hypersexualized Alexandria at this turning point in British and Egyptian history, André Gide traveled to Egypt for a two-month stay in 1939, recording his impressions in a notebook posthumously published as *Carnets d'Égypte* and as yet untranslated into English. In chapter 6, I examine Gide's poetic (and, I argue, modernist) reworking of the genre of the European travel narrative three decades earlier in his Algerian journals of 1899–1904, published under the title *Amyntas*. In stark contrast, the Egyptian journal—a stripped-down, matter-of-fact diary without the literary embellishments and experimental techniques that make the Algerian entries such an evocative investigation of self and otherness

deployed for simultaneously modernist and homoerotic ends—is written by a much older man who harbors few romantic illusions about himself or his desires. In the earlier *Amyntas*, Gide attempts to evoke the essence of a world of sexual difference without objectifying the erotic attraction that its mysteries hold for him; in the Egyptian *Carnets*, in contrast, Gide unabashedly writes as a tourist who patronizes the grand colonial hotels and who is more interested in cruising Egypt's boys than in visiting its monumental ruins. And it is the former activity, more than anything else, that reveals his status in Egypt as a European enjoying colonial privileges that escape his usual critical self-awareness.

Hence, in the initial entries written upon arrival in Cairo, Gide remarks that he is in a "state of total incuriosity"[3] about his surroundings because he has yet to be excited by a single beautiful face. Feelings of boredom, depression, and lack of connection creep over him; without some seductive energy to respond to, some "carnal" or "animal" contact between himself and the land in which he is traveling, "no relation" with "the people" (545) is possible. Arriving in Luxor, Gide dissects the nature of his desires as a sex tourist. On one hand he admits to himself that he no longer wishes to have full intercourse—a few caresses, the frisson of exchanged glances, extended moments of tenderness please him more at this age. On the other, his psychological need is to know that he *could* have sex, if he *wanted* to, and he immediately ties this imperative to his as-yet-lackluster impressions of Egypt: "I mean to say that a country only pleases me if multiple occasions of fucking present themselves. The most beautiful monuments in the world cannot replace that, why not own it frankly?" (547). His agenda is clear: the whiff of erotic possibility, not the sight of fabulous ruins, makes the trip for him.

This very day, Gide continues to write, he has finally glimpsed upwards of "ten, twelve, twenty charming faces," thereby reversing his hitherto negative reactions to Egypt. Having set out on a walk away from the tourist sector to Luxor's outlying "indigenous" villages, Gide finds that the baksheesh he distributes guarantees a string of cute youth clipping at his heels. Baksheesh, of course, functions as the sign extraordinaire of the colonialist—you get what you pay for in this world. While Gide isn't above using this tool in his arsenal, his deeper desire involves a fantasy of reciprocal relation, one which also seems about to be realized on this same walk. Having left behind the panhandling urchins, he passes a "very beautiful lad" walking the opposite direction, his body and face flush with health and arms filled with fresh greens he's carrying home from market as he calls out a friendly salutation to which Gide finally "dares to respond" (in contrast, "apprehensive" of revealing too much about himself in front of the boys his baksheesh has attracted, he has maintained an outward façade of indifference). The youth (whose name is Ali) turns around to follow Gide and, in an act befitting

the classical genre of pastoral idyll beloved by Gide, offers the writer some of the choicest leaves he is carrying (one recalls the aphrodisiac properties attributed to lettuce in the Set and Horus myth, recounted in chapter 4). Instead of having to dispense baksheesh, Gide finds himself receiving an offering freely given, which heightens his desired fantasy of reciprocity. And because Gide surmises that Ali is bringing the greens home to his family for their dinner, the gift also symbolically allows Gide to partake of a fantasy of familial intimacy—he is "breaking bread," as it were, with Ali's family in absentia. In Gide's psyche, this double fantasy transcends crass exploitation of a minor.

Soon enough, Ali leads Gide to an unoccupied hovel to which, magically, the boy produces a key, and he draws Gide deeper and deeper into its tiny, abandoned rooms—a crossing of thresholds that calls to mind the obsession with doors, entrances, and interior spaces that formed a thread from Loti's *Aziyade* to Özpetek's *Hamam* in chapter 3. Writing that he only complies because his "curiosity" to see what "genre of propositions" might follow trumps his fears, Gide stands watching as Ali silently shucks his tunic, drops his drawers, and then, to Gide's surprise, offers him his backside—a willing passivity that Gide maintains is atypical of his prior experiences with Arab and Tunisian males for whom the fiction of being the active partner is paramount. Resolved not to take the adventure any further, Gide announces this knowledge is satisfaction enough in itself: "I'd learned what I wished to know." Gide's wording anticipates Foucault's dictum that knowledge is power and Said's application of this formula to the Orientalist enterprise: private knowledge reveals its colonializing contours.

What Gide has desired to know, of course, is that sex is possible; what he learns, in addition, is Ali's willingness to consent to a sex act that (while it might answer other sex tourists' dreams) upsets Gide's fantasy of reciprocal connection, since it involves roles of dominance and submission that he would rather forget or ignore. Thus it is fitting that the next time Gide encounters Ali—in an intriguingly dreamlike instance of repetition with a difference—he ignores the boy's attempts to persuade him to retire to some nearby ruins for a tryst and, instead, leads Ali to the public bank of the river where he can sit near him and engage in conversation in peace.

If Gide is delighted that Ali doesn't break the latter, idyllic moment by soliciting him (for either sex or money), he finds himself soon bombarded by the "obscene propositions" (556) of, and potential encounters with, willing youth everywhere he turns.[4] This "everywhere," however, is by and large constricted to the venues in which colonials and tourists of Gide's means move: indeed, the overwhelming majority of these propositions come from various of the employees working at Luxor's grand hotels. Retiring to the gardens of the Winter Palace to read and write, for instance, Gide is repeatedly beset by seemingly

all-too-willing *aides-jardiniers* who waylay him with unmistakable looks and obscene gestures: "When one doesn't succeed in his attempts at seduction, the next proposes himself. No shame at all; all are naughty accomplices and participants" (566). Fascinatingly, the more Gide is intrigued by this sexual economy, the more his estimation of the ages of these gardeners—some "more beautiful than any of the adolescents I've encountered in the town"—plummets (a trait, as observed in chapter 2, also characterizing Joe Orton's diaries; in an interesting link, Gide's journals served as the model for Orton's North African diary[5]). The first entry of Gide's *Carnets* remarking on the antics of the hotel's gardeners estimates that they are no older than thirty but assuredly more than twenty; soon, none of them are more than twenty; toward the end of Gide's stay, he notes that one is as young as ten ("but very well trained by the others" [566]). Tellingly, what seems to fascinate Gide as much as the boys' brazenness is how *other* vacationing Europeans react to such sexual come-ons. "What I want to know is how the English comport themselves in front of such advances," Gide writes. He then shrewdly adds, "The insistence of [the gardeners'] propositions can only be explained if they are not always repulsed" (566). Implicit in this musing is Gide's tacit acknowledgment that he is part of a larger, international "sex-tourist industry," with all the exploitative, colonialist connotations that its economy implies; and such commerce abroad, as he later learns, is not without very real dangers.

The gardeners aren't the only native employees catering to Luxor's tourist industry providing Gide with erotic opportunities. Having tea on the terrace of the nearby Savoy, Gide is approached by the "strong Sudanese boatman" he's hired to row him to the hotel, who "ask[s] me to steal away with him with a disarming smile" (562). Another evening, the principal waiter at Gide's hotel "introduces me to, o stupor! *a new boy*"—Gide pens the latter words in English to emphasize his delight—"who," Gide adds, "is the most beautiful child (thirteen without a doubt) that I have seen since my arrival in Egypt" (567). Yet Gide cannot decipher the situation. At first he thinks the waiter is introducing him to his son, but as the boy "rubs himself against me," the waiter discreetly retires. "What did it signify?" (567), Gide wonders, unable to "translate" these signals across cultures. Then there is the hotel's *petit* mechanic, "so cute under the grime and grease," whom Gide runs into outside the hotel one evening. In a fantasy come true (in that it combines both the availability associated with the youths servicing the tourist industry and an illusion of familial intimacy), the boy takes Gide to his home and introduces him to his family before walking him back to the Luxor's gardens. As Gide is about to take his leave, the boy takes his hand and draws him into the darkness of the gardens where, for once, we are left to assume sex occurs. It is probably no coincidence this tryst comes to a head after the mechanic has shared the intimacy of his home life with Gide

(recall Ali offering Gide his family's lettuce)—no better stimulus to propel Gide to go the next step. Likewise, the fact that it's the boy who supposedly pulls Gide into the garden leaves Gide feeling absolved, on the psychological level, of the colonial guilt of being the exploiter of an indigenous minor in this scenario of fulfillment.

Despite the apparent ease with which these sexual solicitations take place, right out in the open, Gide is simultaneously made aware, early on, of the dangers and liabilities that accrue to the homoerotics of Orientalism in which he is engaging. In the second week of his stay, a female guest has sought Gide out to tell him of the "great purification campaign" being "vigorously pursued" in Bali, where the governor-general of the Dutch Indies has arrested 125 Dutch citizens, many in high positions, and expelled a number of other foreigners, for practicing homosexuality with the *indigenes* (significantly, this is the only time in the notebook Gide uses the word "*hommosexualité*"—it is as if the threat of disciplinary action is best expressed in the increasingly used medical-psychological vocabulary distinguishing "homosexuals" as a type—the use of which, as we shall see, marks a significant moment in Mahfūz's novel). Although Gide concedes this crackdown is meant to protect children, he protests that the age of minority under Dutch law (twenty-one years), is much too high, that many Balinese youth don't know their exact ages, and that they are being coerced through fear into testifying. The result, he writes with rue, is that "an island where, only yesterday, one let each live as one desired" is now overrun by irrational "terror and consternation" (553). Clearly at risk, from Gide's perspective, is not only his desire for youths whose ideal ages seem to range from thirteen to fifteen, but all those non-Western meccas—such as Egypt—where European men like himself have hitherto traveled to act on those homoerotic desires legally persecuted and socially condemned at home. Nor is Egypt immune to such crackdowns. At the end of his trip, having returned to Alexandria, Gide notes "not the least trace of solicitation or prostitution," the result, he learns, of "widespread purges, during the last months, [that have] cleaned out the city" (573).

However much Gide seeks to repress the fact of the privileges that his colonial standing in Egypt confers, the inextricability of his status from his fantasies of erotic reciprocity reaches a psychodramatic intensity just before his vacation ends, on a day characterized by an explosion of the polymorphous plentitude that, as the preceding chapter has shown, writers have so often associated with Egyptian sexuality. Off on a walk Gide reencounters the one gardener who's appealed to him because, unlike his comrades, he seems to be reserved and shy. Like Ali, the youth is carrying greens home to his family, begins to follow Gide, and soon "yields to manifestations" which makes Gide wonder why he ever thought the lad timid. As Gide draws him to the steep bank of the Nile, a rower (shades of the Sudanese boatsman whose advances Gide earlier declined) signals

to them to board his craft; Gide thinks the boy is trailing him, but, in a case of misread cues, finds himself alone on the boat with its rower. Downstream, Gide notes on the terrace of the Savoy Hotel an Englishman whom he'd espied covertly watching some fellaheen bathe nude in the river the day before (thereby deducing this tourist's sexual interests); now the Englishman is surrounded by a clique of boys, "the most beautiful" of whom, Gide jealously realizes, is Ali of his first days. Spurred by rivalry with another white man, Gide is uncharacteristically motivated into decisive action, signaling from the barque for Ali to leave the competition and join him instead. Ali complies, and the rower takes the two out to the middle of the river where, under the latter man's seemingly benevolent gaze, Gide and Ali make love, leading to Gide's ecstatic reminiscence in his journal: "Rarely [such] equal reciprocity of caresses, such equal, extended pleasantness. Not a fault in his body, so young and yet already muscled like an athlete's . . . " (569).

If Gide seemingly has it all here—his fantasy of reciprocity realized in slow caresses with the very adolescent who, at the very beginning of his sojourn, first offered the promise of pastoral bliss—the obvious fact is, as the parallel between his own position and that of the crassly soliciting Englishman on shore makes all too clear, that Gide is reaping the benefit of the tourist trade in available boys: he has to win Ali over from a rival European to realize his fantasy of non-appropriative eros. Be that as it may, the culmination of his conquest of Ali is even more telling. In the boy's company, he disembarks at Karnak, where he is finally "happy" to explore "these stupefying ruins" that he has, he admits, "only imperfectly visited" heretofore (569). One recalls that upon arrival Gide confessed that the colossal ruins of a foreign country mean nothing to him compared to its beautiful youth. Having realized his ideal in Ali, Gide can, at last, appreciate those "stupefying ruins" that, for so many other European voyagers, become in their monumentality emblems of hyperphallicized Egyptian sexuality.

THE CLOSET, COLONIALISM, AND SEXUAL PREDATION IN MAUGHAM'S "CAIRO"

The contradictions of colonialism that subtly infiltrate Gide's encounters with Egyptian homoeroticism are explored in self-conscious detail in Robin Maugham's exquisite but deeply disturbing short story "Testament: Cairo, 1898" (composed 1974), in which the repressive morality that inhibits sexual relationships among British men is set against the apparent ease with which a British soldier finds love with an Egyptian lad. At the same time,

the attributions of polymorphous perversity—from the horrors of child prostitution to erotic sadism—that the narrative projects onto Egypt reveal themselves to be aspects of the colonializing machinery itself. The story is narrated by an unnamed British soldier who, sent to the military hospital in Cairo after showing signs of tuberculosis while on a campaign against Dervish rebels up-country, finds himself increasingly attracted to Ted, the sixteen-year-old soldier occupying the sickbed next to his. Under the lure of British propaganda, Ted has joined the army to escape the oppressive religious environment of his family (the same motivation is given to Tommy, the British soldier in Chahine's *Alexandria . . . Why?*, as we will see). The narrator's relentless gaze lingers on Ted's "delicate" features and "skin as soft as a girl's," filling the narrator with a "pain of longing" and an "impatience to find out the truth" of the youth's sexuality.[6] At sick-leave camp, the narrator begins hatching "plans" (16) to seduce Ted that are initially thwarted by the presence of an unwelcome third in the form of another soldier, George, who literally inserts himself between their two beds and brags of his crude heterosexual exploits in what appears a closeted attempt to turn Ted on and win him from the narrator.

The upshot of these machinations, in which homosocial camaraderie masks a range of unacknowledged homoerotic desires, is the threesome's visit to a prostitutes' den in Cairo's medina, in which the spectacle of naked, barely pubescent girls (echoing a similarly sensationalist scene in the *Quartet* as Justine searches Alexandria's child-brothels for her missing daughter) is heightened by the suggestion of sadistic violence, intimated in the doorkeeper's "silver-handled whip . . . [dangling] like a snake" (17) that he uses to "discipline" the girls. These stereotypically Orientalizing touches, however, tell the reader more about the British soldiers' covert and projected desires than about Egyptians: it is George, whose vitriolic misogyny masks his repressed homosexual desires, who sadistically enjoys using brutal sex to make the extremely "tiny" girl he has chosen scream in fear and "pain" (20), and it is both George and the narrator who harbor pedophilic desires for male youths like the "infant" Ted. For the narrator, who forces himself to go through the act of coitus with the prostitute he chooses lest his own "secret" (18) be revealed, the payoff of this sordid episode is voyeuristic: the chance to spy on Ted in the adjoining cubicle and witness the boy's impotence—"I longed *to know* what was going on" (20; emphasis added), he says to justify his act of surveillance. What he sees gives him the knowledge, or so he thinks, to make his next move, since he takes Ted's inability to arouse himself to be proof that Ted isn't interested in women.

The narrator's seduction scheme, however, badly misfires. He has convinced Ted to slip away from the hospital, without George's knowledge, for a boat ride on the Nile. Under the knowing leer of the old man who, with a younger assistant,

mans the felucca, he proceeds to ply Ted with arrack and takes him inside the boat's tent-like private enclosure. In the glow of the lamplight, his prey appears to his eyes "like a boy of fourteen" (23)—a telling sign of the narrator's latent pedophilia. When he finally makes a move by kissing Ted, the "bewildered" (24) youth freezes, at which point the narrator moves his hand to Ted's groin and Ted reacts with a "violent" thrust of his fist. "You dirty rotten bugger," Ted lashes out, "You're filth. . . . George warned me that you were a rotten bloody nance" (25). Fascinatingly, the narrator's "rage of disappointment" is not followed by some excuse or disavowal of the "sorry, Ted, but you've totally misunderstood me" variety. Rather, rage instantly transforms into a potential for violence as brutal as George's in the child-brothel, for the narrator now threatens to "kill" Ted if the youth doesn't get out of his sight. Maugham is consciously staging, I suspect, a scenario that reveals how the furtiveness surrounding homosexuality within the sexual mores of turn-of-the-twentieth-century Europe inbreeds in subjects like the narrator a degree of calculation, predation, and coercion that can instantly transform "love" into "hate" when the price of a misstep is exposure. In a further irony, we never learn whether Ted's own violent reaction is the result of being too repressed to acknowledge his desires for men, or whether the narrator has been mistaken in his surmises all along.

The rest of the narrative forms a chiasmic inversion of this dismaying state of affairs—at least on the surface. As Ted goes to the front of the felucca to sulk, the narrator joins the native fourteen-year-old boy manning the prow, whose presence he has hitherto barely noticed. As he and the latter youth share cigarettes, the narrator begins to notice the boy's beautiful skin, slight build, and delicate features—the same traits that, in an Aryan version, appealed to him in Ted—and as he "gaze[s] steadily" into the boy's eyes, the youth, named Talaat, gazes steadily back, "watching my eyes as if he expected an order" (26). Gradually—reversing the narrator's moves on Ted—Talaat guides the narrator's hand to his groin. The homoerotics of Orientalism underwriting this scene are clear: as opposed to the repression (or plain fear) that inhibits Ted, Talaat is depicted as being immediately open to the narrator's desires. Little is covert in this world; a few coins given to the old man who owns the boat—and who turns out to be Talaat's master—is all it takes for the narrator and Talaat to disembark alone together. Talaat leads the narrator through a warren of alleys that twist "like serpents" to a hamam where, as the narrator remembers having heard, "desires of almost any kind could be satisfied" (27)—a phrase that hearkens back to the Orientalist trope of the hamam outlined in chapter 2. In a private cubicle inside the hamam, Talaat tenderly washes the narrator before they make love, in a symbolic act of purification meant to position their union—which leaves the narrator feeling "happier than I had ever been in my life" (29)—as the antithesis of the dirty, sordid couplings that earlier transpired in the structurally similar

cubicles of the girl-brothel. Before long the narrator has hatched a new "plan" (30), this one centering on removing Talaat from the clutches of his sadistic master and taking him to England once he is invalided home.

But this narrative instance of repetition with a difference, in which repressed, "fair" Ted is replaced by sexually open, "bronze" Talaat, does not entirely break from the undercurrent of exploitation and shame haunting the first half of the text. As Maugham subtly signals, the pedophilic nature of the narrator's desires is even more pronounced in his desire for Talaat, who, curled sleeping, appears a mere "child" (29), yet whom during intercourse the narrator "pull[s] on to [himself] as if he were a glove" (28). Inevitably, the power dynamics of age, race, and cultural difference mark their relationship. In response to the narrator's suggestion that Talaat come with him to England when he's discharged, the boy's passive response—"You are now my Master . . . I do whatever you order me to" (32)—disturbingly aligns the narrator with Talaat's cruel owner, who has also been referred to by the youth as his (not so nice) "Master" (31), as the vicious lash marks that the narrator discovers all over Talaat's frail body evince. Meanwhile, the narrator begins to doubt the efficacy of his "plan," worrying that Talaat might not "take to life in England" (32)—here one recalls Loti's defensive explanation to Samuel that the latter is too much of a "hothouse" flower to survive in England. Such worries, of course, mask the narrator's anxieties, internalized homophobia, and racism: how will English society take to him, the narrator, in the company of a fourteen-year-old youth of another nationality and skin color? Predictably, then, the narrator's fantasy of everlasting romance crumbles before the reality principle when his attempt to smuggle Talaat on board the ship that is taking the soldier back to England falls apart.

On the one hand, if the narrator's status as a colonialist in uniform has informed his ability to cross racial, cultural, and sexual lines in Egypt, temporarily abetting his fantasy of untainted romance with Talaat, on the other hand, with bitter irony and a "surge of powerlessness," he now realizes that *within* his home culture *he* is at the bottom of the power hierarchy, "an unimportant little trooper": "If I had been rich or if I'd been an officer I'm sure that I could have got that boy on board as my servant" (33). All he can do is promise Talaat that he will return to Egypt, after his discharge, to live here with him—but his promise, he knows, is a lie: he will die of consumption before he can make a return trip. Forced to say good-bye in a café that is too crowded to display any signs of affection beyond a covert pressing of hands under the table, Talaat walks away without looking back: he, too, knows that he and the narrator inhabit mutually incompatible worlds. The attempt to bridge East and West through the power of eros is doomed to failure, in Maugham's "Testament," in face of larger global pressures, as well as the internalized ones that subtly infiltrate and distort both the narrator's and Talaat's conceptions of love and mastery.

"H-O-M-O-S-E-X-U-A-L-I-T-Y" IN THE CITY
NOVELS OF MAHFŪZ AND AL-ASWĀNĪ

How, in contrast to these European texts, have modern Egyptian writers and creators depicted male homoeroticism? The development of the genre of the novel in Egyptian literature is a relatively modern invention, paralleling the periods of Western modernization introduced by colonial rule. Intriguingly, the two Egyptian novels that have perhaps most widely represented "modern" male homosexuality to their readers share a similar form—that of the episodic urban community novel, in which a spatial location (a dead-end alley in one, an apartment building in the other) becomes the crossing point for multiple stories of loosely interwoven lives that, taken together, form a composite portrait of lower-middle and working-class Cairo. In addition to sharing a similar structural format, both these works—Najīb Mahfūz's *Midaq Alley* ("Zuqaq al-Midaq," 1947) and 'Ala' al-Aswānī's *Yacobian Building* ("'Imarat Ya'qubyan," 2002)—dramatize the epochal impacts of colonialism and postcolonialism, respectively, on the cross-sections of social types they represent. In both novels the political resonances of the transformations their communities are undergoing are most starkly allegorized, as Joseph A. Massad also argues, in their homosexually inclined characters.[7]

In *Midaq Alley* that character is the café owner, Kirsha, who is married, has sired several children, but harbors an "unwholesome weakness" for two "perversions"—hashish and handsome young men (55-56). Kirsha numbers among the several colorful inhabitants of the title's cul-de-sac neighborhood, Midaq Alley, "one of the gems of times gone by" now worse for wear that, while seemingly frozen in time in its "isolation from all surrounding activity" (11), is in fact prey, like the rest of Cairo, to the pressures of modernity. If the replacement of the oral storyteller who has for generations plied his craft at Kirsha's cafe by a radio (in response to the demand of its clientele) is one symptom of modernization, so too Egypt's strategic position as a battle zone in World War II has not only increased the colonial presence of the occupying British, but created a war economy that is luring the younger members of Midaq Alley to abandon their traditional neighborhood. "Work for the British Army," Kirsha's grown-up son urges the local barber, "It's a gold-mine that will never be exhausted" (46). Others root for Hitler's success—so too we will see in Chahine's *Alexandria . . . Why?*—in hopes that the war will continue indefinitely, along with the black market that it has spawned, only to be left with shattered dreams when the war winds to a close.

Another effect of modernization, critical to Kirsha's story, is the historic change in definitional status that the male love of youths is undergoing in this period. The preceding chapter detailed how Western observations of Egyptian sexuality often focus on the perceived excess and "infinite variety" of its culture's

sexual practices. The lower-middle and working-class inhabitants of Midaq Alley are no strangers to carnal desire, despite their proclamations of respectability. But from Mahfūz's point of view, interestingly, these everyday denizens seem prone to two excesses of a rather different order: the relish for fresh gossip and the love of money. Both appetites have been fed, to some degree, by the forces of colonialism and modernity, but both are also depicted as age-old aspects of the Egyptian city dweller. Kirsha's predictable sexual debauches with younger men provide, if anything, an enjoyable source for the gossip that bonds the alley's residents into a cohesive whole, even as the café owner's avariciousness and worship of money have increased over the years. In a fascinating example of the linguistic "othering" of sexual difference, the same-sex desire that his community refers to as "his other passion," "his other vice," or "the other hashish," is an open secret in Midaq Alley, so much so that Kirsha no longer attempts to hide his courtships but "indulge[s] his perversion openly" (63). To be sure, while Kirsha's proclivities are presented as a quotidian fact of Cairene life, one deviance among many, Mahfūz also demonizes the café owner through the deployment of common stereotypes: Kirsha's hashish habit becomes symptomatic of a general "weakness" in character that leads to ignoble sexual addiction, and his ogling gaze, relentlessly objectifying his prey, shines with "a faint glint of evil" (his lower lip also droops, like that of a drooling pervert).[8]

Some of this ambivalence also filters into Mahfūz's use of male homosexuality as a historical marker. On the one hand, Kirsha's same-sex proclivities demonstrate a continuity with the past, linking him to a traditional masculine "type" in Arab culture (the lover of youths who considers his bisexuality a male privilege). On the other, Mahfūz subtly positions Kirsha's desires as the antithesis to modern nation-building, which depends on abjuring those archaic customs (sexual and otherwise) that stand in the way of independent statehood. For the narrative makes a point of the fact that Kirsha, having taken an active political role in the rebellion of 1919 and in the reform elections of 1924–1925, has grown disillusioned with radical politics over time, cynically deciding to "wed commerce . . . [and] become the supporter of whoever 'paid most'" (160). In effect, he has abjured political passions for financial and carnal ones that serve his individual needs at the expense of the collective whole ("All the spirit of the old revolutionary was gone . . . now he cared only for the pleasures of the flesh" [160–61]). The only political rhetoric he voices these days is used to seduce his most recent object of desire, a clothing store employee to whom Kirsha hypocritically expresses a pious concern for "exploited workers" (58). In fact the only thing on his mind is sexually exploiting this particular worker.

The degree to which male homoeroticism is a tolerated if not wholly condoned aspect of Cairene male culture is evident in the responses of Kirsha's family and neighbors to his latest infatuation. When his wife begins to suspect he is up to

his usual "dirty habits" (83), she is more irate about the public display of his paramour in the café than about the "habit" itself: "She knew that everyone else knew," only refraining from accosting Kirsha because "she did not want to cause a scandal for the gossips" (83). Her son, Husain, has a similar reaction, coupled with a sense of male privilege that he shares with his father:

> His father's misconduct did not concern him in the least. All he objected to were the scandals and disgrace his father caused. . . . Indeed, when news of it first reached him, he merely shrugged his shoulders in indifference and said unconcernedly: "He is a man and men don't care about anything!" (84)

When a neighborhood elder, Radwan Husaini, is asked by Kirsha's wife what action to take, his pragmatic advice is revealing of the community mores: "Don't make yourself and your husband a subject for the tongues of gossips. A really good wife acts as a close-fitting veil over all those things God might wish to keep concealed" (102). Scandal and gossip, however, are the forté of the alley, so when Mrs. Kirsha can no longer contain herself and publicly attacks her male rival in the coffee shop, the customers "thoroughly enjo[y]" the "spectacle" (110). Speculating about whether or not the cowed youth will return, the alley's dentist replies, knowingly, that if he doesn't "another one will." That is, he knows that Mrs. Kirsha's outburst will not alter her husband's proclivities; the community accepts his desires as yet one more of the compulsions that afflict all sinful humans. Occurring in a novel whose various subplots by and large center on issues of heterosexual courtship, seduction, and marriage, Kirsha's homosexual exploits thus turn out to be an element contained *within* the familiar structure of the wedlock-as-deadlock plot, the repeating "hitch" in the ongoing story of the entertaining if depressing public spats between these two spouses.

At the same time, however, Kirsha's commonplace deviance also marks something new. As Sheikh Darwish, once an English teacher and now the alley's walking dictionary, intones at the ignominious climax of Kirsha's affair, "It's an old evil. In English they call it 'homosexuality' and it is spelled H-O-M-O-S-E-X-U-A-L-I-T-Y" (114). On the one hand, he recognizes this perversion as "old," with deep historical roots in Muslim Arab culture. On the other, in spelling out the Western nomenclature marking a sexual identity rather than sexual practice, he introduces the novel's Egyptian readers to a "modern" formation of sexual identity that in time will displace the sense of masculine prerogative that has allowed Kirsha to penetrate whomever he desires, male or female, with relative impunity. This shift in sexual taxonomy can be measured in the differences between Kirsha's characterization and that of Hatim Rasheed, the "representative" homosexual in 'Ala' al-Aswānī's *The Yacobian Building*.

Set in the 1990s, this allegory of the failed promises of the postcolonial Egyp-
tian state after the 1952 Revolution—an instant best seller subsequently made
into the most expensive movie ever produced in Egypt—focuses on the frustrated
lives and broken dreams of the inhabitants of the once-elegant, now-down-on-
its-heels European-styled apartment of its title. Among those still living or main-
taining offices in the Yacobian Building are aged prerevolutionary aristocrats, a
corrupt politician's secret wife, the doorman's idealistic son, the impoverished
families that crowd the storage sheds on the rooftop, and Hatim Rasheed, the
cultured editor of the French-language Egyptian newspaper *Le Caire*, a character
whose homosexuality created a scandal upon the novel's publication. As opposed
to Mahfūz's Kirsha, who represents a traditional variation of acceptable if dispar-
aged deviance, Hatim is a modern "homosexual," in Sheikh Darwish's terms.
A loner and confirmed bachelor whose seduction as a nine-year-old by a Nubian
family servant has early on "fixed" his passive homosexual desire for rugged
types, he maintains two entirely separate lives: he is the epitome of professional-
ism by day who, by night, picks up men among a community of like-minded
souls that frequent a downtown gay bar. Tellingly, al-Aswānī chooses to make
Hatim half-European and half-Egyptian, as if his European heritage helps
explain his sexual difference; indeed, Hatim's aristocratic bearing and European
savoir-faire (indicated by his job as editor of a French-language newspaper) are
tied to the delicate "elegance" in his mien that borders on effeminateness—from
the "practiced touches" with which he "bring[s] out the feminine side of his
beauty" to his "happy coquettish laugh."[9]

Unlike Kirsha, a swarthy Egyptian whose essential masculinity even his wife
admires, Hatim exemplifies a once-common gay stereotype, that of the feminine
queer who moves in a secretive world of queens who call each other by female
names and who can't shake an internalized sense of shame for the "covert, sinful
desire[s]" (76) that compel them to compulsive nightly prowls for the passive
anal gratification that drives Norman Mailer's ancient he-men to distraction.
The narrative subplot involving Hatim also moves to a stereotypical ending.
The former peasant and married ex-serviceman who has become Hatim's lover,
Abd Rabbuh (familiarly called Abduh), is the epitome of masculinity, his "broad,
dark chest covered with a forest of dark hair" (78) almost comically evocative of
Critchfield's descriptions of Shabbat and Durrell's of Narouz. But even though
Abduh's role as the active partner in the relationship allows him to maintain
his claim to masculinity, he instinctively knows that Hatim's financial largesse
renders him powerless to leave, feels demasculinized by his wife's unspoken
knowledge of his dependence on Hatim's "favors" (156), and fears God's eventual
retribution for practicing this "forbidden" love (134). Thus finding his sexual
identity increasingly imperiled by the affair, Abduh murders Hatim in a fit of
remorse brought on by the tragic death of his son (and hence a further loss of

his claim to heterosexual patrimony). Within the novel's symbolic structure, as Massad writes, progeny represent Egypt's only hope of a better future, and the dovetailing of the son's death and the tragic end of Hatim and Abduh's affair figures homosexuality as a deterrent in the advance of national identity. Nonetheless, despite the thematic ambivalence accompanying Hatim's characterization as a "modern" gay subject, the novel's tone remains relatively objective and nonjudgmental,[10] facts in no small part responsible for the furor this subplot created. Simultaneously, as in *Midaq Alley*, the very form of *The Yacobian Building*—presenting a sociological cross-section of intersecting lives in a fixed geographic location within the urban landscape—works to justify the inclusion of a homosexual character as part of its realist texture.

EPIC AMBITIONS REVISITED: CAMP MONUMENTALITY IN CHAHINE'S CINEMA

In contrast, Youssef Chahine—Egypt's most acclaimed film director with a career spanning fifty years, whose bisexuality was unabashedly on display in his films (and who collaborated with Mahfūz on one screenplay)—does more than include the occasional homosexual character in his scripts as a nod to social reality. In his hands, male homoeroticism subtly but powerfully infuses multiple registers of the autobiographical films comprising his "Alexandria" quartet—and if this sobriquet calls to mind Durrell's *Alexandria Quartet*, the two masterworks also invite comparison in terms of authorial ambition, stylistic bravado, and sheer size. Likewise, both Durrell and Chahine use the enveloping presence of metropolitan Alexandria in all its teeming variety to trigger acute explorations of states of masculinity and sexual identity. But telling differences exist between the two as well, differences that shed light on the homoerotics of Orientalism. Most notably, the contradictory valences that make Alexandria such a rich if unnerving site of self-exploration become the wellspring of sexual energy and creative inspiration in Chahine's quartet, rather than, as in the case of Durrell, the cause of the protagonist's impasse. Looking at how Chahine incorporates male homoeroticism into his Alexandria films forms a fitting summation for this and the prior chapter, for his use of cinema's visual and aural languages to imply homosexuality's existence as part and parcel of Egypt's heritage, as well as part of his personal identity and politics, speaks to and revises the representations of Egyptian homoeroticism, both fantasized and observed, in European accounts ranging from Flaubert and Gide to Durrell and Mailer. At the same time, Chahine's films neither merely form a riposte to "Western" visions of the "Orient" nor simplistically

cast the West in the role of "Other." Rather, Chahine incorporates into his plots an unresolved dialogue of never-pure notions of East and West as part of the complexity of Egyptian reality, identity, and desire itself.

These complexities are foregrounded in the quartet's initial film, *Alexandria . . . Why?* (1978), which became the first Arab film to win the Silver Bear and Grand Jury Award at the Berlin Film Festival. The self-reflexive story of a sixteen-year-old protagonist, Yehia (Chahine's fictional stand-in for his younger self), *Alexandria . . . Why?* sets Yehia's passionate yearning to become a Hollywood actor and director against the uncertain fate of Alexandria in 1942, as Allied occupiers brace against Rommel's seemingly unstoppable advance ("Alexandria, you are in my hands!" Hitler declares in inserted newsreel footage, underlining the degree to which the city is at the mercy of contesting European powers, with some Alexandrians candidly wondering whether German masters might be preferable to British ones). From the opening frames—in which panoramic shots in Technicolor of beachgoers basking on the beach below Alexandria's famed Corniche are unsettlingly spliced with black-and-white footage of European cities under aerial bombardment and extracts from an Esther Williams swimming extravaganza—the film highlights the diversity, open-endedness, and profusion typifying Alexandria and its inhabitants. If Flaubert upon landing in Alexandria finds himself "gulp[ing] down a bellyful of colors" and, as his journey proceeds, feels his "poor imagination" dazzled by a "bewildering chaos" of sensations going off like "continuous fireworks" (79), Chahine naturalizes such chaos and fireworks as the lived experience of his characters *and* as cinematic aesthetic. Durrell's Darley, one recalls, exclaims upon arrival in Alexandria that its world is composed of "five races, five languages, a dozen creeds . . . [and] more than five sexes" (J 4). Similarly, Chahine's filmic world explodes with multiple genres, cinematic references, plots, languages, musical styles, nationalities, ethnicities, and political affiliations. "No minimalist Sphinx," one film critic wrote of Chahine after his death in 2008, "he believed less was never enough. Embracing a flashy masala of style, he threw everything—ideas, people, whole nations and regions—up in the air for the intoxicated viewer to try to catch."[11]

On the level of genre, the film is a polymorphous amalgam of Italian neorealism, Hollywood extravaganza, Fellini-like autobiography, magical realism, broad farce, domestic comedy, melodramatic romance, Golden Age Bollywood, and (via inserted newsreels) documentary. The soundtrack is just as polyglot. An Egyptian female singer's cabaret song (in Arabic) is counterpointed by a drunken British soldier's rendition of "There Will Be Blue Birds over the White Cliffs of Dover" and an Aussie chorus of "Waltzing Matilda," while in the upstairs apartment occupied by Yehia's family, the German hit "Lili Marlene" is playing on the radio; Yehia himself has just come home from the cinema with the brassy chorus of "Three Cheers for the Red, White and Blue" accompanying Eleanor

Powell's tap number on board a U.S. naval gunboat ringing in his ears. Arabic speaking characters break easily into French and English; within Chahine's intricate web of interconnected but loose-ended plots, the lives of Egyptians of Islamic, Coptic, and Catholic faiths, Jews and Palestinians, Communist workers on strike, fortune-made Pashas, revolutionary nationalists, and Farouk-era aristocracy twine in and out of each other. Previous chapters have demonstrated how, to some European travelers, such cacophony becomes emblematic of the exotic otherness and the disorder of the Middle East. To Chahine, this medley of simultaneously existing differences is the everyday materiality of a contrapuntally experienced reality—no less exciting or exotic for being everyday—from which future artists, like Yehia, must piece together their imaginative visions.

While difference abounds in Chahine's world, "otherness" in the sense of a fixed opposite to self-identity has no purchase. Hence, the binaries of "East" and "West" common to Orientalism are replaced, in Chahine's vision, not by a reverse Occidentalism but by a series of triangulated oppositions that themselves are ever-shifting. Most immediately, for the war-torn Alexandrians, it is the European West that is riven against itself (with Allied versus Axis powers fighting over Egypt as the immediate prize), but also, within the Allied ranks stationed in Alexandria, there is the potentially conflicting interests of Yanks and Brits ("Do you think the Yankees will help us get rid of the British?" one Egyptian soldier asks another, who replies, "Sure, if it's in their interest"). Other volatile fissures include the relations of the United States and Saudi Arabia (given the huge oil reserves the former has just discovered in the latter), which Egyptians know is bound to have an impact on the future of Palestine, as well as the schisms between the traditional Egyptian Jewry and proponents of Zionist ideology seeking to establish a home state in Palestine. Likewise, the capitalist interests shared by British and Egyptian magnates pit them against the Marxist Egyptian workers who have gone on strike against their bosses. The Egyptian populace, moreover, is split between royalists who support the waning monarchy and radical nationalists who support democratic ideals.

Within this complex system of shifting alliances and differences, Chahine does not represent British colonialism *solely* as an evil to be resisted or expunged (although this doesn't mean that Chahine doesn't also advocate for an end to decades of British occupation, an end that various characters in the film actively scheme to bring about in both dramatic and comedic subplots). Rather, by resisting the binary of colonizer and colonized, Chahine depicts modern Egyptian subjectivity—particularly as filtered through his alter ego Yehia—as inherently polyglot and inevitably transnational. Yehia's education at the elite Victoria College ("the best British education in Egypt," his mother likes to brag), like his love of splashy Hollywood spectacles, his desire to study acting in the States, and his upbringing as a Catholic rather than Muslim (Catholicism itself a minority

form of Christianity in Egypt), are not simply signs of cooptation by some insidi-ous "West" but are by-now-legitimate strands contributing to Yehia's and other Egyptians' inevitably polysemous complexity as subjects of the modern world. Such a flexible identity construction, Chahine implies, is the fortuitous product of the historic commixtures that Egypt has always embodied as a crossing point of multiple cultures, ideologies, and beliefs.

These complexities are apparent, as well, in the film's most overtly homo-erotic storyline: the relationship formed between Yehia's aristocratic uncle, Adel, and a young British soldier, Tommy Frisken. Interestingly, this story of British soldier and native Egyptian "in love" reverses the power dynamic of colonial-ist/colonized most often represented in Western literature (as, for instance, in Maugham's "Testament"). In the latter relationship, as we have seen, the Brit-ish soldier-narrator is the adult, dominant partner, while the adolescent Talaat remains doomed to serve various "masters." In Chahine's reformulation of the star-crossed romance of East and West, however, Adel not only possesses all the power (of money, status, age) but is the aggressor who literally holds the passive Tommy's fate in his hands. That Tommy is a pawn trapped within machinations beyond his control—as well as the eroticized object of the gaze—becomes clear in the scene in which his character is introduced. On the eve of his posting to the front, the unhappy Tommy—who looks nineteen and whose blonde hair and sky-blue eyes mark him as stereotypically Anglo-Saxon—has gotten outra-geously drunk in the nightclub located on the ground floor of Yehia's building. In the background, a female Egyptian singer on stage croons, "I love your uni-form," to the various servicemen, British, Australian, and Egyptian, patronizing the club. Stumbling from one table to another, Tommy catches the attentive gaze—then plops down at the table—of the Egyptian man who manages the club. As Tommy drunkenly rambles on, an associate of the manager suggests, "Why not wrap him for Adel Bey?" Adel Bey, it appears, "wants an officer from New Zealand" and will pay dearly for him. This enigmatic statement, like the manager's initial gaze, seems rife with sexual innuendo until we learn, in a later exchange, that Adel "buys" these soldiers in order to "kill" them—his version of counter-colonialist politics. Yet the possibility that Adel's "purchases" might also be erotically motivated is suggested in the gustatory image used by the intermediary who telephones Adel to tell him that Tommy, who has passed out in the bar, is ready to be spirited away: "Bon appétit! . . . New Zealand meat!" (he neglects to inform Adel that Tommy is neither an officer nor New Zealander).

The erotic frisson also continues on the visual plane as Adel drives off with his prey. As he prepares to execute the soldier, Adel—whose sharp suit and tie distinguish him in terms of class from the conscripted soldier—drapes Tommy's prone body over a railing, buttocks provocatively tilted upward. Before Adel can fire his pistol, however, the youth's unconscious body slides off the railing. Adel's

FIGURE 5.1. **The classic Hollywood clinch.**

Image from Chahine, *Alexandria . . . Why?* (1978). MISR International Films, Egypt.

attempt to prop Tommy up transforms into an embrace, captured by the camera in a close-up that evokes the classic Hollywood clinch. Shot from just behind Adel's shoulder, the camera focuses on Tommy's unearthly beauty as he comes to consciousness, his cheek resting against Adel's and his hands grasping and stroking Adel's back (fig. 5.1). Ironically, given the situation, Adel admonishes Tommy to "behave like a man," only immediately to ask, as if compelled to recognize Tommy is hardly a man, "how old are you?" At this point, Tommy loses his grip on Adel's shoulders and slides down Adel's body to a kneeling position in front of him, creating a visual tableau that, in a pornographic context, would suggest fellatio. At exactly this moment, the camera tilts upwards at Adel's face, now fully lit as he gazes downward at Tommy with unspoken but potent desire. Passion and politics come to loggerheads for the desiring Egyptian subject of this revisionary story of colonial erotics.

Chahine continues to use the camera to imply the subplot's homoerotic subtext when Tommy wakes up the next morning to find himself in Adel's bed. Lying on his back, shirt open to reveal his chest and washboard abs and his trousers removed, Tommy is framed in close-up as the camera pulls back in a cinematic tease that reveals his white army-issue boxers and splayed legs; his body is clearly the object of both the camera and Adel's gaze (fig. 5.2). As the camera continues to pull back, moreover, Adel's phallic gun appears on screen left, pointing at Tommy's torso from where his captor sits in a chair at bedside

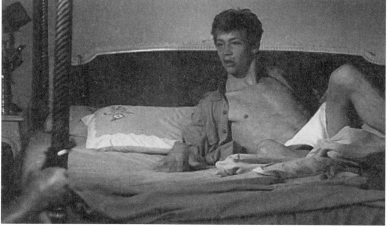

FIGURES 5.2 AND 5.3. **Cinematic striptease at gunpoint.**

Chahine, *Alexandria . . . Why?*

(fig. 5.3). Adel's enigmatic explanation to Tommy's bepuzzlement, "I bought you for a hundred pounds," is followed by Tommy's nonsequitur, "Who took my clothes off?" This exchange implicitly links Tommy as an object for sale and his near-nudity. "I did," Adel responds, explaining "I didn't want my bed soiled with your boots"—an insufficient answer if ever there were one, since the boots could have easily been removed without taking off Tommy's pants. Chahine immediately cuts from this scene to the lovemaking of Ibrahim, a Muslim student radical, and Sarah Sorrel, daughter of one of the most powerful Jewish powerbrokers in Alexandria, as air-fire strafes the night sky. Since both of these subplots feature an intimate encounter between different cultures (Egyptian and

British in one, Muslim and Jewish in the other) and are set against the backdrop of the war, this juxtaposition implies that the relationship between Adel and Tommy is as erotically and romantically driven as the one between Ibrahim and Sarah is explicitly so.

When we see the two men the next morning, they are casually having drinks by Adel's swimming pool, as if the best of friends and as if Tommy had never been Adel's captive (the surreality of this return to "normality" is accented by the fact that on the same terrace Yehia, Adel's nephew, is rehearsing a musical number for an upcoming school production in which his buddies, some clad in short-shorts, are learning how to dance in a chorus line!). "To you," the two men toast each other in turn, after which Adel facetiously bemoans the fact that he didn't kill Tommy at first sight (the implication is that "at first sight" he has instead fallen in love): "I should have never asked you your name, offered you my bed, never spent the whole night . . . looking at you." The erotic tenor of a love that doesn't quite speak its name in these lines resurfaces in the form of a joke moments later, when Adel's crassly nouveau-riche brother-in-law, Pasha Chakar, arrives at the pool. Tommy has no need to worry, Adel quips in an aside, since the avaricious Pasha is avidly pro-British: "Seeing you, he'll probably sit you on his knee and pat your silly little backside." Again reversing the power dynamic encoded in Maugham's allegory of colonialist homoerotics, Tommy is clearly the bottom (or "silly little backside") in this world, both as object of desire and as Adel's inferior in terms of civilization, class, and wealth ("For a bunch of wogs you're living it quite high," Tommy rags Adel; Adel responds that Tommy's ancestors were cannibals while his Egyptian forebears were busy creating civilizations).

The two men's parting is crossed with the ambivalences that inevitably accrue to the relation of East and West, of British soldier and Egyptian nationalist at this historical juncture. "I've no one closer than you, now, have I?" Tommy says when Adel drives him back to his base to report for duty. As the two sit in Adel's car outside the base, deferring the moment of separation, Tommy asks Adel if he really ever killed another soldier and Adel replies in the affirmative, adding with tender wryness, "but with you patriotism did not prevail." In a crucial challenge to the binary between feeling and patriotism that Adel articulates, Tommy retorts that Adel's claims to patriotism are in fact a cover for his sexual desires, in what becomes the film's most explicit articulation of the homoerotic tenor of this "colonial" encounter: "Killing a few blokes won't hinder the British occupation. You did it for your own vicious pleasure *and just sex*. That's what it was. Better you should have cared for them, as you did for me . . . lonely as I was, or for that matter, *as you are*" (emphases added). But Tommy's universalist appeal to love—which Chahine on one level embraces—simultaneously falters on its own recognition of the gaps that exist as long as history places him on one side of an

assumed divide and Adel on the other. For as Adel admits his loneliness—but "not now, *because of* me," fervently responds Tommy—the youth's attempt to make individual love the solution that bridges difference comes up against the verbal limits imposed by economically, historically, and nationally inflected constructions of identity: "I may be a nothing, from the [lower-class] side of Dover . . . but I am still British. I may be . . . oh shit . . . I don't care what I'm called. I only care to care. I care to tell you. You're a son of a bitch." The two seem to separate in anger as Tommy leaves the car—caught in the "not yet, not now" impasse that E. M. Forster dramatizes at the end of *A Passage to India* when Fielding and Aziz fail to connect. But as Adel, his face lit with admiration at Tommy's pugnacity, murmurs to himself, "And I care to tell you, you are divinely vulgar," Tommy at the last moment looks back, over his shoulder, smiling the slightest of smiles as he disappears into his regiment's headquarters.

Indeed, Chahine hints that the men's relationship continues to deepen in absence. A scene follows in which Adel, alone in his bedroom, takes his much fetishized pistol and an envelope from his nightstand as he lies face upward on the bed. The first impression—that Adel has received word of Tommy's death and is about to commit suicide—is quickly overturned, however, as a voiceover repeats the words of the letter as Adel reopens it and gazes at the enclosed photograph of a shirtless Tommy with some buddies on the front: we realize that Adel is enacting words that are already familiar to him rather than preparing to kill himself, and that these words fill him with as much hope as despair. "I can just see you," Tommy writes, his words uncannily recalling Flaubert's epistolary envisioning of his friend Bouilhet in a similarly masturbatory reverie, "stretched out on bed, revolver in hand, reading this letter, panting in emotion. Everything is okay with me now. The shadow of death is away from me. I'm just as alive as you and the rest of the world, full of frustrated desires." At the end of the scene, Adel puts a silencer on his gun and fires it into the pillow next to his. The latter action remains unexplained, but one senses it expresses both his frustration at not being *with* Tommy (for Adel too is one of those "alive . . . [and] full of frustrated desires") and his symbolic attempt to "kill" the emptiness left by Tommy's absence from his bed (as opposed to a symbolic attempt, say, to kill his love for Tommy itself).

Ironically, Tommy's laconic observation in the letter that it is always the "poor bastards [like me] that are *dying* for a puff [of a cigarette]" while the officers, "stinking aristocrats like you," are the ones who chain-smoke to their heart's desire, literally comes true; Tommy goes missing in action, and after V-Day Adel learns that the boy who assured him "I'm not the dying type" indeed died at Al-Alamein, shot down in the decisive battle where Montgomery halted Rommel's march on Alexandria. As Adel kneels at Tommy's grave at the Al-Alamein memorial cemetery, Chahine self-consciously links the wide-scale devastations

and individual losses occasioned by the war by juxtaposing earlier footage of a vibrantly alive Tommy and newsreel images of bombed-out cities: the political and personal are linked parts of the same existential conundrum. Meanwhile, the soundtrack swells with a clashingly upbeat, brass-band version of the ballad Tommy drunkenly belted out in the cabaret, "There Will Be Blue Birds over the White Cliffs of Dover," and the surreal incongruity between soundtrack and panning shot of thousands of identical grave markers makes the moment of Adel's individual mourning all the more poignant.

Within the history of contemporary Egyptian cinema and its frequent censorship (to which Chahine was no stranger), this 1979 film's sympathetic representation of two men's love was groundbreaking.[12] Insinuated as much by facial expressions, camera angles, and mise-en-scène as by what is actually said or graphically depicted, the homoerotics of Chahine's representation is subtle but palpable. With his inversion of the expected power dynamics of an erotic relationship between colonizer and colonized, the director deftly ties Adel and Tommy's tragic romance to the larger politics of national identity, international relations, and dissolving binaries that run throughout *Alexandria . . . Why?* This romance, of course, is only one subplot (albeit an important one) among the plentitude of plots making up the film, whose primary storyline tracks the maturation of Adel's teenaged nephew, Yehia, who dreams of becoming an actor. What is equally fascinating, if hitherto unnoted, about *Alexandria . . . Why?* is the degree to which Chahine suggestively, self-reflexively, inserts suggestions of homoeroticism in this dominant narrative thread as well. An irrepressible fan of musical cinema—the splashier the better—Yehia expresses a sensibility that, in contemporary parlance, is "camp" and a personality that is as infectious as it is irresistible. His comically exaggerated, larger than life reactions to the "big" events that mark his youth are expressed in a similarly camp idiom. Whether putting on the school musical (whose politically unstable parody of goose-stepping Nazis, Chianti-guzzling Brown Shirts, and bumbling G.I. Joes flies in so many directions that it leaves the heads of its audience spinning), or delivering over-the-top monologues from *Hamlet* to his classmates and friends (fig. 5.4), or staging a spectacular theatrical flop funded by one of the royal princesses (which ends with Yehia in glittering jacket dancing to an emptied audience, tears in his eyes, before he unmanfully swoons in a faint), or shrieking at the top of his voice and flapping his hands all over the place as he dances across the desktops of his coworkers when he learns he's been admitted to the Pasadena Playhouse—Yehia is the quintessential drama queen, whether he knows it or not.

The film's very first image of Yehia reveals him standing mesmerized before a poster advertising "Stairway to Heaven" as he prepares to enter the cinema. After the show, when his buddies suggest that they pick up some girls, his discomfort is clear, and he lamely opts out by saying he needs to see the film again,

FIGURE 54. **Yehia's campy** *Hamlet.*

Chahine, *Alexandria . . . Why?*

in case he "missed a few things." If the humorously played scene is meant to suggest that the one "true love" in Yehia's life is cinema, the dialogue leading to his quick escape from his buddies marks the fact that his interest *isn't* in girls or sex, which he proclaims "a repulsive subject!" Indeed, his immediate response to the idea of cruising for girls en masse is the hysterical, "Now? In front of each other?" followed by the cry, "I can't!" "Indeed you can't!" jokes his best friend Mohsen, to whom Yehia responds in kind, "Look who's talking!" (Not coincidentally, these two youths share one of the most deeply felt relationships in the film; if their bond appears chaste, so far as Chahine chooses to depict it, it is one nonetheless tinged with intense, eroticized emotion.) On another afternoon, riding around with his friends in Mohsen's car, Yehia undergoes a similar bout of sexual panic when one of them solicits a prostitute, who crawls into the back seat to service the impatient Lotharios before flouncing off in a huff. Again Yehia melodramatically moans, "I'll never be able to do it! I can't!" (Luckily, Yehia is seated in the front seat with Mohsen, who looks as uncomfortable as his friend, and thus neither is called into action before the prostitute angrily exits the backseat.) What might be called Yehia's "difference" from the norm is humorously accented yet once again as his friends berate him for not showing up at a party the night before—he is ashamed to attend because he's torn his jacket and can't afford to replace it. To which one of his buddies quips, "girls like you for your dancing, not your silly jacket!" Girls, that is, want Yehia at the party not for his appearance (or as the object of their gaze) but because,

unlike the other boys, he "performs" the more "feminine" art of dance so well and is a nonthreatening partner; similarly, the boys want him there because, as the "neutered" class clown, he's the life of the party.

Curiously, various descriptions and promotions of the movie proclaim "falling in love" to be one of the transformative experiences marking this Joycean "portrait of the artist as a young man." Yet exactly *where* in the film commentators find justification for such a romantic reading is frankly mystifying. The one girl who might represent anything close to a potential "love interest" for Yehia is presented as anything but, given Chahine's scripting of her interaction with Yehia's character. This is Mohsen's sister, who surfaces late in the film when Yehia, now a high school senior, screens for his relatives a short film he's made; if she appears silently infatuated with the budding auteur, Yehia only sees, as it were, stars in his eyes and his name on a marquee.[13] Likewise, when she makes her second appearance in the film, showing up at the bank where Yehia's taken a job, and ever so timidly asks whether he's forgotten about "us," Yehia asks about her brother, Mohsen (now in England). Instead of answering her question, he launches into a brilliantly comic riff in which he calculates how many years, at his present salary, it will take to save enough money to go to America to study acting—he estimates he'll graduate at 62 years of age (fig. 5.5). When the sister presses her suit, Yehia again defers by melodramatically quoting *Hamlet*—his existential situation, caught in a menial job when he wants to be a famous actor and director, is *the* predominant "passion" on his mind. "To be or not to be," indeed, is a question subliminally marking Yehia's sexual desires. As such, Chahine subtly codes Yehia as, if not overtly gay, an artist of a "different" persuasion, one whose calling and passion exist *elsewhere.*

Yehia in fact does go to America, at film's end, to study at the Pasadena Playhouse: and, as Glenn Miller's "Moonlight Serenade" fills the soundtrack, the final image depicts him on deck as his boat passes the Statue of Liberty—that monument to the American Dream. Looking at the camera, the Statue's face suddenly comes alive, and she winks with a sluttish look and flashes a gap-toothed smile as she lets rip a ribald laugh before the credits roll (fig. 5.6). "Monumentality," as we have already seen, is a trademark of Occidental projections of Egyptian eroticism; inversely, Chahine pokes fun both at the monumentality associated with America and his young protagonist's epic quest to reach its shores in order to fulfill (so he naively believes) his passion to become a famous actor, which is his version of the American Dream. But Chahine also spoofs his own over-the-top gargantuanism, so apparent in this film's *overflow* of excess stories, characters, and themes, and as such anticipates the messy excess of the succeeding films that continue to tell the story of the adult Yehia as he becomes a renowned filmmaker in Egypt and abroad.

While there is a poignant gay interlude between the middle-aged Yehia and a young English chauffeur in the second film in the series, *An Egyptian Story*

FIGURE 5.5. **Yehia's version of straight romance.**

Chahine, *Alexandria . . . Why?*

FIGURE 5.6. **Spoofing monumentality, East to West.**

Chahine, *Alexandria . . . Why?*

(1982; its French co-title is "Le mémoire"), more germane in terms of the themes this chapter has been tracing is the third film in what, until 2004, appeared to be intended as a trilogy: *Alexandria Now and Forever* (1990; "Alexandrie encore et toujours").[14] Directly spoofing its own pretensions of epic scope (particularly pronounced in a fantasy sequence in which a much older Yehia, now a successful director, imagines a filmed musical version of the life of Alexander the Great) while reveling in its own hyperbolic excess, *Alexandria Now and Forever* is also the most queer, in multiple senses, of Chahine's oeuvre. The triggering event for all the subsequent action is a crisis in the love relationship of the twice-married, much-older Yehia (now played by Chahine himself) and his handsome protégé, Amr, the actor who (within the conceit of the film) has played Yehia's younger self in his first film, *Alexandria . . . Why?* and who is slated to star as Hamlet in Yehia's next film project. Worried about the damage that "gossip" (seemingly rumors about his sexuality) in fan magazines might do to his career, Amr is having second thoughts about his relationship with Yehia. "I don't feel secure. I'll get married . . . have kids," he tells Yehia in a bout of homosexual panic. In a neat visual chiasmus, as he storms out one door, Yehia's wife Gigi enters through another, threatening she'll leave Yehia if he runs after Amr. Throughout the film Chahine presents his fictionalized alter ego's unconventional marriage ("Gigi knows everything about me," he tells a colleague) with the same nonchalance that he jests about his bisexuality ("I'm crazy for boys running about in djellabas like girls, and girls in jeans acting like Rambo").

But there is little casual about Yehia's monumental obsession for Amr, in which questions of identity, reality, and art dangerously overlap; as he tells a confidant, Amr's performance in *Alexandria . . . Why?* "was more me than I am." Having nurtured Amr's talents and shaped his career for ten years, Yehia feels betrayed by his protégé's willingness to troll for "petrodollars," abjuring high art for high-paying television serials. Amr, in turn, feels stifled by Yehia's Pygmalion-like desire to control him and, despite his feelings for Yehia, harbors the desperate need to separate from his "maker" in order to become his own self, even if it means acting in and directing what he admits is "shit." Whatever their unsolvable problems, the depth of love they share even in estrangement is memorialized in an early segment in the film, a flashback in which the two travel together to the Berlin Film Festival to receive awards for best acting and best film respectively. The moment represents their personal and professional relationship at its best, each having been recognized equally by their peers. Chahine pays homage to its ideality in a moment of sheer magical realism when the two exit from the ceremonies onto an empty Berlin street that is clearly a sound stage set. For five minutes, as fake snow falls from above and as the music of "Walking My Baby Back Home" fills the soundtrack, Yehia and Amr execute a choreographed dance number that echoes—amid snow instead of rain—the euphoria of Gene

FIGURE 5.7. **Channeling Gene Kelly.**

Image from Chahine, *Alexandria Now and Forever* (1990). La Sept, Misr International Films, Paris Classics Productions, France and Egypt.

Kelly and Debbie Reynolds in "Singing in the Rain" (fig. 5.7). The self-conscious artifice used in this extended sequence only heightens the viewer's perception of the reality of the emotional intensity once shared by these lovers.

In an interlude in this scene, Yehia recounts to Amr the night that Sir John Gielgud delivered his final performance as Hamlet at the Cairo Opera. In his curtain speech the English actor declared he was passing "the torch" on to whatever younger actor in the audience might become an even better Hamlet, and ever since that formative moment, Yehia has taken himself to be that torch-bearer (Yehia's and Chahine's obsession with *Hamlet* runs throughout all the Alexandria films). But now, he tells Amr, Amr is the better Egyptian Hamlet for the future. Hamlet's limbo of indecision, however, seems more Yehia's than Amr's curse when the latter disappears, leaving Yehia caught in the throes of his obsessive love, unable to act decisively (more shades of *Hamlet*) or move forward without Amr. During a subsequent hunger strike waged by the film-makers' union in which he participates, Yehia seeks solace for his broken heart by beginning a new screenplay—only to find himself writing about Alexander the Great's ascension to power in ancient Egypt, with—inevitably—Amr cast in his mind as its star. Herein unfolds the previously mentioned, ten-minute long fantasy sequence in which Chahine depicts Yehia's script as a full-blown screen musical, with a blonde Amr gaudily decked out in glittery Egypto-Greek drag as

FIGURE 5.8. **'Alexander the Musical' in Eypto-Greek drag.**

Chahine, *Alexandria Now and Forever.*

he is hailed an Egyptian demi-god amid a carnivalesque procession of skimpily dressed backup dancers and musicians (fig. 5.8). "If you could see him through my eyes," Yehia croons in the role of Alexander's lover Hesphastion, "You'll discover he's a sensation." But as Hesphastion's eyes prove, love is blind: Amr-Alexander is a yawning, bubblegum-popping bore, a false god whose elevation depends on henchmen dressed in gay leather-drag and, even more queerly camp, winged bat-boys. The masses revolt (mirroring the strikers in the present-day reality of Yehia's fantasy), and Amr-Alexander literally "falls" from greatness as the elevated platform on which he is being carried topples and he lands in a scummy pond. As Alexander sulkily crawls out of the water, tail between his legs, Yehia-Hesphastion sings, "A fool with love imbued, I got screwed."

Writing this screenplay—which his advisers call "haywire!" and "mental masturbation!"—might seem an act of exorcism, as immediately after the depicted sequence Yehia's interests shift to Nadia, a fiery actress who is one of the hunger strikes' more fervent supporters. Not unlike Mailer's narrative sleight of hand in *Ancient Evenings*, an almost too-revealing fantasy of the ignoble depths to which desire can bring the besotted lover functions as the structural switch point signaling a move from homo- to heterosexual plotting. But nothing, least of all desire, is ever so tidy or categorizable in Chahine's perspective. Nadia indeed, by film's end, emerges as Yehia's new artistic muse, as the idea of a vehicle starring her as

Cleopatra replaces the fantasy of the Alexander film starring Amr, but whether she also becomes Yehia's lover remains (albeit not unlikely) ambiguous. And Nadia's presence in Yehia's life in fact becomes the material means forcing him to wrestle with his unresolved feelings for and obsession with Amr. It is she who takes it upon herself to visit Amr and hear his version of why he has left Yehia in order to become his own person. And it is Nadia who accuses Yehia of joining the strikers to get back at the studio powers and money brokers who have taken Amr from him: what is the meaning of Yehia's stake in the political, she implies, if it only reflects selfish personal ends? Even more pointedly, Nadia charges, "I'm here only to fill the gap he left." If Mailer's plot *enacts* such a principle of displacement, as Nefertiri takes Ramses's place in Meni's affections, Chahine's epic phantasmagoria articulates and exposes the homosocial triangulation underlying such a move, self-reflexively holding the mirror up to its protagonist's sexual politics.

In multiple ways, then, Chahine's overtly autobiographical and implicitly homoerotic Alexandria films both aspire to and achieve an epic monumentality that, as we have seen in chapter 4, underlies the fascination with Egypt and its perceived erotic plenty explored and exploited by writers from Flaubert to Durrell to Mailer.[15] At the same time, the epic scope and breadth of his quartet remains determinedly hybrid in its self-reflexive, half-ironic bid for monumental status: nothing is classically pure about these films, stuffed to the gills with proliferating plots, confusing (and sometimes downright fuzzy) time lines, untidy transitions, wildly mixed genres, and unresolved narrative threads. Little, either, is pure about Chahine's ideological predilections or artistic influences; politics in one form or other—workers on strike, the plight of Egyptian's peasantry, the Palestinian conflict, Algeria in revolution, 9/11—are present throughout his films but often in ways that uneasily rub against and call into question the more personal story lines with which they share screen time. Nor do literary sources heed national boundaries, be it the recurring obsession with *Hamlet* that leads to the singing of the "to be or not to be" soliloquy in Arabic to Middle Eastern music at the opening of *Alexandria Now and Forever* or Chahine's loose adaptation of an André Gide novel into a contemporary parable, in musical form, of the Arab-Israeli conflict in *The Return of the Prodigal Son* (released the same year as *Alexandria . . . Why?*). Given this hybrid poetics, it is fitting, too, that Chahine's depiction of sexuality in his autobiographical quartet challenges boundaries and remains unstable, whether depicting the colonial parameters of homoerotic love in the case of an Adel and Tommy or granting his alter ego Yehia a degree of sexual polymorphousness that, miraculously, passed the Egyptian censors. What remains in this combustive mix is, as Tommy puts it in *Alexandria . . . Why?*, the "care to care," combining a sheer love of homeland, the world, and cinema with the possibilities of visual and textual narrative in order to explore difference without succumbing to rhetorics of otherness.

MODES

and

GENRES

Six

QUEER MODERNISM AND MIDDLE EASTERN POETIC GENRES

APPROPRIATIONS, FORGERIES, AND HOAXES

Ce livre . . . est demeuré anonyme et n'avait jamais été réédité [*This book . . . remains anonymous and has never been translated*].
<div align="right">Anonymous endnote, Le Livre des beaux[1]</div>

Privately Printed . . . for private collectors of erotica.
<div align="right">"Doctor" Pinhas ben Nahum, The Turkish Art of Love[2]</div>

"In Iran we don't have homosexuals like in your country. We don't have that in our country. I don't know who has told you that we have it." So, during an appearance at Columbia University in September 2007, Mahmoud Ahmadinejad responded to a question about the report of executions in Iran of suspected homosexuals.[3] Literary modernism, this chapter suggests, might be able to provide Ahmadinejad with an answer to his bafflement. For the following pages unearth a series of surprising intersections between modernism, homoeroticism, and the Middle East, intersections that cross a variety of topographies of early-twentieth-century literary and popular culture. These paths range from venerable Middle Eastern poetic genres to appropriations by proto-queer European modernists; from anonymous to famous authors; and from turn-of-the-twentieth-century examples of homoerotic photography to turn-of-the-twenty-first-century Taliban studio portraits.

In asserting that Ahmadinejad might have something to learn from modernist literature, I am not talking about European, British, or U.S. modernism but the early-twentieth-century literature of Ahmadinejad's own country. In the well-known "Aref Nameh," an innovative verse satire that appeared in 1921—one year before Eliot's "The Waste Land"—Iraj Mirza, an Iranian poet and advocate of the modern Iranian state, makes graphically clear whom he thinks suffers

from the "curse" of male homosexuality, and he does so in wry verses directed
against a fellow poet and lover of boys, 'Aref of Qazvin (hence the poem's title):

> Oh Lord, what thing is this pedomania
> That plagues Aref and greater Tehrania?
> Why only in this commonwealth
> Does sodomy take place with little stealth?
> The European with his lofty bearing
> Knows not the ins and outs of *garçon*-tearing.

Reversing the dichotomy that Ahmadinejad's rhetoric sets up by declaring
"garçon-tearing" endemic to Iran but foreign to the more high-minded Euro-
pean, Iraj Mirza proceeds to make his polemical and political point: as long as
Iran holds to archaic customs like the separation of the sexes and allegiance to
a decadent monarchy, Persian men will not shed their pederastic predilections
and the nation will remain caught in a regressive past, unable to enter the era
of modernity that Iraj Mirza, as well as many other Middle Eastern advocates of
modernization, associated with European virtues of constitutional government
and heterosexual normativity. Driving his point home in bawdy language worthy
of Abu Nuwas—language whose free-wheeling obscenity becomes central to this
chapter's recovery of a little-known strand of European early-twentieth-century
writing—Iraj Mirza exhorts his fellow countrymen to re-gender their national
and personal preferences alike:

> The cunt's your homeland, the anus too exotic—
> So what's your problem, why so unpatriotic?
> How can you have your motherland at heart
> If you think *kun* [anus] and *kos* [vagina] exchangeable bodily parts?[4]

Obviously, Ahmadinejad disdains the Western values that Iraj Mirza, eighty
years earlier, embraced in the name of modernity, but the two men *do* agree on
one point: sexuality between men has no place in post-Qahar Iran. The rhetorical
difference is that Iraj Mirza sees Iranian homosexuality as a problem in need of
elimination; Ahmadinejad labels it a Western phenomenon completely foreign
to his "motherland." Such a claim, as chapters 1 and 2 have demonstrated, is
belied by the centuries-long legacy of Persian source material, both written and
visual, attesting to the presence of men's homoerotic loves and dalliances in pre-
modern Iran—materials that recent historians of Iranian sexuality, including
Afary, Babayan, and Njamabadi, have made the basis for revisionary studies in the
field. More controversially, the assertion that homosexual behavior is "foreign" to
the region is contradicted by efforts to eradicate not-so-foreign manifestations of

this "phenomenon" from Iran, as well as neighboring Gulf states, by disciplinary measures including execution and documented in a variety of sources.[5]

Behind this tangle of conflicting claims (Ahmadinejad's "we don't have it" versus Iraj Mirza's "yes, alas, we do") lies one of the great ironies in the history of relations between Christian Europe and Islamic Middle East, one whose political and poetic resonances have been highlighted throughout this book: namely, the way in which the condemnatory language used by European commentators for centuries to condemn same-sex practices in the Middle East has now become the rhetoric deployed by Islamic fundamentalists to differentiate their culture from the West, where homosexuality supposedly thrives unchecked. And, yet, sometimes one wonders how much the "enlightened" West has learned by finding itself on the other side of this reversal (a point made by Jasbir K. Puar in her critique of homonationalism in *Terrorist Assemblages*). Viewed from this perspective, the derision that met Ahmadinejad's proclamation at Columbia reveals as much about the modern West's fantasies and misprisions of Middle Eastern sexuality as it does about Ahmadinejad's myopia. A case in point is a photograph that circulated with some frequency on the Internet in the wake of the Columbia incident, picturing Ahmadinejad kissing a fellow Iranian on the lips. The visual punch line plays on the commonplace that those who most vehemently deny homosexuality may protest too much; simultaneously, it allows viewers critical of Ahmadinejad to congratulate themselves for being more liberal minded. Yet this superiority depends on ignoring—or simply not knowing—the cultural mores that make kissing an acceptable expression of male affection in much of the Middle East.

A similar mode of humor operates in the cover illustration of the *New Yorker* (October 2007) depicting Ahmadinejad playing footsie in a men's bathroom stall, which riffs on the Senator Larry Craig scandal (fig. 6.1). However gratifying the exposure of right-wing bigots harboring the desires they condemn, the *New Yorker* cover also unconsciously perpetuates a degree of homophobia by equating closet cases and foreign threats as equivalent objects of ridicule. "Of all the inane comments Ahmadinejad has made," writes Dan Coleman, "it's interesting that the satirists have chosen to focus on this one. . . . [I]s it because sexuality offers an always convenient way to take a political enemy down a peg?"[6] The same might be said of "I-Ran From You," a music video that aired on *Saturday Night Live* and enjoyed a healthy afterlife on YouTube. Despite its no doubt gay-friendly intentions, this mock love ballad verges on xenophobic and homophobic stereotyping when its male singer extols the "butter pecan thighs" of Ahmadinejad and likens him to a "very hairy Jake Gyllenhaal"; meanwhile the visuals imply that this exterior hides a wishfully feminine (read homosexual) inner self, as a cross-dressing look-alike of Ahmadinejad clad in a red evening dress and draped over a grand piano swoons to the vocalist's amorous pleas. Such humor elides an

FIGURE 6.1. **Homophobic humor?**

Barry Blitt, cover art for the *New Yorker* (October 8, 2007). Courtesy of Condenast Publications.

element of truth in Ahmadinejad's otherwise defiantly obtuse denial of sexual diversity, insofar as the historical formation of sexual bonds between men in the Middle East—as the previous chapters have demonstrated—has differed significantly from the West's evolution of sexual taxonomies. Ahmadinejad is hardly a proponent of social constructionism, to be sure, but his avowal that homosexuality per se "does not exist" in Iran is, at least historically and linguistically, accurate.

Are there other ways in which literary modernism might provide some clarification to Ahmadinejad's bafflement? Degrees of Orientalism and homoeroticism commingle in a number of well-known examples of modernist art, from Leopold Bloom's fantasies of Molly in Turkish trousers and Orlando's sex change in Constantinople to Nijinsky's performance as the Golden Slave in "Scheherazade." Chapter 6 narrows this scope, offering insight into the ways in which a handful of innovative early-twentieth-century artists operating outside the penumbra of high modernism participated in, exploited, and responded to the larger paradigm of Orientalist homoerotics explored in this book. These artists encompass

some twentieth-century figures that many students of modernism may never have encountered, such as English aesthete-mystic Aleister Crowley and Dutch Zionist poet Jacob Israel De Haan, some whose names remain unknown, some like André Gide who achieved prominence, and others usually associated with Hellenic rather than Orientalist erotica, such as Wilhelm von Gloeden.

What all these artists share in common is the extent to which they trafficked in the myth of a homoerotic Middle East where male-male desires repressed in the West might more easily find realization, along with the attendant myth of the availability of beautiful youths in such geographies. This subset of queer modernist practice reveals the convergence of three elements. One is the bracing impact of the general modernist rebellion against sexual censorship inspiring these writers to engage in daring, often gleefully graphic descriptions of homosexual activity. Another is the context provided by the burgeoning fields of sexology and anthropology, whose prurient-minded imitators produced innumerable volumes about the "Arabic Orient." Third, and most important, all these writers create self-reflexive, highly allusive texts that imitate or pretend to be examples of centuries-old Arabic, Persian, and Ottoman literary genres, and they do so in order to lend historical authority to their homoerotic imaginings. In particular, the poetic forms of the *ghazal*, the *şehrengiz*, and the *rubbiyat* prove to be crucial to these modernist imitations and appropriations. Sharing significant affinities with these imitations, forgeries, and borrowings of Middle Eastern poetic genres, Gide's ruminations about his Algerian travels illustrate a modernist-inspired transformation of the prior century's tradition of European travel narrative into sensuous prose-poems. Along with these literary texts, this chapter also analyzes the role played by visual modes of representation, particularly turn-of-the-twentieth-century photography, in promoting this queer strand of Orientalist modernism. The conclusion circles back to the contemporary present—by means of an archive of haunting photographs of Afghani Taliban recruits—to demonstrate the continuing resonance of these modernist reorientations as they play out on an international scale today, especially as homosexuality continues to be a touchstone of cultural impasse, forcing Eros to reveal its other face as Thanatos.

MIDDLE EASTERN POETIC LEGACIES

The imaginative work of the early-twentieth-century European queer artists examined in this chapter is not simply the product of unidirectional projections onto other, "exotic" cultures. These imaginative projections, rather, are part of a long history of cross-cultural exchange, in which European access to

information—sometimes exaggerated, sometimes fantastical, but also some-times relatively accurate—about male homoerotic practices and representa-tions in Islamicate culture inspires their artistic endeavors. This flourishing subculture of male lovers and beloved youths, as chapter 1 demonstrated, per-meated to the highest levels of social and political life and inspired a vast liter-ary outpouring celebrating love between males: in poetry, in erotic treatises, in bawdy literature, in the biographies of the great poets and statesmen.

Central to this literary heritage, and at the heart of the modernist appropria-tions of this tradition, is its celebration of the beautiful boy or beloved youth, whose iconic presence was analyzed in chapter 2. To understand the translations that such Middle Eastern genres undergo in the hands of these European artists, a brief review of the key poetic forms centered on the desire for the beloved youth is in order. The popular Persian rubbiyat format—composed of quatrains usually written in AABA format with the end-word of the third line dictating the triple rhyme of next quatrain—typically focused on the epicurean pleasures of life in the here-and-now. Although the rubbiyat may express desire for either sex, the cultural context and gender-segregated settings depicted in these quatrains often meant that the most proximate object of the poet's desire was a male wine server or male beloved.[7] Hence, despite the impression that English translations of Omar Khayyám's famous *Rubbiyat* have given of Khayyám as a legendary womanizer, there is no reason to suppose that the beloved "thou" whom he desires along with his wine and loaf of bread is other than a young man.

The more complex lyric form known as the ghazal, which engaged Arab, Andalusian, Persian, and Ottoman poets for centuries, was dedicated to extol-ling the male beloved's breathtaking beauty and seductive charms.[8] From Rumi to Jāmī to Hafez, the ghazal became *the* form in which to prove one's poetic gifts, largely because of the adroitness with which the talented medieval Persian-Arab poet, Abu Nuwas, manipulated the form. Repeatedly, Abu Nuwas uses erotic metaphor to reinvigorate conventional poetic tropes of male beauty:

From the tangled clothing
Whiteness surprises:
Above the skyline of his waist
The moon suddenly rises! //
See the moon of his face glow
Lit by your lust! Wave, overflow
And flood this lovely garden![9]

In Abu Nuwas's vision, the beloved's white flesh, revealed as his clothing drops away, is illuminated, like the moon by the sun, by the passion burning within the beholding lover. Mustafa Âli mines a similar poetic conceit, using a solar rather

than lunar metaphor, in a ghazal he includes in the autobiographical section of his otherwise dour assessment of the affairs of state in *Counsel for Sultans* (1581):

> O fairy-faced one, throw open your waistcoat with the crossing flaps and
> golden buttons,
> You are an angel, so open [your] wings of light and fly without fear! //
> When the buttons go loose and suddenly uncover the breast
> A resplendent sun rises.[10]

Opened flaps create the illusion of an angel's wings, lit by the brilliance of a body whose illuminating rays hint at more than the sun "rising" below his open waistcoat.

An anonymous Turkish sixteenth-century poem shows how easily these romanticized tropes can transform into sexual innuendo. First apostrophizing the delicacy of the "satin skin" of his "darling boy"—so delicate that even robes made of "rose-petals" chafe him!—the poet shifts from idealizing (and literally "flowery") imagery to the less ethereal desires motivating this paean:

> So fragile is [his] radiant thigh
> It even gets hurt by the morning breeze.
> Men have fought fiercely for his legs and thighs.
> My darling boy's lower half is enough for my eyes.
> Let his beautiful face belong to the others.[11]

In contrast to Abu Nuwas's figuration of the glowing face of the beloved rising like a moon *above* the "skyline of his waist," this poet jestingly trades the "beautiful face" of his beloved for the equally moon-shaped delights existing below the belt, on his darling's "lower half" (round white buttocks are often figured as lunar landscapes in this poetry).

Such carnal declarations are a staple in the tradition of obscene literature and pornographic erotica that also formed a flourishing genre in the pre-modern Middle East.[12] The following lines from Gazali's mock-encomium to the joys of the beloved's anus (*kun*) anticipate the bawdy explicitness this chapter examines in Aleister Crowley's faux-Orientalist poetry:

> Sometimes it opens like a smiling rose, oh *kun*!
> Sometimes it closes and becomes a rosebud lip in wonder, oh *kun*!
> It so appears a silver mug of medicine that
> Fittingly I call it the cure for all, oh *kun*!
> What if cock the dragon always pushes at its edge?
> It is a secret treasure cave filled with gold and silver, oh *kun*![13]

Even closer to the modernist experiments this chapter canvases is the poetic pleasure of cataloguing the range and variety of available beautiful youth that drives the Ottoman genre of the şehrengiz, or so-called "city-disturber," that I have noted on various occasions.[14] The first poet to substitute the more complex ghazal form for that of the four-line rubbiyat in this genre at the beginning of the sixteenth century and hailed by his contemporaries as a great innovator, Sayfī vows in his catalogue of 124 ghazals dedicated to the boys of Bukhārā to drink prohibited wine so that the handsome policeman with whom he's enamored will have to arrest him: "There is no love until I am with my beloved in prison, / I drink wine daily so he can haul me off to jail."[15] In a şehrengiz dedicated to the "heart-ravishers" of Istanbul, Taşhcali Yahya teases the "brilliant Janissary" who's just topped him for being hard to kiss by remarking on his "slender figure."[16] And Ottoman poet Zati, having just sung the praises of some fifty-three beauties of Edirne, claims his effort has only skimmed the surface of the available possibilities:

> I have but limned some droplets from the sea
> Brought some sun motes to visibility.
> Cypress bodies throng this city's earth
> T'would take 'til Judgment Day to tell their worth.[17]

Typically, the genre surveys the gamut of handsome, rambunctious youth of a specific city, but this technique of serial cataloguing goes global—as the next section details—in the work of Fazil Bey, a late-eighteenth-century poet whose şehrengiz plays a central role in an early-twentieth-century appropriation that strategically "reorients" this poetic genre for queerly modernist ends.

IMPROVISATIONS ON AN OTTOMAN ORIGINAL: THE ANONYMOUS *LE LIVRE DES BEAUX*

Fazil Bey Enderuni's *Huban-name* (1792–1793; "Book of Beautiful Boys") is one of five erotic works by this colorful diplomat, administrator, and poet, four of which he composed in şehrengiz form. Fazil Bey's origins may have influenced his fascination with detailing the charms of lads across cultures. Like many handsome youths brought to Istanbul to be trained as pages in the old Seraglio (or Enderun—hence the poet's added name), Fazil was a spoil of war: his father, of Arabic descent and the governor of the Palestinian cities of Acre and Safad, had participated in an unsuccessful insurgency that led to his execution. The head of the occupying Ottoman army was so taken with the good

looks of young Fazil and his brother that the two were presented to the Sultan as tribute-slaves. Fazil rose within the Ottoman bureaucracy to assume various posts, fell out of favor, suffered exile on Rhodes, received a pardon from Selim III, and spent his last years back in Istanbul. His one poetic composition that is not a şehrengiz, the *Defter-i aşk* (1795; "The Register of Love"), is an "amorous autobiography," in Jan Schmidt's phrase, detailing the four great loves of his life, all male and one of whom, the gypsy Çingene Ismail, was a renowned dancer.[18]

The premise for the *Huban-name* is set forth in a frame poem, in which the poet is asked by his lover—metaphorically the "Sultan of the climes of the desolate heart"—to reveal "which nations are filled with the most beautiful countenances of youths, / which have the most beautiful men . . . tell me A to Z!"[19]. Fazil Bey rises to his lover's taxonomic challenge by writing a series of lyrics that reveal the charms not only of Moroccan boys and Greek rowdies, but of British, French, and even New World youths (each beautiful boy is identified by his national affiliation in the poem's title). The manuscript of this verse catalogue in the Istanbul University Library is interspersed with thirty-nine exquisite miniature paintings of such *beaux* (figs. 6.2–6.4; see also figs. 1.3 and 2.19). Each of these visual portraits reinforces the snapshot-like quality of the verses that the miniature accompanies. In addition, the illustrations accompanying the verses dedicated to pink-cheeked European dandies in all their frills and finery (figs. 6.5 and 6.6) demonstrate that the West's Orientalizing gaze was not a one-way street. Indeed, the one poem in the entire manuscript to earn an effusive title description that goes beyond place of origin is the verse dedicated to the British youth, titled "The British Beauty Who Agitates Your Libido."

How does Fazil Bey's *Huban-name* relate to queer permutations of Orientalizing modernism? My initial source—the only one available in a European language—was a slim volume, published as *Le livre des beaux* in a limited edition of 350 copies in Paris in 1909, then reproduced in 1969. While the introduction claims the text is an accurate translation of Fazil Bey's Ottoman Turkish original and gives a brief account of the poet's life, an endnote in the 1969 text mysteriously and contradictorily remarks that "certain people" have attributed the 1909 publication "to Pierre Loti, Pierre Loüys, as well as André Gide . . . [T]his book . . . remains anonymous and has never been reedited."[20]

Robert Aldrich, a historian who also stumbled on this French edition, takes this statement of anonymous authorship at face value, assuming that Fazil Bey never existed and that the volume is a hoax, a pornographic "send-up" of Orientalism that self-consciously uses the form of the lost manuscript—accompanied by pseudo-scholarly introduction and pompous footnotes—to poke fun at European stereotypes of male love in the Muslim East. Thus, Aldrich summarizes, "The book pretends, not very convincingly, to be the work of one Fazyl Bey,

Top row, left to right: illustrations depicting youth of Anatolia, the Christian Muslim West, Istanbul. *Bottom, left to right*: Britain and Russia. *Huban-name* ms. T 5502. Images 1, 4, 5, and 6 courtesy of Istanbul University Library; image 2 courtesy of the Andrei Koymasky collection, the Homoerotic Art Museum.

a contemporary of Louis XIV and Napoleon, translated by 'The Three-Legged Pasha,'" its intent to "satiris[e] and perpetuat[e] European erotic images of the East in the style of soft-core pornography."[21] As the biographical record indicates, Aldrich is wrong on the latter account—Fazil Bey *was*, indeed, a real person, a well-known poet, bureaucrat, and court administrator whose existence is documented in the Turkish record as well as in English histories of Ottoman poetry. The purported source of *Le livre des beaux*, the Ottoman *Huban-name*, as already noted, exists in manuscript form in various libraries, as well as in a transliteration into modern Turkish printed in Istanbul in 1945.[22]

But as a comparison of the Turkish manuscripts and the French "translation" reveals, Aldrich is on target in his surmise that the anonymous editor/translator is an early-twentieth-century aesthete playing loose and easy with the original. True, this French "translator" occasionally borrows random lines verbatim—thus revealing a hands-on knowledge of the original—but he typically bends such borrowings to fit his own poetic conceits, inserting extended riffs and elements of plotting entirely absent in the Ottoman text. The overall result is a series of prose-poems that are far and away the product of his creative imagination. These contemporary additions add a degree of verisimilitude and erotic immediacy lacking in Fazil Bey's allusive, metaphoric style—the latter's portraits are generally universalized types, whereas the French text's "beaux" often become novelistic "individuals" with specific histories and life stories. While there is absolutely no evidence to support the 1969 edition's suggestion that Loti, Loüys, or Gide might have been the volume's anonymous author, the publisher's desire to circulate such rumors, if only as a ploy to sell more copies, attests to the interface between this text's simultaneously modernist, queer, and Orientalist investments.

The most obvious sign of the French text's modern authorship lies in a comparison of the contents of the French volume and the Turkish manuscript. Notably, the French text creates out of whole cloth a number of portraits of boys of nationalities, countries, and cities *not* included in the late eighteenth-century manuscript. These additions extend its Orientalist reach to include the beaux of Ceylon, Java, Malaysia, China, and Borneo. Even more revealing is the fact that the French volume *omits* all the portraits of Western youth who figure as objects of desire in Fazil's "A to Z" taxonomy (including French, Austrian, Dutch, British, Spanish, Russian, and New World boys). Evidently the French author-translator assumed that such Occidental objects of desire were not "foreign" enough to meet the exotic expectations of a select European readership in quest of Orientalist thrills. As such, the French *Le livre des beaux,* as opposed to the *Huban-name*, reveals an expressly European Orientalism. Another suspect element is the pseudonym that the modern volume's introduction gives to *"notre éminent collaborateur,"* the purported

translator working from the original: "*Pacha à Trois Queues*" (LB 16). Literally, the term refers to Turkish nobles who were allowed to use three rows, or lines ("queues") of horses to draw their equipages. But as Aldrich correctly notes and as turn-of-the-century French readers knew, this pseudonym puns upon the fact that "queue" is a vernacular term for "cock." Thus the "third leg" or line of the pasha, dangling as it were between his two other limbs, is his penis.[23] The fact that our "Pacha" is said to be a Turkish native living in Paris and a bibliophile who has disguised himself in an array of native costumes to gather information about the "*beaux de toutes les contrées d'Islam*" (LB 16) provides another hint that the "Pacha" is a fiction, a "front" for the knowing author who has no doubt read his Sir Richard Burton closely.[24]

This trail of evidence suggests that the anonymous begetter of *Le livre des beaux* was a European *belle lettriste* familiar enough with a copy of the actual *Huban-name* to render a convincing imitation; clearly, he is an erudite Orientalist, knowledgeable in the tropes of ghazal poetry, capable of making sometimes telling distinctions among various Middle Eastern cultures and customs. And he's a fairly talented writer as well, creating impressionistic mood pieces in the form of prose-poems that approximate the metaphoric lyricism and arch knowingness of the verse originals.

The opening lines of "The Beauty of Baghdad" give a sense both of the author's familiarity with prior tradition and his tongue-in-cheek self-consciousness, both of which belie the portrait's claim to be a faithful reproduction of the work of Fazil Bey:

> The boy from Baghdad is the Khan of smirks and sugar-sticks.
> His cheek surpasses the fresh rose, and his lips new wine. His curls are of hyacinth and his eyebrow of black ermine.
> He knows the divine *Thousand Nights and a Night* by heart, a book which the Turks have the stupidity of scorning.
> Alas! Where are the Abbasids and my exhilarating precursor Abu-Nuwas? In that epoch, Baghdad was the paradise of poets, jewelers, striplings, and lovers. Now, it's only a heap of ruins. (LB 31)

While the second line repeats the ghazal's traditional tropes of male beauty (cheeks like fresh roses, lips like wine, and so forth)—several of which occur in the much longer opening metaphors unfolded by Fazil Bey—the first line is pure invention, and its sardonic acknowledgment that the city's youngsters are not all hyacinth and roses but adeptly simpering actors puts the conventional description that follows into figurative quotation marks. Likewise, the references to "my exhilarating" (and bisexual) precursor Abu Nuwas and the "divine" *Nights* indicate a self-reflexive use of literary history, a deliberate

establishment of lineage ("*my* precursor"), and a retrospective irony typical of modernist aesthetics (modern Baghdad as a "wasteland" of ruins).[25]

This latter image of Baghdad as a bygone paradise now reduced to a heap of ruins is entirely the creation of the modern author. Further, this mise-en-scène provides the springboard for what becomes the narrator's highly idiosyncratic portrait of the working-class Baghdad youth he claims as his lover:

> But choice adolescents still flow between the ruins, and mine, for example, a carpet merchant from the bazaar, excelling at the art of putting off till tomorrow things that should be done today, wins more money with his idle buttocks than a miller can produce of flour turning his grist-stone always. (LB 31)

The punning analogy between the boy's buttocks and the miller's grist-stone cleverly condenses an anecdote in Fazil Bey's poem, in which the son of a miller who has gone to Baghdad refuses to return home to claim his patrimony because he's found that selling his "ass" in the big city is much more profitable than grinding flour. In fact, this bawdy anecdote is neither original to Fazil nor to his purported translator—a version penned four centuries earlier is included in al-Tīfāshī's *The Delight of Hearts*.[26] What follows for the rest of the portrait, however—the depiction of a sexual tryst between the speaker and the Baghdad boy—is woven whole cloth from the modern author's imagination:

> We became acquainted with each other, he and I, in a narrow alley: there was, at the front of our impromptu chamber, an old wall without window, scaling and rough; and as we rested, he seemed to see in the protruding stone the outlines of figures: there, the beautiful Zummurad, and there, the young jaundiced man, and there the sympathetic adulterer and Princess Nouranhour [characters from the *Nights*]; and our reverie followed their nighttime steps as they traversed the old capital of Al-Rachid, the wild one; his grand vizier, Giafar, uneasy in his thoughts; and the eunuch Massrour who rolls his white eyes. (LB 31–32)

The dream of Baghdad's past grandeur is thus conjured up as a dream itself, a dream shared between sexual partners in a post-coital reverie in a debris-strewn alley where the Baghdad boy uses his imagination to create literary magic from a crumbling wall. This nostalgia for vanished greatness is at once a familiar Orientalist trope *and* a sentiment common to the poetry of the Abbasids and Abu Nuwas; the existential rue in the 1909 speaker's juxtaposition of ephemerality (the tryst) and timelessness (the immortality of art) strikes a

resolutely modernist note. Likewise, the coitus between poet and youth adds a level of erotic immediacy and empathy that, in contrast to Orientalist stereotype, complicates the hierarchies of subject/object. For, in the end, the lyric expression grants the boy an even greater inner life than the speaker—indeed, the last line leaves the reader inside the world of the boy's imagination, in a continuous present where, as the shift in verb tense indicates, Massrour still "rolls his eyes."

The climactic portrait in *Le livre des beaux*, describing the Byzantium boy of Istanbul, captures the melding of the stock images of beauty expected of all Middle Eastern love poetry, the realistic grace notes and glimpses of urban local color typical of the şehrengiz genre, and an almost postcolonial understanding of the melancholies of dispossession and the operation of what Homi K. Bhabha calls native mimicry.[27] In the following lines, the youth—who turns out to be a dancing boy, a profession, as we've seen, associated with sexual availability throughout the Middle East—is following some prospective, lewd clients ("*Francs lubriques*") up the hill of Galata, the Greek and European quarter of Istanbul where, since the establishment of the Ottoman Empire, same-sex trysts between Turks, as well as between Turks and foreigners, most often occurred:

> The Greek boy descended from the Byzantines unites the eternal perfection and precision of form, the grace of ancient times, and a certain modern melancholy.
> . . . As this stripling ascends Galata this morning under the splendor of an azure, sun-filled sky, trailing a group of lewd Franks, one of the latter comments that God must have created the boy from a divine blueprint encompassing all the delicacies born of the Mediterranean.[28] (LB 77)

Imitating the traditional genre's mingling of high and low, the text next juxtaposes its universalizing description of this youth's beauty (his "eternal perfection" unites aspects of the entire Mediterranean) with dashes of local color entirely original to the French text that are meant to evoke his earthy materiality and the immediacy of his daily existence:

> Encircled by blockheads, curs, pickpockets, and Effendis in a string, he holds, from one hand, by its tied talons, a living goose and, in the other, he carries to his violet lips a flaky gateau glistening with honey.
> . . . He has a delicate flaw in his way of pronunciation, though: he can't pronounce "ch": for *Pacha* he lisps *Passa*.
> This is a small blemish, one that makes for piquant ambiguities: for *chic* he says *sik*; so much the better! (LB 77–78)

So much the better because *sik* is Arabic slang for "cock." This pun is another clue pointing to the portrait's European, modern provenance; for the pun only exists if one is speaking in French ("chic" sounded as "sik"). In the original *Huban-name*, the boy mispronounces "shin" as "sin" ("sh" is written with three dots in the Arabic script while "s" has none), leading to the quip: "Do not think his pronouncing of shin as sin is a mistake, it is because there is no more room for dots in his mouth" (line 419). The joke here is entirely grammatical, void of the French version's sexual pun.[29]

In a jaunty tone, the French narrator assures his reader that, even if the market were to suffer a downturn, this cocky Byzantium beauty would always be in demand among his admirers, both Ottoman and Franks. But almost immediately the portrait begins to grow darker, as the narrator moves into the interior viewpoint of the boy himself:

> With reason, he abhors Turks to the bottom of his heart, but he dissimulates with the ease of a jaded diplomat, and he abides peaceably among their symposia of voluptuaries—those sons of Osman whom he wishes God would banish from Grand Constantinople. (LB 78)

The sudden interjection of this boy's hatred of Turks, along with the sardonic reference to the "jaded" profession of diplomacy, permits the narrator to evoke both the Ottoman Empire by which this descendent of Byzantium feels oppressed *and* the practiced (or "diplomatic") arts of disguise that allow the youth to veil his true feelings about the "sons of Osman" who seek out his sexual services.[30] This turn makes for the portrait's final, almost shocking shift in tone:

> If the opportunity were to present itself, he would wrench baby Muslims from the wombs of their mothers: in reality he restrains himself from such ruin, dancing instead in the taverns of Galata for all the bigots of d'Eyoub. (LB 78)

The fact that d'Eyoub (where Loti's narrator, incidentally, establishes his love nest) is a conservative Muslim suburb drives home the point that many of the boy's pleasure-seeking patrons in Galata aren't just "Franks" but in fact are Turks, "sons of Osman." Whatever the overall Orientalizing tendencies of this twentieth-century free improvisation on the şehrengiz original, its portrait of the Byzantium youth provides an acute, even poignant analysis of the psychological workings of colonialism, in this case from the point of view of one of the peoples subsumed under Ottoman rule after the conquest of Greek Constantinople in 1453. The lingering resentments of this conquest

contribute to the "modern melancholy" of contemporary, ethnically diverse Istanbul depicted in this prose-poem (such melancholy or *hüzün* is also central to Orhan Pamuk's memoir, *Istanbul: Memories and the City*[31]), and the residue of this legacy permeates the ambiguous erotics whereby the Greek dancing boy allows himself be the erotic darling of Franks and Muslims alike, as a cover for the profound hatred he really feels. In such instances, the modernist self-reflexivity accompanying this text's homoerotic thematics makes for an unexpectedly keen insight that pierces its Orientalist facade.

ETHNOPORNOGRAPHY, EARLY PHOTOGRAPHY, AND VISUAL EQUIVALENTS OF THE *ŞEHRENGIZ*

The pseudo-scholarly apparatus that accompanies *Le livre des beaux*, including biographical preface and seemingly recondite footnotes, is a trademark of the burgeoning fields of anthropology and sexology from the turn of the century up to the 1930s. Often citing Sir Richard Burton as their inspiration, these texts compose what Schick calls "ethnopornography," a distinctive genre in which citation serves as the pretext for prurient accounts of exotic otherness. The sexual explicitness that characterizes much of literary modernism's rebellion against Victorian prudery gained its traction in part because of the influx of such pseudo-scientific publications into the marketplace, and in part because of those printers and publishers on the Continent interested in profiting from such sexually explicit examples of Orientalist erotica.[32] Boasting titles like *The Turkish Art of Love* (1932), *L'Amour aux colonies* (1893), *The Plague of Lust* (1901), *Moeurs Orientales: Le huis-clos de l'ethnographie* (1878), and *Anthropological and Ethnological Studies in the Strangest Sexual Acts in Modes of Love of All Races* (1933), these texts anachronistically mix source materials from multiple time periods and cultures in order to create the image of a timeless "Oriental sexuality." Significantly, this ethnopornography also included numerous hoaxes parading (like *Le livre des beaux*) as original work: purported translations of ancient Eastern erotica, discovered manuscripts, imprints claiming to have been published in Constantinople by nonexistent presses to lend authority to their specious accounts, and the like.[33]

The Orientalist tradition of the faked translation is not new; Montesquieu exploited the format in *Lettres persanes* (1721), written in the voices of two Persian correspondents traveling throughout Europe; Petis de la Croix produced an entirely fictional "translation" of "found Arabic" tales under the title *Les mille et un jours* (1714) in order to capitalize on the success of Galland's *Les mille et une nuits*. Sir Richard Burton's book of rubbiyat verse inspired by Sufi philosophy,

Kasidah (originally composed in 1850), claimed to be a "found" work of one Haji Abdu. In 1893 Paul de Régla alleged that an old Istanbul scholar gave him the manuscript for his "translation," *El Ktab des lois secrètes de l'amour d'après le Khôdja Omer Haleby, Abou Othman*. Although the evidence of Othman's existence is dubious, the first printing sold over twenty thousand copies and is still cited by some authorities as an authentic source.[34] What is new about many of the early-twentieth-century hoaxes is their degree of sexual explicitness, which owes both to the war on prudery waged by literary modernists and the expanding field of ethnology. What is also new is the range of visual modes of ethnopornography available to such writers and their readers.

From the turn of the twentieth century on, various European entrepreneurs began exploiting the relatively new medium of photography to mass-produce erotic images of North Africa and the Middle East. Such photography often claimed its aims were "scientific," but its primary goal was to cater to Europeans' sexual fantasies of exoticism, as Malek Alloula demonstrates in his analysis of erotic postcards in *The Colonial Harem*.[35] Alloula dwells on the proliferation of images of nude women from the Maghreb, aligning the scopophilic desire to peer inside the harem and the colonial imperative to master the colonized other. Sometimes the results could be humorous, as in the case of the studio of Abdullah Frères in Istanbul. In order to satisfy the European taste for souvenir photographs of Ottoman harem beauties, the studio occasionally dressed up men as women to pose as their subjects, given the reluctance to violate standards of propriety in photographing Turkish women for such purposes (fig. 6.7). Less widely known is the thriving commerce in homoerotic images of Egyptian and North African male youth in the decades that Wilde, Forster, and Gide, among others, were finding sexual fulfillment in these regions. Baron Wilhelm von Gloeden is best known for his vast photographic archive (some 7,000 plates) in which boys of Taormina, Sicily, are posed nude and near-nude in what Roland Barthes identifies as the kitsch trappings of Hellenic antiquity in open-air tableaux.[36] But von Gloeden also dabbled in non-Hellenic modes of Orientalist homoerotica. Borrowing from a long-established practice of commercial photographic practice, the Baron mailed contact sheets of his erotica to his discreet homosexual clientele all over Europe. From such visual catalogues, his customers could select the images they wanted to purchase. Although such photographs were originally slated for private collectors, Gert Schiff notes that they quickly "found their way into the most respected periodicals dedicated to photography, art, or ethnology," making von Gloeden a rich man.[37]

These contact sheets serve as modern-day *visual* equivalents of the poetic genre of the şehrengiz, offering a catalogue, in pictorial rather than poetic form, of the supposedly available boys of the Middle East. Each individual image is crafted to suggest a story in which homoerotic desire and foreign otherness reinforce each

FIGURE 6.7. **Cross-dressed harem beauty.**

Abdullah Frères photograph. Courtesy of the Andrei Koymasky collection, the Homoerotic Art Museum Collection.

other. But the mechanisms of representation complicate these portraits in unpredictable ways. In figure 6.8, from the series *Ahmed 1890–1900*, the pensive eyes of its subject gaze back at the camera from under an Arab headdress, soliciting the spectator's gaze. To the degree that the eloquence of the boy's eyes seems to speak for some truth of self, this particular mise-en-scène succeeds in eclipsing the reality lying behind that gaze: the fact is that "Ahmed" is a Sicilian youth dressed up as an Arab. No doubt his headdress is one that von Gloeden pulled out of his costume box, given that similar garb appears in the photographer's self-portrait, titled, ironically enough, *Il Moro* (fig. 6.9).[38] In a second image from this series, the same model's robes have been parted beneath his neck to convey the suggestion that more warm brown flesh continues below the frame (fig. 6.10).

In contrast to Sicilian youths dressed up as Arabs, von Gloeden shot one series, *Junger Araber*, on location in Algeria. But the fact that he is using natives as his models on this occasion does not mean the images are any the less posed. These photographs make the most of the handsome features of its subjects, as the artful profile of the mascaraed young man in figure 6.11 and the muscular, raised arm

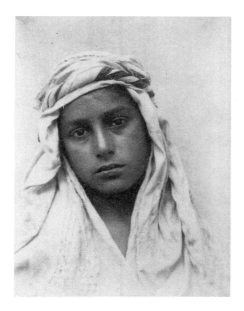
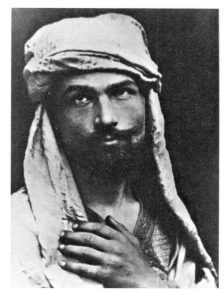
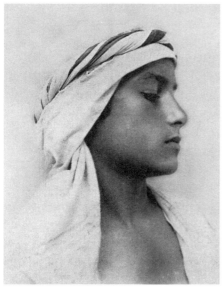

FIGURES 6.8, 6.9, AND 6.10.

"Il Moro" flanked by "Ahmed."

Wilhelm von Gloeden, "Ahmed" Series
(1899); Self-portrait (n.d.). Courtesy of
the Living Room, Andrei Koymasky
Collection.

of the turbaned man in figure 6.12 attest. The Orientalist obsession with tropes
of veiling and unveiling, associated in travel and ethnographic literature with the
unseen mysteries of the female harem, is given an explicitly homoerotic twist by
von Gloeden in several images in which a transparent black veil draped over the
youth's naked body only emphasizes the fact that his anatomy is fully visible. In
other von Gloeden photographs, the teasing veil is replaced by another Middle

FIGURES 6.11 AND 6.12. **von Gloeden in North Africa.**

Wilhelm von Gloeden, "Junger Araber" Series (1890–1900). Courtesy of the Living Room, Andrei Koymasky Collection.

Eastern signifier, the iconic turban (fig. 6.13). Similarly, American photographer Frederick Holland Day, who like Gloeden often employed classical motifs and poses to insinuate a subtle degree of homoeroticism into his reverie-imbued symbolist aesthetic, uses the sartorial motif of the turban as a Middle Eastern marker to add an exotic appeal to several of his male studies (fig. 6.14).

Ethnopornographic photography was also a specialty of the team of Rudolf Lehnert and Ernst Landrock, who established studios in Tunis and Cairo from 1905 through 1930. Revealing an even more discerning eye for nuances of lighting, shadow, frame, and perspective than von Gloeden, photographer Lehnert shot everything from antiquities to nudes of both sexes to feed the European appetite for visual representations of exotic difference. The fact that Lehnert worked on location, using indigenous models, might seem to give his work a stamp of ethnographic authenticity. But his nude subjects are as staged as those of von Gloeden in order to satisfy the predetermined fantasies of his audience (fig. 6.15). Of particular interest are multiple shots of one model wearing the same headdress but different robes in different settings (figs. 6.16 and 6.17). One source identifies the first image *Cairo 1910*, another labels the second image *Tunis 1904*, yet another tags the first as *Tunis 1910*—whereas all were obviously photographed in the same time and place (the correct identification is Tunis 1904). This discrepancy reveals the *spatial-temporal transportability* of the erotic fantasy of the sexually available youth: whether he is Tunisian or Egyptian is less important than the photograph's ability to arouse the viewer's erotic fantasies by implying the subject's ubiquitous availability.[39]

In both of these photos, the seductive lure of the fantasized scenario is accomplished by the self-consciously crafted arrangement of the model's robes to reveal half—and just half—of his upper torso and a single nipple, thereby teasing the spectator to imagine the possibility of further divestiture. The first photograph heightens the homoerotic frisson by having the youth gaze directly into the camera, which fosters a fantasy of knowingness and intimacy, while his pose—one arm behind his head and the other cocked on his hip, jasmine blossom behind his ear—connotes a feminine receptivity without compromising the masculine appeal of his body. The second image creates its erotic charge differently, by positioning the model in front of a grilled exterior that simultaneously suggests the mysterious depths from which the youth has emerged as well as the shadowy private recesses in which an amorous encounter may follow. The way the youth looks to the side, rather than into the camera, connotes a daydreaming state of mind that collaborates with the fantasy of removal to the private realm of the interior where desire can unfold unimpeded by prying eyes.

Other Lehnert images cater to implicitly pedophilic tastes. Viewed in isolation, some of these barely pubescent subjects can pass as sentimental portraits of childhood innocence (figs. 6.18–6.20). Various of these models are photographed

FIGURES 6.13, 6.14, AND 6.15. **Aestheticized orientalist accessories.**

Left: Wilhelm von Gloeden, no title. KI—VG: 239. Courtesy of the Kinsey Institute for Research in Sex, Gender, and Reproduction. *Right*: J. Holland Day, *Il Moro* (1907). DLC/PP-1934:33. The Louise Imogen Guiney Collection, Library of Congress, Prints and Photographs Division, Washington, DC. *Bottom*: Rudolph Lehnert, no title. KI-DC:24585. Courtesy of the Kinsey Institute for Research in Sex, Gender, and Reproduction, Bloomington, IN.

FIGURES 6.16 AND 6.17. **1904 or 1910? Spatial-temporal transportability.**

Left: Rudolph Lehnert, *Ahmed, Tunisie 1904*. T15. 2008.R.3.3918. Permission of Edouard Lambelet / Musee l'Elysee; photograph Courtesy of the Ken and Jenny Jacobson Orientalist Photography Collection, The Getty Research Institute, Los Angeles. *Right*: Lehnert postcard, *Jeune Arabe*. (Tunis, 1904). Author's collection.

in progressive states of undress in other images (the nude in figure 6.21 is the clothed boy on the left in figure 6.20; the model in figure 6.19 appears in an almost identical pose in figure 6.22 stripped of his robe), thereby serving potentially multiple audiences. These more "revealing" nude photographs simultaneously retain a high aesthetic appeal while unabashedly eroticizing the model as an object of the homoerotic gaze (the pose in figure 6.22 channels Ingres's female nudes). The paired boys represented in two slightly different poses in the black and white figure 6.20 and the color-tinted figure 6.32—the latter is reproduced in the last section of this chapter and also in Plate 6—illustrate the sexual suggestiveness that the tinting of the postcard version makes visible. In the latter image, the boys' reddened lips and rouged cheeks add a deliberately feminizing touch, and the robes of both are more suggestively parted as well.

Other images depict child-models placed in poses that make the sexual provocation explicit, as in *Le Petit Porteur* (fig. 6.23). Here the elements of artfully exposed nipple, disturbingly worldly come-hither smile, and hand placed over crotch seem designed to encourage pedophilic fantasies. The taboo of race rather than age is breached in a series of rare plates titled *La Seduction* (Tunis 1907), where two adult men, one indigenous and one European, engage in erotic

FIGURES 6.18, 6.19, 6.20, 6.21, AND 6.22. **Iconic innocence,
with more and less clothing.**

Top row, left to right: Lehnert, *Mohamed. Tunis, 1904–1914*. Courtesy © Musée de l'Elysée, Lausanne. Lehnert postcard, *Jeune Arabe*. Tunis (c. 1904). Author's collection. *Middle row*: Lehnert, *Jeunes arabes*. Tunis (c. 1910). Author's collection. *Bottom row, left to right*: Lehnert, *Mohamed. Tunis, 1904–1914*. Courtesy © Musée de l'Elysée, Lausanne. Lehnert, *Tunis, 1904–1914*. Courtesy © Musée de l'Elysée, Lausanne.

FIGURES 6.23 AND 6.24. **Pedophilic fantasy / Colonial fantasy.**

Left: Lehnert, *Le petit porteur, Tunis, 1904–1914*. *Right*: *La Séduction*. Tunis, 1907. Both courtesy ©
Musée de l'Elysée, Lausanne.

couplings outdoors: they dramatize an explicitly colonialist erotics, in which the
darker partner is at the service of his lighter-skinned companion (fig. 6.24).
Lehnert and Landrock's studio was not the only European business in North
Africa producing images with a homoerotic frisson for a receptive European
audience. The studios of J. Geiser and éditions des Galeries de France Alger
also mass-produced postcard images ranging from cute boys to strikingly
handsome Bedouins (figs. 6.25, 6.26, and 6.27). Not unlike the function that
şehrengiz verse catalogues filled for earlier Middle Eastern culture, the genre of
the homoerotic photograph catered to the fantasy, among its European clientele,
that a cornucopia of male beauty awaited for the taking in North Africa and the
Middle East.

OBSCENE HOAX:
CROWLEY'S POETIC MASQUERADE

The youthful male object of desire forms the through-line of Aleister Crow-
ley's faux-Persian poem sequence, *Bagh-i-muattar* or *The Scented Garden of
Abdullah the Satirist of Shiraz*. This pornographic *jeu d'esprit* appeared in 1910,
the same period in which homoerotic postcards such as those produced by

FIGURES 6.25, 6.26, AND 6.27. **La carte postale: Ethnic "types."**

Left: J. Geiser, *Petite Yaouled*. Alger (1904). *Middle*: J. Geiser, *Arabe de l'interieur*. Alger (n.d.). *Right*: Edition des Gallerie France, *Scenes et types: Jeune Arabe* (n.d.). All author's collection.

Lehnert and Landrock were traversing Europe and England. Notorious in his day as an occultist, experimenter in mind-altering drugs, and proponent of "sex magick," Crowley was also a voluminous writer, producing treatises on mysticism, books of sacred revelations, experimental fiction ("novelissim"), plays, and collections of poetry ranging from the pornographic to the spiritual. Although Crowley is largely forgotten today, aficionados keep his memory alive: the Beatles featured him as one of the cutouts on the cover of *Sgt. Pepper's Lonely Hearts Club Band*, and he lives on in graphic novels and comic books that dabble in the occult. Crowley entered Cambridge in 1895, the year the Wilde trials commenced, where he was exposed to the Decadent movement in literature, explored his bisexuality, and became involved (like Yeats) in the Hermetic Order of the Golden Dawn. While in Egypt in 1904, he had a mystical experience in which Horus appeared to him and dictated the *Book of the Law*, much of it in numerical cipher, which Crowley subsequently made the foundation of the religious philosophy he named Thelema.[40] In Nepal, Crowley set about studying the Persian language and Sufi doctrines, at which point he decided to return to England via Iran. As part of his study, he began composing poems in imitation of the classical Persian poets. These efforts inspired the interconnected series of ghazals published in 1910 as *The Scented Garden* and purporting to be the mystic writings of "Abdullah al Haji" (c. A.D. 1600).

This ribald collection of homoerotic verse, like other modernist texts whose English authors feared the Home Office's censorship, was typeset in Paris, then made available in England by subscription through the London

Orientalist Probsthain and Company in a limited edition of 200. This era was a touchstone for modernist battles against censorship—Lawrence's *The Rainbow* was banned in 1915 on charges of obscenity, Joyce's *Ulysses* was seized by New York Customs in 1923, Woolf and Forster testified at the obscenity trial of Radclyffe Hall's *The Well of Loneliness* in 1928. The prospectus of *The Scented Garden* bore the teasing disclaimer, "As typical of erotic literature, the circulation will be most strictly confined to bona fide scholars of mysticism, anthropology, and the like"—although it doesn't take much to imagine the clientele to whom "the like" refers. Nor did the winking claim of scholarly intent fool the HM Customs office, which confiscated the volume in 1924, destroying nearly all extant copies in 1926.[41]

If *Le livre des beaux* disguises its modernist provenance by claiming to be a straightforward translation of Fazil Bey, *The Scented Garden* wears its pretext much more lightly. Purporting on the title page to be the translation of a "rare . . . manuscript by the Late Major Lutiy and Another," the text is self-consciously structured, as Martin P. Starr puts it, as "a series of veils" (5) that can only be penetrated by those readers of "empathetic interests" who possess the keys to unlock its knowledge.[42] The reader's first clue that this is an invention for a homosexual cognoscenti, much in the same spirit as Djuna Barnes's equally genre-defying *Ladies Almanack* (1928), is the suggestive tone of the dedication that follows the table of contents. Utilizing a series of phallic metaphors, the fictitious translator, Major Lutiy, dedicates the book "to those persons whose unbending uprightness, penetration, retentiveness, capacity for hard work, overflowing ability, and inside knowledge have so much enlarged the fundamental basis of my philosophy" (n.p.)—a philosophy literally grounded in the enlarged "fundament" of the volume's beloved, a not-altogether-faithful Persian boy named Habib. A second clue to its status as a hoax exists in Major Lutiy's name: *liwāt* is Arab for sodomy, and a *lūtī* is the active partner in the act of pederasty. A third key emerges in the fictive Lutiy's account of the discovered volume. Stationed in "Mohammedan India" (and thereby adding to the work's colonialist military frisson), the Major hires an instructor to teach him Persian—a tutor whose last name just happens to be "Tantra," a sly allusion to the Eastern practice in which sexual intercourse leads to the mystical expansion of self.

As Lutiy also reveals in the introduction, Tantra is so impressed that his pupil hasn't, like other exploitative Anglos, peremptorily bid him "procure . . . a fat and fair boy" for his pleasure that he gives Lutiy something even better, namely "a sacred and secret" (4) manuscript expressed, as Crowley puts it with a poker face in his autobiography, "in the symbolism of Persian piety."[43] This manuscript, purportedly dating circa A.D. 1600, is titled *Bagh-i-muattar* (which translates "The Scented Garden"—a playful reference to Nefzawi's medieval erotic treatise *The Glory of the Perfumed Garden*). The introduction's readers are informed that the

author of this "manuscript" is Abdullah el Haji—like Lutiy, yet another fictional construct—whose over-the-top poetic name or *takhallus*, El Qahar, translates "The Conqueror." The text's forty-two ghazals have been shuffled out of order, so Lutiy reports, but soon enough he discovers the key to their arrangement, thereby unlocking a "complete system of philosophy" in which nothing less than pederasty becomes *the* means of attaining transcendent Oneness.

Citing his "very handy" knowledge of Burton's writings—a nod to the cognoscenti for whom Burton was as much a touchstone as Wilde—the fictional Lutiy presents the reader with a "translation" of this mystical text accompanied by complete scholarly apparatus: footnotes, footnotes within footnotes, the singling out of stanzas of spurious authorship (in what is itself a totally spurious text), and—joke of all jokes—an appended essay by a fictional Anglican clergyman living in Mandalay who pleads in florid language for an understanding of the spiritual excellencies of sodomy (3). The good clergyman also makes an implicit case for proto-modernist writing when he links artists who care about form and style to homosexual men as equally elect minorities: "A stylist is as direct a miracle of God as a sodomite." The artist's "perfect freemasonry of style and manner" (30) echoes Lutiy's wording in his introduction to describe that "Freemasonry of Paederasts" who recognize each other instinctively, "mak[ing] the formality of introduction superfluous among free companions of the Craft"—a brotherhood that makes sure that its "secret" doctrines, such as those revealed in el Haji's sacred text, remain the exclusive "property" of those elected ones "worthy of it" (12–13). Indeed, Lutiy claims the *Bagh-i-muattar* manuscript has only been passed on to him because Tantra has recognized in him "one of the *illuminati*," that is, one with whom such contraband knowledge will be safe. The "Craft[s]" of the Artist and Paederast are thus teasingly interwoven in the fictive Lutiy's preemptive defense of the sexually explicit contents of his translation, serving notice to those "notoriously foul-minded Anglo-Saxon[s]" who would dare subject the manuscript's "exquisitely sacred" symbolism to "the prurient jest or prudish reproach" (8).

Halfway through the introduction, Lutiy also reveals that he has teamed up with another scholar (only referred to as "Another" on the title page), whose duty it is "to cover ethnographical, critical, and other interesting points" (10)—a self-reflexive nod to the ethnopornographic traditions described in the prior section, even as the scholarly talents of this collaborator are called into question by his familiarity with those "*other* interesting points" (all the more sexually suggestive for going unnamed). An even more dizzying play of text, intertext, and countertext is created when, in a parenthesis, this second personage informs us that "Lutiy" has died—a modernist sleight of hand not unlike the announcement of Mrs. Ramsay's death in a parenthesis in Woolf's *To the Lighthouse* seventeen years later. Thus this unnamed "Another" has taken over the editorship of the

manuscript, appending his own notes to Lutiy's. In one final twist, a bracket at the very end of the introduction reveals that the Major's name, "Lutiy," is in fact a nom de plume which the current (anonymous) editor has retained in deference to the wishes of the late Major's widow. No ground of origins or authorship remains stable in this jeu d'esprit.

As in a Nabokovian text, the notes are as much part of the text's fun as the poems they gloss. They parody both the kind of note that Burton supplies in his work to squeeze in irrelevant but titillating detail and the pseudo-scholarly citations that ethnopornographers use to throw sand in the eyes of their readers. They serve, too, to show off the author's depth of Orientalist knowledge as he teases out the wordplays in the (nonexistent) Persian text he's "translating" by setting calligraphic equivalents next to each other. The notes also parody the esoteric nature and excesses of literary criticism, especially in glosses where Lutiy and the unnamed second editor assign wildly improbable symbolic and allegorical meanings to sexual passages that are anything but spiritual. The sublimely ridiculous level to which such notes aspire is illustrated in poem 35, where El Qahar boasts of his member rising and falling a thousand times in one night of passion. Fumes "A.L." in the note: "Surely an Oriental exaggeration!" His successor, the second editor, solemnly disagrees in a parenthesis inserted *inside* Lutiy's note: "Not at all. I do not think El Haji necessarily means separate and distinct emissions; he may mean thrusts" (110). Thereupon he calculates the number of thrusts per minute it would take to fulfill this requirement, concluding that El Qahar could have reasonably thrust 1,000 times in four hours and ten minutes (111)—a not unreasonable length of time, he avers, for a person practiced in the arts of tantric self-control!

So much for the notes; what of the poem sequence itself? While the format resembles that of the şehrengiz, Crowley's sequence of ghazals focuses not on a series of boys but on a single erotic object, El Qahar's fifteen-year-old paramour Habib. More specifically, the sequence focuses on Habib's anus—or, in Crowley's preferred Latinate term, his podex. However wildly implausible it might seem to dedicate an entire volume to so "fundamental" a subject, Crowley succeeds by giving the series of poems an arc reminiscent of the sonnet sequences of Wyatt, Sydney, and Shakespeare. The initial euphoria of all-consuming passion is followed by Habib's sexual betrayals and jealousy-inducing triangulation; El Qahar's dejection yields to the sadistic reassertion of supremacy over his straying beloved. In turn, their reunion reinstates love's necessary illusion—which means, ironically, El Qahar's maintaining the fiction of the unblemished, rosebud-like delicacy of his beloved's podex after declaring it has been stretched impossibly wide by the boy's wanton straying.

Crowley's playfulness in mixing the sacred and profane, and in bending traditional Persian and Sufi metaphors to his queer ends, achieves a kind of

mastery in poem 6, whose title, "The Curtain," alludes to the hidden mysteries of the Greater Reality. The italicized summary running across the top of this page—"The Impotence of Thought to Perceive Reality"—provides a clue to the poem's theme: the true path to transcendent Reality, the still center of the spinning world, lies not in the mind but in an altogether more "fundamental" realm, a realm of carnal action rather than elevated thought in which achieving potency is no problem at all:

> Thy podex, like a rose, within
> Thy buttocks, sprays of Jessamine,
> Buds to my kisses; then the wine
> Sets this old head of mine a-spin,
> So that I push thee to thy knees—
> A worship, darling, not a sin. . .

Such mixture of the sacred and profane—worshipping the uplifted buttocks of what could otherwise be a youth kneeling to pray—is typical of the Persian masters that Crowley is imitating. Simultaneously, it heightens the poem's modernist impulse to shock and titillate. In the immediately following lines, El Qahar bemoans the fact that no matter how deeply he plunges, he cannot reach Habib's "Self," the hidden "real," as long as he is consumed by thought. Thereupon he draws the following distinction between reason and feeling:

> So, when I think, I cannot pierce
> The truth of things; I cannot win
> Unto the real; life's wheel is kept
> From turning by its axle-pin.
> But swing thine hips and smile upon
> The hideous world's malicious grin!
> Then when we end, the task is light:
> Bid El Qahar once more begin! (47)

Sex, not thought, is what sets the wheel of life spinning again, just as Habib's podex, the still point at the center of his swinging hips, turns out to be the pivot of the spinning world. If continual intercourse with Habib is the true vehicle to transcendent knowledge, all the more reason, the poet implies, "once more [to] begin!"

For all this sexual bravado, however, Crowley uses the occasion of Habib's infidelities to poke fun at universal male anxieties about prowess, virility, and size. El Qahar's greatest fear is that Habib is attracted to his other suitors because they are better endowed, which makes it all the more imperative that, upon Habib's

contrite return, El Qahar reinstate the fantasy of his own phallic supremacy: "It is indeed the fact, O gazelle-eyed boy, that thy podex is excessively wide"—stretched, that is, by all his infidelities—"but my member can fill it . . .!" whereupon El Qahar proceeds to tell his readers why in graphic terms (70). This image of the "widening" caused by the poet's priapic girth also assumes universal meanings in another poem, where he moves from a paean to Habib's podex to the claim that their love has become a model for lovers and beloveds throughout Persia:

> I made thee famous throughout all Iran
> With these the naughty Ghazals that I sing.
> In every caravanserai the boys,
> As to their lords they fierce or languorous cling,
> Cry: "Lov'st thou me, dear master, as Habib
> Is loved by El Qahar the conquering?" (82)

Having moved from the one to the many, the poet now envisions the entire cosmos as "El Islam goes ever widening"—just as the lover's penis "widens out [the beloved's] anus," adds Lutiy in a note that makes the analogy explicit, even as he rather unconvincingly professes to disapprove of the poet's comparison: "This is a very profane jest. . . . The old sodomite is as keen to promulgate his vice as his religion—the dog!" (83). Such lip-pursing is an exemplary instance of the pot calling the kettle black, given that Crowley is the voice behind "El Qahar" and "Lutiy" personae alike.

According to El Qahar, the ultimate effect of the unity achieved in anal intercourse is a transcendence of self that, as in Sufi doctrine, obliterates distinctions between lover and beloved, and hence between roles of active and passive partners. Thus El Qahar rhapsodically assures Habib that, joined together in the act of sodomy, both will enter

> the glowing rapture of the sphere
> Where HE is manifestly all; and all is
> He; where the I and Thou must disappear.
> We shall not know if thee I sodomize
> Or if thou sodomizest me, my dear! (74)

Ironically, such a blurring of sexual positions becomes the punch line of the entire forty-two poem sequence. Having secured Habib's abject devotion, the speaker in poem 41, "The Riddle" (which editor Lutiy hints "perhaps conceal[s] some details of the Poet's life and amours"), reveals that he is ready for Habib to slip *his* boyishly sized "almond member . . . in the podex of thine El Qahar" (135). For the first time we learn that this conqueror, hitherto all cocky swagger,

also has a podex. His secret desire to be pummeled by his boy provides the "key," then, that unlocks the sequence's final sacred mystery and becomes the climax of the entire volume. "The end" (of the volume), in this case, *is* the "end" (the poet's derrière), the textual and the sexual complementing each other rather perfectly in this odd gem of an eccentrically modernist, punning and playful, obscenely exuberant text.

REVIVING THE *RUBBIYAT:* STATES OF *ONRUST* IN DE HAAN'S *KWATRIJNEN*

Another writer who fits intriguingly into this modernist revision of Middle Eastern erotic verse is the Dutch Jewish lawyer, diplomat, novelist, and poet Jacob Israel De Haan (1881–1924), a married gay man and émigré to Palestine. Like Crowley, De Haan was influenced by the Decadent movement in his university years and, while beginning a career as teacher and journalist, wrote two novels in the first decade of the twentieth century filled with fin de siècle decadence, homoerotic angst, and class rebellion. The first, *Pijpeli- jntjes* ("Pipelines" or "Lines from Pijp," 1904), featuring a promiscuous lover of male youth, led to De Haan's dismissal from his teaching position; the title not only puns on the industrial slum of Amsterdam (Pijp) but—in the spirit of Crowley's lewdly modernist wordplays—tropes on a colloquial Dutch term (*pijpen*) for fellatio. The second novel, *Pathologieen* (1908), plumbs the depths of a sadomasochistic, homosexual relationship. Completing law studies around this time, De Haan began to research the mass imprisonment of Jews in Tsarist Russia, which in turn inaugurated his growing interest in Zionism. Upon his emigration to Palestine in 1919, however, De Haan grew disillusioned with what he perceived as the Zionist party's antagonism toward Orthodox Jews and Arabs alike. Shortly thereafter, he became a leading spokesperson for the ultra-Orthodox Haredim, a group whose willingness to broker a reconciliation of Jewish and Arab interests in Mandate Palestine pitted them against the secular and nationalist interests of the Zionist faction.[44]

The consequence was De Haan's political assassination at the age of 43, the year his final volume of poems, *Kwatrijnen* ("Quatrains," 1924), appeared. Containing some 900 quatrains written in rubbiyat form in Dutch—as yet untranslated into English—the volume charts an interior voyage of discovery, one in which a spiritual quest to Palestine unlocks a simultaneously erotic odyssey. The rubbiyat's traditional celebration of pleasure thus combines with themes particular to De Haan's psychology: his obsession with fleeting time and the inevitability of death; mood swings between restlessness (*onrust* [unrest] is

one of his most repeated words) and states of peace; a tendency to masochism; existential despair; solitude. But what gives this poetic journey of spiritual and sensual revelation its frisson is the frankness with which De Haan turns the Holy Land into a homosexual cruising ground where the objects of his desire are Arab and Muslim boys from east Jerusalem and the surrounding Palestinian countryside.

"Doubt" is one of many quatrains in which the poet uses self-reflexive irony to foreground the dialectic between homoerotic desire and questions of faith at war within him:

> What awaits me in this nightly hour,
> In this City stalked by sleep,
> Seated on the Temple wall:
> God, or the Moroccan lad?[45]

The rhetorical nature of the question presupposes the speaker's answer, as is also the case in the similarly structured quatrain, "Hesitation," where De Haan asks whether the real reason he keeps returning in "the tender evening hours to the Holy Wall" is to unburden his sorrows to God or to meet a boy named "'Hassan . . . [who] asks it of me" (79). While ambivalence and inner struggle create the poetic tension in such stanzas, the recurring circumstance of De Haan's nightly prowls intimate that the Moroccan lad and Hassan win the day. An equally jarring collapse of the sacred and profane characterizes De Haan's eroticized response to the sight of a mother bathing a boy:

> His mother stripped him of his clothes
> The water ripples in the tiny bath.
> My heart trembles, in a shunned softening of endearment,
> Is not Jerusalem God's holy city? (158)

The modernist shock-effect of such sacrilegious juxtapositions combines with a self-awareness of the traditional tropes of rubbiyat verse throughout the volume. In "Nederval," for example, "lofty" prayer is abjured for the lower pleasures as the poet boasts, "I turn from my lofty prayers / With restlessness burning in my limbs / To wine and pleasure" (157). The words "wine and pleasure" deliberately evoke Omar Khayyám, the twelfth-century master of the rubbiyat whom De Haan acknowledges as his great predecessor in several quatrains. More implicitly, his modernist rewriting of Khayyám's thematics for explicitly homoerotic ends can be measured in De Haan's strategic reformulation of the triad, "wine, *women*, and song" associated with Khayyám's *Rubbiyat* ever since Edward Fitzgerald's English translation.[46] For example, in De Haan's "Admonition," the

triad "wine, music, and roses" leads to the oneness of lovemaking that, as in the lyric tradition of carpe diem, momentarily defies time and puts thoughts of consequences or conscience in abeyance:

> Wine, music, and roses,
> Do not think of punishment or pain.
> Until the blush of morning
> Let us be, together. (166)

Implicit here is the degree to which the "women" of the proverbial "wine, women, and song" has been discreetly replaced by other sensations, as in the phrase "wine, music, and *roses*," above, or, in the formulation "roses, *thorns*, and *blood*" concluding "Desperate Night" (166). This elision of female presence clears room for De Haan's male-directed desires to emerge in their place, as in the quatrain "Night," where motifs of roses, wine, and pleasure combine with the imagery of probing hands to imbue the lines with an implied phallicism:

> The boldly probing whoredom of your tender hands.
> The darkness . . . smelling of roses and of wine.
> Tomorrow will brand us once again with cruel remorse.
> But for today: blessed pleasure be ours. (169)

Some quatrains forthrightly declare the male gender and youth of the desired object. "Meeting" begins: "I ask his years. He smiles shyly and tenderly. / He blushes. Then he says 'fifteen years' . . ." (65). In "Bedouin," the poet watches a group of Arab boys frolicking in the ocean—"They stand naked in their brown fragility, / From head to toe slender built"—as he projects onto them youth's lack of "shame or shamelessness," belying his own *adult* guilt as he "contemplat[es]" their nude bodies (103). If such instances of psychological projection and erotic voyeurism are standard features of Orientalism, De Haan's quatrains are also remarkable for his unsentimental acknowledgment of the gap separating himself from his desired objects. "Arab Boys" shows De Haan's self-critical perception of his ultimate status as the outsider, the "other" who lacks a home both existentially and geographically:

> What do they have except for their nakedness and their clothes,
> The breadth of the sea and beach?
> Meanwhile joy and anguish consume my heart,
> Restlessness propelling me through each and every land. (106)

Here, the speaker's inner emotions are "consumed" by the gulf that separates him from these desired youths—the gulf that, no matter how many trysts

he consummates, will always leave *him* the homeless wanderer, moving with "restlessness" from one "land" to the next, alone and unsatisfied. Likewise, De Haan acknowledges—in remarkably frank verse—the economic underpinnings of his sexual forays, recalling the "sweet" boy in bare feet who offers "his companionship" in return for "basheesh." This boy's ability to "hang tough" or "hold his own" (78), in De Haan's pun on the phrase *ons staan*, reveals him to be a seasoned bargainer—in a deflation of the speaker's wishful projections, the youth's "sweetness" is performative, recalling Fazil Bey's knowing description of the Baghdad boy as the khan of "smirks and sugar-sticks."

The portraits of desirable boys sprinkled throughout the 900 stanzas of *Kwatrijnen* thus form a modern-day şehrengiz of the available youth of Palestine. But like the two portraits from *Le livre des beaux* examined earlier, De Haan's quatrains often brutally critique his own Orientalist erotics:

> With Adil I have ridden horses,
> With Said I've shared the forbidden wine.
> With Mahmoud . . . with Nasief . . . I stretch out my limbs
> Restlessly, in cruel agony. (187)

The title tells it all: "The Night Ahead." By the third line, the shared acts drop out, only the names remain; then the names cease, since they could go on forever but without filling the void in De Haan's heart. For no matter how many loves he has enjoyed, the boys' names ultimately form a chain of interchangeable signifiers beneath which the desire, the signified itself, slips away. This absence leaves the poet in an agony of unfulfillment or "restless[ness]" (*onrust*)—and, on this particular night, such unrest also leaves him dreading the hours ahead, in which he will either extend his arms to embrace emptiness or—equally daunting—encounter yet another name in an endless chain. A similar logic governs "Suffering," the quatrain that immediately follows "The Night Ahead":

> With Adil . . . with Mahmoud, driven by lust,
> With Hassan, with Khalil, drinking together.
> I've always remained the same, alas:
> Alone, and just another name. (187)

Here, the modernist appropriation of the rubiyyat's form and content yields a quintessentially modernist insight: while the boys continually replace one another in this mobile chain of desire, De Haan is doomed to sameness, to imprisonment in his own singular consciousness ("I've always remained the same"). He himself is "just another name," the marker of this doomed identity; yet, inversely and ironically, De Haan too is just one more "name" in the

litany of encounters that each of these boys has had, as dispensable to them as they are, in fact, *in*-dispensable to his fantasy of fulfillment.

For De Haan, as for Crowley and the anonymous modern-day "translator" of Fazil Bey, Middle Eastern poetic forms and literary tropes become the venue for modernist revision and homoerotic expression. In De Haan's case, this expression is the poetic record of the very real, and often agonizing, dichotomies marking his personal quest: as a married man who was also homosexual, as a European aesthete who made his ultimate home in the Middle East, as a diplomat attempting to forge alliances between Zionist hopes and Palestine rights, and, ultimately, as an Orthodox Jew seeking sexual fulfillment with Arab youths whose proximity and distance only increased the ceaseless movement of his soul's onrust.

LYRICAL MINIMALISM, DIVERSE MONOTONY, AND GIDE'S MODERNIST REVISION OF TRAVEL NARRATIVE

Like De Haan's poetic rendition of his emigration to Palestine, André Gide's literary record of North Africa as a site of sexual awakening is grounded in experience, not mere fantasy; he traveled to Tunisia and Algeria six times before publishing *Amyntas: A North African Journal* in 1906.[47] *Amyntas* consists of four short journals spanning 1899–1904, in the midst of which Gide published *L'immoraliste*, which discloses a narrative of pederastic awakening beneath its veiled allusions and impressionistic musings. In its own way, *L'immoraliste* constitutes a şehrengiz in novelistic form, as its narrator Michel takes up and discards a series of adolescent local boys while succumbing to the influence of a torrid African landscape that penetrates to "the most . . . secret fibers of [his] being."[48]

Three decades later, Gide's ruminations on sexuality abroad in *Carnets d'Égypte*, analyzed in chapter 5, lay bare in starkly unadorned fashion the mechanisms of the colonial "trade" in boys that receives fictional treatment in *L'immoraliste*. In contrast, the younger Gide's cataloguing of desire in the intensely lyrical *Amyntas* proves of a very different aesthetic order, conveying an almost postcolonialist ethics of difference. Composed of dozens of short, poetic evocations of North African landscapes and cities, this travel journal discreetly discloses a voyage of homoerotic awakening and bliss, in spite of the fact that these journal notes are often void of any human figure—no overt parade of interchangeable Arab youth as in *L'immoraliste* or *Kwatrijnen*. For what Gide seeks to achieve in *Amyntas* is nothing less than a modernist revision of the genre of eighteenth- and nineteenth-century travel narrative, recasting its realist

format in lyrical fragments that become the vehicle for intense, if discreet, homoerotic expression. Whereas traditional travel narratives typically amass hundreds of pages of detail in service of the impossible task of authenticating their record of the foreign and unfamiliar and of convincing the reader of their mimetic accuracy, Gide embraces, instead, the impressionistic subjectivity of the traveler's sensations, fixing them in lyrical prose-poem fragments. These poetic meditations draw on the evocative, rather than descriptive, power of language to convey the traveler's intimations of difference and discovery, of mystery and initiation, of losing one's bearings as one nears, without ever quite reaching, the otherness of one's desires.

Further, Gide's prose in *Amyntas* achieves a kind of photographic stillness, a sense of spots of time frozen in their immediacy, via its temporal structure. Not only are the four journals included in the slim volume arranged to move backward and forward in time, but the lyrical effusions of the entries—sometimes only a few lines long, often no more than half a page—weave back and forth in time, recollecting similar moments, revisiting old scenes, repeating identical tableaux from oblique angles of vision. The white gaps on the page separating these short effusions emphasize their discreteness as individual units while suggesting there is always more that escapes telling. As distinct from generic fantasies of the Middle East as a timeless space in which little changes—a fantasy actively promoted in the examples of Orientalist ethnopornography and photography reviewed earlier in this chapter—the slowing down of time for Gide is more Bergsonian than Orientalizing: entering these snapshot moments, these verbally evocative pictures, allows for a more profound perception of the very foreignness that the tradition of realist travel narrative attempted, but often failed, to capture through the piling on of excess detail and the attempt to impose a comprehensive wholeness on the observed culture.

This is not to say that Gide doesn't also sometimes fetishize and exoticize difference—as when, for instance, he laments that Tunis has lost the "intoxicating flavor of foreignness" that rivaled the "remotest Orient" and "the most secret Africa" (A 16, G 28) a mere two years before.[49] But in general his projections onto North Africa intertwine with an empathetic perception of, respect for, and openness to the differences he encounters on his travels. For his deliberately unvarnished journal entries—each existing on its own, purposefully *not* reworked into a *"more coherent whole"* (A 60, G 88; Gide's italics)—seek to capture an order of seeing and knowing distinct from that pursued by realism, in the process attuning the reader to a different ontology of being in and interacting with unfamiliar cultures. What counts for Gide are the small details, the evanescent flashes of perception, the incidental moments that occur in the margins that his style of lyric minimalism, modernist indirection, and allusive suggestiveness works to evoke. "The distended void of the desert teaches the

love of detail" (A 146, G 203), he observes in a passage that suggests his artistic goal. Listening to a four-noted flute that is the only sign of life in a lonely oasis, Gide reiterates this minimalist aesthetic: "If only, from page to page, evoking four shifting tones, these sentences I am writing here might be for you [*pour toi*] what that flute was for me, what the desert was for me—of diverse monotony [*de diverse monotonie*]" (A 138, G 194). "Diverse monotony" is the perfect enunciation of the state that Gide seeks to capture in *Amyntas*: the plentitude that desire, if liberated from the constraints of rational thought, uncovers in a landscape that only *seems* to be a blank slate.

Gide gilds his aesthetic intentions with a homoerotic frisson through a series of repeating images: half-open doors and portals, glimpses briefly caught through openings, settings on the margins of things or by the "wayside," dreams of permeable boundaries, closed interiors. We have seen how writers like Loti and Durrell transform the labyrinthine streets and alleys of the medina and souk into symbols of the libido that exists beneath the surface of consciousness. Similarly, Gide likens his traversal of the covered alleys of the souks of Tunis to plunging into a "subterranean" realm, a hidden "second city in the city" (A 15, G 27). The lure of anonymity and of losing one's way in such mazes has always held a richly connotative power for the homoerotic male imagination, as the history of gay cruising suggests. This sensibility limns the sense of mystery in the Algerian streetscapes photographed by Gide's closeted contemporary, Frederick Holland Day (fig. 6.28), and it resonates in contemporary gay French-Tunisian artist Michel Giliberti's homoerotic evocation of doors and passageways in Tunis (figs. 6.29 and 6.30).[50] So, too, in Gide's lyrical rewriting of the genre of travel narrative: secret turns in a street, concealed niches in cafés, hidden staircases, and unseen exits become eroticized sites that hold the promise of unnamed, perhaps unnamable, desires that lie on the other side of those thresholds.

A paradigmatic example of such promise occurs in Gide's account of an evening stroll in Blida in the last section of *Amyntas*, "Travel Foregone." It is night and Gide is strolling down the street of the Ouled-Naïls or female prostitutes—a locus that allows an acceptable if illicit aura of overt sexuality to enter the narrative. Yet at the very moment that he hears "a woman . . . calling to me," his attention is diverted *elsewhere*, to the margins of vision:

> But the loveliest thing I saw that evening (in passing, and in the time it takes to blink . . .) through that open door traversed by my desire in a single bound, was a dark narrow garden I could barely make out . . . and further on, lit from behind, closing off a mysterious threshold, a luminous white curtain. (A 99, G 140)

Ignoring the call of the Ouled, Gide responds to a modality of desire that exists "in the time it takes to blink": the fleeting sight of one threshold framed within

FIGURES 6.28, 6.29, AND 6.30. **Mysterious streetscapes, eroticized thresholds.**

Left: J. Holland Day, *A Street in Algiers* (1901). Courtesy of the National Media Museum / Royal Photgraphic Society / Science & Society Library. *Right*: Michel Giliberti, *Repose à Matmata I* (n.d.). *Bottom*: Giliberti, *Promesses d'Orient* [detail] (n.d.). Both from Giliberti, *Voyage secret: Tunisie* (2004). Courtesy of the artist.

another, culminating in the tantalizingly "luminous white curtain" whose translucence intimates an unseen world existing in the glow on its other side.

The opening lines of *Amyntas* metaphorically take the reader across that luminous threshold, as Gide describes coming upon an opening in a craggy range of mountains near the oasis of El Kantara: "Here is the portal; we enter [*Voici la porte; en la franchit*]." What he finds on the other side of this *porte* (this

first page of text is simultaneously the reader's doorway into the volume) is "a different world . . . alien, motionless, taciturn . . . at peace." Beyond the sound of a flute and a child's laughter in the distance, Gide finds what he only now realizes he has always desired but hitherto feared: "*nothing*; no misgivings, no thoughts. Not even repose: here nothing ever stirs. It is still" (A 3, G 11–12; emphasis added). This is the stillness of a desire in which "diverse monotony" can yield its treasures; it is the "nothing" that exists once the rational mind lets go of its inhibitions and strictures. A few pages later, on one of his innumerable nightly "prowls," Gide recounts the breaching of a second portal, and this passage begins to disclose the sensual recompense that underlies the promise of entering a world of "nothing." "Of all the Arab cafés, I have chosen the darkest, the one most out of the way," he notes, then asks, "What draws me here? *Nothing*; the shadows, a graceful body weaving round the room, a song—and not to be seen from outside: the solace of secrecy [*le sentiment du clandestine*]" (A 5, G 14; emphasis added). Gide's carefully chosen images reveal, by way of indirection, the attractions this particular locus holds. For by choosing the café that is "darkest" and "most out of the way," Gide gains, in the first instance, closeted anonymity—"the solace of secrecy," of not being seen "from the outside," as he puts it. But if Gide's answer to his question, "What draws me here?" is "*Nothing*," the immediately following phrases reveal that this *nothing* actually consists of at least two *somethings*. First, there are "shadows," which in the pages that follow become the text's shorthand for Arab men moving through the night in their white robes; second, the "graceful body weaving round the room" is a boy dancer performing for the café's male clientele. Gide's "nothing" turns out to be pregnant with an unspoken but palpable homoeroticism.[51]

This rhetorical technique of asking a question whose answer is implied in the given details of the mise-en-scène is employed in a parallel occurrence recorded toward the end of the short volume. Making the rounds of another town's Moorish cafés, Gide again finds himself "beguiled" by the most run-down one. Inside "three young Arabs" languidly stretch out at full length on the floor matting. "What did this alcove offer them," Gide muses, "that they should prefer it here, to the entertainment of other premises, to the laughter of women[?]." By this sleight of hand, Gide deflects the question that could be asked of himself—"what draws *you* here, away from the entertainments offered by women?"—and projects it onto these supine young men. In an equal sleight of hand, Gide provides an answer that simultaneously reveals and disguises its latent content, when he suggests that the attraction is "precisely the absence of all such things . . . [and] a little kef" (A 101, G 142–43; Gide's ellipsis). This explanation may apply to the lounging Arab youths, who seem to be enjoying the absence of thought as well as the "disappearance of desire" brought on by the kef. But the very wording "*the absence* of . . . such things"—like the use of "nothing" in the prior

passage—more closely speaks to Gide's quite active rather than renounced desires, which build to a climactic outburst that is all about yearning: "Oh, to linger there . . ." (A 102, G 143; Gide's ellipsis). That is, the "absence" of "such things" as women and prying eyes suggests there is *something* here motivating Gide's desire to "linger"—namely the pleasure of gazing upon these recumbent youth undistracted by women. Being sequestered with them in an alcove from which "the outside world [had] vanished" (A 101–2: G 143) constitutes the very nature of active desire for Gide in this moment, a desire that pulses throughout the vignette without speaking its name.

The erotic thrill of discovering such remote places, particularly sites undiscovered by other Europeans, attains psychodramatic intensity in Gide's impressionistic allusions. In "Wayside Pages" he emphasizes that he always uses "that other entrance, narrow and recessed [*cette autre entrée, étroite, retirée*]," to enter the souk in Tunis, where "dim alleyway[s]" lead to equally "dim café[s]" whose seductive habitués, Sudanese men wearing springs of jasmine behind their ears, exude "voluptuous languor [*une langueur voluptueuse*]" (A 17–18, G 31). The French "cannot find such places," Gide writes with a sense of superiority, refashioning himself as the insider who knows how to spot the "low door [*porte basse*]" leading into the dark cubbyhole of a space where spectators watching the "obscene" Karaghioz puppet show rent shadowy "niches" in the wall that serve as private "*couchettes*" or beds (A 19–20, G 32–33). The sexual undertones of such crannies become explicit as Gide describes, in the immediately following passage, "another stall" where the puppet "play is merely an excuse for encounters [*Ici la pièce n'est que le prétexte des rendez-vous*]." Here, a "strangely lovely child" plays bagpipes for an audience of male admirers who throw poetic flatteries back his way, men whom Gide likens to "suitors" not in a brothel ("*un bourge*") but in "a kind of *cour d'amour*" (A 20–21, G 35). Such homoerotic connotations accumulate throughout *Amyntas*. A different Arab town, a different night, a different year: deliberately avoiding the quarter's four or five brightly lit French cafés, Gide discovers a "suspect stairway" that leads to an "upper city" of the town, all darkened and inscrutable, where, following the sound of an Arab guitar, he discerns the "faint glow" of a "scarcely noticeable" Moorish café (A 69, G 101). Pausing in the darkness, he ponders, "Shall I go in? What will I see . . . [?]" Opting to stay outside, he sensuously calls upon "the night [to] penetrate me, insinuate itself with the music," just as—as if in tacit answer to his desires—an Arab emerges from the café and "moves toward me" (A 70, G 101).

If the intimate communion with otherness that Gide so desires materializes before his very eyes in this magical moment, so too it can dematerialize, as when Gide recalls his fascination with a "tiny café," located in "a certain secret turn of the street" in Algiers. Upon entering and sitting down, Gide has the uncanny sensation that there must be a "second room" just out of his view

that "continue[s] on a lower level." His imagination and curiosity are stimulated further as he watches various Arabs disappear into the back of the café, never reappearing. This leads him to fantasize that "at the back of the second room," there must be "a secret stairway [that] led down to further depths . . ." (A 94, G 133; Gide's ellipses). This mystery propels Gide to return night after night "to learn something more, to see something more," keeping vigil over "the still shadow over there, the matting over the rear door where . . . the dubious figure [*ce suspect*] disappear[ed] downstairs . . ." (A 95, G 134; Gide's ellipses). Suspects, disappearing acts, penetrated "depths," "rear" doors—the psychosexual resonances of such phrasings condense into a general image of illicitness when Gide abruptly reports, after the last ellipses, that the café has been mysteriously shut down by the police three months later.

If, in all these instances, the rhetorical questions that the narrator poses—"What draws me here?"; "Shall I go in?"—hinge on a fantasy of penetrating and being penetrated by the worlds of difference imagined to lie beyond these mysterious portals, Gide also knows—and this is where his somber insight, like De Haan's, mitigates his nostalgic Orientalism and supersedes Loti's bathos—that such sentiments are part of an ultimately *impossible* fantasy of leaving the known self behind and becoming the desired other. This awareness adds a note of melancholy to the author's yearning: "Oh, to know, when that thick black door opens in front of that Arab, what will welcome him behind it . . . I should like to be that Arab, I should like what awaits him to await me" (A 106, G 150–51; Gide's ellipses). Michel Giliberti's evocatively titled painting *L'entrée des contes* ("The threshold of stories"), forms a contrapuntal and counter-Orientalizing response to such a cri de coeur. Here we see the "Arab" who occupies the space on the other side of "that thick black door"—but in Giliberti's version, this figure is a watchdog or guardian, whose direct gaze both simultaneously challenges the Orientalist fantasy of entry and invites us to image the *contes* that unfold to those permitted to enter (fig.6.31). What Gide fantasizes awaiting behind the door is part of a dream of homoerotic jouissance that is at once *secret*—uncontaminated by Western disapproval—and *open* to his participation, as open as the "gaping garments of the Arabs!" that he apostrophizes in the last entry when, back in France, he dreams yearningly of "the desert spring" and the "Companions! Comrades!" (A 150, G 219) he has left behind.

The evocation of desert companions raises the question of the place of actual paramours in Gide's entries. The homoerotic reimaginings of Crowley, De Haan, and the author of *Le livre des beaux*—as well as Gide's *Carnets d'Égypte*—depend on the explicitly sexualized representation of youths, often presented serially as interchangeable objects of desire. Every now and then, Gide's entries mention a male friend or acquaintance (some of whom the autobiography reveals to have been sexual companions). But in general sexual corporeality is absent in *Amyntas*—the

FIGURE 6.31. **Threshold of stories.**

Michel Giliberti, *L'entrée des conte* (n.d.). From Giliberti, *Voyage secret: Tunisie* (2004). Courtesy of the artist.

highly autoerotic passages where Gide communes with nature in orgasmic frenzy are as close to "sex" as the text gets.[52] And this overall *absence* of embodied objects of desire is what is most innovative, and interesting, about Gide's modernist reworking of travel narrative for homoerotic ends: his talent lies in being able to make the most insignificant of details or even inanimate objects—the glimpse of a mysterious rear door, the discovery of a staircase, the description of a lonely oasis—resonate with an unnamed yet nonetheless pervasive homoerotic sensibility. Stylistic indirection, fragmentation, and allusion—hallmark traits of literary modernism—work in tandem with Gide's narrative lyricism and episodic structure to give tacit expression to his own desires *and* to suggest the opaque but nonetheless tangible layers of homoeroticism that pervade North African male culture.

The additive quality of these homoerotic tableaux, moreover, forms a modernist version of the Middle Eastern poetic tradition of the şehrengiz by capturing,

like pictures in an album, snapshot images of desire that may be savored in a future time. But whereas the şehrengiz and the camera typically operate by objectifying their subjects, the minimalist aesthetic underlying Gide's prose-poems—staking their claim on life in the margins, on the diversity that exists in seeming monotony—works against blatant appropriations of North Africa and likewise pushes against the European desire to possess the essence of "Oriental" sexuality. To the contrary: Gide intimates that the reader who really wants to understand his message must engage in a textual erotics that figures the journal as an extension of Gide's queer body. "Publish [these entries]—for whom?," he ponders once he's returned to France, adding, "They will be like those resinous secretions which yield their perfume only when warmed by the hand holding them" (153). The erotics of this text takes two; our warm touch is necessary to the release of Gide's "secreted" (in both senses of the word) meanings, making the reader an enabling partner on this intimate journey.

The legacy of Gide's modernist innovations in travel narrative can be felt in the journal entries about Morocco that Roland Barthes included in the post-humously published *Incidents* (1987).[53] Like Gide, Barthes renders his travel impressions in a series of fragmented, brief, lyrical "snapshots" meant to evoke as much as describe. But unlike Gide, Barthes interweaves these textual impres-sions with descriptions of the multiple Tangier youths that catch his cruising eye. In this regard, his technique recalls the erotic catalogues of *Le livre des beaux*, *The Scented Garden*, and *Kwatrijnen*. In stark contrast to Gide's intensely affective engagement with North Africa in *Amyntas*, Barthes's narrative voice remains distant, coolly postmodern; if Gide's aesthetic aims to uncover infinite diversity in seeming monotony, Barthes's entries reduce each boy to a few, often laconic, objectifying brushstrokes: each is fair game in the vacation itinerary that traveling in Morocco offers him.[54] To grant these boys individuality would rob Barthes of the flaneur's frisson of exotic otherness, and himself of the first-world tourist's pleasure of sex without guilt.

FORBIDDEN TALIBAN

How might the particular literary and visual geography of queer modernism traversed in this chapter—a very peculiar, indeed at times idiosyncratic, strand of modernism—inform or transform previous understandings of Orientalism and the relation of sameness to otherness? My discussion has focused on two venues by which early-twentieth-century artists harnessed literary genres and traditions associated with the Middle East to impart often innovative and, for their times, sexually explicit visions of same-sex desire. One venue, embraced

by Gide, involves rethinking travel narrative through a modernist lens, in which understated impressionism and lyricism summon up a more visually tactile image of foreignness than does realism's attempt to create "word pictures" through exacting, exhaustive detail. The second venue, practiced by the unknown author of *Le livre des beaux*, Aleister Crowley, and Jacob Israel De Haan, involves borrowing from Persian, Ottoman, and Arabic literary traditions, freely improvising on poetic forms like the ghazal, şehrengiz, and rubbiyat to convey a modernist homoerotic poetics. These latter genre revisions share in common the topos of the beautiful youth, at once a staple in traditional Middle East literature *and* a marker of Orientalist projections and Western desires that sometimes remain blind to their colonializing propensities. Then again, as in the cases of Gide, De Haan, and the impersonator of Fazil Bey, such genre borrowings may occasionally reveal a surprisingly acute understanding of the mechanisms of colonialism and dispossession. The potential to appropriate difference as fodder for Orientalist fantasy is most obvious in the prior examples of turn-of-the-twentieth-century ethnopornography and photography. The latter's visual catalogues call to mind, in turn, another trait shared by the genres of travelogue and erotic poetry traced in this chapter: the stringing together in serial form of scenarios and/or objects of desire that, like photographs pasted in an album, become mementos of the elusive attempt to fix desire, to remember fleeting moments that have already passed, moments whose framing will always suggest the inadequacy of the effort to bridge otherness.

This is not to intimate that the literary borrowings and improvisations of the queerly inclined modernist artists examined in this chapter are simply the esoteric by-products of a relatively minor offshoot of modernism, to be shelved with other oddities of early-twentieth-century literature—although these texts are also just that, "wayside" pieces meant to exist outside the mainstream. "Minor" as these works individually may be, they participate in the much larger phenomenon of Orientalist homoerotics in which issues of visibility and visuality continue to set off minefields in the cultural politics of Middle East and West. Exemplary in this light is a recently unearthed archive of photographs that uncannily recall—with a major difference—the visual şehrengiz produced 100 years before by purveyors of erotic photographs in the Middle East. Published in the volume *Taliban,* these pensive photographs of young soldiers posing singly and in pairs were found by Thomas Dworzak in a closed-down studio in Kandahar shortly after the Taliban fled the city in 2002.[55] The eerie continuity and discontinuity between images such as the Lehnert portrait of two boys arm in arm and these Taliban youth (compare figures 6.32 and 6.33; see also Plates 6 and 7) exists not only in the subject matter, but in photographic technique, particularly the use of hand-tinted coloration and blatant props.[56]

FIGURES 6.32 AND 6.33. **Uncanny continuities across a century.**
(See also Plates 6 and 7)

Top: Rudolph Lehnert, *Jeunes arabes*. Colorized postcard. Tunis (c. 1910). Author's collection. *Bottom*: Found photography, reproduced in Thomas Dworzak, *Taliban* (2003). Courtesy of T. Dworzak / Magnum Photos.

FIGURE 6.34. **Spectral and material intimacies.**

Reproduced in Thomas Dworzak, *Taliban*. Courtesy of T. Dworzak / Magnum Photos.

It is a commonplace that the Taliban's young recruits came from the countryside where, despite the Taliban condemnation of homosexuality, the tradition of male sexual apprenticeships and relationships is still widely practiced.[57] This historical reality so suffuses these photographs with a palpable if unworldly homoeroticism that Dworzak was accused by some critics of demeaning and "othering" these resistance fighters by taking the pictures himself, colorizing them in the style of gay artists like Gilbert and George in order to turn them into camp aesthetic commodities, then passing them off as "originals" (fig. 6.34). But, as Dworzak attests, these "found objects" are exactly that, photographs whose contradictory valences—artillery, narcissism, intimacy—tell stories worth sharing.[58] So intent on uncovering a narrative of Western appropriation, Dworzak's critics failed to see these images for what they are, revealing, once again, how easily homosexuality can be used as a political weapon to reinstate a reductively West–versus–Middle East binary. Seeing these images "as they are" does not mean their unintended viewers will ever know with certainty the precise nature of the desires inspiring these photographs or the relationships they recorded. But it does mean that viewers can open themselves to the "contradictory cultural context of these oddly beautiful photographs," acknowledging the sheer "risk layered into

FIGURE 6.35. **Contradictory valences.**

Reproduced in Thomas Dworzak, *Taliban*. Courtesy of T. Dworzak / Magnum Photos.

these shots, and the triumph [over risk, over prohibition] they contain," in Jeff McMahon's thoughtful words. These images reveal "an intimacy we have trouble interpreting; we know the frame but don't recognize these pictures. These are men who are comrades, and perhaps more. They are also soldiers of a horrifically repressive and puritanical regime. How can one pose with flowers, arm around your buddy, kohl highlighting beautiful young eyes, and yet be a foot soldier for those who would punish you severely for such an abomination?" (fig. 6.35). [59]

If uncanny similarities of content and style link these images separated by 100 years, there are also equally resonant differences. Unlike Lehnert's youthful models, paid to strike provocative poses to cater to a specialized European market, the subjects of the Kandahar photographs participate in a very different economy and erotics of circulation: they are not performing intimacy for some unknown other but for each other, nor are the images intended for public distribution or for profit. Shot furtively (since photographic studios had officially been banned by the Taliban), these images offer silent testimony to the fact that these recruits have chosen to defy their leaders' prohibitions on representing the human face. Why? Perhaps out of the desire to memorialize themselves, if only for a frozen instant, before embracing martyrdom and

FIGURE 6.36. **A gaze beyond the grave.**

Reproduced in Thomas Dworzak, *Taliban*. Courtesy of T. Dworzak / Magnum Photos.

death. Perhaps, out of a desire to honor bonds whose actual nature can only be guessed at, but whose intimacy is achingly clear. For early-twentieth-century homosexual and bisexual writers like Crowley and Gide, Eros is celebrated precisely as a deferral of the inevitability of death; but here, in these turn-of-the-twenty-first-century images, Eros readies to become Thanatos with each click of the camera's shutter.

Whatever one's thoughts about the ruthless brutality of the Taliban, the subjects in these photos convey an almost excruciating poignancy as, individually and in couples, they yield themselves to the gaze of the camera, preening in their best turbans and accenting their eyes with kohl, standing against incongruous backdrops of American ranch-style houses and Swiss chalets, holding plastic colored flowers along with their guns. The homoerotic genre of the şehrengiz, stretching from medieval Middle Eastern poets to the queer modernist revisions analyzed in this chapter, is granted an ambivalent but haunting afterlife in this photographic archive—an afterlife that, staring one in the eye (fig. 6.36), forces viewers to resist simplifying the complex, unstable, combustible relation of sexuality and the phenomenon we call Orientalism.

Seven

LOOKING BACKWARD

HOMOEROTICISM IN MINIATURIST PAINTING AND ORIENTALIST ART

While visual imagery has played a critical role in supporting this book's arguments about the homoerotic discourses accruing to the relations of West and Middle East, particularly in chapter 2's overview of tropes, it has done so in tandem with written sources, each complementing and enriching the other. My final two chapters take a different tack, focusing on visual modes of representation as phenomena in their own right. Complementing the prior chapter's focus on generic innovations in a specific literary moment, this and the next chapter examine the convergence of aesthetic and ideological modalities within this vast archive of images; together, the two chapters illustrate the astonishingly diverse ways in which visual genres have abetted the spread and dissemination of Orientalist homoerotics. The present chapter focuses on two schools of painterly art. First, it takes up the surprising breadth of visual evidence existing in the genre of Middle Eastern miniaturist painting. Second, it analyzes the examples of homoeroticism hiding in full view in the European genre of nineteenth-century Orientalist painting. As throughout this book, I argue that the contrapuntal resonances of these materials, once brought into relation across time and space, open our eyes—literally as well as figuratively—to articulations of homoeroticism that have otherwise gone largely unnoted.

And opening our eyes, learning to re-see images with which we thought we were familiar, as well as identifying images that have been overlooked, is key to the principles that underlie the organization of chapters 7 and 8. Conventional wisdom has held that there is little in the way of depictions of homoeroticism in the Middle Eastern visual archive—indeed, the research resulting in these two chapters was originally whetted by my desire to test out this proposition, to see whether such visual representations were in fact so lacking. The results emphatically refute this commonplace. For what critics have often taken to be "the apparent invisibility of homosexuality"[1] in regard to Middle Eastern art

traditions turns out largely to be the product of the widespread misperception that Islam prohibits bodily and erotic imagery—a subject to which I will return. This "apparent invisibility" is also a product of the tendency of Western scholars to look for signs of homoeroticism that may be common to Hellenistic and European aesthetics (for instance, sculpture and paintings glorifying the nude male body) but that are absent in Middle Eastern visual representation. If such assumptions have made it difficult to "see" homoeroticism in Islamicate art, the reticence of Middle Eastern studies art specialists to investigate sexually controversial topics until relatively recently has also discouraged investigations of this visual heritage.[2]

In regard to European Orientalist art, which reached its apogee in the nineteenth century, so much critical energy has focused on the heterosexual dynamics scripting its fantasies that the scholarship has, again until recently, neglected to investigate the possibility of coexisting homoerotic investments. Welcome exceptions include Darcy Grimaldo Grigsby's brilliant work on Orientalist depictions of European masculinity in which encounters with the Middle East become sites of loss and failure rather than mastery, Abigail Solomon-Godeau's examination of the networks of homosocial and homoerotic desires leading to the glorification of the male nude in Neoclassical art, and James Small's insights into the homoerotic subtexts present in Girodet's military set pieces. From a historical point of view, Robert Aldrich's chapter on "Artists and Homoerotic 'Orientalism'" in *Colonialism and Homosexuality* brings to light a number of homosexual or homosexually suspect artists inspired by Orientalist themes. Thorough and informative as his work is, however, Aldrich's tendency to give priority to the hypothesized sexual orientation of the artist, as well as to focus his argument on works specifically related to imperial and colonial contexts, lessens his ability to address the wider parameters of the homoerotic subcurrents running throughout the visual cultures of Middle East and West alike.

This broader canvas is what chapters 7 and 8 attempt to illuminate, by attending, as in the prior literary case studies, not simply to the biographical traces of an artist's sexuality, but to the multiple conduits whereby homoeroticism emerges and amasses critical weight in visual representations. This is sometimes the result of grasping for the first time what has always been in front of our eyes, sometimes the effect of deciphering the codes in the specific work of art (a visual equivalent of "reading between the lines"), and sometimes the upshot of learning more about the cultural frame that gives explanatory meaning to the depicted scenario or chosen format. Likewise, such homoerotic expression may at times be the consequence of an artist working within a period's favored genres (as in the case of poets writing homoerotic *ghazals*, not because they are themselves necessarily lovers of beautiful boys but to show off their mastery of the form), and at other times an unconscious but palpable aspect of the work

of which the artist remains unaware. Yet again, this homoeroticism may some-
times be the product of the contemporary viewer's vantage point, heightened by
an awareness of erotic possibilities sparked by contemporary critical modes and
lived practices.

This supposition about contemporaneity and hindsight is critical in the
analyses that follow. For when the images in this archive—ranging from Persian
miniatures to French salon art, and from photography to film—are brought
into contiguity, the repetition of various codes and signs, gestures and glances,
settings and topoi, literally begins to make visible patterns that might have been
occluded or unintelligible in the past, as well as patterns escaping an examina-
tion of the single image or the eye of a single viewer. Central to this method
of "looking backward" in order to look forward is queer theory's rethinking of
the historical imperatives and affective desires involved in the act of revisiting
the past in quest of queer affinities. This method of "seeing" relies less on
attempting to uncover—or recover—a causal sequence that moves teleologically
from some fantasized point of origin to a predetermined end, than on making
one's present position, contemporary insights, and subjective investments the
point of departure for the forging of contingent sets of partial relations between
the contemporary present and those historical phenomena that engage one's
desires. Such affective connections, in Carolyn Dinshaw's words, have the power
of bringing hitherto "incommensurate entities into contact across space, across
time." They also facilitate the analysis of the history of marginal sexualities
without, on the one hand, risking facilely transhistorical generalizations or, on
the other, narrowly alteristic accounts.[3] Applied to the constellation of visual
examples assembled in this and the following chapter—examples spanning
diverse epochs, cultures, and aesthetics—this method brings into our line of
vision an array of nuances, patterns, and elements that, if only viewed in a causal
historical continuum, might escape notice altogether. But approached from this
queer angle of vision, the visual archive related to homoeroticism and the Middle
East, far from remaining "invisible," offers up a startlingly evocative trove of
images for analysis, illuminating the broader contours of the cultural narrative
whose representations constitute a homoerotics of Orientalism.[4]

DECODING MIDDLE EASTERN MINIATURIST PAINTING

The most venerable artistic tradition eroticizing Middle Eastern male subjects
lies in Islamicate culture itself, specifically in the execution of miniature paint-
ings adorning book manuscripts and albums whose production flourished

in Persia since the early medieval period, reached a zenith in the Safavid dynasty, and spread eastward to the Mongol empire and westward to the Ottoman empire. Although Thomas W. Arnold's influential 1928 thesis about the prohibition of figural imagery in Islamic art has been refuted by any number of scholars in the field, the widespread assumption of Islam's hostility to representations of the human figure lingers, coloring various sexual historians' suppositions about the likelihood of locating substantive visual evidence of the erotic—much less the homoerotic—in such cultures.[5] As Layla S. Diba, Jonathan Bloom and Sheila Blair, Kjeld von Folsach, and other authorities have clarified, admonitions against artistic representations (for usurping God's role as the creator of human likenesses) exist in various *hadith* but not in the Qur'an.[6] Indeed, the idea of a "ban" on human figuration never extended beyond sculpture and decorations in mosques where, in contrast to the Christian tradition, icons and artwork are taboo. But in the fine arts, from wall paintings (most of which have been destroyed over time) to illustrated manuscripts to brocaded silk garments and luxury household objects like lacquered pen boxes, idealized human figures of both sexes are everywhere, and their beauty is designed to rivet the viewer's gaze. At the same time, the very stylization of these ideal representatives of beauty—apparent in the depiction of seemingly non-individuated, circular faces on fragile necks, tilted eyes, and pinched lips (traits inherited from earlier Persian contact with Chinese art traditions)—created an aesthetics of beauty whose focus on the ideal, in contrast to the realist tradition of European portraiture, also functioned to protect the artist from accusations of imitating God's creation through mimesis.

In *Pictures and Passions: A History of Homosexuality in the Visual Arts*, James M. Saslow relates what he deems to be "the dearth of surviving homoerotic images" in the Middle East to "Islam's demand for decorum," especially in the public realm. As a result, Saslow dedicates only five pages in his nearly 300-page survey to the region, and much of that discussion focuses on Islamicate literature rather than art, whose explicitly erotic images, Saslow avers, are "overwhelmingly heterosexual." Saslow allows that "Muslim art's one significant cluster of homoerotic images" emerged because of the vogue in the Safavid era for individual miniaturist portraits (as opposed to manuscript illustrations) of epicene male beauties, which "offered a more private artistic sphere" for the discrete appreciation and consumption of such images.[7] Shortly I will have more to say in the way of amending Saslow's statement about the general "dearth of surviving homoerotic images" in Islamic culture and his implication that homoerotic images remained in the private sphere, the prize of book-owning connoisseurs. But even the depth of homoerotic interplay in the body of images that Saslow acknowledges, I will show, was more far-ranging than has commonly been assumed and entails a more nuanced reading of codes, methods, and shared imagery.

Persian (and later Ottoman) miniature art is nothing if not aesthetically self-reflexive, and this self-reflexivity often becomes a key to deciphering the genre's homoerotic subtexts. A single-page image from a Safavid album (the album, as opposed to the book, is a genre whose structure I take up shortly) in the Topkapi Palace Museum depicts a handsome youth, perhaps a prince, contemplating a single folio on which is painted the image of another young man (fig. 7.1). Such an image is not just a self-conscious meditation on art (in which the viewer's contemplation of the miniature is mirrored in the action within the depiction), as might appear on first glance. The fact that this depiction of the act of looking is meant to symbolize the inception of sexual desire—in this case male-male desire—is underlined the way it "quotes" Nizami's *Khamsa*, a revered and continually illustrated *heterosexual* romance epic in which the heroine Shirin falls in love with Krusraw when she sees his portrait. The three different specimens of verse affixed to the same album page, moreover, share the theme of earthly desire. Text, illustration, and context thus all reinforce the representation of a romantic yearning that is in this case homoerotic. A similar self-reflexivity characterizes the 1650 single folio miniature by the Isfahan miniaturist Muhammad Qāsim, *A Display of Verse* (fig. 7.2). In this depiction, the beautiful youth, outfitted in fashionable clothes of the day, stands as he reads a page of verse that is tilted toward the viewer. The lines on the page reveal the youth to be the beloved to whom its verses are addressed: "May the world fulfill your wishes for three lips—the lips of the beloved, the lips of the stream, and the lips of a cup." That two of these "lips" are connected with the sensual world (beloveds and wine) and the third with the symbol of life (water, which forms a pool at the youth's feet) heightens the artwork's aura of reflexive homoeroticism.[8]

The latter two examples are single images formed independently of a larger text, a late development in the tradition of miniaturist art, which originally served as illustrations to the history, verse narrative, medical treatise, or poetic anthology they accompanied. But the miniatures illustrating such canonical texts also include any number whose implicit homoerotic subject matter is unquestionable. One illustration in an anthology of six Persian poets dating to the fourteenth century depicts a ruler who is listening to the reading of scrolls as he is, in Nora Titley's explanation, "temporarily distracted by the love play of two of his courtiers in the royal audience" and "raises his eyes from the scroll to glare jealously at them";[9] a frequently illustrated tale is the story of a Prince on the way to a polo match who is waylaid by an infatuated lover;[10] the cartouches accompanying the portraits of young males in an Ottoman album circa 1600 bear labels such as "Beautiful Georgian Youth" and "The Beauty of Tabriz."[11] Volumes of Saʿdī's revered and incessantly recopied *Bustān* and *Gülistan*, whose anecdotes are largely homoerotic, often include illustrations to accompany the anecdotes.[12] The Walters Art Center's *Khamsa* of Nevʿizade ʿAtayi includes

FIGURES 7.1 AND 7.2. **Homoerotic and textual self-reflexivity.**

Left: Miniature from the Amir Husuyn Bey Album. H. 2161, fol. 101a. Courtesy of the Topkapi Serai Museum, Istanbul. *Right*: Muhammad Qāsim, *Display of Verse*. Courtesy of the Collection of the Prince and Princess Sadruddin Aga Kahn.

illustrations of the story of the Chinese ruler Hursid, who almost drowns in a pool of water with the vizier's son Behzad with whom he has fallen in love, the meeting of the famous historical lovers Sultan Mahmud and Ayaz, a Shah's realization that his son's tutor has fallen in love with the youth when he sees a portrait of the two hanging in a tree outside his window, the merchant Abdullah exchanging words and tokens with a youth in the window of the Shah's palace, and the disconsolate lover Mahzun being thrown out of the palace of the emir whose son is the object of his desire.[13]

While the most famous Middle Eastern long narratives are heterosexual, such as Jāmī's account of the attempts of Potiphar's wife Zulayka to seduce Yusuf, Shaykh-Muhammad's illustration of the latter text makes the youth the center

of the gaze of an all-male entertainment (befitting Yusuf's iconic status as the most beautiful human being who ever lived).[14] In the latter example, textual and visual contents thus convey overlapping but different erotic investments in the same source material. In other examples, there is an entire disjunction between visual and textual elements. Another copy of Jāmī's *Yusuf and Zulayka* (Qasvin, 1550–1570) is a case in point. The two-page frontispiece that opens the volume has absolutely nothing to do with the Biblical story. Instead, it depicts an all-male *sohbet,* or garden party in which, on the right folio, two male lovers rest in a tree house. Directly below them, a second male couple frolics in a pond while on the left folio, as servants prepare a feast, a male adult and youth engage in tender caresses, the two branches springing from the single trunk of the flowering tree behind them symbolizing their union (fig. 7.3).

FIGURE 7.3.

Detail of two lovers from double-page frontispiece.

Picnic in a Treehouse, Jāmī, *Yusuf and Zulayka.* Qasvin (1550–70). Inventory 51–52/1980 (7.3). Detail is from the left panel, upper right corner. Courtesy of the David Collection, Copenhagen.

Since these images most often originated as the property of the elite—produced by royal studios for the Sultan's treasury (or patrons of the Sultan lucky enough to receive them as gifts) and those few aristocrats who could afford to maintain their own ateliers of calligraphers, miniaturists, and illuminators—the question arises whether the homoeroticism pervading them can be said to reflect social values beyond those of their elite viewers. These circumstances of ownership and circulation, in turn, have fostered assumptions that, because aristocratic circles have always made room for "rarefied sexual tastes"—tastes as exceptional as these rare book-objects—such representations do not reflect the social morals or habits of the larger culture. Yet, as the prior chapters have documented, male-male sexuality pervaded Islamicate culture on multiple levels, including literary and poetic traditions whose oral performance reached wide audiences. Likewise, one should not write off the possibility of such imagery also reaching a wider audience, both local and foreign, than is often assumed.

First of all, as Titley notes, the Persian artists who originated the miniaturist motifs that dominated manuscript production for some four hundred years traveled "far and wide" (sometimes freely, sometimes as booty), often bringing their personal caches of manuscripts with them as they set up schools to teach their skills in new locales; manuscripts themselves were often given by rulers to diplomats and important figures from other countries as gifts and received by royal courts as tribute offerings. While Istanbul remained a stable center for art production throughout the Ottoman empire, the ever-shifting political fortunes of the ruling dynasties of Persia meant that its centers of artistic production periodically shifted from one city to another (notably Tabriz, Herat, Shiraz, Qazvin, and Isfahan) as new dynasties relocated their capitals, thus dispersing local traditions of painting widely across the face of Asia Minor and even Europe.[15] Persian art itself was greatly influenced in its beginnings by cross-cultural currents, including ones from both the West (Byzantine, Coptic) and Far East (Chinese); so too the aesthetics developed in important centers of miniature production like Shiraz and Herat traveled internationally, giving birth to similar traditions in Mogul India and Ottoman Istanbul, as well as in the major Ottoman metropolitan centers reaching from Damascus and Cairo (with its flourishing tradition of libraries) to Algiers. While the most talented artisans and calligraphers worked in royal studios, many artists served their apprenticeships in bazaar workshops and, by the fifteenth century, were employed in commercially operated ateliers whose customers included a variety of patrons—"governors, amirs, merchants, and others of the upper and middle classes."[16] Such commercial enterprises also produced illustrated manuscripts expressly for sale to foreign visitors.[17] By the era of European travel to these regions, it is clear that hordes of book manuscripts were available for viewing and sale, along with a number of individual

paintings separated from their original manuscripts and dispersed in urban bazaars across the Middle East.

Londoner William Ouseley conveys a sense of the availability of books and illustrations on view in narrating his Persian travels from 1810–1812. In Isfahan, he comments on the hundreds of pictures, either on separate sheets or collected into boxes, "offered daily for sale in the shops" of the city's bazaars, which depicted an array of subjects and were often 200–300 years old. Among these offerings, he notes a "class of miniature paintings . . . wasted on subjects the most offensive to the modest eye. . . . [O]f several offered for sale, those most highly finished were unfortunately of such a description as precludes further notice." The fact that Ouseley does not hesitate to talk about "voluptuous" paintings of harem beauties on another occasion leads one to wonder if the subjects so "offensive" as to preclude "further" description represented homoerotic themes. Whatever this specific case, his observation makes it clear that by the early nineteenth century an array of erotic images was available for Europeans to purchase for their private collections.[18] Likewise, writing later in the century, Southgate debunks the supposed Islamic taboo on the "representation of the human form" by attesting to the number of paintings and engravings of human figures, including ones of "indecent scenes of the most infamous description," that he has seen for sale in Istanbul shops.[19] Various scholars have noted that the widespread destruction of wall paintings makes it difficult to adduce what subject matters might have been available for public viewing in this format, but as early as 1617, Della Valle's comment on the "lascivious postures" of the figures he's observed in the wall paintings in Shah 'Abbas's summer house indicates that at least some of these images were erotic; other surviving public wall paintings include scenes depicting the motif of male lover and beloved sharing wine or being entertained at *sohbets*.[20]

The potential dissemination of homoerotic images across large geographic areas was also facilitated by three important artistic developments. First was the rise of the poetic collection or miscellany in the 1400s, which consisted of poetry by various authors and combined various themes and styles and full as well as abridged texts. In such volumes, illustrations inevitably tended toward the love themes of much of the poetry and existed in a much looser relation to text than those created for narrative romances or historical chronicles. A typical example is *Five Youths in a Garden* (fig. 7.4), a miniature in Shah Isma'il's *Divan* (produced in Turkman Turkish in Tabriz in 1520; Shah Isma'il was one of many refined rulers who wrote poetry as well as practiced the art of calligraphy). As Eleanor Sims notes, this miniature glosses the general themes of the love poetry in the *Divan* rather than illustrating a specific lyric; everything in this miniature is a visual equivalent of the metaphors that run throughout much of the poetry—a beautiful garden, the princely pair at the top whom Sims identifies

FIGURE 7.4. **Love poetry metaphors in visual form.**

Five Youths in a Garden, Shah Isma'il, *Divan*. S86.0060, fol. 2r. Turkman, Tabriz (1520). Courtesy of the Arthur M. Sackler Gallery, Smithsonian Institution, Washington, DC: Purchase—Smithsonian Unrestricted Trust Funds, Smithsonian Collections Acquisitions Program, and Dr. Arthur M. Sackler.

as "lover and beloved," attendants whose bodies are as elegant as the slender cypresses also evoked in the accompanying poetic caption, the arrows carried by one attendant that symbolize the power of the beloved's gaze to "pierce the lover's heart," and the pool that collects "tears shed by the lover."[21] The second crucial development was the rise of the autonomous book illustration or the self-standing single-page painting as an aesthetic object existing in its own right. This tradition included innumerable portraits of languid, epicene youths in a style, as we will see, perfected by Riza-i 'Abbasi and his most famous student, Mu'īn Muṣavvir.[22]

The third development of significance was the increased popularity in the sixteenth century of the album genre, in which illustrations and poetic texts cut from older texts were affixed to a new page in aesthetically interesting arrangements, allowing collector and arranger to focus on favored themes and subject matters

through juxtaposition and the placement of original materials in new contexts. As David J. Roxburgh notes, the album assemblage was no longer confined to the court cultures in Persia or Ottoman Turkey and became "the preeminent form used to store and present art in Islamic lands."[23] Thus, for instance, the independently minded collector might decide to bring multiple images of beautiful youths by different artists together on a single page. In figure 7.5, the portraits of four young men are cleverly arranged so the two pairs of entertainers (an athlete and a juggler, top and bottom left) are being gazed at by the two princely admirers positioned to their right. This serial presentation of multiple *ghilmān* on a single page evokes in a visual form the *şehrengiz* poetic tradition discussed in chapter 6. Other album pages combine depictions of male couples and beautiful youths "grouped in a variety of social interactions" whose images are arranged to "talk" to each other, thus creating a homosocial continuum within which loving bonds between men form the thematic link. In the I. Ahmed Album at the Topkapi Palace Museum, the collector has deliberately arranged two companion images by the same artist so that their placement on facing folio pages becomes a statement on the relation of lover and beloved (fig. 7.6). Here, form reflects content: the very seam that unites recto and verso suggests the romantic bond of the two lovers who face each other across this binding.

All three of these developments encouraged the disaggregation of pages from their original sources, promoting the image as an object of value to be viewed independently of the text and thereby justifying its reassembling in album form. This was true not only of Middle Eastern collectors but also of European purchasers who brought their collections of separate folios back to France, England, or Germany and formed their own albums from them. Reviewing the dates of the purchase of both manuscripts and albums housed in the rare book collections of the British Library and Bibliothèque Nationale (the two largest holdings of Persian and Ottoman miniature manuscripts and images outside of the Topkapi collection) reveals the portability of Middle Eastern manuscripts and their appearance in Europe from the early modern period onward. Although the gorgeously adorned books crafted by the royal workshops were treasured items in the Persian and Ottoman courts, there were always locals willing to sell these objects (inscriptions in volumes shelved in the British Library occasionally refer to the vizier or pasha who has mediated the sale, verifying the manuscript's quality). Furthermore, as the Ottoman and Persian empires diminished in influence and their economies faltered, the sale of books, pages taken from disassembled books, and individually produced images became more and more common. Thus Claudius James Rich returned from Turkey with 110 Ottoman manuscripts in 1805, which the British Library purchased in 1825.[24]

I turn now to the analysis of an array of images arranged in thematic groupings in order to bring into focus the homoerotic frisson that infuses this tradition.

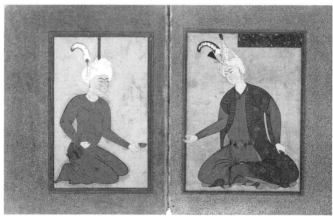

FIGURES 7.5 AND 7.6. **Meaningful assemblages in the album format.**

Top: Page in the Bahram Mirza Album assembled by Dust Muhammad (1544–1545). TPM H.2154, fol. 139a. Tabriz (c. 1530–1540). Bottom: Attributed to Sultan Muhammad, also in the Bahram Mirza Album. TPM H.2154, fols. 146b-47a. Both courtesy of the Topkapi Serai Museum, Istanbul.

The first grouping—single portraits of beautiful youths depicted as objects of desire—not only provides evidence of the potential of the album form to express homoerotic desire but attests to the dissemination of such images to Europe. The following four images belong to an album of fifty-seven folios collected by Sir Charles Hercules Read that now resides in the Pierpont Morgan Library.[25] While textual evidence suggests that several of the Persian illustrations came from the same *muraqqa'* or album (possibly one assembled for Husain Khan Shamlu, governor of Herat, in the early seventeenth century), Read inserted into his album a number of leaves from other sources as well. The result is a hand-picked collection overwhelmingly comprised of images of beautiful youths, which raises the interesting question of whether this thematic played a role in their original assembly, their purchase by Read, and the additions that Read made to the collection. The seated youths in figures 7.7 (see also Plate 8) and 7.8—both dating to Herat between 1600 and 1610—epitomize the *beau ideal* of Safavid art in their combination of indolence, lissomeness, and a coyness that borders on yawning indifference. Anthony Welch aptly describes the type, perfected by the master miniaturist of beautiful youth, Riza-i 'Abbasi: "the solitary youth, usually male and invariably elegant, affluent, and beautiful . . . posed in languid inaction, [his] attention not inwardly focused but wistfully wandering toward unspecified distant points."[26] That detached gaze, of course, acts as one of the motors of desire for the viewer, whom the portrait projects as the wishful male suitor who would rather wrest the youth's attention to himself: frustration and distance only whet yearning. This desire is flamed, simultaneously, by the youth's obvious enjoyment in striking a provocative pose and being gazed upon in all his finery. The epicene dandy lounging on an ornately brocaded pillow in figure 7.7 (see also Plate 8) is depicted as an object of sheer display, from his elaborately wrapped turban to the ermine borders of the cloak that he hugs loosely to his chest with his unseen left arm to the artfully casual strands of hair that lie on his neck, and from his arched eyebrows to the open-legged posture on the raised platform on which he ever so casually lounges.[27]

If this youth is all indolence waiting to be admired, the equally elegantly attired youth with pet falcon in figure 7.8 combines a suggestive array of gendered signifiers: the refinement with which he slips on his glove, his fingers elegantly poised, bespeaks a feminine delicacy, but the fact that he is preparing to go hunting with his falcon (hence the putting on of the chamois glove) hints at a martial tendency toward masculine action, as opposed to indolence, underlined both by the deadly violence that the falcon—the object of the boy's gaze—will wreak and the phallic sheath that dangles strategically between the youth's splayed legs. The image's accompanying quatrain only heightens the erotics suffusing the portrait: "The moon cannot set its face against yours, / If it did, everyone would find fault with the moon."[28]

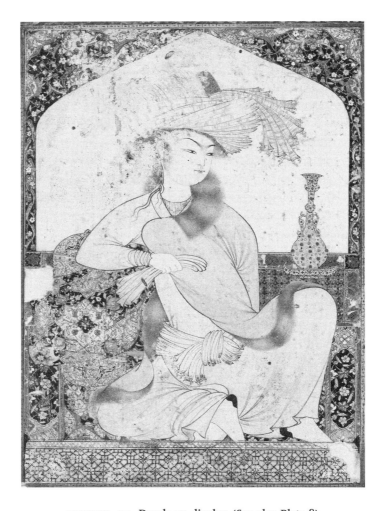

FIGURE 7.7. **Dandy on display. (See also Plate 8)**

A seated dandy wrapped in a fur-lined coat, recto. Read Album. M.386.13. Herat (c. 1600). Image courtesy of the Pierpont Morgan Library, New York. Purchased by J. Pierpont Morgan (1837–1913) in 1911. Photograph © The Pierpont Morgan Library, New York.

Yet another variation on the youthful male object of desire included in the Read album features an athlete exercising by flexing his bow (fig. 7.9). Bareheaded and barefoot, robe hoisted to allow maximum freedom of movement (displaying, in the process, his shapely legs in the tight trousers worn by Persian strongmen and wrestlers), this smiling youth forms a seventeenth-century equivalent of the "beefcake" models featured in American physique magazines of the 1950s. "If it is a sin to gaze upon your face," the verse affixed to the image reads, "then let

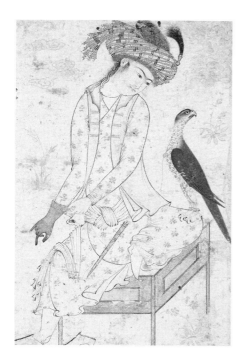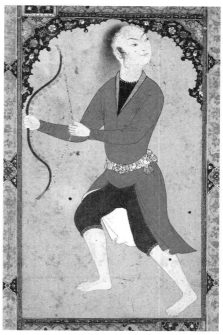

FIGURES 7.8 AND 7.9. **Persian pin-ups.**

Left: A seated youth putting on a falconer's glove as his pet falcon sits on his knee, recto. Read Album. M.386.13. Herat (c. 1600). *Right: A youth flexing an excise bow, recto.* Also Read Album. M.386.10r. Both images courtesy of the Pierpont Morgan Library, New York. Purchased by J. Pierpont Morgan (1837–1913) in 1911. Photograph © The Pierpont Morgan Library, New York.

my eyes be ever drenched in sin." This wittily sacrilegious credo encapsulates the homoerotics of the image, aligning the gaze of the male viewer with the "sin" of passionate desire inspired by the beauty of the athlete.[29] Two pages earlier, the Read album includes still another desirous type: in this case, an Iranian youth dressed in the latest *European* fashion (fig. 7.10).[30] This Persian beau in Western dress resembles, both in posture and attitude, Mu'īn Muṣavvīr's depiction of a European youth holding an Iranian pot (fig. 7.11). The latter's embrace of a beautiful Persian art object creates a deliberate dialogue between East and West, not unlike the cross-cultural referentiality created within von Gloeden's photographs in which he poses his nude Sicilian models with classical Greek artifacts.[31] Another visual example of Occidentalist homoerotics is the late Safavid oil canvas painting of a Caucasian youth dressed in elaborate Persian court attire (fig. 7.12), a work that may have been made for the European market. Its cross-cultural subject matter carries over into its aesthetic influences: note the

FIGURES 7.10, 7.11, AND 7.12. **European influences.**

Left: Āqā Zamān, *A persian youth in European costume*. Read Album. M.386.8. Isfahan (1650–1675). Courtesy of the Pierpont Morgan Library, New York. Purchased by J. Pierpont Morgan (1837–1913) in 1911. Photograph © The Pierpont Morgan Library, New York. *Middle*: Muʿīn Muṣavvīr, *European Youth with an Iranian Pot* (1673). Courtesy of the Collection of the Prince and Princess Sadruddin Aga Kahn. *Right*: *A Causcasian Youth in Court Dress*. Oil on canvas. Isfahan (1650–1722). Courtesy of the Fatema Soudavir Farmanfarmaian Collection.

Dutch-influenced vase of flowers at bottom left and the Baroque Italianate-style column to the right.

Another common depiction of homoerotic desire in the miniature tradition features male couples. Figure 7.13, attributed to Muhammad Qāsim in 1627, is the most famous of many representations of Shah ʿAbbas in the company of a handsome youth, as well as the one whose homoerotic signifiers are most artistically encoded. Note how the Shah clasps the extended wrist of the smiling boy with his own right hand, bringing flesh into contact with flesh, as the two stare intently into each other's eyes. The boy appears ready to chuck the Shah under the chin (an iconic gesture of amorous affection in miniature art—here reversed, since the youthful beloved is usually the recipient of the gesture), while the Shah's left arm, draped over the youth's shoulders, pulls him closer into a near embrace. Meanwhile, the boy's left hand strokes the tilted neck of the equally iconic wine flask, which rises between the youth's thighs (one of which is exposed) as if an erect phallus and extends into the

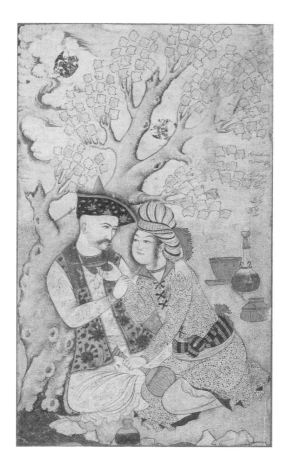

FIGURE 7.13. **Shah 'Abbas and a favored wine server.**

Muhammad Qāsim, *Portrait of Shah, Abbas I embracing one of his Pages.* Safavid, Ishafan (1627). © RMN-Grand Palais / Art Resource, NY.

vicinity of the Shah's lap, visually linking their erogenous zones. The miniature is accompanied by the same script embedded in Muṣavvīr's portrait of the youth reading verse in figure 7.2: "May life grant all that you desire from three lips, those of your lover, the river [of life—flowing at the bottom left corner of the frame], and the cup."

Frequently, such intimate interactions between man and beloved are naturalistically interwoven into the background of larger group scenes. An excellent example occurs in one of the most discussed of the superb full-page paintings in the Freer *Haft Awrang* by Jāmī, in which Majnun (barely perceptible at the left margin of the scene) approaches the camp of his beloved Leyla. The camp

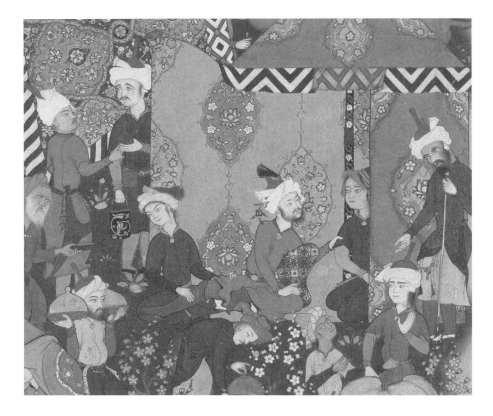

FIGURE 7.14. **A leg massage.**

Detail from *Majnun Approaches the Camp of Layla's Caravan*, illustration to "Majnun and Layla," in Ibrahim Mirza, *Haft Awrang* by Jāmī. Fol. 253a. Safavid (1556–1565). Courtesy of the Freer Gallery of Art, Smithsonian Institution, Washington, DC: Purchase, F1946.12.253.

teems with human life and activity, with the angles of the various tent roofs and canopies creating a zigzag movement that moves the eye in a sweeping circle clockwise around the painting. Inside one of the many tent-pavilions occupying the center of the composition, a man reclines between two youths (fig. 7.14, detail). As he grasps the bicep of the youth kneeling on both knees with his left arm, he nonchalantly extends his right leg, clad in a soft green boot, across the lap of a second youth, whose hands knead the man's calf and upper thigh. The very casualness of this depiction of physical intimacy, occurring in open sight (of both the camp followers and of the viewer) but hardly noticeable within the overall range of activities, is remarkable for its implication that such behavior is, within this milieu, thoroughly unremarkable, a part of everyday life. Such depictions of casual intimacy among men and youths are echoed in other

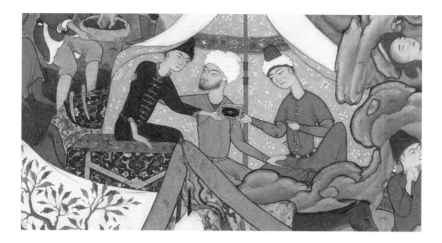

FIGURE 7.15. **Threesome intimacies.**

Detail from *Yusuf is Rescued from the Well*, illustration to "Yusuf and Zulayka," in Ibrahim Mirza, *Haft Awrang* by Jāmī. Fol. 105a. Safavid (1556–1565). Courtesy of the Freer Gallery of Art, Smithsonian Institution, Washington, DC: Purchase, F1946.12.179.

encampment scenes. An example, also in the Freer *Haft Awrang*, is the illustration accompanying the story of Yusuf's rescue from the well (an event displaced to the margins of the composition). In the detail reproduced in figure 7.15, a tent's flaps have been pulled back to give us an "inside" view, where a man is affectionately embracing the youth on his right around the shoulder while caressing the thigh of the youth to his left. Meanwhile, the two youths are passing a book between them, completing a triangulation of touches echoed in the triangular shape of the tent itself.

To this point I have been pointing to the eroticism encoded in images of older men paired with male youths. Part of chapter 2's discussion, however, emphasized the degree to which amorous affection expressed between youths of the same age is also part of the literary and visual tradition. There I noted examples in which the youths' arabesque intertwining of limbs makes it difficult to tell where one body ends and the next begins, contributing to the simultaneously sensuous and formal appeal of the image. The same aesthetic characterizes the depiction of the "youthful frolic" in the late-sixteenth-century album miniature, in the Bukhara style, depicted in figure 7.16 (see also Plate 9).[32] As the two wine-drinking youths engage in a flowing embrace, the anonymous artist expertly captures the sensation of bodies caught in motion: the S-like curve of the horizontally extended arms of the youth in front, who holds his turban in one hand

and the wine flask in the other, forms links in a chain created by the overlapping limbs of his companion. The latter youth drapes one arm over the bareheaded boy's shoulder and down his torso, his hand directing the viewer's eye to the leg that he has simultaneously twined around the boy's waist. One can almost feel the pressure of this leg pulling the bareheaded boy into his companion's inner thighs; all the while the turbaned youth's other hand tantalizingly extends the wine cup to his companion's mouth.

Likewise, an aura of autoerotic reverie and dreamlike euphoria imbues the depiction of two shepherd boys in a landscape painting by 'Ali Quli Jabbadar (fig. 7.17; see also Plate 10), whose style shows European influences. Unlike the prior example, these youths do not engage each other in tactile play; rather, the painting's implicit eroticism exists in associations of the pastoral with homoerotic yearning since Theocritus. In Jabbadar's bucolic depiction, these two daydreaming youths, with their transparent trousers drawn up to expose bare legs, form individual objects of beauty to be appreciated by the viewer; their beauty exists in harmony with the natural beauty surrounding them. The fact that this artist probably came to Iran from Europe and converted (as his name indicates) provides a fascinating instance of cross-cultural East-West influence at work in representations of the desirable youth.[33]

In contrast to images in which the paired intimacy of lover and beloved is depicted as one activity amid many others, there also exist numerous miniatures depicting groups of men in which the entire mise-en-scène is suffused with male-male desire, thereby making homoeroticism the image's dominant trope. One exquisitely rendered example is a very small Ottoman miniature (fig. 7.18; see also Plate 12), just a few inches square, in a volume of poetry, *Kâsim-i Envâyr*, probably copied in Isfahan in 1456–1457 but with its illustrations added by Ottoman artists later in the sixteenth century. Eight figures (plus a nearly off-stage musician) form a visual circle that gives the painting its formal symmetry. At bottom right, a *köçek* entertains this all-male group of refined aristocrats in a sumptuous palace setting. The participants in this pleasure-party form a range of types of couplings (and age pairings) that attests to the sheer variety of acceptable homoerotic desires in its world, a variety familiar to viewers of the image. At the top center of the group, the man with the slight moustache who is holding the wine bottle—his position indicating that he is probably the host of this indoor sohbet—is extending his free hand to meet that of the youth he is engaging in conversation, while the lad positioned on the far left looks on—thereby constituting a variation on the triangular formulation of one man and two youths familiar in these group scenes. Meanwhile, at the right border, two young men hold hands. But, most notably, in the lower left corner the two seated and embracing youths, also of the same age, are depicted in the passionate act of kissing (fig. 7.19, detail)—a degree of intimate lovemaking very rarely illustrated in the miniature tradition.

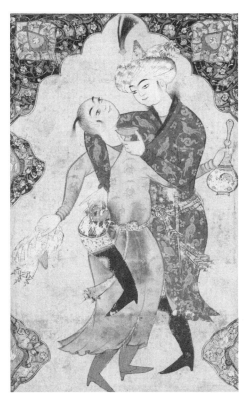

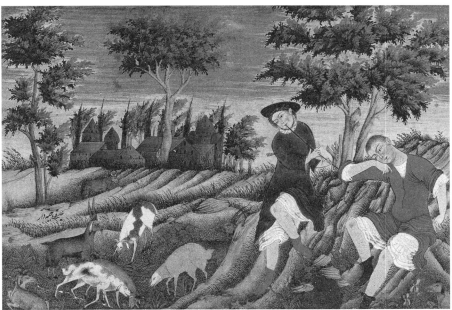

FIGURES 7.16 AND 7.17. **Arabesque intertwinings, lithesome pastoral.**
(See also Plates 9 and 10)

Top: *A Youthful Frolic. Miniature in the Bukhara Style.* J. 56.1218. (late 16C) India Office Library
of the British Library. Courtesy of the British Library Board. *Bottom*: 'Ali Quli Jabbadar, *Two
Shepherds with Sheep and Goats.* Isfahan (c. 1675). Courtesy of the Aga Kahn Museum, Toronto.

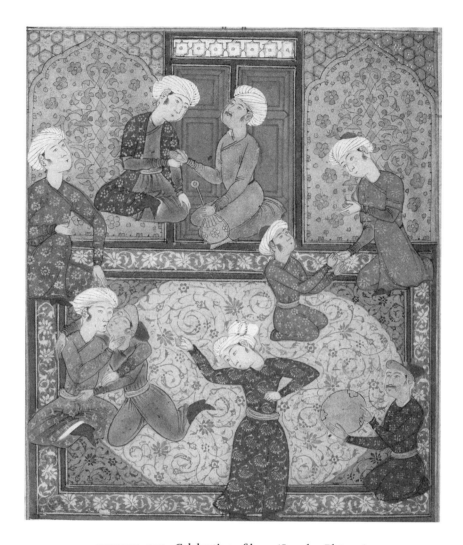

FIGURE 7.18. **Celebration of love. (See also Plate 12)**

Miniature in *Kâsim-i Envâr*. BL OR. 11363, fol. 148a. Ottoman, copied in Isfahan (c. 1455–1457). Courtesy of the British Library Board.

Festivities have moved outside, and have already passed their climax, in the illustration of an all-male garden party included in the I. Ahmed Album in the Topkapi Palace collection (fig. 7.20; see also Plate 11). The narrative encoded in the illustration registers, on the left, the surprised looks on the faces of the attendants, who have just appeared with refreshments and take in the scene of drunkenness and debauchery that greets them. Just below the central fish pond, one youth is attempting to revive his older companion, who, as the broken bottle

FIGURE 7.19. **The kiss (detail).**

Kâsim-i Envâr, BL OR. 11363, fol. 148a. Courtesy of the British Library Board.

and fallen turban indicate, appears to have passed out from too much wine. In an equally humorous touch, the sage sitting by the fish pond is so caught up in a moment of creative inspiration that he remains as oblivious to the amorous antics taking place around him as the cat intently watching the fish circle the pond. Meanwhile, the gazes of three of the four attendants on the left direct the viewer to the post-coital "pillow talk" occurring between the two youths reclining on the ground on the right half of the folio. That the two have just

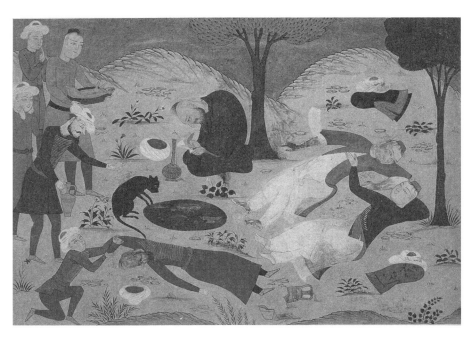

FIGURES 7.20 AND 7.21. **After the debauch: post-coital conversation (detail).**
(See also Plate II)

Miniature in Kalendar Pasa, *I. Ahmed Albumu*. B 408. Ottoman (1603–1618). Courtesy of the
Topkapi Palace Museum, Istanbul.

engaged in sex is not only indicated by the fact that they have removed their outer garments and turbans, as the neatly stacked clothing of each indicates. It is also signaled by the way in which their transparent undergarments teasingly reveal their still-tumescent penises. That of the youth who faces the viewer lies draped across his left thigh, while the genitals of the youth whose back is to the viewer are tucked between his legs, visible along with his buttocks (fig. 7.21, detail). The overall depiction is both whimsical and erotic, its outdoor setting in a lovely landscape lending a bucolic carefreeness to an afternoon of excessive indulgence in the double pleasures of wine and lovemaking.

Illustrations of male patrons and workers in the hamam also provide the occasion for homosocial scenes suffused with sensuality, reinforcing the discussion of this trope in chapter 2. In some cases, the implied eros may exist independently of the actual narrative context. This is true of the miniature included in Darvish Mahmūd Mesnevī Khān 's *Tarjuma-i Thawāqib-i manāquib* ("The Bright Stars of the Legends [Legendary Life Stories]"), a mythic history of the early leaders of the Mevlevi order of dervishes produced in Baghdad in 1590 in an edition that translates the Persian original into Ottoman Turkish (fig. 7.22). The illustration accompanies a moral fable in which Mevlānā, the primary founder of the order, has gone to the hamam to cure a cold caused by too much contact with human vanity. For the artist, as well as the viewer, however, the interest lies less in the character of Mevlānā (the figure washing himself in the bathing pool to the left upper margin) than in the lively array of activities unfolding in various parts of the hamam. Indeed, if Mevlānā were truly interested in "washing away" human contact, he might have chosen a less busy hour to patronize this particular bath; instead, this artist's rendition casts the dervish looking rather enviously on the youth and man sharing the adjacent tub! Notable in this miniature is the sheer degree of nearly naked bodily contact that it represents. The man drying himself in the upper right chamber (one hand modestly clasped over his genitals) is one of few completely nude male figures in non-pornographic miniature art—even the ubiquitous pestemal is missing. Moreover, the activities of depilation and massage enjoyed by two couples in the foreground appear to have transformed into a sleeping embrace for a third couple—the youth and darker-skinned attendant resting in the private cubicle at bottom right—a touch that subtly suggests the other pleasures that might be purchased from complaisant bath attendants.

If in this case narrative content seems a mere excuse for the accompanying artwork, homoerotic content and representation mesh perfectly in the full-page representation of a hamam accompanying one of the fables in the Freer *Heft Awrang* (fig. 7.23). Its splendid rendition of architectural layout in the miniaturist style, whereby all the chambers and functions of the hamam are visible at once, accompanies the first of the seven stories recounted in Jāmī's masterpiece, the *Silsilat al-dhahab* ("Chain of Gold"). In this story, a poor dervish has been so

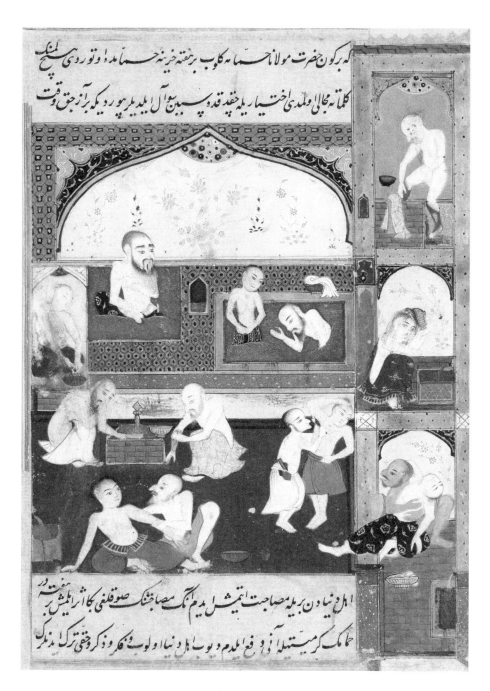

FIGURE 7.22. **More than meets the eye at the hamam.**

Miniature in Darvish Mahmūd Mesnevī Khān, *Tarjuma-i Thawāqib-I manāquib*. M.466, fol. 90v. Baghdad (c. 1590–1599). Courtesy of the Pierpont Morgan Library, New York. Purchased by J. Pierpont Morgan (1837–1913) in 1911. Photograph © The Pierpont Morgan Library, New York.

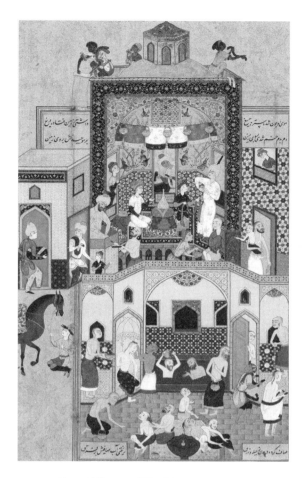

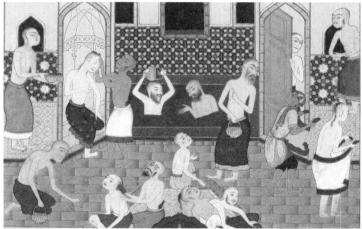

FIGURES 7.23 AND 7.24. **The dervish reclaiming his beloved's shaved hair (detail).**

The Dervish Picks Up his Beloved's Hair from the Hamam Floor, illustration in "Chain of Gold" in Ibrahim Mirza, *Haft Awrang* by Jāmī. Fol. 59a. Safavid (1556–1565). Courtesy of the Freer Gallery of Art, Smithsonian Institution, Washington, DC. Purchase: F1946.12.59.

enraptured by the beauty of a dismissive youth that he follows his beloved to the hamam to pick up every hair shaved from his head (the dervish is the abjectly kneeling figure in the lower left foreground; the youth and his barber sit on the raised pedestal). The visual narrative of the illustration takes the viewer through the front entrance—the structure that juts out of the left margin—through the upper dressing rooms, then to the right where the man carrying an infant is entering a door that leads to (unseen) stairs descending to the lower floor's bath chamber. Here the viewer's eyes span the hamam's activities from right to left till they come to rest, climactically, on the rebuffed lover and object of his affection. In the text, the dervish desperately asks the youth what he can do to engage his complete attention; the vain youth replies, "die in front of me." Which the smitten dervish does. The moral of the story comes with the youth's realization of his folly, his repentance, and his taking the orders of a dervish brotherhood himself: he should have realized that his admirer was, as Sims puts it, honorably seeking "union with God in his adoration of youthful beauty."[34]

Yet if spiritual transcendence is the dervish's ultimate goal, the worship of male beauty in anticipation of physical culmination is the path, which is to say that within this worldview homoerotic desire puts one on the path *to* God, rather than leading one away from it. As if confirming this truism, a heady atmosphere of male homosociality and sensuality pervades the miniature (fig. 7.24, detail), from the convoluted massage occurring to the right of the dervish's beloved (in which the youth with the hair lock is totally enmeshed in the arms and legs of his masseur) to the youth exiting to the lower right, whose open towel encourages the viewer to imagine the unimpeded frontal view privy to those just entering the hamam; indeed, the coy look on the face of the youth peeking through the adjacent half-opened door encourages the sense of voyeuristic delights to which the setting lends itself.

Another illustration from the *Haft Awrang* combines several of the motifs reviewed to this point, forming an apt conclusion to this discussion of the homoerotic encodings of miniature art (fig. 7.25; see also Plate 13). In the accompanying tale, a beautiful youth beset by suitors has asked his father for advice: "Whom shall I join with, from whom shall I flee?" The father's sage advice is to pick the suitor who looks beyond purely physical beauty and loves the youth for his inner qualities. As in the anecdote of the dervish in the hamam, the sufi-inspired thematic is readily apparent—one must look beneath the surface of fleeting, earthly appearances to find divine love, the true form—but, again, homoerotic love creates the path to the spiritual goal. No question is raised about the appropriateness of the boy being sought after by other men or about his making a choice among these suitors. This homoerotic theme suffuses the whole illustration. Aptly, the father's discourse is set in a beautiful garden, the usual setting for lovers and love poems, and the garden is peopled by a variety of figures, "all male and many

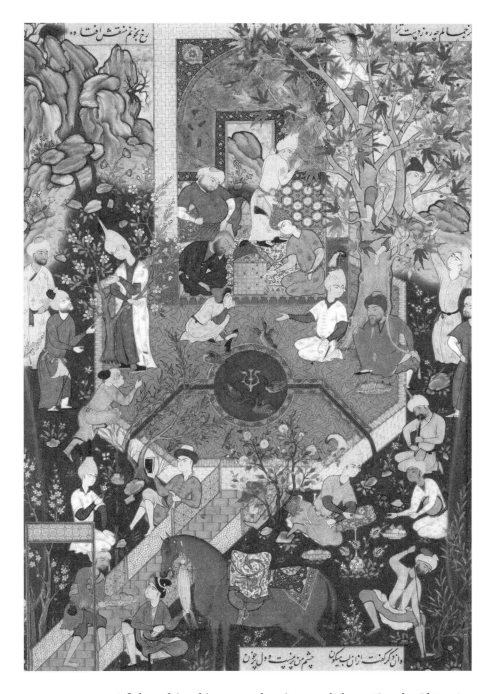

FIGURE 7.25. **A father advises his son on choosing a male lover. (See also Plate 13)**

A Father Advises His Son About Love, illustration in "Chain of Gold," Ibrahim Mirza, *Haft Awrang* by Jāmī. Fol. 52a. Safavid (1556–65). Courtesy of the Freer Gallery of Art, Smithsonian Institution, Washington, DC. Purchase: F1948.12.52.

FIGURE 7.26. **Courtship rituals (detail).**

A Father Advises His Son, Haft Awrang. Fol. 52a. Freer Gallery.

presumably lovers," as Marianna Shreve Simpson notes.[35] The tile staircase that bisects the page on the diagonal visually draws the viewer to the father and son, who are sitting beneath the tree on the right side of the raised terrace. The groupings and interactions of the painting's other characters most likely represent the various stages of passionate earthly love. For instance, the youth talking to the two bearded men to the left (fig. 7.26, detail) may well be a "double" of the son being courted by two of his suitors; the game of chess taking place just above the father and son is a traditional metaphor not only for the vicissitudes of life but for the relations of lover and beloved (in this case, the beloved seems to be winning, to the lover's chagrin!). A visual metaphor for achieving union is also conveyed by the painting's water motifs. Two springs of water flow from the rock formation at the upper left-hand margin and unite in the central pond; from here they again diverge, this time into two man-made channels that represent the inevitability of love in the earthly realm falling short of eternal union, which can only occur after death.[36] These symbolic commentaries on the nature of love are self-reflexively mirrored in the subtle action occurring behind the chess-players. Here, a forlorn lover, pen in hand, is writing couplets on the wall that gloss the very action that is engaging him:

> I have written on the door and wall of every house about the grief of my
> love for you,

FIGURE 7.27. **Self-reflexive layers of love-commentary (detail).**

A Father Advises His Son, Haft Awrang. Fol. 52a. Freer Gallery.

That perhaps you might pass by one day and read the explanation of my
 condition.
In my heart I had [my beloved's] face before me.
With this face before me I saw that which I had in my heart.[37]

This mirroring "face" is indeed "before" the scribbler, in the form of a
drawing—a beloved youth surrounded by text (fig. 7.27, detail)—on the same
wall. The result is a dizzying interplay of self-reflexive doublings. Just as the
Haft Awrang's reader is pursuing a poetic narrative about a beloved and his
lovers that is visually complemented by an illustration of the youth and his
suitors, so too this picture contains a picture within a picture and a poem
within a poem. The thread connecting all these mirroring planes is the fact
that these expressions of love and passion, frustration and union, are occur-
ring between males whose desire for each other is as natural as their desire
for eternal union. From the single portraits of beautiful youths with which
this section began (comparable to the portrait of the youth painted on this
back wall) to depictions of couples of similar and differing ages (also included
in this painting) to illustrations of all-male venues ranging from palaces to
hamams to pleasure gardens (such as that depicted here), the tradition of
Islamic miniature art is suffused with a sensuality that is both explicitly and
implicitly homoerotic.

EUROPEAN ART AND THE
ORIENTALIST TRADITION

If Persian and Ottoman miniature painting on first glance appears an unlikely genre in which to find representations of male homoeroticism, the great European tradition of Orientalist art looms as an obvious place to look, given the degree of sexual fantasy that inundates its practice as a whole. To date, however, no systematic study has yet been made of the male homoerotic elements in European artistic representations of the Middle East, although, as I've noted, art historians such as Grigsby and Solomon-Godeau have made important inroads in this direction by questioning the masculinist and heterosexist assumptions underlying this tradition. It is understandable that in the wake of feminist postcolonial theory the genre's heterosexual dynamics garnered most attention. Linda Nochlin's argument for a Saidean reading of the genre was pivotal in challenging art historians to look at the conflux of imperialist and sexist ideologies dictating its contents and aesthetic properties.[38] If in the first half of the nineteenth century, the painterly aesthetic of expressive romanticism dominating Orientalist art lent itself to the psychosexual dynamics invested in the erotic fantasies fomented by imperialism, in the second half of the century the technique of "ethnographic realism" practiced by Jean-Léon Gérôme and others became, in one critic's paraphrase, "the literal style of imperial rule," in which the polished surface of an apparently transparent naturalism passes off its fantasies as unvarnished "truth."[39] Nochlin's trenchant reminder that it is the art historian's responsibility to ask *whose* reality is being spoken for in such representations is, of course, on the mark, helping to undo decades of critical myopia by revealing the ideological stakes underpinning such projections.[40] This makes it all the more ironic that, even though she uses Gérôme's *The Snake Charmer* (see figs. 2.1 and 2.30) as her opening salvo in denouncing Orientalist mystification, Nochlin does not ask for whom "the manifest attractions" of the snake charmer's "rosy buttocks and muscular thighs" (her phrase) might be most appealing, nor does she ponder *whose* reality is being solicited by this painting's circuit of eroticized gazes.[41] A sustained examination of the role played by homoeroticism—whether on the part of the artist, the artwork, or the viewer—within Orientalist visual forms is needed in order to reveal how such elements complicate assumptions about the heterosexist, imperial, and aesthetic ideologies embedded in these representations.

I will return to these complex issues, as well as to Gérôme's painting. First, I want to review some of the responses of recent art scholars to postcolonial critiques that view European depictions of North Africa and the Middle East as hegemonic expressions of the West's desire to dominate and control. In *Orientalist Aesthetics*, Roger Benjamin makes the case for Orientalist painting as "an art of the interstices, often literally made on the move." While he acknowledges that

such border crossings may inflame the "cultural misunderstanding[s]" that ensue when one culture attempts to represent another, he also suggests that the artistic practice of Orientalism, precisely because it *was* "eminently cross-cultural," at times participated in dialogic encounters with other cultures in ways both subtle and profound. "Even in situations of unequal power," Benjamin states, there is "an endless mutual inflection of participants."[42] Emily M. Weeks concurs, arguing that the genre evinces "genuine moments of cross-cultural understanding, respect, and commemoration" that "have yet to be restored to the historical record."[43] While it has become axiomatic to view Orientalist painters as agents of an imperial will to power in the wake of postcolonial critique, Benjamin notes that many of the artists who turned to the Middle East for inspiration did so because of their deep ambivalence about Western conceptions of modernity and progress. Indeed, several nineteenth-century Orientalist painters now deemed colonial propagandists were savaged by their contemporaries for quite the opposite crime—lack of patriotism—in making the Middle East rather than their homelands the source of creative inspiration. In addition to charges of being unpatriotic, some Orientalists like Eugène Fromentin were also accused of being *anticolonialist* for failing to record the presence of French colonizers in their depictions.[44] Anti-Western sentiments, of course, do not absolve Western artists of reproducing the values of their home cultures, evincing attitudes of cultural superiority, or distorting "reality" in their paintings, but these instances remind us of the more complex relationships to alterity that may underlie articulations of visual Orientalism.

Likewise, several artistic tropes that have been identified as expressions of colonial hegemony turn out to be misleading or factually wrong. One is the claim that European depictions of the Middle East inevitably enforce a deliberate distance between the (Western) spectator's gaze and the observed (Eastern) spectacle. Such a perspective overlooks the intentions of an artist like Fromentin, who maintained that such distance was a moral obligation of the painter traveling in the Arab and Islamic worlds, as well as a sign of respect for a different culture's priorities: "This people must be seen from the distance at which it chooses to reveal itself."[45] Another trope identified with Orientalist imperialism is its deliberate occlusion from the field of representation of Europeans living in metropolitan sites such as Cairo, Istanbul, or Algiers, the better to maintain the Western fantasy of the Orient as a place beyond history, a realm in which "time stands still."[46] Yet, as already noted, the absence of French presence in representations of its colonies struck many contemporary art critics as exactly the opposite: the manifestation of an anticolonial (and hence unpatriotic) attitude. As a matter of fact, there are several depictions that *do* include Europeans or allude to contemporary events involving European presence, often in ways designed to heighten the paintings' cross-cultural significance.[47] Such contrapuntal resonances can also be seen in the way that Middle East societies themselves received and reacted to Orientalist art. Mary Roberts brings this

dimension to vivid life in her studies of Ottoman women's commissions from visiting European female artists and Gérôme's reception in Istanbul, including his role as the Sultan's procurer of European art for the latter's collection.[48]

As Benjamin puts it, the "visual technologies implanted" in a given colonial situation become available for reuse and reinscription by those supposedly objectified by it in complex and sometimes surprising ways.[49] Today, one of the greatest markets for Orientalist paintings is made up of Middle Eastern, particularly Arab, customers;[50] for a century Ottomans appropriated European renderings of Turkish city views for use in their school textbooks;[51] Egypt's Muhammad Ali Pasha and his successor Khedive Said Pasha offered patronage to a number of European artists;[52] Middle Eastern artists like Osman Hamdi Bey traveled to France and studied with painters like Gérôme, who himself was treated as a celebrity when visiting Istanbul;[53] the Istanbul studio of the Abdullah Frères supplied European artists with photographic images used to recreate their travels from their studios or as backdrops for places they had never visited.[54]

Attempts to rehabilitate Orientalist painting have also focused on the degree to which many artists were attracted to the Middle East and North Africa for aesthetic reasons that outweighed the political contexts from which they hailed. From Delacroix to Matisse, painters who traveled to the Islamicate world were fascinated by the shimmering play of sunlight and the radical challenge it posed to European notions of shading, chiaroscuro, and color—the way that fabrics in the marketplace, for example, absorbed the ambient light filtering into shadowy medina alleyways posed an exciting formal challenge. Likewise, the immense expanses of landscape, especially in desert climates, raised provocative questions of framing and perspective,[55] and the aesthetics of open-ended, reciprocal relations intrinsic to arabesque design and ornamentation intrigued European artists for their own merits.[56] Other revisionist accounts have begun to view the penchant for exacting detail apparent in artists like Gérôme less as pseudo-ethnography and more as an attempt to counter the masculinist prerogatives of academic historical painting by embracing an aesthetics of decoration that has historically been abrogated to the domain of the feminine or the inconsequential.[57]

Needless to say, none of these revisionist perspectives attempts to exonerate the genre from its equal share of complicities; they admit that many Orientalist artists unabashedly objectified and exoticized their subjects (especially female ones), used their canvases to convey their sense of Western entitlement, and promulgated stereotypes of the Islamic "Orient" as a timeless realm of lethargy, cruelty, unreason, sexual abandon, and the like. The point, rather, is that this artistic movement is far from uniform in its responses, both in terms of themes and aesthetic imperatives. And within this diversity of responses there exist many openings for a more capacious critical understanding of the desires impelling the cultural crossings implicit in such ventures. Assuming that Orientalist painting is, by definition, a "sordid imperialist mode of art"[58] limits our ability

to see the cultural work that may actually be occurring in such representations. A case in point once again involves Fromentin, in this instance his 1859 painting *Street in Laghouat*, which depicts a sun-drenched street lined by battered buildings, in whose shadows groups of Arab men sleep on the pavement and propped against the walls. On the surface, the somnolent scene might seem to confirm Orientalist stereotypes of languidness and decay. The work was painted, however, with Fromentin's awareness of the recent sack of the town by the French army in response to sporadic uprisings in 1852; Fromentin is thus not attempting to capture some "timeless" Eastern tendency toward indolence but the specificity of a historical moment in which Laghouat's inhabitants have repossessed their town and, in reinstituting local customs like the afternoon siesta, have begun to overwrite the French incursion (and its colonialist standards) with the values of their own tradition.[59]

Another telling example of how Orientalist subject matter might be misread by those intent on imposing a preformulated hypothesis is John Frederick Lewis's *The Reception* (1873). While its decorous representation of a group of unveiled women receiving female guests within their Cairo domicile sidesteps the voyeurism often solicited in harem paintings, Lewis's artistic rendering might nonetheless seem to epitomize a colonialist will to power through the rigidly imposed perspectival grids that bring the ornamental architectural excess, burnished furnishings, and richly colored costumes of this female domestic space into visual harmony. Yet the concept of female domestic space, as Emily M. Weeks demonstrates, is exactly what this painting throws into question. The subtitle of the painting, *Mandarah, the Lower Floor of the House*, reveals Lewis's deliberate placement of these women in the downstairs room or *mandarah* that is, in fact, the realm of the male host and his male visitors, rather than in the women's second-story quarters or *qu'a* (as a long-time resident and homeowner in Cairo, Lewis was fully aware of these architectural distinctions). The fact that women never entered the male-defined space of the mandarah without a veil makes the women represented in Lewis's painting rebels in their own home. Thus "explod[ing] architectural conventions and patriarchal systems of order," Weeks argues, *The Reception* not only creates a deliberately "disquieting allusion to female power," but stages a contrapuntal dialogue between British and Egyptian conceptions of female domesticity, adding multiple layers to the painting's implicitly political and potentially feminist implications.[60] Darcy Grigsby reveals a similarly subversive dimension to Antoine-Jean Gros's *Bonaparte Visiting the Plague Victims of Jaffa* (1804), in which the dying Frenchmen occupy the sprawling nude positions usually occupied by the "barbarian" Mamluks and in which the calm doctors and attendants are Arabs who freely offer their services.[61]

The ability of such paintings to subvert Orientalist clichés as well as the dynamics of power associated with empire also marks, in varying degrees, those instances of homoeroticism insinuating themselves into this visual tradition.

Sometimes, of course, such homoerotic shadings repeat the dynamics of sexual objectification that have given Orientalism a bad name. But in general the inclusion of illicit same-sex desire within the visual field—whether an unconscious result of the scene being represented, the deliberate provocation of the artist, or an effect of reception—begins to destabilize Western frameworks of masculine heteronormativity. For the deconstructive entrance of homoerotic desire into this genre brings into focus "situations, experiences, people and objects"[62] often overlooked in readings predisposed to locate a demonstration of Said's thesis (whereby West equals male and East equals female). On the level of composition, as James Smalls suggests, the viewer–critic must learn to read "the constituent parts . . . *between the lines* and not just on the surface," for it is in the "ambiguous space between 'reading' and 'seeing'" that homoerotic significations resonate most suggestively.

A second entry point for male homoeroticism lies in what Nicholas Tromans identifies as the quandary of all European "genre painting when transported to the Orient," given the focus of genre painting on domestic life and the relation between the sexes. In a world in which the domestic realm is off-limits to outsiders and women are generally sequestered from public view, the artist is of necessity forced "to make more of male-only genre subjects." Fromentin voiced the same conclusion a century before in *Une année dans le Sahel* (1859), making it a dictum for the Orientalist artist: "[Arab life] must be seen from the distance at which it discloses itself: *men close up*, women from afar."[63] Such an emphasis on male interactions brings into focus, however unintended by the artist, configurations that, as we shall see, on occasion reflect and mutely confirm European travelers' accounts of the pervasiveness of homoerotic relations in Arab-Islamic culture.

A third conduit empowering homoerotic interpretations of what Smalls calls the space between "seeing" and "reading" lies in repeated figural and sartorial details that—at least on the surface—seem to flout Western gender categories and, given the tight fit between Western nineteenth-century gender norms and sexual identities, thereby give rise to speculations of Middle Eastern sexual "deviance." These "suspect" visual elements range from the oxymoronic combination of a mercenary warrior's ferocious masculinity and the seemingly "feminine" frilliness of his skirts, to the lounging postures and sensually tilted hips often assumed by standing figures, to the dark-lashed eyes of epicene Arab youths peering out of individual portraits. A fourth aspect of Orientalist painting susceptible to homoerotic projection lies in its supersaturated realism. Chapter 3 demonstrated ways in which the metaphoric language of uncontrolled excess in European accounts of the Ottoman world mirrored a more general fear of the breakdown of moral boundaries and sexual norms. Likewise, the sheer excess of objects and details that spill across Orientalist

canvases evokes this libidinal flow, as well as the marginal sexual practices that are part of this uncontrollable excess.

At this point, I would like to return to Gérôme's *The Snake Charmer* (c. 1880; see fig. 2.1), the century's most famous example of the convergence of homoeroticism and visual Orientalism, before proceeding to a series of pictorial categories expressive of the homoerotics of Orientalism. The titular subject of Gérôme's exquisitely rendered oil is a naked, prepubescent boy—seen from his backside—as he performs for a group of raptly watching men dressed in sundry costumes as they recline against a tiled wall of dazzling blue and aquamarine hues. The painting's position of prominence on the cover of Said's *Orientalism* has inevitably led to its status, for postcolonial critics, as *the* "locus classicus of artistic imperialism," an "iconic distillation of colonial ideology couched in a language of would-be transparent realism."[64] There is little doubt that Gérôme was an Orientalist in both senses of the word; he had few qualms about promulgating Eastern stereotypes or titillating his eager customers with sexually provocative narrative paintings, even as he served as an intermediary, as Roberts details, between the Ottoman Sultan and the Parisian art world.[65] The sight lines deployed throughout Gérôme's oeuvre, moreover, seem to insist on the "controlling gaze" of "[t]he white man, the Westerner,"[66] thus linking Gérôme's aesthetics and the desires roused in his viewers to the political project of empire.

What difference does it make, however, if this "controlling gaze," as in *The Snake Charmer*, constructs the viewer as a participant in a circuit of homoerotic desires? As already noted, Nochlin briefly takes note of the "sexually charged" aura of *The Snake Charmer* without asking whether the homoerotic specificity of its "sexual charge" might alter her more general deductions.[67] Rather, she emphasizes the manner in which Gérôme's documentary realism suggests, first, a world that is timeless and unchanging (except for its decline, signified by the telltale chips in the tile work); second, a world in which the uneducated populace thrills to infantile pleasures (such as those offered by snake charmers and street magicians); and, third, a world whose perverse eroticism connotes a general moral decadence. Several critics argue that the ethnographic attention that Gérôme and his followers paid to detail and smooth surfaces on the level of execution serves to create an illusion of reality that is not to be questioned. This seeming realism, in turn, has also led to charges of "bad faith" on Gérôme's part, since he in fact takes considerable artistic license in borrowing his "realistic" details from various cultures and mixing them indiscriminately.[68] Thus, because in *The Snake Charmer* he uses photographs to reproduce the tile patterns and calligraphy found in two different locations in Topkapi Palace, he is charged with deceit in using the palace's premises to stage a spectacle more likely to occur in the bazaar; similarly because the boy's snake does not conform to a known herpetological type, he violates the painting's realist contract—arguments, however,

that hold only if one agrees in advance that his primary purpose in creating this mise-en-scène has been that of mimesis.

Such an assumption does not adequately explain the complex desires encoded in this work's images, which, as Holly Edwards puts it, are inundated with "homoerotic overtones."[69] Despite its painterly realism, *The Snake Charmer* conjures forth a state of dreamlike psychological intensity that, on the visual plane, is represented as a fantastical (rather than actual) world—a world of magical potency and of the senses evocative, for most European viewers, of *The Thousand Nights and a Night*. Intensifying this sense of dreaminess, the enclosed world depicted in the painting is presented as a stage set, a world of artifice in which *multiple* forms of art operate in concert to foment inchoate desires—the wish to return to a child's belief in a world of magical possibility, the wish to luxuriate in sensuous beauty, the wish to be swept away on a magic carpet spun from the imagination. For critics of Gérôme, his realist effect depends on the painting's apparent *absence* of its artistic production in order to lull the viewer into an acceptance of "the total visual field as a simple, artless reflection . . . of a supposed Oriental reality."[70] But such views overlook the fact that art and artifice are *everywhere* in the painting: from the intricately repeating arabesque patterns of the fabled tile work to the calligraphic design on the upper wall (calligraphy was considered the highest of all art forms in the medieval Middle East), from the music being piped by the flutist to the boy's performance, from the storytelling element that well may be accompanying his performance to the implied narrative within the painting itself.

And that narrative, from the upright rifles leaning against the wall to the tumescent snake, is subliminally one of masculinity, prowess, and phallic potency.[71] Moreover, as the sightlines built into the painting insist, this fantasy is routed through a homoerotically constructed gaze. Not only do these sightlines irrevocably draw the viewer's gaze to the buttocks of the youth (thereby conjuring up associations of the Middle East with pederasty), but the intense gazes of the group of male spectators, along with the diagonal alignment between the head chieftain and the rug on which the boy stands and the flutist's instrument (pointing like a signpost), all converge on the boy's unseen penis. This talisman of future manhood is, in turn, signified by the muscular snake that rises from his arms. The intimate embrace of boy and snake contributes to the tableau's erotic charge, while the iridescent play of light on the tiles directly behind the male observers creates an uncanny aura that enhances the painting's dream-like "feel": it cues us to the fact that the scene we are witnessing transcends "reality," its psychosexual intensity tapping into the realm of polymorphous, unconscious desire.

Such exotic and erotic projections, of course, depend on and define the heady Orientalism of this painting, but they operate according to a logic that supersedes the power dynamics and binaries common to postcolonial critique. Nowhere is

this more apparent than in interpretations of the painting as a demonstration of colonial mastery over potentially threatening otherness. Since Orientalist painting ostensibly maintains a distance between viewer and spectacle, such critics argue that *both* the boy and his audience of male watchers function as objects of the Western viewer's delectation, and that this separation allows the viewer to categorize all these humans as consumable objects from a position of outside and beyond the painting. But the homoerotic dynamics of Gérôme's representation collapse that distance. Instead of existing at a safe remove, the viewer's gaze mirrors, in reverse, the desirous gaze of the observers within the painting. Just at the latters' eyes are predatorily directed to the boy's genitals, our eyes are directed toward the boy's buttocks. Together these two gazes "create" the totality of the thus entirely eroticized body of the snake charmer—which is to say that "Eastern" and "Western" viewers, rather than existing as opposites, become mirrors of each other, linked in a shared act of homoerotic triangulation that occurs over this boy's nude body.

The following pages analyze specific categories of homoerotic imagery recurring within the Orientalist visual tradition, arranging them in groupings that make their underlying dynamics more apparent. One such strand involves individual portraits of male youths whose not quite fully mature beauty is made the focus of the painterly gaze. Several examples occur in the tinted etchings executed by Louis Dupré (a student of Jacques-Louis David) during his tour of Ottoman Albania and included in *Voyage à Athenes* (1825). These striking portraits convey a vivid sense of the beautiful young men attached to the court of Ali Pasha, Ottoman vizier in Albania, and of Ali's son, Veli. Both father and son were notorious lovers of boys. "The vizier is almost exclusively given up to the Socratic pleasures," wrote Baron de Vaudencourt in 1816, and other contemporaries said the same about Veli.[72] Every detail in Dupré's rendering of Veli's page in figure 7.28—from the youth's frank gaze, bee-stung lips, and delicate features to his posture of open-legged repose and opulent attire—epitomizes the desirous youth immortalized in numberless ghazals and described as part of the courtly retinue of Middle Eastern pashas and beys in European travel literature.

An equally common trope in European travel writing, as noted in chapter 2, involves similarly well dressed, handsome youths employed in cafés as "stales" or bait to bring in male customers. The German-born artist Carl Haag (who became a naturalized British citizen in 1847, served as Queen Victoria's drawing master, and traveled widely throughout the Middle East) envisions a soulful representative of this profession in *The Coffee-Bearer* (1875; fig. 7.29). Interestingly, no traces of the boy's trade are on display; clearly, his major business asset is his beauty. Haag's loving attention to the coffee-bearer's delicate wisps of facial hair—signaling that the model is on the very cusp of manhood—forms a visual equivalent to centuries of Middle East love lyrics celebrating youths whose downy cheeks have yet to grow a beard. The slight tilt of the model's head, the

FIGURE 7.28. **European rendition of the page boy.**

Louis Dupré, *Voyage à Athènes et à Constantinople* (Paris, 1825).

way his soft eyes are made to brim with moisture and gaze slightly off-center, the embroidery that emphasizes the open V-neckline of his tunic and outer garment, all work together to suggest an androgynous ideal of beauty that make him the most sensuous of Haag's many paintings of attractive Arab youths and men.[73] The fulsome eyes of Dupré's page and Haag's coffee-bearer also characterize Gérôme's intimately sized portrait of the *Bisharin Warrior (Boy of the Bisharin Tribe)* (1872; fig. 7.30), a youth who languidly gazes over his bare shoulder as if he has just apprehended an admirer viewing him from behind. His adolescent moustache—like the fuzz on the chin of Haag's subject—emphasizes the recent ascension to manhood also signified by his weaponry. At the same time, his titular status as a "warrior" is balanced by an androgynous softness resembling Caravaggio's minions. "Gérôme seems to have responded less to the warlike than to the sensual nature of this young man," one critic comments. "Although he is

FIGURES 7.29, 7.30, AND 7.31.

**Languid-eyed youths on the
cusp of manhood.**

Top left: Carl Haag, *The Coffee-Bearer* (1875).
Courtesy of Sotheby's Picture Library.
Top right: Jean-Léon Gérôme, *Bisharian
Warrior (boy of the Bisharian Tribe)* (1872).
Private collection. Courtesy © Christie's
Images Limited. *Bottom*: Charles Landelle,
Jeune bohémien serb (1872). Courtesy of
Bridgeman Art Resources / Nantes, Musée
des Beaux Artes.

armed, his relaxed pose, heavy eyelids, full lips, and provocatively splayed fingers
on the hilt of the sword create an intimate allure and physical presence."[74] In
effect, he represents the ideal of androgynous male beauty that Charles Landelle
carries a step further in *Jeune bohémien serb* (1872; fig. 7.31). Tellingly, this deli-
cately featured subject was long mistaken to be a young woman, echoing the

gender blurring that often occurs in poetic descriptions of beloveds in ghazal poetry.[75]

An equivalent homoerotic frisson asserts its presence in certain Orientalist studies of grown men, where attributes of virility and prowess, on the one hand, and a sensual abandon that exceeds Western convention of masculine behavior, on the other, become flash points for subliminal to explicit erotic cathexis. A stellar example is Charles Bargue's studio sketch, *Fumeur Arabe* (1871; fig. 7.32).[76] Two adult men (or the same man, drawn twice) are depicted nonchalantly lounging against an invisible wall, their faces offset by sensuous folds of fabric falling down the length of their bodies that highlights, by contrast, the degree of well-formed, bare flesh on display. In addition to their exposed torsos, there is a louche quality to their poses—a "come-hitherness" accentuated by their suggestive gazes, slightly tilted pelvises, and teasingly exposed nipples—that

FIGURES 7.32 AND 7.33. **Suggestive poses.**

Left: Charles Bargue, *Fumeur Arabe* (1871). Private collection. Courtesy of ACR Publishing. *Right*: Mariano Fortuny, *Moroccan Man* (1869). Courtesy of Album / Art Resource, NY / Museo del Prado Museum, Madrid.

conveys an unsettlingly frank eroticism. This erotic allure and sexual invitation reappears in very similar pose in the Spanish painter Mariano Fortuny's beautifully executed 1869 watercolor *Moroccan Man* (fig. 7.33). Here, as well, the half-bare, well-shaped body, directly facing the viewer, hints at the possibility of further undressing, while the luminescent whiteness of the head wrap makes the model's gaze all the more arresting.

Fromentin expressed an equally sensuous appreciation of Arab masculinity, revealing a keen pleasure in rendering the male body and making its sculptural form seem to come alive. His North African notebooks are peopled with drawings of strikingly handsome natives, such as *Akmed* (1853; fig. 7.34), whose commanding visage captures a masculinity—with firmly resolute jaw, pronounced cheekbones, smoothly bronzed skin—repeated in Charles Bargue's paintings. In this vein, Bargue's 1887 *Turkish Sentinel* (misnamed, since the outfit is actually that of an Albanian Arnaut, one Bargue likely borrowed from his collaborator Gérôme's costume chest[77]) and 1876 *Albanian Soldier* (figs. 7.35 and 7.36) are especially intriguing, since Bargue uses the same studio model in both but outfits him in different regional costumes and places him in different contrived settings. The result, as in the case of the examples of ethnopornographic photography surveyed in chapter 6, attests to the temporal and spatial transportability of erotic fantasies of the ideal Arabic other. In each painting, the model strikes an identical pose, hand resting on cocked hip while he leans into the wall (compare to the pose that Bargue captures in figure 7.32). The upright rifle (a signature of masculinity), tilting slightly to the left, mirrors the direction of the three-quarter-turned, handsome profile (fig. 7.37 [detail]). The fact that neither sentinel nor soldier seems to be guarding anything suggests that they are simply present as objects to be seen. Dress codes add to the connotativeness of both paintings. In the case of the former, the combination of body language and intricately pleated Arnaut skirt adds a slightly discordant note, given European associations of skirts with women; in the latter case, the skin-tight breeches and accentuated breech-cloth eroticize the guard's maleness, suggesting his relaxed masculinity is the object of this artist's appreciative gaze.

Bargue's appreciation of the male form and masculine beauty runs throughout his work, forming a counter-discourse to his fellow Orientalist painters' repetition of harem scenes filled with half-clad women. A highly polished oil painting, *A Bashi-Bazouk* (1875; fig. 7.38), displays Bargue's talent in using light, color, and shadow to bathe this seated man in a sensuous glow: note the calf muscle of the crossed leg pushing forward and outward where it touches the knee across which it rests, the perfectly rendered foot from which a slipper has fallen, the pulse of veins in the forearm that presses to the stone seat, the barely visible, moustachioed profile that gazes off-stage, the vague shape of an

FIGURES 7.34, 7.35, 7.36, AND 7.37. **Echoing ideals of masculine beauty.**

Top left: Eugène Fromentin, Detail from *Akmed and Mohammed* (1853). Private collection. Courtesy of ACR Publishing. *Top right*: Charles Bargue, *Turkish Sentinel* (1877). Courtesy of the Museum of Fine Arts, Boston. *Bottom left*: Charles Bargue, *Albanian Soldier* (1876). Courtesy of ACR Publishing. *Bottom right:* Detail of *Turkish Sentinel*.

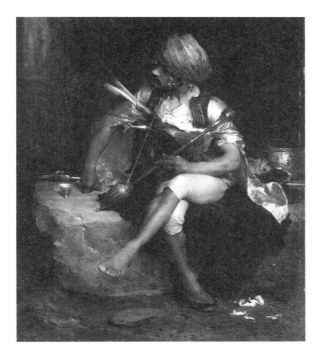

FIGURE 7.38. **Masculinity suspended between action and repose.**

Charles Bargue, *A Bashi-Bazouk* (1875). Image copyright © The Metropolitan Museum of Art, New York. Image source: Art Resource, NY.

arched entrance in the upper left corner that implies egress to this scene. Taken together, these fetishistic details create a sensation of momentary suspension in the midst of a narrative whose mysteries are all the more suggestive for remaining just out of reach.

Orientalist portraits of single youths and men have a built-in alibi when it comes to imputations of homoerotic meaning; the representation, one can claim, is simply a "type" that has sparked the artist's creative curiosity rather than the bearer of sexual connotation. Orientalist depictions of male couples, however, aren't as easily explained away, and hence such examples are rarer. This forms a telling contrast to the frequency of the trope in Middle Eastern miniature art, where such depictions are not only ubiquitous but normative. Nonetheless, academic Orientalism's representation of the public world of men seen "up close" (in Fromentin's phrase) occasionally yields depictions of male pairs in which the erotic subtext is fairly apparent. This is true of Dupré's drawing in *Voyage à Athènes* euphemistically subtitled *Un Turc and un jeune Grec* (fig. 7.39). The palace of Janina seen from the lake is the ostensible subject, but the

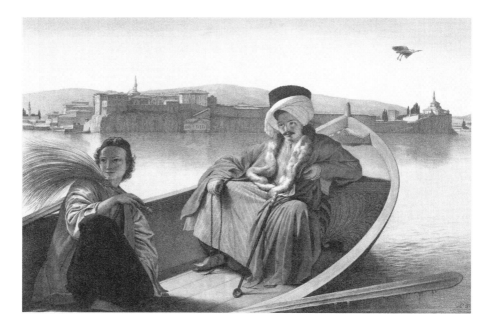

FIGURE 7.39. **Age-differentiated couple.**

Louis Dupré, *Voyage à Athènes et à Constantinople* (Paris, 1825).

artist takes as his vantage point the kayak occupied by the two figures alluded to in the subtitle. One needn't have read of the Ottoman predilection for Greek youths, frequently noted in both European and Ottoman texts, to decipher the visual cues marking the relationship between this older man and epicene youth. The Ottoman's gaze at his servant, whose sole duty appears to be that of fanning his master, is clearly loving and amorous.

Another example of the trope of older man and youthful assistant is Fromentin's *Interieur d'une Atelier de Tailler Arabe* (1854–1857; fig. 7.40), which subtly evokes, in the words of Barbara Wright, a "paternal or homo-erotic coupling of youth and maturity . . . in parenthetical poses." Indeed, the complementary "parentheses" formed by the posture of the tailor, seated on a level just above the boy as he intently pursues his labor, and that of the "languid" or "indolent" youth in "meditative relaxation," as Wright puts it, bring the two figures together in a formal as well as personal intimacy that—in light of Fromentin's other work—suggests deeper intimacies.[78] The homosocial workplace also forms the site of highly suggestive eroticism in Léon Bonnat's tightly-focused *Barber of Suez* (1876), painted eight years after a trip to Egypt (fig. 7.41; see also Plate 14). Although Bonnat is primarily known for his fashionable society portraits, this particular painting, as Bonnat's contemporaries recognized, conveyed a unique

FIGURE 740. **Maturity and youth in the workplace.**

Eugène Fromentin, *Interieur d'une Atelier de Tailler Arabe* (1854–57). Courtesy of Bridgeman Art Resources / Musee des Beaux-Artes, Rochelle, France.

flash of genius and unusual degree of intimate engagement that elsewhere in his oeuvre only emerges in the male nudes featured in his Biblical studies. Indirectly referring to this never-married (and strikingly handsome) artist's sexual orientation, Orientalist art historian Christine Peltre attributes this "surprising tour de force" to what the painting leaves unsaid but powerfully suggests, its "elegant ellipses betray[ing] a personal vision" that supersedes "the ethnographic tendencies that determined the choice of subject."[79] (It is intriguing that both Wright and Peltre rely on grammatical tropes—parentheses and ellipses—to articulate the latent homoeroticism of these two works.) The barber's client, eyebrow slightly raised, stares from behind half-parted eyes directly at the viewer—almost as if he is silently asking, "Why are you looking?" The look of pure sensuous pleasure on his face is matched by the ease with which he leans into the embrace of the barber's hands and relaxes his head against the barber's crotch and strong thighs. Meanwhile, the barber, dressed only in a short white loincloth that accentuates his dark skin and foregrounds the head of his client, leans forward in a posture that causes the muscles in his arms and thighs to bulge; likewise, the disheveled state of the client's blue robe, parted down his

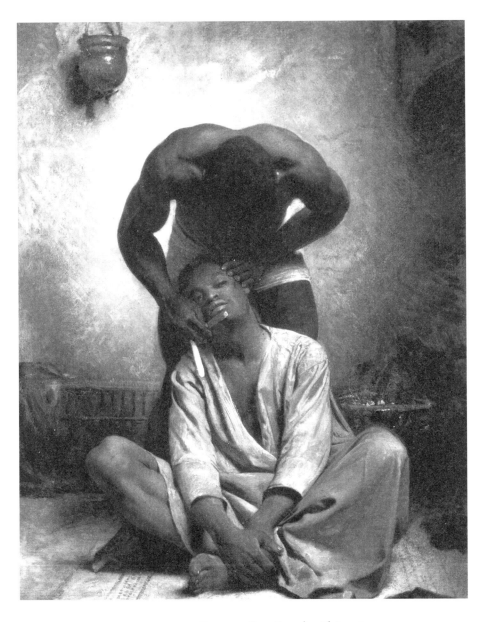

FIGURE 741. **Razor erotics. (See also Plate 14)**

Léon Bonnat, *Barber of Suez* (1876). Courtesy of the Curtis Galleries, Inc., Minneapolis, MN.

FIGURE 742. **The love language of flowers.**

Glyn Philpot, *Apès-Midi Tunisien* (1922). Location unknown. Reproduced in J. G. Paul Delaney, *Glyn Philpot: His Life and Art* (1999).

chest and riding up his right leg to reveal his own manly body, adds to the painting's aura of sensuous potency: the two men momentarily exist in a private world of two, "completely absorbed in one another."[80] Orientalism, in this case, clearly forms the conduit for the outburst of eroticism that makes this painting one of Bonnat's most successful works.

Relevant to this grouping of images is the male couple depicted in Glyn Philpot's *Après-midi Tunisien* (1922; fig. 7.42). Executed in the early twentieth century, the painting's aesthetic derives directly from the late-nineteenth-century tradition of Orientalist realism. Designed on a horizontal axis rather than the vertical one used by Bonnat, Philpot captures a similar intimacy between the two Tunisians, one older and one younger, lounging at opposite ends of a recessed wall niche. This setting gives their interchange, however public, the illusion of privacy, recalling Gide's description in *Amyntas* of the niches in café walls that serve as trysting spots. A practicing if discreet homosexual who traveled to North Africa three times (and who once executed a commissioned portrait of Egypt's King Fouad), Philpot was fascinated, writes his biographer, by the way foreign cultures such as those of the Maghreb "dealt with sexual relations that in England were illegal and seen as immoral." This appreciation gives the seemingly ethnographic realism of

Après-midi its latent erotic charge: "At first sight, the painting is simply a record of a foreign land in the tradition of the 'Orientalists' of the prior century," J. G. P. Delaney writes, but "on a closer study . . . hints of homosexual flirtation become apparent in the way the older man is toying with the carnation."[81] The older man's active engagement in this courtship is mirrored, in turn, by his companion's suggestive body posture, as Robert Aldrich notes: "the young companion reclines, leaning back invitingly, his shapely leg stretched towards his companion, an arm raised behind him in a debonair fashion, a flower charmingly placed behind his ear"[82]—a flower, perhaps, that he has already received from the older man, the giver of love tokens. The topos of harem master and female odalisque is subversively rewritten, in Philpot's scene, as a male homoerotic exchange.

Somnolent lovers yield to ferocious warriors in a fourth, perhaps surprising, category of Orientalist art laden with homoerotic implications: namely, grand-scale history paintings in which East and West clash on the battlefield, a genre particularly popular during the Romantic period. James Smalls and Darcy Grigsby have written brilliantly of the way the homosexual artist Anne-Louis Girodet de Roissy-Troison subverts not only the conventions of history painting but representations of the colonizer and colonized in *Revolt at Cairo* (1810; fig. 7.43), a commissioned work in the academic style that depicts a failed revolt by Mamluk soldiers and Arab Bedouin against the occupying French in 1798 (thousands of Egyptians perished in the tumult, with minimal French casualties). For Girodet, the subject matter provided him with an excuse covertly to express his psychosexual interests and wage a rebellion against the politics of nation and empire. He does so by downplaying the expected theme of French heroism and staking out his own identification with the victimized Mamluks and Arabs, whose active resistance and fight to the death Girodet infuses with intense emotion, nobility, and a transgressive politics of sexuality.[83]

This subversive element emerges as the center of the painting's whirling mass of carnage, as the viewer's eyes, led by the charging French hussar with uplifted sword, move from left to right, coming to rest on the two figures under attack that Smalls identifies as a "pasha and his Arab protector." If heroism exists anywhere in this conflict, it resides in these two figures and the narrative implied by their presence. For, as Smalls argues, Girodet "upset[s] the Orientalist paradigm of aggrandizing the West and disempowering the East" not only "by investing strength, courage, fanatic determination, and sensuality inside the camp of the enemy," but also by encoding within these two figures "the 'unspeakable' subtext—Arab sodomy," that motivates the Mamluk's anguished defense of his fallen lover (fig. 7.44, detail; see also Plate 15).[84] His naked muscularity (the dangling strap of leather that hides his genitals was added after its initial exhibition at the Empress's demand) and the swooning femininity of the gorgeously dressed youth (his turban unwinding, his sword drooping in

FIGURE 743. **A Mamluk warrior defends his swooning beloved.**

Anne-Louis Girodet de Roissy-Troison, *Revolt at Cairo* (1810). Courtesy of Bridgeman Art Resources / Musée National du Château Versailles, France.

detumescence), his body perforated everywhere by wounds, encode a series of binaries (active/passive, older/younger, darker/lighter) conventionally associated with male lover and beloved: in effect, Girodet presents an Arabic equivalent of the Hellenic myth of Achilles avenging the death of his beloved Patroclus.[85] The "unbridled erotic charge" that Smalls locates in this pairing[86] manifests itself as well in the muscular torso of the fallen Arab in the left foreground (fig. 7.45, detail). In contrast to the sumptuous materiality and sensuality of these warriors, the charging Napoleonic soldier, despite his tight breeches and uplifted sword, seems the epitome of a rigid masculinity constrained to the point of desexualization; as such he illustrates the soldier-male that Klaus Theweleit diagnoses as symptomatic of Western constructions of ultimately sterile militaristic manhood in his classic *Male Fantasies*.[87]

Indeed, the genre of battle scenes in Orientalist art, when revisited through these perspectives, reveals a number of male pairings or embraces hidden in full view amidst the chaos of clashing bodies. The range of homoerotic and homophobic shapes that such representations may take are illustrated in the following figures, all details of much larger set pieces. In Horace Vernet's *The Massacre of the Mamelukes in the Citadel of Cairo* (1819; fig. 7.46, detail), for instance, two soldiers in the retinue of Ali Pasha, who appear to the right side of the larger

FIGURE 744. **Activity and passivity (detail). (See also Plate 15)**

Girodet, *Revolt at Cairo* (detail). Bridgeman / Musée National du Château Versailles.

FIGURE 745. **Fallen Bedouin beauty (detail).**

Girodet, *Revolt at Cairo* (detail). Bridgeman / Musée National du Château Versailles.

FIGURES 746, 747, AND 748. **Warrior couples.**

Top: Horace Vernet, *The Massacre of the Mamelukes in the Citadel of Cairo* (detail) (1819). Courtesy of the collection of the Musée de Picardie, Amiens. Photo © Musée de Picadie / Hugo Maertens. No. Inv. M.P.2004.17.176. *Middle*: Pierre-Narcisse Guérin, *Napoleon Pardoning the Rebels at Cairo 1808* (detail). Courtesy of Bridgeman Art Resources / Musée National du Château. *Bottom*: Théodore Chasseriau, *Arab Horsemen Reclaiming Their Dead* (1859). Courtesy of the Fogg Art Museum, Harvard University, Cambridge, MA.

painting, iterate the warrior-ephebe pairing that forms the centerpiece of Giro-det's battle scene. An encoded depiction of "Eastern" male love and nobility in the midst of defeat occurs among those surrendering to Napoleon in Pierre-Narcisse Guérin's *Napoleon Pardoning the Rebels at Cairo 1808* (fig. 7.47, detail). Likewise, in Théodore Chasseriau's *Arab Horsemen Reclaiming Their Dead* (1859; fig. 7.48, detail),

FIGURES 749 AND 7.50. **Extraneous nudity and sexualized violence.**

Top: Antoine-Jean Gros, *The Battle of Aboukir, 25th July 1799* (detail) (1799). Courtesy of Bridgeman Art Resources / Palaise de Versailles, France. *Bottom*: Antoine-Jean Gros, *Battle of Nazareth, 8th April 1799* (detail) (1801). Courtesy of Bridgeman Art Resources / Musée de Beaux Artes, Nantes.

a painting that the sexually ambiguous Gustave Moreau admired so much that he displayed a reproduction in his private rooms,[88] the bodies of two slain Arabs (victims of a sortie by French spahis in Algeria) intertwine in a virtual embrace, one younger and beautiful, the other more masculine and muscled. As the near-naked body of the latter combatant illustrates, Orientalist artists often made these set pieces the excuse to depict the male body undraped.

Predictably, it is almost always the "barbarian other," never his European combatant, who is sartorially deprived, contrary to the fact that Turks, Mamluks, and Arabs *never* fought in the nude or near-nude (as did some Greek soldiers of the Hellenic period, another favorite occasion for the depiction of male anatomy).[89] Thus, in Antoine-Jean Gros's *The Battle of Aboukir* (1799) a totally nude Arab falls backward with legs splayed, while the genitals of the nude soldier on his knees to the right are fortuitously draped by the bit of cloth that descends from his headdress (fig. 7.49; detail). The individual representations of hand combat between French soldiers and Palestinian Arabs in Gros's *The Battle of Nazareth* (1801), moreover, take on a tenor of symbolically sexualized violence, their stagey postures only reinforcing imperial propaganda and European myths of superiority. Note, for example, the backward-swooning position of the Arab to the right in figure 7.50 (detail), who has fallen between the phallically braced legs of the French soldier who is about to plunge his sword into his victim, and the last-ditch effort made by the fallen Arab in the left foreground, whose curved scimitar mimics the shadowing on his opponent's crotch (the French soldier seems so confident of victory that he needn't even look down at his foe!).

From portraits of delicate page boys to these histrionic battle scenes, the Orientalist tradition in nineteenth-century realist art thus provided multiple grounds for the covert expression of homoerotic desires and fantasies whose aesthetic and ideological ramifications are just now beginning to be taken into account. In the following chapter, we will see how these subliminal and overt connotations are manipulated, extended, and rewritten with new, occasionally subversive, occasionally retrograde meanings in a variety of twentieth- and twenty-first-century forms of visual culture.

Eight

LOOKING AGAIN

TWENTIETH- AND TWENTY-FIRST-CENTURY VISUAL CULTURES

Over the past century, the role played by visual culture in producing and disseminating a discourse of homoerotic Orientalism has expanded into multiple facets of contemporary life, culture, and commerce, and it has done so in ways unimaginable prior to the increased visibility of homosexuality as a fact of modern life in the West. This chapter continues the work of the preceding chapter, examining art movements from pre-Raphaelitism and modernism to postmodern incorporations of Orientalist tropes as a self-conscious part of its aesthetics and politics. Next I trace a variety of visual conduits whose emergence in the twentieth century has changed the face of the homoerotics of Orientalism itself. These include the rise of photography as a high and popular art form, the increased commercialization of erotica (including gay pornography), print artifacts of popular culture (including club fliers, political cartoons, and book jacket designs), and cinematic productions ranging from the popular to the populist. As representations of same-sex sexuality have become less taboo over the course of the century, the perceptual gap has narrowed between contemporary queer critics "looking backward" to recuperate the trace of past histories and the visual archives containing these talismans of affective affinity. However, as the following pages document, this narrowing gap does not prevent various forms of individual and cultural myopia. Hence this chapter's methodological imperative remains similar to that of chapter 7, enjoining the observer to continue to "look again" in looking backward—that is, to set aside one's presuppositions about how visual representation might encode or disclose homoerotic meanings in order to re-see the spectrum of existing possibilities. Maintaining such double vision enables relatively recent enunciations of homoerotic desire and practice to come into focus—or to reframe the focus; hence the organization of these materials into groupings that give them critical mass, allowing images to be read both individually and in context of similarly themed depictions. The

result, far from forming one grand teleological narrative, provides moving evidence of the richly varied, always partial stories that have emerged and are still emerging from the crosscurrents created by homoerotic desire in the negotiations of Middle East and West.

FROM PRE-RAPHAELITISM TO LATE MODERNISM

The ethnographic impulse fueling much Orientalist painting in the second half of the nineteenth century encouraged an exacting realism that lent itself especially well to coded expressions of homoeroticism, whether in the form of representations of "types" like the coffee bearer, male spaces like the barbershop, or male lovers fighting (and dying) side by side on the battlefield. Avant-garde reactions against realism, accelerating as the century moved to an end, also occasionally contributed to the homoerotics of Orientalism. In rejecting academic training in mannerism and classical form and in rebelling against Victorian moral hypocrisy, the Pre-Raphaelite and Symbolist movements, for instance, developed a repertoire of stylistic traits—willowy figures verging on the androgynous, expressions of tremulous emotion breaking through states of repression, and lushly heraldic symbolism—that easily lent themselves to the depiction of scenes of scapegoated sexuality. Most often, these took the form of the "fallen woman" (and, occasionally, hinted-at lesbianism), but the male homoerotic potential latent in the fascination with the sensuous and the symbolic also breaks through on occasion.

One example is William Holman Hunt's *Design for Haroun al-Raschid*, included in his two-volume *Pre-Raphaelitism and the Pre-Raphaelite Brotherhood* (1905; fig. 8.1). The Caliph's indolent posture, the one hand languidly raised to shade his brow, the shimmering waterway on which his boat floats as if in a dream—taken together these elements connote fin-de-siècle decadence and ennui that hin at sexual difference or inversion. Holman Hunt was no stranger to the reputation of the Middle East for same-sex behavior among men. During his travels in the East he grew his beard, so he claimed, to ward off the sexual solicitations that "he and fellow Pre-Raphaelite John Everett Millais affected to fear in their letters to one another of this period."[1] In a similar vein as Hunt's Haroun al-Raschid, aesthete Sir Lawrence Alma-Tadema's Biblical subject, *Joseph, Overseer of the Pharaoh's Granaries* (1874; fig. 8.2; see also Plate 16), presents the viewer with an overly dandified, androgynous, and rather bored-looking youth of ambiguous gender (this ambiguity is compounded, ironically, by the wig that Alma-Tadema's model is wearing, which was taken from a female mummy). The

FIGURES 8.1 AND 8.2. **Innervated (inverted?) masculinity.**

Top: William Holman Hunt, *Design for Haroun al-Raschild*, in Hunt, *Pre-Raphaelitism and the Pre-Raphaelite Brotherhood* (1905). *Bottom*: Lawrence Alma-Tadema, *Joseph, Overseer of the Pharaoh's Granaries* (1874). Courtesy of Bridgeman Art Resources / Dahesh Museum, New York.

fact that within the traditions of the *ghazal* and miniature painting Yusuf was celebrated as history's most beautiful man, the Beloved of all Beloveds and hence as object of other men's most ardent desires, dovetails with the homoeroticism latent in Alma-Tadema's depiction—Joseph's bare skin is visible through his translucent linen garment—of the Jewish youth raised as an Egyptian in the Pharaoh's court. As Jason Edwards has argued, the homosexual panic following the Wilde trials of 1895 did not stop heterosexual turn-of-the-century Aesthetes from turning out male nudes that were suggestively feminine; they did so, in no small part, because of the patronage of a "subset of . . . queerer viewers" to whom such nudes appealed and because of the influence wielded by Frederic Leighton, the sexually ambiguous president of the Royal Academy from 1870–1896. Indeed, this painter made Leighton House, famous for its Arab-themed décor, a shrine to Orientalist Aestheticism, a combination that struck some viewers as too "strangely sensuous," too "effeminate," too telling a reflection of its owner's rumored proclivities.[2]

The Biblical Joseph's crossing of ethnic identities is mirrored in the heritage of the French Symbolist painter, Lucien Lévy-Dhurmer, a Jewish-Algerian Frenchman associated with the Art Nouveau movement. Lévy-Dhurmer's best-known Orientalist work is his striking portrait of Pierre Loti—one of the subjects of chapter 3—seen against the pastel haze of the Constantinople skyline. The same impressionistic swirl of brushstrokes works to even greater effect in *Le Marocain ou la fanatique* (c. 1900; fig. 8.3). The still point in this portrait's surface of fluid dabs of color is the piercing gaze of its Moroccan subject, whose passionate "fanaticism" (referenced in the painting's title) calls to mind the homoerotic ardor that inspired the Sufi worship of earthly male beauty as a means of attaining ultimate transcendence. On a decidedly less spiritual plane, Leon Bakst's campy costume designs for the Ballets Russes' 1910 production of *Scheherazade* (fig. 8.4), set to the music of Rimsky-Korsakov, epitomize the modernist creative energy, fascination with an exoticized Orient, and heady homoeroticism that coalesced in the multimedia ballet productions engineered by the combined geniuses of Sergei Diaghilev and his lover-protégé Vaslav Nijinsky in the beginning decades of the twentieth century.[3]

With the increased abstraction and fracturing of the visual plane by successive movements of modernism, instances of homoerotic Orientalism in art of the first half of the twentieth century are rarer. This decline in Middle Eastern subject matter was not only the offshoot of the modernist rejection of the realism and décor associated with Orientalist aesthetics; it was also an index of the degree to which African primitivism had replaced Middle East exoticism as a source of artistic inspiration and difference. Citations of Orientalist homoeroticism exist, however, in cubist-influenced works like Kuzma Sergeevich Petrov-Vodkin's portrait (1931) of a shirtless tea boy in Samarkand (fig. 8.5). The latter's status as

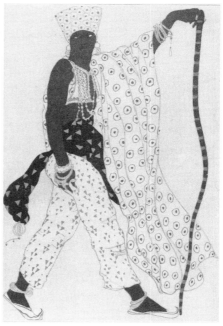

FIGURES 8.3 AND 84. **Fervent Impressionism versus surface camp.**

Left: Lucien Lévy-Dhurmer, *Le Marocain ou le fanatique* (1900). Musée de Quai Branly/Scala / Art Resource, NY. *Right*: Léon Bakst, Costume of the Pilgrim, *Le Dieu Bleu* (1912). Courtesy of the Picture Collection, New York Public Library, Astor, Lenox, and Tilden Foundation.

the object of the viewer's gaze is echoed in the admiring look of the older man on the left, while the reverse-gaze of the boy on the right, looking directly out of the frame at the viewer, completes this circuit of desirous looks. The implicit homoeroticism of this painting becomes more pronounced when viewed in context of the often fully naked, nubile adolescents that form a constant motif in this Russian artist's canon, most apparent in works like his iconic *Bathing of a Red Horse, Dream, Thirsty Warrior, Bathing Boys,* and *Boys at Play.*

Another hint of homoerotic Orientalism in the visual arts in the first half of the twentieth century exists, intriguingly, in a number of sketches archived in the Imperial War Museum, executed by British servicemen while serving in North Africa during World War II. The role played by this war in laying the groundwork for the later-century homosexual rights movement has long been recognized; as men left provincial backgrounds, shared unprecedented intimacy, and encountered different cultures, horizons inevitably expanded. W. P. Moss's watercolor of a Druze regiment washing camels in the River Jordan (fig. 8.6) captures a bucolic moment in the midst of warfare in its rather humorous depiction of

FIGURE 8.5. **Cubist circuit of looks.**

Kuzma Sergeevich Petrov-Vodkin, *Chaikhana of Samarkand* (1921). Courtesy of Bridgeman Art Resources / Christies CH615076.

FIGURE 8.6. **Comrades in arms.**

W. P. Moss, *The Druze Regiment Washing Camels in the River Jordan* (c. 1941). IWM ART LD 5743. Courtesy of the Imperial War Museum, London.

naked soldiers washing down their towering (and rather phallic) camels, unintentionally giving a new spin to the trope of the hamam reviewed in chapter 2. The work balances a kind of rural innocence, Whitman-like brotherhood of men, and unabashed voyeurism (focalized through the clothed onlooker to the right).

Soldiers and warfare also mark the explicitly homosexual themes of the midcentury paintings of the artist and writer François Augiéras, the American-born son of French and Polish parents who lived most of his adult life in Algeria after having been posted to the colony by the French navy in 1944. As Robert Aldrich notes, Augiéras was a man of deep paradoxes, one who, like T. E. Lawrence, often expressed the desire of "becoming an Arab" and a hatred of Western influence yet "seemed unaware of how close his dreams"—and indeed his sexual desires— "came to the classical French imperialist project." Those dreams—expressed in Augiéras's promotion of North Africa as an Arcadian alternative to modernity in which "a new, purified man" might come into being, his sexual desires uncorrupted by puritanical Western morals—are hauntingly portrayed in dozens of oneiric paintings (usually executed on cardboard or wood rather than canvas) of Algerian youths silhouetted against starry skies or fiery desert backdrops.[4] Paintings like *À L'arrière d'un camion* (1966; fig. 8.7), depicting two teenaged soldiers by the rear of a truck, hauntingly evoke the inner conflicts inhabiting

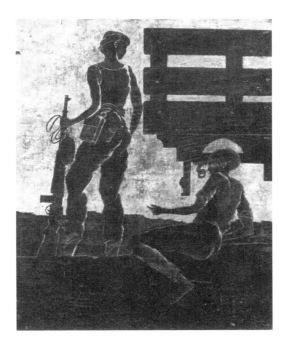

FIGURE 8.7. **Oneiric freedom fighters.**

François Augiéras, *À L'arrière d'un camion* (1966). Courtesy of Editions la différence, Paris.

Augiéras's dream visions. On one hand, the depiction suggests his admiration of the rising independence movement. On the other, the fetishistic outlining of the youths' buttocks in their improbably tight khakis, here and in similar paintings of barely teenaged freedom fighters such as *Soldats Moissonneurs* (1966), suggests the pull of erotic desires that, in Augiéras's personal life, trumped politics and depended on a series of inequalities (of nationality, of economics, of age) made possible by colonial French rule.

POSTMODERN INTERVENTIONS

The techniques of irony, pastiche, and self-conscious borrowings from past traditions that are hallmarks of postmodernism have made contemporary art much more conducive to interventions in the discourses of Orientalism than modernist abstraction and formalism. Sylvia Sleigh's feminist revision of Ingres and Delacroix in *The Turkish Bath* (1973), examined in chapter 2, is one striking example: replacing the traditional female odalisques with men of all ages not only becomes a powerful critique of the sexual and gender politics of this nineteenth-century art form but also raises questions about masculine identity to which associations of the male hamam with homoeroticism inevitably give rise. A brilliant extension of Sleigh's feminist revisionism exists in the work of Abelina Galustian, who recreates Orientalist paintings in which Arab women take the place of male harem masters and naked men that of the female concubines in the originals. The style often combines an exacting realism with the aura of romance paperback novel covers, and the effect of the double displacements is quite stunning (fig. 8.8).[5]

Another self-consciously staged foray into this thematic nexus occurs in Joseph Beuys' contribution to a 1977 exhibit in Naples calling itself an "Intervention" between Wilhelm von Gloeden and contemporary artists (Andy Warhol was another participant). Beuys' composition (fig. 8.9) takes the form of postmodern pastiche, in which he scribbles texts and icons over vintage postcards bearing photographs by von Gloeden. Intriguingly, he gives a grouping of postcards with images of von Gloeden models in Arab dress the title "La rivoluzione," thereby suggesting the forces of decolonization that have reshaped North Africa and the world of the southern Mediterranean since the artist's era. In fact, the image "Asrah" is the same Sicilian model merchandized under the name "Ahmed," as noted in chapter 6, while "Mohammed" is one of the models that von Gloeden photographed on his trip to Tunisia. The multiple levels of authenticity and inauthenticity called into question by these labels are underlined—which I take to be Beuys' point—by the devices of modern mechanical reproduction that first

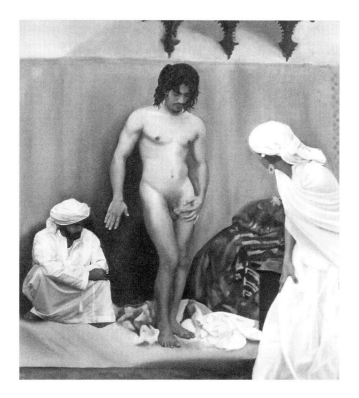

FIGURE 8.8. **Orientalism's gender positions reversed.**

Abelina Galustian, *Examining Slaves, After Ettore* (detail). Courtesy of the artist.

presented these models as "native" exotic objects of desire in photographs for von Gloeden's clientele, then as mass-produced postcards promoting tourism under the aegis of ethnographic realism, and now, in Naples, as this artist's medium in an exhibition whose "intervention" in von Gloeden's legacy is explicitly critical and implicitly political: "We are the Revolution" is the motto scribbled in Italian over all these portraits.[6]

If Beuys incorporates photography into the art object itself, the staged photographic image becomes both canvas and frame for art that makes the camera, rather than the paintbrush, the instrument of an aesthetics of postmodern citation. Two masters of postmodernist pastiche, queer artists Pierre and Gilles, have repeatedly drawn on Middle Eastern motifs to create intentionally disruptive effects by blending them with equally gay iconography. One of the duo's frequently reproduced images, *Le Fumeur di Narguile—Asiz* (1996; fig. 8.10; see also Plate 17) depicts an Aladdin-Adonis sporting West Hollywood muscles and bronzer tan while reclining amid a variety of blatantly orientalizing props—gold-lamé

FIGURE 8.9. **"La rivoluzione"—Beuys's postmodernist "Intervention."**

Joseph Beuys, "The von Gloeden Series" (1977). Courtesy of the Walter Arts Center, Minneapolis / Artists Rights Society, New York. © Estate of Joseph Beuys.

turban, phallic hookah, gaudy pillows and fabrics—all of which are presented in super-saturated color. The image "winks" at the spectator through a mass of associations on which the two artists play: commodified Orientalism (nothing here that tourists might not have purchased); the incongruity between the model's gym-sculpted body—reflective of a Western gay aesthetic—and the

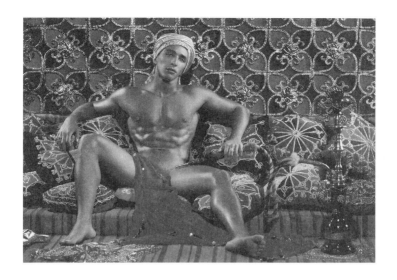

FIGURES 8.10 AND 8.11. **Pierre and Gilles' pomo-homo
Aladdin-Adonis. (See also Plate 17)**

Top: Pierre and Gilles, *Le Fumeur di Narguile—Asiz* (1996). *Bottom*: Pierre and Gilles, *Aladdin—Karim* (1993). Both courtesy of the artists and the Galerie Jérôme de Noirmont.

willowy physiques attributed to the beloved of Middle Eastern ghazals; the camp citation of the genre of the male pinup in homoerotic muscle magazines of the 1950–1960s; a nod at von Gloeden's technique of presenting a romanticized fantasy of a queer past through the embrace of kitsch; the provocative positioning of the model—splayed legs facing the viewer—as compliant object of the gaze; the model's return-gaze inviting the spectator to join him in the photograph's artificially constructed erotic fantasy. Cueing its viewers in to the artifice of that fantasy while simultaneously titillating them with a soft-core pornographic image that plays on the materiality of the objectified body, *Le Fumeur di Narguile* strikes a deliberately provocative balance between Orientalist appropriation and queer critique. Something of this same send-up of the Orientalist stereotype for queer ends characterizes *Aladdin—Karim* (1993), in which a beefcake genie in a bejeweled, golden jockstrap appears against a multilayered arabesque background as if rising from a bottle (fig. 8.11).

Holding a critical mirror up to the homoerotics of Orientalism becomes even more powerful in the hands of the French-Tunisian artist Michel Giliberti, whose work builds on the complicated visual dialogue that ensues when the male object of desire begins to "talk back" to Empire.[7] The artist repeatedly combines homoerotic themes, North African subjects, and a critique of colonialism, but nowhere so powerfully as in the drawings and paintings catalogued in the provocatively titled volume *Voyage secret: Tunisie*. Utilizing his trademark technique of beautifully shaded and sculpted figures, set against flattened backgrounds that make their bodies seem all the more lifelike, and often incorporating esoteric personal symbols that give these works a mythic aura, Giliberti deliberately arranges his North African subjects as objects of the gaze—and most often as explicitly erotic objects of the gaze. At the same time, he positions his figures so that they seem to dare the viewer to attempt appropriating them; they may be the objects of our look, but they refuse to give up their subjectivity. One subset of Giliberti's paintings furthers this implicitly colonial critique by depicting men whose heads are wrapped in iconic turbans or draped in headdresses, from which their piercing gazes stare directly into the eyes of the viewer, challenging the authority of the spectator's gaze. In the ambiguously titled *Mes déserts* (fig. 8.12), the man in white turban who stares at the viewer with such coolly appraising eyes evokes the image of Arab manhood that led Lawrence, among other Western men, to don white robes and take to the desert ("mes déserts") in search of the masculine alter ego that he projected onto his Arab companions.[8] But the insistent gaze of Giliberti's model reminds the looker of the fictive nature of such projections, as do the double meanings that accrue to the possessive pronoun, "mes," in Giliberti's title. Is "my" a reference to the Orientalist fantasies the West has projected onto desert manhood, as in the case of Lawrence, or does it emanate from the subject, the sign of his emphatic claiming of the desert as his own? In a companion painting *Noir Désert* (not shown here), Giliberti obliterates the Laurentian fantasy of Arab

FIGURE 8.12. **Laying claim to "mes deserts."**

Michel Giliberti *Mes déserts* (n.d.). From Giliberti, *Voyage secret: Tunisie* (2004). Courtesy of the artist.

"whiteness" by overwriting the image with threatening blackness—now the challenging gaze of the Arab looms out of sable robes and dark night.

The aura of mystery associated with this darkly robed figure is further eroticized in *Mohamed* (fig. 8.13), in which the same model as in "Mes déserts" has parted his burnous to display, for the benefit of an unseen observer whose gaze he solicits, a totemic necklace dangling against his chiseled chest. The painting glows with a ruby-red background that heightens the implied erotic intensity. We are allowed to watch, but not participate, in the reciprocal exchange of looks that is precipitating this visual striptease of revealed flesh.

A number of Giliberti's images, all featuring handsome Tunisian men with well-defined bodies, even more explicitly eroticize their otherness as a presence that is at once alluring and distant, creating ambiguous question marks in the viewer's eye. What, for instance, is the augury, symbolized by the sacrificial chicken, that Moez offers in figure 8.14 (*Moez et l'augure*), as he stares out at the viewer from the corner in which he reclines in supine nonchalance? Is it a dire warning concerning the future of those foreign others who have attempted to possess or dominate the mystery that Moez has symbolized to them? Or the promise of a more proximate intimacy, as the tease of the single nipple (recalling the technique of tease-and-display in Lehnert's photography, Bargue's drawing, and Fortuny's watercolor [see figs. 6.17, 6.18, 7.38, and 7.39]) might suggest, as well as the inverted triangle formed by his raised legs, directing the viewer's gaze down his bare chest to his crotch? In *Lumière de l'enfance* (fig. 8.15), the title's reference to "the light of infancy" (visually manifested in the small figure of the child running up the alley to the left) makes all the more ambiguous the

FIGURES 8.13 AND 8.14. **Playing on menace and mystery: augury or invitation?**

Left: Giliberti, *Mohamed* (n.d.). *Right*: *Moez et l'augure* (n.d.). From Giliberti, *Voyage secret: Tunisie* (2004). Courtesy of the artist.

strictures of manhood experienced by the two shirtless men in the foreground. There is a deliberate disjunction between the men's appearance—they look like sullen Armani models—and their realities as inhabitants constrained to the economic realities of life in this medina. Adding paradox to paradox is the message of hope that the graffiti artist holding the paint brush (a stand-in for the artist himself?) has inscribed in Arabic script on the wall behind him: the single word "love"—which, as a blow-up of the image reveals, has been painted on the walls all the way down the alley to the left.

The political meanings that accompany these eroticized images of masculinity—a masculinity that, as Giliberti acknowledges, reflects a Western-originated gay aesthetic of masculine desirability that has now migrated to other cultures—are ratcheted up a notch in *Les larmes de la Palestine* (fig. 8.16), in which the shirtless Palestinian appears lost in thought, gazing at nothing, his image set against a backdrop composed of a sepia-toned portrait of his own face enlarged to the size of the entire frame, from which his eyes peer downward at the viewer. The "larmes" of the title are indicated by the blue streaks running from the

FIGURE 8.15. **Coming of age—hope, despair, love?**

Giliberti, *Lumière de l'enfance* (n.d.) From Giliberti, *Voyage secret: Tunisie* (2004). Courtesy of the artist.

FIGURE 8.16. **Tears for Palestine.**

Giliberti, *Les larmes de la Palestine* (n.d.). From Giliberti, *Voyage secret: Tunisie* (2004). Courtesy of the artist.

left eye of the enlarged image, streaks that deliberately insist on their status as brushstrokes. Whose tears, then, do they symbolize? Those of the artist who has added them as a gesture of solidarity; those of Western sympathizers to the Palestinian cause whose vocal support nonetheless remains as immaterial, as artificial, as these superimposed tears? Or might they mark an inward sorrow that is too deep for mimetic representation? Intriguingly, the young man's six-pack abdominal muscles are so well defined that they appear to have been etched with a knife. Taking on the appearance of bodily scars, this detail disturbs the viewing pleasure of the gazes simultaneously solicited by this image.

The motif of scarring, along with the gaze of the dispossessed "other," recurs in one of Giliberti's most thematically and visually rich works, *La Cour des Maux* ("the court of heartaches"; more figuratively, the "courtyard of wrong") (fig. 8.17; see also Plate 18). The title is appropriate, since the subliminal narrative of the image gives the sensation of the viewer's having made a "wrong turn"—that is, of having just turned the corner in some North African medina and stumbled onto the alley or cul-de-sac inhabited by this intense young man. Having encroached on his private space, we are confronted with a harsh stare that seems to ask, "Why are you here? Why are you looking? Do you think I care?" These are the questions that Giliberti intends his viewers to be asking. At the same time, the work's appeal for gay spectators is overtly incorporated into the painting. From the rendering of the model's bronzed skin, muscular leanness, and cropped hair to that stylishly seductive inch of white underwear peeking above the waistband of his sweatpants, these details invite a contemporary homoerotic gaze. Yet, simultaneously, Giliberti's composition makes the spectator feel as if, in staring, one is violating this man's personal space. For he not only "inhabits" this dead-end turn in the road, it is literally marked as his habitus, his home. The bloody handprints on the wall say as much: marking the entrance to the home with this folkloric talisman to keep the evils outside is common rural practice in Tunisia. But if this court is the youth's "home," what message does this fact convey about his present circumstances or his future possibilities? Is his life already as dead-ended as this cul-de-sac, with nowhere to go? This troubling possibility is reinforced by two additional details. The man's hands hold a shard of glass, which presumably has been used to let the blood that marks the wall with these prints; the implication is that the blood is the young man's own, sliced from his palms. If so, his act resonates with the phenomenon of cutting so widely reported upon among contemporary troubled teens; in inflicting pain on themselves, the cutters attempt to break through the numbness of existence and convince themselves that they are alive. Behind the man hang what appear to be sheets, but which on the symbolic level, Giliberti notes, also suggest death shrouds, indicating how much of this youth's future hangs in balance.

FIGURE 8.17. **Confrontation in a blind alley. (See also Plate 18)**

Giliberti, *La cour des maux* (n.d.). From Giliberti, *Voyage secret: Tunisie* (2004). Courtesy of the artist.

That this painting is negotiating the distance between the status of the young man as an object of Orientalist desire, his own masculinity and subjective identity, and the values of the Islamic culture that ground his identity is further underscored by this painting's most controversial detail: the lines from the Qur'an faintly inscribed on the wall beneath the bloody handprints. Fascinatingly, when Giliberti mounted an exhibition of these paintings in Tunis, the homoeroticism of his male-oriented subject matter went unnoted; what stirred unease was this one painting's incorporation of sacred scripture. Taken from the last chapter of the Qur'an, it asks for succor from the tempter (Satan) "who whispers in the breasts of mankind and makes them go astray" and ends with a question mark. In the context of the homoerotic circuit of gazed and gazed upon being invoked in the image, the citation is thought provoking in its many levels of ambiguity. Is the address directed to the implied Western viewer, who figures as the satanic tempter who might lead this object of desire astray by stirring untoward desires in his heart? Is the youth himself the tempter who might lead the viewer astray? Or, more generously, is homosexuality itself the temptation that the youth is trying to repress in himself, because of cultural prohibitions,

even as he provokes our gaze and, perhaps, wishes he were free enough of inhibition to respond in kind? What is clear, in face of this ambiguity, is that this young man, "trapped" in a dead-end courtyard like other young Tunisian men lacking jobs, prospects, or homes to call their own, becomes an emblem of the troubles that roil in the human heart. At the same time, he is depicted as a subject who defiantly maintains his selfhood, willing to stare back confrontationally and catch viewers in their efforts to pigeonhole him (whether as object of desire, exotic other, or third-world "hood"). For even as he puts his sexual appeal on bold display, even as his and the viewer's gazes intersect, the moment hints at realities and subjectivities extending beyond the pictorial frame, at a life that remains "foreign" to the viewer's "outside" apprehension. The fact that Giliberti is parlaying all these significations from his own subject position—as a gay artist who is Tunisian by birth, who emigrated to France in childhood, and who is now again living in Tunisia—makes all the more powerful the levels of complexity comprising the visual narrative of *La Cour des Maux* and dictating its relation to the homoerotics of Orientalism.

More recently, the U.S.-Iraqi war has inspired various contemporary artists to use their medium to shock the spectator into a deeper recognition of the fraught relation between imperialist politics and constructions of sexuality. Although their renderings of the nude male body to create this shock effect differ greatly, paintings by Guy Colwell and Fernando Botero draw on homoerotic connotations to underscore the U.S. military's abuse of Iraqi prisoners at Abu Ghraib. As such, the two artists expose the rhetoric of "perverse" sexuality that so often becomes a means of demonizing one's political foe by constructing "East" and "West" as irreconcilable opposites locked in perpetual face-downs. Both paintings were included in the 2008 exhibition, "Art and Democracy: War and Empire," shown at the Meridian Gallery in San Francisco. The earlier mounting of Colwell's *Abuse* (fig. 8.18) in Lori Haigh's San Francisco gallery in 2004 garnered international attention when she was physically attacked and her gallery vandalized by protesters offended by what they saw as the painting's antipatriotism.[9] The image depicts two gloating U.S. guards, to the left, readying to apply electric shock to three prisoners, naked except for the bags over their heads meant to strip them of their individuality and literally made spectacles on display by the round kegs on which each is forced to stand at attention. The faces of the two guards epitomize the stereotype of the ignorant redneck; on closer inspection, the pair turns out to be a male and female (as the strategically creased fabric in the crotch of the female's trousers indicates), implying that sadistic torture is an equal opportunity job. Damningly, the one dash of color in this otherwise gray-toned image, except for the blood faintly trickling down the first prisoner's neck, belongs to the flags stitched onto the two guards' upper sleeves—even as America's war machine sucks the life (and color) out

FIGURE 8.18. **Abu Ghraib and Colwell's *Abuse*.**

Guy Colwell. *Abuse* (2004). Courtesy of the artist.

of other cultures, it shows its own true "colors." In the center background, a third, African American soldier (repeating Colwell's message that the acts at Abu Ghraib spanned all categories, uniting gender, class, and race as one against the perceived "enemy") leads a blindfolded Iraqi woman into the room; for both the prisoners and the woman, her presence during their naked humiliation is an ultimate act of shaming. On the right half of the picture, the three naked prisoners stand on cylindrical stands that are connected to the same circuit of electrical wiring (held by the female guard) that attaches to each victim's body at a hypersensitive area—finger, penis and finger, and finger.

All this is horrific but perhaps even more destabilizing, on the visual plane, is Colwell's canny decision to make the body types of the three prisoners mimic a Hellenic ideal of heroic manhood—these three nearly identical Apollonian physiques do not faithfully represent the body types of the actual Abu Ghraib detainees, as the widely circulated photographs of the latter make clear. The disconcerting effect is to make the U.S. guards seem to gape, in sadistic glee, at icons of the West's classical heritage put on display. This suggests that the guards are projecting fantasies of their own lack onto their victims—for not only is the behavior of the guards the antithesis of heroic militarism, there is nothing

appealing or "classical" about their physical appearances. This surreal scenario ultimately implies that what is also undergoing torture are Western standards of ideality themselves: that is, in using torture to break down these Iraqi prisoners, the guards are breaking apart the conceptual underpinnings of the United States and Western civilization itself in Hellenic democracy. A hint of sexual prurience commingled with envy also marks the way in which the two guards leer at these stripped bodies, a prurience that hovers between the unconsciously homoerotic and consciously homophobic (in the military's effort to shatter the prisoners' sense of masculinity, first by stripping them naked, then by exposing them in this state of utter degradation to a woman of the same culture and faith).

There may be another reason that Colwell chooses to represent the bodies of these Iraqi prisoners nonrealistically, one that he shares with the Columbian artist Botero: the belief that such a traumatic event is beyond the scope of the conceivable and hence beyond art's ability to reproduce it mimetically. Botero's solution, in *Abu Ghraib 43* (fig. 8.19), is to use body types that have become his artistic trademark—rotund, healthy, jocular—as the template for his representation of the Iraqi torture victims, a choice that creates an eerie visual dissonance between what we see—fleshy, powerful bodies—and what we know—the unhealthy, emaciated physiques of the cowed prisoners at Abu Ghraib. In several of the images, Botero links the degradation of the prisoners to violations of their culture's gender and sexual taboos; thus, in some tableaux, the prisoners are "feminized" by being forced to wear women's undergarments glaringly unsuited to their oversized and hirsute bodies, and in others they are coerced into bodily contact suggestive of sexual acts. Not only is the guards' devising of such humiliating tactics intrinsically homophobic, such shaming also deliberately plays into what they perceive as the homophobia of Islamic cultures where such "unmanly" acts call one's sexuality into question. Yet even as the suggestion of sexual deviance (dressing like a woman, men fellating other men) becomes the means whereby one national power dominates and breaks the resolve of its threatening Other, so too persecutor and persecuted alike are potentially linked by a shared if differently articulated homophobia.

Another variation on this theme occurs in the photographs that Clinton Fein displayed at the Art Basel exhibition in 2007. Fein's means of conveying the events at Abu Ghraib also grapples with the question of whether such horror can ever be adequately represented. His solution is to take realism to its limits— using models to stage precise enactments of the photographs, then shooting these reenactments in high-resolution film that adds back to the original images details that were "sanitized" when they were released to the public (for instance, the blurring over of genitals and orifices) or that were difficult to perceive in their originally low-resolution format (blood and grime). The simple act of arranging

FIGURES 8.19 AND 8.20. **Botero and Fein respond to Abu Ghraib.**

Left: Fernando Botero, *Abu Ghraib 43* (2005). Courtesy of the University of California, Berkeley Art Museum and Pacific Film Collection. *Right*: Clinton Fein, *Number Ten* (2007). Courtesy of the artist.

bodies to mirror the positions in the photos, Fein recounts, drove home the fact of how premeditated most of these poses must have been. This lack of spontaneity indicates that the guards were staging preformed fantasies to serve their voyeuristic and sadistic pleasures; torture here has little to do about extracting information and much to do about phantasmatic entertainment.[10] Part of the discomfort that ensues from looking at Fein's revision of these "entertainments" lies not only in their staged quality but in the recognition that Western models are being forced to hold themselves in the same sexually degrading positions originally assumed by the Iraqi detainees.[11] The use of simulated homosexual acts to humiliate and dominate the West's enemy is the graphic subject of the scene of fellatio reenacted in *Number 10* (fig. 8.20).[12] It is also hauntingly explicit in *Rank and Defile I* (not shown here) in which the prisoners were made to pile onto each other in a human pyramid that left their buttocks spread open and anuses vulnerably exposed to the camera's flash. In the originally released photographs, the prisoners' anal orifices are discreetly blurred; the shock of

seeing them realistically presented in Fein's recreation underlines the degree to which the threat of anal penetration is part of the psychological warfare against the "enemy" being waged in such acts. As such, the act of sexual penetration (of the East by the West) that Said has argued is a metaphor for colonial domination reveals its alliance with those masculine anxieties of identity—whether Western or Eastern—that position men's same-sex acts as the enemy of morality and the harbinger of death. The homoerotics of Orientalism and the politics of nation, as contemporary artists from Giliberti to Fein demonstrate, are never far apart.

Issues of nation and masculinity also powerfully coalesce, but in a more reparative mode, in the work of Iranian artist Sadegh Tirafkan. The defining event in Tirafkan's early life came when his family (which had fled Iran before the Islamic revolution for Iraq) returned to Tehran, upon which Tirafkan was conscripted into the youth militia during the eight-year Iran-Iraq war. From the trauma of that experience has emerged his abiding concern with using art to challenge and redefine conceptions of Iranian masculinity. Hence, in one series of photographs, *Zoorkhaneh* (2003–2004), the same group of shirtless men dressed in traditional exercise outfits and wielding traditional equipment pose in different configurations that accentuate their physical well-being. In the process, the Zoorkhaneh or traditional Persian sports club, a centuries-old space of male homosociality, becomes backdrop for a reconfigured masculinity (fig. 8.21). More recently, Tirafkan has completed a series of "human tapestries," in which hundreds of clipped headshots are assembled to evoke Persian carpet designs—another

FIGURE 8.21. **Using tradition to rescript Iranian masculinities.**

Sadegh Tirafkan, *Zoorkhaneh* (2003–2004). Courtesy of the artist.

FIGURE 8.22. *Huban-name* for the modern age. (See also Plate 19)

Sadegh Tirafkan, *No. 3 Human Tapestry* (2009–2010). Courtesy of the artist.

reclaiming of heritage for a new collective human spirit. Especially evocative is execution of *No. 3. Human Tapestry* (2009–2010), in which minute headshots of young men overlay a large-scale group portrait (replicated over and over) of male wrestlers in singlets or shirtless (fig. 8.22; see also Plate 19). Whether or not the work is intentionally erotic, I would argue that Tirafkan—who has repeatedly made a critique of traditional masculinity and a commitment to the politics of gender explicit in his public statements—has uncannily created a modern-day visual equivalent of the *şehrengiz*. By citing this literary form (and its implicitly homoerotic contents), he brilliantly reinterprets, much as Sylvia Sleigh achieved in her feminist recasting of Orientalist paintings of the hamam, the poetic form for a new age.

PHOTOGRAPHIC LEGACIES

Chapter 6 has extensively explored the intersection of photography, homo-eroticism, and Orientalism in the early-twentieth-century's efflorescence of the genre that Schick terms ethnopornography. There I discuss the role of North African–based studios like Lehnert and Landrock's in catering to and

promulgating gay male fantasies of the Middle East and North Africa as sites of ubiquitous homoeroticism. In this section, I focus on an array of alternative routes—ranging from the blatant to the surreptitious, the official to the unofficial, the aesthetic to the clinical—whereby photography became the vehicle for simultaneously Orientalist and homoerotic expression.

In addition to studios making a business of catering to the tastes of a homosexual and bisexual clientele, numbers of individual, amateur, and often anonymous photographers took advantage of this technology to create homoerotic images both for their own private delectation as well as for clandestine commercial purposes. A striking example is the anonymous photograph *Les Esclaves* (c. 1920; fig. 8.23), which creates the fiction of a privileged glimpse inside what appears a North African male brothel or bathhouse. The artifice of staged reality that Malek Alloula unmasks in his examination of turn-of-the-century "harem" postcard erotica is fully deployed in this photograph: note the carefully arranged poses of these "sex slaves," along with the stage-like platform levels on which the young men stand or sit; the artistic arrangement of the flowing drapery to give the composition unity; the fetishistic props meant to stimulate the observer's fantasies (the shackles on the arm of one "slave," the rope around the neck of another, the totemic turbans, skull cap, and loop earrings). The most telling detail, though, is the carefully arranged still life of shells in the foreground,

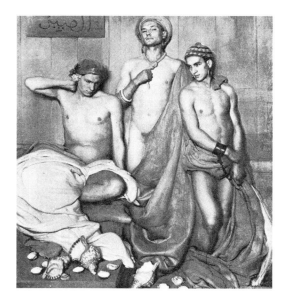

FIGURE 8.23. **Sex-slaves: staging an erotic fantasy.**

Anonymous photograph, *Les esclaves* (n.d.). Author's collection.

adding an "aesthetic" touch (why else would shells be here?) that shatters the illusion of unmediated reality. Indeed, the three large conch shells serve as symbolic reminders of the material object of desire at hand, the three youths' draped genitals. Just as invisible but commanding is the sensed presence of the photographer, to which the central figure's come-hither gaze directs the viewer. The colonialist fantasy being played out here, as the Arabic word on the sign in the upper corner ("slaves") suggests, is one of erotic domination, in which it is the youths' role to submit.

The implication that money buys sex with youth makes a disconcerting return in a photograph in *Queer Things About Egypt*, a 1911 travel book by Douglas Sladen. The image in question, depicting local boys stripping for coins, bears the description: "THE YOUNG IDEA. Taken at a village just outside Karnak. The idea of these boys is to make small piastres by stripping to run races or pose for the 'Kodaker' [fig. 8.24]. In a text whose tone is jocular and patronizing, Sladen occasionally betrays what seems to be an undue interest in cute donkey-boys, some of whom "would have done for an artist's model of a male nymph," and naked well-workers "bronze and graceful as John of Bolgna's Mercury." But

FIGURES 8.24 AND 8.25. **The anthropological lens.**

Left: Douglas Sladen, *The Young Idea*, in Sladen, *Queer Things About Egypt* (1911). *Right*: *Arab Couple*, in Magnus Hirschfeld, *Geshchledchtskunde* (1930). Courtesy of Tom Waugh.

nothing prepares the reader for this photograph and its caption's blatant equation of money, underage youth, and colonialist privilege. That this exchange of money is blithely written off as pure entrepreneurship on the boys' part erases, of course, any complicity on the author's (or Kodakers') part. In a volume whose other photos illustrate the narrative content, *The Young Idea* stands out precisely because it bears no relation to the text whatsoever, making its inclusion all the more pronounced.[13]

The combination of quotidian reality and prurience in Sladen's photograph seems a world apart from the image of a same-sex Arab couple included by Magnus Hirschfeld in his encyclopedic *Geschledchtskunde* (1930) (fig. 8.25). Perhaps its most striking aspect—as opposed to the trappings of fantasy implicating photographer and viewer in the erotic circuit of gazes in photos like *Les Esclaves* or *The Young Idea*—is the ordinary, even mundane looks of the two men. There is nothing performatively gay about the duo, apart from the fact that the older partner is bearded and the younger smooth-faced, thus conforming to a conventional model of age-differentiated desire. Both appear proud to have their image taken together, having dressed in fine robes for the occasion. Nor does either evince any sense of being exploited by the camera, leading to the surmise that this was a studio portrait, one for which they willingly posed, having no idea this personal item would one day serve as ethnographic evidence in an encyclopedia about variant sexuality across cultures.

In addition to the photographic genre of ethnographic types, ranging from the exploitative to the legitimate, Orientalist themes appealing to homoerotic tastes have often infiltrated the producers of art photography in subtle but telling ways. Particularly interesting are those examples designed or destined to promote the career of the celebrity being photographed. A case in point involves Frederick Holland Day's studies of his protégé Khalil Gibran, the Lebanese-born immigrant whose early artistic promise, as a fifteen-year-old teenager, attracted the Boston photographer's patronage (fig. 8.26).[14] Day captured Gibran's dark-eyed, exotic looks in numerous photographs, several featuring Gibran in a variety of Eastern costumes that Day acquired on his travels to the Middle East. As Gibran's fame as a poet, painter, and author of the international best seller *The Prophet* grew, Day's frequently reproduced portraits became, in effect, a merchandizing brand, consolidating Gibran's status as world-famous artist while subliminally expressing both the homoerotic and Orientalist desires that inspired Day to make Gibran his protégé in the first place.

The publicity photographs of Emil Otto Hoppe documenting Nijinsky's star turn as the Golden Slave in *Scheherazade* (fig. 8.27) operate similarly, in that the conjunction of Orientalist spectacle, artistic genius, and Nijinsky's reputation for outrageous behavior on and off the stage (as well as his reputation as

 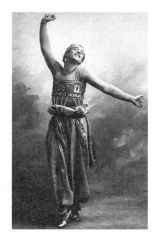 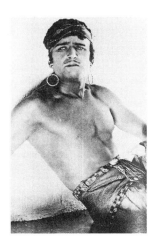

FIGURES 8.26, 8.27, AND 8.28. **Celebrity shots.**

Left: Fred Holland Day, *Gibran with a Book* (1896). Steiglitz Collection. Image copyright © The Metropolitan Museum of Art, New York. Image source: Art Resource, NY. *Middle*: Emil Otto Hoppe, *Vaslav Nijinsky as The Golden Slave in Michel Fokine's 'Sheherazade'* (c. 1911). Courtesy of the Victoria & Albert Museum Images, London / Art Resource. *Right*: Douglas Fairbanks, image from *The Thief of Baghdad* (1924).

Diaghilev's lover) became the cover for the homoeroticism that permeates his ecstatic performance of enslaved, non-normative masculinity and that exerted a disconcertingly seductive power over his fans, many of whom, as Tirza True Latimer documents, were homosexual.[15] In contrast to the scandal and decadence associated with the Ballets Russes, nothing could appear, on the surface, more wholesome than Hollywood's *The Thief of Baghdad*, (1924), an early example of celluloid Orientalist fantasy (the set designs incorporate Art Deco elements, the dance movements evoke the Ballets Russes, and costumes like the one Fairbanks wears imitate Bakst's designs), wedded to the genre of swashbuckling adventure. The widely distributed film stills featuring its lead actor, Douglas Fairbanks, in beefcake poses not only highlight the athletic prowess that was part of his star appeal; they open themselves up to a degree of homoerotic suggestion that exceeds anything in the film diegesis or in the all-American persona of the film's resolutely heterosexual star.[16] Note, in figure 8.28, the ambiguously blurred regions where Fairbank's costume meets what seems to be hirsute leg and ambiguously hovering hand (which turns out to be holding the hilt of a sword), as well as the combination of masculine torso and feminine accessories—visual details which, combined with campy bronze makeup, lend themselves to homoerotic and Orientalist appreciation and appropriation.[17]

FIGURE 8.29. **The iconic turban as Orientalist signifier.**

Nickolas Muray, *Nude Study of Hubert Stowitts* (c. 1922). Courtesy of George Eastman House, International Museum of Photography and Film and Mimi Levitt, Nicolas Muray Photo Collections.

Oriental and homoerotic signifiers also converge in the nude studies of the dancer Hubert Julian Stowitts, taken by the renowned New York photographer Nickolas Muray (best known today for his portrait of Frida Kahlo, his lover of ten years). Figure 8.29 is a superb study of the male body in its own right. The turban wrapped around Stowitts's head (which reappears throughout a series of photographs of the dancer) adds an aura of the "Orient" that, in Stowitts's case, provided a running motif throughout this homosexual dancer's long and varied career. Discovered by Russian ballerina Anna Pavlova while he was an undergraduate at the University of California at Berkeley, Stowitts became a dance sensation throughout Europe, performing with Pavlova in pieces like *Assyrian Dance* and appearing with the Folies Bergère in an Egyptian-themed extravaganza in 1924 in which a huge Sphinx towers over a set filled with dancers in skimpy costumes designed by Erte (Romain de Tirtoff).[18] At the height of his career, Stowitts turned to painting, where his homosexuality found even more forthright expression in highly erotic paintings of Nijinsky in Orientalist costumes from early Diaghilev productions. He also dabbled in film acting, where he was featured as a satanically nude satyr in the "vision of hell" sequence

of Rex Ingram's 1926 film *The Magician*, the screenplay of which was adapted from a Somerset Maugham novel based, fascinatingly, on the notorious life of Aleister Crowley, the author of the obscene sequence of poems masquerading as Persian manuscript examined in chapter 6.[19] These visual manifestations of Stowitts's life and career illustrate the intertwined, overlapping worlds of homosexual men—Stowitts, Nijinsky, Erte, Maugham, Crowley—working across a range of art media who all, in one form or another, participated in and helped promulgate early-twentieth-century visual culture's fascination with the East as a site of exotic otherness and erotic transgression.

Cecil Beaton, a well-known society and celebrity portraitist like Muray, adds to this dialogue in the photographs interspersed in his memoir of war service in North Africa. In chapter 2 we saw one example of the subliminally gay aesthetic that gives Beaton's headshot of an Arab legionnaire its erotic magnetism (see fig. 2.32). Beaton's stylized portrait of *A Tunisian* (fig. 8.30), in which a dark-skinned, nude native stands on a pebbled rooftop while holding an unraveling white sheet, overtly uses foreign and Orientalist trappings to imbue the image with its homoerotic charge.

A half-century later, an unabashedly gay male aesthetic permeates the work of well-known celebrity photographer Bruce Weber. Indeed, a strong argument can be made that a gay aesthetic has been key to his fame and success, measuring the growing influence of gay-inflected iconography in the public sphere and marketplace since the discreet circulation of von Gloeden and Lehnert's images. Of special interest in the context of celebrity art photography is Weber's 1997 book *The Chop Suey Club*. A visual paean to the beauty of one youth, Peter Johnson, as he matures over four years, this compilation of portraits of Peter in various milieus, costumes, and states of undress calls to mind Crowley's technique in *The Scented Garden*, in which the poetic persona, El Qahar, crafts a series of poems around the object of his obsessive desire, Habib. One of the better known of Weber's portraits of Johnson (fig. 8.31; see also Plate 20) features the nude young man draped in a swath of exotic fabric and sporting a turban. The pose is at once reminiscent of Muray's portrait of Stowitts (see above, fig. 8.29) and Lehnert's of Ahmed (fig. 6.16). But this is a case of repetition with a difference, since Weber, even more self-consciously and playfully than Crowley, foregrounds his appropriation of Orientalist motifs for homoerotic ends. Such self-reflexivity is apparent in the punning title (*Arabian Knight*, which conjures up the literary *Arabian Nights*), the exaggerated positioning of Johnson's arm just above his jauntily cocked hip, and the colorizing process Weber uses to tint the final image, so that Johnson's cherry-red lips pop out as if rouged—a "feminizing" touch that evokes the colorizing techniques used by Lehnert to make the youths featured in the studio's tourist postcards all the more suggestive (see fig. 6.32: see also Plate 6). As such, the more immediate precursor for *Arabian Knight* is

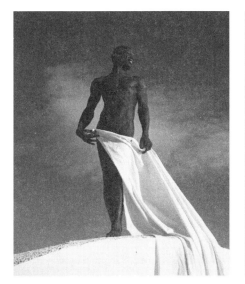 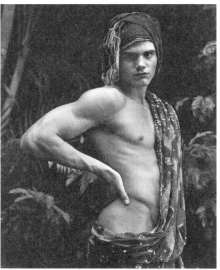

FIGURES 8.30 AND 8.31. **Celebrity photographers turn East. (See also Plate 20)**

Left: Cecil Beaton, *A Tunisian* (1958). Courtesy of and © Sotheby's, the Cecil Beaton Studio Collection. *Right*: Bruce Weber, Peter Johnson as *Arabian Knight*, from *The Chop Suey Club* (1997). Courtesy of and © Bruce Weber.

the duo Pierre and Gilles, whose use of saturated color achieves a similar camp aesthetic (fig. 8.10).

As Sladen's *The Young Idea* has illustrated, candid shots taken "on the go" by nonprofessionals during their travels form an important strand in this photographic history. Exemplary are the images liberally sprinkled throughout Sir Wilfred Thesiger's well-received narratives of his explorations of the Arabian desert (figs. 8.32 and 8.33). These photographs of attractive-looking Bedouin males, ranging from prepubescent adolescent to teenaged youth, appear innocuous enough until considered en masse (why *so many*, and why such a *singular* focus on younger boys?). Borrowing from the poetic analogy developed in chapter 6, I suggest that the candid shots included in Thesiger's travels also form a şehrengiz of youthful objects of desire. The author's disclaimers about Bedouin homosexuality and his defensive statements about the attraction that he admits the beauty of these youths (see chapter 2) holds for him only underscore the force of his subliminated desires, as well as the self-censorship governing most pre-Stonewall-era writing for the general public. The numerous photographs of Salim bin Ghabaisha (figs. 8.34 and 8.35) document for Thesiger the growth of his favorite companion from pensive adolescent to smiling teen-warrior.

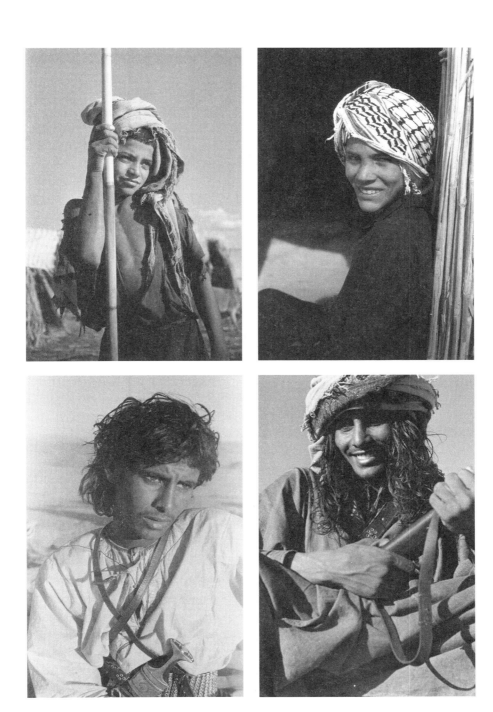

FIGURES 8.32, 8.33, 8.34, AND 8.35. **Bedouin youth in Thesiger's travels.**

Top, left to right: Wilfred Thesiger, *Suaid herder.* 2004.130.38340.1. *Suaid boy.* 2003.130.13722.1.
Bottom, left to right: Salim bin Ghabaisha. 2004.130.6882.1. *Seated portrait of Salim bin Ghabaisha.*
2004.103.25556.1. All courtesy and © Pitt Rivers Museum, University of Oxford.

One senses that Thesiger initially took these photographs for his own pleasure and as record of his travels, not with an eye toward his readers. Another example of a writer whose nonprofessional photography was not originally shot to be published but rather to hone a hobby at which he proved quite talented is Paul Bowles, whose handsomely executed images of equally handsome Moroccan men exude (like much of his fiction) a coolly detached sensuality that accrues homoerotic ambience through context as much as overt content.[20] The portrait of Yacoubi (fig. 8.36) transforms Bowles' companion—whom he took up as a sixteen-year-old—into an icon of desire that is at once tangible and enigmatic. The composition shapes itself around the physical beauty of Yacoubi's body, whose sculpted torso occupies the vertical center line of the frame, standing out against the horizontal lines created by the wall-like ramparts (which meet at a right angle behind the youth). The result is a striking balance of the aesthetic and sensuous that melds a classical sense of harmonious form with the North African milieu that was the expatriate writer's home. The pose is self-conscious, deliberate: Bowles has arranged Yacoubi with djellaba hoisted to shoulders to expose a taut, burnished midriff and with face turned in profile, smiling as he looks out of the frame. Placed against the austere background of the whitewashed walls, Yacoubi becomes part of the architectural landscape, a living statue temporarily frozen into place, remote yet bodily present, untouchable yet inviting one's touch, a muted fusion of classical ideality and Orientalist desires who seems, for the moment, as timeless as the bleached-out medina he inhabits—its blankness an invitation for spectators to project onto its white spaces the fantasy of their own desires. A vertical strip of thumbnail images (fig. 8.37) captures another protégé, Mohammed Mrabet, showing off his acrobatic skills and flexing his muscles for Bowles' delectation; one has a sense of them passing the camera back and forth, with Bowles avidly taking most of the pictures. Mrabet was an oral storyteller and novelist in his own right; his 1968 novella *Love with a Few Hairs* constitutes a retelling of and riposte to the plot of Gide's *L'immoraliste* as experienced from the perspective of the kept Arab youth.[21] Bowles' many portraits of the usually shirtless Mrabet—who remained his companion for decades—as well as photographs of the two men together taken with Bowles's camera thus not only record a fantasy of desirable otherness but document the lasting relationship between American expatriate and Moroccan writer.

Over the past decade, the Internet has made it increasingly easy for contemporary photographers, nonprofessionals and professionals alike, to share their work with an infinite number of viewers. The online photostream of "CharlesFred" contains hundreds of images of handsome young men from across the Middle East and North Africa taken by the quite talented nonprofessional photographer Charles Roffey during his frequent travels with his partner Fred.[22] The title of one image, *Marokkaanse von Gloeden*, indicates Roffey's awareness of the

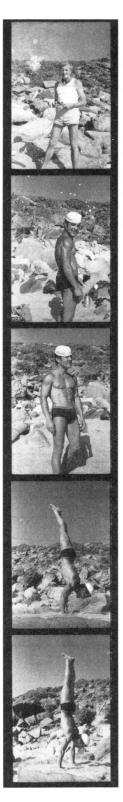

FIGURES 8.36 AND 8.37. **Classical harmonies
and spontaneous takes.**

Paul Bowles, *Ahmed Yacoubi on the Terrace of the hotel Palais Jamaï,
Fez* (c. 1947; *above*), and *Mrabet and Bowles on the Beach at Cap Spartel*
(film strip), Tangier (c. 1969). Courtesy and © Paul Bowles / Fotos-
tiftung Schweiz and Rodrigo Rey Rosa.

FIGURES 8.38 AND 8.39. **Roffey's travel photography.**

Charles Roffey, *Syria—Young Beauty at the Ummayyid Mosque* (2005) and *Smoking a Narjileh in Petra, Jordan* (2005). Courtesy of the photographer.

homoerotic tradition that his own work extends. The sheer abundance of these high-definition images, many of whose subjects are handsome enough to grace the pages of *GQ* and most of whom appear aware of and perfectly willing to pose for Roffey's camera, might seem to certain observers an example of Western objectification and Orientalism. Yet is it really sufficient, in images such as *Syria—Young Beauty at the Ummayyid Mosque* and *Smoking a Narjileh in Petra, Jordan* (figs. 8.38 and 8.39), to categorize Roffey as yet another "sexual tourist" who appropriates (the image of) the Middle East for "Western" consumption, commodification, or domination? Obviously, there is pleasure in taking these photographs, in searching out and capturing these images of masculine beauty. But, reciprocally, most of Roffey's subjects seem to take genuine pleasure in being admired; their agency remains intact, rather than diminished by his lens. Even paraphernalia that might appear as Orientalist trappings in other art—the hookah being smoked in figure 8.39, for instance—seem in Roffey's hands to be indices of his subjects' lived cultural practices, rather exotic props appropriated to stage a voyeuristic fantasy of otherness.

Earlier in this chapter, I described the ways in which such questions of looking and appropriation are tackled head-on by Michel Giliberti in his paintings. On his Web site, Giliberti has posted dozens of photographic studies of often incredibly handsome men of North African descent. Some of these images are obviously posed (serving as studies for later paintings), and some feature the confrontational stares that, as in so many of Giliberti's paintings, unsettle assumptions that the European spectator "owns" the gaze. But the majority of these photographs—in contrast to the paintings—feature men who *smile back* at the camera. This intersubjective receptivity recasts the role of Giliberti from that of voyeuristic outsider to reciprocal subject of shared ethnic origins and language. The act of representing his male subjects as cheerful and open, rather than mysterious and closed, becomes a political statement that, in shattering an Orientalist stereotype, engages and rewrites the homoerotics of Orientalism in an affirmative vein. Likewise, in ways both extradiegetic and visual, Giliberti includes in several of these seemingly candid shots "Western" or global references that cease, within his frame, to represent domination but instead figure as part of the fabric of inevitably multicultural life in the contemporary Maghreb. Thus Giliberti borrows from Greek sculpture to give one image the title *Belvédère de Tunis, un des ouvriers* (fig. 8.40) and frames the youth in *Tunisie Recontré à Kerkennah* (fig. 8.41) so that his Banana Republic T-shirt is prominent

FIGURES 840 AND 841. **Smiles instead of stares.**

Michel Giliberti, *Belvédère de Tunis, un des ouvriers* (n.d.) and *Tunisie Rencontré à Kerkennah* (n.d.). Courtesy of the photographer.

(the ironies embedded in this logos are, of course, many: the American company began as a "travel-friendly" brand whose safari-themed lines of clothing nostalgically evoked the heyday of African colonialism, and its name derives from the pejorative term for Latin American dictatorships). All the while, these photographs serve as Giliberti's record of his love of the beauty of these Tunisian men. Thus he links his work to a venerable homoerotic tradition within Middle East arts and aesthetics: the male beloved of the poetic ghazal and manuscript miniatures is reborn in contemporary form through an eye that dissolves, even as it recognizes, the boundaries constructing East and West.

EROTICA AND PORNOGRAPHIC TRADITIONS

While definitions of pornography are notoriously slippery, and while the line between erotica and obscene material varies temporally and culturally, some visual images are created to be sexually stimulating.[23] A brief return to the tradition of Middle Eastern miniatures forms a helpful context for the discussion of twentieth- and twenty-first-century pornography that follows. As this book has already made clear, far more (and far more graphic) images of sex between men exist within this tradition than have previously been recognized. Intriguingly, some of these examples incorporate heterosexual and homoerotic elements alongside each other: the image of male-male sodomy in the lacquered box frieze discussed in chapter 2 (fig. 2.7), for instance, also enfolds three heterosexual couples in its arabesques. Such representations remind us that well into the early-twentieth-century Middle Eastern formations of sexuality and desire were not constructed on an either/or polarity pitting hetero- and homosexuality as binary opposites, as was increasingly the case in Christianized Europe. One consequence has been a circumspect flexibility in regard to men's object choices without such choices necessarily calling one's manhood into question.

This conceptual fluidity is stunningly illustrated in a Shiraz miniature in a mid-sixteenth-century *Külliyat* of Sa'dī, depicting a brothel scene (fig. 8.42; see Plate 21). The size of the miniature—mere inches—is deceptive, for it depicts a world teeming with activity, including six couples (and four other onlookers, clients, or attendants). Not only do men engage in sex with both female and male partners in a shared architectural space and on the same visual plane, the artist has taken care to represent as many variations of acts and age-pairings as possible. Of the five couples involved in sexual activities, two are male-male and three are male-female. In addition, a man woos the seated woman on the carpet to the right, while the man entering the door

FIGURE 842. **Equal opportunity brothel scene: erotic porosity. (See also Plate 21)**

Miniature in Sa'dī's *Kulliyat*. BL ADD.24944, fol. 333a. Persian (1566). Courtesy of the British Library Board.

at the bottom left seems to be pursuing the boy whose body is cut off by the bottom margin. In terms of visual as well as architectural hierarchies, the pride of space is the decorated alcove at the top center, generally occupied by the highest-ranking person in the miniature, which accords the action occurring in it—in this case a man penetrating a youth—elevated prominence. In contrast to this model of age-differentiated sodomy, the second male pairing—located at the bottom right corner—involves two youths of the same age. Given their parity and the fact that certain brothels served not only as sites where one might pay for sex (with either a male or female), but also as "safe spaces" rented by males, it is not unreasonable to surmise that the latter couple are not in fact client and prostitute but lover-companions. A hint of this erotic porosity also infuses the scene's depiction of heterosexual congress. While two involve

face-to-face intercourse between an older man and younger woman, the third depicts a youth on his knees, erection exposed, as he manually pleasures his female companion. In sum, this remarkable image celebrates a plethora of erotic activity whose fluidity is encouraged by the privacy that the brothel's enclosed world provides its patrons. Within this erotic zone, adulterous inter-course (between male clients and female prostitutes) and sodomy (between males) are equally permitted and occupy the same playing field, occurring in "full sight" of each other.

Two of the *mesnevi* ("Nefhat el-ezher" and "Sohbet el-abkar") in a manuscript of 'Atayi's *Khamsa*, dated 1738–1739, contain relevant illustrations of sodomy that closely resemble counterparts in the more lavishly illustrated eighteenth-century *Khamsa* in the Turkish and Islamic Arts Museum as well as copies at the Walters Art Collection and the Free Library of Philadelphia. In miniaturist aesthetics, making near copies of set piece illustrations was a sign of the highest artistic achievement. Thus the fact of four miniaturists producing nearly identi-cal tableaux suggests that other miniatures based on this same, sodomitical template once existed in manuscripts that have been destroyed or survive in undocumented private collections. Two images mounted on facing pages in the 1738–1739 *Khamsa* (figs. 8.43 and 8.44) are part of the same narrative, moving from the wooing of a youth by three men at a feast (a serving boy stands at the left) to his seduction, in which he is mounted by one of the party while a second, erection in hand, kneels behind him waiting his turn. In a subsequent episode, these age-differentiated positions are inverted in an illustration (fig. 8.45; see also Plate 22) to the tale in which a man is discovered being penetrated by a youth by a crowd of music-playing spectators who peer on the scene from behind a drawn-back curtain (compare to the same scene depicted in figure 2.15; in the depiction of this scene in the Walters' *Khamsa*, however, it is difficult to perceive any age difference between the two).[24]

A 1794–1795 Ottoman manuscript page (fig. 8.46) whimsically depicts another configuration of group sex, in this case a round-robin circle of sodomy in which the men are attached recto-verso.[25] Compare this overtly sexually graphic image to its less blatant but nonetheless homoerotic counterpart in figure 8.47, an early-seventeenth-century Persian drawing in which Sufis and their beloveds also form a circle as they dance their way to spiritual unity. The latter circle is dominated by the alternation between masters and boys: for nearly every Sufi there is a complementary beloved. In the round-robin sodomy depicted in the Ottoman miniature, however, symmetrical alternation has been replaced with diverse couplings as a moustachioed man penetrates a youth, who penetrates a man who penetrates a still older (or at least bearded) man. All their coun-tenances are remarkably individualized (figure 8.48, detail; see also Plate 23), complementing the human touches added by the types of socks some wear.

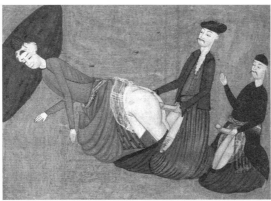

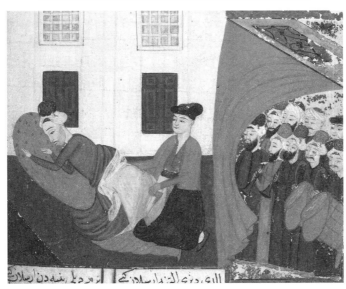

FIGURES 843, 844, AND 845. **Sequential seduction stories. (See also Plate 22)**

Miniatures from Nev'izade 'Atayi, *Khamsa*. BL OR 13,382 fol. 160b; 161a; and 108b. Ottoman (1738–39). Courtesy of the British Library Board.

FIGURES 846, 847, AND 848. **Round-robin activities, earthbound and spiritual (detail). (See also Plate 23)**

Left: Miniature from Shaykh Muhammad bin Mustafa Al-Misr, *Tuhfat Al-Mulk* (1794–1795). Courtesy of the Alain Kahn-Sriber Collection, Paris. Image © Gilles Berquet. *Right*: Ustad Muhammadi of Herat, "Dancing Sufis." Album drawing. Safavid (c. 1575). Courtesy of the Freer Gallery of Art, Smithsonian Institution, Washington, DC. Purchase F1946.15. *Bottom*: Detail of Figure 8.46.

Within this more earthly if pornographic tableau, conventional hierarchies give way to heated imaginings and a fluid eroticism that recalls the *Külliyat*'s brothel miniature. As different in intent as this image may be from the spiritual goals of the dancing Sufis, both share a commonality in making homoerotic desire the unifying force that binds their male participants in the oneness represented by the circle.

In contrast to Middle Eastern visual erotica—dependent on miniaturists painting each image by hand—modes of European pornography reached a far wider distribution with the explosion of mass-produced books and images beginning in the sixteenth century. A fascinating depiction of sodomy using the Orient as backdrop to heighten its titillation occurs in a deluxe 1884 reissue of German classical scholar Friedrick Karl Forberg's 1824 *De Figuris Veneris, Manual of Classical Erotology*, a compilation of classical references to sexuality that included twenty erotic plates exquisitely rendered and color-tinted by Édouard-Henri Avril (pseudonym Paul Avril; he is also the artist depicting the dancing boys of the desert in fig. 0.1).[26] All of Avril's plates *except* the one reproduced here (fig. 8.49) use Greco-Roman classical settings to illustrate sexual acts. Intriguingly, this Egyptian-themed plate is only one of three that include homosexual acts, and one of two that bears a descriptive title as opposed simply to naming the

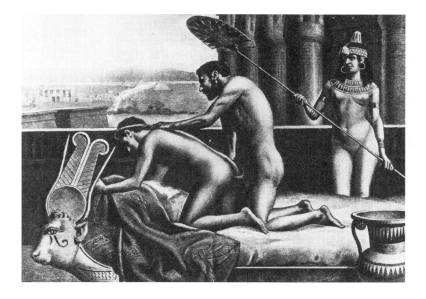

FIGURE 849. **Sodomy by the pyramids.**

Paul Avril, *Hadrian and Antinous in Egypt*, illustration in Friedrick Karl Forberg, *De Figuris Veneris, Manual of Classical Erotology* (1824; Avril illustrations added in 1884).

sexual position being depicted (in this case, the title is "Hadrian and Antinous in Egypt"). Strategically, the identification of the two lovers as historical figures serves to legitimize Avril's inclusion of a scene of male sodomy not only by placing it in "real" history but in a foreign land already associated in the popular imagination with same-sex activity, even if the emperor himself was Roman (Antinous hailed from Bithynia, in northwest Turkey; the fact that Antinous drowned in the Nile, leading Hadrian to build the Egyptian city of Antinopolis in memory of his beloved, also gives credence to the choice of setting).

Avril's plate mines Orientalist visual iconography to maximum effect. Framing this scene of sodomy, the three Egyptian pyramids located in the left background are inversely mirrored in the triangular pudendum of female slave to the right, ironically underlining the irrelevance of female sexuality to this act of intercourse. The raised couch on which the sex occurs functions as a kind of stage, transforming the scene into a spectacle expressly designed for the viewer's voyeuristic pleasure. The centrality of sodomy to the fantasy being summoned forth is emphasized by placing the act of penetration at the illustration's center; it forms the exact axis at which vertical and horizontal sight lines cross, with Avril's use of light and shadow further emphasizing the act of insertion. The curiously flat eye of the bull carved into the bed's headboard implicates the viewer in the represented scene: if one is viewing this drawing, it is because one knows where to look to find it. That this detail appears more Assyrian than Egyptian attests the sheer hybridity of this fantasy: temporal/spatial contradictions like these only heighten the scene's ubiquitously "Eastern" exoticism. Indeed, the artwork's wild mix of geopolitical signifiers—Hellenic, Egyptian, Assyrian, Semitic, Arabic—contributes to the drawing's Orientalizing frisson by rendering its pornographic fantasy at once specific (destined for an appreciative coterie) and generically omnipresent (all Eastern locales blend into one vast Arabic Orient of wild perversion).

The simultaneous rise of photography, ethnography, and cross-cultural studies of human sexuality helped usher into being the mass distribution of homoerotica shot on location in the Middle East and distributed in the West, as documented in chapter 6. For some of these photographers, like Lehnert and von Gloeden, the *quality* of the image is as important as its content; aesthetics is part and parcel of the erotic effect for which these artists aim. Other examples of photography that mine Middle Eastern motifs to heighten the depiction of sex between men drop the pretense of being "art," or even of being scientific "ethnography," altogether. The Kinsey Institute possesses a series of eight images in which the same models—older man in tarbrush and younger in turban—somewhat clumsily enact a series of sexual acts against a painted studio backdrop depicting a desert scene with palms, an indication they were staged for commercial ends rather than for private consumption. In one, a reversal of

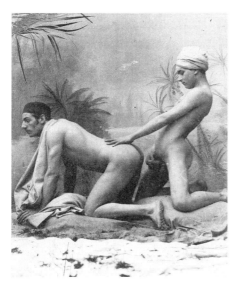 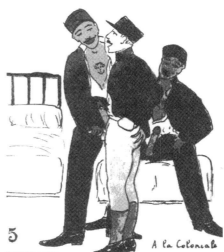

FIGURES 8.50 AND 8.51. **Colonial tropes in commercial pornography.**

Left: Anonymous photograph, no title. KI-DC: 41950. Courtesy of the Kinsey Institute for Research in Sex, Gender, and Reproduction, Bloomington, IN. Right: *À la Coloniale* (n.d.). Courtesy of Robert Aldrich.

age-differentiated sexual positions occurs as the younger partner penetrates the older (fig. 8.50, detail).[27]

Humorous homoerotic drawings form another conduit of pornographic Orientalism. The truism that colonial forays into North Africa might expose European colonialists to homoerotic temptation is the source of humor in a mid-twentieth-century caricature, *À la Coloniale*, reproduced in Aldrich's *Colonialism and Homosexuality*, in which a French soldier is happily fondled by his Tunisian cohorts (fig. 8.51).[28] This cartoon-style genre of pornography comes vividly alive in a series of drawings with explicit Orientalist overtones executed in the 1960s by the American gay erotic artist Dom Orejudos (who most often signed his work as "Etienne"). Working in the vein of Tom of Finland, Etienne depicts super-masculine hunks with bulging muscles and impossibly large endowments engaging in hard-core, often sadomasochistic leather sex. His Orientalist contributions are no exception. What *is* surprising, however, is the degree of witty intelligence informing these pornographic fantasies of homoerotic commerce between East and West. One image introduces the viewer to two U.S. sailors—one with a blonde crew cut, the other a brunet, and both sporting military dog tags—who have been enticed to "El Yanno's bar" in an unidentified North African setting, where they have been drugged and taken

captive by the fez-capped proprietor. In a companion drawing, the same two captive sailors, now stripped naked, kneel obediently on either side of a generically depicted sultan—swarthy-skinned, bearded, wearing turban, sandals, and little else—who reclines on a divan with wine goblet lifted in one hand as the two servicemen "service" his literally monumental (and bejeweled) erection. The narrative formed by these drawings deliberately reverses the colonialist hierarchies of West/East by placing icons of U.S. military might in the submissive position: within Etienne's erotic imagination, submitting to a superior foreign power forms part of the erotic charge.

The Western fantasy of dominating the "other" is also turned on its head in two of Etienne's drawings featuring Crusaders at the mercy of Infidel captors. In figure 8.52's detail, Etienne depicts a bevy of buck-naked Crusaders who, having been captured by their Saracen foes, are being auctioned off at a slave bazaar. Banners in the background humorously proclaim "All ages . . . All sizes," "Come in and Browse," and "Today! Fresh Shipment of Blonde Young Crusaders." This tongue-in-cheek debacle wittily inverts centuries of salacious descriptions of naked females being hawked in slave markets from Constantinople to Cairo in European travel writing and Orientalist painting. Forced to kneel on all fours on barrel-like pedestals, these Christian captives find themselves in the feminized position of object-to-be-penetrated, their lifted buttocks exposed to all takers. In

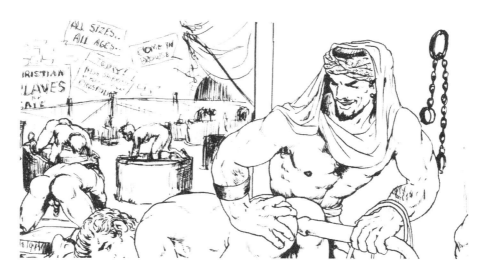

FIGURE 8.52. **Crusaders on sale.**

Detail of Etienne, *Arab Market* (n.d.). Courtesy of Robert Ballantyne / Arsenal Pulp Press. Reproduced in Felix Lance Falkon with Thomas Waugh, *Gay Art* (2006).

the foreground, a diabolic yet sexy Arab, naked except for his iconic headdress, is readying to plunge the phallic-shaped end of his whip up the rectum (Mapplethorpe *avant la lettre*) of one panicked Crusader. The interpolated position of the viewer—whom Etienne constructs as Western, gay, and male—is thus that of the powerless victim about to undergo sadistic violation at the hands of his virile captor. Reversing the conventional power dynamics of Orientalism, Etienne clears space for a homoerotic revision of that fantasy, one that suggests the homoerotics already latent in Orientalism. Etienne continues to riff on the anxieties associated with heterosexual prowess in a drawing that pits Crusader against Barbary Corsair (fig. 8.53 detail). Having overrun a ship of Crusaders, these sadistically gleeful Infidels are in the process of castrating their prisoners, as the gruesome litter of severed penises (visible in the larger image from which this detail is taken) lying at the feet of the panicked, blond hunk, who is about to meet the same fate, indicate. While conjuring up "universal" male castration anxieties, Etienne's scenario locates the fear of losing one's "masculine signifier" within a specific historical context: the early modern European anxiety that contact with Eastern otherness and perversion may compromise one's manhood, making one, in essence, a eunuch—a sexual category associated with the Middle East that both horrified and fascinated numerous European travelers (see chapter 2). Simultaneous with the "ugh" factor that this visual realization

FIGURE 8.53. **Corsairs and castration anxiety.**

Detail of Etienne, *Arab Capture* (n.d.). Courtesy of Robert Ballantyne / Arsenal Pulp Press. Reproduced in Falkon with Waugh, *Gay Art* (2006).

of castration fears evinces, Etienne's gay viewers are provided with the perverse pleasure of enjoying the surplus of hunky, naked, turned-on bodies comprising this contest of warring masculinities.

Another mode of visual pornography, unique to the twentieth century, is that of cinema, which since the inception of motion pictures has routinely been used to stimulate sexual arousal by capturing "live" sex on screen. We have already seen the Orientalist and homoerotic ends to which the medium can be put in this book's opening example, the 1920s silent short *Mektoub*. For the European clientele for which it was made, the Middle Eastern milieu becomes an excuse both for depicting sex between men and enjoying the sight thereof. As taboos against homosexuality have lessened in the later twentieth century, there has been less need for commercial pornography to resort to the guise of exoticism to justify same-sex content. Nonetheless, the genre has persisted in blending Middle Eastern and gay themes, attesting to the continued power that the homoerotics of Orientalism exerts in popular gay culture. Advertisements for "John Holmes: The Man," proclaiming itself to be the legendary porn actor's only "gay fuckflick," inform the prospective buyer that "John Holmes and his cock play a Shah in ancient Persia who commands a court of male subjects to become his willing love slaves!" (unwittingly, the conjunction "and" posits porn star *and* his penis as an acting duo performing the single role of "Shah").[29] In a film like this, as the actors' fake-looking turbans indicate, the Oriental mise-en-scène is window dressing, the flimsiest of pretenses to get to the hard-core action as quickly as possible, and the Eastern narrative elements are shucked as quickly as the actors' costumes. This haphazard use of Middle Eastern motifs for homoerotic ends becomes more thoroughly Orientalist, as well as historically specific, in the filmography of Jean-Daniel Cadinot, a gay French director celebrated for introducing a degree of gritty realism in his pornographic films and for using actors with natural rather than super-buffed bodies. In *Hammam, Sex Bazaar (aka Harem),* and *Nomades*, all of which were filmed in the Maghreb, Cadinot taps into France's North African colonial legacy while promoting a generalized fantasy of Orientalist sex, replete with colonial stereotypes and clichés.[30]

Since the advent of digital video production in the 1980s led to an explosion in the making and marketing of pornography, an increasing number of hard-core gay films, ever in search of new settings and contemporary reference points, have turned to Middle Eastern motifs. Pacific Sun Studios produced a trilogy beginning with *Lovers of Arabia* and culminating in *Arabian Knights* in 2003. Likewise, beginning in 2001 with *Arabian Fever*, the Brazilian studio Alexander Pictures has created a series of Arab-themed videos that boast "all Arab casts" but in fact simply give their South American actors Arab names.[31] Most prominently, Raging Stallion Productions has mined the media attention commanded by political developments in the Middle East since the U.S. invasions of Iraq

and Afghanistan by promoting the (fantasized) rugged virility of the Arab as an object of gay male desire (such hirsute masculinity is marketed as a refreshing alternative to depilated American gay porn stars).[32] The press statements on Raging Stallion's online site illustrate the degree to which Orientalist stereotypes continue to be mined for commercial purposes:

> As the scorching sun pounds down upon the shimmering sands of the Sahara, a people struggle thru their daily living, eking out a way to survive the brutal daylight that beats them into submission between dawn and dusk. Life in these exotic lands is harsh and cruel, a world thrown back in time to an era of absolute power and uncontrolled passion.
>
> But when night falls a welcome breeze blows across the still desert and another world awakens, a world where pleasure rules and men rise triumphant to satisfy an overwhelming lust that has been building since the dawn of time.

In this description, the "uncontrolled passion" of the Sahara is represented as timeless, going back to "the dawn of time"; masochistic "submission" to "brutal" daily life is counterbalanced by the sadistic reign of "overwhelming lust" that "rise[s] triumphant" when "night falls"; and the film promises, in Orientalist fashion, to usher the viewer across the threshold to "another world" whose exotic otherness will "awaken" desires stifled by civilization and modernity. The studio's first Middle Eastern–themed film, *Arabesque,* featured an outdoor bazaar that reviewers touted as "one of the best sets ever built for a porn movie in America,"[33] and its success has since spawned *Mirage* (whose plot involves tomb robbers in Egypt), *Collin O'Neal's World of Men: Lebanon* (billed as "the first ever porn movie filmed entirely on location in the Middle East"), *Tales of the Arabian Nights, Parts One and Two* (a six-disc set, whose "tales" include *The Tunisian Stable Boy, Lebanon Strikes Back, Hairy Arabs*, and *Sucking on the Hookah Pipe*), and *Arab Heat.* Eager to encourage the illusion of giving viewers access to authentic reality, Raging Stallion's promotion materials intimate that its stars are "authentic" men of the Middle East, when in fact their national origins are largely European. Ironically, the French superstar of *Arabesque* and *Mirage*, the rugged François Sagat—who passes as Arab and was billed as "Azzedine" in video work for another studio—is Slovak in origin. As is true of Orientalism in general, what one gets is not necessarily what one thinks one is seeing in these fantasies.

Over the past decade, gay male culture in France has elevated the outcast figure of the *beur* (a racial term designating a man of mixed French and North African descent) into a fetishized object of desire, and the sex film industry has not been far behind. Jean-Noel Rene Clair's Studio Beurs series is one example;

others include the online French Web site Gayarabclub and the independent local studio Citibeur. In an insightful essay on these developments, Maxime Cervulle and Nick Rees-Robert argue that Citibeur marks a break from the "blatant sexual tourism of the colonialist porn" and "old-school racial fetish[izing]" fueling the films of Cadinot and Clair.[34] In Citibeur's multiethnic, mixed-race productions, these critics suggest, one can see the rise of an independent beur subculture that departs from stereotypes of "savage" Arab masculinity, as well as from the hegemony of bourgeois French gay culture (although Citibeur's claim that *Gay Arab Club, 1 and 2* is "shot in typical oriental settings" appears to suggest more of an affinity with mainstream Orientalism than with historically specific representations of French gay "beur" subculture). Meanwhile, various entrepreneurs located in cosmopolitan centers of the Middle East have seized on this trend, setting up independent studios and shooting features and streaming videos with local actors. Nor are some of these studios and online sites (such as Arab-Gay.com, Istanboys.com, and ArabianDicks.com) shy about using Orientalist stereotypes as part of their merchandizing campaign. As the ArabianDicks site proclaims, "For centuries, Arab men have been considered the most masculine on the planet. With their massive cocks, astounding physiques, and incredible dark facial features and skin, *your Arab stud craving* will be fulfilled here. . . . Watch them as they fuck one another with all the passion and lust only men from the Middle East possess" (emphasis added).

Zip Productions, located in Istanbul, has produced its own version of exploitative sex-tourism—in which Turks travel throughout the country seeking sex with the locals—beginning with *Ahmed's Fuck Tour* and evolving into a series dedicated to the men of various Turkish cities—*Men of Bursa, Men of Edirne, Men of Istanbul*, etc. The series thus recapitulates, ironically, the structure of the urban-based poetic genre of the şehrengiz. Ethnopornography lives on, in such examples, not simply the property of exploitative white pornographers creating "niche markets for . . . 'ethnic pornography.'"[35] The appeal to fulfill "your Arab stud craving"—who is the "you" here?—becomes a cross-cultural signifier that is both "empty" (signifying, in effect, anything and everything) and filled with a politically freighted history of accrued meanings.

VISUAL MANIFESTATIONS IN POPULAR CULTURE

Throughout this book we have seen how homoerotic subjects tied to Middle Eastern iconography have entered popular visual culture on a number of fronts. In this spirit, chapter 8 closes with a reminder of how the reach of this

homoerotics of Orientalism has extended beyond art and photography and left its mark on a variety of visual products, from cartoons to advertisements, from book jacket covers to cinema. One such formation is the genre of visual humor. Nineteenth-century colonialism and political humor come together in the illustration of the ephebe-like *Egyptian Pet* in an 1891 issue of *Punch* (fig. 8.54), which links racial inferiority explicitly to empire and implicitly to sexual-gender deviance. Appearing as a humorous gloss on Lord Salisbury's parliamentary defense of British intervention in Egypt, this dark-skinned weakling is not yet "man" enough to take on the job of self-rule, despite his British patron's attempt to give him muscles. He thus remains not only a "pet" project of empire, but also, perhaps, the "pet" of colonists of a certain persuasion.[36]

There is little subtle about the nineteenth-century caricature by A. Barrère (fig. 8.55) that appeared in the French magazine *Fantasio* (May 1913), accompanying an article about a recent celebration of Pierre Loti at the Fémina Theatre in Paris. The cartoon, depicting a tarbrush-capped author Loti applying eye makeup while resting his rump on a phallic minaret, blatantly equates the author's effeminacy with a penchant for Middle Eastern sodomy (and the passive role therein).[37] Homophobic humor also undergirds pairings of Saddam Hussein and Osama bin Laden as gay lovers—hence equating all Middle Eastern tyrants with sexual "deviancy"—in myriad photoshopped images circulating on the Internet (one uses the mock-up of a tabloid's front page to announce their pending nuptials; another appends their faces onto chiseled bodies on a porn video titled *Muscleheads*). While vilifying homosexuality and these two figures alike, such images advertise their own sense of the ludicrous, bearing no claims to represent some hidden "reality" to Hussein or bin Laden's private lives. For the CIA Iraq Operations group entertaining ideas about how to undermine Hussein's regime in 2003, however, creating gay-porn fictions of his sex life nearly became a matter of military policy; the group also seriously contemplated faking a video of bin Laden and his cronies "sitting around a campfire swigging bottles of liquor and savoring their conquests with boys," although both projects were ultimately squelched by upper authorities.[38] One person's taste in humor, it appears, becomes a lethal political weapon in another's hands, with homophobic aspersions forming the linchpin in the continuing contest of Middle East and West. Nor has homophobic visual humor only been a political tool of the West, as shown by the cartoon *Dancing Boys* (fig. 8.56) appearing in 1906 in the progressive newspaper of diasporic Iranian intellectuals, *Molla Nasreddin*, which often used satire to advocate democratic reforms—in this case, equating the tradition of dancing boys with boy concubines and seeing both as a threat to the development of heterosexual modernity.[39]

These examples of visual humor work by *deflating* desire—funny bones are all that get aroused by such images. Stimulating rather than deflating desire, in

FIGURES 8.54, 8.55, AND 8.56. **Oriental(ist) humor.**

Top left: Egyptian Pet, signed "Swain." *Punch* Magazine (November 21, 1891). *Top right:* A. Barrère, *Loti Pacha* in *Fantasio* magazine (1913). Courtesy of the Collection Maison de Pierre Loti © Ville de Rochefort. *Bottom: Dancing Boys, Molla Nasreddin* (1906). Courtesy of Janet Afary.

FIGURES 8.57 AND 8.58. **Suggesting homoerotic themes between the covers.**

Left: Jacket cover, *Sodomies in Elevenpoint* (1988). Illustration by Irene von Treskow. Courtesy of Faber and Faber, London. *Right*: Jacket cover, *Dreaming of Samarkand* (1989). Illustration by Andy Walker. Courtesy of HarperCollins Publishers, New York.

contrast, is the goal of advertisements aimed at U.S. and Anglo-European gay consumers that attempt to increase commercial profits by yoking the Muslim world to homosexual fantasy; chapter 4, for example, detailed the use of Egyptian motifs in gay club advertisements from Paris to Los Angeles. A related form of promotional literature, book jacket and magazine cover designs, aims—not unlike these club fliers—to stimulate the viewer's desire to purchase the item at hand. Intimations of the homoerotic themes of two novels that depict the intersection of European and Arab cultures are evocatively conveyed in the use of collage in the jacket designs in figures 8.57 and 8.58. The paperback edition cover of postmodern Italian novelist Aldo Busi's *Sodomies in Elevenpoint* (1988; trans. 1992) ingenuously incorporates the watercolor sketch *Three Fellahs* (1835) by Orientalist painter Charles Gleyre into its tableau. The faces of Gleyre's nineteenth-century fellahs seem to float in a body of vivid blue water, their profiles framing the handsome visage of a contemporary European submerged in the same pool; the enlarged pattern of a leopard-skin print, in fuchsia, forms the backdrop to the watery scene, punning on associations of primitive exoticism.

These visual cues, along with the title's reference to "sodomies," work to Oriental-ize and homoerotize a visual composition that is not overtly homoerotic in itself.[40]

The dust jacket created for Martin Booth's *Dreaming of Samarkand* (1989) also juxtaposes superimposed elements to suggest more than the image overtly reveals. Booth's novel fictionalizes the life of bisexual English poet, scholar of Orientalist languages, and career diplomat James Elroy Flecker (best known for his iambic pentameter poem "The Golden Journey to Samarkand" and the closet-drama *Hasan*). Not only did Flecker's posting to Beirut intersect with T. E. Lawrence's in Syria, but Flecker's tormented sexuality fostered an internalized masochism that came to depend—as in Lawrence's case—on flogging rituals.[41] In Booth's fictionalization, this shared masochistic desire brings poet and freedom fighter into intimate, intensely homoerotic, conjunction. If Lawrence's identification with the Arab cause served as a compensatory outlet for his largely sublimated homosexual feelings, Flecker's closeted sexuality, in Booth's telling, opens the poet to political blackmail. It is Lawrence, indeed, who uses the veiled threat of exposing Flecker's secrets to "seduce" the poet into joining a secret cadre within the foreign service dedicated to promoting England's imperial cause. "[A] nation requires," Lawrence lectures Flecker, "a band of dedicated men of special ability who will strive for that nation." In Flecker's case, as in Lawrence's, that "special ability" is "the ability to keep yourself—your true self—hidden. Just as you do . . . so well."[42] The implication is that the British Empire's Middle East policy thrives on the sublimated homosexuality underlying the intensely homosocial bonds formed by this secret brotherhood. The jacket design for *Dreaming of Samarkand* hints at these thematics by superimposing the images of Lawrence and Flecker—their faces turned to each other but their gazes not quite intersecting—over an architectural backdrop of domes and minarets, the symbolic terrain against which the two men's fraught sexuality—and unrequited attraction—seeks outlet and, in more ways than one, goes undercover.

By the latter twentieth century, T. E. Lawrence had gained iconic status as a gay person of historical note, and consequently his name and image have been used as marketing devices to signal the "gayness" of various commercial products. This coding is overt in the cover of the July 1978 issue of the magazine *Blueboy* (fig. 8.59). The model, dressed to evoke the white-robed mystique of Lawrence, simultaneously draws attention both to the issue's short story about Lawrence (by the best-selling lesbian writer Patricia Nell Warren) and to the "White on White" centerfold section. The latter, in playing on Lawrence's famous desert wear, subliminally registers the racial contradictions and complicities underlying the colonial fantasy of white men dressing up as dark-skinned "others." The erotics of costume are also deployed in the cover of a mid-century volume by Reşat Ekrem Koçu, the homosexual author of the *İstanbul Ansiklopedisi* (1957–1972)

FIGURES 8.59 AND 8.60. **Magazine marketing.**

Left: Cover, *Blueboy* (July 1978). Courtesy of Don Embinder, *Blueboy*, publisher. *Right*: Cover, Koçu, *Patrona Halil*. Author's collection.

whose homoerotic affinities were detailed in chapter 3. Occasionally Koçu culled encyclopedia entries and illustrations on specific topics into separate publications, as in this issue on Patrona Halil, a Janissary-turned-hamam-attendant who became a Turkish folk hero for leading the mob revolt that deposed Sultan Ahmed III and instated Mahmud I in 1730 (fig. 8.60). The cover illustration of brawny, loose-shirted men—lifted from an unrelated encyclopedia entry on ethnic Algerian costumes—shows how homoerotic appreciation of the male body (masked as "history") could surreptitiously find visual expression in a Middle Eastern publishing context.

HOMO-ORIENTALISM ON SCREEN

The elements of spectacle, exoticism, and mystery associated with the Middle East have made it a natural target for Hollywood cinema. Over the century such films have generally taken one of two routes: either the splashy, fantasy-filled Technicolor extravaganza in which whimsy, magic, and wizardry

predominate, often inspired by tales from *The Thousand Nights and a Night*, or libidinously charged dramas with "exotic" love interests.[43] Quintessential embodiments of the latter are the Rudolph Valentino vehicles *The Sheik* (1921) and *The Son of the Sheik* (1926). The conjunction of this particular star's "foreign" sex appeal, his idiosyncratic performance of masculinity in public and private, and the plots of these films unleashed a sexual charge in which— despite fainting female fans—the homoerotic is implicit.

The script of *The Sheik*, based on Edith Hull's 1921 best seller, is Orientalist storytelling pure and simple, charting the irresistible libidinal attraction of the strong-willed (and pants-wearing) Diana Mayo to her masculine dark Other, the brutal Sheik who abducts her in the Algerian desert and proceeds to ravage her until she learns the masochistic thrills of feminine surrender. In both novel and film, this heterosexual scenario is accompanied by homoerotic innuendo, specifically in its iteration of Diana's androgynous qualities. As Hull has one of Diana's English compatriots note, she "looks like a boy in petticoats, a damned pretty boy"—and the purported leaning of Arabs for "pretty boys" had long before entered public consciousness, as the previous chapters have demonstrated. Thus the Sheik's arousal by what the novel calls Diana's "slender boyishness" assumes an archly if unself-consciously homoerotic cast.[44] Of course, the primary function of the Sheik's smoldering gaze—Valentino's screen trademark—is the symbolically phallic one of penetrating to the "real" woman quivering in passive anticipation behind her boyish bravado, and soon enough Diana forgoes her male trousers for slinky evening dresses, so eager is she to please, in Hull's words, this "magnificent specimen of manhood."[45] Clothes don't only make the woman, however, since, on an extradiegetic level, the spectacle of Valentino as "this magnificent specimen of manhood" decked out in Arabic chic—the latter wording is Marjorie Garber's pun[46]—was sufficient to transform him into America's foremost male sex symbol. But this status, interestingly, cut two ways. On the one hand, for millions of American women, Valentino became the symbol of heterosexual desirability, the quintessential "Latin Lover"; on the other hand, as the sexualized object of the gaze, Valentino occupied a position culturally associated with women, thereby rendering him as something less than a "real" man.[47] Attacks on this "Theda Bara in trousers" reached near-hysterical proportions among Valentino's male detractors in a classic instance of homosexual panic. These slurs on Valentino's manhood, and hence his sexuality, were fed by reports of his two unconsummated marriages (to Hollywood lesbians), the "slave bracelet" (a gift from his second wife) proudly sported by this on-screen "master," and his narcissistic interest in fine clothes, perfume, and cosmetics.[48]

Among fantasy-inspired cinematic visions of the Arabic "Orient," Alexander Korda's 1940 remake of the Douglas Fairbanks silent vehicle *The Thief of*

Baghdad, subtitled "An Arabian Fantasy in Technicolor," reveals a subliminal kinship with the visual homoerotics of Orientalism we have been tracing.[49] Overtly the picaresque tale of the adventures of a handsome young prince who has been cheated of his throne and Abu, the adolescent street urchin and "thief" of the title who saves the prince's life and helps him win his princess, the film is also the story of Abu's adolescent crush on his companion and his despair at being displaced in the prince's affections by the princess. Sentimental male bonds, of course, are a beloved Hollywood staple as long as the relationship remains couched in a *Huck Finn*–like "innocence" that ostensibly de-eroticizes the scenario. In contrast to this benign reading, however, the on-screen image of man and youth running throughout this "Arabian Fantasy in Technicolor" contrapuntally gestures toward a different story, particularly for viewers familiar with the exploits of writers from Wilde to Orton with third-world boys. For what visually stands out when Ahmed and Abu share the screen is not simply their affection, but the fact that a white Western man is playing the part of the prince and a brown, scantily clad boy is acting the part of Abu (the fact that a *Persian* character is being played by the *Indian* child star Sabu underlines the degree to which one "brown" actor serves as well as another in mainstream cinema's homogenization of difference). The overt hierarchies of age and economic status inscribed into the film—man/boy, prince/beggar—are thus underscored by the racial and geographical hierarchies (white/brown, West/East) that made possible the colonial trade in boys motivating many pre-Stonewall bisexual and homosexual European men to travel to the Middle East and North Africa. This interpenetration of filmic and cultural texts is only heightened by the fact that the loinclothed Abu is cinematically represented as pederastic fantasy material—indeed, we watch the actor undergo puberty during the course of the film.[50]

Disney's 1992 computer-animated *Aladdin* takes its storyline almost directly from Korda's film. A note of gay campiness enters this G-rated family fare through the hyperbolic character of the Genie, voiced by Robin Williams (at one point the Genie tells Aladdin, "I've gotten really fond of you, kid. Not that I'm picking out curtains or anything" [fig. 8.61]). Indeed, this chameleon (whose transformations include several turns in drag) embodies the polymorphous perverse gone wild once freed from the prison of repression symbolized by his lamp. Perhaps this camp undertone explains why a specifically gay audience was invited to celebrate the transformative magic both of Aladdin's famous lamp and of cinema itself at a fund-raiser at Hollywood's El Capitan Theatre for an AIDS charity billed as "A Gay Night"—a charity sponsored, no less, by a gay porn entrepreneur (fig. 8.62).[51] Tellingly, Disney's atypically chiseled version of Aladdin has attracted an underground cult gay following, as numerous online pornographic cartoon sites showing him topping the Genie and being fondled and assaulted by hirsute Arabs demonstrate.

FIGURES 8.61 AND 8.62. **Gay resonances in and around** *Aladdin*.

Left: Image from *Aladdin* (1992). Disney Pictures. *Right*: Promotion Flier, "Matt Sterling Presents a Gay Night at Walt Disney Picture's *Aladdin*." Author's collection.

Korda and Disney's fantasies derive from the medieval *The Thousand Nights and a Night,* whose tales have undergone myriad cinematic adaptations. Among these, Pier Paulo Pasolini's *Il fiore delle mille et una notte* (1974) stands out for the way that it combines the exotic visual appeal and fantastical elements common to Hollywood renditions of the Middle East with the psychodramatic sexuality of films like *The Sheik* in a decidedly nonmainstream production that reflects the iconoclastic vision of its Marxist, homosexual creator. The result is a significant contribution to the homoerotics of Orientalism on both aesthetic and

political levels. Rather than merely appropriating Eastern otherness for Western titillation, *Il fiore* is striking for its attempted if imperfect fidelity both to the medieval Arabic text and to the cultural milieu that produced it. First, Pasolini brilliantly captures within the film's narrative structure the layered effect of the written text, in which the endless regress of framed, inset, and interrupted tales creates, in Pasolini's phrase, the possibility of "limitless narration."[52] Second, he positions his camera as a neutral recorder of events rather than a prying eye that attempts to impose an interpretation on what it sees. "I have increased the passivity of the camera," Pasolini explains. "Except for a few panning shots . . . I let the profilmic world flow, just as dreams and reality flow."[53] Third, Pasolini attempts to remain authentic to the spirit of Arabic text by filming on location in third-world countries, peopling his frames with the "dust and faces of the poor," and relying largely, as in his early sub-proletariat films, "on popular milieus, nonprofessional actors, and regional dialects" as the backdrop for his adaptation.[54] Through his trademark techniques of the single shot, repudiation of the traditional matching shot, and immobile camera, Pasolini thus creates the sense of a remote world of medieval popular culture that exists "as given fact," without elucidation, just as the enigmatically laughing faces of the nameless peasants that fill the screen remain "just faces," without assignable meaning—faces that the spectator must simultaneously respect for their complete but indecipherable "presence" as well as their inevitable otherness.[55]

As part of this attempt at representational authenticity, Pasolini does not simply seize upon and amplify the more explicitly homoerotic moments in the tales, which would have been a possible, indeed tempting, tactic. Rather, he chooses to honor, on the level of plot, the dominant heterosexuality of the original: the film is thus framed by the saga of the youth Nur al-Din's quest for his abducted slave girl Zumurrud, an adventure complemented with three extended inset fables motivated by heterosexual desire.[56] Nonetheless, as its first audiences and reviewers sometimes uneasily intuited, the film pulsates with a queer sensibility that ultimately resides in Pasolini's manipulation of the cinematic apparatus. For his strategy is to inflect the predominantly heterosexual erotics of the film's superstructure with a subtle homotextuality that exists as much within the mise-en-scène and between spectator and screen as in the narrative proper. As such, the heterosexual negotiation of the homoerotic characterizing so many Western accounts of Middle Eastern sexuality (as in Flaubert, Loti, and Mailer) gives way, in Pasolini's vision of the *Nights*, to a homoerotic negotiation of the heterosexual. These filmic strategies are threefold. The first is the thematic incorporation of two of the written text's more frankly homoerotic tales into the film's diegetic flow, shooting both scenes with full frontal male nudity. One, the story of how the Caliph Harun al-Raschid's court poet Sium (the historical Abu Nuwas in the original) uses lines of verse to entice three handsome, naked youths into his tent

FIGURE 8.63. **Shipwrecked romance.**

Image from Pasolini, *Il fiore delle mille et una notte* (1974). P.E.A. (Produzioni Europee Associate), Les Productions Artistes Associés.

to pleasure each other and himself, occurs a brief twelve minutes into the film.[57] The second—the film's last inset narrative, which is modeled on the Third Kalandar's Tale—recounts the tragic love affair of Prince Yunan and the jeweler's son. The latter has been hidden in an underground chamber on the remote island where he's discovered by the shipwrecked Yunan, who has providentially lost all his clothes (fig. 8.63) and who promptly falls in love with the youth.[58] However well both stories work as cinematic and erotic moments, their ideological impact is limited by the fact that their homoerotic content is presented as structurally *detachable* from the rest of the film, a fact signaled by the remote settings in which each of these two incidents occurs—the darkened interior of a tent, an underground chamber on a deserted island.

This equivocal structuring of homosexual behavior as an isolatable anomaly within the film's episodic superstructure is only partially allayed by Pasolini's second mode of destabilizing the heterosexual arc of the filmic text. This he attempts by incorporating episodes in the original that involve elements of gender disguise or bisexuality. But as in Shakespeare's cross-dressing comedies, the momentary illusion of same-sex desire created by such masquerade is at best a playful tease, the homoeroticism adding "spice" to what remains heterosexual lovemaking. Pasolini's third strategy for disrupting heterosexual norms, however, is both his most subtle and what he calls his most "radically ideological."[59] It centers, ironically, on the moments of male-female intercourse that recur throughout the film. For in filming these scenes Pasolini uses his entire arsenal

of cinematic tools—scenic composition, camera angles, lighting, cropping—to focus the spectator's gaze specifically on the *male* body of the male-female couple. Moreover, it is not just the male partner's body that the viewer is forced to contemplate but, through Pasolini's framing of such shots, the actor's genitals. Hence Pasolini's comment to those Marxist critics who criticized the film for its apparent social irrelevance: "ideology [is] really there, above [your] heads, in the enormous cock on the screen."[60]

The sheer iterativeness of projecting that "enormous cock on the screen," if only for a few seconds at a time, begins to undermine patriarchal "ideology" on at least two levels. First, this focus unsettles the position of the heterosexually identified male viewer, forcing him to engage in a homoeroticizing aesthetic that, in deemphasizing the objectification of the female of the couple and in forcing an identification with the homoeroticized male, upends the overtly heterosexual trajectory of such scenes. Second, these phallic framings serve as an "in" for non-straight male viewers, giving them something more interesting to look at in the heterosexual love stories unfolding on the screen. As such, audience and artifact participate in a parlay of identification and desire, of subject and object positions, that keeps Pasolini's visual text from repeating the dominance of the "male gaze" by merely substituting a male body for the traditionally objectified female one. For the naked male bodies on which Pasolini's camera lingers are not the hyperbolic or homogenized icons of masculine beauty that Etienne or Pierre and Gilles repeat and parody. Rather, these torsos, of varying shapes and conditions, are presented in states of repose and openness that recall Sylvia Sleigh's feminist rendering of the male nude in *The Turkish Bath* and Sadegh Tirafkan's reconfigurations of Iranian masculinity in his *Zoorkhaneh* photographs. Likewise, Pasolini's frequent close-ups of the male genitals most often depict the penis, represented in various states of arousal and flaccidity, as a vulnerable rather than as an aggressive extension of the male body. Even the editing, cropping the actor's head or limbs from the frame to focus the audience's gaze on his penis, works less as an objectifying *blazon* of the male body than as the creation of a contestatory position for the spectator.

One of Pasolini's strategies is the repeated scenario of a passive male body being disrobed by a female agent. In the framing sequence, for instance, Nur al-Din does not seduce Zumurrud, but waits, laughing, as she takes charge, first stripping him of his waist-skirt and then unwinding his loincloth (fig. 8.64). Thus the spectator is forced to wait and watch, wondering how long the camera will hold the image before cutting to a less explicit shot. Against Hollywood expectations, it rarely does. In conjunction with such scenes, Pasolini often uses hands as on-screen markers to direct the audience's gaze within the wider frame to the gradually focalized crotch of the male torso. Hands extended toward, brushed across, or molded about the penis become a means of creating sensations in the

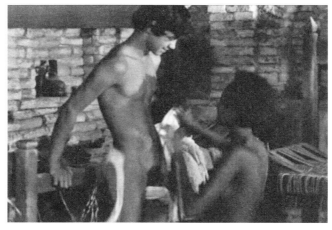

FIGURES 8.64 AND 8.65. **Cinematic strategies for homoeroticizing heterosexual love-play.**

Images from Pasolini, *Il fiore delle mille et una notte* (1974).

off-screen as well as on-screen body, thereby involving spectators even further in the image and ideology of "the enormous cock" unfolding on screen. Third, as can be seen in the scene of Zumurrud unwinding Nur al-Din's loincloth, Pasolini uses lighting, shading, and blocking to foreground the male body while deemphasizing the female participant (even when both sexes occupy equal screen space).[61]

Another technique involves the camera's composition of the "phallic still life," in which the actor's genitals occupy the center of the screen, forming the momentarily static object around which the entire frame arranges itself. A noteworthy example occurs in Pasolini's adaptation of the tale in which Prince Taji falls asleep after having successfully wooed the Princess Dunya.[62] Dunya places a golden robe over Taji's upper torso so that it stops just short of his

pubis. She then rests her head, eyes closed, on Taji's thighs, so that her profile points at Taji's genitals (fig. 8.65). Framed on screen-left by the golden fabric, on screen-right by Dunya's sightless gaze, Taji's unaroused penis occupies the center screen. Seconds later, Pasolini repeats the shot, without any narrative time lapse, from a slightly different angle. While this strategy of repeating shots from more than one angle, without the passage of any time, exemplifies one of Pasolini's most celebrated techniques for breaking conventional filmic linearity, in this case the atemporal iteration also has the function of providing gay viewers with a "second glimpse" of the phallic still life. The technique lauded by film critics for its aesthetic effects thus also serves a subversively queer agenda. Pasolini's attempt to recreate the world of the *Nights* is not without Orientalist or colonializing tendencies, particularly when it comes to the conservative nostalgia underlying his declaration that the homoeroticism possible in the "third world" is more "free" and "happy" because its celebration of the "beauty of boys" exists in a medieval past untouched by modernity.[63] Regardless of these ambivalences—which also pervade Pasolini's troubled attitudes toward homosexuality in general and toward gay politics in particular—his adaptation of the *Nights* remains a striking intellectual and artistic attempt whose engagement with the tradition of Oriental homoerotics creates a reverse discourse that at once subverts the status quo and articulates an alternative narrative of Europe's erotic projections onto the Middle East.

The sexual politics embedded in homoerotic encounters of Middle East and Europe also occupy a range of European films that, for the past decade, have explored the clash of cultures and masculinities. A protégé of the director André Téchiné, who has often incorporated colonial critique and homoerotic themes in his own work, Gaël Morel has directed two intriguing if not completely successful films, *Full Speed* ("À toute vitesse," 1998) and *Three Dancing Slaves* ("Le clan," 2004), in which Algerian immigrants in France contend with homoerotic desires in a racially insensitive country haunted by its colonial heritage. Ferzan Özpetek's 1997 film *Hamam* ("Il bagno turco"/"Steam"), discussed at length in chapter 3, also charts the intersection of European and Middle Eastern cultures and sexual attitudes, in which homoerotic desire provides both conduit and barrier to cross-cultural understanding. Likewise, Kutluğ Atalug's emotionally compelling first feature, a German-Turkish production titled *Lola and Bilidikid* (1998), explores the conflicted sexual identities of three Turkish brothers who have grown up in Berlin. The older brother, the patriarch of the family, represses his gay urges in displays of destructive machismo; the middle son, expelled from the family, is a transvestite in love with the title's macho hustler Billy; the youngest, a sensitive university student, is in the process of "coming out" as understood in a contemporary construction of homosexuality. For each, their status as second-class citizens (the result of Germany's now-contested Turkish-visiting-worker

policy of the 1970s), suffering continual discrimination and abuse, exacerbates the difficulty they face in attempting to surmount the cultural and psychological barriers that stand in the way of sexual self-realization and community.

The arc of coverage in the last three chapters—brought together under the heading "Modes and Genres"—has grown exponentially: from chapter 6's period-specific focus on one literary-cultural manifestation of modernism and one genre (the poetic hoaxes and imitations of various gay-identified modernist artists), to chapter 7's focus on two different artistic genres and epochs (the early modern Middle Eastern miniature, nineteenth-century Orientalist art), to this chapter's survey of a wide range of visual modes and genres crossing high and popular culture, easily accessible and contraband texts. In demonstrating the extent to which a homoerotics of Orientalism has proliferated across any number of representational venues in the visual field, this chapter has necessarily sacrificed much of the in-depth analysis of single artifacts characterizing earlier chapters, though even here there are exceptions, such as the extended readings of Giliberti's paintings and Pasolini's adaptation of *The Thousand Nights and a Night*. But as a "final word" in this book, I wanted to leave readers with a sense of the sheer degree to which such a homoerotics has filtered its way into so many aspects of popular culture, in some cases more flashily, in some cases more subtly. Laying out the parameters and extent of the available source material, as chapter 8 has only begun to do, is meant to inspire future critics to probe even further the range of political and cultural work that such images and representations do in the cultural imagination, as well as to account for the variable ways in which this work may differ according to categories of identity, individual communities, means of distribution, and modes of desiring. Finally, setting these many types of sometimes seemingly incongruous genres and modes—from postmodernist citation to pornographic exploitation, from fashion photography to political cartoon—beside each other, each touching the other in partial conversations, returns us to the founding methodological principles articulated in preface and so well summed up by Sedgwick and Stoler among others. Reading along the grain of twentieth- and twenty-first-century manifestations of Orientalist homoerotics, we confront an inestimable number of half-completed stories whose large strokes as well as tiny details—despite the wear and tear, the scuff marks, created by a history of crossings and recrossings—contribute to a narrative whose ghostly traces shape and reshape themselves in present-day conflicts, conundrums, and surprising alliances whose reverberations and material consequences we feel to this day.

NOTES

PREFACE

1. İrvin Cemil Schick coins the term "ethnopornography" to describe early-twentieth-century exposés of Middle Eastern sexuality that pass themselves off as scholarly works when their main intent is titillation in *The Erotic Margin: Sexuality and Spatiality in Alternist Discourse* (London: Verso, 1999).

2. *Mektoub* appears on "Vintage Erotica anno 1930, Cult Epics," Editions Astarté-Paris. The other short using an Oriental setting to highlight homosexual activity is "Song of the Butterfly," which winkingly nods to Puccini's opera, *Madame Butterfly*.

3. Hector France, *Musk, Hashish, and Blood*, trans. Alfred Allinson (1886; London and Paris: For Subscribers Only, 1900), 384, 287–88.

4. The film was written and directed by Aldo Lado and produced by Films Jean Alexandre and Futura Films (1987).

5. Such fetishistic operations evoke D. A. Miller's description of connotation (and its ultimate deniability) as a tool of homophobic inscription in "Anal *Rope*," *Representations* 32.1 (1990): 114–33.

6. Dina Al-Kassim, "Epilogue: Sexual Epistemologies, East in West," *Islamicate Sexualities: Translations Across Temporal Geographies of Desire*, ed. Kathryn Babayan and Afsaneh Najmabadi (Cambridge, MA: Center for Middle Eastern Studies/Harvard UP, 2008), 317.

7. In the preface to *Islamicate Sexualities*, Babayan and Najmabadi explain their decision to employ Marshall G. S. Hodgson's coinage, "Islamicate," to "highlight a complex of attitudes and practices that pertain to cultures and societies that live by various versions of the religion Islam" (ix).

8. In *Islamicate Sexualities*, Babayan and Najmabadi, ix, note that the term was coined by European cartographers at the turn of the twentieth century to categorize naval and oil-shipment operations in the Persian Gulf for military purposes. In *Reading Orientalism: Said and the Unsaid* (Seattle: U of Washington P, 2007), Daniel Martin Varisco attributes its first usage to American naval historian Alfred Thayer Mahan in 1902, who employed it to describe the British-held dominions between India and Arabia (68). Clayton R. Koppes hypothesizes an even earlier usage in "Captain Mahan, General Gordon, and the Origins of the Term 'Middle East,'" *Middle East Studies* 12.1 (1976): 95–96.

9. Dror Ze'evi, *Producing Desire: Changing Sexual Discourse in the Ottoman Middle East, 1500–1900* (Berkeley: U of California P, 2006), p. 167.

10. Valerie Traub, "The Past Is a Foreign Country? The Times and Spaces of Islamicate Sexuality Studies," *Islamicate Sexualities*, 2.

11. Dipesh Chakrabarty, *Provincializing Europe: Postcolonial Thought and Historical Difference* (2000; reissued with new preface, Princeton, NJ: Princeton UP, 2007), 3–4, 46.

12. Michel Foucault, *The History of Sexuality, Volume 1: An Introduction*, trans. Robert Hurley (1976; New York: Random House/Vintage, 1978), 36–49 and passim.

13. Walter G. Andrews and Mehmet Kalpakli, *The Age of Beloveds: Love and the Beloved in Early-Modern Ottoman and European Culture and Society* (Durham, NC: Duke UP, 2005), 114; emphasis added.

14. See Sahar Amer, *Crossing Borders: Love Between Women in Medieval French and Arabic Literatures* (Philadelphia: U Pennsylvania P, 2008); the commentator is Al-Kassim, 304.

15. Mary Roberts, *Intimate Outsiders: The Harem in Ottoman and Orientalist Art and Travel Literature* (Durham, NC: Duke UP, 2007).

16. Nabil Matar, *Turks, Moors, and Englishmen in the Age of Discovery* (Chicago: U of Chicago P, 1999).

17. Traub, "The Past," 12.

18. Lisa Lowe, *Critical Terrains: French and British Orientalisms* (Ithaca, NY: Cornell UP, 1991), 7. As Kwame Anthony Appiah notes in "Is the Post- in Postmodernism the Post- in Postcolonial?" *Critical Inquiry* 17 (1991), the binary of self and other "is the last of the shibboleths of the modernizers that we must learn to live without" (354).

19. Joseph Allen Boone, *Libidinal Currents: Sexuality and the Shaping of Modernism* (Chicago: U of Chicago P, 1998), 19–25.

20. Varisco, *Reading* Orientalism, 203.

21. Eve Kosofsky Sedgwick, *Touching Feeling* (Durham, NC: Duke UP, 2003), 8; see also chap. 4, "Paranoid Reading and Reparative Reading, or You're So Paranoid, You Probably Think This Essay Is About You"; Rita Felski, *Uses of Literature* (Malden, MA: Blackwell, 2008), 3.

22. Edward Said, *Culture and Imperialism* (New York: Random/Vintage, 1993), 32; see also 49, 51, 66, 259.

23. Ann Laura Stoler, *Along the Archival Grain: Epistemic Anxieties and Colonial Common Sense* (Princeton, NJ: Princeton UP, 2009), 2, 20, 24.

24. Sedgwick, *Touching Feeling*, 8–9.

25. See also Gayatri Gopinath's call for "an alternative set of reading practices" in *Impossible Desires: Queer Diasporas and South Asian Public Cultures* (Durham, NC: Duke UP, 2005), 21, 13.

26. Ali Behdad, *Belated Travelers: Orientalism in the Age of Colonial Dissolution* (Durham, NC: Duke UP, 1994), 9.

27. See Amer's impressive moves, from a comparative literature perspective, to fill this gap in *Crossing Borders*, as well as Emily Apter's fascinating study of European lesbian culture's appropriation of Orientalist tropes in the early twentieth century in "Female Trouble in the Colonial Harem," *Differences. A Journal of Feminist Cultural Studies* 4 (1992): 203–24. On Middle Eastern perspectives of lesbianism, see Samar Habib, *Female Homosexuality in the Middle East: Histories and Representations* (New York: Routledge, 2007).

28. Chakrabarty, *Provincializing Europe*, 21 in 2000 edition; 2007 preface, xiv.

29. Ze'evi, *Producing Desire*, 11.

30. As Jarrod Hayes puts it in *Queer Nations: Marginal Sexualities in the Maghreb* (Chicago: U of Chicago P, 2000), "no sexologist of the Western world would think of using *medieval* texts to describe *modern* sexuality" (4; emphases added). This myopia isn't restricted to Western scholars; see Joseph A. Massad's critique of Fatima Mernissi's *Beyond the Veil* (1987) in *Desiring Arabs* (Chicago: U of Chicago P, 2007), 154–55.

31. Khaled El-Rouayheb, *Before Homosexuality in the Arab-Islamic World, 1500–1800* (Chicago: U of Chicago P, 2005), 11; emphasis added.

32. See Traub, "The Past," 4–7, 9, and Al-Kassim, "Sexual Epistemologies," 304–5, on Massad's theory of the "Gay International." In *Women with Moustaches and Men Without Beards: Gender and Sexual Anxieties of Iranian Modernity* (Berkeley: U California P, 2005), Najmabadi notes that while she shares "this reluctance to map later formations of desire onto those of earlier sociohistorical periods," nonetheless "one needs to be aware of the current effects of pushing this argument to the limit of drawing lines of alterity," a position equally embraced "by homophobic cultural nativists who are happy to (al)locate homosexuality in 'the West'" (19).

33. Arnaldo Cruz-Malavé, and Martin F. Manalansan, "Introduction: Dissident Sexualities / Alternative Globalisms," *Queer Globalizations: Citizenship and the Afterlife of Colonialism*, ed. Cruz-Malavé and Manalansan (New York: New York UP, 2002), 6.

34. Janet Afary, *Sexual Politics in Modern Iran* (Cambridge: Cambridge UP, 2009), 2; Najmabadi, *Moustaches*, 19.

35. Hayes, *Queer Nation*, 26.

36. Gobinath, *Impossible Desires*, 11.

37. Hayes, *Queer Nation*, 6.

38. Traub, "The Past," 17.

39. In *Desiring Arabs*, Massad argues that the "categories gay and lesbian are not universal at all and can only be universalized by the epistemic, ethical, and political violence unleashed on the rest of the world by the very international human rights advocates whose aim is to defend the very people that their intervention is creating" (41). Puar argues that the political climate in the United States post 9/11 has led to the creation of "properly queer" or "good" gay U.S. subjects who collaborate with the state in its Islamophobic ends; the result is a wholesale collusion between Western "homosexuality" and "American nationalism," producing the Muslim as queerly deviant and marked for death. See Jasbir K. Puar, *Terrorist Assemblages: Homonationalism in Queer Times* (Durham, NC: Duke UP, 2007), xiii, xvi, xxiv. Rather than the one-sided collusion theorized by Puar, chap. 1 delineates a centuries-long history of mutual homophobic aspersions used for political ends by Anglo-Europeans and Middle Easterns alike.

40. Traub, "The Past," 14.

41. Arjun Appadurai, *Modernity at Large: Cultural Dimensions of Globalization* (Minneapolis: U of Minnesota P, 1996), 17.

42. Both Vanita and Jackson are quoted in Traub, "The Past," 14–15. See Ruth Vanita, ed., *Queering India: Same-Sex Love and Eroticism in Indian Culture and Society* (New York: Routledge, 2002), 5–6, and Peter A. Jackson, "The Persistence of Gender: From Ancient Indian *Pandakas* to Modern Thai Gay-*Quings*," in "Australia Queer" (Special Issue), ed. Chris Berry and Annamarie Jagose, *Meanjin* 55.1 (1996): 118–19.

43. Sedgwick, *Touching Feeling*, 13.

44. Sedgwick, *Touching Feeling*, 128–29; David Roman, *Acts of Intervention: Performance, Gay Culture, and AIDS* (Bloomington: Indiana UP, 1998), xxvi.

45. James Howell, *Instructions and Directions for Forren Travell* (London, 1650), 95.

1. HISTORIES OF CROSS-CULTURAL ENCOUNTER, ORIENTALISM, AND THE POLITICS OF SEXUALITY

1. Ali Behdad, *Belated Travelers: Orientalism in the Age of Colonial Dissolution* (Durham, NC: Duke UP, 1994), 9.

2. This unattributed image, titled "Osama bin Donkey," has appeared (and disappeared) from a number of online "humor" websites, including rotten, humor4you, ajokes, and fotografi humoristike. Another variant exists on http://www.humor4you.com/fundoc.asp?image=41.jpg.

3. The Old Testament prohibition of pederasty (Leviticus 18:22) is immediately followed by that on bestiality (Leviticus 18:23). Early modern English jurisprudence assumes that sodomy and bestiality—along with witchcraft, rape, and other crimes—are equivalent sins against God and nature. Thus Sir Edward Coke, addressing the "detestable and abominable sin . . . not to be named" among Christians in *Institutes* (1644), defines sodomy as "carnal knowledge . . . committed by mankind with mankind, or with brute beast." Quoted in Bruce R. Smith, *Homosexual Desires in Shakespeare's England: A Cultural Poetics* (Chicago: Chicago UP, 1991), 50.

4. Puar comments on this image in *Terrorist Assemblages*, p. 37, which can be found on the website humor4you at http://www.humor4you.com/fundoc.asp?image=sky.jpg. A similar composition, where a masked Osama figure kneels on a sofa while being penetrated by a world trade tower, is located at http://www.humor4you.com/fundoc.asp?image=osam29.jpg.

5. In a similar vein, Jonathan Goldberg opens his essay "Sodometries" with a reading of a T-shirt advertisement in *Rolling Stone* (November 1990), in which Saddam Hussein's head is affixed to a camel's anus. The image is surrounded by the caption "America Will Not be Saddam-ized." See Susan Gubar and Jonathan Kamholtz, eds., *English Inside and Out: The Places of Literary Criticism* (New York: Routledge, 1993), 68–71.

6. Nico Hines, "YouTube Banned in Turkey after Video Insults," *Times Online* (March 7, 2007). The offending video, according to Claire Berlinski, "Turkey's YouTube Ban is Cause for Concern," *Radio Free Europe Online* (July 8, 2009), showed Ataturk weeping lavender-colored tears to the music of the Village People. In Turkey it is illegal to defame Ataturk or the Republic.

7. Walter G. Andrews and Mehmet Kalpakli, *The Age of Beloveds: Love and the Beloved in Early-Modern Ottoman and European Culture and Society* (Durham: Duke UP, 2005), 19.

8. *The True Narrative of a Wonderful Accident, Which Occur'd upon the Execution of A Christian Slave at Aleppo in Turky* (London, 1676), 2. Subsequent page numbers are included in parentheses in the text.

9. Incorporated into the Ottoman Empire in 1516 and strategically located as the final destination on the "Silk Road," Aleppo had served as Britain's main commercial base in the Levant since 1581. Hence its description by the Italian traveler Pietro Della Valle as a crossroads of East and West: "here, in one district, converges all the Orient, with its silks, drugs, and clothes, and it is also joined by the Occident." Pietro Della Valle, *The Pilgrim: The Travels of Pietro Della Valle*, trans. George Bull (1658; London: Hutchinson, 1989), 93. Aleppo was renowned for its ethnic and religious diversity, with an "infinite number of Greeks, Armenians, Arabs, and Persians" living beside Turks, Syrians, and schismatics, as Ambrosio Bembo observed during his visit to the city between 1671 and 1675, in *The Travels and Journal of Ambrosio Bembo*, trans. Clara Bargellini, ed. Anthony Welch (Berkeley: U of California P, 2007), 53.

10. Typically seamen from mercantile vessels taken prisoner by Turkish corsairs were sold into slavery or ransomed to the home country. Multiple accounts exist of Englishmen and Europeans seized in the Mediterranean. Barbary piracy was particularly pronounced in the 1670s and 1680s—the time of this account—as evinced in C. R. Pennell, *Piracy and Diplomacy in Seventeenth Century North Africa: The Journal of Thomas Baker, English Consul in Tripoli, 1677–1685* (Rutherford, NJ: Fairleigh Dickinson UP, 1989). David Delison Hebb, *Piracy and the English Government, 1616–1642* (Aldershot, UK: Scolas P, 1994) includes a public record office document from 1619 reporting that all the crew of a vessel seized by Barbary Turks were set free save a cabin boy retained for "their Sodomitical use" (150). Building on his experiences while held captive in Algiers for five years, Cervantes wrote two plays circa 1580–1590, *El trato de Argel* and *Los baños de Argel*, in which handsome Christian young men are either captured by Moors or sold into slavery in Algiers for purposes that are overtly dramatized as sodomitical.

11. Silke Falkner, "'Having It Off' with Fish, Camels, and Lads: Sodomitic Pleasures in German Language Turcica," *Journal of the History of Sexuality* 13.4 (2007): 402, 405, 425, 427.

12. See chap. 1, "The Passions of Pelagius," in Mark D. Jordan, *The Invention of Sodomy in Christian Theology* (Chicago: Chicago UP, 1997); quotations are from pp. 15 and 13, respectively.

13. The "Seven Stories" was fourth of a series of five *mesnevi* poems (making up a *hamse* or pentad) composed by Nev'izade 'Atayi in emulation of the *hamse* masterpiece of his Persian predecessor Nizami. My redaction is adapted from a translation I commissioned from N. Evra Gunhan of the Ottoman text in the Bogacizi University Library collection. Occasionally I enhance Gunhan's wording with word choices used in the prose paraphrase and partial poetic translation in Andrews and Kalpakli, *Age of Beloveds*, 59–62, where it forms a touchstone for their third chapter. Andrews and Kalpakli note that whereas the first six *mesnevi* of "Seven Stories" relate bawdy goings-on under the pretense of inspiring the reader to moral behavior, the seventh tale concerns lovers who are not evil-doers and are eventually rewarded for loving rightly (59).

14. Pera is the European sector of Istanbul in Galata, where the Sultans allowed Christians—mostly Greeks and Portuguese—to operate wine establishments, making it the city's de facto pleasure center. Gosku was a famous excursion spot on the Bosporus where lovers often clandestinely met.

15. As Andrews and Kalpakli note, this particular sect was particularly popular among sixteenth-century Ottoman elites, so joining this sect would, paradoxically, represent an elevation in status for the boys despite their loss of portable income (73–74). Sufi conclaves were uniformly associated with male homoerotic practices by contemporaries, since part of the ritual to reach transcendent ecstasy involved gazing upon beautiful male youths. Ze'evi analyzes the war in religious literature between the Sufi-based dervish societies and more conservative religious movements in chap. 3, "Morality Wars: Orthodoxy, Sufism, and Beardless Youths," in Dror Ze'evi, *Producing Desire: Changing Sexual Discourse in the Ottoman Middle East, 1500–1900* (Berkeley: U of California Press, 2006).

16. On this institution, see Andrews and Kalpakli, *Age of Beloveds*, 77–79, as well as chap. 54, "Wine Gatherings," in Mustafa Âli, *Tables of Delicacies Concerning the Rules of Social Gatherings*, trans. Douglas S. Brookes (Cambridge, MA: Harvard U Department of Near Eastern Languages and Civilization, 2003), 111–13. See also chap. 3,

"Spaces of Garden Rituals" in Bahar Deniz Çalış, *Ideal and Real Spaces of Ottoman Imagination: Continuity and Change in Ottoman Rituals of Poetry (Istanbul, 1453–1730)*, Ph.D. Dissertation in Philosophy and Architecture (Middle East Technical University, September 2004).

17. Andrews and Kalpakli, *Age of Beloveds*, 61.

18. This threat underlies Mustafa Âli's warning against the "slanderous preachers" inveighing against the ruling elite's privileges in *Counsel for Sultans*, trans. and ed. Andreas Tietze, 2 vols. (Vienna: Akademie der Wissenschaften, 1979), 1:55.

19. André Gide, *The Immoralist*, trans. Richard Howard (1902; New York: Vintage, 1970), 163.

20. Orhan Pamuk, *My Name is Red* (1998; New York: Vintage International, 2002), 218.

21. Ze'evi, *Producing Desire*, 1–15, 167–71.

22. Afsaneh Najmabadi, *Women with Moustaches and Men Without Beards: Gender and Sexual Anxieties of Iranian Modernity* (Berkeley: U of California P, 2005), 3, 7.

23. Joseph A. Massad, *Desiring Arabs* (Chicago: U of Chicago P, 2007), 5, 1, and 73. A 1930 reprint of *A Thousand and One Nights* eliminated the homoerotic elements included in the 1836 edition.

24. Massad, *Desiring Arabs*, 40.

25. Scott Long, "The Trials of Culture: Sex and Security in Egypt," *Middle East Report* 230 (Spring 2004): 18, 19–20.

26. Massad, *Desiring Arabs*, 112.

27. The headline appeared in the government majority newspaper, *Al-Ahram al-Arabi*, August 25, 2001; the next quotation in "An Egyptian View," *Al-Akhbar*, May 30, 2001; the third in "Confessions of the 'Satanists' in 10 Hours: We Imported the Perverse Ideas from a European Group," in the government-owned *Al-Masa'*, May 15, 2001, which claimed all the men under detention had confessed to being Satanists and listed their full names. For more on this case, see Brian Whitaker, *Unspeakable Love: Gay and Lesbian Life in the Middle East* (London: Saki, 2006), 49–51, 214–15, and the Human Rights Watch report, *In a Time of Torture: The Assault on Justice in Egypt's Crackdown on Homosexual Conduct* (2004). Twenty-two defendants were ultimately sentenced to one to three years in prison for "obscene behavior," one was sentenced to five years with the additional charge of "contempt for religion," and twenty-nine defendants were acquitted. I am grateful to Issandr El Amrani, former editor of the *Cairo Times*, for supplying valuable information.

28. Long, "Trials of Culture," 14–15.

29. Sherif Farrag, "Will the Real Sherif Farhat Please Stand Up? The Main Defendant in the Queen Boat Trial Risks Losing More than His Family," *Cairo Times*, Nov. 1–7, 2001.

30. Long, "Trials of Culture," 13.

31. Long intriguingly suggests that the prisoners' self-veiling may had such a powerful emotional effect on Western viewers because it tapped into the Orientalist stereotype of the veiled woman, making the prisoners seem "obscurely feminine, assimilat[ing] them to an antiquated vision of the East as a territory of mysterious invisibilities, where desire was repressed but omnipresent" (13).

32. See Robert Irwin, *Dangerous Knowledge: Orientalism and Its Discontents* (Woodstock, NY: Overlook P, 2006); Daniel Martin Varisco, *Reading* Orientalism; and Ibn Warroq, *Defending the West: A Critique of Edward Said's* Orientalism (New York: Prometheus Books, 2007). Aside from the vitriol Irwin expresses for Said, he provides an excellent account of scholarly Orientalism, carefully pointing out discrepancies between

its development and Said's account. Varisco's tome attempts to deconstruct Said's methodology piece by piece; Warroq's book is primarily a screed.

33. Edward Said, *Orientalism* (New York: Vintage, 1978), 1, 51, 63, and passim. Said's work was soon followed by a distinguished cadre of feminist theorists extending while critiquing his theory by applying issues of gender and women to analyses of Orientalism and empire. See, among others, Lata Mani and Ruth Frankenburg, "The Challenge of Orientalism," *Economy and Society* 14.2 (1985): 174–92; Gayatri Spivak, *In Other Worlds: Essays in Cultural Politics* (New York: Metheun, 1987); Lisa Lowe, *Critical Terrains: French and British Orientalisms* (Ithaca, NY: Cornell UP, 1991); Chandra Talpade Mohanty, "Under Western Eyes: Feminist Scholarship and Colonial Discourses," Chandra Talpade Mohanty, Ann Russo, and Lourdes Torres, eds., *Third World Women and the Politics of Feminism* (Bloomington, IN: Indiana UP, 1991); Jenny Sharpe, *Allegories of Empire: The Figure of Woman in the Colonial Text* (Minneapolis, MN: U Minnesota P, 1993); Karen R. Lawrence, *Penelope Voyages: Women and Travel in the British Literary Tradition* (Ithaca, NY: Cornell UP, 1994); Billie Melman, *Women's Orients: English Women and the Middle-East, 1718–1918* (New York: Palgrave, 1995); Emily Apter, "Female Trouble in the Colonial Harem," *differences: A Journal of Feminist Cultural Studies* 4 (1992): 203–24; Anne McClintock, *Imperial Leather: Race, Gender and Sexuality in the Colonial Contest* (New York: Routledge, 1995); and Reina Lewis, *Rethinking Orientalism: Women, Travel, and the Ottoman Harem* (New Brunswick, NY: Rutgers UP, 2004). A useful anthology gathering together many of these viewpoints is Reina Lewis and Sara Mills, eds., *Feminist Postcolonial Theory: A Reader* (Edinburgh: Edinburgh UP, 2003). Since the 1990s a number of studies began to look more closely at issues of sexuality and/or race within a colonial and postcolonial framework. Several of these made male homosexuality a major part of their analyses, including Rudi Bleys, *The Geography of Perversion: Male-to-Male Sexual Behavior Outside the West and the Ethnographic Imagination* (New York: NYU Press, 1995); Michael Lucey, *Gide's Bent: Sexuality, Politics, Writing* (Oxford, UK: Oxford UP, 1995); Christopher Lane, *The Ruling Passion: British Colonial Allegory and the Paradox of Homosexual Desire* (Durham, NC: Duke UP, 1995); Jarrod Hayes, *Queer Nations: Marginal Sexualities in the Maghreb* (Chicago: U of Chicago P, 2000); Greg Mullins, *Colonial Affairs: Bowles, Burroughs, and Chester Write Tangier* (Madison, WI: U of Wisconsin P, 2002); and Robert Aldrich, *Colonialism and Homosexuality* (London: Routledge, 2003). From a more anecdotal angle, issues of colonialism and homosexuality figure in Ronald Hyam, *Empire and Sexuality: The British Experience* (Manchester, UK: Manchester UP, 1990) and Derek Hopwood, *Sexual Encounters in the Middle East: The British, The French, and the Arabs* (Reading, UK: Garnet, 1999).

34. See Homi Bhabha's influential essays collected in *Nation and Narration* (New York: Routledge, 1990) and *The Location of Culture* (New York: Routledge, 1994); Ali Behdad, *Belated Travelers: Orientalism in the Age of Colonial Dissolution* (Durham, NC: Duke UP, 1994); Lowe, *Critical Terrains*; Sharpe, *Allegories of Empire*; and Aijas Ahmad, *In Theory: Classes, Nations, Literatures* (London: Verso, 1994).

35. Steve Clark, "Introduction," *Travel Writing and Empire: Postcolonial Theory in Transit*, ed. Steve Clark (London: Zed, 1999), 7.

36. See E. S. Creasy, *History of the Ottoman Turks*, vol. 1 (London: Richard, 1854), 39, 125, 264, respectively.

37. Creasy, *Ottoman Turks*, 364; Varisco, *Reading* Orientalism, 123.

38. A. L. Macfie, *Orientalism* (London: Longman, 2002), 29.

39. Andrews and Kalpakli, *Age of Beloveds*, 65.

40. Sonia P. Anderson, *An English Consul in Turkey: Pasul Rycaut at Smyrna, 1667–1678* (Oxford: Clarendon, 1989), 9.

41. The Ottoman practice of collecting youths from the provinces began in the mid-fifteenth century. See Creasy, *Ottoman Turks*, 161. An interesting counterpoint to Christian sermonizers decrying this corruption of "innocence" occurs in Evilya Çelebi's account of his travels through eastern Europe, as he takes note of the levy of hundreds of smiling Christian boys—the region's "most handsome"—eagerly preparing for their journey to the seraglio for their training. See Evilya Çelebi *Seyahatname* ("Book of Travels"), books 5–8, trans. and ed. Robert Dankoff, and Robert Elsie, ed., *Evliya Çelebi in Albania and Adjacent Regions* (Leiden: Brill, 2006), 225. Charles MacFarlane gives evidence of the custom of impoverished parents from the provinces offering their sons for tribute service up to mid-nineteenth century in *Turkey and Its Destiny*, 2 vols. (London: John Murray, 1850), 1:414.

42. Irwin, *Dangerous Knowledge*, 73.

43. C. J. Heywood and Ezel Kurel Shaw, *English and Continental Views of the Ottoman Empire, 1500–1800* (Los Angeles: Clark Library, 1972), 34; Falkner, "Having It Off," 403.

44. Arjun Appadurai, *Modernity at Large: Cultural Dimensions of Globalization* (Minneapolis: U of Minnesota P, 1996), 4 and passim.

45. Mary Louise Pratt, *Imperial Eyes: Travel Writing and Transculturation* (New York: Routledge, 1992); Clark, *Travel Writing*, 4, 5; Nigel Leask, *Curiosity and the Aesthetics of Travel Writing, 1770–1840: "From an Antique Land"* (Oxford, UK: Oxford UP, 2002), 20–21 and *British Romantic Writings and the East: Anxieties of Empire* (New York: Cambridge UP, 1992), 2; Dennis Porter, *Haunted Journeys: Desire and Transgression in European Travel Writing* (Princeton, NJ: Princeton UP, 1991), 9, 14.

46. Behdad, *Belated Travelers*, 15.

47. The homoeroticism that Europeans found all too visible is precisely what some Middle Eastern travelers to Europe in the same period found startlingly absent. Visiting Paris between 1826 and 1831, Egyptian scholar Rifā'ah al-Tahtāwī remarks on the Franks' striking lack of a predilection for or literature about male youths. Quoted in Khaled El-Rouayheb, *Before Homosexuality in the Arab-Islamic World, 1500–1800* (Chicago: U of Chicago P, 2005), 2.

48. *Veniamus ad deteriora. Totius aetatis et ordinis viros, id est pueros, adolescents, jevenes, sense, nobiles, servos, et, quod pejus et impudentius ets, clericos et monachos*, quoted both in John Boswell, *Christianity, Social Tolerance, and Homosexuality: Gay People in Western Europe from the Beginning of the Christian Era to the Fourteenth Century* (Chicago: U Chicago P, 1980), 279–80, and Norman Daniel, *The Arabs and Medieval Europe* (London: Longman, 1975), 236.

49. This is Michael Uebel's translation from the Latin, in his reading of the economic imperatives of Christian trade in Egypt underlying Guillaume's propaganda in "Reorienting Desire: Writing on Gender Trouble in Fourteenth-Century Egypt," in Sharon Farmer and Carol Brown Pasternack, eds., *Gender and Difference in the Middle Ages* (Minneapolis: U Minnesota P, 2003), 244. His source is *De modo Sarracenos extirpandi*, vol. 2 of *Recueil des historiens des croisades Arméniéns* (Paris, 1841–1906), 524–25.

50. Robert C. Davis, *Christian Slaves, Muslim Masters: White Slavery in the Mediterranean, the Barbary Coast, and Italy, 1500–1800* (New York: Palgrave, 2003), 125, 127. See Diego Haedo, *Topographia e historia general de Argel* (1612), 1:176 and the commentary of Miquel Angel de Bunes Ibarra, *La imagen de los musulmanes y del norte de Africa en la España de los siglos XVI y XVII* (Madrid: Consejo Superior de Investigaciones

Científicas, 1989), 239. Both are quoted in Adrienne L. Martin, "Images of Deviance in Cervantes' Algiers," *Cervantes* 15.2 (1995): 5–15.

51. Everett K. Rowson, "Homoerotic Liaisons among the Mamluk Elite in Late Medieval Egypt and Syria," *Islamicate Sexualities*, 205. Ironically, as noted by Stephen O. Murray, "Male Homosexuality, Inheritance Rules, and the Status of Women in Medieval Egypt: The Case of the Mamluks," in *Islamic Homosexualities: Culture, History, and Literature* (New York: NYU Press, 1997), most of these Christian recruits were "transported to Egypt by Frankish vessels, even when the Mamluks were fighting European crusaders" (171, no. 14)—a reminder of the power of economics to trump moral precepts and religious platitudes. As Norman Daniel states in *The Arabs and Medieval Europe* (London: Longman, 1975), 225, these inflammatory clerical charges of Muslim homosexuality were at root economically motivated attempts to win boycotts against Arab trade that would favor European shipping interests.

52. Everett K. Rowson, "Two Homoerotic Narratives from Mamlūk Literature: al-Safadī's Law'at al-shākī and Ibn Dāniyāl's al-Mutayyam," in *Homoeroticism in Classical Arabic Literature*, ed. J. W. Wright, Jr. and Rowson (New York: Columbia UP, 1997) 161–62.

53. Quotations are from Rowson, "Two Homoerotic Narratives," 163, 171.

54. Rowson, "Two Homoerotic Narratives," 169.

55. Janet Afary, *Sexual Politics in Modern Iran* (Cambridge: Cambridge UP, 2009), 97. See accounts of Mahmud and Ayaz in *Four Discourses*, trans. Edward G. Browne (London: Luzac, 1899), anecdote xiv, 57; Sa'dī, *The Gūlistan or Rose Garden*, trans. John T. Platts (orig. composed 1258; London: Corsby Lockwood and Son, 1904), anecdote 1, 198; and Kai Kā'ūs ibn Iskandar, *A Mirror for Princes, the Qābūs-nāma*, ed. and trans. Reuben Levy (c. 1080; New York: Dutton, 1951), 74–75.

56. The anecdotes in this chapter are broken down statistically in Minoo S. Southgate's useful "Men, Women, and Boys: Love and Sex in the Works of Sa'di," *Iranian Studies* 17.4 (Autumn 1984): 431–33. Another indication of the frequency of homoerotic themes in medieval Arabic literature is the title index of all known works in Arabic produced by the late-tenth-century bibliographer Ibn al-Nadim. See Bayard Dodge, ed. and trans., *The Fihrist of al-Nadim: A Tenth-Century Survey of Muslim Culture*, vol. 1 (New York: Columbia UP, 1970).

57. El-Rouayheb, *Before Homosexuality*, 62–64, decisively puts to rest the claims of conservative Arab literary historians that the gender-ambiguous pronouns of these lyrics refer to female beloveds. He cites as evidence poems set in male homosocial spaces where a female addressee would make no sense, male beloveds addressed by name whose historical identity can be cross-referenced in nonfictional works, and biographical dictionaries mentioning the homoerotic predilections of any number of celebrated poets whom the compilers have no stake in defaming. On the ghazal tradition, see the essays in Angelika Neuwirth, Michael Hess, Judith Pfeiffer, and Borte Sagaster, eds., *Ghazal as World Literature II: From a Literary Genre to a Great Tradition. The Ottoman Gazel in Context* (Wursburg: Ergon Verlag Wurzburg, 2006). John Hindley, first major translator of Persian verse into English, informs his readers that "the disgusting object[s]" of these love poems have been feminized "for reasons too obvious to need any formal apology," in *Persian Lyrics; or, Scattered Poems from the Diwan-i-Hafiz* (London: Harding, 1800), 33.

58. Andrews and Kalpakli, *Age of Beloveds*, 28.

59. Manwaring's account is included in E. Denison Rong, ed., *Sir Anthony Sherley and His Persian Adventure* (London: Routledge, 1933), 186–87. Aside from one use of the epithet "beastly" to describe sodomy, Manwaring's account is relatively non-sensationalizing

in tone. The Spanish term *berdache* was derived from Persian by the way of Arabic and applied by New World writers to transgendered North African Indians.

60. George Sandys, *Travels, Containing an History of the Original and Present State of the Turkish Empire* (1615; 7th ed. London: 1673), 32; Pedro Teixeira, *The Travels of Pedro Teixeira*, trans. William F. Sinclair (London: Hakluyt Society, Series 2.9, 1902), 62.

61. Sir John Chardin, *Travels in Persia*, ed. Sir Percy Sykes (orig. English translation 1720; rpt. London: Argonaut, 1927), 241–42.

62. Ibrāhīm Peçevi, *Tarih-i Peçevi*, 2 vols. (Istanbul, 1864–1867), 1:363. Quoted in Bernard Lewis, *Istanbul and the Civilization of the Ottoman Empire* (Norman, OK: U of Oklahoma P, 1963), 132–33. For a history of the coffeehouse and their reputation as sites of homosexual debauchery, see Ralph Hattox, *Coffee and Coffeehouses: The Origins of a Social Beverage in the Medieval Near East* (Seattle, WA: U of Washington P, 1985), 78–109.

63. The Ottoman title is "Mevā'idü'n-Nefā'is fī Kavā'idi'l-Mecālis." Disappointed in his own lackluster administrative career and failure to receive desired promotion, Mustafa Âli used his barbed wit to satirize what he saw as the decline of civility and rise of corruption in Ottoman society; among other trends, he lampoons the sexual profligacy of his times. His translator and editor, Douglas S. Brookes, cautions against taking his sometimes strong language about the impropriety of "sexual[ly] cavorting with beardless youths" as a denunciation of the sodomitical practices he himself indulged in freely in his younger days: "in terms of sexual morality, his point is that the proper gentleman will carry out his activities in private and with extreme discretion." See Âli, *Tables of Delicacies*, xiv. Âli's life, homoerotic proclivities, and contradictory statements are documented in Cornell H. Fleischer, *Bureaucrat and Intellectual in the Ottoman Empire: The Historian Mustafa Âli (1541–1600)* (Princeton, NJ: Princeton UP, 1986). For additional information on Âli's biography and works, see Jan Schmidt, *The Joys of Philology: Studies in Ottoman Literature, History and Orientalism (1500–1923): Volume 1: Poetry, Historiography, Biography and Autobiography* (Istanbul: Isis P, 2002), 123–43.

64. Âli, chap. 73, "Wine Taverns," *Tables of Delicacies*, 131–32. I have altered a few words of Brookes's translation to accord with that provided in Andrews and Kalpakli, *Age of Beloveds*, 140–42.

65. Quoted in Andrews and Kalpakli, *Age of Beloveds*, 283.

66. See the collection of documents dealing with guild relationships in the seventeenth century, later published by Mahmūd 'Ali 'Ata 'Allah, *Wathā'iq al-tawa'if al-hirafiyya fi'l-quds fil'-qam al-sabi ashar* (Nablus, 1992), 2:146–47; quoted in Amnon Cohen, *The Guilds of Ottoman Jerusalem* (Leiden: Brill, 2001), 55. Yaron Ben-Naeh gives an illuminating example of a similar incident in Ottoman Damascus of the eighteenth century, in "Moshko the Jew and his Gay Friends: Same-Sex Sexual Relations in Ottoman Jewish Society," *Journal of Early Modern History* 9 (2005): 84.

67. Such wishful projection sometimes colors Marc Daniel's "Arab Civilization and Male Love" (orig. 1975–1976), rpt. *Gay Roots: Twenty Years of Gay Sunshine: An Anthology of Gay History, Sex, Politics, and Culture*, ed. Winston Leyland (San Francisco: Gay Sunshine, 1991). It also typifies several contributors to Arno Schmitt and Jehoeda Sofer, eds., *Sexuality and Eroticism Among Males in Moslem Societies* (New York: Harrington Park P, 1992).

68. By the beginning of the seventeenth century, travelers' narratives make it clear that wine taverns and raki shops have resurfaced as sites of homoerotic debauchery. See Monsieur Joseph Pitton de Tournefort, *A Voyage into the Levant, Perform'd by the Command of the Late French King*, 3 vols. (1701; trans. John Ozell, London, 1741) 1:192; and MacFarlane, *Turkey and Its Destiny* 1:432–44.

69. William Lithgow, *The Totall Discourse, of the rare adventures, and painful peregrinations of long nineteene years travayles* (1632; London, 1640), 14. Subsequent page numbers are included in parentheses in the text.

70. Âli, chap. 8, "Beardless Boys," *Tables of Delicacies*, 29–30.

71. Michael Baudier, *Histoire générale du Serrail, et de la cour du Grand Seigneur*, trans. E.G.S.A. [Edward Grimeston, Sargent at Arms] (1626: London, 1636), 1. Subsequent page numbers are included in parentheses in the text.

72. Falkner, "Having It Off," 425.

73. Aaron Hill, *A Full Account of the Present State of the Ottoman Empire in All Its Branches* (1709), 81; emphases added. Subsequent page numbers are included in parentheses in the text.

74. Evliya Çelebi, *Seyahatname* in Dannoff, ed., 182–83, 213.

75. Charles Thompson, *The Travels of Charles Thompson*, 2 vols. (London, 1744) lifts entire passages from Paul Ricaut (see chap. 3).

76. James Silk Buckingham, *Travels in Mesopotamia* (London: Colburn, 1827) and *Travels in Assyria, Media, and Persia* (London: Colburn, 1829). Subsequent page numbers are included in parentheses in the text.

77. This is the reading that Stephen O. Murray gives the passage in "Some Nineteenth-Century Reports of Islamic Homosexualities," in *Islamic Homosexualities*, 204–8. Although I disagree with Murray's assessment, I am grateful to his essay for first bringing Buckingham's narrative to my attention.

78. Buckingham's political radicalization as the result of his travels began with his sojourn in India in the mid-1820s. His denunciation of the practices of the East India Company led to his expulsion by the colonial authorities, whereupon he undertook the Middle Eastern travels that resulted in this volume. Thanks to Mary Ellis Gibson for this insight.

79. Henry Blount, *A Voyage into the Levant* (1636; London: Theatrum Orbis Terrarum, 1977); quotations are from pp. 61, 3, and 2 respectively. In Gerald M. MacLean, *The Rise of Oriental Travel: English Visitors to the Ottoman Empire, 1580–1720* (New York: Palgrave, 2004), MacLean notes the occasions on which Blount uses homosexuality to turn a question of moral "vice" into one of cultural difference (150).

80. Horatio Southgate, *Narrative of a Tour Through Armenia, Kurdistan, Persia and Mesopotamia: With Observations upon the Condition of Muhammadanism and Christianity in Those Countries*, 2 vol. (London, 1840), 2:200.

81. Evliya Çelebi, *Çelebi in Albania*, 85; emphasis added.

82. Monsieur [Jean] de Thevenot, *The Travels of Monsieur de Thevenot into the Levant. In Three Parts*, trans. from the French (London: H. Clark, 1686), 1:252. Lord Charlemont [James Caulfeild], *The Travels of Lord Charlemont in Greece and Turkey 1749*, ed. W. B. Stanford and E. J. Finopoulos (1749; West Africa House, 1984), agrees: "the gratification of the sensual appetites seems to be the sole object of their wishes" (196). The same stereotype dominates C.S. Sonnini's perceptions of Levantine sexuality, in Henry Hunter, trans. from the French, *Travels in Upper and Lower Egypt*, 3 vols. (1798; London, 1807), where he claims all "sensual transports" are "merely paroxysms of brutality" (1:251–52).

83. C. F. Volney, *Voyage en Egypte et en Syrie*, ed. Jean Gaulmier (rpt. Paris: Moutin, 1959) 108; trans., *Travels through Syria and Egypt, in the Years 1783, 1784, and 1785* (Dublin, 1793), 115.

84. Blount, *Voyage*, 14.

85. De Thevenot, *Travels*, 56–57. Similarly, the Earl of Sandwich, in *A Voyage Performed by the Late Earl of Sandwich Round the Mediterranean in the Years 1738 and 1739*,

Written by Himself (London, 1794), sympathizes with the plight of harem wives whose husbands "have other delights to which they are so entirely addicted, that you find few amongst them, the great especially, who do not prefer the company of a Ganymede to that of a Venus" (157–58).

86. Abdelwahab Bouhdiba, *Sexuality in Islam*, trans. Alan Sheridan (London: Routledge, 1985), 126, comments on the tradition of temporary marriage.

87. Charlemont, *Travels*, 202.

88. The theory that overindulgence in women turns Turks to sodomy also occurs in a number of early twentieth-century ethnopornographers, including "Doctor" Pinhas ben Nahum, *The Turkish Art of Love* ["Privately Printed . . . for private collectors of erotica"] (New York: Panurge P, 1933), 87, and Iwan Bloch, *Anthropological Studies in the Strange Sexual Practices of All Races in All Ages*, trans. Keane Wallis (Privately Printed; New York: Anthropological Press, 1933).

89. Bouhdiba, *Sexuality in Islam*, 86, 124, 156–57, and passim. Although uneven, Bouhdiba's work was the first modern scholarly work by an Arab to speak so frankly of Arab-Muslim sexuality in all its forms. See critiques of Bouhdiba in Ze'evi, *Producing Desire*, 3–4, and Massad, *Desiring Arabs*, 144–48.

90. Daniel, *Arabs*, 42.

91. Daniel seems to be paraphrasing Sir Richard Burton, who refers to Muhammad's "philosophical indifference" in regard to pederasty. See Burton, "Terminal Essay," *The Book of the Thousand Nights and a Night: A Plain and Literal Translation of the Arabian Nights Entertainments*, trans. and ed. Sir Richard Burton, 10 vol. (London: Burton Club, 1885–1886) 10:194.

92. Jehoeda Sofer, "Sodomy in the Law of Muslim States," in Schmitt and Sofer, eds., *Sexuality and Eroticism*, 132; Daniel, *Arabs*, 40; Louis Crompton, *Homosexuality and Civilization* (Cambridge, MA: Belknap, 2003), 162. Crompton also notes the extension of forgiveness to repenting sinners in the Qur'an: "And as for the two of you [men] who are guilty thereof, punish them both. And if they repent and improve, let them be. Lo! Allah is Relenting, Merciful" (162).

93. Quoted in El-Rouayheb, *Before Homosexuality*, 16.

94. Ahmad bin Qāsim, *Nasir al-Deen 'ala Qawm al-Kafireen*, trans. N. J. Dawood, *The Koran* (Penguin Books, 1990), 50–52.

95. El-Rouayheb, *Before Homosexuality*, 118–123; Afary, *Sexual Politics*, 82–83; Andrews and Kalpakli, *Age of Beloveds*, 272 and ch. 9: "Love, Law, and Religion." Ze'evi gives an excellent overview of the various schools in ch. 2: "Regulating Desire."

96. Andrews and Kalpakli, *Age of Beloveds*, 280–81.

97. Moshe Sluhovsky notes, in conversation, that pre-modern European society also operated in a similar fashion, overlooking infractions, including sexual-moral ones, in order to keep social harmony and peace; the difference is the public openness of much homoerotic display in Middle Eastern cultures.

98. See Michel Foucault's similar arguments on Hellenic pederasty in *The Use of Pleasure*, vol. 2 of *The History of Sexuality*, trans. Robert Hurley (New York: Vintage, 1985), 191.

99. El-Rouayheb, *Before Homosexuality*, 25.

100. "The art of liwāt is the way of masculinity," the poet Rūmī wrote. Quoted in El-Rouayheb, *Before Homosexuality*, 21.

101. Also known as *ibne* and *ma'bun*. See Ze'evi, *Producing Desire*, 35–36.

102. Al-Kassim, "Sexual Epistemologies," 302.

103. Najmabadi, quoted in Al-Kassim, "Sexual Epistemologies," 315.

2. BEAUTIFUL BOYS, SODOMY, AND *HAMAMS*: A TEXTUAL AND VISUAL HISTORY OF TROPES

1. Edward Said, "Opponents, Audiences, Constituencies, and Community," *The Anti-Aesthetic: Essays on Postmodern Culture*, ed. Hal Forster (Port Townsend, WA: Bay P, 1983), 157.

2. Carolyn Dinshaw, *Getting Medieval: Sexualities and Communities, Pre- and Postmodern* (Durham, NC: Duke UP, 1999), pp. 1–20; and "Got Medieval?" *Journal of the History of Sexuality* 10.2 (April 2001): 212. See also the dismantling of linear temporalities from queer theoretical perspectives in Lee Edelman, *No Future: Queer Theory and the Death Drive* (Durham: Duke UP, 2004), and Elizabeth Freeman, *Time Binds: Queer Temporalities, Queer Histories* (Durham, NC: Duke UP, 2010).

3. İrwin Cemil Schick, *The Erotic Margin: Sexuality and Spatiality in Alternist Discourse* (London: Verso, 1999), 109.

4. Khaled El-Rouayheb, *Before Homosexuality in the Arab-Islamic World, 1500–1800* (Chicago: U of Chicago P, 2005), 11.

5. Edward Said, *Orientalism* (New York: Vintage, 1978), p. 188. See also Linda Nochin, "The Imaginary Orient," orig. 1983; rpt. in Vanessa R. Schwartz and Jeannene M. Przyblyski, *The Nineteenth-Century Visual Studies Reader* (New York: Routledge, 2004), 289–98; Tom Hastings, "Said's Orientalism and the Discourse of (Hetero) sexuality," *Canadian Review of American Studies* 23.1 (Fall 1992): 127–47; Daniel Varisco, *Reading Orientalism: Said and the Unsaid* (Seattle: U of Washington P, 2007), 24–25, 167; and J. W. Wright Jr., "Masculine Allusion and the Structure of Satire in Early 'Abbasid Poetry," *Homoeroticism in Classical Arabic Literature*, ed. J. W. Wright, Jr. and Everett K. Rowson (New York: Columbia UP, 1997), 17, n. 4.

6. For the specific form and development of the Arabic ghazal, see Robert Irwin, *Night and Horses and the Desert: An Anthology of Classical Arabic Literature* (Woodstock, NY: Overlook, 2000), 42–56 and 122. In "The Arabic Ghazal: Formal and Thematic Aspects of a Problematic Genre," in *Ghazal as World Literature II: From a Literary Genre to a Great Tradition: The Ottoman Gazel in Context*, ed. Angelika Neuwirth, Michael Hess, Judith Pfeiffer, and Borte Sagaster (Wurzburg: Ergon Verlag, 2006), 4–9. Thomas Bauer notes that by the ninth and tenth centuries the beloved is "almost certainly a male youth," as distinct from traditional *nasib* love poetry where the beloved is a girl. The Arabic ghazal was typically 5–12 lines, the Persian 7–14 lines, with a specific rhyme scheme and the author's penname, or *takhallus*, embedded as wordplay in the final line; the intent was less to create an original expression than to evoke emotions the audience would recognize and respond to through the manipulation and extension of a standard repertoire of images and situations. Franklin Lewis, "The Transformation of the Persian Ghazal: From Amatory Mood to Fixed Form," in *Ghazal as World Literature*, explains the evolution of the Persian ghazal from the Arabic original (127).

7. Monsieur [Jean] de Thevenot, *The Travels of Monsieur de Thevenot into the Levant. In Three Parts*, trans. from the French (London: H. Clark, 1686), 60.

8. El-Rouayheb, *Before Homosexuality*, is good on this point, 77.

9. Quoted in Ahmad al-Tīfāshī, *The Delight of Hearts, or What You Will Not Find in Any Book (Nazhat al-albab fī-ma la yujad fī kitab)*, ed. Winston Leyland and trans. Edward A. Lacey (San Francisco: Gay Sunshine P, 1988), 60. For more examples of Abu Nuwas's extensive homoerotic poetry translated into English, see *The Diwan of*

Abu al Hasan ibn Hani al Hakami, translated from the recension of Abu Bakr al Suli (d. 946 A.D), trans. Arthur Wormhoudt (Oskaloosa, IA: William Penn College, 1974).

10. Abu Nuwas, "The City Life for Me!" *Carousing with Gazelles: Homoerotic Songs of Old Baghdad,* trans. Jaafar Abu Tarab (New York: iUniverse, 2005), 9.

11. On the rise of the genre in its Persian form, and its relation to the prior tradition of rubbiyat written about youthful craftsmen, see Sunil Sharma, "Generic Innovations in Sayfī Buhārā-ī's Shahrashub Ghazals," in *Ghazals as World Literature,* 141–144. Noting that the şehrengiz had been popular in the Ottoman world since the poet Meshi (d. 1513), Jan Schmidt, *The Joys of Philology: Studies in Ottoman Literature, History and Orientalism (1500–1923): Volume 1: Poetry, Historiography, Biography and Autobiography* (Istanbul: Isis P, 2002), points out that a central artistic amusement of such poetry was "the invention of puns on the names of the boys" (36) being celebrated within the verse's metaphors and language, and that by the nineteenth-century, the format was "regularly suppressed by the Ottoman censor" for its homo-erotic content (38).

12. Quoted in Selim S. Kuru, "Naming the Beloved in Ottoman Turkish Gazel: The Case of İshak Çelebi (d. 1537/8)," in *Ghazals as World Literature,* 170.

13. I examine the *Huban-name* at length in chapter 6. This cataloguing tendency reaches its apogee in the widely read Persian memoir of 1872, *Risalah-i fujuriyah* ("An Essay on Debauchery") in which Vali Khan Gurjistani recounts his sexual adventures with 28 Qajar princesses, 65 male and 15 female prostitutes, and 27 male and 18 female servants! See Afsaneh Najmabadi, *Women with Moustaches and Men Without Beards: Gender and Sexual Anxieties of Iranian Modernity* (Berkeley: U of California P, 2005), 23.

14. Quoted in Schmidt, *Joys of Philology,* 29, n.1.

15. *Nine Essays of al-Jahiz,* trans. William M. Hutchins (New York: Lang, 1988), pp. 139–66. The Arabic title is *Kitāb Mufākharat al-jawārī wa-l-ghilmān.* See Franz Rosenthal, "Male and Female, Described and Compared," *Homoeroticism in Classical Arabic Literature,* 25.

16. *Jannat al-wildān fī l-hisān min al-ghilmān* and *al-Kunnas al-jawārī fī l-hisān min al-jawārī.* Cited in Rosenthal, "Male and Female," 33. Other variations on this format include twelfth-century Abū l-Hasan 'Alī b. Nasr al-Kātib's debate between the *lūtī,* the advocate of boy-love, and the *zānī,* the advocate of heterosexuality, in *Jawāmi' al-ladhdha* ("Synopsis of All That Is Known About Pleasure"), cited in Rosenthal, "Male and Female," 25; thirteenth-century Mamluk al-'Adilī's twin anthologies "Thousand and One Boys" and "Thousand and One Girls," cited in Everett K. Rowson, "Two Homoerotic Narratives from Mamlūk Literature: al-Safadī's Law'at al-shākī and Ibn Dāniyāl's al-Mutayyam," in *Homoeroticism in Classical Arabic Literature,* 160; and "The Man's Dispute with the Learned Woman on the Relative Excellence of the Sexes" in *Thousand Nights and a Night.* See Tale 94 in Sir Richard Burton, *The Book of the Thousand Nights and a Night: A Plain and Literal Translation of the Arabian Nights Entertainments,* trans. and ed. Sir Richard Burton, 10 vols. (London: Burton Club, 1885–1886), 5:154.

17. *Al-Husn al-sarīh fī mi'at malīh.* Cited in Rowson, "Two Homoerotic Narratives," 161.

18. Mustafa Âli, *Tables of Delicacies Concerning the Rules of Social Gatherings,* trans. Douglas S. Brookes (Cambridge, MA: Harvard U Department of Near Eastern Languages and Civilization, 2003), 29–30.

19. Evliya Çelebi, *Seyahatname* ("Book of Travels"), books 5–8, trans. and ed. Robert Dankoff, and Robert Elsie, ed., *Evliya Çelebi in Albania and Adjacent Regions* (Leiden:

Brill, 2006), 47–49. For an account of the life and travels of Evliya, see Robert Dankoff, *An Ottoman Mentality: The World of Evliya Çelebi* (Leiden: Brill, 2004). He remained (atypically) single and unmarried his entire life; his travels took place over a forty-year period. As Dankoff notes, 118–120, although the writer remains appropriately discreet about his actual sexual relations, his volumes are rife with witty homoerotic anecdotes and banter.

20. Evliya Çelebi, *Çelebi in Albania*, 119.

21. Klaus Kreiser, ed.; trans., commentary, and intro. Martin Van Bruinssen and Hendrik Boeschoter, *Evliya Çelebi in Diyarbeber: The Relevant Sections of the Seyahatname* (Leiden: Brill, 1988), 156–57; emphasis added.

22. Thomas Herbert, *Travels in Persia, 1627–1629*, ed. Sir William Foster (London: Routledge, 1938), 249.

23. A. Roberts, *The Adventures of (Mr. T.S.), An English Merchant, Taken Prisoner by the Turks of Argiers* (1670), 29 and 34.

24. Adolphus Slade, *Records of Travels in Turkey, Greece, Etc. . . . in the Years 1829, 1830, and 1831*. 2 vols. (London, 1833), 2:288, 2:33. 2:432, 1:24, 1:231; the smoking reference is on 2:168.

25. See Louis Crompton, *Byron and Greek Love: Homophobia in 19th-Century England* (Berkeley: U of California P, 1985), 148–49 and 137–38. The illustrations are in Louis Dupré, *Voyage à Athènes et à Constantinople* (Paris, 1825).

26. Richard Knolles, *The Generall Historie of the Turkes* (London, 1603), 363.

27. [Jean] Dumont (Sieur du Mont), *A New Voyage to the Levant, translated into English* (London, 1696), 278; Slade, *Records of Travels*, 1:231. Other examples are given in Charles MacFarlane, *Turkey and Its Destiny*, 2 vols. (London: John Murray, 1850) 2:165, and Michel Baudier, *Histoire générale du Serrail, et de la cour du Grand Seigneur*, trans. E.G.S.A. [Edward Grimeston, Sargent at Arms] (1626: London, 1636), 170.

28. Walter G. Andrews and Mehmet Kalpakli, *The Age of Beloveds: Love and the Beloved in Early-Modern Ottoman and European Culture and Society* (Durham, NC: Duke UP, 2005), 52.

29. Âli, *Tables of Delicacies* , 128.

30. "The beauty of a male slave enhances the value as much as it does that of a female, occasioned by the frequency among them of a crime not to be named," writes C[arl]. B[enjamin]. Klunzinger, *Upper Egypt: Its People and Its Products* (London: Blackie and Son, 1878), 35. Slade concurs in *Records of Travels*: "Boys fetch a much higher price (than the women), for evident reasons" (2:243), and MacFarlane in *Turkey and its Destiny* notes the slave trade continues despite being ostensibly banned in the 1860s, with "Boys now and then fetching still higher prices" than even beautiful Circassian women (2:417). See also Alexander Russell, *National History of Aleppo and Parts Adjacent* (1756; rpt. London: A Miller, 1856), 113.

31. P. Bossu, letter of August 9, 1749, quoted in Robert C. Davis, *Christian Slaves, Muslim Masters: White Slavery in the Mediterranean, the Barbary Coast, and Italy, 1500-1800* (New York: Palgrave, 2003), 125.

32. Quoted in Rowson, "Two Homoerotic Narratives," 175. Rowson notes that this racially marked preference marks a shift from classical Arab poetry to a poetic ideal in the Mamluk era that "celebrate[s] the beauty of Turkish boys, sometimes explicitly to the disadvantage of Arabs" (167).

33. Muhammad al-Nawaji, *La Prairie des Gazelles*, trans. Rene R. Khawam (Paris: Phebus, 1989), quoted on the website *World History of Male Love*, "Gay Poetry," *The Meadow of the Gazelles*, 2002.

34. "Franks" is the generic Ottoman term for all Europeans. Lâtifî, *Éloge d'Istanbul suivi du Traité de l'invective (anonyme)*, trans. into French by Stéphane Yerasimos (Paris: Sindbad, 2001), 97, 115–16; I follow Andrews and Kalpakli's translation, 34, 64. Revani is quoted in Andrews and Kalpakli, *Age of Beloveds*, 65.

35. See Louis Crompton, *Homosexuality and Civilization* (Cambridge, MA: Belknap, 2003), 162. On Jewish poets in Spain writing "Arab-style" love poetry to young men, see Norman Roth's "'Deal gently with the young man': Love of Boys in Medieval Hebrew Poetry of Spain," *Speculum* 57.1 (January 1982): 20–51. Andulasian poet Ibn Sahl wittily writes of leaving a Jewish lover (Moses) for a Muslim favorite (Muhammad) in a poem quoted by Wright, "Masculine Allusion," 10.

36. Metin And, *A Pictorial History of Turkish Dancing* (Ankara: Dost Yayinlari, 1976), 139–40.

37. Likewise, European travelers comment on the wide-ranging tastes of boy-lovers in the larger Arabic world. A passenger on an English merchant vessel captured by Algerian corsairs in the 1660s is surprised that the king takes as a portion of the spoils "a pretty German Boy of ruddy Countenance," until he learns that the "good old man" is moved by the same "unnatural" flames that "consumed Sodom and Gomorrah." See Roberts, *Adventures*, 29. The journal kept by the English consul in Tripoli during the 1670s records the fate befalling a Dutchman's son, "a Brisk young Fellows of the Towne" who is followed into a tavern by two Turks who rape him, the ruckus of which draws 34 more soldiers who "successively were as kind to [the Dutch lad] as the other Two Turks had been." C. R. Pennell, ed., *Piracy and Diplomacy in Seventeenth Century North Africa: The Journal of Thomas Baker, English Consul in Tripoli, 1677–1685* (Rutherford, NJ: Fairleigh Dickinson UP, 1989), 161.

38. The poem can be found online at http://www.fordham.edu/halsall/pwh/donleon.asp.

39. Najmabadi, *Women with Moustaches*, 16. Najmabadi perceptively makes the same point about the Persian tradition of the *mukhannos* or *ubnah*, the passive adult male desiring to be the object of other men's desires, arguing that "there is no reason to assume that these men want to appear female. Perhaps they simply wish to look like beardless male adolescents."

40. J[ohn]. A[ugustus]. St. John, *Egypt and Nubia: Their Scenery and Their People* (1844; London, 1856), 119.

41. Wilfred Thesiger, *Arabian Sands* (1959; London: Penguin, 1964), 188; emphasis added. An ambiguous relationship between Thesiger's sublimated homosexuality, his sometimes almost coy references to his intimacy with these boys, and his disclaimers of Bedouin homosexuality runs throughout his writings. See Richard Asher, *Wilfred Thesiger: A Biography* (London, 1994), 323–34.

42. Sa'dī, untitled poem, lines 3–4, in Paul Sprachman, trans. and ed., *Suppressed Persian: An Anthology of Forbidden Literature* (Costa Mesa, CA: Mazda P, 1995), 40. Janet Afary in *Sexual Politics in Modern Iran* (Cambridge: Cambridge UP, 2009) observes that in Persia strongmen (*luti*), like wrestlers, were known for their homosexual practices and "their prowess, often shun[ning] marriage as sapping away their vitality" (90).

43. Abu Nuwas in al-Tīfāshī, 61. Al-Mu'tazz, quoted in Bauer, "The Arabic Ghazal," *Ghazal as World Literature*, 9–10.

44. Pietro Della Valle, *The Pilgrim: The Travels of Pietro Della Valle*, trans. George Bull (1658; London: Hutchinson, 1989), 21.

45. Charles MacFarlane, *Turkey and Its Destiny*, 2:30.

46. Mustafa Âli, *Counsel for Sultans*, trans. and ed. Andreas Tietze, 2 vols. (Vienna: Akademie der Wissenschaften, 1979), 2:66.

47. Quoted in El-Rouayheb, *Before Homosexuality*, 72; 'al-Sa'dīqi died in 1680/1681. El-Rouayheb surveys the literature debating the relative merits of downy and smooth-cheeked lads on pp. 68–74. In an elegy for his boon companion Musa, the traveler Evliya Çelebi defends the younger man's beard in clever verse:

> His weapon is perfect beauty . . .
> "What do you say of my cheek," he asked, "with its newly sprouted down?"
> "That cheek is very fine [*güzel*], and the jasmine-scented down is very fine."
> Quoted in Dankoff, *Ottoman Mentality*, 40.

48. The former is Riza scholar Sheila Canby's opinion, which she bases on the convention of the always smooth-cheeked wine bearer, in an e-mail exchange dated June 12, 2012. But even if this anomaly is just a fashion trend, its simulation of facial hair shows the artist's willingness to play with the idea of an attractive youth sporting a beard.

49. St. John, *Egypt and Nubia*, 22.

50. William Burroughs, *Interzone* (New York: Viking, 1989), 94; Joe Orton, *The Orton Diaries*, ed. John Lahr (New York: Perennial-Harper, 1986), 158, 161.

51. Angus Stewart, *Tangier: A Writer's Notebook* (London: Hutchinson, 1977), 99, 112, 225. The passive-aggressive actions of Meti, who enters Stewart's service at the age of 11 and stays for four years, bespeak a history of sexual-colonial politics worth analyzing in depth. Another memoir detailing pederastic affairs in Morocco is Michael Davidson's *The World, the Flesh, and Myself* (1962; rpt. London: Gay Modern Classics, 1985); these themes are fictionalized in Robin Maugham's Moroccan novel, *The Wrong People* (1964; New York: McGraw-Hill, 1971), published under the pseudonym David Griffin.

52. Orton, *Diaries*, 160, 185, 260.

53. Rudolf Lehnert, *L'album des nus masculins* (1905–1931), ed. Nicole Canet (Paris: Galerie au Bonheur du Jour, 2008), photocopy of letter to Renaud Icard, May 26, 1932, 35–36; my translation.

54. Arno Schmitt, "Differential Approaches to Male-Male Sexuality/Eroticism from Morocco to Usbekistan," *Sexuality and Eroticism Among Males in Moslem Societies*, 5. A more nuanced account of the prevalence of a penetrative model of age-segregated sodomy appears in El-Rouayheb, *Before Homosexuality*, chap. 1: "Pederasts and Pathics."

55. Dina Al-Kassim, "Epilogue: Sexual Epistemologies, East in West," *Islamicate Sexualities: Translations Across Temporal Geographies of Desire*, ed. Kathryn Babayan and Afsaneh Najmabadi (Cambridge, MA: Center for Middle Eastern Studies/Harvard UP, 2008), 301. See also Robert Aldrich, *The Seduction of the Mediterranean: Writing, Art, and Homosexual Fantasy* (New York: Routledge, 1993).

56. Najmabadi, *Moustaches*, 16; Al-Kassim, "Epilogue," 301.

57. Abu Nuwas, cited in Muhammad Nafzawi's erotic anthology *The Glory of the Perfumed Garden* (c. 1410; rpt. London: Neville Spearman, 1975), 9.

58. Suzani (d. 1166–1173), quoted in Sprachman, *Suppressed Persian*, 24.

59. On the *ubnah*, see Dror Ze'evi, *Producing Desire: Changing Sexual Discourse in the Ottoman Middle East, 1500–1900* (Berkeley: U of California P, 2006), 38–39. The ninth-century poet Jahshawayh's gleeful proclamations of his joy in being penetrated by his youthful partner form a counter to claims that no adults admitted to such pleasures without shame; see excerpts from Jahshawayh in Abu l-Hasan

440 ❖ 2. BEAUTIFUL BOYS, SODOMY, AND *HAMAMS*

'Ali ibn Nasr al-Kātib, *Encyclopedia of Pleasure*, ed. Salah Addin Hawwam (Aleppo: Aleppo P, 1977), 62.

60. Al-Tīfāshī, *The Delight of Hearts*, 132.

61. I commissioned these translations from Fatih Kursun; the first quotation refers to Kalyoncu Süleyman, the pride of Hasan Ağa's hamam, a "fierce and brawny fucker" who can "spew" as many as five times in a session, but who, on occasion, is willing to bottom; and the second to Peremeci Benli Kara Davud, whose seduction techniques are detailed step-by-step.

62. In Egyptian temple cult worship, the shaking of the sistrum was associated with sexual arousal, as noted by David O'Connor, "Eros in Egypt," *Archaeology Odyssey* (September–October 2001), 5; Sufis were said to enhance their rituals with acolytes with percussive instruments: hence, the sardonic verse of Meccan judge Ahmad al-Murshidī, "The Sufis of the age and time . . . have outdone the people of Lot by adding the beating of drums to fornication." Quoted in El-Rouayheb, *Before Homosexuality*, 37.

63. Afary, *Sexual Politics*, 95–99. Afary suggestively argues that a model of more reciprocal homoeroticism occurs in Sufi mystical verse, rites, and life stories. Although the relation of disciple to master is initially hierarchical, the goal of the disciple is to reach the point where he becomes a master himself, and thus simultaneously becomes "the lover and beloved" (96).

64. Al-Tīfāshī, *Delight*, 84. Stephen O. Murray in "The Will Not to Know: Islamic Accommodations of Male Homosexuality," *Islamic Homosexualities: Culture, History, and Literature*, ed. Stephen O. Murray and Will Roscoe (New York: New York UP, 1997), 21–23, also cites the passage from al-Tīfāshī, noting the gap between idealized descriptions (of properly pederastic relations) and what taste and daily behavior dictate.

65. Al-Tīfāshī, *Delight*, 92. See also a similar sentiment expressed in Abu Nuwas's couplet on Muhammad Ibn Harun, sixth Abbasid Caliph, in al-Katib's *Encyclopedia of Pleasure*: "The pleasure of life lies in being both an active / And a passive sodomite and in practicing sexual union with him who does it to you" (171).

66. Ze'evi, *Producing Desire*, 67, 55, 60; see also Andrews and Kalpakli, *Age of Beloveds*, 16–17, 90, 274, 281.

67. I have silently regularized all spellings to "hamam"—variantly translated "hamman," "haman," and "hammam."

68. Representative Western male fantasies of lesbianism in the female hamam include Ogier G. de Busbecq, *The Four Epistles of A. G. Busbequius, Concerning His Embassy into Turkey* (London, 1694), 181; George Sandys, *Travels, Containing an History of the Original and Present State of the Turkish Empire* (1615; 7th ed. London: 1673), 54; and Baudier, *Histoire générale*, 167. The latter fictionalizes a seduction scene, complete with dialogue, in the female hamam. Mary Wortley Montagu famously comments on her experience of the female baths during her 1716 residency in Istanbul in *The Turkish Embassy Letters*, intro. Anita Desai, ed. Malcolm Jack (1763; London: Virago, 1996), letter 27, 57–60.

69. Contrary to many Western fantasies assuming that nudity in the male hamam creates a voyeur's paradise, a pestemal or waist-towel was worn throughout the entire experience, due to the religious taboo on displaying nudity below the navel (nudity seems more casual in the female bath). A more realistic note is sounded in Charles Thompson, *The Travels of Charles Thompson*, 2 vols. (London, 1744), 2:41; and de Thevenot, *Travels*, 31.

70. Abdelwahab Bouhdiba, *Sexuality in Islam*, trans. Alan Sheridan (London: Routledge, 1985), 167–68, 171, 165. Indeed, the expression "going to the hamam," according to Bouhdiba, has come to mean "making love" in many Arab countries, and it is no coincidence that English eighteenth-century brothels were often called bagnios. In *Turkish Baths: A Guide to the Historic Turkish Baths of Istanbul* (Istanbul: Citlembik 2005), 30, Orhan Yilmazkaya reviews all the uses of sexual slang that draw on bath metaphors, noting, like Bouhdiba, that "bath boy" has become slang for homosexual.

71. M. [Louis de] Chenier, *The Present State of the Empire of Morocco*, trans. from the French, 2. vols. (London, 1788), 1:73; Byron, Letter to John Murray, August 12, 1819, *Byron's Letters and Journals*, ed. Leslie A. Marchand, 12 vols. (Cambridge, MA: Harvard UP, 1973–1982), 6:207.

72. See text at note 61 for more translated passages from the *Dellak-name*; Orhan Yilmazkaya also translates some of the descriptions in *Turkish Baths*, 54–55. Explaining the Ottoman tradition of *hammamiye* poetry, usually written in fifteen rhyming couplets and dedicated to the joys of the hamam, that proliferated from the sixteenth century onward, Yilmazkaya notes the homoerotic elements in an anonymous epic written about the dellaks of the Şengül Bath, Tosyali Aşik Mustafa's nineteenth-century 150-couplet bath epic, and Aşik (Bard) Veysel's twenty-couplet poem on the boys of the Grand Bath of üsküdar. Most Ottoman baths were staffed by Albanians until a 1734–1735 decree outlawed their presence after an Albanian revolution. From the eighteenth century on, janissaries increasingly supplemented their income by working as dellaks. Until the 1908 constitution most dellaks, aged 13–14, lived and ate in the hamam; they received no wages but tips. Reform legislation in 1908 stipulated they be at least 21, undergo medical examinations every two months, and not be prostitutes. See Reşat Ekrem Koçu, *İstanbul Ansiklopedisi* (İstanbul: İstanbul Yayinevi, 1966), 8:4362ff.

73. El-Rouayheb, *Before Homosexuality*, 42–43.

74. This ghazal is quoted in full in Gabriele Mandel, *Oriental Erotica*, trans. Evelyn Rossiter (New York: Crescent Books, 1983), 79.

75. Iraqi poet Jirjis al-Adīb transforms the male hamam into a site of explicit sexual fantasy as the speaker imagines seeing the beloved "without clothes!":

> The body is visible, and the protrusion of the buttocks, and you may even catch a
> glimpse of him with the loincloth off.
> And maybe one night [he'll] agree to drink wine with you and to spend the night in sweet conversation.
> . . . Only a knower knows.
>
> <div align="right">Quoted in El-Rouayheb, Before Homosexuality, 69.</div>

Poets often use metaphors drawn from the baths to express homoerotic desire, as when Mustapha Âli laments, "Until a silver-bodied fair one enters my embrace / The tank of the bath house is drained a thousand times." See *Counsel for Sultans* (1581) 2:65.

76. Âşik Çelebi's *Meşā'iru üş-su'ara* is quoted in Andrews and Kalpakli, *Age of Beloveds*, 284, who use G. M. Meredith-Owens's edition, *Mesair Ussuara: Tezkere of Âşik Çelebi* (London: Luzac, 1971).

77. See Andrews and Kalpakli, *Age of Beloveds*, 239–40 and 284–85, who quote the offending couplet: "It is not that clear who is ruled and who rules these days / It is a wedding feast, so who is dancing and who plays" (239).

78. Andrews and Kalpakli, *Age of Beloveds,* also use this illustration to accompany their discussion of Gazali's bath.

79. See also the hamam miniatures analyzed in chapter 7.

80. Jean-Baptiste Gramaye, *Relations of Barbary and Algiers,* in *Purchas* (1619), 282. (This edition doesn't identify the author.)

81. Cited in Richard Bernstein, *The East, The West, and Sex: A History of Erotic Encounters* (New York: Knopf, 2009), 126.

82. C. F. Volney, *Voyage en Egypte et en Syrie,* ed. Jean Gaulmier (rpt. Paris: Moutin, 1959), 108; trans., *Travels through Syria and Egypt, in the Years 1783, 1784, and 1785* (Dublin, 1793), 154; emphasis added by translator.

83. This tendency to project a Western version of homoeroticism onto the hamam's sensuous atmosphere reaches a preposterous level in turn-of-the-century ethnopornography such as Julius Rosembaum's *The Plague of Lust, Being a History of Venereal Disease in Classical Antiquity* (Paris, 1901), where the author coyly resorts to Latin and Greek in speaking of those "amateurs" cruising the Turkish baths "for bene vastatos and xahhinvyous (men with fine instruments; men with handsome buttocks)" (223). Similarly Orientalist projections characterize William Fitzgerald's *Istanbul After Dark* (New York: MacFadden-Bartell, 1970). Narrated by a voraciously heterosexual American businessman living in Istanbul, this self-proclaimed "swinger's guide to Istanbul" escorts the reader through the city's erotic topography, including the obligatory trip to the baths, where the narrator is approached by a hypermasculine masseur with a muscular body right out of a physique magazine ("heavy chest, large biceps, and powerful shoulder muscles" [112–13]) who offers his "special" services (which the narrator good-naturedly turns down). Again, one notes the layering of a Western ideal of masculinity (buff to the point of bursting) onto a figure of homoerotic fantasy that differs markedly from idealized, boyish bath attendant of Ottoman tradition or the reality of the middle-aged, often paunchy bath attendants employed in this occupation in Istanbul in Fitzgerald's day.

84. On homosexuality and Egyptian cinema, see Garay Menicucci, "Unlocking the Arab Celluloid Closet: Homosexuality in Egyptian Film," *Middle East Report* 206 (Spring 1998, special issue: "Power and Sexuality in the Middle East"): 32–36.

85. Kathryn Tidrick, *Heart-Beguiling Araby* (London: Tauris, 1981), 10–13, 24–31.

86. This collapse of difference into a universalizing trope of insatiable "Arabic" masculinity is comically confirmed in the 1971 porn novel *Sherbet and Sodomy* (the title makes a tongue-in-cheek reference to Lord Byron's description of Istanbul's baths). As the American gay protagonist is gang-raped by a cult of terrorists (who are in fact Persian), he orgasmically moans, "Go on, you big Arabian stallion, give it all you've got . . . Ride 'em Bedouins!. . . . You brawny Moslems! You thousand and one Nights! You Nomad of my asshole! Allah's Flying Carpet! . . . You Seventh Pillar of Wisdom, Shoot!!" Persians, Saudi Arabians, Bedouins, Lawrence of Arabia: all collapse into one universalized, exotic "stud" who drives the swooning initiate—like the ravished maidens of *The Lustful Turk* and *The Sheik*—wild with desire. See *Sherbet and Sodomy* (New York: Traveller's Companion, 1971), 171–72, published under the pseudonym "I. B. Ebbing." A rather witty and well-written text (I suspect an academic wrote it), the novel wears its "Orientalism" knowingly.

87. Hollis Clayson, "Henri Regnault's Wartime Orientalism," *Orientalism's Interlocutors: Painting, Architecture, Photography,* ed. Jill Beaulieu and Mary Roberts (Durham, NC: Duke UP, 2002), 141.

88. Clayson, "Wartime Orientalism," 141.

89. Clayson, "Wartime Orientalism," 141, 152; Clayton quotes from Theophile Gautier's "Three Unpublished Watercolors," on 150–51; see the Gautier essay in full in F. C. de Sumichrast, ed. and trans., *Paris Besieged, The Travels of Theophile Gautier*, 24 vols. (Boston: Little, Brown, 1912), 6:204–6.

90. On the development of these traditions in Arab poetry, see Sprachman, *Suppressed Persian*, xii, xxi–xxii.

91. Abu Nuwas, quoted in Allen Edwardes and R.E.L. Masters, *The Cradle of Erotica* (New York: Julian P, 1963), 34; Suzani, quoted in Sprachman, *Suppressed Persian*, 25.

92. See, respectively, Monsieur Joseph Pitton de Tournefort, *A Voyage into the Levant, Perform'd by the Command of the Late French King*, 3 vols. (1701; trans. John Ozell, London, 1741) 2:287; and de Thevenot, *Travels*, 42.

93. Ali Behdad, "The Exoticized Orient: Images of the Harem in Montesquieu and his Precursors," *Stanford French Review* 13 (1989), notes the paradox whereby the despotic, voraciously sexual sultan must simultaneously be represented as "feminine, sensual, lazy, and weak" in order to stand as "Other" to Europe's superior force and mastery (125).

94. See T. E. Lawrence, *Seven Pillars of Wisdom: A Triumph* (1926; London: Penguin, 1963), 443. The psychosexual complexities of Lawrence's narrative of this experience are explored in my "Vacation Cruises: or, The Homoerotics of Orientalism," *PMLA* 110.1 (January 1995, special issue on "Colonialism and the Postcolonial Condition"): 97–99.

95. Sundip Roy, "The Persians are Coming," March 8, 2007, blogs.newamericamedia. org/sandip-roy/506.

96. Jasbir K. Puar, *Terrorist Assemblages: Homonationalism in Queer Times* (Durham, NC: Duke UP, 2007), passim.

97. Behdad, "Exoticized Orient," 116–19; Pinhas ben Nahum, *The Turkish Art of Love* (New York: Panurge P [Privately Printed], 1933), 224, 229.

98. Riza Bey's sensationalist chapter on eunuchs in *Darkest Orient* (London: Arco, 1937) is titled "The Land of the Twilight Men."

99. Various attempts to taxonomize degrees and types of castration are also found, among others, in Sandys, *Travels*, 55; Lord Charlemont [James Caulfeild], *The Travels of Lord Charlemont in Greece and Turkey 1749*, ed. W. B. Stanford and E. J. Finopoulos (1749; West Africa House, 1984), 191–92; Slade, *Records of Travels*, 1:465–66; and Allen Edwardes, *Jewel in the Lotus: A Historical Survey of the Sexual Culture of the East* (New York: Julian P, 1960), chap. 6: "Eunuchism: Honor in Dishonor." On the historical eminence of the eunuch in the Byzantine Empire, see Kathryn M. Pingrose, *The Perfect Servant: Eunuchs and the Social Construction of Gender in Byzantium* (Chicago: U Chicago P, 2003).

100. See, for example, Paul Ricaut, *The Present State of the Ottoman Empire*, 3 vols. (London, 1668), 1:154, and Charlemont, *Travels*, 93.

101. Baudier, *Histoire générale*, 23.

102. Theophile Gautier, *Constantinople*, trans. Robert Howe Gould (New York: Henry Holt, 1875), 181; Thevenot, *Travels*, 24; Slade, *Records of Travels*, 465–66. On such projections of monstrous femininity, see also Ricaut, *Present State*, 1:154, and M. Duhousset (Colonel), *Mœurs Orientales de la Circoncision des filles. Le Huis-Close de L'Ethnographie* (undated pamphlet, c. 1900), 8. Photographs of early-twentieth-century palace eunuchs reveal quite normal if sometimes hefty looking men.

103. Further artistic renderings of the eunuch to intimate a homoerotic undertow include Antonio Maria Fabres y Costa's "The Arab Sentinel" (1879), whose bare-chested hunk exudes a hypermasculinity offset by the decorative peacock feathered staff he holds

and come-hither look in his eyes; George Geeter's seductive, near-nude "The Harem Guard" (1885), whose sagging loincloth paradoxically draws attention to an endowment that is supposedly missing; Ludwig Deutsch's "The Emir's Guard" (1893) and "The Palace Guard" (1892); Paul Seiffert's "A Moroccan Guard" (n.d.); and Maurice Bompard's "Palace Guard" (n.d.).

104. The köçek was variously termed a *çengi*, *khawal*, or *gink*, depending on region and status.

105. And, *A Pictorial History*, 138.

106. Jacob Ludwig Bartholdy, *Voyage en Grèce fait dans les années 1803 et 1804* (Paris, 1807) 2:80–89, cited in And, *A Pictorial History*, 140. Fazil Bey's *Çengi-name* includes ghazals detailing an array of colorfully nicknamed dancers; his autobiographical *Defter-i Aşk* ("Notebook of Love") includes 170 couplets praising the gipsy dancer, Çingene Ismail, who captured his heart.

107. Vivant Denon, *Travels in Upper and Lower Egypt, trans.* 3 vols. (New York, 1803), 1:104. Likewise George Keppel, *Personal Narrative of a Journey from India to England* (Philadelphia, 1827), traveling through Iraq in the 1820s, describes as the evening entertainment offered by two Arab guards "a dance of the most grotesque description," in which one imitates a lover . . . [while] the other . . . impersonated a female" (127, 214).

108. "Dr. John Covel's Diary" (1670–1679), manuscript in the British Museum (Add. 22916, folio 208). Expurgated version printed in ed. James T. Bent, *Early Voyages and Travels in the Levant* (London, 1893), 214–15; see also And, *A Pictorial History*, 149, and de Thevenot, *Travels*, 2:6.

109. Herbert, *Travels in Persia*, 248.

110. Covel, "Diary," folio 208; Thevenot, *Travels*, 2:36.

111. François Baron De Tott, *Memoirs*, 2 vols. (1785; facsimile, New York: Arno P, 1973), 2:130, quoted in Ze'evi, *Producing Desire*, 154.

112. Slade, *Records of Travels*, 2:392–96. The field notes of a gipsy specialist using the penname "Andreas" include a section titled "A Turkish Scandal," in which the author reports on a men's-only dance exhibition in a Muslim gipsy encampment in Salonika. Stripped to the waist, the two dancers' "supremely indecent" movements (the details of which are given in Latin) are met with thunderous applause from the audience. Unlike many reports that suggest the principal dancers simulate heterosexual intercourse, in this case the dancers seem to play directly to the homoerotic enjoyment of its audience. See the pseudonymous Andreas, "Balkan Notes," *Journal of Gypsy Lore Society* 7 (1913–1914): 41–53.

113. William Ouseley, *Travels in Various Countries of the East; More Particularly Persia*, 3 vols. (London, 1823), 3:405.

114. Alvan S. Southworth's *Four Thousand Miles of African Travel: A Personal Record of a Journey Up the Nile and Through the Soudan to the Confines of Central Africa* (Weed, Parsons, and Co., 1875), includes a lithograph (facing 77) that is clearly drawn from a second photograph of the same male dancer in figure 2.46 (also in the Getty's Jacobson collection). Ironically, the performer here is labeled "A Dancing Girl," attesting to the persistent gender confusion that the köçek has historically caused in Western observers.

3. EMPIRE OF 'EXCESSE,' CITY OF DREAMS: HOMOEROTIC IMAGININGS IN ISTANBUL AND THE OTTOMAN WORLD

1. Monsieur Joseph Pitton de Tournefort, *A Voyage into the Levant, Perform'd by the Command of the Late French King*, 3 vols. (1701; trans. John Ozell, London, 1741) 1:150.

2. George Sandys, *Sandys Travels, Containing an History of the Original and Present State of the Turkish Empire* (1615; 7th ed. London: 1673), 28. The poet and philosopher J. C. Scaliger (1484–1558) was the father of one of the first great scholars of Orientalism, Joseph Justus Scaliger (1540–1609). See Robert Irwin, *Dangerous Knowledge: Orientalism and Its Discontents* (Woodstock, NY: Overlook P, 2006), 76.

3. Aaron Hill, *A Full Account of the Present State of the Ottoman Empire in All Its Branches* (1709), 80 and 107.

4. Michel Baudier, *Histoire générale du Serrail, et de la cour du Grand Seigneur*, trans. E.G.S.A. [Edward Grimeston, Sargent at Arms] (1626: London, 1636), 167. As a Catholic, Baudier uses imagery reflecting the Church's propaganda against the false faith since the Crusades. Protestant attitudes hardly differ, as illustrated in Martin Luther's references to the Ottoman Empire as an "open and glorious Sodom" in "Vom Kreige Widder"—"openness" connoting a polymorphous lack of boundaries. Quoted in Silke Falkner, "'Having It Off' with Fish, Camels, and Lads: Sodomitic Pleasures in German Language Turcica," *Journal of the History of Sexuality* 13.4 (2007): 411.

5. Quotations are from, respectively, Baudier, *Histoire générale*, 166; F[rancois]. C[harles]. H. L. Pouqueville, *Travels Through the Morea, Albania, and Several Other Parts of the Ottoman Empire to Constantinople* (London: Richard Phillips, 1806), 189; and W[illiam]. Eton, *A Survey of the Turkish Empire* (London, 1798; facsimile New York: Arno, 1973), 172.

6. Baudier, *Histoire générale*, 57.

7. I use Marjorie Laurie's translation of Loti's *Aziyade* (London: Kegan Paul, 1989), read in tandem with the French text, ed. Bruno Vercier, *Aziyade: Extrait des notes et letters d'un lieutenant de la marine Anglaise entré au service de la Turquie le 10 Mai 1876, Tué dans Les Murs de Kars, le 27 Octobre 1877* (Paris, Flammarion, 1989). Occasionally I make silent alterations based on my reading of the original. Subsequent page numbers are included in parenthesis in the text; those to Laurie's translation are marked by the letter "A," those to the French text with a "V."

8. J[ohn]. L[loyd]. Stephens, *Incidents of Travel in Greece, Turkey, Russia, and Poland* (Edinburgh, 1839), 43. Charles White notes these diverse populations in *Three Years in Constantinople; Or Domestic Manners of the Turks in 1844*, 2 vols. (London, 1845), 1:113–14.

9. Stephens, *Incidents of Travel*, 43; Monsieur Joseph Pitton de Tournefort, *Voyage*, 1.151.

10. Lâtifî, *Éloge d'Istanbul suivi du Traité de l'invective (anonyme)*, trans. into French by Stéphane Yerasimos (Paris: Sindbad, 2001), 51, 56–7, 94; the translations are mine.

11. Evliya Çelebi, *Evliya Çelebi in Diyarbeber: The Relevant Sections of the Seyahatname*, Klaus Kreiser, ed.; trans., commentary, and intro. Martin Van Bruinssen and Hendrik Boeschoter, (Leiden: Brill, 1988), 157; Çelebi, *Seyahatname* ("Book of Travels"), books 5–8, trans. and ed. Robert Dankoff, and Robert Elsie, ed., *Evliya Çelebi in Albania and Adjacent Regions* (Leiden: Brill, 2006), 87, 145.

12. Mustafa Âli, *Tables of Delicacies Concerning the Rules of Social Gatherings*, trans. Douglas S. Brookes (Cambridge, MA: Harvard U Department of Near Eastern Languages and Civilization, 2003), chap. 8, "Beardless Boys," 29–30.

13. Paul Ricaut, *The Present State of the Ottoman Empire* (London, 1668), 1:10. Ricaut's name is alternatively spelled "Rycaut."

14. Lord Charlemont [James Caulfeild], *The Travels of Lord Charlemont in Greece and Turkey 1749*, ed. W. B. Stanford and E. J. Finopoulos (1749; West Africa House, 1984), 205, 202–3.

15. Baudier, *Histoire générale*, 57; Lithgow, *The Totall Discourse, of the Rare Adventures, and painefull Peregrinations of longe nineteene yeares travailes* (1632; London, 1640), 163. For similar sentiments see Charlemont, *Travels*, 202–3; Hill, 79–80.

16. Ricaut's father, who made his fortune in Mediterranean trade, emigrated to London from the Netherlands around 1600; Ricaut was educated at Cambridge before joining Charles II's court in exile. After serving the Earl of Winchelsea during the latter's ambassadorship, Ricaut was appointed consul in Smyrna; around this time he began spelling his name Rycaut. A firm advocate of religious toleration, Ricaut maintained an impartial attitude to the Turkish population. Although some of his colorful rhetoric, as in the passages quoted here, sounds prejudicial to modern ears, Sonia P. Anderson, in *An English Consul in Turkey: Paul Rycaut at Smyrna 1667–1678* (Oxford: Clarendon, 1989), maintains that he was far more biased "in writing of his fellow Franks" (244). *Present State*, which appeared in 1666 but was postdated 1667, then reissued in 1668, was translated into French, Italian, German, Dutch, and Polish in Ricaut's lifetime. See Anderson, *English Consul*, 20–25, 41–44, 243–44. C. J. Heywood and Ezel Kurel Shaw, *English and Continental Views of the Ottoman Empire, 1500–1800* (Los Angeles: Clark Library, 1972), 43, speculate that Ricaut's taxonomic interest in presenting a "systeme or model" of Turkish governance has a Hobbesian bias. It no doubt also reflects his mind-set as a royalist whose experience of the overthrow of the British throne made him particularly keen to issues of right "order" and wrong "disobedience." See also Linda T. Darling, "Ottoman Politics Through British Eyes: Paul Rycaut's *The Present State of the Ottoman Empire*," *Journal of World History* 5.1 (1994): 71–97.

17. Gazali was the pen-name of Mehmed of Bursa, also known as Deli Birader ("Crazy Brother"). I use the translation Selim S. Kuru provides in his well-annotated Ph.D. thesis, *A Sixteenth Century Scholar: Deli Birader and his Dāfi'ü'l-gumūm ve rāfi'ü'l-humūm* (Cambridge, MA: Harvard Dept. of Near Eastern Languages and Civilizations, 2000). Subsequent page numbers are included in parentheses in the text. Kuru notes the text's innovativeness in its "conscious attempt to combine the traditional Islamic literary forms with folk material: Tongue twisters, riddles, and proverbs alternate with gazels, quatrains, and tales from the Islamic tradition throughout the text" (viii). Gazali enjoyed state patronage as a writer and courtier, became a teacher of Islamic law, and was an unrepentant lover of boys. After years in Korbud's court and teaching at various medreses, he retired to Istanbul to achieve renown—as noted in chapter 2—by building a mosque, dervish lodge, garden, and bathhouse in what is now modern-day Beşiktaş. If Gazali's establishment cemented his reputation as a devotee of his own sex—or, as he puts it in one of his fund-raising panegyrics, as "the leader of the bachelors" (6)—so too *The Book that Repels Sorrows* clearly evinces, beneath its lampoon of all sexualities, the author's preference for the male sex.

18. As this frame situation—gossip about a famed disquisition on Eros that leads to its retelling—suggests, Gazali's romp forms a ribald version of Plato's *Symposium*; indeed, Gazali includes a kind of "inverse" myth of androgyny (to explain why one shouldn't get married and have children—it splinters the original self!), also suggesting his familiarity with Plato's text.

19. Roland Barthes, "Pierre Loti: *Aziyade*." Rpt. *New Critical Essays*, trans. Richard Howard (New York: Hill and Wang, 1980), 119. While Barthes's short piece brilliantly pinpoints the rhetorical strategies that Loti uses to make his "fugitive text" of homoerotic desire audible, his essay suffers from the Orientalizing tendency to universalize the "East" as a spatial-temporal zone before modernity and as the locus of "pure" desire (117), which he then valorizes as a zone of unfettered homosexual freedoms.

20. Dipesh Chakrabarty, *Provincializing Europe: Postcolonial Thought and Historical Differ-ence* (2000; reissued with new preface, Princeton, NJ: Princeton UP, 2007), 3–4, 46.

21. Barthes, "Pierre Loti," 10, 113, 119. Aside from Barthes, few critics who have tackled Loti's sexuality in depth. Richard M. Berrong's *In Love with a Handsome Sailor: The Emergence of Gay Identity and the Novels of Pierre Loti* (Toronto: U of Toronto P, 2002) is the only full-length study of Loti and homosexuality. Berrong argues that Loti self-consciously promulgated a gay-positive ideal anticipating "the modern idea of the male homosexual"—a view that, in my reading, leaves too little room for the ambivalence, denials, and homosexual panic that are part of Loti's conflicted desires. Christian Gundermann's article, "Orientalism, Homophobia, Masochism: Transfers Between Pierre Loti's *Aziyadé* and Gilles Deleuze's 'Coldness and Cruelty,'" *Diacritics* 24 (1994): 151–67, is the most nuanced discussion to date of the novel's homoerotic subtexts and Orientalizing tropes. Lesley Blanch's biography, *Pierre Loti: Portrait of an Escapist* (London: Collins, 1983), goes to almost comical efforts to refute claims that Loti was "too" homosexual (128, 99, 123).

22. Because the French navy prohibited its officers publishing under their actual names, the novel was unsigned upon publication.

23. Blanch, "Pierre Loti," 51.

24. See, respectively, Edmond and Jules de Goncourt, *Journal, mémoires de la vie littéraire*, ed. Robert Rocatt, 4 vols. (Paris: Fasquelle and Flammarion, 1956), 3:757–58 (Feb-ruary 21, 1888); Loti, *Journal: Volume II (1870–1886)*, ed. Alain Quella-Villéger and Bruno Vercier (Paris: Les Indes Savants, 2008), 2:740 (October 21, 1886); and Frank Harris, *Contemporary Portraits: Second Series* (New York: Frank Harris, 1919), 196.

25. For a psychological reading of Loti's propensity toward masquerade, see Peter James Turberfield, *Pierre Loti and the Theatricality of Desire* (Amsterdam and New York: Rodopi, 2008).

26. See Loti's journal entries for March 30, 1882, and March 28, 1882, *Journal* 2:386–8.

27. Blanch, *Portrait of an Escapist*, 30. In the autobiographical *Le roman d'un enfant* ("The Story of a Child"), Loti remembers dreaming of foreign shores as an escape from his quotidian life: "Oh! What troubling and magic qualities that the simple word 'the colonies,' had in my childhood, a word which, at that time, designated for me all the hot countries. . . . Oh! 'the colonies'!" Quoted in Berrong, *In Love*, 147. Obvious in the reduction of all "hot countries" to the homogenizing phrase "the colonies" is Loti's tendency to project an intensely personal vision of self-transformation onto France's colonial outposts; such blindness to the less than magical realities of colonial rule is a necessary precondition of his Orientalist erotics. For Loti's adolescent projections onto sailors, see *Fleurs d'ennui* ("Blossoms of Boredom") (Paris: Calmann-Levy, 1893), 168; his response to mascaraed Moroccan women is quoted in Blanch, *Portrait of an Escapist*, 65.

28. Harris, *Contemporary Portraits*, 196. See Clive Wake, *The Novels of Pierre Loti* (Paris: Mouton, 1974), 28–29, on Loti's detestation of his perceived physical unattractive-ness and Blanch, *Portrait of an Escapist*, on his feminized nickname (24), "hothouse" upbringing (36), and feelings of unattractiveness (41–42).

29. Loti, *Journal: Volume I (1868–1878)*, ed. Alain Quella-Villéger and Bruno Vercier (Paris: Les Indes Savants, 2006), 1:257–8 (April 1876). Subsequent pages are included in parentheses in the text prefaced with the letter "J."

30. Intense, romanticized friendships with handsome, brawny sailor-types like the ones depicted in this drawing were a mainstay of Loti's life, one new *frère chéri* succeed-ing another. Loti's first romantic friendship occurred with a fellow cadet, Joseph Bernard, who accompanied Loti to Tahiti and Senegal; their intensely intimate bond

lasted six years, until Bernard inexplicitly broke it off, forbidding anyone in his family to mention the name of Viaud-Loti for the rest of his life.

31. Hence Goncourt, *Journal*, writes on November 3, 1895, that Loti does everything possible "to be thought a pédéraste" (4.81); on September 21, 1890, he records the rumor (passed along by Napoleon III's sister) that Loti had been caught in an act of pederasty during a naval tour of duty. See Berrong, 5–6.

32. Mark Mazower, *Salonica, City of Ghosts: Christians, Muslims, and Jews 1420–1950* (London: HarperCollins, 2004), 145–46, 104.

33. Tellingly, the verb used on this occasion, "fleurit," is the same—"fleurissent"—used in the novel's first reference to Sodom (A 13, V 49–50): sodomy blossoms, opens out, spreads.

34. Metin And, *A Pictorial History of Turkish Dancing* (Ankara: Dost Yayinlari, 1976), 141.

35. See the discussion of the dancing boy trope in chap. 2, as well as the entries "Geysû," on a style of wearing the hair common to köçeks throughout history (11:7023); "Göbbek Çalkamak, Göbek Dansi," on the history of male belly-dancing (11:7057–59); and "Bayram Sah," a famous mid-seventeenth-century köçek (5:2310) in Reşat Ekrem Koçu, *İstanbul Ansiklopedisi* (İstanbul: İstanbul Yayinevi, 1966–1973).

36. See John Covel and Thomas Herbert's comments on male dancers in chap. 2, 102–4.

37. See Berrong, *In Love*, 19.

38. Laurie's translation of *Aziyade* diffuses the ethnic diversity of the scene by rewriting the "jeunes garçons israelites" as "young Turkish boys." In Ottoman literature, the profession of the boy dancer is frequently filled by Greek, Jewish, and gipsy youths.

39. See Dror Ze'evi's meticulous research in *Producing Desire: Changing Sexual Discourse in the Ottoman Middle East, 1500–1900* (Berkeley: U of California P, 2006), chap. 2; Walter G. Andrews and Mehmet Kalpakli, *The Age of Beloveds: Love and the Beloved in Early-Modern Ottoman and European Culture and Society* (Durham: Duke UP, 2005), 271, 280–81; and my discussion in chap. 1. The novel provides a glimpse of this simultaneous coexistence of worlds in the two appearances made by an otherwise unremarked-upon character, Izeddin Ali, the acquaintance who escorts Loti to the underground den of dancing boys. Later in the text, Izeddin Ali invites the protagonist to his private home to socialize with the "scions of old Turkey" (A 125) in a languorous drinking and smoking party that lasts the night. The former scenario, which Ali easily inhabits, is homoerotic and louche; the latter scene is homosocial, aristocratic, and nonsexual, in addition to being marked by heterosexual domesticity (the women of Ali's haremlik constantly find excuses to peek at the male company). Again, Loti's narrative subtly reflects a material reality of Ottoman life—seemingly contradictory but in fact overlapping subcultures—that makes the possibility of the protagonist's erotic transgressions more than mere Orientalist fantasy.

40. Loti's strenuous effort to distance himself from the lure of "hothouse" homoeroticism makes all the more ironic the two occasions Samuel reenters the story, for both plant him squarely in his master's bedroom. The first is a comic episode in which Samuel thinks his bed has been jinxed by a cat who's deposited her litter there; Loti finds that Samuel has "taken possession of my bed and was sleeping the sleep of youth and innocence. Which was all very well for him . . ." (A 92; Loti's ellipses). Although the tone is light-hearted, it is striking that this first mention of Samuel in dozens of pages gets him, literally, into the bed of his object of desire. The way Loti's sentence trails off in ellipses leaves unanswered the question of where Loti sleeps this night; we've seen his ease in crawling under the covers with Samuel when the latter is asleep. The second incident occurs when Aziyade is out of town and Samuel, spooked by the sight of a drowned corpse, uses this "childish" excuse to bring his

blankets into Loti's bedroom, where he curls on the floor "beside me," Loti writes, "sleeping calmly as a child" (A 100). Again, Samuel penetrates the most intimate of his master's spaces. At the same time, the narrative disavows any erotic connotations by emphasizing Samuel's innocent childishness.

41. Wake, *Novels*, 62, makes a similar point.

42. In "Acting Out Orientalism: Sapphic Theatricality in Turn-of-the-Century Paris," *Performance and Cultural Politics*, ed. Elin Diamond (London: Routledge, 1996), Emily Apter also examines the demise of Loti's "masculinist" pose in this scene, nicely calling it a "failed heterosexual pass" (26).

43. Kars was the decisive battle in which Russia defeated Turkey, an event that historians see as marking the final stage in the dissolution of the Ottoman Empire; Loti's death thus presciently marks the death of the Empire itself.

44. Orhan Pamuk, *Istanbul: Memories and the City* (London: Faber, 2005). Quotations are from 150, 140, and 152, respectively; for the general facts of Koçu's life, see the entire chapter, 137–54.

45. The accompanying illustration features a near-naked Don Adam hoisting a banner that reads "To strip is an art, not a vice." Koçu, *İstanbul Ansiklopedisi*, 9:4593. I am immensely grateful to Yekta Zulfikar for spending two months of her senior year with me on these translations.

46. Although the encyclopedia draws on a range of (uncompensated) artists for its illustrations, by far the greatest number—including those of shirtless, nubile male youths—are the work of the female artist Sabiha Bozcali. This intriguing fact adds yet another level of complexity to the encyclopedia's homoerotic undercurrents. The only female included among Koçu's cadre of aging intellectuals, raconteurs, and habitués of all-night meyhanes, Bozcali studied art in Germany after World War I, worked with neomodern impressionists in Paris, and studied in Chirico's workshop in Rome in the 1920s and 1930s. Koçu pens an entry on Bozcali in which he commends her in the warmest terms as a true friend and confident person who never married: reading between the lines, one infers that this no-nonsense, professional, single woman was a lesbian, which might explain the ease with which she fit into his circle of largely homosexual and bachelor friends, as well as the degree to which her drawings so precisely channel Koçu's homoerotic desires. Intriguingly, Bozcali felt that her most important artworks were her portraits of women. See the entry on Bozcali, 6:3053.

47. See Koçu, *İstanbul Ansiklopedisi*, "Bulgaroğlu," 6:3112.

48. See Koçu, *İstanbul Ansiklopedisi*, "Bübül (Bilâl)," 6:3166.

49. Koçu, *İstanbul Ansiklopedisi*, 9:5085; illustration is on the following page.

50. Anita's freedom, as Özpetek is aware, is also attached to her outsider status. Because she is a European woman, Turkish men allow her leeway that they would not necessarily allow Turkish women.

4. EPIC AMBITIONS AND EPICUREAN APPETITES: EGYPTIAN STORIES I

1. "Antony and Cleopatra," *William Shakespeare: The Complete Works*, gen. ed. Alfred Harbage (Baltimore, MD: Penguin, 1969), 2.3.38–40. Subsequent citations are included in parentheses in the text.

2. Sir Richard Burton, *The Book of the Thousand Nights and a Night: A Plain and Literal Translation of the Arabian Nights Entertainments*, trans. and ed. Sir Richard Burton, 10 vols. (London: Burton Club, 1885–1886), 10:194.

3. Robert Gorham Davis, "Excess Without End" [review of Mailer's *Ancient Evenings*], *The New Leader* 66 (May 16, 1983): 14.

4. The phrase "The Big One" is applied to Mailer in James Wolcott, "Enter the Mummy: Norman Mailer Finally Gets His Egyptian Novel Out of His System," *Harper's* (May 1983): 83.

5. Lawrence Durrell, *Balthazar*, vol. 2 of *Alexandria Quartet* (1958; New York: Pocket, 1961), 185. The *Quartet* was originally published by E. P. Dutton in the following order: *Justine* (1957), *Balthazar* (1958), *Mountolive* (1959), *Clea* (1960). Subsequent page numbers are included in the text, along with the first initial of the volume unless the context makes the citation clear.

6. Harold Bloom, "Norman in Egypt," *The New York Review of Books* 30.7 (April 28, 1983), rpt. *Contemporary Literary Criticism, Volume 28*, ed. Harold Bloom (New York: Gale, 1984), 260.

7. Josephus, *Jewish Antiquities*, 8 vols., trans. Ralph Marcus (Cambridge, MA: Loeb Classical Library, 1963), 8:13–17 [XV.21–33]; emphasis added.

8. However bisexual Antony may have been, he was not averse to using charges of passive homoerotic behavior to castigate his foes: thus, Suetonis reports in *Augustus*, chap. 68, Mark Antony accuses Octavius Caesar of having bought his adoption from his uncle [Julius Caesar] by prostituting himself to him. See J. C. Rolfe, trans. and ed., *Suetonis*, 2 vols. (Cambridge, MA: Harvard Loeb, 1979), 229. In turn, relying on the common rhetorical device of character assassination by homosexual aspersion, Cicero in the *Philippics* holds forth at length about Antony's alleged sexual depravities (2:44–47): "You assumed the toga virilis, which you at once turned into a woman's toga. . . . No boy bought for the sake of lust was ever so much in the power of his master as you were in Curio's." Cicero goes on to say that certain shameful acts Antony engaged in with Curio "cannot [be] pronounce[d] with decency"—presumably oral intercourse, which Amy Richlin, from whom this passage is quoted, notes was the ultimate insult to launch in an invective. See Amy Richlin, *The Garden of Priapus: Sexuality and Aggression in Roman Humor*, Revised Edition (New York: Oxford UP, 1992), 14–15. Neither Suetonis nor Cicero should be taken as factual evidence for anyone's same-sex preferences—both are examples of satiric invective working within a set of conventions.

9. Allen Edwardes and R. E. L. Masters, *Cradle of Erotica* (New York: Julian P. 1963), 298. They call Lucian's text *Pseudologistae*.

10. Allen Edwardes, *Erotica Judaica* (New York: Julian P, 1967). Here Lucian's text is cited as *De Timarcho*.

11. A. M. Harmon, *Lucian, With an English Translation* (Cambridge, MA: Harvard UP, 1972), "The Mistaken Critic," 5:405. I suspect Edwardes's source may not be Lucian but the loose paraphrase of his invective in Frederick Charles Forberg's Latin *Manual of Classical Erotology (De Figuris Veneris)* (1824; New York: Grove Press, 1966), 197.

12. See Lisa Manniche, *Sexual Life in Ancient Egypt* (New York: Kegan Paul, 1987); David O'Connor, "Eros in Egypt" *Archaeology Odyssey* (September–October 2001), http://fontes.lstc.edu~rklein/Documents/eros_in_egypt.html; and Ruth Schuman Antelme and Stephane Rossini, *Sacred Sexuality in Ancient Egypt: The Erotic Secrets of the Forbidden Papyrus*, trans. Jon Graham (Rochester, VT: Innes Traditions, 2001).

13. "The Contendings," Chester Beatty Papyrus I, in *The Literature of Ancient Egypt*, ed. William Kelly Simpson (New Haven, CT: Yale UP, 1972). I have collated Simpson's text with the translations provided in R. B. Parkinson, "'Homosexual' Desire and Middle Kingdom Literature," *JEA* 81 (1995), and Bruce L. Gerig, "Homosexuality in Ancient Egypt," in "Homosexuality and the Bible" on the website *The Epistle: A Web*

Magazine for Christian Gay, Lesbian, Bisexual, and Transgender People, http://epistle. us/hbarticles/ancientegypt1.html. Following the work of David Halperin on Greek pederastic roles, Parkinson highlights the Horus-Set combat as a demonstration of the "ethos of phallic penetration in domination" (65).

14. Quoted in David F. Greenberg, *The Construction of Homosexuality* (Chicago: U of Chicago P, 1988), 130, 129. The first inscription (Coffin Text VI, 258f–g) is also cited in Parkinson, 64.

15. Parkinson, "'Homosexual' Desire," 71.

16. Dominic Monserrat, *Sex and Society in Graeco-Roman Egypt* (London: Kegan Paul, 1996), 143.

17. Parkinson, "'Homosexual' Desire," 72.

18. See Greg Reeder, "Same-Sex Desire, Conjugal Constructs, and the Tomb of Niankh-khnum and Khnumhotep," *World Archaeology* 32.2 (October 2000): 193–98.

19. See Dominic Montserrat, *Akhenaten: History, Fantasy, and Ancient Egypt* (London: Routledge, 2000), especially chap. 7, "Sexualities," which traces the shift from an image of Akhenaten as the first "family man" and proto-Christian (as a practicing monotheist) to that of effeminate mother's boy, hermaphrodite, gay "rebel with a cause," and camp icon. In chap. 6, "Literary Treatments," Montserrat notes that over sixty novelistic treatments of Akhenaten have appeared in the last century. Gerig sums up gay mythologizing of Akhenaten in "Homosexuality in Ancient Egypt."

20. See for instance Maxim 32, "The Teaching of Vizier Ptahhotep" (1991–1785 b.c.), a manual of good conduct, which advises one not to copulate with (*nk* or penetrate) a *hmt* (a male who takes the penetrative role like a woman), since such desires cannot be extinguished except by renunciation. See Gerig, "Homosexuality in Ancient Egypt," 5; Parkinson, "'Homosexual' Desire," 68–70.

21. See St. Clement, *Miscellanies*, 3:11, *Paedogogus* ("Educator"), 3.4.26, and *Protrepticus* ("Exhortation to the Greeks 2"), trans. J. W. Butterworth (Cambridge, MA: Harvard Loeb, 1919). With his usual hyperbole, Richard Burton declares that Alexandria was a hotbed of "Coptic orgies" (10:194) during the reign of the Ptolemies, an ascription echoed in Sonnini's account of the history of Canopus: "dissoluteness of manners soon arrived . . . at [its] highest pitch; licentiousness raged without controul" (1:354).

22. See Everett K. Rowson, "Homoerotic Liaisons," *Islamicate Sexualities*, 204–38; and Stephen O. Murray, "Male Homosexuality, Inheritance Rules," *Islamic Homosexualities: Culture, History, and Literature*, ed. Stephen O. Murray and Will Roscoe (New York: New York UP, 1997), 161–73. Dror Ze'evi, *Producing Desire: Changing Sexual Discourse in the Ottoman Middle East, 1500–1900* (Berkeley: U of California P, 2006), 143, notes that shadow puppetry in medieval Egypt was almost exclusively homosexual in its thematics. See also *Three Shadow Plays by Mahammad Ibn Dāniyāl*, ed. Paul Kahle (Cambridge: Leda House, 1992). On the erotic nature of the layering of Egyptian and Syrian tales into *Thousand Nights* in the Mamluk period, see Robert Irwin, *The Arabian Nights: A Companion* (London: Tauris, 2004), 43, 162, 168–69. William Popper provides a good introduction to Mamluk history in *Egypt and Syria Under the Circassian Sultans, 1382–1468 A.D.: Systematic Notes to Ibn Taghribirdi's Chronicles of Egypt* (Berkeley, CA: U of California P, 1955).

23. Norman Daniel, *The Arabs and Medieval Empire* (London and New York: Longman, 1975), 224, 230, comments on both William of Adam and Simon, 230.

24. Daniel, *Arabs*, 190. Leo Africanus comments on fifteenth- to sixteenth-century Alexandria as the pit of unwholesome, diseased ripeness in John Pory, trans., *The History and Description of Africa*, 4 vols. (London, 1896), 3:864.

25. *Mustafa Âli's Description of Cairo of 1599: Text, Transliteration, Translation, Notes*, ed. and trans. Andreas Tietze (Vienna: Verlag der Osterreichischen Akademie der Wissenschaften, 1975), 54.

26. Joseph Pitts, *A True and Faithful Account of the Religion and Manners of the Mohammetans* (1704) quoted in Zahra Freeth and H[arry]. V. F. Winstone, *Explorers of Arabia, From the Renaissance to the End of the Victorian Era* (London: George Allen, 1978), 48.

27. Sir William Eton, *Survey of the Turkish Empire* (London, 1798), attributes the lack of progeny among the Mamluks to "their being greatly addicted to an unnatural vice" (295).

28. C. F. Volney, *Voyage en Egypte et en Syrie*, ed. Jean Gaulmier (rpt. Paris: Moutin, 1959) 108; trans., *Travels through Syria and Egypt, in the Years 1783, 1784, and 1785* (Dublin, 1793), 115–16.

29. C. S. Sonnini, *Travels in Upper and Lower Egypt*, 3 vols. (trans. Henry Hunter; Stockdale, 1799), 1:251–52; emphasis added.

30. William Lane, *An Account of the Manners and Customs of the Modern Egyptians*. Facsimile of the Fifth Edition published in 1860. (1836, rpt. New York: Dover, 1973), 295; emphasis added.

31. John Ninet, *Lettres d'Égypte 1879–1882*, ed. Anouar Louca (Paris: Éditions du Centre National de la Resherche Scientifique, 1979), 236–37. A Swiss agronomist invited to Egypt by Muhammad [Mehemet] Âli in 1839 to oversee the cotton crops, Ninet fell in love with the country and stayed fifty years, helping to draw up manifestos protesting British colonial rule. See Daniel Varisco, *Reading* Orientalism: *Said and the Unsaid* (Seattle: U of Washington P, 2007), 229.

32. Anthony Sattin, *Lifting the Veil: British Society in Egypt 1768–1956* (London: Dent, 1988), 209. See also Brian Montgomery on Alexandria, *A Field Marshall in the Family* (London: Constable, 1973), 202; Derek Hopwood on Port Said, *Sexual Encounters in the Middle East: The British, the French, and the Arabs* (Reading, UK: Garnet, 1999, 128; Ronald Storrs on Cairo, *Orientalisms* (London: Nicholson and Watson, 1943), 42; and Derek Hopwood on Cairo, *Tales of Empire: The British in the Middle East 1800–1952* (London: Tauris, 1989), 66–67.

33. Nigel Hamilton, *The Full Monty. Volume 1: Montgomery of Alamein, 1887–1942* (London: Allen Lane Penguin, 2001), 202. In *Empire and Sexuality: The British Experience* (Manchester: Manchester UP, 1990), Ronald Hyam comments that "Egypt escaped the big clean-up" (151, 155). Hopwood, *Sexual Encounters*, 177, comments on Alexandria's boy brothels.

34. Pietro Della Valle, *The Pilgrim: The Travels of Pietro Della Valle*, trans. George Bull (1658; London: Hutchinson, 1989), 47.

35. E[llis] Veryard, M.D., *An Account of Diverse Choice Remarks . . . Taken on a Journey* (1701), 288. Veryard embarked for Egypt in 1686.

36. Gustave Flaubert, *Flaubert in Egypt: A Sensibility on Tour*, trans. and ed. Francis Steegmuller (Chicago: Academy Chicago, 1979), 103.

37. Frances Cobbe, *Cities of the Past*, 57, quoted in John Pemble, *The Mediterranean Passion: Victorians and Edwardians in the South* (Oxford: Clarendon, 1987), 124; Lucie Duff Gordon, *Letters from Egypt (1862–1869)* (New York: Praeger, 1969), 42, 135.

38. Âli, *Description of Cairo*, 42, 43, 52, 53, 54.

39. Monsieur [Jean] de Thevenot, *The Travels of Monsieur de Thevenot into the Levant. In Three Parts*, trans. from the French (London: H. Clark, 1686), 252.

40. Blount, *Voyages*, 79; Sanderson, *Voyages and Observations*, in Samuel Purchas, *Hakluyt Posthumus or Purchas his Pilgrimes*, 20 vols. (rpt. Glasgow, J. MacLehose, 1905), 9:46; and Lane, *Manners and Customs*, 391.

41. J. W. McPherson, *The Moulids of Egypt (Egyptian Saints-Days)* (Cairo: N. M. Press, 1941), 151.

42. Riza Bey, *Darkest Orient* (London: Arco, 1937), 28.

43. Bey, *Darkest Orient*, 42.

44. Ezekiel 16.26. This is a rare occasion in which Edwardes, *Erotica Judaica*, 93, isn't stretching the translation to make the phrasing mean what he lasciviously wants it to mean; the King James Bible translates the phrase as "big of flesh," but the Jamieson-Fausset-Brown Bible Commentary notes that "great of flesh" actually means "of powerful virile parts."

45. Sir Richard Burton, *Personal Narrative of a Pilgrimage to Al-Madinah and Meccah*, 2 vols. (1893; New York: Dover, 1964), 2:83.

46. Dr. Jacobus [Jacob Sutor], *Untrodden Fields of Anthropology* (New York: Falstaff P, 1937), 276, 278.

47. This Orientalist mode of racializing Egyptians as almost-Negros, thus superior to pure African blacks, can also be found in James Cowles Prichard, *The Natural History of Man* (London, 1843), 151–52.

48. Edwardes and Masters, *Cradle of Erotica*, 124.

49. Edwardes, *The Jewel in the Lotus: A Historical Survey of the Sexual Culture of the East* (New York: Julian P, 1960), 62.

50. Richard Critchfield, *Shabbat, An Egyptian* (Syracuse, NY: Syracuse UP, 1978), 10, 3, 5, 11, 17. Timothy Mitchell's intriguing sleuthwork in *Rule of Experts: Egypt, Techno-Politics, Modernity* (Berkeley, CA: U of California P, 2002), 123–29, shows how Critchfield plagiarized the descriptions of the fellaheen in Lane, *Customs*, and Henry Habib Ayrout, *The Fellaheen* (1938), in order to create a picture of the "timeless" life of rural Egyptians.

51. Critchfield, *Shabbat*, 17–18.

52. De Thevenot, *Travels*, 248; Charles Perry, *A View of the Levant: Particularly of Constantinople, Syria, Egypt, and Greece* (London, 1743), 244.

53. Sonnini, *Travels*, 2:252.

54. Lane, *Manners and Customs*, 295.

55. Âli, *Cairo*, 26.

56. Perry, *A View of the Levant*, 245.

57. Lane, *Manners and Customs*, 381–82. Lane draws a distinction between the Egyptian ethnicity of the *khawal* and *gink*, the latter typically of Jewish, Armenian, Greek, or Turkish background.

58. Vivant Denon, *Travels in Upper and Lower Egypt*, trans., 3 vols. (New York, 1803), 1:205.

59. Timothy Mitchell, *Colonizing Egypt* (Cambridge: Cambridge UP, 1988), 1, 9.

60. Georg Schweinfurth, "Preface" to C[arl]. B[enjamin]. Klunzinger, *Upper Egypt: Its People and Its Products* (London: Blacke and Son, 1878), vii. Subsequent page numbers are included in parentheses in the text.

61. I am grateful to Elizabeth P. Callaghan for theorizing the concept of the "narrative tour" in her Ph.D. dissertation, "Domestic Topographies: Gender and the House in Nineteenth-Century British Novel," University of Southern California (February 2009).

62. These are compiled, along with excerpts from his traveling companion Maxime Du Camp's writings, by Steegmuller in *Flaubert in Egypt*. Subsequent page numbers are included in parentheses in the text.

63. This is not to deny the heterosexism and misogyny that attend Flaubert's encounters with native women—though in various instances I might argue that his perceived objectification is less pronounced and less imperialistic than some critics have deemed them. Nor do I mean to downplay or deny the degree of heterosexual

Oedipalization that seems to underlie Flaubert's sexual desires and, indeed, inspire his travels to Egypt. An excellent account of these psychosexual formations is provided in Dennis Porter's chapter on Flaubert as "perverse traveler" in *Haunted Journeys: Desire and Transgression in European Travel Writing* (Princeton, NJ: Princeton UP, 1991), 165–82.

64. Flaubert facetiously suggests that this "duty" is related to his colonial status, "traveling as we are for educational purposes, and charged with a mission by the [French] government" (84).

65. See Lisa Lowe's reading of Flaubert's representation of Kuchuk Hanem in *Critical Terrains: French and British Orientalisms* (Ithaca, NY: Cornell UP, 1991), chap. 3. Ali Behdad, *Belated Travelers: Orientalism in the Age of Colonial Dissolution* (Durham, NC: Duke UP, 1994), comments on how the clichés of "orientalist eroticism" that emerge in the description of the encounter with Kuchuk include an "ironic self-consciousness that problematizes the ideological underpinnings of their thematic indulgence" (69).

66. Du Camp's document, "The Crew of the Cange," forms an appendix to Steegmuller's volume. See 225, 228, and 224 respectively.

67. George Plimpton, "Unbloodied by the Critical Pounding: Norman Mailer Defends the Egyptian Novel that Took a Decade to Write," interview in *People Weekly* (May 30, 1983), rpt. in J. Michael Lennon, ed., *Conversations with Norman Mailer* (Jackson, MS: UP of Mississippi, 1988), 299.

68. See George Wickes, ed., *Lawrence Durrell—Henry Miller: A Private Correspondence* (New York: Dutton, 1963), 5, and Michiko Kakutani, "Mailer Talking," *Conversations with Norman Mailer*, ed. J. Michael Lennon (Jackson, MS: UP of Mississippi, 1988), 298.

69. George Stade, "A Chthonic Novel," *New Republic* 188.17 (May 2, 1983): 32.

70. James Gifford notes in "'The Frontiers of Love': Sexual and Territorial Ambiguity in Lawrence Durrell's *Monsieur*," forthcoming *Deus Loci*, that Durrell originally wanted the phrase to read "an investigation of *bisexual* love," but "Faber objected and so it became the anodyne and meaningless 'investigation of modern love.'"

71. See Durrell's comments on his colonial background in Joan Goulianos, "A Conversation with Lawrence Durrell About Art, Analysis, and Politics," *Modern Fiction Studies* 17 (1971): 164–65.

72. Wickes, *Lawrence Durrell*, 189–90; emphasis added.

73. Wickes, *Lawrence Durrell*, 190, 195.

74. The analysis that follows is a much abbreviated version of my discussion of the modernist implications of this "return of the repressed" in *Libidinal Currents: Sexuality and the Shaping of Modernism* (Chicago: U of Chicago P, 1998), 364–88.

75. For this insight and many others, I am intended to David Wingrove's superb paper, "Dance of the Dominos: Narrative and Sex-Roles in Durrell's *Balthazar*" (Harvard, April 1985).

76. Richard Poirier, "In Pyramid and Palace," *Times Literary Supplement* (June 10, 1983): 591.

77. Stade, "A Chthonic Novel," 24.

78. For Benjamin DeMott, the novel neglects its ancient subjects in favor of "the preoccupations and obsessions of a late 20th century mind—Norman Mailer's." See "Norman Mailer's Egypt Novel," *The New York Times Book Review* (April 10, 1983), 1:24–36, rpt. *Contemporary Literary Criticism*, 258. According to Harold Bloom, *Criticism*, the novel only masks itself as a historical fiction, for its actual "relevance [is] to current

reality in America" (260). Anthony Burgess concurs: "Mailer's eye is on the modern age, especially the psychic problems of America." See Burgess, *99 Novels: The Best in English Since 1939* (New York: Summit Books, 1984), 133. Nigel Leigh, *Radical Fictions and the Novels of Norman Mailer* (New York: St. Martin's P, 1990), writes that the novel is "a reckoning with a repressed set of values from which modernity only appears to have been liberated" (177).

79. Anthony Burgess, "Magical Droppings," *The Observer* (June 5, 1983): 30, quoted in Bloom, ed., *Contemporary Literary Criticism*, 262.

80. Joseph Epstein, "Mailer Hits Bottom," *Commentary* (June 1983): 2, 68; James Wolcott, "Enter the Mummy," *Harper's* (May 1983): 83.

81. Michael K. Glenday, *Modern Novelists: Norman Mailer* (New York: St. Martin's, 1995), 115.

82. George Plimpton, "Critical Pounding," 299.

83. Wolcott, "Mummy," 83. Likewise, the headline for an interview with Mailer in *The Los Angeles Herald Examiner* read "Norman Mailer Finally Delivers 'The Big One'" (February 23, 1983): C1.

84. Mailer, *Advertisements for Myself* (New York: Putnams, 1959), 412.

85. Digby Diehl, "Norman Mailer Finally Delivers the 'Big One,'" article-interview in *The Los Angeles Herald Examiner* (February 23, 1983): C1, 6.

86. Robert Begiebing, "Twelfth Round: An Interview with Norman Mailer," *Harvard Magazine* 85 (1983): 40, 42–50, rpt. in Lennon, ed., *Conversations*, 323.

87. Quotations are from, respectively, Davis, "Excess," 14; Christopher Lehmann-Haupt, "Books of the Times," *The New York Times Book Review* (April 4, 1983):C17; Bloom, "Norman in Egypt," *Contemporary Literary Criticism*, 262; Bloom, "Norman in Egypt," 262; Walter Clemons, *Vanity Fair* (May 1983): 657; Lehmann-Haupt: C17; DeMott, "Egypt Novel," *Contemporary Literary Criticism*, 259.

88. Epstein, "Mailer Hits Bottom," 82; Ian Hamilton, "Mummies," *London Review of Books* (June 16, 1985): 307.

89. Paul Gray, "And Now, the Book," *Time* 121.16 (April 18, 1983): 85.

90. Norman Mailer, *Ancient Evenings* (Boston: Little, Brown, 1983), 70, 140, 149, 267, 311, 587, 618. Subsequent page numbers are included in parentheses in the text.

91. Epstein, "Mailer Hits Bottom," 68. "[E]ven the most avid enthusiasts of buggery," Harold Bloom, "Norman in Egypt," wryly notes, "may flinch at confronting Mailer's narrative exuberance in heaping up sodomistic rapes" (260).

92. The two exceptions are Bloom, "Norman in Egypt," 261, and Richard Poirier, "In Pyramid and Palace," *Times Literary Supplement* (June 10, 1983): 591–92, who both tie Mailer's fascination with anality to his metaphysics of being and non-being. Neither, however, queries the sheer amount of corporeal desire that infuses Mailer's descriptions.

93. Themes of male homosexuality and anal sodomy recur throughout Mailer's career, but only in this novel do they take on such an overwhelming degree of intensity and descriptive pleasure. Gary Snyder assesses Mailer's complicated attitude toward homosexuality in *The American Dream* and *Why Are We in Vietnam?* in "Crises of Masculinity: Homosocial Desire and Homosexual Panic in the Critical Cold War Narratives of Mailer and Coover," *Critique* 48.3 (Spring 2007): 250–77.

94. This homosocial triangulation creates what James M. Mellard refers to as "Mailer's fundamental 'hommosexuality,'" since "in Mailer's universe, there is really only one sex, and that one is male." See "Origins, Language, and the Constitution of Reality: Norman Mailer's *Ancient Evenings*," *Traditions, Voices, and Dreams: The American*

Novel Since the 1960s, ed. Melvin J. Friedman and Ben Seigal (Newark, DE: U of Delaware P, 1995), 140.

95. Mellard, "Origins, Language," 144, also notes that both Menenhetet plots take on the shape of "paternal romance" in the latter segments of the novel.

96. Leo Bersani, "Is the Rectum a Grave?" *AIDS: Cultural Analysis/Cultural Activism*, ed. Douglas Crimp (Cambridge, MA: MIT P, 1987): 197–222.

97. This fear of the loss of corporeal integrity and ego boundaries is expressed in similar language by T. E. Lawrence in his account of the feelings he experiences when raped and beaten by the Bey's soldiers at Der'a: "That night the citadel of my integrity [was] irrevocably lost." See *Seven Pillars of Wisdom: A Triumph* (1926; London: Penguin, 1963), 456.

98. Christopher Ricks, "Mailer's Primal Words," *Grand Street* 3 (1983): 161–72, offers a superb exegesis of Mailer's approximations of Egyptian language-play in the novel's metaphors and linguistic puns. He achieves this density not only through his knowledge of ancient Egyptian etymologies but through subtle word plays that no other reviewers came close to realizing: note, for instance, how the phrase, "the *loins* of this *lion* [Ramses's pet animal] . . . began to swell," incorporates the word "lion" inside "loins," an instance of what Ricks, 166, calls verbal metamorphosis, or the fact that "*seams* mixes or unties *same*" (Ricks 164) when Meni declares, "It is the *same*. I always mixed one with the other, and then the *seams* came apart in My head. All untied!" (emphasis added).

99. Poirer, "Pyramid and Palace," 91.

100. Carl Rollyson, *The Lives of Norman Mailer* (New York: Paragon, 1991), 322.

101. Plimpton, "Critical Pounding," 305.

5. COLONIALISM AND ITS AFTERMATHS, GIDE TO CHAHINE: EGYPTIAN STORIES II

1. Najīb Mahfūz, *Midaq Alley, The Thief and the Dogs, Miramir* [*Midaq Alley* trans. Trevor Le Gassick] (New York: Quality Paperback/Anchor, 1989), 55–56. Subsequent page numbers are included in parentheses in the text.

2. "*Eros e cultura*: Interview with Massimo Fino," *Europeo* (October 19, 1974), quoted in Naomi Greene, *Pier Paulo Pasolini: Cinema as Heresy* (Princeton, NJ: Princeton UP, 1990), 183.

3. André Gide, *Voyage au Congo, Le retour du Tchad, Retour de l'U.R.S.S., Retouches à mon retour de l'U.R.S.S., Carnets d'Égypte*, Preface by Gilles Leroy (Paris: Gallimard, 1993), 543. Subsequent page numbers are included in parentheses in the text. Translations are my own.

4. As David LeHardy Sweet notes in "Orientalist Divagations: Four French Authors in Egypt," *Studies in Travel Writing* 14.2 (2010), this swirl of propositions alternates with Gide's writing efforts—he is busy editing his private journal about his deceased wife, Madeleine, for publication as *Et nunc manet in te*. Ironically, this editing primarily consisted of deleting "the most compromising journal entries concerning his unconsummated marriage" (204). This textual and physical diminishing of Madeleine as his homoerotic desires increase echoes the ending of *L'immoraliste*, where the protagonist insures his wife's death by returning to the North African landscape that provides him fulfillment (205). Naomi Segal reads these two texts in tandem in "Gide in Egypt 1939," *Cultural Encounters: European Travel Writing in the 1930s*, ed. Charles Burdett and Derek Duncan (New York: Berghahn, 2002), 143–55. Aldrich comments on Gide's Egyptian notebook in *Colonialism and Homosexuality*, 331–34.

5. John Lahr, *Orton Diaries*, 12.

6. Robin Maugham, "Testament: Cairo, 1898," *The Boy From Beirut and Other Stories* (San Francisco: Gay Sunshine P, 1974), 14–15. Subsequent page numbers are included in parentheses in the text.

7. Joseph A. Massad, *Desiring Arabs*, see 273, 279–80, 284 on *Midaq Alley* and 388–89 on *Yacoubian Building*.

8. The term that Mahfūz uses to refer to Kirsha's sexual habits is *shudhnth* or "deviance." Massad notes that this term at the time referred broadly to all nonnormative sex or behavior (278). See also Nabil Matar, "Homosexuality in the Early Novels of Negeeb Mahfouz," *Journal of Homosexuality* 26.4 (1994):77–90.

9. 'Ala' al-Aswānī, *The Yacoubian Building*, trans. Humphrey Davies (2002; New York: Harper Perennial, 2004), 37, 131, 234. Subsequent page numbers are included in parentheses in the text.

10. For instance, Rubbah's neighbors on the building's roof "kno[w] the truth" of his actual relation to Hatim "and accep[t] it. In general their behavior with any deviant person depended on how much they liked him . . . telling one another that everything in the end was fate" (154–55).

11. Richard Corliss, "Youssef Chahine: From Egypt with Love and Anger," *Time*, suppl. 172.6 (Aug. 11, 2008): 26.

12. The one earlier example of an Egyptian film foregrounding homosexuality was Salah Abu Seif's 1973 *The Malatili Baths* (Hammam al-Malatily), as noted in chapter 2. For overviews of the treatment of homosexuality in Egyptian cinema, see Garay Menicucci, "Unlocking the Arab Celluloid Closet," *Middle East Report* 206 (Spring 1998, special issue: "Power and Sexuality in the Middle East"): 32–36, and Omar Hassan, "Real Queer Arabs: The Tension Between Colonialism and Homosexuality in Egyptian Cinema," *Film International* 8.1 (2010): 18–24.

13. Literally so; as the friends exit, loitering outside by Adel's car, Yehia delivers a spontaneous soliloquy from *Hamlet* in front of the headlights.

14. The last film in the Quartet, *Alexandria . . . New York* (2004), currently unavailable on DVD, is a philosophical meditation on the post-9/11 era. The plot involves the elder Yehia traveling to New York for a film festival and encountering a son he fathered forty years ago while studying in California.

15. Chahine inserts a camp send-up of European *and* Egyptian notions of "monumentality" in a fantasy sequence in *Alexandria Now and Forever* that follows the Alexander-Not-So-Great musical sequence. It involves a Buster Keaton–like chase scene among the gigantic, sculpted body parts littering the workshop of the builder of Alexandria's lighthouse, where a huge statue of Alexander is being erected for the top of the lighthouse.

6. QUEER MODERNISM AND MIDDLE EASTERN POETIC GENRES: APPROPRIATIONS, FORGERIES, AND HOAXES

1. *Le livre des beaux, par Fazyl Bey, Traduit du Turc par un Pacha à Trois Queues* ([1909] rpt. Fontfroide: Bibliotheques Artistique and Littéraire, 1996), n.p. Subsequent page numbers are included in parentheses in the text with the notation "LB." Translations are my own. Thanks to Jack Yeager for his helpful suggestions.

2. Pinhas ben Nahum [pseud.], *The Turkish Art of Love* (New York: Panurge P, 1933), n.p. One surmises that "Pinhas" is a play on the word "penis" Nahum means "comforter."

3. For a transcript of the speech and answers to questions, see "President Ahmadinejad Delivers Remarks at Columbia University," *CQ Transcripts Wire*, for Monday,

September 24, 2007, on http://www.washingtonpost.com. For Ahmadinejad's use of the Farsi slang term *hamjensbaaz* (equivalent in English to "sodomize, faggot") as opposed to the politically correct term, *hamjensgara*, see Arsham Parsi, "Queer Iranians and Mr. Ahmadinejad in the Press," *Cheraq Magazine* 33 (October 1, 2007), at http://www.cheraq.net/33/arsham.htm.

4. Paul Sprachman translates the entire poem in *Suppressed Persian: An Anthology of Forbidden Literature* (Costa Mesa, CA: Mazda P, 1995), 82–83. Iraj Mirza's tongue-in-cheek vitriol is complicated, as noted by Janet Afary, *Sexual Politics in Modern Iran* (Cambridge: Cambridge UP, 2009), 93–94, by the fact that the poet was well known as a lover of male youth and author of homoerotic ghazals before his political alliance with the Constitutionalist movement "converted" him to heterosexual advocacy. Afsaneh Njamabadi, *Women with Moustaches and Men Without Beards: Gender and Sexual Anxieties of Iranian Modernity* (Berkeley: U California P, 2005), 149, cites the poem in her analysis of the excision of homoerotic relations entailed by the birth of Iranian feminism.

5. Although sodomy was criminalized in the Iranian Penal Code in 1925 (article 207), the law had little effect on daily life during the Pahlavi period. Willem Floor, *A Social History of Sexual Relations in Iran* (Washington, DC: Mage, 2008), reports that upon the establishment of the Islamic Republic of Iran in 1979, "hundreds of political opponents were executed on the grounds of having engaged in sodomy"; the new Penal Code instituted in the early 1990s added articles 108–126 defining the crime and punishment of sodomy in great detail. Ironically, a 1978 decree allowed for sex-change surgery, since it is not mentioned in the Qur'an, as a "remedy" for male homosexuals. See Floor, *Social History*, 352–61. State sanctioning of homophobic violence isn't unique to Iran, but part of a growing pattern across the Middle East. In addition to the Queen Boat prosecutions detailed in chap. 1, see, on Saudi Arabia, "Islam's Loathing and Lust for Homosexuality" (October 19, 2007), on the website http://www.islamicmonitor.org; "Hate Army Beats Gay Students" on the website of Iraqi LGBT; Molly Hennessy-Fiske, "Since Invasion, Gays in Iraq Lead Lives of Constant Fear," *Los Angeles Times* (August 5, 2007): A6; Liz Sly, "Gays Being Targeted and Killed in Iraq," *Los Angeles Times* (August 18, 2009): A19; and Brian Whittaker, *Unspeakable Love: Gay and Lesbian Life in the Middle East* (London: Saki, 2006). Even in Turkey, as of 2011 the Telecommunications Directorate of the secular state has banned the word "gay," its Turkish pronunciation "gey," and a cluster of related words from Turkish internet domains.

6. Dan Coleman, "Satirizing Ahmadinejad: The *New Yorker* Picks Up Where *Saturday Night Live* Left Off" (October 8, 2007), on http://www.openculture.com.

7. See Franklin Lewis, "The Transformation of the Persian Ghazal," *Ghazal as World Literature*, 121–27; Robert Irwin, *Night and Horses and the Desert: An Anthology of Classical Arabic Literature* (Woodstock, NY: Overlook, 2000), 42–56, 122; and Thomas Bauer, "The Arabic Ghazal: Formal and Thematic Aspects of a Problematic Genre," in *Ghazal as World Literature II: From a Literary Genre to a Great Tradition: The Ottoman Gazel in Context*, ed. Angelika Neuwirth, Michael Hess, Judith Pfeiffer, and Borte Sagaster (Wurzburg: Ergon Verlag, 2006), 2–9.

8. Variant spellings are *ghazel* and *gazel*. It derives from the Arabic verb for "to spin" and later became spuriously linked to the Arabic word for gazelle because of the animal's shy grace.

9. Quoted in Ahmad al-Tīfāshī, *The Delight of Hearts, or What You Will Not Find in Any Book*, trans. Edward A. Lacey (San Francisco: Gay Sunshine P, 1988), 63.

10. Mustafa Âli, *Counsel for Sultans*, trans. and ed. Andreas Tietze, 2 vols. (Vienna: Akademie der Wissenschaften, 1979), 2:61.

11. Quoted in Sema Nilgun Erdogan, *Sexual Life in Ottoman Society* (Istanbul: Donence Basim ve Yayin Hizmetleri, 1996), 92–93.

12. On the tradition of obscene, bawdy, and erotic genres as it first developed in Arab and then Persian literatures, see Sprachman, *Suppressed Persian*. Since the early medieval period, *sokuf* and *mujun* genres mixed ribald prose and poetry, their themes typically those of "sodomy, pederasty, pimping, and adultery" (xiii).

13. Gazali (also known as Deli Birader), *The Book that Repels Sorrows and Removes Anxieties*, trans. Selim S. Kuru in *A Sixteenth Century Scholar: Deli Birader and his Dāfi'ü'l-gumūm ve rāfi'ü'l-humūm* (Cambridge, MA: Harvard Dept. of Near Eastern Languages and Civilizations, 2000), 179. See the discussion of this work in chap. 3.

14. See chap. 2, n.11, on the rise of the genre and its basic features. Selim S. Kuru notes the innovations of Ottoman poet İshak Çelebi in "Naming the Beloved in Ottoman Turkish Gazel: The Case of İshak Çelebi" (d. 1537/1538), *Ghazal as World Literature II*, 163–73. Lists of extant *şehrengiz* about Istanbul can be found in Agâh Sirri Levend, *Türk Edebiyatinda şehrengizler ve şehrengizlerde İstanbul* (İstanbul: İstanbul Enstitüsü Yayinlari, 1957) and İsmail Hakki Akosyak, "Gelibolulu Mustafa Âli'nin Gelibolu Şehrengîzi," *Türklük Bilimi Araştrimalari* 36 (1996): 157–72.

15. Quoted in Sunil Sharma, "Generic Innovations in Sayfī Buhārā-ī's Shahrashub Ghazals," *Ghazal as World Literature II*, 146.

16. Quoted in Erdogan, *Sexual Life*, 90.

17. Quoted in Walter G. Andrews and Mehmet Kalpakli, *The Age of Beloveds: Love and the Beloved in Early-Modern Ottoman and European Culture and Society* (Durham: Duke UP, 2005), 41.

18. Jan Schmidt, *The Joys of Philology: Studies in Ottoman Literature, History and Orientalism (1500–1923): Volume 1: Poetry, Historiography, Biography and Autobiography* (Istanbul: Isis P, 2002), 36–40. A companion volume, *Zenan-name*, enumerates the beautiful women of the world; its verse portraits are far less complimentary than those in *Huban-name*, reflecting the male elite's general misogyny. *Zenan-name* has been translated into various European languages and is included in vol. 3 of *Eastern Love*, ed. E. Powys Mathers (London: John Rodker for Subscribers, 1928).

19. Lines 65, 57, 59, respectively; the translation from the original was made in collaboration with Fatih Kursun. Kursun collated manuscripts in the Bağdatlı Vehbi collection (no. 1618) and the H. Hüsnü Paşa collection (no. 1009) in the Suleymaniye Library (Istanbul), and the Yazma Bağışlar manuscript (no. 4231 in Istanbul University Library). Although a similar narrative frame triggers the female portraits in *Zenan-name*, the first European translator, Jean-Adolphe Decourdemanche, changed the gender of Fazil's male bed partner to a woman, thereby obscuring the homoerotic play that gives rise to its portraits. See İrvin Cemil Schick, *The Erotic Margin: Sexuality and Spatiality in Alternist Discourse* (London: Verso, 1999), 181.

20. Along with Loti, Loüys, and Gide, the note mentions as a possible candidate Edmond Fazy, author of *La Nouvelle Sodome* (1907), whose style and content, however, share little in common with *Le livre des beaux*.

21. Robert Aldrich, *Colonialism and Homosexuality* (London: Routledge, 2003), 111–12.

22. The only twentieth-century translation into modern Turkish (expurgated) is Ercumend Muhib, *Hubanname ve Zenanname* (Istanbul: Yeni Sark Kitabevi, 1945). An earlier version appears to have been printed in Turkish in 1810.

23. Aldrich, *Colonialism and Homosexuality*, 12. Here, the anonymous author again reveals his familiarity with Middle Eastern poetic traditions: ghazal poetry typically included clever puns on the author's "signature" or poetic name (*takhallus*) in the final line of the verse.

24. As we shall also see in the case of Crowley, Burton figures as a patron saint among European homophiles.

25. While the original, line 12, does cite Abu Nuwas in context of the Abbasids, the reference to the *Nights* is the modern writer's interpolation. This reference may be another clue to the European status of the anonymous author, since the work had fallen out of favor in Ottoman court circles for hundreds of years, whereas it had been an overnight sensation in the West—the second-best-selling book next to the Christian Bible.

26. See al-Tīfāshī, *Delight of Hearts*, 129, where the youth from Homs, a Syrian city famous for its water mills, learns that his "shapely ass in Baghdad is a lot more profitable than a mill at Homs!" Compare to Fazil Bey's text, lines 18–19: "What counts here is the ass! Not the mill . . . what do you think the mill can yield compared to ass?" There is no reference to the death of the father or the summons home in Fazil's version; in his variant, the boy's home is Kufe, a city in Iraq.

27. Homi Bhabha, "The Other Question," *Screen* 24.6 (1983): 33.

28. The local-color touches and on-the-scene immediacy are the modern author's fabrication.

29. In Greek there is little differentiation between "s" and "sh" sounds, with both represented by the letter *sigma*; thus Fazil Bey is subtly playing on ethnic/national difference as well. Thanks to Fatih Kursun for these insights. In the French text, the author makes the same pun on "sik"/penis in the very first portrait, where the beau of the Indies is identified as a "Sikh"—a footnote appears on the same page to make sure we get the lewd joke. The fact that this portrait does not appear in the original *Huban-name* underlines the degree to which the joke is the work of the modern creator.

30. In this dramatization, the modern author condenses a series of unrelated, scattered references in the original into a unified set piece reflecting his own creative imagination.

31. Orhan Pamuk, *Istanbul: Memories and the City* (London: Faber, 2005), 81.

32. Schick, *Erotic Margin*, chap. 3, passim.

33. Schick, *Erotic Margin*, 192–94.

34. See Schick's discussion in *Erotic Margin*, 183–84.

35. Malek Alloula, *The Colonial Harem* (Minneapolis: U of Minnesota P, 1986). Visual pornography, especially in the form of the erotic postcard, exploded in the 1880s and 1890s. See Lisa Z. Sigel, "Filth in the Wrong People's Hands: Postcards and the Expansion of Pornography in Britain and the Atlantic World, 1880–1914," *Journal of Social History* 33.4 (2000): 859–85. While images showing genitalia were prohibited by the postal service, the British censors applied a different set of criteria to postcards representing "foreign" or "colonial subjects," allowing "images of naked men to pass if the subjects were 'natives'" (861).

36. What constitutes von Gloeden's "kitsch" quality for Barthes is his indiscriminate mixing of codes of antiquity and present-day peasant boys without irony. See Barthes's untitled essay (orig. 1978) in *Taormina: Wilhelm von Gloeden*, ed. Jack Woody (Santa Fe, NM: Twelvetrees, 1997). Bruce Russell, "Wilhelm von Pluschow and Wilhelm von Gloeden: Two Photo Essays," *Studies in Visual Communication* 9.2 (1983): 57–80,

argues Barthes overlooks the degree of intention fueling von Gloeden's compositional juxtapositions and rejection of beaux-arts traditions. See the biographical commentary in Charles Leslie, *Wilhelm von Gloeden, Photographer: A Brief Introduction to His Life and Work* (New York: Soho Photographic Publishers, 1977).

37. Gert Schiff, "The Sun of Taormina," review essay in *The Print Collector's Newsletter* 9.6 (1979): 199. Jason Goldman comments on the surreptitious circulation of the more explicit images among von Gloeden's contemporary clientele in "'The Golden Age of Gay Porn': Nostalgia and the Photography of Wilhelm von Gloeden," *GLQ* 12.2 (2006): 237–58.

38. Intriguingly, Il Moro was the nickname that von Gloeden gave Pancrazio Bucini, the model who became his long-time lover and partner in the photographic enterprise. See Leslie, *Wilhelm von Gloeden*, 50.

39. The former identification occurs in Thomas Waugh, *Hard to Imagine: Gay Male Eroticism in Photography and Film from Their Beginnings to Stonewall* (New York: Columbia UP, 1996), 51; the same model is identified as Tunisian without a date in James Gardner, *Who's a Pretty Boy, Then? One Hundred and Fifty Years of Gay Life in Pictures* (London: Serpent's Tail, 1998), 21; Nicole Canet identifies the first as Tunis 1910 but similar poses by the same model as Tunis 1904 in *Photographies orientalistes 1903–1930*, ed. Canet (Paris: Galerie au Bonheur du Jour, 2004) and *Tunis intime, portraits et nus 1904–1910*, ed. Canet (Paris: Galerie au Bonheur du Jour, 2007).

40. See Lawrence Sutin, *Do What Thou Wilt: A Life of Aleister Crowley* (London: St Martin's Griffin, 2002) and Sandy Robertson, *The Aleister Crowley Scrapbook* (Berkshire, UK: Quantum, 1988).

41. Publication history appears in Martin P. Starr's introduction to the first facsimile edition of *The Scented Garden* (Chicago: Teitan P, 1991), 9–12; the quotation is from 10. Subsequent page numbers are included in parentheses in the text.

42. Starr, introduction, *The Scented Garden*, 5.

43. *The Confessions of Aleister Crowley: An Autohagiography*, ed. John Symonds and Kenneth Grant (New York: Hill and Wang, 1969), 451.

44. See Michael Berkowitz, "Rejecting Zion, Embracing the Orient: The Life and Death of Jacob Israel De Haan," *Orientalism and the Jews*, ed. Ivan Davidson Talmar and Derek Penslar (Waltham, MA: Brandeis UP, 2005), 11–14. Thanks to Moshe Sluhovsky for bringing De Haan to my attention.

45. *Kwatrijnen* has not been translated into English. The translations presented here are my own. Page numbers, included in parentheses in my text, refer to the Dutch edition found online at http://www.dbnl.org/auteurs/auteur.php?id=haan008. This quotation is from 77.

46. Translations into English tend to obscure the implied male gender of many of the objects of desire in Khayyám's quatrains.

47. I use Richard Howard's translation, *Amyntas: North African Journals* (1906; New York: Ecco P, 1988), reading it in tandem with the French original, *Amyntas* (Paris: Gallimard, 1925). Subsequent page numbers are included in parentheses in the text, an "A" signaling Howard's translation and a "G" marking the Gallimard edition.

48. André Gide, *The Immoralist*, trans. Richard Howard (1902; rpt. New York: Vintage, 1970), 52. See my reading of this novel in "Vacation Cruises; or, The Homoerotics of Orientalism," *PMLA* 110.1 (January 1995, special issue on "Colonialism and the Postcolonial Condition"): 101.

49. The homoerotics with which Gide imbues North Africa is inseparable from the economic and colonial factors that made Algeria available to him. For a reading of the

ambivalence in Gide's sexual/colonial politics, see Michael Lucey's excellent *Gide's Bent: Sexuality, Politics, Writing* (Oxford, UK: Oxford UP, 1995). Jonathan Dollimore reads *Amyntas* in *Sexual Dissidence: Augustine to Wilde, Freud to Foucault* (Oxford: Oxford UP, 1991), 240–44, as a pastoral narrative of loss and self-recovery that veils the extent to which privilege and power facilitate its appropriation of Africa's "otherness" for artistic emergence.

50. I examine Giliberti's artwork in greater detail in chap. 8.

51. Such suggestive but simultaneously elliptical wording recalls the rhetorical device of the *anacoluthon* that Barthes locates in *Aziyade*'s introduction of thoughts that never finish and "drift away." See Roland Barthes, "Pierre Loti: *Aziyade*," rpt. *New Critical Essays*, trans. Richard Howard (New York: Hill and Wang, 1980), 110, 119. Emily Apter, *André Gide and the Codes of Homotextuality* (Stanford, CA: Stanford French and Italian Studies, 1987), uses this trope to analyze the "unstated subtext of homoeroticism" that lies behind Michel's language in *L'immoraliste* (113–15).

52. Only one entry, dated November 13, 1904, comes close to glossing an actual sexual encounter. "On this abandoned divan," Gide writes in the one-sentence entry, "I shall inhale for a long while still the earthy, vegetal smell which the faun left behind; then, in the morning, wakened at dawn, I shall fling myself into the delicious air" (104).

53. Roland Barthes, *Incidents* (Paris: éditions du Seuil, 1987); I use this edition (marked ES) in tandem with the translation by Richard Howard (Berkeley: U of California P, 1992), in the following note.

54. Thus, at the Socco, the odd palette of colors worn by a dark-skinned youth, more than the boy himself, captures Barthes's gaze: "Young black: crème-de-menthe shirt, almond-green pants, orange socks, and apparently very soft red shoes" (18; ES 29); at the train station, he identifies a "certain Ahmed" by his "sky-blue sweater with a fine orange stain on the front" (22: ES 35). One could argue that the "incidental" nature of these moments allows these boys to remain part of a textual mosaic whose lives are never fully captured by Barthes's gaze or by their narrative framings. But the predominant feeling in reading *Incidents* is one of reductive depersonalization. Diana Knight discusses the ambiguities of Barthes's Orientalist sexual politics in this text in "Barthes and Orientalism," *New Literary History* 24.3 (Summer 1993): 617–33.

55. Thomas Dworzak, *Taliban*, with additional text by Jon Anderson and Thomas Rees (Great Britain: Trolley, 2003).

56. In the tinted Lehnert and Landrock image (see Plate 6), colorization adds to the image's sexual connotations, the rouge added to their lips and cheeks clearly feminizing the boys (colorization in other Lehnert images creates the impression of mascara and eye makeup). Sigel, "Filth in the Wrong People's Hands," hypothesizes the use of supplementary color in colonial postcards is meant to "accentuate the primitiveness of the scene" (862). This idea, while intriguing, may well be an over-reading, since many turn-of-the-century photographs in America and Europe were also tinted— some by the photographer, some at home—to bring the images "to life." In the era of pre-color photography and in situations where colorized photography is less affordable, tinting may have been and may continue to be a substitute that then becomes an aesthetic in itself, not simply a marker of the "primitive."

57. Anderson, in the section of *Taliban* titled "After the Revolution," notes that "Afghans from other regions joke about the high incidence of pederasty among Kandahari men. They say that when the crows fly over Kandahar they clamp one wing over their bottom, just in case" (n.p). In "Forbidden Taliban," a *Slate* online podcast featuring Dworzak's project, historian Ahmed Rachid comments on the region's "very strong

homosexual tradition" of older man and younger apprentice. Ironically, Mullah Omar's Taliban movement gained momentum, according to Rachid, when Omar killed a local warlord who was kidnapping young boys to serve as his concubines. Thence Omar emerged as a kind of Robin Hood figure protecting the poor against oppressive warlords. One of Omar's first acts was to ban homosexuality, but given long-standing tradition, it continued, albeit surreptitiously. In "Shh, It's an Open Secret: Warlords and Pedophilia," *New York Times* (Feb 21, 2002), Craig S. Smith confirms these origins of Taliban popular support and notes the resurgence of pederastic relations since the defeat of the Taliban (A4).

58. "I didn't take these pictures," Dworzak comments in *Taliban*, "I found them and wanted to make them public because I think they look great. A lot of people thought it was my way of representing the Taliban, that I went to Afghanistan, photographed the Taliban and made them look like Gilbert and George icons. . . . So I got a lot of criticism in Europe from the liberal Left who found it demeaning for me to make them look like this." See the *Slate* interview, cited in the prior note.

59. Jeff McMahon, "Painted Warriors of Kandahar" (book rev. of *Taliban*), *The Gay and Lesbian Review Worldwide* 11.1 (January–February 2004): 41–42.

7. LOOKING BACKWARD: HOMOEROTICISM IN MINIATURIST PAINTING AND ORIENTALIST ART

1. Kieron Devlin, "Islamic Art," *Encyclopedia of GLBTQ Culture*, gen. ed. Claude J. Summers (online encyclopedia at http://www.glbtq.com, 2002): 1.

2. Turkish scholarship is an exception to this generalization; see Metin And's extensive survey of Ottoman miniatures in *Osmanli tasvir sanatlari: I: Minyatir* (Istanbul: Turkiye Is Bankasi, 2004) and the plates of erotic artwork in Murat Bardakci's *Osmanli'da Seks* (Istanbul: Inkilap, 2005).

3. Carolyn Dinshaw, "Got Medieval?" *Journal of the History of Sexuality* 10.2 (April 2001): 212; and *Getting Medieval: Sexualities and Communities, Pre- and Postmodern* (Durham, NC: Duke UP, 1999), 1–20.

4. In order to focus on a given image's details, I sometimes crop the artwork in this and the next chapter. For the same reasons, I generally eliminate the borders and calligraphy of miniatures although I'm aware that they form part of the "total" artwork within the Persian and Ottoman aesthetic.

5. As Layla S. Diba notes in "Images of Power and the Power of Images: Intention and Response in Early Qajar Painting (1785–1834)," *Royal Persian Paintings: The Qajar Epoch 1785–1925*, ed. Diba with Maryam Ekhtiar (New York: Tauris P, 1998), Arnold's thesis was "so forcefully argued that, not withstanding subsequent numerous exceptions, its validity for the study of later Persian painting has rarely been questioned" (31). See Thomas W. Arnold, *Painting in Islam, A Study of the Place of Pictorial Art in Muslim Culture* (Oxford: Oxford UP, 1928).

6. See Diba, "Images of Power," 31; Jonathan Bloom and Sheila Blair, *Islamic Arts* (London: Phaidon, 1997), 3; Kjeld von Folsach, *For the Privileged Few: Islamic Miniature Painting from the David Collection* (Denmark: Louisiana Museum of Modern Art, 2007), 9–10; and Nicolas Tromans, ed., *The Lure of the East: British Orientalist Painting* (London: Tate, 2008), 20.

7. James M. Saslow, *Pictures and Passions: A History of Homosexuality in the Visual Arts* (New York: Viking, 1999), 148–49.

8. Translated in Anthony Welch and Stuart Cary Welch, *Arts of the Islamic Book: The Collection of Prince Sadruddin Aga Kahn* (Ithaca, NY: Cornell UP, 1982), 110.

9. British Library [hereafter BL], India Office MS 132, in Nora Titley, *Persian Miniature Painting and Its Influence on the Arts of Turkey and India: The British Library Collections* (Austin: U of Texas P, 1983), 20.

10. See Titley, *Persian Miniature Painting*, 92 and plate 13 on the illustration to this manuscript version of Sa'di's *Gülistan* (1513) at the British Library (OR 11847, f. 65b). A textual source for this familiar story is 'Arifi's Sufi poem *Guy u Chaugan* ("The Bull and the Polo-Stick"). See Eleanor Sims, with Boris I. Marshak, *Peerless Images: Persian Painting and its Sources* (New Haven, CT: Yale UP, 2002), 63.

11. Titley, *Persian Miniature Painting*, lists these and other inscriptions, 152, 157; her source is a British Library album (OR 2709) "produced for foreign travelers depicting Ottoman costumes, ranks, and occupations."

12. These include the tales "Doctor Visiting His Love-Sick Patient" (having fallen in love with his handsome doctor, the latter's desire is to remain ill "in order to maintain contact with his beloved"), "Sa'di Begging His Beloved to Stay," and the account of Sa'di's falling in love with a beautiful youth at the Great Mosque in Kashghar. For images representing these anecdotes, see, respectively, the image in the *Gülistan* assembled for Amir 'Ali-Shir Navā'i, in Abolala Soudavar, *Art of the Persian Courts: Selections from the Art and History Trust Collection* (New York: Rizzoli, 1992), 192; the image attributed to Mirzā 'Ali (c. 1565), in Sa'di's *Bustān* (Herat school, 1527), in Soudavar, 175; and the double-page illustration in Sa'di, *Gulistan* (late Timurid ms. of the Bukhara school, 1547), in Sims, *Peerless Images*, 248–49.

13. In the Walters Art Center's *Khamsa* (M.666) see the illustrations on folios 118b, 123a, 127a, 130a, and 134a and Gunsel Renda's excellent commentary on this manuscript in "An Illustrated 18th-Century Ottoman Hamse in the Walters Art Gallery," *The Journal of the Walters Art Gallery* 39 (1981): 15–32.

14. See "Yusuf Entertains at Court Before His Marriage," *Heft Awrang* (Freer Gallery of Art, 46.12, folio 132r), reproduced in Sims, *Peerless Images*, 124.

15. Titley, *Persian Miniature Painting*, 11. "Persian painting," notes Titley, "became interwoven with other cultures, both Eastern and Western, through the centuries."

16. Sims, *Peerless Images*, 65. See also Folsach, *Privileged Few*, 13; Titley, *Persian Miniature Painting*, 148, 151; and Stuart Cary Welch, *Wonders of the Age: Masterpieces of Early Safavid Painting, 1501–1576* (Cambridge, MA: Fogg Art Museum, 1979), 14.

17. Titley, *Persian Miniature Painting*, 151, 157–58.

18. William Ouseley, *Travels in Various Countries of the East; More Particularly Persia*, 3 vols. (London, 1823), 69.

19. Horatio Southgate, *Narrative of a Tour Through Armenia, Kurdistan, Persia and Mesopotamia: With Observations upon the Condition of Muhammadanism and Christianity in Those Countries*, 2 vols. (London, 1840), 1:75, 76.

20. Pietro Della Valle, *The Pilgrim: The Travels of Pietro Della Valle*, trans. George Bull (1658; London: Hutchinson, 1989), 127. See *A Turbaned Youth Leaning Against a Bolster*, a wall painting of a *ghilmān* in the 'Ali Qapu (Isfahan, c. 1610), and *Shah 'Abbas I Hosts a Convivial Gathering in a Garden*, painted on a wall in the Courtly Room of the Chihil Sutun Isfahan (after 1647), in Sims, 233 and 120 respectively.

21. Sims, *Peerless Images*, 227.

22. Sims, *Peerless Images*, 65–66, notes that a factor contributing to the emergence of single-page illustrations was the loss of patronage that occurred when Safavid Shah Tahmasp renounced the secular arts in the second half of his long reign, an act that forced royal studio artisans to find other means of profiting by their skills.

23. David J. Roxburgh, *The Persian Album, 1400–1600. From Dispersal to Collection* (New Haven, CT: Yale UP, 2005), 9.

24. Titley, *Persian Miniature Painting*, 148.

25. Read was keeper of British and Medieval Antiquities at the British Museum from 1896 to 1921.

26. Welch and Welch, *Arts*, 107. Riza flourished in Shah 'Abbas I's Isfahan court during the years 1587–1605 and 1615–1635. In the interval, he was reputed to have taken up with companions of "ill-repute" and "wrestlers," the latter profession often shorthand for a homosexual demimonde existing outside royal circles. This insinuation of Riza's sexual proclivities has led some modern art historians to betray their discomfort with the non-masculine traits of Riza's subjects, declaring that his portraits reek of the "green-yallery of decadence" (Titley, *Persian Miniature Painting*, 115) or feature unduly "degenerate . . . pre-Wertherian young men" (Folsach, *Privileged Few*, 144). Such wording betrays the degree to which they are projecting their own moral viewpoints on Riza's oeuvre.

27. In *Islamic and Indian Manuscripts and Painting in The Pierpont Morgan Library* (New York: Morgan Library, 1997), Barbara Schmitz aptly refers to this youth as a "haughty figure caught in the web of his surrounding rich accoutrements" (135).

28. Schmitz, *Islamic and Indian Manuscripts*, 125, provides the translation.

29. Schmitz, *Islamic and Indian Manuscripts*, 132, provides the translation.

30. Schmitz, *Islamic and Indian Manuscripts*, 130–31, notes that the fad of depicting Persian youths dressed in a mixture of English, Portuguese, and Dutch clothing was at its height between 1628 and 1678 and a particular trademark of Isfahan painting.

31. The 1630s dating of the European fashions worn by this dandy suggests this painting is self-reflexively paying homage to an earlier work (1635) that depicts the master Riza drawing the portrait of an European boy similarly holding an Iranian pot decorated with a painting of a graceful crane—symbolic of the youth's own grace.

32. "Youthful frolic" is the descriptor given the image in B[asil]. W[illiam]. Robinson, *Persian Paintings in the India Office Library: A Descriptive Catalogue* (London: Sotheby Parke Bernet, 1976), 185.

33. Welch and Welch, *Arts*, 127.

34. Sims, *Peerless Images*, 198, 200.

35. Marianna Shreve Simpson, *Persian Poetry, Painting, & Patronage: Illustrations in a Sixteenth-Century Masterpiece* (New Haven, CT: Yale UP, 1998), 103.

36. Sims, *Peerless Images*, 172, reads this water imagery as "an allegorical comment on the Sufi's everlasting quest for union and the inevitability of separation."

37. Translation in Simpson, *Persian Poetry*, 27.

38. Linda Nochlin, "The Imaginary Orient" (1983), rpt. *The Nineteenth-Century Visual Culture Reader*, ed. Vanessa R. Schwartz and Jeannene M. Przyblyski (New York: Routledge, 2004), 289–98.

39. Emily M. Weeks, "Cultures Crossed: John Frederick Lewis and the Art of Orientalist Painting," *The Lure of the East: British Orientalist Painting*, ed. Nicholas Tromans (London: Tate, 2008), 24, is summarizing other critics' views, not her own.

40. Nochlin, "The Imaginary Orient," 289.

41. Nochlin, "The Imaginary Orient," 290.

42. Roger Benjamin, *Orientalist Aesthetics: Art, Colonialism, and French North Africa, 1880–1930* (Berkeley: U California P, 2003), 4–5. In a similar vein, John M. MacKenzie, *Orientalism: History, Theory, and the Arts* (Manchester: Manchester UP, 1995), writes: "[I]n looking at Orientalist painting, we require not a theory of 'Otherness,' but a theory of cultural cross-reference" (55).

43. Weeks, "Cultures Crossed," 23.

44. Benjamin, *Orientalist Aesthetics*, 12, 25.

45. Eugène Fromentin, *Une année dans le Sahel* (1859), quoted in Benjamin, *Oriental-ist Aesthetics*, 19; see also Fromentin's *Un été dans le Sahara* (1876); the two books together constitute an aesthetics and ethics of artistic Orientalism.

46. Nochlin, "The Imaginary Orient," 292.

47. Two examples are William Holman Hunt's "A Street Scene in Cairo: The Lantern-Maker's Courtship" (1854–1857), in which, behind the suitors, one glimpses a top-hatted European striding in the opposite direction (with whip in hand!), and Adrien Dauzat's "Place du Gouvernment à Algiers" (1849), in which European and Algerian strollers evoke the aura, in Benjamin's phrase in *Orientalist Aesthetics*, of "the poly-glot city" (15).

48. Mary Roberts, *Intimate Outsiders: The Harem in Ottoman and Orientalist Art and Travel Literature* (Durham, NC: Duke UP, 2007), 8–11; Mary Roberts, "Gérôme in Istanbul," *Reconsidering Gérôme*, ed. Scott Allan and Mary Marton (Los Angeles: Getty Museum, 2010), 119–21.

49. Benjamin, *Orientalist Aesthetics*, 4.

50. Roger Benjamin, "Post-Colonial Taste? Non-Western Markets for Orientalist Paint-ing," *Orientalism: Delacroix to Klee*, ed. Roger Benjamin (Sidney: Thames and Hud-son, 1997), 32–40.

51. Olga Nefedova, *A Journey into the World of the Ottomans: The Art of Jean-Baptiste Van-mour (1671–1737)* (Milan: Skira, 2009), 15.

52. Christine Peltre, *Orientalism in Art*, trans. John Goodman (New York: Abbeville P, 1998), 37–38.

53. Edouard Papet, "'Father Polychrome' The Sculpture of Jean-Léon Gérôme," *The Spectacular Art of Jean-Léon Gérôme (1824–1904)* (Paris: Serka, 2010), 294; Roberts, "Gérôme in Istanbul," 120.

54. Mary G. Morton, "Gérôme in the Gilded Age," *The Spectacular Art of Jean-Leon Gérôme*, 210.

55. On qualities of light, see Peltre, *Orientalism in Art*, 9–10; on panorama and wide angles of vision, see Tromans, *Lure of the East*, 17. Likewise, Fromentin writes that the Oriental landscape "escapes every convention, it is outside any discipline, it trans-poses, it inverts everything" when attempting to frame one's field of vision. Quoted in Benjamin, *Orientalist Aesthetics*, 21. See also Alastair Wright on the influence of North Africa on Matisse's aesthetics in *Matisse and the Subject of Modernism* (Prince-ton, NJ: Princeton UP, 2005).

56. Devlin, "Islamic Art," 5, notes the contrast between the Middle East preference for open-ended geometric forms in its arabesque designs and the Greek preference for closed circles and polygons.

57. Scott A. Allan, "Gérôme Before the Tribunal: The Painter's Early Reception," *Spec-tacular Art of Gérôme*, 96. See also Naomi Schor, *Reading in Detail: Aesthetics and the Feminine* (New York: Methuen, 1987), and Weeks, "Cultures Crossed," 32, on compa-rable use of detail in Frederick Lewis.

58. Weeks, "Cultures Crossed," 24, here parodies polemical reactions spawned by pro forma applications of postcolonial theory.

59. Benjamin, *Orientalist Aesthetics*, 12.

60. Weeks, "Cultures Crossed," 25–23; the quotation is from 30.

61. Darcy Grimaldo Grigsby, *Extremities* (New Haven: Yale UP, 2002), 73, 83.

62. Weeks, "Cultures Crossed," 25.

63. Tromans, *Lure of the East*, 17; Fromentin, quoted in Benjamin, *Orientalist Aesthetics*, 19; emphasis added.

64. Weeks, "Cultures Crossed," 24; Nochlin, "The Imaginary Orient," 289. A less well-known but visually arresting companion-piece to Gérôme's "Snake Charmer" is Russian Orientalist Vasily Vereshchagin's "Selling a Slave Boy" (1872). Painted in the same decade, "Slave Boy" features the same essential elements—naked boy, buttocks facing the viewer and genitals facing the seated, elderly man who is examining him up close—in an opulent interior space; the tight framing of the encounter of potential purchaser and displayed boy, his discarded robe at his feet, adds an uneasily visceral quality that Gérôme's distancing of viewers and youthful spectacle renders more languid and dream-like.

65. Roberts, "Gérôme in Istanbul," 123–24.

66. Nochlin, "The Imaginary Orient," 291.

67. Carol Ockman, in *Ingres's Eroticized Bodies: Retracing the Serpentine Line* (New Haven, CT: Yale UP, 1995), forms a contrasting example of a feminist art historian arguing for the subtleties of male Orientalist artists' representation of male nudes.

68. See Nochlin, "The Imaginary Orient," 292; Rana Kabbani, "Regarding Orientalist Painting Today," *Lure of the East*, 43; Mary Anne Stevens, "Western Art and Its Encounter with the Islamic World 1798–1914," *The Orientalists: Delacroix to Matisse: European Painters in North Africa and the Near East* (London: Thames and Hudson, 1984), 21; Sophie Makariou and Charlotte Maury, "The Paradox of Realism: Gérôme in the Orient," *Spectacular Art*, 262–65.

69. Holly Edwards, "A Million and One Nights: Orientalism in America, 1870–1930," *Noble Dreams, Wicked Pleasures: Orientalism in America, 1870–1930*, ed. Holly Edwards (Princeton, NJ: Princeton UP with the Streling and Francine Clark Art Institute, 2000), 130.

70. Nochlin, The Imaginary Orient," 292.

71. Makariou and Maury, "Paradox," object to the "improbable nudity" (262) of the snake charmer as a sign of Gérôme's exploitation of the Middle East. In fact, as previous chapters have shown, a number of European commentators comment on unclothed boys working as street performers up to the early twentieth century.

72. Quoted in Louis Crompton, *Byron and Greek Love: Homophobia in 19th-Century England* (Berkeley: U of California P, 1985), 135. See Veli's biographer, William Plomer, *Ali, the Lion* (London: Jonathan Cape, 1936), 162, and Murray, "Male Homosexuality in Ottoman Albania," *Islamic Homosexualities: Culture, History, and Literature*, ed. Stephen O. Murray and Will Roscoe (New York: New York UP, 1997), 193.

73. A frequent traveler to the Middle East, Haag shared residences in Cairo as well as London with friend and fellow artist Frederick Goodhall, whose oeuvre not only includes various skimpily clad Middle Eastern women but a number of sensitive-looking youths.

74. Mary Morton, Cat. 159 entry, *The Spectacular Art of Jean-Leon Gérôme*, 277.

75. Bertrand Delanoë et. al., *Pierre Loti: Fantomes d'Orient* (Paris: Paris-Musées, 2006), 40.

76. Gerald M. Ackerman, *Charles Bargue, with the Collaboration of Jean-Leon Gérôme: Drawing Course* (Paris: ACR Edition, 2003), 291. Bargue was most well known for his collaboration with Gérôme in producing a book of anatomical designs to teach art students to draw and sculpt the human figure.

77. Ackerman, *Charles Bargue*, 298.

78. Barbara Wright, *Eugène Fromentin: A Life in Arts and Letters* (Bern: Peter Lang, 2000), 186–87.

79. Peltre, *Orientalism in Art*, 162.

80. The quotation is from Hugh Honour, *The Image of the Black in Western Art, Vol. 4, Parts 1 and 2* (Cambridge, MA: Harvard UP, 1989), 4: 2.112. Cited in Robert Aldrich, *Colonialism and Homosexuality* (London: Routledge, 2003), 153, who comments extensively and intelligently on the eroticism of this image.

81. J. G. P. Delaney, *Glyn Philpot: His Life and Art* (Brookfield, VT: Ashgate, 1999), 52.

82. Aldrich, *Colonialism and Homosexuality*, 159. The language of flowers as coded expressions of love is rife in Arabic literature. If the jasmine is worn over the right ear, it means that the beau's heart is already taken, explains Michel Mégnin, *Tunis 1900: Lehnert and Landrock photographes* (Paris: Amis de Paris-Mediterranée, 2005), 153. Preliminary sketches of these two figures, often nude, housed at the Courtauld Institute, accentuate the latent homoeroticism of this painting.

83. Three years after Smalls's article appeared, Grigsby published her even more in-depth reading of the homoerotic signifiers of this painting in *Extremities*. She makes the point that the actual revolt didn't involve Mamluks, who had already been expelled from Cairo. Hence Girodet's choice to populate the mosque with Mamluks and Arab Bedouins was deliberately anachronistic, reflecting his desire to inflate the painting's homoerotic charge given popular associations of the two latter groups with sodomy, which Grigsby amply documents.

84. James Smalls, "Homoeroticism and the Quest for Originality in Girodet's *Revolt at Cairo* (1810)," *Nineteenth-Century Contexts* 20 (1999): 455–488; quotations from 459, 461, and 467 respectively.

85. Smalls, "Homoeroticism," 475. Rather than Achilles, Peltre, *Orientalism in Art*, 71, refers to the Mamluk as the youth's "Oriental Leonidas" in her reading of the painting's "ambiguous" effect"—an intriguing description, given Jacques-Louis David's homoerotic rendering of the Greek hero in "Leonidas at Thermoplyae" (1814).

86. Smalls, "Homoeroticism," 468.

87. Klaus Theweleit, *Male Fantasies: Women, Floods, Bodies, History, Volume 1*, trans. Stephen Conway (1977; rpt. Minneapolis: U of Minnesota P, 1987), 224.

88. Peltre, *Orientalism in Art*, 230.

89. Grigsby makes this point in "Rumor, Contagion, and Colonization in Gros's Plague-Stricken of Jaffa [1804]," *Representations* 51 (1995) and the longer chapter on Gros in *Extremities*; this painting marks an exception, for the plague-ridden, dying French are the nude figures, reclining in positions usually assigned the "Oriental other," while the Arab physicians tending them are the fully clothed, noble personages.

8. LOOKING AGAIN: TWENTIETH- AND TWENTY-FIRST-CENTURY VISUAL CULTURES

1. Nicolas Tromans, "Introduction," *The Lure of the East: British Orientalist Painting*, ed. Nicholas Tromans (London: Tate, 2008), 16. See Diana Holman-Hunt, *My Grandfather, His Wives and Loves* (London: Hamilton, 1969), 121–22.

2. Jason Edwards, *Alfred Gilbert's Aestheticism: Gilbert Amongst Whistler, Wilde, Leighton, Pater, and Burne-Jones* (Burlington, VT: Ashgate, 2006), 3–4, 10, 16, 63–66.

3. Peter Wollen places the ornamental boldness, experimentalism, and gender-bending aspects of Bakst's Orientally inspired costume designs for this ballet in context of a specific moment in late decadence and early modernism before modernism's fetishizing of the machine eclipsed its embrace of the decorative in *Raiding the Icebox: Reflection on Twentieth-Century Culture* (Bloomington: Indiana UP, 1993), 1–34.

4. Robert Aldrich, *Colonialism and Homosexuality* (London: Routledge, 2003), 350–51. See also Claude Michel Cluny and Paul Placet, *Augiéras: Le Peintre* (Paris: Editions de la Difference, 2001).

5. Galustian's work can be seen on her website http://www.womansword.com. Figure 8.8 is a detail from "Examining Slaves," after Ettore Cercone (1890).

6. See the catalogue reproduced in Roland Barthes, *Wilhem von Gloeden: Interventi di Joseph Beuys, Michelangelo Pistoletto, Andy Warhol* (Naples: Amelio Editore, 1978).

7. In an interview with Giliberti in Paris in 2006, the artist confirmed my intuitions about his blending of the homoerotic and indigenous to form a counter-colonialist visual response to Orientalist stereotypes.

8. See Kaja Silverman, "White Skin, Brown Masks: The Double Mimesis; or, With Lawrence in Arabia," *Differences* 1.3 (1989): 17–19. See my reading of Lawrence in "Vacation Cruises; or, The Homoerotics of Orientalism," *PMLA* 110.1 (January 1995, special issue on "Colonialism and the Postcolonial Condition"): 96–99.

9. Matthew Rothschild, "McCarthyism Watch: S.F. Art Gallery Owner Beaten Up for Showing Anti-Torture Painting," *The Progressive* (June 3, 2004), rpt. http://www.commondreams.org.

10. See "Art Basel; Miami 2007, Clinton Fein, and the Abu Ghraib Prison Torture," on Patricia Helena Micolta's blog, "Eclectic Fusion" (December 2007), based on her discussions with Fein.

11. As Jasbir K. Puar, *Terrorist Assemblages: Homonationalism in Queer Times* (Durham, NC: Duke UP, 2007), 83–84, notes in her reading of Abu Ghraib, the guards' belief in the effectiveness of such torture depends on their stereotypical assumption that Arab men uniformly experience sexual shaming more intensely than Westerners—a stereotype equally deployed, in Puar's argument, to construct Muslims as perverse others.

12. As Fein noted in an e-mail exchange (February 26, 2012), in military vernacular "10" on a scale of one to ten is considered the worst possible thing that could happen to a person; thus his title ironically plays on the sense that being portrayed as gay "wasn't just [what] the torturers thought would be the ultimate humiliation for the detainees based on their culture and religion" but a sentiment shared by the torturers themselves.

13. Douglas Sladen, *Queer Things About Egypt* (Philadelphia: Lippincott, 1911), 413; quotations from 135 and 333 respectively.

14. On Day and Gibran's relationship, see Patricia J. Fanning, *Through an Uncommon Lens: The Life and Photography of F. Holland Day* (Amherst: U of Massachusetts P, 2008), 69–71. There is an ongoing debate about how to spell Gibran's first name. He was born Khalil, but his name was misspelled in a school registry as Kahlil, which he adapted on the title pages of his books.

15. Tirza True Latimer, "Balletomania: A Sexual Disorder?" *GLQ* 5.2 (1999): 173–97. See also Wollen, *Raiding the Icebox*.

16. Holly Edwards, "A Million and One Nights: Orientalism in America, 1870-1930," *Noble Dreams, Wicked Pleasures: Orientalism in America, 1870-1930*, ed. Holly Edwards (Princeton, NJ: Princeton UP with the Streling and Francine Clark Art Institute, 2000), comments on Fairbanks's transformation from rogue to "a well-muscled, enterprising, and romantic hero, generally bare to the waist," who projects "boyish charm, heroic chivalry, and a virile but traditional masculinity" (50–51).

17. In "Stealing the Spectacle: Gay Audiences and the Queering of Douglas Fairbanks's Body" *The Velvet Light Trap* 42 (Fall 1998), Daniell Cornell comments on how the

camera's objectification of Fairbanks's athletic body works in tandem with the production's Art-Deco set-designs—which connote decadence and excess (79)—and its exotic costuming to create a "queer" spectacle particularly geared to gay male audiences. He further notes that the "diaphanous material" of Fairbanks's trousers, "when combined with the highly lit and reflective set[,] allows the viewer to see his legs and the clearly defined bulge of an apparently well-endowed basket through these pants" (80–81).

18. See Anne Holliday's information on Stowitts's career on the website of the Hubert Stowitts Museum and Library at http://www.stowitts.org.

19. For a fascinating history of this film and its intersections with the Crowley legend, see David Del Valle, "Paul, Aleister, Rex, and Alice," *Camp David* website (March 25, 2010), at http://www.filmsinreview.com/camp-david.

20. See Simon Bischoff, ed., *Bowles, Photographs: "How could I send a picture into the desert?"* (Zurich: Scalo, 1994), 20–28.

21. I analyze *Love with a Few Hairs* as an implicit response to *L'immoraliste* in "Vacation Cruises," 99–104. On the conundrums posed by the literary translation/collaboration of Mrabet and Bowles, see Richard Patteson, "Paul Bowles/Mohammed Mrabet: Translation: Transformation, and Transcultural Discourse," *Journal of Narrative Technique* 22.3 (Fall 1992): 180–90.

22. See the "Charles Fred" link on Flickr, where they post their travel photography and Roffey's blog, http://charlesfred.blogspot.com.

23. Pivotal in bringing a gendered and feminist critique to the visual operations of pornography is Linda Williams, *Hard Core: Power, Pleasure, and the "Frenzy of the Visible"* (Berkeley: U of California P, 1989). This analysis is extended to ethnographic "exotic" subjects in Christian Hansen, Catherine Needham, and Bill Nichols, "Pornography, Ethnography, and the Discourse of Power," *Representing Reality: Issues and Concepts in Documentary*, ed. Bill Nichols (Bloomington: Indiana UP, 1991), 201–28. Todd D. Smith insightfully examines the implications of such theories for gay colonial pornography in "Gay Male Pornography and the East: Re-Orienting the Orient," *History of Photography* 18.1 (Spring 1994): 13–21. In "The 'World' of All-Male Pornography: On the Public Place of Moving-Image Sex in the Era of Pornographic Transnationalism," in *More Dirty Looks: Gender, Pornography, and Power*, ed. Pamela Church Gibson (London: British Film Institute, 2004), Rich C. Cante and Angelo Restivo deftly use the filmography of Kirsten Bjorn to challenge "the tendency in cultural studies today to automatically characterize . . . as 'orientalist'" any transnational porn filmed in the "underdeveloped or developing world as well as the formerly colonized developed world" (115, 113).

24. In the same illustration in the 1728 *Khamsa* in the Topkapi Palace Museum (R 816, folio 112b), the two copulating male partners have been rubbed out. Such defacement reminds us how many other similar illustrations may have disappeared over the centuries.

25. The manuscript is Sheikh Muhammad b. Mustafa al-Misri's *Tuhfat Al-Mulk* (1794–1795), an Ottoman translation of part of the Arabic manuscript, *Ruju as-Shaykh ila sibah* (1773). The calligraphy above the image shows traces of Sufi philosophy: "We are all here because of a sexual act . . . The union of two bodies is an act of extraordinary physical and emotional intimacy. The prelude, the process of seduction, the act itself, and the immediate aftermath provide the focus for the exhibition . . . as humans, we have developed elaborate social frameworks for its expression and its regulation." Translation appears on the blog "Treat Yourself to the Best."

26. A German classicist and philosopher, Friedrich Karl Forberg (1770–1848) inter-spersed his edition of the medieval Latin erotic poem sequence by Antonio Bec-cadelli, *Hermaphroditus*, with commentary and classical citations. The latter has commonly been published as a self-standing publication variously titled *De figuris Veneris* and *Manual of Classical Erotology*.

27. Todd D. Smith analyzes the Kinsey series in "Gay Male Pornography." Thomas Waugh in his magisterial *Hard to Imagine: Gay Male Eroticism in Photography and Film from Their Beginnings to Stonewall* (New York: Columbia UP, 1996), reproduces one of these images from a series of twelve that he located in the Piet collection at the Hague.

28. See, for example, Doctors Tranchant and Desvignes, *Les condamnes militaires pourdel-its militaires du Penitencier de Bossuet* (Paris: Minuet, 1911), 26–29, who recommend the construction of brothels for soldiers and natives alike to reduce the frequency of homosexuality among French soldiers stationed in Algeria.

29. Thanks to Timothy Cook for bringing this advertisement to my attention.

30. For an evocative reading of Cadinot's Orientalism, see Jaap Kooljman, "Pleasures of the Orient: Cadinot's Maghreb as Gay Male Pornotopia," *Indiscretions: At the Intersec-tion of Queer and Postcolonial Theory*, ed. Murat Aydemir (Amsterdam: Rodopi, 2011), 97–110.

31. The obvious clue to this deception lies in the press kit's description of the films' "hugely hung, *uncut* men" (emphasis added)—whereas most Arabs, in contrast to most Brazilians, are circumcised.

32. This marketing of the Middle East as a place to find "real" (i.e., hairy) men has led to the creation of gay tours to the region for male tourists in quest of "bear" culture, as Jared McCormick uncovers in his analysis of LebTours, which operated in Lebanon from 2007 to 2011, in "Hairy Chest, Will Travel: Tourism, Identity, and Sexuality in the Levant," *Journal of Middle East Women's Studies* 7.3 (Fall 2011): 71–97.

33. See Radvideo rev. (February 20, 2010), posted on the studio's website at http://www.ragingbull.com. *Arabesque* is periodically intercut with black-and-white footage from *The Sheik* and *Son of the Sheik*, creating an interface between the latter films' het-erosexual subject matter, the gay appeal attached to Valentino's persona, and this pornographic appropriation of the Sheik template.

34. Maxime Cervulle and Nick Rees-Roberts, "Queering the Orientalist Porn Package: Arab Men in French Gay Pornography," *New Cinemas: Journal of Contemporary Film* 6.3 (2008): 197–208. Royce Mahawatte examines the aesthetics of Clair's Studio Beurs series in "Loving the Other: Arab-Male Fetish Pornography and the Dark Con-tinent of Masculinity," in Gibson, *More Dirty Looks*, 127–36.

35. Cervulle and Rees-Roberts, "Queering," 206.

36. The cartoon is accompanied by a verse satire by a "Professor of the Noble Art of Self-Defence (the 'Pet's' Trainer)" who laments that since this weakling isn't "up to it yet"—that is, hasn't yet developed his fighting muscles and hence masculine self-sufficiency—"we have charge of, and don't mean to leave you, 'Pet,' / Till you are 'fit.'"

37. Joy James, "Madame Butterfly: Behind Every Great Woman . . .," *A Vision of the Ori-ent: Texts, Intertexts, and Contexts of* Madame Butterfly, ed. Jonathan Wisenthal et al. (Toronto: U. of Toronto P, 2006), points out that while Loti's position on top of the minaret puts him in the symbolic position of imperial omnipotence, he is too narcis-sistically enraptured with his mirror image to take advantage of this status.

38. Jeff Stein, Spytalk column: "CIA Unit's Wacky Idea: Depict Saddam as Gay," posted on *Washington Post* online (May 25, 2010).

39. Reproduced in Janet Afary, *Sexual Politics in Modern Iran* (Cambridge: Cambridge UP, 2009), 138; see Afary's discussion of the formation of the newspaper, its circulation in Iran, and its role in the feminist campaign for normative heterosexuality, 134–41.

40. The fact that Gleyre's drawing is of *Egyptian* peasants and that Busi's text deals with *Morocco* creates a disconnect that is telling in itself: advertising has no qualms in wrenching art out of its original context to create its messages.

41. See John M. Munro, *James Elroy Flecker* (Boston: Twayne, 1976), 32, 41, and 92. Photographs taken in Beirut show Flecker dressed in T. E. Lawrence's robes while posing for Lawrence's camera.

42. Martin Booth, *Dreaming of Samarkand* (New York: William Morrow, 1989), 33, 42.

43. The conjunction of Oriental film extravaganza and gay sensibility is palpable in the career of Jack Cole, choreographer for many of these films, who, according to Adrienne L. McLean, slyly infused their dance numbers with a camp sensibility and an inversion of visual gender codes to "enact a queer identity" (131). See "The Thousand Ways There Are to Move: Camp and Oriental Dance in Hollywood Musical," *Visions of the East: Orientalism on Film*, ed. Matthew Bernstein and Gaylyn Studlar (New Brunswick, NJ: Rutgers UP, 1997), 131–51.

44. E[dith]. M. Hull, *The Sheik* (1919; Boston: Small, Maynard, 1921), 2, 200. "The association of Araby with homoeroticism and boy love here has come full circle, as the 'Lady' in pants displaces the 'boy' as the object . . . of the . . . Sheik's desire," Marjorie Garber notes in *Vested Interests: Cross-Dressing and Cultural Anxiety* (New York: Routledge, 1992), 311.

45. Hull, *The Sheik*, 144.

46. See Garber's chapter, "The Chic of Araby," in *Vested Interests*.

47. See Miriam Hansen, "Pleasure, Ambivalence, Identification: Valentino and Female Spectatorship," *Cinema Journal* 25.4 (1986): 6–32, and Gaylyn Studlar, "Discourses of Gender and Ethnicity: The Construction and De(con)struction of Rudolph Valentino as Other," *Film Criticism* 13.2 (1989): 18–35.

48. See Kenneth Anger, "Rudy's Rep," *There Is a New Star in Heaven—Valentino: Biographie, Filmographie, Essays*, ed. Eva Orbanza (Berlin: Verlag, 1979), 105–7; Alexander Walker, *Rudolph Valentino* (London: Elm Tree Books, 1976), 119; and Noel Botham and Peter Donnelly, *Valentino: The Love God* (London: Everett, 1976), 198. Still under debate is the question of whether Valentino's "Sheikdom"—and the whole Hollywood apparatus transforming him into a heterosexual love god—in fact provided a cover for the actor's covert gay activities. Justin Spring's recent biography, *Secret Historian: The Life and Times of Samuel Steward, Professor, Tattoo Artist, and Sexual Renegade* (New York: Farrar, Straus and Giroux, 2010), notes that Steward listed Valentino as one of his sexual partners in his meticulously kept index of conquests, but Thomas Gladysz's "The Secret Historian and the Silent Film Star: One Was Gay" (August 31, 2010), *Huffington Post*, http://www.huffingtonpost.com/thomas-gladysz, counters that evidence.

49. Korda's film is a direct reworking of the silent version starring Douglas Fairbanks. Other adaptations include *Aladdin's Lamp* (1907), *Aladdin and his Wonderful Lamp* (1917), and *The Wonders of Aladdin* (1961).

50. Sabu's "gay" appeal for closeted youths growing up in pre-Stonewall America is noted by bloggers Durian Gray (obviously a pseudonym!), in "Remembering Sabu, 'The Elephant Boy'" (March 12, 2004) on the site "Sticky Rice: Gay Guide Asia and World"

and Mark Horn, in "How a Gay Boy Lost His Heart to India" (September 30, 2007) on "Another Queer Jewish Buddhist."

51. I comment on this event in "Rubbing Aladdin's Lamp," *Negotiating Lesbian and Gay Subjects*, ed. Monica Dorenkamp and Richard Henke (New York: Routledge, 1995),148–52. The fact that Howard Ashman, Academy Award–winning lyricist of *Aladdin's* songs, died of AIDS complications while the film was in production added to the cultural resonances of the event. Sean Griffin details the subliminal and overt connections between the gay community and Disney franchise in *Tinker Belles and Evil Queens: The Walt Disney Company from the Inside Out* (New York: NYU Press, 2000); he comments on the gay undertones of *Aladdin* on 190–94. The political resonances of representing the Middle East after 9/11 amid fears of Iraq and Iran's quest for nuclear power is the subject of Alan Nadel's analysis of the film in "A Whole New (Disney) World Order: Aladdin, Atomic Power, and the Muslim Middle East," in Bernstein and Studlar, eds., *Visions of the East*, 184–201.

52. Quoted in Naomi Greene, *Pier Paulo Pasolini: Cinema as Heresy* (Princeton, NJ: Princeton UP, 1990), 189. I discuss Pasolini's film at greater length in "Rubbing Aladdin's Lamp."

53. Pier Paulo Pasolini, "Interview with Paul Willeman," in *Pier Paulo Pasolini*, ed. Paul Willeman (London: British Film Institute, 1977), 76.

54. Quotations are from Pasolini, "Interview," 76, and Greene, *Pier Paulo Pasolini*, 184, respectively.

55. See Geoffrey Nowell-Smith, "Pasolini's Originality," in Willeman, ed., *Pier Paulo Pasolini*, 9–11.

56. The analogue in *Nights* is the tale of "Ali Shar and Zumurrud." See Sir Richard Burton, *The Book of the Thousand Nights and a Night: A Plain and Literal Translation of the Arabian Nights Entertainments*, trans. and ed. Sir Richard Burton, 10 vols. (London: Burton Club, 1885–1886), 4:191 and following. For reasons I have not been able to determine, Pasolini has changed Ali Shar's name to that of Nur al-Din, an unrelated character in the tales.

57. See "Abu Nuwas with the Three Boys and the Caliph Harun Al-Raschid," Burton, *Nights*, 5:64–67.

58. See "The Third Kalandar's Tale," Burton, *Nights*, 1:139–49.

59. Pasolini, "Interview," 77.

60. Pasolini, "Tetis," *Erotismo, eversione, merce* (Bologna: Cappelli, 1974), 100–101, quoted in Greene, *Pier Paulo Pasolini*, 183.

61. This and similar moments encode the unequal power dynamic between the sexes in the film, attesting to the misogyny that frequently accompanies Pasolini's homoeroticizing aesthetic. At the same time, Pasolini's thematic representation of women is more complex than immediately meets the eye. Throughout the film, women seem more actively in control than the hapless Nur al-Din, who has repeatedly to be saved from his various scrapes by their knowledge. Women, moreover, become the agents of the film's trajectory of narrative desire in one very significant regard: they are the possessors of books and of the knowledge of reading in this world.

62. See "Tale of Taj Al-Muluk and the Princess Dunya," Burton, *Nights*, 2:283–298 and 3:8–47.

63. Pasolini, "Interview," 76. See also Boone, "Rubbing Aladdin's Lamp," 159 and 166.

INDEX

Abbasid era, 19, 54, 64, 266–67, 460n25

'Abd al-Ramân III (Caliph), 8–9

Abbas Pasha (Viceroy), 195, 197

Abdullah Frères, 271, 338

Abu Ghraib, 378–82

Abu Nuwas, 18–20, 55–58, 64, 69, 95, 256, 260–61, 266–67, 417, 435–36n9, 436n10, 460n25

An Account of the Manners and Customs of the Modern Egyptians (Lane), 179, 452n30

Account of the Present State of the Ottoman Empire (Hill), 38, 40, 433n73

Ackermann, Gerald M, 467n76

al-Adīb, Jirjis, 441n75

Advertisements for Myself (Mailer), 211, 455n84

Afary, Janet, xxii, xxix, 18, 31, 76, 256, 410, 425n34, 438n42, 440n63, 458n4, 472n39

The Age of the Beloveds (Andrews and Kalpakli), xxiii, 424n13, 427n13, 427n15

Ahmad, Aijas, 429n34

Ahmadinejad, Mahmoud, 255–58

Akhenaton (Pharaoh), 176–77, 451n19

Aladdin (Disney version), 415–16

Aldrich, Robert, 263, 266, 266, 306, 354, 367, 403, 456n4, 468n80; *Colonialism and Homosexuality* 306, 403, 429n33; *Seduction of the Mediterranean* 439n55

Alex I Commenus, 29

Alexandria Now and Forever (Chahine), 249–252, 457n15

Alexander the Great, 171, 173, 174, 178, 249–52

Alexandria Quartet (Durrell), 164, 201–8, 209, 212, 214, 224, 230, 236, 237, 450n5

Alexandria . . . Why? (Chahine), 230, 233, 237–248, 252

Âli, Mustafa, 34, 59–60, 62, 64–65, 115, 178, 181, 188, 260–61, 428n18, 432n63, 441n75; *Counsel for Sultans* 261, 428n18; *Description of Cairo* 452n25; *Tables of Delicacies Concerning the Rules of Social Gatherings* 34–35, 38, 59, 62, 115, 427n16

'Ali ibn Nasir al-Kātib, Abū' l-Hasan, 439–40n59

'Ali Quli Jabbadar, 324

Allan, Scott A., 466n57

Alloula, Malek, xxx, 271, 384; *Colonial Harem* 271, 460n35

Alma-Tadema, Sir Lawrence, 77, 362, 364

Amrad (beardless youth), 48, 63, 64

Amer, Sahar, xxii, xxiii; *Crossing Borders* xxiii, 424n14

L'amour aux colonies (Sutor), 184, 453n46

Amyntas (Gide), xxxiii, 224–25, 290–98, 353, 461n47

Anacoluthon, 121, 462n51

Ancient Evenings (Mailer), 173, 202, 209–22, 251–52, 455n90

And, Metin, 102, 104, 463n2; *Pictorial History of Turkish Dancing* 102, 438n36

Anderson, Sonia, 430n40

"Andreas" (pseud.), 444n112

Andrews, Walter G. and Mehmet Kalpakli, xii, xxii, xxiii, 5, 10, 14–15, 26, 31, 35; *Age of the Beloveds* xxiii, 424n13, 427n13, 427n15, 441n77

Anger, Kenneth, 472n48

Une année dans le Sahel (Fromentin), 340, 466n45

Anon, *Le livre des beaux*, 255, 262–70, 281, 289, 296, 298, 457n1

Anon, *The Lustful Turk, or Lascivious Scenes from a Harum*, 91, 442n86

Anon, *The True Narrative Of A Wonderful Accident, Which Occur'd Upon The Execution of a Christian Slave at Aleppo in Turky*, xii, 6–11, 14, 15, 23, 29, 32, 426n8

Antony and Cleopatra (Shakespeare), 163–164, 168, 218, 449n1

Appadurai, Arjun, xxxi, 27, 430n44

Apter, Emily, 424n27, 429n33, 449n42, 462n51

Āqā Mirak, 72

Āqā Zamān, 320

Arab renaissance, 18–20

Arabian Sands (Thesiger), 63–64, 438n41

"Aref Nameh" (Iraj Mirza), 255–56, 458n4

'Arifi, 464n10

Arnold, Thomas W., 308, 463n5

Art Deco, 387, 469–70n17

Asher, Richard, 438n41

Âşık Çelebi, 80–81, 441n76

al-Aswānī, 'Ala, xxxiii, 224, 233, 235–37; *Yacobian Building* 233, 235–37, 457n9

Ataturk, Mustafa Kemal, 5

'Atayi, Nev'izade, 6, 10–16, 23, 34, 36, 43, 71, 75, 309, 398; *Heft han* 10–16, 34, 427n13; *Khamsa* 69, 72, 309, 398, 464n13, 470n24

Augiéras, François, 367–68

Avril, Paul (Edouard Henri), xix, 401–2

Aziyade (Loti), xxxiii, 112–13, 116, 120–22, 124–44, 154, 156, 160, 207, 214, 226, 232, 445n7

Babayan, Kathryn, xxii, xxiv, 256, 423n7, 423n8; *Islamicate Sexuality* xxii, 423n6

Al-Badrī, Abū i-Tuqā, 58

Bakst, Leon, 99, 364, 387, 468n3

Balthazar (Durrell), 204, 207, 214

Bardakci, Murat, 463n2

Bardash (passive partner), 32, 195–98

Bargue, Charles, 346–47, 373

Barnes, Djuna, 281

Barthes, Roland, 120–21, 271, 298, 446n19, 460n36, 462n54, 469n6; *Incidents* 298, 462n53

Baths. *See* Hamam, Dellak

Baudier, Michel, 36–38, 43, 99, 112, 113, 116 ; *Histoire générale du Serrail* 36–38, 433n71

Bauer, Thomas, 435n6

Bartholdy, Jacob Ludwig, 102, 444n106

Bayesid II (Sultan), 116

Beardsley, Aubrey, 96, 98

Beaton, Cecil, 91, 389

Beardless boys, 34–36, 59, 64, 119; defense of beards 64–65, 77

Beautiful boys or youths, 36, 37, 51, 54–67, 90, 107, 115, 146, 147, 152, 198, 225, 229, 259, 260–62, 263, 266–67, 268–69, 279, 306; age range 64–67, 227–28; as object of desire 54, 57, 58–60, 131, 135, 147, 149; gender assumptions about 63–64; in photography 271–79; in miniaturist art 306, 315, 317–24, 326–27, 329, 332, 334–35, 243–46. *See also* Amrad; *Ghilmān*

Béchard, Henri, 164

Before Homosexuality (El-Rouayheb), 47, 425n31

Behdad, Ali, xxvii, 3, 28, 99, 443n93, 454n65; *Belated Travelers* 3, 424n26

Belated Travelers (Behdad), 3, 424n26

Bembo, Ambrosio, 426n96

Ben-Naeh, Yaron, 432n66

Benjamin, Roger, 336–38, 466n50; *Orientalist Aesthetics* 336, 465n42

Begiebing, Robert, 455n86

Berber-name, 145

Berdache, 432n59

Berkowitz, Michael, 461n44

Bernstein, Richard, 442n81

Berrong, Richard M., 447n21

Bersani, Leo, 220–21, 456n96

Beuys, Joseph, 368–69

Bhabha, Homi, 268, 429n33, 460n27

Blair, Sheila, 308, 463n6

Blanch, Leslie, 124, 447n21

Bleys, Rudi, 429n33

Blitt, Barry, 258

Bloch, Iwan, 434n88

Bloom, Harold, 165, 450n6, 454n78, 455n91

Bloom, Jonathan, 463n6

Blount, Henry, 43–44, 45, 65, 181–82; *Voyage into the Levant* 43, 433n79

Bompard, Maurice, 443–44n103

Bonnat, Léon, 350–53

Book of a Thousand Nights (Burton), 434n91

Book of the Dead, 177

The Book That Repels Sorrows and Removes Anxieties (Gazali), 113, 118–120, 446n17

Boone, Joseph Allen, 424n19, 443n94, 443n74, 469n8, 470n21, 473n51

Booth, Martin, 412; *Dreaming of Samarkand* 412, 472n42

Bossu, P., 62, 437n31

Boswell, John, 430n48

Botero, Fernando, 378, 380

Botham, Noel, 472n48

Bouhdiba, Abdelwahab, 45–46, 78, 434n86

Bouilhet, Louis, 195–201, 244

Bowles, Paul, 17, 392, 470n21; *The Sheltering Sky* 17

Boy dancers. *See* Koçek

Bozcali, Sabiha, 449n46

Brookes, Douglas S., 432n63

Brothels. *See* Prostitution

Buckingham, James Silk, 40–43, 45, 433n78; *Travels in Mesopotamia* 43, 433n76

Burckhardt, J. R., 91–92

Burroughs, William S., 65, 439n50

Burgess, Anthony, 209, 454–55n78, 455n79

Burton, Sir Richard, 163–64, 184, 186, 266, 270, 282, 283, 434n91, 451n21, 460n24; *Book of a Thousand Nights* 434n91; *Personal Narrative of a Pilgrimage to El-Medina and Mecca* 184, 453n61

de Busbecq, Ogier G., 440n68

Busi, Aldo, 411

Byron, Lord (George Gordon), 61, 78, 442n86

Cadinot, Jean-Paul, 90, 406, 408

Carnets d'Égypte (Gide), xxxiii, 224–229, 290, 296, 456n3

Cairo Times, 21, 428n27

Çalış, Bahar Deniz, 427–28n16

Callaghan, Beth P., 453n61

Canby, Sheila, 439n48

Canet, Nicole, 461n39

Cante, Rich C., 470n23

Castration, fears of, 94, 99, 107, 405–6

Cervantes, 427n10

Cervulle, Maxime, 408, 471n34

Chahine, Youssef, xxxiii, 222, 224, 230, 233, 237–52; *Alexandria Now And Forever* 249–252, 457n15; *Alexandria . . . Why?* 230, 233, 237–249, 252; *Egyptian Story* 247, 249

Chakrabarty, Dipresh, xxii, xxviii, xxix, 121, 424n11

Chardin, Sir John, 32, 432n61

Charlemont, Eduard, 91–92, 94

Charlemont, Lord (James Caulfeild), 45, 116, 433n82

Chasseriau, Théodore, 357

de Chenier, Louis, 78, 441n71

Cicero, 450n8

Clark, Steve, 25, 27–28, 429n35

Clayson, Hollis, 94, 442n87

Clemons, Walter, 455n87

Cleopatra (film), 167–68

Cobbe, Francis, 181, 452n37

Coffee houses as homoerotic sites, 32–35, 102, 146, 178

Coleman, Dan, 257, 458n6

Colonizing Egypt (Mitchell), 188, 453n59

Colwell, Guy, 378–80

The Colonial Harem (Alloula), 271, 460n35

Colonialism and Homosexuality (Aldrich), 429n33

Confessions (Crowley), 461n43

Contact zone, 27, 111–12, 121

"The Contendings" (Chester Beatty Papyrus I), 174–75, 213, 450n13

Contrapuntalism, xxii, xxiv–xxvii, 6, 22, 28, 30, 53, 129, 113, 140, 142, 239, 296, 305, 337, 339, 415

Cook, Timothy, 471n29

Corliss, Richard, 457n11

Cornell, Daniell, 469n17

Counsel for Sultans (Mustafa Âli), 428n18

Covel, John, 102, 103–4, 444n108

Cradle of Erotica (Edwardes and Masters), 169, 185, 443n91

Critchfield, Richard, 186, 206, 236; *Shabbat, An Egyptian* 186, 453n50

Crompton, Louis, 434n92, 437n25

Cross-dressing, 104, 138, 145, 149, 188, 194, 271, 415, 418

Crossing Borders (Amer), xxiii, 424n14

Crowley, Aleister, 259, 261, 279–86, 290, 296, 299, 303, 389; *Confessions* 461n43; *Scented Garden* 279–86, 298, 461n41

Cruz-Malavé, Arnaldo, xxiv, 425n33

Culture and Imperialism (Said), xxii, xxv, 424n22

Dancing boy(s). *See also* koçek, khawal

Dankoff, Robert, 436–37n19

Daniel, Marc, 46, 432n67, 434n91

Daniel, Norman, 430n48, 431n51
Darkest Orient (Riza Bey), 183
Darling, Linda T., 446n16
Dauzat, Adrien, 466n47
Davidson, Michael, 439n51
Davis, Robert C., 29, 430n50
Davis, Robert Gorham, 164, 450n3
Day, Frederick Holland, 275, 292, 386
Decadent movement, 280, 286, 362
Defter-i aşk (Fazil Bey), 263
De Haan, Jacob Israel, 259, 286–90, 296,
 299 ; *Kwatrijnen* 286–90, 298, 461n45
Delacroix, Eugène, 88, 101, 338
Delaney, J. G. P., 354, 468n81
Deli Birader. *See* Gazali
The Delight of Hearts (al-Tīfāshī), 55, 74,
 267, 435n9
Della Valle, Pietro, 64, 181, 313, 426n9
Dellak (bath boy), 75, 78, 80, 85, 86, 150,
 195, 441n72. *See also* Hamam
Dellak-name-i Dilküşa (Dervish İsmail), 75,
 78, 145
DeMott, Benjamin, 454n78
Denon, Vivant, 82, 102, 164, 188, 444n107
Dervish İsmail, 75, 78–80; *Dellak-name-i
 Dilküşa* (Book of Bathboys) 75, 78, 145
Description of Cairo (Mustafa Âli), 452n25
Description of Istanbul (Lâtifî), 62–63,
 114–115, 438n34
Devlin, Kieron, 463n1
Deutsch, Ludwig, 444n103
Diaghilev, Sergei, 99, 364, 387, 388
Diba, Layla S., 308, 463n5
Diehl, Digby, 455n85
Dinshaw, Carolyn, 52, 307, 435n2
Dollimore, Jonathan, 462n49
Donnelly, Peter, 472n48
Dreaming of Samarkand (Booth), 412,
 472n42
Du Camp, Maxime, 193–95, 198
Duhousset, M. (Colonel), 443n102
Dumont, [Jean] (Sieur du Mont), 61, 437n27
Dupré, Louis, 60–61, 343, 344, 349–50,
 437n25
Durrell, Lawrence, xxxiv, 164, 170,
 201–9, 212, 214, 220, 222, 224, 230, 236,
 237–38, 292; *Alexandria Quartet* 164,
 201–9, 212, 214, 222, 230, 237, 450n5;
 Balthazar 204, 207, 214, 450n5; *Justine*
 203, 204, 205, 230, 450n5
Dworzak, Thomas, 299–303, 463h.58;
 Taliban 299–303, 462n55

Ebbing, I. B., 442n86
Eberhardt, Isabelle, xxviii
Edelman, Lee, 435n2
Edwardes, Allen, 169–170, 184, 186, 203;
 Erotica Judaica 450n10; *Jewel in the Lotus*
 443n99
Edwardes, Allen and R. E. L. Masters,
 169–170, 184–86, 203; *Cradle of Erotica*
 185, 443n91
Edwards, Holly, 342, 467n69
Edwards, Jason, 364, 468n2
Egyptian Story (Chahine), 247, 249
Eliot, T. S., 255
Eton, Sir W[illiam], 445n5
Epstein, Joseph, 209, 212, 455n80
Erdogan, Sema Nilgun, 459n11
Erotica and pornography, vii–xx, xxxiv, 81,
 86, 90, 113, 118–20, 147, 241, 261, 265,
 270–71, 279–80, 299, 347, 361, 372, 383,
 396, 401–2, 403, 406, 408
Erotica Judaica (Edwardes), 450n10
Erte (Roman de Triftoff), 388–89
Etienne (Dom Orejudos), 403–6, 419
Ethnopornography, xvii, xxxiv, 196, 270–71,
 275, 283, 291, 299, 347, 383, 408
Eunuch, 51, 99–101, 405
Evliya Çelebi, 38, 40, 44, 59–60, 115,
 430n41, 439n47; *Evliya Çelebi in Albania*
 430n41; *Evliya Çelebi in Diyarbeber*
 437n21; *Seyahatname* (Book of Travels)
 59–60, 115, 430n41
Evliya Çelebi in Diyarbeber, 437n21
Evliya Çelebi in Albania, 430n41

Fabrés y Costa, Antonio Maria, 443n103
Fairbanks, Douglas, 387, 414, 469n16,
 470n17
Farhat, Sherif, 21–22
Falkner, Silke, 8, 38, 427n11
Fanning, Patricia J., 469n14
Farrag, Sherif, 428n29
Fazil Bey Enderuni, 58, 60, 63, 102,
 262–70, 281, 289–90, 299; *Defter-i aşk*
 263; *Huban-name* ("Book of Beautiful
 Boys") 58–59, 63, 262–70, 444n106;
 Zenan-name ("Book of Women")
 459n18
Fazy, Edmond, 459n20
Fein, Clinton, 380–82, 469n12
Fellaheen, 181, 186, 229, 411
Felski, Rita, xxv, 424n21
"Fero" (pseudonym), 86

Il fiore delle mille et una notte (Pasolini), 416–21

Fitzgerald, William, 442n83

Flaubert, Gustave, xxxiii, 104, 164, 170, 181, 189, 193–201, 203, 208, 209, 211, 213, 220, 222, 237, 244, 252, 417, 452n36; *Madame Bovary* 201

Flecker, James Elroy, 412, 472n41

Floor, Willem, 458n5

Fleischer, Cornell H., 432n63

Folsach, Kjeld von, 308, 463n6

Forberg, Frederick Karl (also Frederick Chas. [Charles]), 401, 450n11, 471n26

Forster, E. M., 244, 271, 281; *Passage to India* 244

Fortuny, Mariano, 347, 373

Foucault, Michel, xxiii, xxx, 24, 116, 119, 226, 424n12, 434n98

France, Hector, xviii; *Musk, Hashish, and Blood* xviii, xix, 423n2

Freeman, Elizabeth, 435n2

Fromentin, Eugène, 337, 339, 340, 347, 349, 350, 466n55; *Une année dans le Sahel* 340, 466n45

Fuzûlî, 80

Galland, Antoine, 270

Galustian, Abelina, 368, 469n5

Garber, Marjorie, 414, 472n44

Gautier, Theophile, 94, 99, 443n89, 443n102

Gazali (nicknamed Deli Birader, born Mehmed of Bursa), 80–81, 113,116, 118–120, 144, 261; *The Book That Repels Sorrows And Removes Anxieties* 113, 118–120, 446n17

Geeter, George, 444n103

Gerig, Bruce L., 450–51n13

Gérôme, Jean-Léon, 54, 77, 86, 88, 89, 336, 338, 341–43, 344, 347, 467n64, 467n76; *The Snake Charmer* 54, 88, 89, 336, 341–43, 467n64

Ghawazee (Egyptian female dancer), 188, 192

Ghazal (lyric form), xxiii, 31, 54–58, 64, 80, 115, 259–262, 266, 280, 282–83, 285, 299, 306, 343, 346, 364, 372, 396, 431n57, 435n6, 458n8, 460n23

Ghilmān (fair youth), 48, 58, 64, 315

Gibran, Kahlil, 386, 469n14

Gibson, Mary Ellis, 433n78

Gide, André, xxxiii, 17, 222, 224–29, 237, 252, 259, 263, 265, 271, 290–298, 303, 353, 392; *Amyntas* xxxiii, 224–25, 290–98, 299, 353, 392, 461n47; *Carnets d'Égypt* (in *Voyage au Congo*) xxv, 224–229, 289, 297, 456n3; *L'immoraliste* 17, 290, 392, 428n19

Gifford, James, 454n70

Gilbert and George, 301

Giliberti, Michel, 292, 296, 372–78, 382, 395–96, 422; *Voyage secret: Tunisie* 372

Glenday, Michael K., 455n81

Goldberg, Jonathan, 426n5

Goldman, Jason, 461n37

de Goncourt, Edmond and Jules, 447n24, 448n31

Goodhall, Frederick, 467n73

Gopinath, Gayatri, 424n25

Gordon, Lucy Duff, 181, 452n37

Goulianos, Joan, 454n71

Gramaye, Johann Baptiste, 81, 442n80

Gray, Paul, 211, 455n89

Green, Naomi, 473n52

Greenberg, David F., 451n14

Griffin, Sean, 473n51

Grisby, Darcy Grimaldo, 306, 336, 339, 354, 466n61, 468n89

Gros, Antoine-Jean, 339, 468n89

Guillaume, Adam, 29–31

Gülistan (Sa'dī), 31, 309, 431n55, 464n10, 464n12

Gundermann, Christian, 447n21

Haag, Carl, 343–44, 467n73

Habib, Samar, 424n27

Hafez, 260

Haedo, Diego, 29, 430n50

Haft Awrang (Jāmī), 321, 323, 329, 332–35

Hall, Radclyffe, 281

Hamilton, Nigel, 452n33

hamam (baths), 51, 77–90, 145–46, 180, 191, 195–197, 200, 231, 329–332, 335, 367, 368, 383, 413, 440n62, 440n67, 440n68, 440n69, 441n70, 441n72, 442n83. *See also* Dellak

Hamam (film), xxxiii, 90, 113, 144, 152, 154–61, 226, 421

Hamamiyi poetry, 80, 441n72

Hamdi Bey, Osman, 338

Hansen, Miriam, 472n47

Harris, Frank, 447n24

Hassan el-Belbeissi, 194–96

Hassan, Omar, 457n12

Hattox, Ralph S., 432n62

Hayes, Jarrod, xxix, 425n30

Heart-Beguiling Araby (Tidrick), 91, 442n85

Hebb, David Delison, 427n10

Heft han (Nev'izade 'Atayi), 10–16, 34, 427n13

Hemingway, Ernest, 202

Herbert, Thomas, 60, 63, 102–3, 437n22

Hill, Aaron, 38, 40, 43, 116; *Account of the Present State of the Ottoman Empire* 38–40, 433n73

Hindley, John, 431n57

Hines, Nico, 426n6

Hirschfeld, Magnus, 386

Histoire générale du Serrail (Baudier), 36–38, 433n71

Homoerotics of Occidentalism, 62–63, 265, 319

Hoppe, Emil Otto, 386

Hopwood, Derek, 429n33, 452n32

Horus and Set myth, 174–75, 213–14, 220, 226

Howell, James, xxxiv, 425n45

Huban-name ["Book of Beautiful Boys"] (Fazil Bey), 58–59, 63, 262–70, 444n106

Hull, Edith, 91, 414; *The Sheik* 91, 414, 442n86, 472n44; *Son of the Sheik* 414

Hunt, William Holman, 362, 468n1

Hyam, Ronald, 429n33, 452n33

Hypervirility, 51, 90–96, 166, 168, 183, 186, 191, 208, 211, 217, 284, 407–8; and phallicism 57, 92, 95, 170, 171–73, 182–84, 186, 198, 211–12, 217, 219, 284, 419; paired with effeminacy 98

Hypotyposis, 8, 29

Ibn al-Mu'tazz, 64

Ibn al-Nafīs, 178

Ibn al-Nadim, 431n56

Ibn Dāniyāl, 62; "The Man Distracted by Passion and the Little Vagabond Orphan" 62, 451n22

Ibn Iskandar, Kai Kā'ūs, 431n55

Ibn Laden, Osama, 3–5, 21, 23, 409

Ibn Mustafa al-Misri, Sheikh Muhammad, 470n25

Ibn Qāsim, Ahmad, 46, 434n94

Ibn Sahl, 438n35

Ibn Warroq, 428n32

Ibrahim I (Sultan), 117

L'immoraliste (Gide), 17, 290, 392, 428n19

Incidents (Barthes), 298, 462n53

Ingres, Jean Auguste Dominique, 77, 88

Iraj Mirza, 255–57; "Aref Nameh" 458n4

Irwin, Robert, 26, 428n32, 435n6, 451n22

İshak Çelebi, 58, 459n14

Islamicate Sexuality (Babayan and Najmabadi), xiv, 423n6

Istanbul: Memories and the City (Pamuk), 144, 270, 449n44

İstanbul Ansiklopedisi (Koçu), xxxiii, 83, 85–86, 113, 138, 144–153, 412, 441n72

Jackson, Peter A., xxxi, 425n42

Jacobus, Dr. *See* Sutor.

Jahshawayh, 439–40n59

James, Joy, 471n37

Jāmī, 260, 310–11, 321; *Haft Awrang* 321, 323, 329, 332–35

Jarman, Derek, 176

al-Jāhiz, 58, 436n15

Janissaries, 26, 35, 62, 78, 86, 115, 117, 138, 262, 413, 441n72

Jewel in the Lotus (Edwardes), 443n99

Jewish Antiquities (Josephus), 168, 450n7

Jordan, Mark D., 9, 427n12

Josephus, 168–170; *Jewish Antiquities* 168, 450n7

Joyce, James, 145, 201, 258, 281

Justine (Durell), 205, 208, 230

Kabbani, Rana, 467n68

Kakutani, Michika, 454n68

Kanun (Ottoman administrative law), 18, 47, 140

Al-Kassim, Dina, xx, xxix, xxx, 48, 68, 149, 423n6

Kasim-i Envâyr, 324, 326–27

al-Kawkabānī, Ahmad al-Haymī, 80

Keppel, George, 444n107

Khamriyya (wine poetry), 54, 57

Khamsa (Nev'izade 'Atayi), 71–75, 309–10, 398, 464n13, 470n24

Khawal (male dancer), 188, 453n57. *See also* Köçek

Khayyám, Omar, 260, 287

Kinsey Institute, 402

Klunzinger, Carl Benjamin 104, 189–193, 206, 437n30

Knight, Diana, 462n54

Knolles, Richard, 61, 437n26

Köçek (boy dancer), xviii, 63, 102–107, 138–39, 188, 196, 268–69, 324, 409, 444n112, 448n35, 448n38

Koçu, Resat Ekrem, xxviii, xxxiii, 83, 86, 106, 113, 138, 144–53, 412–413; *İstanbul Ansiklopedisi* xxxiii, 83–86, 113, 138, 144–153, 412, 441n72

Kooljman, Jaap, 471n30

Korda, Alexander, 414–16

Kuchuk Hanem, 194, 198–99, 454n65

Külliyat (Sa'dī), 396, 401

Kuru, Selim, xiv, 436n12, 459n14

Kursun, Fatih, 440n60, 459n19, 460n29

Kwatrijnen (De Haan), 286–90, 298, 461n45

Landelle, Charles, 345–46

Lane, Christopher, 429n33

Lane, Edward, 104, 164, 179, 182, 187, 453n57; *Account of the Manners and Customs of the Modern Egyptians* 179, 452n30

Lane-Poole, Edward, 164

Lâtîfî, 62–63, 114–115; *Description of Istanbul* 62–63, 114–115, 438n34

Lattimer, Tirza True, 387, 469n15

Lawrence, D. H., 281

Lawrence, Karen, 429n33

Lawrence, T. E., 17, 96, 98, 367, 372, 412, 456n97; *Seven Pillars of Wisdom* 17, 443n94

Leask, Nigel, 28, 430n45

Lehnert, Rudolf, 67, 198, 275–80, 299, 302, 373, 389, 402, 439n53, 462n56; and Ernst Landrock, xxx, 152, 275–80, 383, 462n56, 468n82

Leigh, Nigel, 454–55n78

Leighton, Frederic, 364

Leo Africanus, 451n24

Lesbianism and/or sapphism, xxviii, 77–78, 101, 362, 412, 414, 449n46

Leslie, Charles, 460–61n36

Lettres persanes (Montesquieu), 270

Levi-Dhurmer, Lucien, 364

Lewis, Bernard, 432n62

Lewis, Franklin, 435n6

Lithgow, William, 35–36; *Totall Discourse, of the Rare Adventures* 35, 433n69

Le livre des beaux (anon.), 255, 262–70, 281, 289, 296, 298, 457n1

Liwāt, 46–47, 281, 434n100

Long, Scott, 20–21, 428n25, 428n31

Loti, Pierre (Louis Marie Julien Viaud), xxxiii, 104, 112–113, 116, 118, 120–144, 160, 214, 226, 232, 263, 265, 292, 296, 364, 409, 417; *Aziyade* xxxiii, 112–113, 116, 120–122, 124–44, 154, 156, 160, 207, 214, 226, 232, 445n7; *Marriage of Loti* 122; *Story of a Spahi* 122

Loüys, Pierre, 263, 265

Love, between males, 10–15, 31, 38–40, 41–43, 44, 45, 149, 216; egalitarian or reciprocal aspects 30–31, 72–74, 149, 176

Love with a Few Hairs (Mrabet), 392, 470n21

Lowe, Lisa, xxiii, 424n18

Lūṭī, 48, 281

Lucian, 170, 450n11

Lucey, Michael, 429n33

The Lustful Turk (anon.), 91, 442n86

Luther, Martin, 445n4

Luyken, Jan, 9

MacFarlane, Charles, 64, 430n41

Macfie, A. L., 429n38

Maclean, Gerald M., 433n79

MacKenzie, John M., 465n42

Madame Bovary (Flaubert), 201

Mahfūz, Najīb, xxxiii, 223, 224, 228, 233–35, 236; *Midaq Alley* 223, 233–236, 456n1

Mahmud (Muhammed) of Ghanzi and Ayaz, 31, 310, 431n55

Mahomet IV (Sultan), 117

Makariou, Sophie, 467n68, 467n71

Mahawatte, Royce, 471n34

Makhannath (male cross-dresser; also *Mukhannos*), 30; 438n39

Mailer, Norman, xxxiii, 164, 170, 173, 175, 201, 202, 209–22, 223, 236, 237, 252, 417; *Advertisements for Myself* 211, 455n84; *Ancient Evenings* 173, 202, 209–22, 251–52, 455n90

The Malatili Baths ("Hammam al-Malatily"), 90, 457n12

Male couples, artistic representations of, 320–24, 349–59

Mamluks, 25, 26, 30, 54, 58, 62, 77, 178–79, 188, 339, 354, 359, 431n51, 436n16, 437n32, 451n22, 452n27, 452n39, 468n83

"The Man Distracted by Passion and the Little Vagabond Orphan" (Ibn Dāniyāl), 62, 451n22

Manalansan, Martin F. *See* Cruz-Malavé.
Mandel, Gabrielle, 441n74
Manniche, Lisa, 450n12
Manwaring, George, 32, 34, 431n59
Marriage of Loti (Loti), 122
Martin, Adrienne L., 430n50
Mascarenhas, João, 81
Massad, Joseph A., xxii, xxxi, 18–20, 233, 425n30, 425n39
Masters, R.E.L. *See* Edwardes, Allen and R.E.L. Masters
Matar, Nabil, xxiii, 424n16, 457n8; *Turks, Moors, and Englishmen* xxiii
Maugham, Robin, 222, 224, 229–32, 240, 439n51; "Testament: Cairo" 224, 229–232, 240, 457n6
Maugham, Somerset, 389
Mazowar, Mark, 129, 448n32
McMahon, Jeff, 302, 463n59
McClintock, Anne, 429n33
McCormick, Jared, 471n32
McLean, Adrienne L., 472n43
McPherson, J. W., 182–83, 453n41
Mégnin, Michel, 468n82
Mehmet II (Sultan), 26, 61, 114
Mellard, James M., 454–55n94
Mektoub, Fantasie Arabe, xvii–xviii, 406
Menicucci, Garay, 442n84
Melman, Billie, 429n33
Midaq Alley ["Zuqaq al-Midaq"] (Mahfūz), 223, 233–236, 456n1
Miller, D. A., 423n5
Miller, Frank, 98
Miller, Henry, 202–3
Les mille et un jours (Pétis de la Croix), 270
Miniaturist painting in Middle East, 54, 58, 65, 69, 72, 74, 80–81, 263, 307–335, 349, 364, 396; album genre 314–15; dissemination of 312–13; self-reflexivity in 309, 319, 334–35
Mirza Ali, 56
Mitchell, Timothy 188, 453n50; *Colonizing Egypt* 188, 453n59
Modernism, 224–25, 255, 259, 267–68, 270–71, 280–81, 282, 284–85, 286, 287, 289, 290–91, 297, 298–99, 361, 364
Mohanty, Chandra Talpade, 429n33
Monserrat, Dominic, 176, 451n19
Montagu, Mary Wortley, Lady, 77, 440n68
Montesquieu, 270; *Lettres persanes* 270
Montgomery, Bernard, General, 180, 244
Montgomery, Brian, 452n32

Moreau, Gustave, 358
Morton, Mary G., 466n54
Moss, W. P., 365
"Mr. T. S." 60. *See* Roberts, A.
Mrabet, Mohammed, 392, 470n21; *Love with a Few Hairs* 392, 470n21
Muhammad (the Prophet), 14, 46, 102, 178, 434n91
Muhammad Ali (Viceroy of Egypt), 179
Muhammad al-Nawaji bin Hasan bin Ali bin Othman (Shams al-Din), 62
Muhammad Qāsim, 309, 320
Muhammad-Sherif, 76
Mu'īn Muṣavvir, 314, 319, 321
Mullins, Greg, 429n33
Munro, John M., 472n41
Murat III (Sultan), 102
Muray, Nickolas, 388–89
Musk, Hashish, and Blood (France), xviii, xix, 423n3
Murray, Stephen O., 431n51, 433n77, 440n64
My Name Is Red (Pamuk), 17, 428n20

Nadel, Alan, 473n51
Najmabadi, Afseneh, xii, xxiii, xxiv, xxix, xxx, 18, 48–49, 63, 68, 256, 425n32, 438n39, 458n4
Napolean, 82, 179, 265, 357
al-Nawaji, Muhammad, 437n33
Nefedova, Olga, 466n51
Neferkare (Pharoah) and General Sisene, 175–76, 213
Nefzawi, 281
Niankhkhum and Khnumhotep, tomb of, 176
Nijinsky, Vaslav, 258, 364, 386–88
Ninet, John, 179, 452n31
Nizamī-i Arūzī-i of Samarkand, 31
Nizami (of Ganja), 309, 427n13
Nochlin, Linda, 336, 341, 435n5
Nouÿ, Jean-Jules-Antoine Lecomte du, 100
Novell-Smith, Geoffrey, 473n55
Nudity, male, xix, xxx, 9, 78, 80, 81, 82–83, 86, 88, 146–47, 152, 180–86, 191, 205, 207, 273, 275, 277, 279, 288, 418–21; in art 329, 341–43, 354, 358–59, 364, 378–81, 384–85, 388, 401–5, 468n89

'Obeyd-e Zākāni, 64; *Rishnāma* ("The Book of the Beard") 64
Ockmann, Carol, 467n67
O'Connor, David, 440n62

Orientalism (Said), 23–27, 54, 429n33
Orientalist art, 336–59, 404; post-colonial critiques of 336–37; responses to critiques 336–41
Orientalist Aesthetics (Benjamin), 336–37, 465n42
Orton, Joe, 65, 67, 227, 415
Ouseley, William, 104, 313, 444n113
Özpetek, Ferzan, xxxiii, 90, 113, 144, 152, 154–61, 226, 421; *Hamam* ("Steam: The Turkish Bath") xxxiii, 90, 113, 144, 152, 154–61, 226, 421

Pamuk, Orhan, 17, 144–145, 270; *My Name Is Red* 17, 428n20; *Istanbul: Memories and the City* 144, 270, 449n44
A Passage to India (Forster), 244
Papet, Edouard, 466n53
Parkinson, R. B., 176, 450n13
Pasolini, Pier Paulo, 223, 416–21, 422; *Il fiore delle mille et una notte* 416–21
Pastoralism, 226, 229, 324, 461–62n49
Patrona Halil, 85, 413
Peçevi, Ibrāhīm, 32, 432n62; *Tarih-i Peçevi* 32
Pederasty, 5, 6, 9, 54, 57, 67, 68, 72, 99, 100, 103, 119, 178, 224, 281–82, 290, 342, 415, 426n3, 434n91, 434n98, 448n31, 462–63n57
Pedophilia, 63, 64, 65–66, 224, 230–32, 277, 279, 462–63n57
Pelagius, 8–10, 29
Peixeira, Pedro, 32, 432n60
Peltre, Christine, 351, 466n52
Pennell, C. R., 427n10
Perry, Charles, 187–188, 453n52
Personal Narrative of a Pilgrimage to El-Medina and Mecca (Burton), 184, 453n45
Pétis de la Croix, François, 270; *Les mille et un jours* 270
Petrov-Vodkin, Kuzma Sergeevich, 364–65
Philpot, Glyn, 353–54
Pictorial History of Turkish Dancing (And), 102, 438n36
Pierre and Gilles, 369–70, 372
Pingrose, Kathryn M., 443n99
Pinhas ben Nahum, 255, 434n88
Pitts, Joseph, 178, 453n26
"Plaint of the Lovelorn and Tears of the Disconsolate" (al-Safadī), 30–31
Plato, 446n18

Plimpton, George, 454n67
Poirer, Richard, 221, 454n76, 455n92
Polymorphous perversity, 96, 163, 170, 186, 194, 205, 207, 221, 230, 415
Polymorphous sexuality, 17, 119, 124, 168, 195, 197, 201, 202, 207, 208, 252, 342
Popper, William, 451n22
Pornography. *See* Erotica and pornography
Porter, Dennis, 28, 430n45, 453–54n63
Postmodernism, 368–72
Pouqueville, F[rancis]. C[harles]., 445n5
Pratt, Mary Louise, 27, 430n45
Present State of the Ottoman Empire (Ricaut), 113
Prostitution, 116, 180, 188,192, 195, 198, 206–7, 228, 230, 246, 292, 397–98; male prostitution 43, 62, 102, 188, 206
Proust, Marcel, 201
Puar, Jaspir K., xxxi, 4, 98, 257, 469n11; *Terrorist Assemblages* 257, 425n39

Quaintance, George, 185
Queen Boat arrests (Cairo), 19–23, 180
Queer theory, xx, xxi, xxiii, xxvi–xxvii, 16, 48–49, 52, 138–39, 307, 361, 435n2; and the Middle East xx, xxii, xvii–xix, xxv–xxvii, xxix–xxxi.
Queer Things About Egypt (Sladen), 385, 469n13
Qur'an, 46, 308, 377, 434n92, 458n5

Race, xviii, 62, 99, 115, 171, 178, 184–85, 195, 232, 238, 277, 279, 379, 389, 408, 412, 415, 453n47
Rape, 91, 216–17
Read, Sir Charles Hercules, 317–19
Realism, 121, 189, 190, 192, 193, 197, 268, 336, 340–42, 353, 359, 362, 369, 380, 381
Rees-Roberts, Nick, 408, 471n34
Régla, Paul de, 271
Regnault, Henri, 91–92, 94
Renda, Gunsel, 464n13
Repetition with a difference, 10, 14, 129, 133, 159, 226, 232, 389
Revani, 63
Return of the repressed, 204, 212, 214, 221
Ricaut, Paul, 113, 115, 116–18, 120, 144, 443n100, 446n16; *Present State of the Ottoman Empire* 113
Rich, Claudius James, 315
Richlin, Amy, 450n8
Ricks, Christopher, 456n98

Rishnāma ["The Book of the Beard"] ('Obeyd-e Zākāni), 64

Riza Bey, 183–184, 186, 206, 453n42; *Darkest Orient* 183

Riza-i 'Abbasi, 65, 314, 317, 465n26, 465n31

Roberts, A., 437n23, 438n37

Roberts, David, 164

Roberts, Mary, xxiii, xxvii, 337, 341, 424n15, 466n48

Rollyson, Carl, 221, 456n100

Román, David, xxxii, 425n44

Romanticism, 41, 99, 130, 133, 189–90, 192–93

Rome (HBO), 163, 166–69, 170, 187

Rosenthal, Franz, 436n15

Rosenbaum, Julius, 442n83

Roth, Norman, 438n35

Rothchild, Matthew, 469n9

El-Rouayheb, Khaled, xxii, xxix, 35, 47, 53, 431n57, 439n47, 439n54; *Before Homosexuality* 47, 425n31

Rowson, Everett K., xxii, 30, 431n51, 431n52, 437n32

Roxburgh, David J., 315, 464n23

Roy, Sundip, 98, 443n95

Rubbiyat (verse form), 260, 262, 270, 286–290, 299

Rūmī, 434n100

Russell, Alexander, 437n30

Russell, Bruce, 460–61n36

Rycaut. *See* Ricaut

Sabu, 415, 472–73n50

Sa'dī, 31, 64, 309, 396, 438n42; *Gülistan* 31, 309, 431n55, 464n10, 464n12; *Kūlliyat* 396, 401

al-Sādiqī, 'Atāllah, 65

al-Safadī, 30–31, 58; "Plaint of the Lovelorn and Tears of the Disconsolate" 30–31

Safavid era, 72, 74, 308, 309, 317, 319, 464n22

Sahara Heat (Amantide-Scirocco), xviii

Said, Edward, xxi, xxii, xxxii, 6, 23–27, 51, 53, 54, 194, 226, 336, 340, 382, 435n1; *Culture and Imperialism* xxiiv, xxv, 424n22; *Orientalism* 23–27, 54, 429n33

Saki (wine server), 54, 57

Sanderson, John, 182, 452n40

Sandwich, Earl of, 433–34n85

Sandys, George, 32, 111, 432n60

Saslow, James M., 308, 463n7

Sattin, Anthony, 180, 452n32

Sayfī, 262

Scaliger, J. C., 111

Scheherazade (ballet), 99, 258, 364, 386–87

The Scented Garden (Crowley), 279–86, 298, 461n41

Schick, İrwin Cemil, xvii, 1, 52–53, 270, 383, 423n1

Schiff, Gert, 271, 461n37

Schmidt, Jan, 263, 432n63, 436n11

Schmitt, Arno and Jehoeda Sofer, 67, 76, 432n67, 439n54

Schmitz, Barbara, 465n27

Schor, Naomi, 466n57

Schweinfurth, George, Dr, 189–191, 453n60

Scotin, Gérard Jean Baptiste, 102

Seduction of the Mediterranean (Aldrich), 439n55

Şehraşub, 57

Sedgwick, Eve, xxv, xxvi, xxxi, 122, 422, 424n24

Şehrengiz (poetic genre), 57–59, 86, 102, 115, 145, 259, 262–70, 271, 279, 283, 289, 290, 297–98, 299, 302–3, 315, 383, 390, 408, 436n11, 459n14

Seif, Salah Abu, 90, 457n12

Seiffert, Paul, 443–44n103

Segal, Naomi, 456n4

Selim III (Sultan), 263

Seven Pillars of Wisdom (Lawrence), 17, 443n94

Sexual tourism, xxix, 180, 225–27, 229, 394

Seyahatname ["Book of Travels"] (Evliya Çelebi), 59–60, 115, 430n41

Shabbat, An Egyptian (Critchfield), 186, 453n50

Shadow-puppetry (*Karaghioz*), 18, 107, 178, 295, 451n22

Shah 'Abbas, 60, 63, 313, 320

Shah Isma'il, 313

Shakespeare, William, 163, 168, 218, 283, 418; *Antony and Cleopatra* 163–64, 168, 218, 449n1; *Hamlet* (in Chahine) 245, 247, 250, 252

Sharī'a (religious law), 18, 47, 140

Sharma, Sunil, 436n11

Sharpe, Jenny, 429n33

Sheykh-Muhammad, 310

The Sheik (film), 414, 416

The Sheik (Hull), 91, 414, 442n86, 472n44

The Sheltering Sky (Bowles), 17

Sigel, Lisa Z., 460n35, 462n56

Silverman, Kaja, 469n8

Simon of Semeon, 178

Sims, Eleanor, 313, 332, 464n10

Simpson, Marianna Shreve, 334, 465n35

Slade, Adolphus, 60, 99, 104, 437n24, 437n30

Sladen, Douglas, 385–86, 390; *Queer Things About Egypt* 385, 469n13

Sleigh, Sylvia, xxvii–xxviii, 88–89, 368, 383, 419

Sluhovsky, Moshe, 434n97, 461n44

Smalls, James, 306, 340, 354–55, 468n84

Smith, Bruce, 426n3

Smith, Craig S., 462–63n57

Smith, Todd D., 470n23

The Snake Charmer (Gérôme), 54, 88, 89, 336, 341–43, 467n64

Snyder, Gary, 455n93

Sodomy, xvii–xviii, 3–5, 6, 7–9, 15, 20–22, 29, 30–31, 32, 35–36, 38, 43–44, 33, 45–46, 48, 51, 54, 62, 67–77, 78, 80, 81, 98, 103–4, 107, 113, 116, 130, 133–34, 138, 139, 141, 174–75, 178, 185, 186, 195–96, 199, 202, 212–13, 217, 220, 221, 256, 281, 285, 355, 396, 397, 398, 401–2, 409, 412, 458n5; age-differentiated 48, 51, 75, 107, 397; alternative practices 69, 72, 74, 75–77, 219; and penetration as power 69, 175, 212–13, 216–17, 382; conventional roles in 48, 67–69, 235, 236; role-reversals 74–75, 226, 285, 402–3; simulated in dance 103–4

Sofer, Jehoeda, 434n92

Sohbet (refined garden party), 13, 38, 40, 74, 311, 313, 324, 332

Solomon-Godeau, Abigal, 306, 336

Son of the Sheik (Hull), 414

Sonnini, C. F., 179, 433n82

Southgate, Horatio, 44, 313; *Travels* 44, 433n80

Southgate, Minoo S., 431n56

Southworth, Alvin, 444n114

Spivak, Gayatri, 429n33

Sprachman, Paul, 438n42, 459n12

Spring, Justin, 472n48

Stade, George, 209, 454n69

Stein, Jeff, 471n38

St. Clement, 178, 451n21

St. John, John Augustus, 63, 65, 438n40

Starr, Martin P., 281, 461n41

Stephens, J[ohn] L[loyd], 115, 445n8

Stewart, Angus, 65–66; *Tangier: A Writer's Notebook* 65, 439n51

Stoler, Ann Laura, xxvi, 28, 422, 424n23

Storrs, Ronald, 452n32

Story of a Spahi (Loti), 122

Stowitts, Hubert Julien, 388–89

Strimpe, Louis, 96

Studlar, Gaylyn, 472n47

Suetonis, 450n8

Sweet, David LeHardy, 456n4

Sufis, Sufism, 11, 18, 62, 64, 76, 107, 135, 270, 280, 283, 285, 332, 364, 398, 401, 427n15, 440n62, 440n63, 470n25

Süleyman (Sultan), 32, 81

Sutin, Lawrence, 461n40

Sutor, Jacob (Dr. Jacobus), 184, 186; *L'amour aux colonies* 184, 453n46

Suzani, 69, 95

Tables of Delicacies Concerning the Rules of Social Gatherings (Mustafa Âli), 34–35, 36, 38, 59, 62, 115, 427n16

al-Tahtāwī, Rifā'ah, 430n47

Takhallus (poetic signature), 282, 435n6, 460n23

Taliban, 259, 299–303

Taliban (Dworzak), 299, 462n55

Tangier: A Writer's Notebook (Stewart), 65, 439n51

Tarih-i Peçevi (Peçevi), 32

Taşhcali Yahya, 262

Taylor, Elizabeth, 167, 168

Terrorist Assemblages (Puar), 257, 425n39

"Testament: Cairo" (Maugham), 224, 229–232, 240, 457n6

al-Tīfāshī, Ahmad, 55, 64, 74, 77, 267, 460n26; *Delight of Hearts* 55, 74, 267, 435n9

Thesiger, Wilfred, 63–64, 390–92; *Arabian Sands* 63–64, 438n41

de Thevenot, Monsieur [Jean], 45, 54, 57, 99, 102, 104, 181, 187, 433n82

Theweleit, Klaus, 355, 468n87

Thief of Bagdad (film versions), 387, 414–15

Thompson, Charles, 433n75

Thousand Nights and A Night, The Book of the (also Thousand and One Nights, Arabian Nights, Book of One Thousand Nights and a Night), 96, 178, 190–91, 223, 266, 267, 270, 342, 389, 414, 416, 417, 421, 422, 428n23, 434n91. See also Burton, Galland, Pasolini

Tidrick, Kathryn, 91; *Heart-Beguiling Araby* 91, 442n85

Tirafkan, Sadegh, 382–83, 419

Titley, Nora, 309, 312, 464n9
Tom of Finland, 86, 403
de Tournefort, Monsieur Joseph Pitton, 111, 114, 432n68
Totall Discourse, of the Rare Adventures (Lithgow), 35, 433n69
Tott, François Baron, 104, 444n111
Traub, Valerie, xxii, xxix, xxx, xxxi, 424n10
Travels in Mesopotamia (Buckingham), 43, 433n76
Tromans, Nicolas, 340, 436n6
Travel narrative, xxii, xxiii, 27–44, 78, 104, 165, 170, 192, 193–94, 224–25, 290–92, 297–98, 299, 343, 385, 404
Travels (Southgate), 44, 433n80
The True Narrative of A Wonderful Accident, Which Occur'd Upon The Execution of a Christian Slave at Aleppo in Turky (anon.), xii, 6–11, 14, 15, 23, 29, 32, 426n8
Turberfield, Peter James, 447n25
Turhan Hatice, 117
Turks, Moors, and Englishmen (Matar), xxiii

Ubel, Michael, 430n49
Ubnah (passive adult male), 48, 74, 438n39, 439n59
Umayyad era, 54

Vali Khan Gurjistani, 436n13
Valentino, Rudolph, 414, 471n33, 472n48
Vanita, Ruth, xxxi, 425n42
Varisco, Daniel Martin, 423n8
Vereschchagin, Vasily, 467n64
Vernet, Horace, 355–56
Veryard, E., 181, 452n35
von Gloeden, Baron Wilhelm, 68, 259, 271–75, 319, 368–69, 372, 389, 392, 402, 460n36, 461n38
Volney, C. F., 45, 81, 178, 433n83
Voyage into the Levant (Blount), 43, 433n79
Voyage secret: Tunisie (Giliberti), 372

Wake, Clive, 447n28
Walker, Alexander, 472n48
Warren, Patricia Nell, 412
Waugh, Thomas, 404–5, 461n39
Weber, Bruce, 389
Weeks, Emily M., 337, 339, 465n39
Welch, Anthony, 317, 463n8
Welch, Stuart Cary, 463n8, 464n16
Warhol, Andy, 368
Whitaker, Brian, 428n27
White, Charles, 445n8
William of Ada, 178
Wilde, Oscar, 271, 280, 282, 364, 415
Williams, Linda, 470n23
Wingrove, David, 454n75
Wojtkowiak, Swiatek, 88–90
Wolcott, James, 209, 212, 450n4
Wollen, Peter, 468n3
Women, roles in homoerotics of Orientalism, xix–xx, 18, 45, 117, 119, 141–42, 160, 247, 414
A Wonderful Accident. See True Narrative of.
Woolf, Virginia, 258, 281, 282
World War I, 180
World War II, 91, 203, 233, 238, 244–45, 365
Wright, Alastair, 466n55
Wright, Barbara, 350–51, 467n78
Wright, J. W. Jr, 435n5

Yeager, Jack, 457n1
Yilmazkaya, Orhan, 441n70
Yacobian Building (al-Aswānī, ʿAla), 233, 235–37, 457n9

Zati, 262
Zulfikar, Yekta, 449n45
Zeʾevi, Dror, xii, xxi, xxii, xxviii, 18, 35, 47, 48, 77, 424n9, 427n15
Zenan-name ["Book of Women"] (Fazil Bey), 459n18